MOONSEED

Stephen Baxter

HarperPrism
A Division of HarperCollinsPublishers

♛ HarperPrism
A Division of HarperCollins*Publishers*
10 East 53rd Street, New York, NY 10022–5299

ISBN 0-06-105903-X

A hardcover edition of this book was published
in 1998 by HarperPrism.

First paperback printing: October 1999

Printed in the United States of America

Visit HarperPrism on the World Wide Web at
http://www.harperprism.com

❖ 10 9 8 7 6 5 4 3 2 1

BOOKS BY STEPHEN BAXTER

Novels and stories in the Xeelee Sequence:

Raft

Timelike Infinity

*Flux**

*Ring**

*Vacuum Diagrams**

*Anti-Ice**

*The Time Ships**

*Voyage**

*Titan**

Traces

*Silverhair**

* Published by HarperPrism

For Sandra, with all my love

Dramatis Personae

Henry Meacher, geologist, NASA
Geena Bourne, Space Station astronaut
Jane Dundas, shopkeeper
Arkady Berezovoy, Space Station astronaut

Great Britain

EDINBURGH:

Jack Dundas, son of Jane
Mike Dundas, technician
Ted Dundas, retired police officer
Ruth Clark, neighbor of Ted Dundas
Hamish Macrae, aka Bran, cult leader
Billy Macrae, brother of Hamish
Alan Macrae, father of Hamish
Dan McDiarmid, geologist, Edinburgh University
Marge Case, geologist, Edinburgh University
Constable Morag Decker, police officer
Blue Ishiguro, geologist, USGS
William MacEwen, police superintendent
Paula Romano, Chief Constable
Archie Ferguson, Emergency Planning Officer
Janice Docherty, hospital patient
Siobhan Reader, Musselburgh Rest Center manager

OTHER:

Bob Farnes, Prime Minister
Dave Holland, Environment Secretary
Indira Bhide, Home Secretary
Debbie Sturrock, firefighter, Dunbar
William Calder, Jackie Brown, rig workers
Jenny Calder, wife to William

United States

Japan

Lunar Federal Republic

I

BIG WHACK

It began in a moment of unimaginable violence, five billion years before humans walked the Earth.

There was a cloud, of gas and dust, slowly spinning. Much of it was the hydrogen and helium which had emerged from the Big Bang itself, but it was tainted by crystals of ice—ammonia, water and methane—and dust motes rich in iron, magnesium and silica, even some grains of pure metal. These were flotsam from older stars, stars already dead.

. . . And now another star died, a giant, in the conclusive spasm of supernova. A flood of energy and matter hammered into the cloud.

The cloud lost its stability, and began to collapse, to a spinning disc. The central mass shone cherry red, then gradually brightened to white, until—after a hundred million years—it burst into fusion life.

It was the protostar which would become the sun.

Within the disc, solid particles began to crystallize. There were grains of rock—silicate minerals called olivines and pyroxenes—and minerals of iron and nickel, kamacite and taenite. The particles, stuck together by melting ice, formed planetesimals, muddy lumps which swarmed on looping, irregular orbits around the sun.

The planetesimals collided.

Where an impact was head-on, the worldlets could be shattered. But where the collisions were gentle, the worldlets could nudge into each other, stick together, merge. Soon, some aggregations were large enough to draw in their smaller companions.

Thus, young Earth: a chaotic mixture of silicates, metals and trapped gases, cruising like a hungry shark in a thinning ring of worldlets.

Earth's bulk was warm, for the heat of accumulation and of supernova radioactive decay was trapped inside. The metals, heavier than the silicates, sank to the center, and around the new, hot core, a rocky mantle gathered. Gases trapped in the core were driven out, and formed Earth's first atmosphere: a massive layer of hydrogen, helium, methane, water, nitrogen and other gases, amounting to ten percent of Earth's total mass.

Earth's evolution continued, busily, logically.

But something massive was approaching.

"Look up, Tracy. Look at the Moon. You know, we take that damn thing for granted. But if it suddenly appeared in the sky, if it was Mercury hauled up here from the center of the Solar System, my gosh, it would be the story of the century . . ."

It was 1973.

Her father, Jays, had been back from the Moon only a couple of months. Tracy Malone, ten years old, thought he'd come back . . . different.

"Look up," he said again, and she obeyed, turning from his face to the Moon.

The face of the Man in the Moon glared down at Tracy. It was a composition of gray and white, flat and unchanging, hanging like a lantern in the muggy Houston sky.

"The Moon looks like a disc," said her father, in his stiff schoolteacher way. "But it isn't. That's an optical illusion. It's a rocky world, a ball. You know that, don't you, sweet pea?"

Of course I know that. "Yes, Dad."

"People used to think the Moon was like the Earth. They gave those dark gray patches the names of oceans. Well, now we know they are seas of frozen lava. Think about that. And those brighter areas are the highlands, rocky and old. Now, look for the Man's right eye: you see it? That dis-

tinct circle? That's what we call the Mare Imbrium. It's actually one huge crater, big enough to swallow Texas. It was gouged out by a gigantic meteorite impact almost four billion years ago. What a sight that must have been."

"But there was nobody around to watch it. Not even the dinosaurs."

"That's right. And then, much later, it got flooded with basalt—"

"Where did Neil Armstrong land?"

"Look for the Man's left eye. See the way it's sort of sad and drooping? Follow that eye down and you come to Mare Tranquillitatis."

"Tranquillity Base."

"That's right. Neil put his LM down just by the Man's lower eyelid."

"Can I see your crater?"

"No. Most craters are too small for people to see. But I can show you where it is. Look again at that big right eye. See the way the mare's gray extends beyond the circle, out of the Imbrium basin itself? That's Procellarum, the Ocean of Storms. That's where Apollo 12 landed, where Pete Conrad put his LM down right next to that old Surveyor. Well, my crater is on the border there, between Imbrium and Procellarum."

"I can't see it."

"It's called Aristarchus. It's named after the man who figured out how far away the Moon is, two thousand years ago . . ."

She looked at his pointing hand. Even though he had washed and showered, over and over, she saw there was still black Moon dust under his fingernails, and ground into the tips of his fingers. It was going to take a long time for him to get clean.

He was still dog tired after the trip. But he couldn't sleep. Even when he lay flat in his bunk, he said, it felt as if his body was tilted head down. There was, he said, too much *gravity* here.

A lot of stuff had happened up there, she suspected, that he would never tell her.

He ruffled her hair. "You think you'll ever get to go to the Moon?"

"What for? There's nothing there but a bunch of old rocks."

"I thought you liked rocks. Your collection—"

"I like real rocks."

"Moon rocks are real."

"But they won't let you touch 'em."

"Maybe. Anyhow, you're wrong. About the Moon. It's not just rocks. If you lived there you could make metals, and oxygen to breathe, and there's silica to make glass. And with the water from the Poles, you could farm up there."

"Water? I thought there's no air."

"There isn't. But there is ice at the Poles. Deep in the dark, where the sun never shines."

"Really? A lot of ice?"

Her father hesitated. "Well, some people think so."

"Anyhow," she said, "I don't want to be a farmer."

Her father stared up at the Moon. "You know, you're special. I wrote your name up there, in the dust, and it will be there for a million years."

"You told me, Dad."

"Yeah."

A cloud passed over the Moon's face. It got colder.

They went indoors to watch TV.

One day, human scientists would call it the Impactor.

It had about the mass of Mars, a tenth of Earth's. Humans would later speculate that it was a young planet in its own right.

But they were wrong. It was not a planet.

The object barreled through the dusty plane of the Solar System.

But there seemed to be something in the way.

* * *

. . . And on the Moon, the Rover had jolted across the bright dust, climbing gentle slopes under the black sky, bathed in the sun's flat light.

It must have looked strange, Jays thought, if there had been anyone around to see it. The Rover looked like a beach buggy from somebody's home workshop. And yet here were the two of them in their shining white pressure suits, like two dough boys riding a construction-kit car, bouncing across the Moon itself.

They rose up a slight incline.

Suddenly there was the rille: Schröter's Valley, a gap in the landscape in front of them. It wound into the distance, its walls curving smoothly through shadows and sunlight. Jays could see boulders that must have been the size of apartment blocks, strewn over its floor.

Jays tried to keep the excitement out of his voice. "Look at that old rille. I'm sure I can see layering in the far side. Look, Tom. Over at one o'clock."

Tom, distracted by the driving, said, "Let's get up there before we do any geology."

The Rover jolted to a stop.

Jays released his seat belt, and let it snap back into its frame. He tried to stand up. But the slope was deceptive; it was an effort to haul his suited frame out of the Rover's lawn seat.

He took a step away from the Rover.

His suit was a stiff bubble around him, shutting out the Moon. He could hear the whir of pumps and fans in his backpack, feel the reassuring breath of oxygen over his face. The sunlight caught scuffs and scratches in his gold-tinted sun visor, creating starbursts.

He looked up, toward the south, and there was the Earth, hanging in the sky like a blue thumbnail. He could see a depression over the South Atlantic, a fat white swirl. Other than the Earth and the big white spotlight that was

the sun, the sky was empty: save only for a single bright star that tracked across the zenith every couple of hours. That was the Apollo Command Module, waiting in orbit to take them home.

Jays, when you climb off, could you dust off our TV lens, please?

"Roger."

He turned back to the Rover. The TV camera, operated from Houston, was a block covered by gold-colored insulation, mounted on a bracket at the front of the Rover. He could see that dust had kicked up over the lens and insulation and cabling.

He leaned forward. He took a breath, out of instinct, as if he could just blow the thin dust layer away. But this wasn't Earth; there was no air here; and his head was locked inside a bubble of Plexiglas . . . He looked for the soft lens brush, and swept away the dust.

As soon as he was done the camera turned away by itself, and began to pan across the landscape in eerie silence.

It was, perhaps, the most dramatic collision event in the history of the Solar System. Humans—trying to figure out how their world and its unlikely, huge Moon had come to be— would call it the Big Whack.

The Impactor hit Earth obliquely, like a cue ball kissing its target. Earth, much more massive, absorbed the momentum of the Impactor and spun up its rotation. Mantle material vaporized and entered orbit around the Earth. Earth's crust melted; Earth became, as if young again, a roiling ball of lava.

The orbital cloud of superheated mantle rock condensed into droplets, a dusty, rocky ring circling the Earth. But the ring was not stable. In a miniature rerun of the formation of the Solar System itself, the debris began to accrete.

It took a mere century for the debris to assemble into a new world: it was the Moon, a ball of magma glowing bale-

fully in Earth's sky. The remains of the Impactor were trapped in the Moon's heart.

The new world was coming of age in a Solar System that was still very young, and huge leftover planetesimals continued to bombard its surface. Impact basins formed, wounds huge and deep, and waves of pulverized rock rushed over the surface of the Moon to form gigantic ringed structures. Immense blankets of ejecta were hurled thousands of miles over the battered ground. But so intense was the continuing flux that the formations were themselves soon shattered and covered over.

At last the flux of planetesimals began to tail off. In a moment of geological time, the last great impacts formed basins and mountains which froze forever the face of the Moon.

The Moon became a small, cold world, its evolution over a billion years after its birth, its youngest rocks more antique than Earth's oldest.

And, far beneath the dusty plains, the remnant of the Impactor brooded, embedded in darkness.

On the Moon, Tom Barber was going through Rover read-outs for Houston. "Amp-hours 90, 92. Voltages 68, 68. Battery temperatures 101 and about 100; motor temps off scale, low. Bearing is 088, range 1.8, distance 2.5 klicks."

Thank you . . .

Jays picked up a couple of sample bags from the stowage in back of the Rover, and took the geology hammer from Tom's backpack, and his tongs from the Rover's footpan. He pulled the gnomon out from its stowage sleeve behind his seat. In stowage, the gnomon's three legs were folded against the central staff to make a slender sheaf. When he extracted it the legs sprang out into a spindly tripod.

Carrying his tools he loped away, toward the rille.

The regolith crunched under his feet, sinking maybe a half-inch, before he settled to a firmer footing. The dust

sprayed around his feet, sinking quickly back to the surface. It was like walking on crisp, frozen snow, or maybe a cinder track.

He had to climb up a slight incline to reach the rille's rim. He was out of breath in a few steps.

Still, he persisted.

He paused for a breath. He turned and looked back at the skeletal Rover. It looked like an ugly toy: squat and low, sitting there in a churned-up circle of dust. Its orange fenders and gold insulation were the brightest things on the surface of the Moon. A few yards beyond the Rover, Tom was working. He was gouging at the surface with a long-handled tool, taking a rake sample of the dust. His red commander's armbands were bright.

Jays took a swig of water from the bag inside his suit. He felt his chin strap rasp against a week-old beard. He'd promised his daughter, Tracy, that he wouldn't shave until he got home. After all, in the picture books, the explorers always came home with beards.

The Rover's television camera was watching him, cold and judgmental. Time is ticking on, it seemed to say, billion-dollar seconds wasting while you stand there and goof off.

He turned and continued.

He reached a flat crest, and came suddenly on the rille.

He stopped. He raised the five-hundred-mil camera from its bracket on his chest, and took a horizontal pan, turning slowly, and then a vertical pan, all the time geologizing, describing what he saw.

The rille was up to eight miles wide, a half-mile deep, and all of a hundred miles long. Schröter's Valley, the biggest rille known on the Moon. It was a river valley, but cut into the bottom of this dead lunar sea—not by water—by a lava flow, some time in the deep past.

He stepped forward again.

As he approached, the surface of the mare sloped gently toward the rille rim, and the regolith was getting visibly

thinner. The rille walls sloped at maybe twenty-five or thirty degrees.

The sun was behind him. The far walls were in full sunlight, and now Jays was sure he could see layers: distinct strata in the rock, poking through the light dust coating.

Excited, he described what he saw. "Okay, Joe, I think I can see from top to bottom, one distinct layer about ten percent, which has multiple layers within it. And another at about forty percent down, which looks like a solid unit of a somewhat harder, tan-colored rock, but it's covered with fines and talus. We haven't seen to the bottom; I think I'll get the chance to go farther down . . ."

He felt his heart thump. The rille layers were a record of the Moon's volcanism, the strata left by ancient basalt floods, driven by an internal heat that had all but died almost as soon as the Moon formed.

The only other volcanic remnants Apollo crews had found had been dug out by impacts, shattered and melted and reformed, scattered over the surface, heavily processed. In the rille walls, though, he was facing true lunar bedrock. What he had come for.

Samples of basalt from the maria—the lunar seas, like Apollo 11's Tranquillity—would take you back as far as the age of mare volcanism, when founts of lava had flooded the great impact basins. But if you wanted to look further you had to go find bedrock: dusty windows on even greater antiquity, all the way back to the birth of the Moon.

Bedrock was the core of the mission, as far as Jays was concerned. And a big fat sample of bedrock, maybe from deep inside that old rille, would be his trophy fish.

He felt his soul expanding.

Nobody had ever seen this sight before, nobody. And, no matter who came after him, for whatever purpose, no matter how much smarter they were than him, they could never take that away. Schröter's Valley would forever be a part of him.

He went over a crest, and was now descending into the rille itself. But there was no sharp drop-off; like every other

surface here the rille wall was eroded to smoothness, and the footing was secure, the regolith layer thin.

For a moment he thought he glimpsed a stretch of the very bottom of the rille. Something shining there. But that was impossible, of course. It had to be a trick of the light. A scuff on his faceplate.

. . . And then he saw it, sheltering beneath a hummock in the regolith. It was a dark basalt, a lava lump about the size and shape of a football. When he brushed away the regolith he could see it was protruding from a rock layer, like the ones he could see so clearly on the far side of the rille.

Jays wanted to get this one right.

He took careful photographs of the rock in its resting place. Then he tried to set up the gnomon beside it, the smart little tripod that would give him scale, local vertical and orientation compared to the angle of the sun.

This was called *documenting the sample*. The idea was that back on Earth, if they knew exactly how the sample had been taken, the scientists would be able to reconstruct the geology of the area at leisure.

But the documenting turned out to be a scramble. The slope was too steep for the gnomon, and he wasn't sure the photographs would pick out the rock from its background. He did his best; but the guys in the geology back rooms didn't always understand how tough their procedures were to follow once you were *here* . . . Still, surely the rock would be worth it.

Of course the rock would be given a number of its own. A five-digit code: "eight" for Apollo 18, "six" because this was their sixth survey stop, and a number for the sample in the order they'd taken samples here, which had to be up in the forties or fifties already, he figured.

He bent sideways, stiff in his inflated suit. He was able just to pick up the rock; it fit his hand as if it had been meant for him.

He put his prize in a numbered Teflon bag. Then he photographed the place the rock had come from.

Movement. The dust was *stirring,* where he'd lifted the rock. When he looked again, the movement wasn't there.

Never had been there. *Been out here too long, Jays.*

Tom was calling. They had to complete a rake sample, a random representative selection of the rocks here, and then move on.

He had just arrived, having come all this way, and it was already time to leave.

Jays took a last glance down inside the rille. He tried to peer down as deep as he could, straining to see to the bottom. The slope looked easy; he wished he could go a little farther, deeper into the rille. But he knew he mustn't. He was a long way from Tom's helping hands, if he ran into trouble. And anyhow, he was behind the timeline.

He knew he wouldn't mention what he'd seen to Tom.

On impulse, he leaned over, scooped up another fragment of the bedrock sample, stuffed it inside a sample bag and crammed it into a pocket on his leg.

Then, his bedrock under his arm, he snapped shut his sun visor and clambered back up the slope, toward Tom and the waiting Rover.

After a four-billion-year wait, the visit with its burst of activity had lasted only three days, the final flurry of dust settling after only seconds.

At Aristarchus Base, Rover tracks and footprints converged on the truncated base of the abandoned Lunar Module. The blast of the departed ascent stage's engine had left a new ray system, streaks of dust which overlaid the footprints.

Now the Moon was inert once more, the sculpted hills of the Aristarchus ejecta blanket rising above this puddle of pitted, frozen basalt, their slopes bathed in sunlight, shining like fresh snow.

Waiting.

In places, the disturbed dust stirred. Glowed softly silver.

Part 2

ARD TOR

1

Geena Bourne woke up before dawn. She was, of course, alone in the apartment.

She got up in the dark and walked around putting on lights.

Henry had gone.

Fled. But he'd taken nothing. No furniture, no carpets or curtains, no CDs or books, not even his own clothes. Nothing but his geology hammer, as far as she could see.

Oh, and Rocky, their labrador, the Rock Hound.

Shit.

It was worse than if he'd taken everything, or trashed the place.

Still, she knew where he'd be. She pulled a coat over her pajamas, got in the car and drove out, through the night, to the USGS.

It was cold. Always cold, here in the mountains.

The Cascades Observatory of the United States Geological Survey was a squat, unimposing two-story building, a slab of cinder block. In the harsh, incomplete glow of its security lights it looked sinister, like some prison block transported from Soviet Russia.

She had a little trouble with the guards. *Lady, it's 3 A.M. Do you know what time it is? 3 A.M.* . . . But her NASA pass and a little sweet-talking got her inside.

And here was Henry, tucked up on top of a sleeping bag he'd spread out on the floor of his cramped office. The clutter of his work lay everywhere: geological maps and structure charts, trays of samples, microscope slides with slivers of rock, electronic parts, his precious polarizing

microscope inside its grimy, worn-smooth wooden box. And Henry himself in the middle of it all, as sound asleep as if he were out on a field expedition in the Kalahari, his long, thin body folded over, his heavy black hair falling around his face.

Rocky was here, lying on a blanket in a crate in the corner. The mutt came forward, licked her hand regretfully, and went back to the crate and fell asleep.

She prodded Henry's kidney with her toe, reasonably gently. "Hey. Crocodile Dundee. Wake up."

He came awake, with an ease she'd always envied.

"It's you." He rolled over and sat up.

"Of course it's me."

"I left, Geena. It's over."

"Do you have any coffee in here?"

He ran his hand over his stubble and yawned. "No," he said. "Go away and leave me alone."

"Believe me," she snapped back, "there's nothing I'd like better. But I can't just walk away."

"Why not?"

"Because we have things to talk about."

"Geena, my lunar probes just got canned. My career is stiffed. *What* things?"

"Our assets, Henry. Our property."

"All there is, is *stuff.* Burn it. I don't care. Sell the apartment. It was no use anyhow, since we both spent the last two years working out of Houston."

She said heavily, "We're taking apart our home."

He closed his eyes.

"I know."

"Then you can't just walk away. You have to go through the pain, Henry . . ."

There was a light in the window.

Maybe it was the torch beam of some security guy, Geena thought, distracted. Rocky whined a little, and padded over to the window. Whatever the light was, it was high up; it cast Rocky's shadow on the floor behind him.

Not a torch beam, then.

Even as she tried to deal with this situation with Henry, her damn problem-solving brain kept working. Something in the sky. A chopper beam, maybe a police patrol? But the beam would shift. And there'd be noise. The Moon, then? But the light was the wrong quality, vaguely yellow-white. And besides, the Moon was near new tonight.

The dog was staring up at the light as if he'd seen a ghost.

She said, "What about the dog?"

"He comes with me. He's my dog. He predates you."

"I suppose he does. But he's used to staying with my mother—"

Henry unfolded off the floor and stretched, tall and wiry, strong hands flexing. His face was dark in the uncertain light from the window, weather-beaten by all those days in the field. He looked toward the yellow glow at the window. "What the hell's that?"

"I thought it was a chopper. But it isn't."

"No."

They walked toward the dog, still standing in his shaft of light, Henry's bare feet padding on the tiled floor.

". . . Jesus," he said.

"What is it?"

Henry was standing over the dog, staring up into the anomalous light. She came to stand beside him.

The light, beaming in through the window, was so bright it was glaring, dazzling, like a spotlight in the face. But she could see it was a point source.

It was fixed in the sky. There was no noise, no rotor clutter.

The light was eerie. Not part of the natural order. This is bad news, she felt instinctively.

"What do you think?" he said. "A planet?"

"Too bright."

"A satellite?"

"Not moving quickly enough."

"A star, then," he said. "It would have to be a nova. Or a supernova." He frowned. "I don't like it."

"In case it's a supernova?"

"Even if not. It shouldn't be there." He glanced at her. "Don't you feel it?"

"Yes," she said reluctantly. "I guess I do." Bad news. "What would a supernova do to Earth?"

He shrugged. "Depends how close. Supernovas are candidates for causing extinction events in the past. The radiation burst, the heavy particles ... A massive star exploding within a hundred light years might give the planet a dose of five hundred roentgens."

"Enough to kill."

"Oh, yes. Even the trees. Did you know that? Trees are about as sensitive to radiation as humans. Also, all that ultraviolet hitting the atmosphere—disassociated nitrogen will oxidize to form nitrous oxide, which will react with the ozone and deplete it—"

"Just as well we destroyed the ozone layer already, then," she said dryly. "But maybe it isn't a supernova."

She couldn't identify what part of the sky this lamp hung in. Her astronomy wasn't so good, considering her career choice. But then it didn't need to be, if you planned to spend your working life in low Earth orbit. "What else could it be?"

He leaned forward, resting his hands on the window ledge, and looked around the sky. "I wish they'd clean these windows. Kind of a poor observing platform we have here . . . Oh."

"What?"

"I think it's Venus."

She frowned. "Venus, the planet?"

He said heavily, "What other Venus? It's right where Venus is supposed to be, tonight. And I don't see any bright object nearby that could be Venus. So, it's Venus."

"But how can it suddenly become so bright?" She remembered an old science fiction story. "*Oh.* Venus is

closer to the sun than Earth. What if the sun has flared? Or even gone nova? And the reflected light—"

"No." He shook his head. "It's near superior conjunction right now. Which means it's on the far side of the sun, so showing us a full face. So if you think about it, by the time the increased sunlight reflected off Venus and crossed space to get here—"

"The sunlight would have reached us direct, already." A suppressed sigh of relief. "So Venus itself must have gotten brighter."

"Which is impossible."

"Is it? Maybe it's some kind of volcanic thing."

"What kind of *volcanic thing?*"

She was used to his sarcasm. "You're the geologist. Think of something."

He went to the back of the office, and came back with a scuffed pair of binoculars. He raised them and focused them briskly.

He whistled.

"What?"

He passed her the binoculars, leaving the strap around his neck, so she had to lean toward him to use them. She scanned around the sky, seeking the glare.

The binoculars resolved the distant, fixed stars to points. The glasses were too weak, she realized, to resolve Venus—on normal nights—to anything better than a minute disc, or crescent, at best.

But this wasn't a normal night.

Where Venus ought to have been there was a bright, smudged disc, not quite symmetrical.

"Holy God," she said.

"I think," Henry said, "that Venus has exploded."

The call didn't wake Monica Beus, for the simple reason that she hadn't been asleep.

"Yes?"

Monica. It's me. Alfred.

Alfred Synge: astronomer, colleague, lover back when they and the world were young.

"Where are you?"

Kitts Peak. The observatory. Have you seen it yet?

"What?"

Take a look out the window.

She lay for a minute in the stale warmth of her bed. The insomnia was the worst thing, for her, about the diagnosis.

Breast cancer. What the hell kind of thing was that for her to contract? Her breasts had gotten her nothing but unwelcome attention when she was younger; she was of a generation that had been encouraged to use them as little as possible for what they were intended, which was to suckle children; and now some cosmic ray, a random piece of debris from some long-gone supernova explosion, had come whizzing across space in order to zap her *just so* . . .

If any of it made sense, it might be acceptable. But it didn't. If she had no stake in the world—if her son, Garry, and his family, didn't exist—it might be reasonable. But she did have.

She missed the ability to sleep, though. She longed for the ability to turn off her mind, the constant *thinking,* like a camera watching the world that never let up.

But sleepless or not she was warm and comfortable here, her aches and pains fooled into silence for a while, and she felt reluctant to climb out into the harshness of the cold, vertical world. And for what?

"What is it, Alfred? A lunar eclipse? A meteor shower?" Alfred did get a little carried away with his profession at times. It was enviable, a man whose job was his hobby, his passion. Also a little irritating.

Uncharacteristically, he hesitated. *I think you ought to see for yourself.*

"Why?"

You might want to think about waking the President.

Not a lunar eclipse, then.

She got out of bed, and her body set up a chorus of aches. She pulled on a housecoat, picked up the phone handset, and walked to the window.

She pulled back the heavy drapes and looked out over Aspen.

Dawn was coming, she saw, and the leaves of the trademark aspen trees were already glowing with the pearl light, bone white; the quaint street lamps were starting to dim. Another hour or so and the first light of another early spring day would be touching the Rockies.

Beautiful place. She had moved here to be close to her faculty, at the Center for Physics. She suspected she was going to have to move before long, though. She couldn't see how she could stand to die *here,* to leave behind so much beauty. Everybody should die someplace ugly, where it wouldn't matter so much . . .

On the other hand, maybe it was this beautiful place that was killing her. Up so high, poking out of Earth's shielding blanket of air, Aspen received twice the sea-level dose of radiation.

There was a new star in the morning sky, bright as a piece of the sun.

It's Venus, Alfred, on the telephone, was telling her. *Venus.*

It was casting shadows, long raking shadows, from the aspen tree stands.

The astrologers will be jumping up and down, she thought. We're only a few years into the new millennium . . . and now *this.*

"Venus? How can it be?"

I'm afraid there's no doubt. What you're seeing is reflected light from the sun, with some intrinsic illumination from the planet itself.

"Reflected light?"

Monica, the atmosphere seems to have—blown off. The planet is surrounded by an expanding sphere of gases and other debris.

"Debris? You mean rock?"

Yes. Also fusion products. And the intrinsic illumination—Monica, something is happening on the surface, or maybe in deeper layers. Something very energetic.

Alfred had first gotten the call from his night assistant, a graduate student. It was the student's job to control the big telescope Alfred was working on at Kitts Peak. Alfred, sitting in an office, confirmed whatever target star he wanted, and observations were made with spectroscopes and charged-couple detectors.

Nobody had been watching the planets, at Kitts Peak Observatory. It was just a casual glance out the window by the night assistant that had led to her noticing the change to Venus.

That was the way with modern astronomy, Monica thought wryly. Nobody looked *through* the big telescopes anymore.

We were finishing up for the night. We were actually getting ready to park the telescope and—

"Tell me what you did."

The first thing was to get on the IAU nets. The International Astronomy Union, the astronomers' jungle telegraph. *There are ground-based observers working on this all over the planet already, Monica. Also the radio telescopes. I contacted NASA; they're repositioning some of the satellites, for example the ultraviolet and X-ray and gamma ray observatories. We're also speaking to the Europeans, Canadians and Japanese. The Space Station astronauts are doing some good work. NASA are sending up high-altitude experiments, by balloon and sounding rocket and aircraft. NASA are responding quickly, in fact.*

"Well, NASA would," she said dryly. "They're probably putting together a budget proposal for a new Venus probe as we speak."

If they are you ought to back it, Alfred said. *Monica, we don't have the faintest understanding of what we're seeing here. Right now Venus is on the far side of the sun. It took around fourteen minutes for the light curve to show up here. Photons, traveling at light speed. A minute later, a cosmic ray shower showed up.*

"Cosmic rays, from *Venus?*"

You heard right. Very high-energy particles. And in about four hours we're expecting a blast shell to impact the top of Earth's atmosphere. The lower energy stuff, coming at thirty or forty million miles an hour. Monica, it's as if a miniature supernova went off in our back yard. Hell, we're even seeing a neutrino flux.

"That's impossible."

Nevertheless. I'm not anticipating a lot of sleep in the next few days. Monica, that thing is going to be naked-eye visible, even at noon. It's going to be unmissable.

So the public would wake up to it, to funny lights in the sky. Monica was one of the President's senior science advisors. How was Monica going to brief her on this? "Tell me what to expect."

The low-energy cosmic rays will be deflected by the Van Allen belts, which will fill up. We have to expect auroras. Spectacular stuff. Alfred sounded excited, as well he might, she mused; it sounded as if he might get priority on this discovery. *The higher-energy stuff will make it through to the atmosphere. Crack the air molecules, create showers of secondary particles. We have to expect a significant increase in background radiation.*

"How much? For how long?"

We don't know, Monica. We've never seen anything like this before. There is also the shower of X ray and gamma rays. We don't know how strong it will be at its peak. Maybe there will be some immediate deaths. More likely we will see a pulse of internal cancers, skin cancers, cataracts, in the coming months and years. We will have to monitor the food chain.

"What should the President tell people?"

To take radiation precautions. Get underground if they can; rock and soil is a good shield. The military and politicos ought to get into their nuclear shelters. If they still have them.

"They have them."

If the shower persists we'll have to think about lead-lining our surface buildings. Oh, air travel ought to be curtailed, at least monitored. And we ought to think about bringing the astronauts home from the Space Station.

"Enough. All right, Alfred. Thanks. I ought to make some calls."

Yes. Take care, Monica.

"And you. Keep in touch."

Oh, I will.

She put down the phone, and tried to think this through.

It was hard to focus on anything outside her own, failing body. As if she was a self-obsessed character in some daytime soap.

But, it seemed, she was still engaged with the world.

Outside, the light of day was gathering, but the ugly wound in the sky that was Venus was barely dimmed.

She put through a call to the White House.

Even after a week the light of new Venus, bright in the blue sky of a Scottish morning, made Jane Dundas shiver.

Anything so far out of the natural order made her shiver.

Or then again, maybe it was just *this place*. She looked up at the tower block. Its faceless windows reflected Venus a hundred times over, somehow without generating a shred of beauty. She clung a little harder to the hand of Jack, her ten-year-old son, and stepped forward.

Cordley Road was the site of some of Edinburgh's more notorious blocks of council housing. Even here, at the entrance, the block was intimidating: evidently repainted

and fitted with entry phones, but a leaking overflow had stained the entrance with damp, graffiti was splashed over the hall, and the shrubbery outside, newly planted, was littered with lager cans and cigarette packets.

The irony was the location here should be prized. Cordley Road was less than fifty yards from the perimeter of Holyrood Park, which contained Arthur's Seat—Ard Tor, the greatest of the extinct volcanoes on which Edinburgh had been built. She could see the Seat now, a lumpy shoulder of rock looming high to the east; just here she was in the shadow of the Salisbury Crags, a cliff-like extrusion of compounded ash from the old eruptions, glaring over the city like the guns of a battleship.

But what went on in the tower blocks here had nothing to do with anything so wonderful as extinct volcanoes.

Billy Macrae was here to let them in. Billy, ten years old, was one of Jack's friends from school, and brother to Joe, eleven, who was the kid who had been killed in the lift shaft. Billy had a pixie face compressed under a mat of black hair, and he looked like a wee rascal, as her father might have said. But today he looked subdued. No trouble at all, in fact.

Billy led them to his family's flat, which was, ironically, on the ground floor. The father let them in. Alan Macrae was a tired-looking man who was probably younger than Jane. No sign of a mother, Jane noted.

He waved them to the sofa. The place was sparsely furnished but clean enough, no more than the usual clutter kids created. Macrae offered them tea but Jane declined.

"We don't want to keep you."

"Aye. I'm sorry we couldn't have wee Jack to the funeral. We tried to keep it small. Just family."

"I understand."

Macrae made an effort to smile at Jack. "Joe used to talk about you."

"We played soccer," Jack said.

"Aye. Not in the hall here, I hope."

"No."

Jane nudged her son, and he produced his gift, a little parcel. Billy Macrae came forward and unwrapped it. It was an elephant, carved of black stone.

Jane smiled. "Jack chose it himself from my shop. The rock's basalt. Lava. The youngest rock on the planet. So it's appropriate."

Macrae nodded, and put the knick-knack on the shelf over the gas fire. "We got a lot of flowers. People put them in the lift. But they get robbed, of course. The council say they will put steel plates on the lift doors to stop the kids breaking in, fat lot of good that is now." He eyed Jane. "You're the one who runs that shop in Waverley Market. Rocks and stuff. Crystals."

"That's right."

He looked at the elephant. "I saw it, you know."

"What?"

"I was on the seventh floor, talking to a mate up there. The windows in the lift shaft doors are broken there. So I saw him fall. Terrible crashing and screaming."

Jane sat silently, and the boys looked at their feet miserably. It sounded as if Macrae was beyond grief, as if he'd told this story a hundred times over already, as if he couldn't stop telling it; his voice and face were empty of expression.

"Lift surfing, they call it," he said now. "Bloody stupid."

Jane forced a smile. "I used to play chicken on the motorway. All kids are stupid, until they learn better."

Macrae didn't seem to have heard. "They jam open the shaft doors, see, and that stops the lift going down. Then they get on the roof, and they know how to set the engineer's switch to "test," so they can control the lift. Joe got his bloody hand caught, and for some reason the lift started going down, and he fell down behind it, in some kind of maintenance shaft. And that's what I saw. Crashing and screaming. The thing of it was, at the bottom, he looked all right. Except for his mangled hand. Just asleep . . ."

And so on.

She stayed for a while longer, letting him talk out his grief a little more. Jack was restless, but she made him sit through it. Survival lesson, she thought. Listen and learn.

But it was hard. It seemed a long time before little Billy led them out.

In the yard, they all cast double shadows from sun and Venus, twin stars, and Jane shivered again.

"It was our Hamish," Billy said unexpectedly.

"What?"

Hamish turned out to be the elder brother of Billy and dead Joe. Eighteen years old. Jane realized, in retrospect, that there had been no sign of Hamish in his father's flat.

Hamish, it turned out, had led on the others.

"Hamish used to take stuff up there," Billy said.

"Stuff?"

"Lager. Ciggies and things. He even had a seat, so he could sit on top of the lift and ride up and down." Even now, even after all that had happened, Billy smiled faintly at the bravado and daring of his brother, and Jane realized anew how very, very difficult it was to restrain boys from following the pack, all the way into the jaws of death.

"But it was Hamish's fault," Billy said.

"It was?"

"He saw that planet thing." Billy pointed. "When it flared up, like. Hamish saw it through a window. That's why he let go of the doors, and the lift started going, and Joe fell down."

This boy will have to live with this. "Billy, Hamish is really just a kid too. Nobody's to blame—"

"Hamish says it's not his fault. It's the fault of *that*." And Billy's small, grubby hand pointed straight at Venus.

. . . And elsewhere in Edinburgh, a young policewoman called Morag Decker was pulling on her uniform, about to start her tour of duty. She was on attachment to a commu-

nity policing unit that night, and would be working with drug addicts. Not an assignment she was looking forward to, but a major problem in Edinburgh. When Venus had first flared up it had caused a problem, as the full-Moon types had crawled out from under their rocks to howl at the new light in the sky; and tomorrow the local Emergency Planning Officer was going to brief them on Scottish Office guidelines on radiation poisoning and other stuff . . . But all that seemed to be fading, like any other nine-day wonder. For tonight her head was full of apprehension, and she tried to comfort herself with thoughts about the video and takeaway Chinese meal and bottle of wine she'd treat herself to tomorrow night, and she scarcely noticed Venus any more . . .

. . . And to Debbie Sturrock, a trainee firefighter based along the coast in Dunbar, Venus was invisible, a light in the sky masked by the tower of flame she and her fellow students were trying to control, under the growling command of an unsympathetic station master. Fire in the sky meant nothing when you were confronted by fire on Earth . . .

. . . And in Glasgow, Scotland's biggest city, Jenny Calder had tried to follow the news—she had been interested in astronomy and science and stuff as a kid, and the Venus incident was strange and somehow disturbing—but now the kids were fighting again, this flat in the Gorbals, renovated or not, was just too small for all of them, and William, her husband, was worrying that if his new employers found out about his record he'd be kicked off the oil rig again, and so she pushed her hair from her eyes and stumbled from crisis to crisis, never quite falling over, and Venus was just too far away and too strange to deserve her attention . . .

. . . And around the world, in the U.S., an Air Force pilot called Garry Beus test-flew an enhanced F–16 over the baked desert of California and looked up at Venus, smeared and distorted by his canopy in an eggshell sky, and

thought with wistful sadness of his dying mother, Monica, and how she must be fascinated by this . . . And in Los Angeles, a journalist called Joely Stern, dismayed by yet another rejected job application, stared up at a Venus made Mars-red by filthy L.A. smog, and she stared at it, wishing she was up there, up in space, anywhere but *here* . . .

. . . And in Japan, a geologist called Blue Ishiguro watched the evolving light in the sky, fascinated, and wondered if he should call his friend Henry Meacher at NASA who might know more about this—but then he'd heard Henry was leaving NASA, not to mention Geena, and it mightn't be a good time . . . And, atop a Japanese mountain called Nantai, a Buddhist monk—originally from Ireland, called Declan Hague—stared at the strange light and wondered what it might mean for his self-imposed exile and the guilt that still racked him . . .

. . . All around the planet, as it turned in the wash of Venus light, human faces were lifted to the sky, shining in the strange light like coins in a well, amused or puzzled or wondering or indifferent . . .

. . . And in Houston, Tracy and Jays Malone spoke in hushed tones, so as not to wake the kids.

More than three decades after his Moonwalk, a few years into a whole new century, and here was Tracy with kids of her own, kids to whom Apollo was some sort of Cold War relic—not even that, something prehistoric and incomprehensible, something their grandfather had done. For somehow, as if mocking the old dreams, the space program had become a thing of the past, not the future.

But her name was undoubtedly, famously, written on the Moon—she'd seen photographs of it—and it would indeed be there for a million more years, less the few summers she had spent growing up since Jays came home.

So there had been only one place to come on this strange and cosmic night.

She stood with Jays on his verandah. It was just like all those years ago, except that now she cradled a pina colada in her hand instead of a soda.

And, in the dawn sky, there was a new light, which outshone even the battered old Moon.

"Quite a night," said Jays, the light casting sharp point-source shadows on his face. "Quite a week, in fact."

"Yeah." So it had been, all of seven days after the Venus event first showed in the sky.

According to the TV there had been Venus-watching parties all over the U.S., a predictable run on telescopes and binoculars in the stores. The Hubble Web sites had crashed from the hit traffic, even though NASA hadn't turned the Hubble that way yet.

She said, "Those guys on the TV, yammering about anti-matter comets and alien invaders. *The most remarkable week since Neil Armstrong touched down on the Moon—*"

"Or *since man came out of the caves.* Makes you miss Cronkite," he said, "and I've been farther out of the cave than most."

The heatless light of dying Venus made her shiver. "So what do you think has happened up there, Dad?"

"Danged if I know." His voice was light, but his face was a mask, expressionless. "I don't think it's a good omen, though."

And that made her more queasy than all the fantastic speculations of the TV pundits.

He touched her arm. "Come on. I want to show you something." He led her indoors, toward the lounge. "Something I never showed anyone. Not even your mother."

"Why not?"

He grinned, and put his beer down on top of the piano. "Because it's a federal offense." He started to rummage at the back of a dresser drawer.

She looked around the room. So familiar, nothing changed since she was a kid, it was like being transported back in time. It was an old guy's trophy room, with Jays's

photographs of airplanes and spacecraft, a whole-globe view of Earth taken with a hand-held Kodak, a little framed patch of spacesuit, gray with Moon dust. But everything was old and faded. Even the spacesuit piece looked like it had come over on the *Mayflower*.

Jays approached her. He was carrying something in a fist-sized plastic envelope. The plastic had gone yellow and brittle with age. In the gathering dawn light, she could see it held a piece of rock, black as tar.

"Oh, Dad. Is that what I think it is?"

"It's a piece of bedrock, sweet pea. It froze out of a lava flow, that bubbled out of the Moon more than three billion years ago . . ."

It was, of course, Moon rock.

"Are you supposed to have that?"

He grinned, his teeth white in Venus light. "Hell, no. I told you. It's a federal offense. I grabbed it when I was deep inside the rille, out of sight. They never missed it. Our documentation wasn't worth jack shit anyhow. I wanted to leave it to you and the kids. So I will. I never even took it out and looked at it before, all these years. Come on." He stepped toward the porch.

The eastern sky, behind the house, was growing pink, but the Atlantic behind them was a mass of darkness still. Jays found a place to hold his rock so it cast two shadows in his hand, from sun and Venus.

"It looks like coal," she said.

He laughed. "The Moon is dark. If it was bright as Earth, acre for acre, you could read by its light. But you'd never see the stars . . ."

There was a sharp smell. Like before a storm. Or like a beach.

"Dad, what's that?"

"What? . . ." But now his older senses registered it. "Ozone. Electrical fire."

We're not in a spacecraft now, dad, she thought. But still, maybe she should go get the kids—

Jays dropped the rock—it thumped dully on the wooden patio—and he tucked his hand under his arm. "Jesus, that's hot."

2

The day of Geena's post-flight press conference was, it turned out, the last day Henry would spend in Houston. So Geena, with a sinking heart, realized she had no excuse to duck out of seeing him, one last time.

She drove the couple of miles to the Johnson Space Center from their abandoned Houston home, in the decaying 1960s suburb of Clear Lake. On NASA Road One, she found herself queuing in a bumper-to-fender jam. Once more, NASA Road One was being rebuilt; it was choked by huge, crudely assembled contraflows, and the multiple surfaces made ramps that slammed into the suspension of her Chevy.

The short drive took her the best part of an hour, and she had no option but to sit there with her starched collar itching at her neck, the skirt of her suit riding up around her knees.

At length she crawled past the wire fence that separated JSC from the rest of the world. Through the chicken wire she could see the JSC buildings, black-and-white cubes scattered over the old cow pasture, looking small and cramped and closed-up, out of place in an era when every office building was a glass-walled rhomboid.

She tried the radio. Every station she found seemed to be playing country music, the modern stuff that sounded to her like soft rock. The DJs harangued her about a write-in campaign to have TNN—The Nashville Network, country music TV—retained by the local cable company. She flipped around to another station, 93.7FM, which seemed to play nothing but "fun oldies." They had a policy of no repeats during a single day, and on Sunday mornings, she learned, she could enjoy breakfast with the Beatles. The

music, every track of which she'd heard before, was depressing Boomer stuff, and sounded much worse than she remembered; it made her feel very old.

At last she found a news channel, and listened to an earnest debate about whether ebonics should be allowed in schools, and an ill-informed discussion about the latest news from Venus.

She had flown in space on four missions now: two Shuttle missions and two stays on Station. Her last Shuttle flight had finished a month ago, just before the Venus event. And every time she returned to *this*—from the black silence of space, the simplicity of her life and objectives up there—she felt depressed as all hell.

The traffic lurched forward in spasms.

She'd made Houston her home for ten years now, but she was San Francisco born and bred, and she'd never quite gotten used to Texas. Houston was hot and flat, water towers and shining green lawns and under-used malls that sprawled untidily around the downtown towers poking out of the city's heart. Houston was new, its growth fueled mostly by oil money, but it was half-empty and soulless.

Oh, Houston could give you its moments—driving around the Loop you would sometimes get a fine view of the Port of Houston, refineries draped in feathers of steam, lights on the stacks glowing yellow—but then she'd never had an ambition to live in a *Blade Runner* diorama.

And this area, Clear Lake/NASA, was really pretty seedy. It was a long way out of downtown Houston, off the Galveston Freeway, I–75. The Johnson Space Center was the home of the nation's space program, but at heart it was just an old-fashioned government facility, fading 1960s buildings stranded in an area full of desolate mini-malls and little else.

But even so, she thought, maybe it wasn't Houston's fault she felt so sour about life here.

It would be better when Henry had gone: *Henry,* ex-husband of three days, the living, breathing embodiment of everything that had gone wrong with her life.

As she approached the JSC entrance, she realized she wasn't up to facing the press, or Henry. Not just yet.

She pulled into a parking lot close to the Days Inn NASA, a chalet-style motel almost directly opposite the JSC entrance. She used to stay here when she was an impoverished ascan, an astronaut candidate, in happier days a hundred years ago. Near the Days Inn was the Puddruckers hamburger restaurant where she used to eat, and a Chinese restaurant. She bought a *Houston Chronicle,* fifty cents from a vending machine, and walked into the Chinese. It was full of old folks watching TV, and she bought herself soup and a sandwich for $2.95.

The *Chronicle* was stuffed full of ad sections and bewilderingly dull local news. But it had reasonable coverage of the space program, especially when a mission was in progress, with two or three features a day. A lot more informative than NASA TV, she thought.

Her soup arrived. When she looked up, past the middle-aged waitress, she could see spacecraft, the superannuated inhabitants of JSC's rocket garden, poking above the trees like minarets from some ruined temple. And there was the white-and-black flank of the Saturn V, an operational Moon rocket, lying in the grass.

In the *Chronicle* there was a series of ads for stomach stapling, aimed at those more than a hundred pounds overweight. *Americans always eat too much,* Arkady often told her. Maybe she'd clip this out to show him.

She ate her soup, trying to make it last.

Through the JSC security gate she parked her car. It was a late February day, unusually cold. She walked to where Henry would be working, at the Lunar Curatorial Facility in Building 31N. This was the building where, for thirty years, they had stored the Moon rocks.

She had to climb two and a half stories. The height was for protection against Class 5 hurricane floods; Mission

Control was raised to this level for a similar reason. The weather was thought to be the most likely danger to the rocks, in these post–Cold War days. But just in case of a nuclear attack or similar catastrophe, a proportion of the irreplaceable samples were stored in Brooks Air Force Base at San Antonio, separation being the only defense in case of such a disaster.

To be destroyed in such an attack would have been a strange fate for the battered old rocks which had seen so much, she thought.

She found a friendly technician who would take her in. The woman had worked here for twenty years. The tech was pregnant. That struck Geena as odd: what a start to life, here in the Moon rock lab, halfway off the Earth.

She had to go through the clean room. In an outer changing room she put on a bunny suit: two layers of overshoes, and a button-up white coat and McDonald's-server hat. The garments were labeled "Lockheed Martin." There were no gloves, but she had to take off her wedding ring—gold evaporating from its surface could contaminate the samples—and when she slipped it into a pocket she realized, for the first time, she needn't put it back again.

Then the two of them crowded into an airlock, a little two-doored glass-walled room little bigger than a phone booth. Air blowers blasted at them from the ceiling.

The tech opened an inner door, and there she was, in the same room as the most famous rocks in the world.

And Henry.

The lab was a place of rectangles, of big stainless steel glove boxes and staff in white clean-room coats and hats and overboots. The roof was crowded with fluorescent tubes which filled the room with a sickly gray light, a grayness emphasized by the polished steel of the glove boxes and the nondescript floor tiles. At the back of the room, a heavy door led to a vault where the bulk of the lunar samples were stored.

This lab didn't do much original science, in fact. It was

really just a service lab, providing sample processing for external researchers. The cleanness standard was tighter than an operating room, though not so tight as, for example, a microelectronics lab.

There was a tour going on, bigwigs garbed out in their white coats, having their photographs taken with the rocks, enduring a running commentary from some flack in a white coat and a trilby.

. . . Eight hundred pounds of Moon rock is stored here, as two and a half thousand samples, split into eighty thousand subsamples. Something like a thousand samples a year are taken, mostly less than one gram. The subsamples are stored in nitrogen, in triple-shelled containers. Efforts are made to reuse the samples, even ones which have been driven to destruction in some way—it is possible that other unrelated tests could be performed even on the detritus. There is a computer database on all eighty thousand subsamples, and handwritten notes and photographs on each one are stored in a fireproof vault. Even today, sixty percent of the samples have remained unopened since they were locked up on the dusty surface of the Moon . . .

The receiving lab had been built at the height of the Cold War Apollo era, when funds flowed relatively freely, and everyone worried that there might be bugs in the Moon rocks that would devastate the world. But the Moon rocks had turned out to be the deadest things ever seen.

She could see Henry at the far end of the room.

He was obviously busy, organizing the packaging of some precious rock or other. He was clustered around a stainless steel workbench with three or four techs, all of them in their white bunny suits, like a conference of surgeons.

She drifted to the front of the lab, and waited until Henry came free.

At the front of the room was a glass wall, beyond which was a viewing gallery, dimly lit.

And here there were three big rocks on display. Each of them was maybe the size of a grapefruit, sawn in half.

These were Moon rocks, she knew.

She'd been with Henry long enough to pick up, however reluctantly, a little geology. The rock on the left was obviously a basalt—a kind of lava—a dark gray structure shot through with vesicles. The rock on the right was a breccia, its structure compound like a granite, big shapeless blobs of different materials. Breccias were the result of violent events, which smashed up rocks and welded them back together again. On Earth they usually formed in river environments. But these lunar rocks had been shoved together by an ancient meteorite impact which pulverized some part of the Moon. Even that impact was more than three billion years ago, older than almost all rocks on Earth. And the center rock, perhaps the most nondescript, was all of four and a half billion years old.

". . . Treat that with respect, Geena; it cost forty billion bucks."

It was Henry, of course, his fleshy nose like a bird's beak, his black hair an unruly tangle that wouldn't stay put under his NASA-regulation trilby.

Geena said, "I thought I ought to—"

He talked fast. "What? Come say good-bye? Gee, thanks. You want to see 86047? That's the rock I'm taking to Edinburgh. Or rather, it is taking me. The only piece of lunar bedrock you're likely to see. What an honor. And the centerpiece of what's left of my career." He eyed her. "Maybe you'd like to stomp it, like you stomped my balls."

She stepped back, until her butt came up against the display case of Moon rocks. She hadn't expected so much anger; it was like an explosion in her face.

"Change the record, Henry. You aren't good at bitterness."

"You think I'm giving you a hard time?"

"I don't deserve it."

"Like hell. You shafted the *Shoemakers*. We were going to the *South Pole*," Henry said. "A place your Man-in-Space heroes had never dared think about. Great sci-

ence, and two probes for two hundred million bucks apiece. Christ, do you know how much we could have learned?"

"I know, Henry."

"Do you? Listen to me—there's water at the South Pole. Not just the bathtub full that *Prospector* found, but a whole frozen ocean of it, laid down by the comets, in great dusty layers, carbon dioxide too, maybe enough to flood the whole damn Moon—"

"I *know,* Henry. And your fancy probes would have performed the deep core sampling that would have proved it. You told me a dozen, a hundred times. You told everybody else. Maybe—"

"Maybe what?"

Maybe if you didn't shoot your mouth off so much, to me and the NASA managers and on the TV chat shows and in the tabloid papers and in the goddamn JSC staff canteen, you'd exert a little more influence. Maybe this wouldn't have happened to you."

Suddenly, she felt weary of all this. "You do blame me, don't you?"

"Hell, yes. If you hadn't come out publicly and backed shutting down *Shoemaker* . . ."

"It wouldn't have made a difference. Don't you get it? It's all about money and politics and power and rivalry between the NASA centers, Henry. It's a game, that you never figured out."

He thought about that. "So what game were *you* playing? If it made no difference what you said, why say anything at all?"

"I was trying to advance my career. What else?"

"At my expense?"

"Look, Henry, it could be worse. You got your lunar bedrock, haven't you? The most important unanalyzed Apollo sample left, so they tell me."

"86047? It's a piece of shit."

"How can you say that? It's *bedrock.*"

"But that asshole Jays Malone didn't do his documen-

tation right. I don't have the context."

She knew enough geology to understand him. The geologists had been complaining about the astronauts' performance on the Moon since 1969. Without its context— knowing exactly where a sample had come from, how it was positioned, all the rest—a rock's value was hugely diminished, for a geologist. Maybe that was why they fobbed off Henry with it.

He was still talking.

". . . And I have to go to Edinburgh to work on it. The only place that would have me."

"Come on, Henry."

"Where the hell is Scotland anyhow?" He waved an arm vaguely. "Some Scandinavian country, thataway somewhere."

"You need a change, Henry. A career break. Face it. All this bitterness—"

"The thing of it is, *we'll never know.* Don't you get it yet, Geena? We'll never know, about the South Pole ice. Not in my working lifetime. That's what is killing me."

She tried to focus, to stay sympathetic, but her attention drifted.

She'd heard this before, too.

Was this the definition of the end of a relationship? When you've heard everything the other person has to say—not once, but many times?

She started to think ahead to her appointments later in the day.

Henry had, she realized guiltily, stopped talking.

He turned, and walked back to his work.

The *Shoemaker* had been Henry's project, the centerpiece of his career. It had actually got farther than most. Two prototype landers had been built for real, by the Jet Propulsion laboratory out in Pasadena. Now, as far as she knew, they were being put in storage, or maybe cannibalized for other missions . . .

For the *Shoemaker* program had been canned. The

manned program—delays to the Space Station, cancella-tions by the cash-strapped Russians—had taken too much out of NASA's budget.

It had always been thus, Geena knew. A single Shuttle launch, of whatever value, cost as much as both Henry's unmanned science missions put together.

The project on 86047 was no sop, though. The mother rock was being broken up and sent around the world to top geophysics labs for independent analysis. Edinburgh was just such a lab. They'd done the same, for instance, with the famous meteorite from Mars which had looked as if it held life traces; Edinburgh had got a piece of that too.

And Henry was being sent along with the rock. There was valuable work to be done here, genuine research. But . . .

But she'd been with him long enough to understand how he felt.

The cancellation of *Shoemaker* was like the cancella-tion of his whole career; it meant he wasn't likely to meet the long-term objectives he had set himself, like all scien-tists, objectives which underlay his choice of particular proj-ects.

Digging aimlessly into 86047 was, by comparison, no consolation.

The visitors were still here. A tech opened a cylindri-cal case inside a glove box, and pulled out a Moon rock: small, fist-sized, nondescript, sawn in half. Geena could see the vertical burns of the saw. The visitor had his picture taken with it, his grinning face outside the glass, the rock held by a black-gloved hand inside the glass, the camera angled so as to avoid the flash's reflection from the glass.

And in the sterile light of the lab, the ancient rocks from the Moon—many of them older by a billion years than *any* rock that had survived on Earth—sat, wizened and lumpy and willfully irregular, like resentful old men in a rest home.

Monica Beus was with Alfred Synge, on the Hawaiian island of Oahu.

She emerged from the dark crater into the blinding light of the sun. She pulled on her sunglasses and checked her floppy hat. She'd snapped Alfred's head off when he showed up with this big hat for her. For the sun, he said. But he was right, of course; the chemotherapy had left her so bald her scalp would fry like an egg, and she was too damned stubborn, naturally, to wear a wig.

So be it. She wore the damn hat, and forgave Alfred for his residual love for her.

Breathing hard from the climb, she clambered on top of an old gun emplacement with a bunch of other tourists and studied the view.

She was at the highest part of Diamond Head crater, here on Oahu. She was surrounded on three sides by Pacific Ocean. The water was royal blue, laced with whitecaps, in its beauty showing no signs of the problems Venus had brought: the plankton die-backs, the collapse of the food chain in some parts of the oceans, depletion of stocks of fish and mammals. In the south she could see windsurfers skimming over the waves, radiation-proof skinsuits gleaming, their elegance and speed a balance between forces, aerodynamic and gravitational. In the west, the sun was already dropping toward the horizon. To the north the Miracle Mile along Waikiki Beach was a thin, golden strip of sand walled off from the interior by slab-like high-rise hotels. Sun, sand, sea, tourists.

And when she looked back she could see into the crater of a volcano two million years dead.

They found a seat. Alfred dug under his poncho and pulled out a laptop; without preamble, he started showing her images of Venus.

"Before and after," he said dryly. He retrieved a classic Venus-from-space image, the featureless pool ball.

"Venus was our neighbor," he said. "At its closest, only a hundred times as far away as the Moon. And it wasn't so different from Earth in size. But that's as good as it gets. Otherwise, it was a hell-hole. Fifty miles of carbon dioxide, laced with a little sulphuric acid. So hot the rocks *glowed,* dull orange."

He showed her surface images, craters and domes and valleys and mountains, constructed from a radar survey by the *Magellan* spacecraft. "Venus was covered by volcanism. There were flood lavas and volcanic cones and domes, and other features which don't have any analogues on Earth. We didn't see plate tectonics, like Earth; we think Venus was a one-plate planet dominated by hot-spot volcanism. My favorite hypothesis is that there was a catastrophic global resurfacing every half-billion years."

"A what?"

"The crust melting, globally. There are problems with the heat flow from the interior otherwise . . . It would be like five hundred million years of geology crammed into a few centuries. Now," he said. "*After.* An image taken by the Hubble this morning."

There was no evidence of a spherical shape. She made out a crudely defined, blurred oval, with extensive tails, like a comet's.

Alfred said, "You're looking at a cloud of atmospheric gas, mostly frozen, and ground-up rock."

"The rock's from the surface?"

"Mostly the mantle, as far as we can tell. Most of the mass is still concentrated near the point where the center of gravity of the planet used to be. We tried radar pulses from Arecibo, and . . . Well. Monica, we can't find a solid object there any more. The substance of the planet is spreading out along the orbit. The ring probably won't stay stable; the perturbation by Earth's gravity will—"

"Hold it. Alfred, I can't follow you. You're saying that Venus no longer exists."

"Not as a coherent solid, no."

"That's impossible. How much energy would it take to destroy a *planet*?"

He considered. "Well, roughly speaking, you would have to lift every piece of rock to escape velocity, out of Venus's own gravity well. There's a quantity called the gravitational binding energy . . . For Venus, which had eighty percent of Earth's mass, it works out as ten to power thirty-two joules—umm, something like a thousand billion times our nuclear arsenal."

"Just for the record, we aren't talking about your global volcanic resurfacing here, are we?"

He smiled. "Even that would be quite a spectacle, if it occurred in the lifetime of this astronomer. But no, it's orders of magnitude beyond that." He rubbed his nose, smearing the gaudy sun block there. "Those are big numbers. But there's another way of looking at it. If you consider the energy *density* required, averaged over the planet's volume, it isn't so high. Something like a tanker of gas per cubic yard or so, I guess."

"What are you telling me?"

"We think we are looking at some funny physics over there, Monica. Which is why you and the rest of the particle physicists are going to have to work on this with us."

"Funny physics?"

"Look at this." He pulled up results from a cosmic ray detector, tracks left in bubble chambers, accompanying analysis. "We've found some strange products from the Venus event. Some exotic beasties, escaping from that particular zoo. Have you seen this result?"

A spiderweb of tracks, of splits and decay events and spirals and tiny explosions.

She whistled. "No. I'd *remember*."

"Well, the results haven't made it onto the nets yet. The authors are still checking."

"I don't blame them," she said. "If this is right—"

"You're looking at a particle with a charge a fraction of an electron's. Which is something we've never seen before."

"And this mass—" She looked at him. "Alfred, this is the signature of an elementary particle with a fractional charge, and the mass of a *bacterium*. Now, what processes do we know of which could produce such a thing?"

"We don't know of anything since the Big Bang." He studied her. "We're measuring the symptoms here. Guessing at a cause isn't so easy."

"A cause?"

"A purpose, then. Something has taken Venus apart. It seems to have transformed the planet's own mass energy to use against it." He grinned, uneasily. "We're speculating. Maybe there is something out there that doesn't like planets, deep gravity wells. Something that prefers thin matter clouds. Like the primordial cloud from which the Solar System formed in the first place."

"*Something?* You make it sound as if this was somehow deliberate."

He didn't reply to that.

"Listen," he said. "We're on Hawaii. We should have ice cream. You want some ice cream?"

She shrugged, indifferent, and he went anyway.

After the Venus event Alfred had come here to the islands to work at the observatory on the summit of Mauna Kea, fourteen thousand feet above sea level. Up there, the air was so rarefied it was as clear a sky as anywhere on Earth, but human lungs only received forty percent of their normal intake of oxygen. Nobody slept at the summit; the astronomers came down four thousand feet every dawn to sleep over at Hale Pohaku.

Alfred had come down to meet her. Monica knew there was no way she would be able to tolerate the summit conditions.

Thus, death was already closing in on her, already cutting the options available to her, the circles closing in. She would never see another mountaintop.

Bullshit, she thought.

She tried to focus on Hawaii.

This island, Oahu, was dying too, though a little more slowly than she was. It had bloomed out of the sea in a fiery birth, amid gouts of lava and steam. But every year erosion dragged it down toward the water, and there was nothing, no process, to restore it.

It had happened before. There was a flaw in Earth's mantle here, a great plume of magma which had welled up steadily for a hundred million years. It had generated Oahu; right now the Big Island was over the plume, and was being pushed toward the sky by that lithic fountain. But the relentless sliding of the tectonic plates beneath the Pacific would eventually, in a few million years, take the Big Island away from the plume. The volcano at its heart would die, and the island would be abandoned to the forces of erosion.

Thus there was a chain of dying islands tailing off to the northwest, Oahu and Kauai and Niihau, and beyond that a trail of corpses, nameless undersea mountains, each of which had once been a paradise of forests and beaches, just like this one.

Somehow it seemed an appropriate place to come to talk about the death of Venus.

Alfred returned, bearing two immense cones of ice cream. He was wearing a broad, floppy hat, a garish shirt, and shorts that made his legs look as if he had spent ten years in space.

They found a seat, and ate up the ice cream companionably.

Small talk: *How are Garry and your grandkids? Fine, Alfred, when I get to see them . . . he's flying out of Edwards now . . . I don't think Jenine is enjoying life as an Air Force wife . . .*

She let her attention drift. A part of her mind was already composing the report she would have to pass up to the Administration.

She wondered about telling the President about the funny physics results. Was it appropriate to include some-

thing so exotic, something nobody yet understood, something it wasn't even possible yet to check?

On the other hand, she thought bleakly, suppose Alfred's wilder speculations have some bearing on reality. If there is something loose in the Solar System, something *transforming,* something powerful enough to destroy a planet like Venus—won't it be seen immediately in terms of a threat to the Earth?

And if it was a threat, how could they possibly deal with it, even recognize it?

"You know," Alfred was saying around his ice cream, "no matter what the other implications of this event, one thing's for sure."

"What?"

"We've lost Venus. Forever. Although I suppose the truth is we lost it a long time ago, when the first space probes got there. I'm old enough to remember—"

"You're younger than *me,* Alfred."

"—when Arrhenius's theory was still the paradigm. He thought the clouds were water droplets. The land was choked by swamps. A hothouse, with amphibians and dinosaurs and cavemen. Even later, when it became clear from the spectroscopic evidence there was no water in the cloud tops, we still thought there might be a loophole. Maybe a world-spanning ocean of Perrier water. Or seas of oil. Why the hell not?

"But when the Mariners got there, what they found was a big disappointment." He shook his head. "But it needn't have stayed that way. All those stupendous schemes to terraform Venus the fringe types cooked up. You'd have to block out the sun, and let all that carbon dioxide liquefy, strike it with comets to spin it up and bring in water—"

She laughed. "What bull."

"But just think what you'd finish up with. A planet much more like Earth than Mars could ever be: continents called Aphrodite and Ishtar, oceans called Guinevere and

Niobe; even enough geological activity to sustain a bio-
sphere for billions of years." He sighed. "It was always
remote. But it was *possible*. Maybe that is why Venus was
put in the Solar System in the first place."

She eyed him. "As a place for us to colonize?"

"Why not? But now, it's *gone*. Taken from us . . ."

"You sound as if you're mourning. Mourning a
planet."

"A whole world has died here, Monica. Everything we
could have learned from it, all its future possibilities lost,
for all time. A *world*. What more appropriate object of
mourning is there? . . . Maybe we ought to hold a wake. A
global wake."

She shivered, despite the warmth of the day. She was
aware of Alfred watching her with barely concealed con-
cern, but she had no time for that.

She looked around the bright sky for Venus, but it was
either below the horizon or lost in the glare.

4

Henry Meacher flew British Airways direct into Edin-
burgh.

His ticket was for what BA called World Traveller
Class, which meant, essentially, steerage. Henry found him-
self in a middle seat in the central bank of four, a long way
away from the 747's tiny windows. The stewardesses,
expertly encased in makeup, were all anorexic-slim English
girls with what he thought of as cut-glass accents; they
walked as if their orifices were all sewn up. The distant
communal video screen showed a BBC news round-up pre-
ceded by a tourist's-eye view of the alleged ancient beauties
of Britain; a little menu card told Henry he would be eating
a roast beef dinner—American beef—and, later, a tradi-
tional English breakfast.

Henry buried his face in the *Journal of Geophysical
Research* and tried to ignore all this fake Englishness. It

was like a chintz spread thrown over the battered American engineering of the aircraft. Who did they think they were kidding?

BA irritated him. The Venus scare had caused a huge curtailment in long-haul flights, so every airline was suffering—the rules about every passenger wearing a radiation exposure dosimeter badge had seen to that—but even so the length of queues BA maintained at check-in astounded him. But they pretty much seemed to have a monopoly on direct flights to Britain aside from into London, so BA it was.

The flight was late leaving Houston Intercontinental. An O-ring on one of the aging 747's engines had to be replaced, and the engineers, worryingly, seemed to have trouble finding the right inspection hatch.

The seat next to Henry was occupied by a USAF airman who was stationed at a base in Suffolk. He was returning with his two kids from leave in Texas, and he was homesick before the Boeing left the ground. "The bathrooms in Britain are just disgusting. Even the hotels. They just never heard of sanitary seals. The Germans aren't so bad with the bathrooms. But the French, my God, one place we stayed there was just a hole in the ground you were supposed to squat over . . ." Bathrooms on planes and on trains and in stations and in hotels, bathrooms in Britain and Italy and Greece and Sweden. It was, Henry realized with dismay, nothing so much as an asshole's travelogue of Europe.

And after a couple of hours, the plane had metamorphosed, as ever, to a giant, stinking pigpen in the sky, and every toilet Henry tried had a sticky floor and an overflowing trash can.

They flew out of bright morning light, from the west, toward Edinburgh. Henry peered out a window near the stewardess' station, and took his first look at Scotland.

He was descending into the Midland Valley, a broad

belt of lowland that stretched from Glasgow to Edinburgh.
This was actually what geologists called a graben: a rift, a
block of land that had dropped between two faults. He
could see the roads from England, to the south, sweeping
down out of the hills to the valley floor, which was settled
and arable, coated with picture-book fields and towns,
though he could see, in some places, the scars left by Venus:
failing crops, fields left brown and bare, a portent of trou-
bled times to come.

But what made this valley different were the extinct
cores of old volcanoes that stuck out of the ground, rem-
nants of a volcanism spasm three hundred million years
gone. The cones were an uncompromising demonstration
of the old geologist's saw that the stuff that's left sticking
out of the ground is harder than whatever has been worn
away.

And as he descended toward Edinburgh itself he caught
a glimpse of Arthur's Seat, a composite volcano that was
the greatest of the volcanic plugs; the buildings of the old
city lapped around its flanks.

He landed at 7:00 A.M. local, having missed an entire
night out of his life. A bright early spring day stretched
ahead of him, and he felt like a piece of shit.

"The name's Mike Dundas."

The kid was waiting for Henry at the departure gate,
when he finally got through queuing to have his passport
checked.

Henry shook his hand. "We e-mailed. Good to meet
you, Mike."

Mike took Henry's bag, a wheeled suitcase, and hauled
it away through the terminal toward the car park. Mike was
a technician in the University geology department here; he
was in his early twenties, with—to Henry's eye—brutally
short-cut hair, a disconcertingly pierced nose, placid blue
eyes. He wore the bright Day-Glo sunscreen popular with

the young around the world, huge dabs of orange and yellow on his nose and cheeks. His accent was distinctly Scottish, but gentler than Henry had expected—lots of strong r's, "ye" for "you," "tae" for "to," and so on. No big deal.

"The rock's already here," Mike said.

"The rock?"

"86047. The Moon rock. We've set up our sample lab. I don't mind telling you we're all excited about this, having the rock here."

"It'll be glad to know it's a celebrity."

Mike looked cut by the mild sarcasm, and Henry instantly regretted it.

"I'm sorry," Mike said. "We're glad to welcome you too, sir."

"I know what you meant, Mike. And for Christ's sake call me Henry; you make me feel old enough as it is."

"I'm sorry."

"Stop apologizing, already."

"I'm—" Mike laughed, and seemed to relax a little. "You're the boss."

Mike's car, in the multi-level airport car park, turned out to be a small, battered Rover. Henry, unfamiliar with the Brit numberplate system, couldn't tell its age, but he was willing to bet it hadn't been radiation-proofed according to the new international code. There was room in the trunk—no, the *boot*—for Henry's luggage, but Mike had to clear boxes and papers off the seats before Henry could sit down.

"Sorry," Mike said. "I wanted to pick you up myself. But the car's always full of shit."

Henry shrugged as he buckled up his seat belt. "We're geologists, remember. Geologists live in shit. It's in the job description."

"Here." Mike handed Henry a cardboard carton of orange juice.

"What's this for?"

"Jet lag. I know how it feels."

Henry grinned, and held the carton to his mouth.

Mike queued his way out of the car park, and set off along the freeway—*motorway*—toward central Edinburgh, eight miles away. The sky was blue, fresh, marked by a few moist-looking cumuli; but, when Mike opened a window, it was *cold*.

He became aware that Mike hadn't spoken since the airport. Mike seemed to have picked up Henry's inner sourness; maybe the poor kid thought Henry's mood was somehow his fault.

"So," Henry said with an effort. "What's the shit, specifically? The boxes in the car."

"Oh." Mike looked vaguely embarrassed. "They're for my sister. I get her samples through my buddies at the University. She sells rocks."

"She's an academic supplier?"

"Not exactly."

"Oh. Don't tell me. Not rocks; *crystals.*"

Mike shrugged. "She knows more about geology and mineralogy and stuff than she admits. But she has to make a living."

"So, what about you? You have a pet rock at home?"

Mike laughed. "No. But I have a rock collection. I started when I was a kid. The first item was a piece of basalt from Arthur's Seat. When I was a schoolkid I joined a local geology society. Field trips to the Pentland Hills, and stuff."

"Sounds fun."

"You know, Edinburgh is the home of geology—"

"So they tell me."

Mike looked embarrassed, and again Henry found himself absurdly regretting his sharpness.

"Go on," Henry said. "So you wanted to be a geologist."

"I never got that far."

"As far as what?"

"As taking A-levels. The exams that would have got me to University." He shrugged. "But I learned a lot about rocks. I was always good in the field, and I turned out to be

good in the lab. I got a job as a technician in the geology department here."

"You could study. Do some kind of correspondence thing."

Mike flashed a weak smile. "I'm happier with the rocks."

"Especially Moon rocks, huh."

"Oh, yes. Especially the Moon rocks."

To Henry the British roads looked clean, wide, kind of crowded; this was indeed a small island, he thought. The exit ramp from the motorway was a baby-gentle curve, signposted miles in advance. They emerged onto a round-about, a system of ordered chaos, with an unspoken etiquette about giving way Henry was going to have some trouble mastering. Not to mention the fact that Mike was sitting on the right, and the roundabout traffic turned clockwise, counter to the way God intended humans to travel . . .

Henry felt irritated by all this. He wasn't interested in learning about the eccentricities of the British road system. The truth remained that he didn't want to *be* here, and still wouldn't even after he got past his jet lag. He let himself get annoyed at Edinburgh, Scotland and Britain, however unfair it was.

They entered the city itself. Henry's immediate impression was bustle, color, lovely old sandstone buildings, hills everywhere.

Mike, following the traffic along a broad, sunlit shopping street, turned toward the train station. "Your hotel's the Balmoral. Kind of swank. We checked you in here until you find somewhere more permanent. NASA are paying . . ."

Henry peered gloomily at the hotel, a sandstone pile punctured with slit windows, topped by a huge, fairy-cake clock tower. Builders were working on the roof, adding what looked like a layer of radiation-proof lead shielding. Overall, the hotel looked like a prison.

He checked his watch: 9:00 A.M., British time.

"How far are we from work, Mike?"

He shrugged. "A few minutes. Do you want to check in first, freshen up—"

Henry scratched the stubble on his cheeks. "Hell, no." He grinned. "First impressions are vital. Let's go see that Moon rock."

Mike pulled away from the curb.

The Edinburgh University Department of Geology and Geophysics turned out to be part of a sub-campus called the King's Buildings, a couple of miles south of the city center. Most of the science and engineering departments lived out here, Henry learned, along with a couple of government research institutes. The department itself was housed in a building called the Grant Institute of Geology, a blocky 1930s frontage with rambling modern extensions to the rear.

The suburbs of Edinburgh ran away to the north. To the south there was an open area, trees and grassland, that turned out to be a golf course.

From Mike, Henry learned that Edinburgh was in fact pretty much ringed by golf courses.

When Henry and Mike walked up to the entrance a couple of undergraduates came out, carrying notebooks. They both seemed to have pierced tongues—*my God*—and, in their lurid war-paint sunscreen, to Henry they looked about twelve years old.

There was a security check at the door. Henry signed the book, alongside where Mike had already filled in his name for him. He'd spelled it wrong: HNERY.

Oh, Henry thought.

The entrance hall was 1930s grandiose, but its glory was faded. There were portraits of the department's great men on the walls, and three granite slabs with lists of former professors. But the slabs weren't up to date, and the hall was cluttered with a couple of fish tanks and a small

seismology station. Mike shrugged. "We've been putting in stuff for the undergraduates. That's a saltwater aquarium over there, and this seismology station is live. Educational. But we have to scramble for the funding. And it costs a couple of hundred quid for every word you get carved on those big granite tombstones up there . . ."

Thus, thought Henry, times change, and not always for the worse.

Mike gave Henry a quick tour of the department.

The core of the Institute was the handsome old 1930s building, tall ceilings, oak panels, echoing; the modern extensions were cramped and rambling, with cheap ceiling tiles and linoleum floors. But, like every geology lab Henry had ever been in, the place was cluttered with samples. Even in the corridors there were big oak chests of drawers, all neatly numbered by hand-drawn labels. There were basement storage areas for the bigger samples—the foundations would have had trouble with the weight otherwise—and the rocks there were stored in open pallets or, sometimes, in cruder containers, like photocopier paper boxes. There was a cold room where ocean floor core samples were stacked up, in grimy metal tubes; Mike pointed out the department's milk store here, ready to fuel the British need for a continual tea supply.

Rocks everywhere, all carefully labeled and tracked by a full-time curator. Grad students were encouraged to discard whatever they didn't *absolutely* need for the future, but Henry knew that no geologist would willingly give up a single grain of sand.

To Henry it felt like coming home, after the crush and squalor of the plane, the jangling confusion of his first jet-lagged encounter with Edinburgh.

The clean lab, where the Moon rock would be processed, was a couple of stories up. Henry was expecting a close cousin of the Lunar Curatorial Facility back home at JSC.

Well, there was a small, cramped airlock chamber

here, a couple of wooden doors, like JSC. But there were no bunny suits or hats. It was just another lab, dusty, lined with grubby-looking wooden benches. There were fume cupboards on the walls, with safety notices, but their doors were ajar. Mike said the room had mostly been used, previously, by oceanographers looking for trace elements in sea water, like osmium or helium. At least there were steel-and-glass glove boxes sitting on the antique wooden benches, cheerfully bolted in place. And there were rocks, nondescript lumps, inside each of the boxes.

There was nobody working here right now. Too early in the morning, maybe.

". . . The samples here are mostly just dummies," Mike said. "A couple of meteorites and stuff. We really wanted to learn how to handle the samples. The containers are under positive pressure. I mean, the interiors contain air at a higher pressure than outside, so if there is any breach of containment the lunar material would be blown outward, rather than have earthly contamination blow inward. By comparison, if we were looking at radioactive material the pressure would be negative—air would be sucked inside a box in a breach, so that radioactivity would be contained. We store the samples in ultra-dry nitrogen . . ."

I know, Henry thought as Mike chattered nervously on. I know.

The positive pressure made the gloves, of black rubber, stick out from the boxes like questing arms, two or three feet long. As Henry walked past, the gloves seemed to bat at his chest, blindly.

"This clean room," said Henry mildly, "doesn't seem too clean to me. The lab at NASA is like Fort Knox."

Mike looked defensive. "We're trying to establish positive pressure in the room as a whole, but we're having some trouble."

"Trouble?"

"It's kind of leaky. We don't have the funding you guys have. And—"

Henry laughed. "My friend, I couldn't give a rat's ass. Moon rocks are just rocks. We'll just roll up our sleeves and scrape off the shit. What do you say? Come on, show me one of these fancy boxes NASA has paid for."

Mike grinned, still nervous. He led Henry to a glove box.

Henry knew from long experience that putting your hands into the gloves was a trick. You had to position your fingers over the fingers of the glove section, and then ram your arm into the aperture, pushing the glove right-side out by main force. It was easy to get your fingers in the wrong hole. And once inside the thick, somewhat stiff gloves, it was impossible to feel anything, and your hands got hot quickly. Learning to do delicate work in these things took time.

He noticed Mike had gotten his hands in there, ready to work, in seconds. Now he was picking up tools inside the box, confidently.

"We're working to the same standards as you do at Houston," he said. "The tools are Teflon, aluminum alloys and stainless steel. Stuff that won't corrupt the rocks. The samples are sliced with lubricant-free handsaws and power saws, stainless steel blades edged with diamond."

"How do you find those things to work with?"

Mike shrugged. "Buggers. The lack of lubricant makes the saws heavy and difficult to work, and the blades wear out quickly. But you get the job done. You need strong arms, though."

"That you do."

Mike pulled his arms briskly out of the gloves, and led Henry to the largest, best-lit case in the room, right at the center. And there, on a small pedestal, sat sample 86047, an unprepossessing fist-sized lump of coal-black basalt, untidy and inert. Beside it rested a small plastic cube, labeled up-down and with the four points of the compass.

Mike bent to the case, and the fluorescent lighting underlit his face, making him look even younger.

"Here it is," he said. "I can't quite believe it's here. That it's—you know—*real*. That some guy picked it up on the Moon, and now it's here."

"Believe it. You know about the documentation trail on these babies?"

"Sure . . ."

In principle each Apollo sample had been photographed before it was picked up off the surface. The photo was the clue to the rock's context. For instance, the pattern of shadows from the unremitting lunar sunlight gave the clue to its orientation. Since the scientists knew exactly when the rock was picked up, and where, and how high the sun would have been in the black lunar sky at that moment, they could position the rock in a strong light to recreate the shadows in the photograph, and so work out the rock's precise orientation. Then they photographed the rock again alongside the small dicelike orientation cube. The cube stayed with the rock forever after. All this was important because, for instance, the underside of the rock would have been protected from the sun, and so processed differently.

". . . Great theory," said Henry sourly. "But it heads out the window when your astronaut fouls up. The orientation we have here is just a best guess. Shit. This rock sits there a billion years, waiting to be found, and we screw it up in the first second of contact . . ."

Two people bustled into the lab: a graying, portly older man, and a woman of about twenty-seven.

The man shook Henry's hand. "Dr. Meacher."

"Henry, please."

"Dan McDiarmid. I'm heading up the investigation here, from our side of the pond. Welcome to Edinburgh."

"Good to meet you, Danny."

McDiarmid flinched but held his ground. "We weren't expecting you quite so—informally." He was eyeing Henry's stubble.

There wasn't a trace of Scottish in his accent, as far as Henry could tell. He knew the type, he thought. His creative

days long past, McDiarmid had used whatever reputation he had earned to win power and wealth, to turn himself into a Great Man.

Authority. The antithesis of science.

Now the woman pressed forward, thin and intense, sharp blue eyes. "Marge Case," she said. "I took my degree at Cambridge, and a doctorate in lunar feldspathic breccia crystallization history—"

"I know about your work." Henry noticed both McDiarmid and Case had just ignored Mike; in fact Case had literally pushed past Mike to get to Henry.

Henry retrieved his hand from Case. "Hey. Mike. Stick around."

Mike turned, confused. "You want me to get you a coffee?"

"Hell, no, I don't want a coffee. Well, yes I do, but not right now. Just hang loose, bubba."

McDiarmid said with evident difficulty, "We want to offer you every hospitality and resource. Marge here will work as your lead technician, and—"

"Sorry." Henry reached out to Mike, got hold of the shoulder of his jacket, and pulled him back. "Post's taken."

Case looked at Mike with precisely the reaction Henry had expected. "But I have a doctorate in—"

"You said already. I'm sure Mike and I can find you something to do." Henry put his arms around their shoulders, and began to lead them to the door; McDiarmid followed, hands fluttering over his belly. "We're going to be one big family," Henry said. "Just like the Waltons. Do you get the Waltons? Now, Mike. Where do we get that coffee?"

When he was done tormenting Case and McDiarmid, he relented and let Mike drive him back to the Balmoral.

Mike drove in silence, apparently confused. Henry wondered if he was being cruel to him, in some obscure way.

Am I just playing games with this guy? Or do I really think he will do a better job than Marge Case?

Well, sure he did.

But maybe he was being too smart at filling in Mike's life story.

Henry suppressed a sigh. When the divorce from Geena was finalized—when he learned the *Shoemaker* was canned and he was going to have to leave Houston—it was as if his life was ending. He was glad when that crummy BA 747 left the tarmac at Houston Intercontinental, because it was like a little death.

But, unlike whatever lay beyond death, Edinburgh contained people, and choices, and already, just a few hours here, Henry had, on a whim, made two enemies and one dubious friend. And for what?

Anyhow, it was done.

Mike dropped him at the hotel, and Henry lugged his suitcase inside. Mike drove back to the King's Buildings; he said he wanted to start work, preparing for the first samples from 86047.

Henry checked in.

The room rate was quite fantastically expensive. What was it with Brit hotels? Henry wasn't paying, but he hated to waste money; the sooner he got out of here the better.

Still, his room wasn't so bad. A big double bed—a duvet, not blankets—and a kettle and a whole stack of tea bags and a mini bar, and complimentary sunscreen in the bathroom. He was on the fifth floor, and he was looking east; he would get the sun in the morning.

He took off his shoes and his stinking socks, and padded to the window.

Looking north beyond the city's rooftops he could see the Firth of Forth, a dreamy-blue arm of the sea. Calton Hill pushed out of the foreground. Calton was one of the ancient volcanic plugs that underpinned the city. It was coated with grass, and crowned by absurd-looking classical-style buildings, such as an open portico—some kind of

unfinished temple, it seemed—and a telescope tower.

Mike had been right that Edinburgh was the home of geology. The old igneous structures here had been studied right from the beginning of the discipline. In fact James Hutton in the eighteenth century, based in Edinburgh, was the first to come up with modern theories of the processes that shaped Earth—the first man in history, perhaps, to understand the extent of the vast deserts of geological time that surrounded him.

Henry wondered, briefly, how that must have felt: to be the only human on the planet who *knew* . . .

I ought to sleep, he thought.

He tried the TV. There were five main channels and cable and satellite. The main channels were full of soaps and other daytime bullshit. He found a British news channel called Sky and watched that for a while, but the news meant little to him. There was a story about problems for the Government over integration into Europe, and some kind of IRA bomb threat that had caused gridlock in Birmingham, and, my God, a riot in some part of Scotland—what looked like a dire residential area called the Gorbals, in Glasgow—a spokesman who said in a thick accent, *We never accepted the Union of the Parliaments, and that's that.* It turned out he wasn't talking about the modern devolved assembly but the abolition of a Scottish Parliament in favor of a single British one, which had happened, for God's sake, in *1707.* And then commentators on the Irish stuff talked about some guy called William of Orange, who had his fifteen minutes of fame in *1688.*

1707, 1688. Dates from prehistory for North America, dates as remote as 5000 B.C.

There was no U.S. news at all.

He tried to remember the last British news story he'd noticed back home. Some royal bullshit, probably.

Britain, he was coming to see, was built on a long and complex history. Shame they hadn't got more of it right, he thought.

But then that was complacent. Britain was peaceful

and prosperous and proud of itself and, hell, even pretty democratic. The U.S. should last to be a thousand years old; then we'll see what shape we're in . . .

He flipped around until he found CNN. Lying on his bed, he studied baseball scores, one of his routines for conning himself to sleep.

But, though he was tired, he was not sleepy, and some part of him was reacting to the fact that it wasn't even midday outside, and the day was a-wasting.

He'd done a lot of traveling in the course of his career. But he'd never yet got used to this planet-hopping.

He considered raiding the room's minibar. Or maybe he should go back to the institute and rattle McDiarmid's cage a little more. Or maybe he should just go find a *USA Today*.

Bored, sour, he got up, pulled on a fresh T-shirt, and walked out of the room.

He found himself on Princes Street, a broad, straight road that ran east to west. It seemed to be the spine of the shopping area, and it was crowded with traffic and shoppers. The pedestrians were all in big floppy hats and baggy white clothes with their faces smeared with cream.

The street's north side was lined with plastic shop frontages, and on its south side there was a park called Princes Street Gardens: set in a valley, crammed with monuments and features. Pretty. But, Jesus, it was *cold,* a breeze gusting down the street like it was a wind tunnel. Henry, with just his T-shirt, wrapped his arms around his chest. Maybe he'd get more tolerant to this when he got over the loss of Houston's muggy, comfortable warmth.

Anyhow, if he was lucky he'd be out of here before winter came.

He got his orientation quickly.

He could see the asymmetrical profiles of Calton Hill and Castle Rock from here, with the heart of the city

stretching between them, and Arthur's Seat on the out-skirts of the city, a blocky, uncompromising mound. The glaciers had flowed east over this place, scraping off the younger sedimentary rocks and leaving these three igneous plugs exposed. All three plugs had been left with a sharp western face and a long, shallow eastern debris scarp. To Henry, musing, it looked as if some gigantic explosion had overwhelmed the area from the west, leaving these tails of debris, sheltered by the plugs.

He walked to the west along Princes Street. The shops were full of the new radiation-proofed clothing lines, heavily advertised. Here was a Realtor—no, an *estate agent*—with a lot of properties price-hiked because they had cellars, or room for underground development.

He passed the train station entrance and the roof of an underground mall, decorated with obscure statues of what looked like abseilers. He came to a steep road called the Mound, which twisted up the glacial tail to the Castle, a brooding pile on top of its own basaltic plug. The Castle looked as out of place, viewed from this glitzy plastic shop-ping area, as a bubo in the armpit of a supermodel.

He thought about climbing up there, taking a look around.

Or, he could go back to that little mall by the station, get under cover, and have a coffee.

He went back to the mall.

It turned out to be a complex of staircases and escala-tors and glass-walled elevators. It was brightly lit and crowded, though Muzak pumped out from too many places. There were fountains, with more of those bizarre stainless steel abseilers.

At least it was warmer here. But he couldn't find any-thing that looked *right*. What he'd really like to find, he thought, was a big out-of-town-style Barnes and Noble, lined with books, with a fat Starbucks coffee shop on the end of it. *You're getting parochial, Henry.*

He came to a shop called The World Store. It was just

the kind of place you'd expect to find in a mall like this: full of bead necklaces, wooden carvings, bamboo curtains. At the back there were shelves full of rocks: sparse metal frames lit by spot lamps, the merchandise glowing.

There was a girl behind a counter at the back, blonde and slim, sorting through some kind of box of samples.

On impulse, Henry walked in. The girl looked up, took him in at a glance—so it seemed—and went back to her rocks.

On her desk, there was a card. *THE WORLD STORE. S. Kapur & J. Dundas, props.* Telephone, fax and E-mail.

Dundas. He remembered the rocks in the car, Mike's crystal-gazing sister.

Henry drifted past the wooden elephants and pan pipes and other New Age crap, and made for the racks of minerals. It was mostly the usual eye-catching commercial stuff, sliced geodes and quartz crystals and pyrite clumps. Some of it looked native, but most of it was polished, even dyed and carved. Here was a necklace of bottle-green beads, for instance. And he found a tiger carved from a shining black rock, covered in pale gray blotches.

He looked sideways at the girl.

She was older than Mike, maybe as old as thirty, but she had the same Nordic coloring. Blonde hair tied back, revealing a composed, thoughtful face. Strong hands. Blue eyes you could swim in. One hell of a set of cheekbones, the essence of beauty. No body parts pierced that he could see, which was a good thing. She was eating something. A rice cake, maybe.

She glanced up and caught him looking at her. She put down the rice cake.

He was holding the tiger; he fumbled and nearly dropped it.

"You pay for breakages," she said. Her accent was the same as Mike's—soft Scottish—but her tone was cold.

"Sorry." He put the tiger back. "I was just thinking."

"What?"

"You ought to put a best-before date on that tiger. Ultimately it's going to turn gray all over—"

"I know. In sixty million years. It's snowflake obsidian."

He nodded, surprised, approving. "You know about rocks."

"I know my job." Her eyes narrowed as she studied him. "You're an American. And you just arrived."

He faced her. "Is it that obvious?"

She looked him up and down. "Look at the way you're dressed. It's only February, for God's sake."

"You don't like Americans?"

"I don't dislike them. I don't know you well enough to dislike you. Yet."

He glanced around. "You like rocks. I know about rocks."

Those eyes narrowed again. "You're a geologist."

Strike two, he thought. "Is that bad too?"

"If you're with one of the oil companies, yes."

He shrugged. "Edinburgh may not like me, but maybe I'll like Edinburgh."

"Why?"

"Volcanoes and a river sound. It reminds me of Seattle."

She snorted. "Seattle in three hundred million years, maybe, when the volcanoes have died."

He was impressed; that was about right.

She said, "What have you seen?"

"Just the walk from the hotel. The Balmoral."

She went back to her rocks. "This is the New Town. You need to go see the Old Town before you decide you like us."

"How new is the New Town?"

"1760."

"Older than my whole damn country. I should have known."

"Most things in life are older than your country." She studied him. "Look, are you going to buy anything, or—"

He shook his head. How do I get myself into these situations? He turned to go. The girl didn't acknowledge him.

He stopped at the door and turned back. "Look—"

"What?"

He went back to the mineral racks and picked up the necklace of bottle-green beads. "Do you know what this is?"

"Peridot," she said.

"Well, yes. The gem form of olivine. And that's what the lithosphere and asthenosphere are made of. That is, the solid layers that hold in the liquid interior of the Earth. So olivine is important stuff."

She took it dubiously. "You want it wrapped?"

"No," he said. He dug his hands into his pockets, seeking money. "Take it. As a gift."

She pushed it back over the counter. "Stuff it up your jacksie."

"I mean it. No strings. I want to apologize. I've done nothing but make enemies since I landed . . ." He had no British money; he pulled out what he had, a crumpled roll of dollars. "Will you accept this?"

"Christ. Dollars. You Americans."

Strike three, he thought. "Here. Fifty bucks. I'm sure that's more than it's worth. Please. On me."

"Stuff it," she said again, but he thought he could see a smile in her face.

He left the fifty, and got out while he could.

When the door had closed and the shop was empty again, Jane Dundas picked up the fifty dollars, and the necklace, and ran the bottle-green beads through her hands.

5

Mike Dundas lived with his father, in the western shadow of Arthur's Seat, to the east of the city center.

It was a fine spring morning, the sky clear and deep

blue, and the air off the Firth was fresh and cool, even this far inland. So, before getting the Rover out of the garage to drive into work, Mike put on his walking shoes and set off to the Seat.

He walked east around Queen's Drive, the road which skirted Holyrood, the park that contained the Seat. He reached the entrance opposite the Palace of Holyroodhouse, the Edinburgh seat of the royals. Holyroodhouse was a twee picture palace, shut away behind railings; Mike had grown up in Edinburgh but had never been tempted to go visit it.

He set off up the Volunteer's Walk to the summit of the Seat itself.

Everyone but the tourists knew the Seat had nothing to do with the English King Arthur, but was named from Gaelic: *Ard Tor*—the Height of Thor.

The climb, he knew from a lifetime's experience, looked a lot stiffer than it was. The grassy ground was dark, still in the shadow of the turning Earth, even though the sky was already bright; and the dew made it a little slippery underfoot. The path was heavily eroded—too many visitors—but the climb was one Mike had been completing since he was a kid, and it didn't take long to reach the broad, flat summit.

He stood on the red-brown, lumpy rock here. The rock was agglomerate, the exposed neck of the old volcano. There were two summit monuments up here, sparse concrete blocks.

He was alone. The Seat attracted few tourists, compared to the Castle Rock anyhow; mostly you saw locals, dog walkers.

He turned slowly around. From here you got a panoramic view of the city and its environs, nestling around the volcano plugs; Arthur's Seat was the highest hill in Edinburgh.

He could see the Pentland Hills to the south, the central lowland plain stretching off to the west, and the river to the north, the city splashed along its southern coast. He

could make out the docks and the twin stacks of the Port Seton power station; the water beyond looked so flat and still it might have been molded from steel. And there was the rocky northern coast of the Forth; on a good day you could see the peaks of the Highland massif, all of seventy or eighty miles away.

Venus was setting, but it was still bright enough to cast a reflection from the small waves on the Forth.

The air, blowing off the Forth, was fresh and laced with salt; he breathed it deeply, swinging his arms, invigorated, exhilarated.

All this out of his back door, and a Moon rock waiting for him back at the lab. Already he had more than a good feeling about how his relationship with this Henry Meacher was going to pan out. God, he thought, I love this job.

But first, he had to see his sister. He patted his pocket, to make sure the little vial of dust he had secreted there was safe.

Then he made his way down Arthur's Seat, by a different track.

He descended toward a sandstone ruin called St. Anthony's Chapel.

This was a gray heap of rubble not far below the summit of the Seat, in the lee of an exposed crag; time had left one wall intact, with a door and window gaping into nothing. The chapel was thought to date from the fifteenth century, but nobody actually knew; Edinburgh's history had been chaotic.

As he headed toward the Chapel, through a steep-walled old glacial cwm called the Dry Dam, Mike could hear a single voice—a man's—floating into the morning air.

". . . I want to tell you the story of the original Bran. With twenty-seven companions, he was lured away to a place called the Land of Women, an island supported by four pillars of gold. There was a great tree full of sweet

singing birds that was permanently in blossom, and the air was full of music . . ."

Mike, descending into the Dry Dam, saw that the speaker was a kid—seventeen or eighteen, hair shaven, so skinny the bones showed in his face and skull. He was dressed in what looked like purple pajamas. He was sitting beneath the steep rear wall of the cwm, as if cupped by the geology; there were maybe thirty people sitting in the grass in a circle facing him. They were all clean-shaven, with close-cropped hair; they were slim, even gaunt-looking. Mike, in fact, had trouble telling the men from the women, even what age they were. They were all wearing the purple jim-jams, as far as Mike could tell, and they must be cold— he could see where the morning dew had seeped into the thin fabric of their uniforms—but they didn't seem to be reacting to it. They looked relaxed, obviously fascinated by what the speaker was saying.

Beyond the pajama party there was a thin, scattered circle of onlookers, dog walkers and ramblers, a few tourists. Among them he could see Jane, in a woolen hat and sheepskin jacket.

The speaker's voice echoed around the natural amphitheater.

". . . Bran landed. There was a bed—and a wife—for each man, and the food and drink were constantly replaced. Bran's men stayed in this wonderful place for what they thought was a year—but when they returned home, they found a *hundred* years had passed. Nobody believed he was Bran, who they only knew as a distant legend. Bran was forced to sail away, into oblivion . . . Come."

Mike started; he hadn't been hiding, but it wasn't obvious how the speaker could have spotted him. But here he was, waving a skinny arm at Mike.

"Come and join us. You're very welcome. Everyone's welcome to listen."

Mike would have backed off, but there was Jane, waving at him. So he nodded at the storyteller, and stepped cau-

tiously through the pajama party circle, and crouched in the damp grass close to Jane. She was wearing a bottle-green necklace he hadn't seen before.

"I've got something for you," he whispered.

She raised a forefinger to her lips to shush him.

". . . Now you can see why I took the call-sign I did: *Bran.*" The kid looked around his flock; some were nodding, but others looked a little confused.

"Think about it," Bran said. "The pillars of gold, the birds singing—the sort of lurid detail you'd expect after three thousand years of retelling. But what about the replenished food and drink? What does that sound like, to you, but *replicator technology?*" He opened his hands, rested them on the back of his folded legs, and looked around the group, nodding persuasively. "Just like *Star Trek.* Right? And what about the women that just happened to be available for every man? Were they just hanging around, waiting for visitors? Isn't it more likely that these were some kind of constructs— what we might call holograms, or even androids?

"Which is why, of course, we find all that sci-fi stuff so easy to accept. Because it's not part of our future—*it's part of our past.*"

Jane leaned to Mike and whispered, "Here comes Einstein."

"What?"

"Wait and see."

"What is this?"

"A staff meeting of Egress Hatch," Jane hissed back. "Morning prayers."

"Egress Hatch? That new cult?" He'd heard pub talk about this; the cult had come out of nowhere to gather, apparently, a couple of thousand adherents in a month. But then, since Venus, it seemed as if the whole human race was splintering into cults and enclaves and pressure groups . . . He studied his sister. "What are you doing here?"

She frowned. "I think I know *him.*" She pointed at Bran.

"... And, of course, the clinching element in the whole story is the time lag. A century passing on Earth for a year of the travelers' time! It's just the twin paradox of relativity—the time dilation effect suffered by every interstellar traveler up to, but not including, Captain Kirk—*foreshadowed in a story first told three thousand years before Einstein was born.* Now, how can that be? ..."

"I told you," Jane whispered.

Bran's sermon was a mish-mash. The underlying theology seemed to be Celtic, but it was mixed in with a bit of New Age, a bit of post-millennial anxiety, a lot of sci-fi stuff about UFOs.

"... Our faith is rooted in that of the Celts. But this was the native religion of Britain and Western Europe, before it was suppressed by the conquering Romans, three thousand years ago, and then absorbed by Christianity, and so emasculated. Now, we're reclaiming it ..."

Mike straightened up to speak; he could feel Jane plucking at his sleeve, but he ignored her.

"So what's that got to do with spacemen?"

Bran smiled. "The old religion, long buried, is a memory of an even older human experience. It's only now, in our modern age, we can make sense of it. Look—have you ever had the feeling that your conscious self is sitting somewhere inside you? Like an inner person in a vehicle, looking out on the world and controlling the actions of your body—"

"Like the Wizard of Oz?"

That got him a laugh from the outer fringe. Bran laughed along with them. "Something like that. Well, that's a common feeling—"

"A common illusion—"

"Because it's based in reality." Bran patted his rib cage. "*These* are not our true bodies. *This* is not our native world. We believe that we are from somewhere else, and we're destined to return."

Intrigued despite himself, Mike asked, "So what are we doing here?"

"We are on an EVA, as the astronauts would say: an extravehicular activity. And these, our bodies, are like spacesuits we put on to preserve us here, on this alien world. We were an away team, so to speak. Or our remote ancestors were. But, long ago, we forgot what we were doing here. We forgot how to get back. Do you see?"

"You're speaking by analogy," Mike said.

Jane covered her mouth with her hand. "Mike, for God's sake—"

"You can prove anything by analogy."

"But," Bran said mildly, "I don't need to prove anything. It's simply an expression of our common experience. The lost legend of the ship—the place we came from—transmuted into myth, even as we went native . . . Listen: our brains, the electrical impulses that flow through them, have nothing to do with *us*. Any more than the computer processors in an astronaut's spacesuit are in any way part of *her* . . ."

"Jesus," Mike said. "He's a crackpot."

"He's Hamish Macrae," Jane whispered.

"Who?"

She told him about the kid in the Cordley Road lift shaft, Jack's friend.

"And suddenly," Jane said, "he's Bran. I saw his picture in the paper. I just wanted to see what he was up to. He's clever. I'll give him that."

"He's just working through what happened to his brother. He's crazy."

She eyed him. "We're *all* crazy, Mike. We always have been. At the end of the second millennium we were all just as crazy as at the start. We all believe *something*. And it's all started up again thanks to Venus. Funny lights in the sky . . . My view is, if you're going to spout craziness, it might as well be something harmless. At least Bran and his people don't hassle anyone else. Unlike some I could mention." She told him about the American who'd disrupted her lunch yesterday. "I think he was with the oil people. Arsehole."

Mike frowned. "What did he look like?"

"Tall. Skinny. In a T-shirt, of course. Wild-eyed, hairy."

Henry. "You're sure he was with the oil companies?"

"No, I'm not sure. Why?"

"No reason."

She fingered her bottle-green necklace. "The arrogant arsehole paid for this with dollars, in cash. As if we're the fifty-first state already."

"But you're wearing it. Did he give it to you?"

She looked defensive. "Well, he had bought it. If I'd put the necklace back in the stock I'd never have reconciled the books—"

"Of course not."

She studied him suspiciously. "Why are you so interested? Do you know this guy?"

He shrugged. "How could I?"

A shadow fell across them. Mike looked up.

The leader of the pajama people, Bran, was standing over them. Looking beyond Bran, Mike saw the various groups had broken up; the pajama people were standing in a knot, talking quietly.

"You were persuasive," Bran said to Mike with a rueful good humor.

"Thanks."

"Come to our Belenus festival."

"When's that?"

"May Day. We'll hold it here, on the Seat."

"Will there be replicator food and a woman for every man?"

Bran laughed. "No, but there will be spectacle. And oatcakes. Mustn't forget the oatcakes."

"Do I have to wear pajamas?"

"Pajamas are optional. Will you come?"

"I don't know. All that stuff you were saying sounded—"

"Cracked?" Bran smiled sadly. "But I have proof."

"Proof?"

For answer, Bran turned and pointed to Venus.

* * *

Mike and Jane strode back up the flank of the Seat, toward the summit. They found a place to sit on the agglomerate, looking north over the city.

Mike, agitated, disturbed, said, "You know, that guy was in control from the moment he walked up to us. Even before. He used everything I said to make his case stronger."

She shrugged. "That's what it takes to be a cult leader, I suppose."

"He ought to be a politician."

"Oh, I think he has his eye on higher goals than that . . . You said you wanted to see me."

"Yeah. I have something for you."

He glanced around to ensure they were alone. A couple of walkers, a hundred yards away; the steady susurrus of noise from the city.

Pleasurably anticipating her reaction, he dug into his pocket, and pulled out his vial. It was just a small plastic test tube, stoppered with a rubber bung.

He held it up in the morning light so she could see. There was a little puddle of dust in its base, a handful of grains. It was coal black, and when Mike shook the vial the dust clung to the sides.

"It sparkles," Jane said.

"That's the glass in it. Shards of it, from volcanic activity and meteorite impact—"

"Mike, what is this?"

He grinned. "Can't you guess? Look, no one will ever know. Whenever you take a power-saw sample from a rock there's always a little wastage. A few grams. There has to be—the rock just crumbles. They expect it, when they reconcile the weights later. I was just careful to capture every loose grain. And here it is. I even pumped the vial full of ultra-dry nitrogen to keep it pure."

"Are you telling me this is *Moon dust*?"

She looked—not pleased, not awed, as he'd expected—but horrified.

"Well, yes. That's the point." He frowned, puzzled. "Don't you want it?"

"You're giving it to *me*? Mike, what the hell am I supposed to do with it?"

"I don't know." He shrugged. "Give it to Jack. Put it in a locket. Sell it, to someone who will appreciate it."

"Mike, you've brought me a lot of stuff in the past—stuff I could never have gotten hold of otherwise—but this is different."

"Why?"

"Because it's against the law." She looked into his eyes, the way she used to when he was a kid. "You must have let someone down, to take this."

"What?"

"Someone who trusted you. Someone who gave you responsibility."

Shit, he thought. ". . . I suppose so."

She pushed the vial back into his hand. "You'll have to take it back."

"I can't. What do I do, glue it back to the rock?"

"You can't keep it, Mike."

"It's *Moon dust.*"

"Even so."

He hesitated.

"You know I'm right," she said.

"Oh, Christ. I hate it when you're right."

"That's what big sisters are for."

He took hold of the rubber stopper. "You may as well look. You'll never be so near a piece of the Moon again."

She crowded close.

He pulled out the bung; it came loose with a soft pop.

She sniffed the vial. "I can smell wood smoke."

"That's the Moon dust. It's never been exposed to free oxygen before. It's oxidizing. Burning. Here."

He tipped up the vial, and tapped its base; the Moon dust poured into Jane's palm. It was just a few grains; there really was hardly any of it.

Jane pushed at it with the tip of her little finger. "It's sharp. Like little needles." She lifted her fingertip and inspected it. "It's stuck to my skin. Oh, well . . ."

She tipped her hand, and let the grains scatter. They sparkled briefly before dispersing.

Talking, arguing, they made their way down the flank of Arthur's Seat, toward the Dry Dam. Above them, the sky brightened.

. . . They were just grains of basalt, falling through the air.

A little piece of the Moon, come to Scotland. But, though different from any terrestrial samples, the grains themselves were unremarkable.

They fell now to a massive plug of agglomerate. They would not be found again, by the most determined petrological inspection.

. . . Except that where they fell, the bare rock glowed, softly silver, in spots a fraction of an inch wide.

6

The debriefing session for Geena's mission was held in the Teague Auditorium in JSC Building 2, the Public Affairs Office. Geena had to sit behind a desk on a stage with the four others from her crew, bathed in the glare of TV lights. As clumsy young sound technicians tried to fix microphones to their lapels and ties, the astronauts chatted awkwardly, like newsreaders under the credits.

Geena had to shield her eyes to see the audience. She could see the platform on which the NASA TV cameras were mounted, and before it a thin scattering of journalists—mostly science correspondents, mostly men, mostly bearded, many of them familiar to her. This briefing wasn't

a formal press conference but had become a post-flight tra-
dition; the idea was for the crew to come share their expe-
rience with colleagues and families. So there were engi-
neers and controllers and mission managers from Mission
Control and the science backrooms, here at Houston, and
some pad technicians and managers from the Cape; but
there were also grandmothers and little kids, relatives or
friends of the crew.

There was nobody to see Geena.

That was her choice. Such events made her cringe,
without her mother wanting to muscle in too.

It was a sparse crowd, and it looked as if today the
audience was filled out with a tram-load or two of specta-
tors from the Space Center, the flashy visitors' center on
the edge of the JSC complex. The gaggle of tourist types sat
together in their slacks and T-shirts, cameras dangling from
their necks.

At last the proceedings began.

First there was a long ceremony of team awards, pre-
sented corporate-style by the director of JSC. Every astro-
naut who flew got a "Spaceflight Medal" specific to the
mission, pinned on her chest. When it was her turn, Geena
got up to a ripple of polite applause, her palms sweating,
suddenly as nervous as a grade school kid on show-and-tell
day.

The Center director was a man called Harry Maddi-
cott, somewhere in his sixties, hair slicked back, waistcoat
stretched over an ample gut, fat and sleek and self-satisfied
as a seal. He grinned at her as he pinned her medal to her
suit jacket lapel, taking obvious care not to let his hands
stray anywhere near her breast.

Next came the awards for the mission controllers,
"outstanding performances" by the Flight Dynamics Offi-
cer and the Guidance, Navigation and Control Officer and
even the Public Affairs Officer. There were awards for the
guys who planned the EVAs, the mission's spacewalks—
even though the EVAs, which Geena had been scheduled

to take part in, had both got canceled because of a loose screw that stuck the Shuttle orbiter's hatch mechanism.

Then, to Geena's embarrassment, she was called up again. She was given an EVA credit because—Maddicott said—she and her partner had got suited up and taken to vacuum, even though they never left the vehicle, and that counted for the record. Then the mission commander got up and gave the two of them a special award: the balky screw, smaller than her thumbnail, that had fouled up the hatch. It was wrapped up in a plastic bag, for them to saw in half and mount on wood, half each.

It was moments like this that made her realize what NASA was really all about: it was forty years old now, a well-entrenched piece of Government bureaucracy, where ceremonies like this were an essential part of motivation, the little plaques and medals and in-jokes a measure of the development of your career.

All the applauding NASA managers here seemed to be white males, it struck her, even though the astronauts, the showcase, were a reasonable mix of ethnicity, creed and sex. Many of the managers were of that sleek rotundity that comes to men of bulk and stature in such positions. Men of influence. She looked at Harry Maddicott, for instance. With his jowls gray and dragged down by gravity, it was difficult to remember that he had only been in his twenties during the era of flower power. How had he looked then? And yet now he had seamlessly become the kind of man who seemed to emerge from each generation to run the country, as long as Geena had been alive, and probably a lot longer before.

The inevitability of her own likely metamorphosis with age, into some female equivalent of Maddicott, depressed her. Well, Henry probably thinks I'm there already.

She tried to pay attention to the continuing presentations. There was a slide-and-video show of highlights of the mission. Images of the Mission Control Center here at JSC,

guys sitting at their blue workstations with their jackets over the backs of their seats, scratching their bellies and working with mind-numbing slowness. The Shuttle's docking with Station was more fun to watch, with intercuts between computer graphics of the converging spacecraft and the Station docking adapter making a slow geometric sense, the Shuttle flying up an invisible cone to its target, the black dots of the adapter's Space Visioning System which helped the computers bring the huge spacecraft together. But this too proceeded with glacial slowness, the two huge machines converging at no more than an inch a second.

Now there were pictures from their stay in orbit on Station, usually of an astronaut—sometimes herself— struggling with some incomprehensible piece of equipment in a cluttered interior.

Here was Bonnie Jones, the other woman on the crew, floating around the Shuttle with her long graying hair loose and in a fan around her. As a crewmate, that had driven Geena quickly crazy. Of course the media outlets loved it; Henry told her there had been at least two daily occurrences of "bad hair day" jokes. Later in the mission, Bonnie had tied her hair into a rope-like ponytail, which swung around behind her. The novelty of *that* wore off after the first crew member got a hairy slap in the face.

Geena was, of course, all for equal access to space. But she thought women like Bonnie ought to cut their damn Barbie-doll tresses to a crewcut for the duration; that wasn't such a sacrifice.

The show limped on. The movement of objects in zero gravity, a milky-slow ballet, had some appeal. But the audience started getting restive, the kids and old people bored. The fact was, the novelty of watching nondescript people performing incomprehensible tasks soon palled, zero gravity or not.

There was a brief sequence of Arkady Berezovoy on board Station, using a Station power tool, floating upside

down. He grinned out of the screen, it seemed directly at her. He spoke to camera in his thick, earthy, accented English: *It was like a dream when Shuttle came floating up to Station. Last night I slept on the Shuttle for the first time. It was unusual. Station had become my whole universe. After 128 days in space, I couldn't believe anything existed beyond its walls . . .*

Arkady was still on orbit. Listening to his voice, Geena realized how much she missed him.

The most striking images, the ones that stunned the audience to silence, were those of the Earth: the visible evolution of the three-dimensional diorama of clouds and ocean and desert, filled with blue light, sliding past the orbiter's dinged-up wing or tail. Here was a slide taken by Geena, the shimmering blues and greens of the coastline near the Bahamas.

And now here came images from the flight deck of the Shuttle's reentry and landing. Geena's favorite showed a view from the rear windows of the plasma trail stretching behind the orbiter, a pink road reaching all the way back to Mach 25 and orbit . . .

The time came for questions for the crew. Most of them came from the journalists, but given the nature of the event these were mostly harmless lobs.

Sixt, how do you feel about your career now? Do you want to fly again? Do you have any regrets?

Sixt Guth prepared his answer. He was an Apollo-era relic still flying at sixty-four, who seemed to be trying to defy age. It was incredible to think he was actually older than Harry Maddicott, she thought.

"I was recruited, in the 1960s, as a scientist-astronaut," Sixt said. "You have to understand I was actually recruited to go to Mars, maybe in the 1980s. That was what I expected, and so did everyone else, and it was the ultimate purpose of my job. But it didn't pan out that way. At least I got as far as LEO, low Earth orbit, and I enjoyed my time there . . ."

Sixt had actually completed seven flights already and was hoping for more. He was an obsessive learner, having taken at least five degrees in with his two-year stretches of Shuttle training. He was undeniably *old:* he was totally bald, his head and face seemingly polished smooth. He moved with an odd gait, as if awkward in Earth's gravity, and—like others of his generation—he was, Geena thought, rather clumsy and too brief in his public pronouncements, not so articulate and media-friendly and practiced as the rest of them, even Geena. She wondered briefly how they must all look to outsiders: like younger, slimmer, ethnically mixed versions of the Center director maybe, sleek and rich-looking and confident and articulate. The epitome of space travel as a career move.

It was for the sake of this corporate coziness, she thought with uneasy regret, that Henry's mission had been broken.

Sixt fumbled with his lapel microphone. "You ask me about regrets. We weren't ready to go to Mars, I understand that now. Spaceflight is not easy. I don't know personally how I would have fared, psychologically, if, in some other universe, I had ever gotten to do that hundred-million-mile trip to Mars. Months of isolation from my family and home, not just days . . ."

Sixt, do you still think we should go to Mars?

"Well, I guess so. But it remains a heck of a long way to go. I've come to think we should put our hearts into a return to the Moon. Sure, the Moon's not an ideal destination. It's a desert compared to Mars. It would be better if Mars was in orbit around the Earth, just three days away, but it isn't, and we ought to make the best of what we got. But even on the Moon it might be possible to live off the land, if we're smart enough."

And then came the questions for Geena. The first couple were about her last flight but two, the first by an all-woman crew in U.S. space history. It seemed to have aroused as much interest and curiosity as if NASA had

appointed a team of chimpanzees to make the flight. But Geena had gotten used to handling those questions now.

After that, they got tougher.

Your husband thinks there's an ocean on the Moon, doesn't he?

Gentle laughter.

"Not an ocean."

But enough to flood the Moon, if it was all melted. Is that right?

"It's a possibility." She smiled tightly. "I don't pretend to understand the theory of how it got there. But it seems possible."

Geena, do you think NASA should have brought the astronauts home from Station?

"No. The evidence we have is that the radiation pulse from Venus was transient. The danger's already over . . ."

Geena, I can't help notice Dr. Meacher isn't here.

Sixt tried to help out. "Nor are my ex-wives. Attendance isn't compulsory, thank God."

That got a laugh. But the questioner, a journalist, was persistent. *You didn't back his* Shoemaker *proposal. We hear he's leaving NASA over it. Is there any bitterness between you?*

She was aware of a shift in the body language of the crew up here on the stage, the managers, the rest of the audience. Everyone was quietly waiting for her answer, as always fascinated by some other poor sap's domestic difficulties.

"There's no bitterness. Henry and I have our separate careers. Even when we were married, that was so. And now our marriage is over, but the break-up had nothing to do with our differences over Agency policy. I hope that answers you."

It was, at least, enough to shut him up. But she knew—and everybody else in the room seemed to know—that it wasn't the truth.

The briefing broke up, and they were led out to an autograph session.

* * *

Later in the day, on impulse, she phoned Henry, at his hotel in Edinburgh.

"I'll help you," she said.

What? How?

"I'll find out the context. Of your rock."

He paused. She thought he was gathering his strength, as if he was about to come back with another put-down. But then he said, tenderly, *You do that.*

Tenderly. But, she saw clearly, without love.

7

Mike Dundas picked Henry up from the Balmoral.

It was a balmy Saturday evening, at the end of Henry's first full week in Edinburgh, and Mike had asked Henry over for dinner. Henry had accepted uneasily. He still didn't feel much like being sociable; and besides, he wondered what horrors of northern British cuisine he was going to be subjected to.

But he couldn't see any way out of it, with grace. Mike seemed pathetically grateful to Henry for giving him the chance to work on the Moon rock. Maybe this would let the kid get that out of his system.

They drove south for a mile or so, and arrived at a small estate of identikit houses. Mike pulled up in front of one house, maybe 1960s vintage: a nondescript box, a small garden to front and back, like, Henry sensed, millions of similar suburban homes all over Britain. A little farther away there were rows of tower blocks, the result of some misconceived housing policy of the recent past. Not a great place to live.

But it was redeemed by one hell of a view of Arthur's Seat, to the east.

This was actually his father's house, Mike said; his mother died a few years before.

"So who's cooking?"

"Dad. With a little help from me."

"Oh, shit."

Mike laughed, and locked the car.

A plastic soccer ball hit Henry in the nose.

A kid came running around the side of the house: a boy maybe ten years old, all stringy muscle and energy, his elbows and ankles sticking out of his clothes. "Oh, bugger," he said.

Mike said, "Jack!"

"Mister, I'm sorry."

Henry had to stand there and wait while the blow's effects worked their way along his nervous system, and when it reached his pain center the agony was disproportionately huge.

Holding his nose, he waved his free hand. "Forget about it."

The kid retrieved his ball and ran off out of sight.

"Who the hell was that?"

"Jack. My nephew. Come on, I think you deserve a beer."

"Damn right."

They walked into the house. Mike called ahead, and an older man came out of the back, wearing a plastic apron with a picture of a French maid's torso on it. The apron had to stretch over the guy's beer belly. He stuck out his hand. "Ted Dundas. Mike's father." His accent was different to Mike's, stronger almost to the point of incomprehensibility, with half the consonants missing and every vowel distorted. He was, Mike had told him, an ex-cop.

"Thanks for inviting me."

Ted waved a hand. "Help yourself to a beer." He went back to the kitchen.

Mike followed, and returned with two pewter tankards, unopened cans of beer inside them. It was the cold light ale the Brits called lager.

They wandered through the house. It was minimally

furnished, a big color TV in the living room, a sliding glass door that gave onto a brick patio, walls painted in pastel whites, a lot of brickwork throughout the house.

Henry wondered what to say. "Tasteful."

Mike laughed. "You don't fool me. But thanks for trying."

They went out through the open patio doors to the small garden. It was east-facing, Henry saw, so it was in the shadow of the house in the evenings; but it had a good view of Arthur's Seat. Henry took a couple of breaths. The evening air was fresh and cold.

They were close to the western face of the Seat here; the Salisbury Crags loomed a half-mile or so to the east, their rust-brown faces glowing with color in the low sun.

"Oh. It's *you*." A familiar woman's voice.

Henry turned.

It was the sister, Jane, who he had met in that disastrous encounter in her shop. She was wearing a long floral-patterned dress, open at the neck, some kind of wooden clogs, and a hair band. She was standing there holding a glass of wine, the low sun on her face. She wasn't wearing the peridot necklace, Henry realized with vague, unreasonable disappointment.

Mike stepped forward, grinning. "Jane, meet Henry Meacher. My colleague at—"

"You bastard," she said to Mike. "You *knew*." She turned on Henry. "So did you, in the damn shop. Big joke, guys."

Henry spread his hands. "Believe me, I wasn't expecting you."

"Or you wouldn't have come. Right?"

"No. I mean, yes." He drained his beer. "Mike, could I get another one of those?"

But Jane had turned on Mike. "As for you, you little shit—"

Mike's grin didn't fade. "Hello, Jack."

Here came the kid, his soccer ball moving at his feet as if stuck there with glue.

"Kid's got a good shot on him," Henry said dryly.

"You like kids?"

"I loathe the little assholes."

Jack laughed, and got himself a glare from Jane.

Mike touched Henry's shoulder. "Keep that up and you'll have a friend for life."

Mike's father stuck his head out the door. "Snouts to the trough!"

The five of them sat around a table of some polished wood. It might even have been mahogany. But the setting wasn't too formal—plates and cutlery that didn't match, paper napkins, the table scattered with sauces and condiments and wine and beer, and a Diet Coke for the kid. The body language of the adults made it clear the soda was some kind of special treat.

Out of his apron, the father, Ted, revealed a shirt and tie. In the middle of the table Ted put out a steaming bowl of what looked like chili, some kind of minced meat with tomatoes, kidney beans, big chunks of onion; there was a choice of tortilla chips or rice. Henry took the chips, some fresh bread, and a couple of healthy ladlefuls of the chili. He tried a mouthful; it was hot and sharp.

"I'm impressed," he said.

Jane eyed him. "You were expecting haggis and kilts."

"No. I didn't think you British were eating beef."

"Not beef," the father said through a mouthful of chili. "It's quorn. Meat substitute." He slapped his belly. "Better for you. I'd generally serve up salad but what with all this radiation you can't get fresh vegetables for love or money—"

Henry sneezed, suddenly. Then sneezed again.

Ted stared. "What's wrong with him?"

Jane said, "Serves him right for walking around Edinburgh in a T-shirt."

"I get allergic." He looked around. "You got a cat?"

"Yes," Ted said. "Willis. The little beastie isn't here right now."

"Randy little sod," Jane said mildly, eyeing her father. "Like his owner."

"Don't speak about your father like that," said Ted.

"Doesn't matter if the cat's here or not," Henry said. Sneeze. "One hair is enough." Sneeze. "Do you have any antihistamines?"

Ted eyed him. "Do *I* look as if I have any antihistamines?"

The boy was staring at him. "Do you like cats?"

"No. I loathe cats."

"I thought you loathed kids."

"I loathe kids and cats. I'm big on loathing. I have a dog, called Rocky. I had to find him a foster home when—"

"Are cats little assholes too?"

Jane went into glaring-parent mode, but the father was guffawing, and the moment passed.

"So," Ted said. "You like Edinburgh?"

Henry thought over his answer. "I guess," he said. "I'm not a city guy. But it has a comfortable scale. It reminds me of Prague."

Jane laughed. "Prague?"

"Why not Prague?"

"Just remember," Ted said. "Edinburgh is all fur coat and no knickers."

The kid giggled, and Jane said, "For God's sake, Dad."

"Well, it's true."

Mike leaned to Henry. "He's from Glasgow."

Now the kid spoke to Henry. "So you're a geologist too, like Uncle Mike."

"Yeah. You want to be a geologist when you grow up?"

The kid gave him a pitying look. Jane looked amused. Henry plowed on.

"When I was a kid I wanted to be an astronomer. I used to hang out at weekends at the Griffiths Observatory, above

Los Angeles, when my buddies were down on the beach. I even made a map of the Moon, when I was fifteen or so. But real-world astronomy wasn't for me. I think it was because nobody looks through a telescope anymore. I missed the tactile stuff." He hesitated. "I liked the *feel* of starlight, light that was a thousand years old, tickling my eye."

Jane cocked an eyebrow.

"And if that's too poetic for you—"

"Poetry's fine," she said. "Just don't make a habit of it."

"Anyhow, I turned to geology. The world is full of rocks you can touch, after all. I majored in geology at Pomona, in Southern California, and UCLA at Berkeley and LA. At UCLA I learned to live like a geologist, which is to say," he said to Jack, "in the middle of messy oil fields and mines and heat, or cold, and rattlesnakes and poison oak and cow pies . . ."

The kid's eyes were pleasingly round. "Do you get to see volcanoes?"

Henry said, "Not much. I have friends who do that. What I mostly study is the Moon. Do you know about the Moon?"

"Some."

"During the grind at UCLA I visited JPL—the Jet Propulsion Laboratory, where they run the space probes out of, and I saw the pictures of the Moon they had there, and it was like being a kid again. So there I was. I wanted to be a geologist, working with Moon rocks. But only one geologist ever flew to the Moon, and that was thirty years ago, and there was no prospect of anybody going back soon.

"Anyhow after that I was a little stuck. I wasn't interested in the oil companies which hire most geologists. I decided I had to bite the bullet. I had to go work for the only place specializing in Moon rocks, thirty-year-old collection or not, and that is the Lunar and Planetary Institute in Houston. NASA."

"NASA," breathed Jack.

"It's not as cool as you might think. What I found when I got there was they were throwing out half their collection of Lunar Orbiter and Apollo photographs, maps and mission documents. You wouldn't believe it. I had to pull them out of the Dumpster, literally, forty billion dollars' worth of trash. NASA is much better at gathering data than storing it . . ."

Jack looked baffled.

Jane said, "You don't talk to kids much, do you?"

"I know about the craters on the Moon," Jack said. "Like Tycho."

"Well, that's good."

"Are the craters volcanoes?"

"No. The craters are impact scars. But we used to think they were volcanic. You know, they took the Apollo astronauts crawling over Hawaii for their training, the big volcanic calderas there. All those lava surfaces. They thought the Moon would be like that. Wrong . . . They should have stayed on the beaches; that turned out to be a closer match. Anyway I hate Hawaii."

"Why?"

"I was once studying active lava flows there, and I broke through a solid crust and sank into molten lava up to my knees. Not pleasant. But I recovered."

"Wow," said the kid, round-eyed. "Is lava dangerous?"

"No. Lava is friendly. Unless you're unlucky, or careless, like I was. You can walk around on lava. It smells odd, like scorching paper. And it moves slowly; you can get away from it. Pyroclastic flows are what you have to look out for if you're ever close to a volcano."

"Pyro—"

"Ash."

Ted helped himself to more chili. "So why do all geologists look like they've been living in a hole in the ground?"

Jane laughed.

Mike said, "They probably have, dad."

Henry said, "It's true. There are other types of people who study the Earth. Like photogeologists, for instance, who work from photographs, and petrologists, who treat their rocks like lab specimens, and geochemists and geophysicists. But old-time geologists will look down their noses at any of that and say, "Needs field checking." By which they mean, if you can't walk on it and rub your hands in it and get yourself good and dirty in it, it ain't geology."

"Hey," Mike said. "I have a joke about that. Maybe you heard it. What's two plus two? The geologist says, 'Well, around four.' The geochemist says, 'Four plus or minus two.' The geophysicist says, 'What number do you want?'"

Henry laughed, though he'd heard it before. The others just looked baffled.

"So," said the father. "You divorced, separated or what?"

After the meal, Mike's father said he would wash up, and Mike and Jack went out to the garden to play some more soccer.

Jane and Henry sat in the living room, regarding each other warily.

Jane said unexpectedly, "You want to go for a walk?" She stood briskly. "We'll climb the Seat. Shouldn't take more than an hour. Unless you think that's too far."

Henry stood. "I'll be fine."

She handed Henry a heavy radiation-screen poncho, and marched him out the door and down the path.

They tramped for a brisk half-mile on the road, going northeast, skirting the base of the Seat. Then they turned off and began to climb a path over the Seat itself. Soon, Henry was walking over spongy grass, with hard basalt beneath, tough through the soles of his training shoes.

The noise of the traffic diminished, and the only sounds were their breathing, growing deeper as they walked, and the soft susurrus of the wind in the grass. As the fresh air filled his lungs, even his sneezing diminished.

It was *cold,* however, despite the poncho, but, after nearly two weeks in Scotland, he wasn't about to admit that.

They turned west again, and followed a path Jane called the Radical Road, which ran at the foot of a low crag. She said, "This is the north end of Salisbury Crag."

He stepped forward and ran his fingers over the exposed rock. "It's a sill," he said. "A sheet of basalt."

"I know."

"Geologists like basalts," he murmured. "They're what you get when planets melt. And they tell you a lot about hidden processes . . ." He ran his hands over the other layers. "Looks like baked shale above it. Maybe cementstone. And below, this is sandstone—"

"I know that too. This is what's left of the Old Red Sandstone Continent."

"You're a smart cookie."

They walked on, along the base of the crag.

At length she said, "I don't know if I like being called a 'cookie.' "

"You're very competitive, aren't you?"

"And you're not too good with people."

He made to deny it, or to come back with a snappy answer. But he shrugged. "Maybe not. You know, when I was doing my doctoral research I spent eighteen months in Norway, clambering around the fjords there. A lot of that time I spent alone. Working alone in tough terrain like that is something most geologists would frown on, but you do it anyway, when you are short on time or you're too poor to pay for a field assistant. As I was.

"So I climbed over the ice rivers, trekked past sheer rock walls, trying to make the most out of the money it had cost me to go there. Oh, I knew my limits; I saved the really

tough country for those times when I was accompanied. But I wasn't afraid of being out on a limb. Relying on myself."

"And," she said dryly, "your point?"

"Well, when I look back on it that was one of the happiest times of my life. Because it was the simplest. People just—"

"Make things complicated?"

"Something like that."

"You never answered Dad's question."

"Divorced," he said. "Just."

"Jack's father left when he was still small. He doesn't remember him."

"You don't need to tell me."

"I want to tell you. Jack was a glue baby, if I'm honest. You know what that means?"

"I guess."

"So, good riddance."

"Right . . ."

He liked the way the deepening light caught the planes of her face. It seemed to emphasize the strength and intelligence there.

He sneezed violently.

They walked on for a time. The path ascended and descended, a gentle switchback, as the lava sill waxed and waned in thickness.

At the end of the sill, they clambered up a steep, eroded path toward the summit of Arthur's Seat.

At the summit, they sat on broad, worn-smooth patches of ancient agglomerate. Henry found the backs of his legs were aching pleasurably; he hadn't been getting enough exercise, he realized.

They looked to north and west, over the city. A blue mist, sharply defined, lay across the land. The spires and towers of the city poked out of the mist. A waning Moon, thin and attenuated, hung in the sky.

"The old folk call the mist the *haars*," Jane said.

"It's beautiful."

"On a clear day you can see a long way. All the way across the Midland Valley graben from the Highlands, fifty miles or so to the north, and down to the Southern Uplands, ten miles southeast of here, beyond the coalfield—"

"I'm impressed."

"By the view?"

"By the fact that you know terms like *graben.*"

"You're such a patronizing arsehole." But this time her tone was so mild it almost sounded affectionate.

"Thank you," he said. "So what about you? How did you get into, uh, rocks?"

"And all the other cookie-girl New Age stuff, you mean?"

"I didn't say that."

She pulled at a tuft of grass. "Actually, it was the Moon."

"The Moon?"

"I read a science fiction story which shocked me. I was only ten or so—about Jack's age, I guess."

"What story?"

"I don't remember the title. I think it was a Heinlein. The point was, he suggested the Moon is the way it is because of a nuclear war up there. It blasted off the atmosphere, and boiled the oceans, and killed everybody."

He nodded. "And Tycho was just the biggest arms dump."

"You know it. You don't need to tell me it makes no sense."

"I wasn't going to."

"It scared me to death. As I got older I started to read about all the perils we faced—still do face. Before I left school I was organizing recycling drives. I read politics and economics at university. I got into real politics later, mainly with the Greens. Not that I ever got elected anywhere. But that doesn't pay the bills—"

"Hence the rock shop."

"Yeah."

"So," he said. "You're what we'd call a survivalist? You think that when it all falls apart we should pack up and head for the hills?"

"No." Now she did sound offended. "Of course not. We're human beings. We got where we are by cooperating, by helping each other. It's just that the future is so dangerous."

"Yep."

"We're going to have to be smart to survive, on any timescale you care to think about. My dad says he thinks I went a little crazy, back when I was a kid. But I think I went a little sane. It was like waking up. It seems to me that everyone else is a little crazy, not me." She was looking out over the city, and the last of the sunlight picked out her profile, her strong nose and chin.

He said, "Maybe you're too sane. Nobody should be burdened with too much future."

"I'm not so tough. I'm a twentieth-century baby like everybody else. Spoiled rotten. As soon as anything serious happened, I'd run round in circles."

"I wouldn't be so sure."

The light was diminishing. The Moon grew brighter, as if to compensate, and she looked up at it.

"You know," Henry said, "the project I was working on for NASA was about going back to the Moon. Looking for water ice there. I think it's possible there is so much ice you could actually terraform the Moon."

"Make it like the Earth."

"Yes. Somewhere else for people to live. But my project got canned, and we may never know about the ice. Nobody's going to the Moon any time soon. Least of all me."

"Would you go if you had the chance?"

He grinned. "In those ropy World War Two rockets they fly? No, sir."

"So you're a childless man who wants to build a new world."

"Oh. Sublimation, you think."

"Could be."

"And you're a parlor psychoanalyst. Lucky me."

She said, "You know, after I read that Heinlein story, I colored in maps of the Moon, figuring out where the oceans and cities must once have been."

He nodded. "How about that. So did I. We have something in common after all."

"I was just a kid . . ."

He stared up at the Moon. "It would be a beautiful thing. A terraformed Moon. It would be much brighter. A twin of the Earth. And if you were on the Moon—well, with that low gravity, it would be like something out of H.G. Wells. *The First Men In The Moon.*"

"Umm." She stood up, and brushed down her dress. "And people call me crazy."

"I never did."

"But you thought it. I know why. I run a shop where people come and pick up the rocks, trying to feel their vibrations—"

"Now *they're* the crazy ones."

"Are they?" she said mildly. "But there's a rock in my digital watch; its vibrations keep the time. And they vibrate rocks to send laser beams, all the way to the Moon. We live in a strange world. Come on. We'd better go down before it's too dark. Although you'll like the Northern Lights displays we've been getting since Venus . . ."

He unfolded his legs and stood.

She led him down a different track, a path that would lead through a glacial cwm and then to a ruined chapel.

"So," he said. "What about dinner?"

She frowned, but she didn't immediately say no. "We just ate dinner."

"Hell, you know what I mean. What about the weekend? I—*woah.*" He stopped in his tracks.

She slowed beside him. "What's wrong?"

"What is *that*?" He pointed ahead.

It was a patch, on the exposed shoulder of the summit agglomerate, roughly circular. It had been hidden from where they had sat. It was, Henry estimated, two yards across. Its surface was metallic silver, flat as steel. At first it looked like some liquid—there was even a fuzzy reflection of the Moon—but he could see it was too sluggish, even for the scummiest pond.

He approached its edge.

It was a pool of some kind of fine silvery dust, or maybe rock flour. He crouched down to see. The contact with the surrounding basalt was quite clean. The rock flour seemed to be stirring slightly, almost bubbling, sluggish currents moving through its substance.

He found a loose pebble. He dropped it into the edge of the puddle. It vanished without so much as a splash.

Jane was standing over him, leaning with her hands propped on her thighs. "What do you think it is?"

He scratched his head. "I've never seen anything like it. Maybe it's liquefaction. It could be some kind of magmatic event."

"Magmatic?" She straightened up. "Come on. Arthur's Seat has been dormant for three hundred million years."

"I know."

"It's probably some kind of toxic waste," she said.

"Maybe."

He got up and walked off around the rim of the puddle, counting his footsteps.

Jane called, "What are you doing?"

"Measuring."

"Why?"

"It's an annoying thing geologists do. Can you smell anything?"

"Apart from bullshit, you mean."

"Work with me here."

She took a deep breath. "Nothing but the grass and the *haars.*"

"Nor can I."

"Is that good?"

"I don't know."

"Is it bad?"

"When was the last time you were up here?"

She shrugged. "A couple of weeks."

"And it wasn't here then?"

"No."

He returned to her. "Listen, do you have a bottle? Maybe makeup. Perfume or somesuch."

"I don't wear perfume."

"Anything, then."

As it happened, she did have something. It was a sample of an aromatherapy oil she'd been given by a salesman at the shop. She'd tucked it in a pocket and forgotten about it.

He took the bottle, unstoppered it, and tipped out the oil.

"Hey."

"I'll pay you."

He shook the bottle dry, and then, carefully, he scraped the bottle along the top of the rock flour puddle.

When he was done, he stoppered the bottle and tucked it in a pocket of his jeans.

"What is that stuff?"

"I don't know," he said. "Maybe I'll be able to find out."

She looked around. "It really is getting dark now."

"Yes."

But he hesitated.

He walked to an outcrop of basalt near the pool, picked up a loose lump of rock, and hit the outcrop. He frowned at the result.

She said, "What's wrong?"

"Did you hear that?"

"One rock hitting another? Flintstone chic—"

"The pitch was low. Basement rock will ring with a high pitch. This boulder is loose." So something is breaking up the basement here.

Not good, he thought. Not good at all.

He walked carefully around the puddle. "I wouldn't tread in that thing if I were you."

"Why not?"

"You were saying about dinner . . ."

"No. *You* were saying about dinner."

They worked their way down the hill, arguing. Henry stumbled occasionally in the deepening dark; each time he patted his jeans pocket to make sure his sample was safe.

Behind them, the puddle glowed softly in the wan Moonlight. Where it stirred, the rock flour rustled.

8

Toward the end of Geena's eight-hour shift as capcom for Station, a problem came up with a seat liner for one of the Soyuz escape craft.

Because the seats in Soyuz were molded to fit an individual astronaut or cosmonaut, liners had to be stored for every crew member on Station at any moment. But one of the Russian crew who had just been carried to Station, on board Space Shuttle *Endeavor,* was complaining that when she tried to install her seat liner into the Soyuz it didn't fit her. So the ground controllers, in Moscow and Houston, had gotten into a wrangle about what the cosmonaut's home vehicle was, and Geena found herself on the voice loops to Station trying to explain—in English and Russian—the home vehicle rules.

She read, "The home vehicle for Shuttle-Station crew members is defined as follows. The home vehicle for Americans launched on the Shuttle is the Shuttle. The home vehicle for Americans on Station becomes the Shuttle immediately after the hatches are opened between Station and Shuttle. The home vehicle for cosmonauts launched on

the Shuttle becomes the Soyuz, and becomes the Shuttle for cosmonauts on Station after—one—the seat liners are installed for the Station crew in the Soyuz, and—two—the Station crew are briefed on emergency procedures . . .'"

Traditionally, the Americans tried to use Russian, while the Russians replied in English. It was slow and painfully clumsy, but it did seem as if less mistakes got made that way.

The Russian Interface Officer, a heavy-set woman from New York, was at her side, checking the agreed English-Russian translations of technical terms and acronyms.

The Mission Control Center here at JSC hummed around her, rows of sleek black touch-screen workstations like *Star Trek* props, littered with coffee cups and yellow stickies and laptops and binders of mission rules. Beside her desk there was a huge recycling bin for soda cans. At the back of the room was a row of potted plants, their tubs littered with more soda cans. At the front of the room, the big screens carried computer-graphic images of the Station's position and orientation in orbit, a view of the Earth from an external camera, and a shot of a science lab where a European astronaut was freezing saliva scrapings taken from the crew.

It was a familiar working place for Geena, so homely that coming in here was like taking an adrenaline antidote.

Bored to tears, she tried to focus on seat liners.

She'd spent the morning attending a press conference on the plans the boys from JPL were putting up for a fast probe to Venus. It had been exciting, energetic; in fact NASA as a whole had been energized by the Venus event, Geena thought. Whatever the ominous implications, the amount of attention space issues had received since then had been gratifying, and NASA's speed and flexibility of response invigorating.

But even so, when you got to the coal face of manned spaceflight, it was still a crushing bureaucracy to work in.

The seat liner controversy went on and on.

The hardest thing about managing the Station project was not the technology or the work on orbit. Geena knew from experience that once on orbit, isolated in that collection of tin cans, people tended to drop their personal differences and work together. Integrating two forty-year-old management hierarchies on the ground had proven *much* more difficult.

Even the basic philosophy of operation of the two control centers differed. For instance, previous Russian space stations—Mir and the Salyuts—had been out of contact with their controllers for most of each day, because of a lack of ground stations around the globe. So the Russians had developed a shift system based on that fact, which differed from the American system. And they'd had to allow their cosmonauts more latitude in day-to-day operations and decision making than American astronauts, checklisted to death, were generally permitted.

American and Russian mission controllers had worked together for some years now, on the Station assembly project and before that on the Shuttle-Mir docking missions, and had thrashed out a set of common procedures. NASA had given all its astronauts and controllers accelerated Russian language training, and had provided joint training and simulations, and so on.

But it was never going to be *easy*.

Day to day, they ticked along. But every time a real problem blew up, like this one, it seemed to go to the top of both hierarchies before resolution.

Gradually, the liner problem was eroded to bureaucratic smoothness. And, toward the end of the shift, she was able to snatch a little personal time on the loop with Arkady.

Of course, the whole of the MCC would listen in, as would TsUP, the Russian mission control at Korolyov; in fact a smart IBM computer somewhere would transcribe every word they spoke. But there was still room for a little intimacy. This was one area where the Americans had found they had had a lot to learn from the Russians; those

guys seemed to have a better instinct for the internal needs of the people they thrust up there into orbit.

So, thanks to Russian mission rules, Geena and Arkady were allowed their air time.

She read him a poem Arkady's mother said he had always liked, called *Poltav Battle*. And then they sang together, her own toneless grunts along with Arkady's voice—more musical, but reduced to a scratch by the loop—an old Russian song called *On the Porch Together*. She got the odd stare from her fellow controllers, but she couldn't care less about that.

When she was done, she had a warm feeling which persisted even after her shift broke up.

She left the MCC, and made her way out of Building 30. She'd been intending to go straight to her car and home.

But she hesitated.

It was late afternoon. Spring: the least offensive period in Houston's calendar. There was blossom on the trees, and there were, she saw, birds nesting in the big air-conditioning grilles on the side of the faceless concrete block that was Building 30.

She walked to the central quadrangle of the campus, concrete paths criss-crossing the bristly grass between the buildings. No doubt, she thought, there would now be trails of ducklings quacking their way across the campus, if the ducks hadn't been chased out of JSC twenty years ago for the noise and mess they made. *We ain't here for ducks.*

She remembered her promise to figure out the context for Henry's precious Moon rock. She hesitated. Maybe the spring air was making her mellow.

She walked over to Building 2, Public Affairs, to find out how she could get hold of Jays Malone. It turned out he was coming in the next day, for a lecture and a tour of the lunar colony studies going on here at JSC. She talked her way into an invitation to join the party.

*　　*　　*

The next day, Geena made her way to the back of a lecture room in the PAO building, while Jays Malone fielded questions about his work from the scattered handful of journalists.

Jays Malone turned out to be a big man, still muscular, slim and supple for his age, which was—Geena knew from the biographies—about 70. He was crisply tanned, right to the crown of his head, which was totally free of hair, polished to a billiard-ball shine. He looked a little dwarfed by the giant show cards his fiction publisher had sent over—*Rocky Worlds—A Vision of the Future by a Man Who's Been There . . .*

Geena had never met Jays before. He had retired before she had even joined NASA. She'd seen him on Apollo retrospectives and the like, but he was a few generations too remote from her astronaut class to have made any difference to her career here.

Jays stood up to speak. He propped his leg up on a chair, leaned on his knee, held a mike with one hand, and when he spoke, his free hand fluttered around his head like a bird, as if out of conscious control.

So, Colonel Malone, why "Jays"?

"It was my sister. When she was a kid she couldn't say 'James' right. It came out 'Jays.' It stuck as a nickname."

Is it true you changed your name by deed poll to Jays?

"No. And it's not true I trademarked it, either . . ."

Laughter. The journos were friendly enough, Geena realized, rows of faces turned to Jays like miniature moons.

Why the title?

"Something that occurred to me on the Moon," he said. "Maybe Earth is unique. But the Moon isn't, even in our Solar System. The Galaxy has got to be full of small, rocky, airless worlds like the Moon, Mercury. Right? I was only a quarter million miles from Earth, but if I looked away from Tom and the LM, away from the Earth, if I

shielded my eyes so I could see some stars, I could have been anywhere in the Galaxy—hell, anywhere in the universe . . ."

The audience shifted, subtly, showing he had hit the wonder nerve. With the younger ones anyhow.

But Geena knew he was cheating a little. There could have been no time for such reflection during those busy three days on the Moon; such insights had come from polishing those memories in his head, over thirty years, like jewels, until he probably couldn't tell anymore what was raw observation on the Moon, or the maundering of an old man.

Your books are full of geology. But you weren't trained in geology for your Apollo flight . . .

"That's not quite true," Jays said, and he expanded.

The Apollo guys had some training from geologists attached to the project—they'd be taken to Meteor Crater, Arizona, or some such place, and taught to *look*—they had to try to be geologists, at least by proxy, in a wilderness no true scientist had ever trodden before them. But in the end Jays had spent three days bouncing across the Moon, wisecracking and whistling and cussing; for the point of the journey was not the science of the Moon, of course, nor even the political stuff that pushed them so far, but simply to get through the flight with a completed checklist and without a screw-up, so you were in line for another.

But for Jays, there never *had* been another. After returning home he was caught up in the PR hoopla, stuff he'd evidently hated, stuff that led him to drink a lot more than he should. And by the time he'd come out of *that* he found himself without a wife and out of NASA, and too old to go back to the Air Force.

Jays talked about all this now. "It was a time," he said with a smile, "I still think of as my Dark Age."

The audience was silent.

"But I kept in touch with the studies of the Moon rocks we brought back. I showed up at lunar and planetary

science conferences. And that got me interested in geology. I took a couple of night classes, even made a few field trips, over the years. For a while it was just a way to fill up time between Amex commercials and daytime talk shows. But I soon came to know a lot more about the Earth than I ever did about the Moon."

And, he said, gradually, the geology stuff had hooked his imagination.

Death Valley, for instance: one of the most famous geological showpieces in America. But if you managed to look beyond the tourist stuff about bauxite miners and mule trains, what you had there was a freshwater lake, teeming with wildlife and flora, that had gotten cut off from the sea. Over twenty thousand years the lake had dwindled and become more and more saline; the trees and bushes died off and the topsoil washed away, exposing the bedrock, and the lake's inhabitants were forced to adapt to the salt or die . . .

His first piece of fiction, a short story, was slight, a tale of a human tribe struggling to survive on the edge of such a lake.

Nods, from the sf enthusiasts in the audience. *The Drying*. It had won a prize.

The story sold for a couple hundred bucks to one of the science fiction magazines, Jays said he suspected for curiosity over his name alone. A novel, painfully tapped into a primitive word processor, followed soon after. He hadn't read sf since he was a kid, but now he rediscovered that sense of time and space as a huge, pitiless landscape that had impelled him toward space in the first place.

Are you arguing for a return to space, in your books?

"I guess so. I think we need to be out there. You don't need to know much geology to see that . . . On Earth, in a few thousand years the ice will be back, scraping the whole damn place down to the bedrock again, and I don't know how we're proposing to cope with that. And then there are other hazards, farther out . . ."

The next big rock. The dinosaur killer.

"It's on its way, maybe wandering in from the Belt right now, with all our names written on it . . . Or maybe there is some other hazard, waiting out there to bite us. But I'm not propagandizing here. This is just fiction, right? I want your beer money, not your vote."

Laughter.

Of course, propagandizing was *exactly* what Jays was doing.

Jays had said on a multitude of talk shows how he was dismayed by the Shuttle program—a clumsy, compromised, primitive design, just a V–2 with air conditioning, it seemed to him—and by the lack of any serious consideration being given to any more advanced follow-up.

For the fact was there *were* smarter ways to get into space, to reach the Moon and beyond. For instance, orbits of spacecraft passing between the Earth and the Moon were actually unstable, because of the tweakings of the lumpy gravity fields of Earth, Moon and sun. If you gave your spacecraft the right kind of push, in the right direction, at the right time, you could use that instability to make your spacecraft drift to the Moon. It would take longer to get there than the three days it had taken *him,* but that wasn't necessarily a problem, for it would be a fraction of the cost in fuel and mass in low Earth orbit.

"Then," he said, "once you are on the Moon, there's oxygen, and water, and materials for rocket fuel, and materials to make glass and concrete . . . Once you are on the Moon, with all those resources out of Earth's deep, heavy gravity well, hell, you can go anywhere!"

It was a vision he shared with a handful of others, inside and outside NASA: how, with a little imagination, the Solar System could, after all, be opened up for colonization, with the Moon as the key.

Unfortunately, nobody with any power, financial or political, wanted to listen. Even to somebody who had been there.

So he began to work in more subtle ways. He joined

the board of the National Space Society, for instance. He published his conceptual studies wherever he could, and plugged them on chat shows. He started to work his ideas into his fictions, building up a body of work that, piece by piece, it seemed to Geena, amounted to a kind of schematic of the future, a ladder to history.

Robert Heinlein had done something similar, back in the '40s and '50s, and so nurtured the minds of the youngsters who would go on to run NASA, and touch the Moon. Now—in less optimistic times, with a deeper understanding of how God-awful difficult the whole enterprise would be—Jays Malone was trying the same trick.

"I tell you," he said, "I've given up on you guys. Your generation. All this New Age crap. But there are always the kids. Always the kids."

Jays talked on, taking the questions—dumb, perceptive, intrusive, whatever—with a clumsy, good-humored grace.

She waited until the autograph queue had dissipated, and approached Jays.

Jays regarded her gravely. "I know you. Geena Bourne. You just came down from Station."

"Yes." She felt vaguely surprised that he should follow the current program so closely. "I'm glad to meet you."

"You are?"

"I'd like your help. I need to talk to you about 86047."

A frown crossed his face.

Geena told Jays what she wanted. She hoped that if they went through the moment at which he collected rock 86047 one more time—with the help of the mission transcript and such documentation as existed—they would be able to reconstruct the rock's context sufficiently to help Henry.

Jays was resistant. "I've been over those damn three days a hundred, a thousand times. What more is there to say?"

"Henry thinks there's plenty you could tell him."

"Oh, he does. It was my piece of bedrock, you know."

"86047."

"Yeah. I guess I risked my life to collect it. And they let it sit in the vault for a quarter-century."

"Not anymore." She outlined Henry's project. "That's why the context is so important—"

Jays glared. "How the hell was I supposed to document it?"

"Well, that's the point, Jays—"

"I had to hang upside down in that damn rille to capture it in the first place. Those geology back-room guys weren't *there*. They couldn't see how hard it was to follow their precious procedures, if you were *there*. I told them that."

And so on. A one-way conversation.

"Anyhow," he said to Geena, "there's no good reason to ignore a rock like that for so long. I mean the attention they all gave that Genesis rock from Apollo 15—"

Ah, Geena thought. That was it. Rivalry with the other crews, the trophy fish *they* brought home. Even after all this time.

"But now," she persisted, "late in the day or not, Henry is going to study it. But he needs your help. I need your help."

He regarded her, his eyes pale blue.

Jays let her drive him out to his home.

She drove along NASA Road One east through the Clear Lake area—marinas, apartment complexes, parks. When the road reached the coast and turned up to go north toward the Port of Houston, they came to Seabrook. This was an old run-down village, with wooden houses mounted on five-feet stilts.

Jays's house must once have been handsome, but now it was faded by sun and busted down by the weather and

neglect. Some of the houses in the area were being restored now, but not Jays's. It looked, in fact, like a prop from *Gone With The Wind.*

It was kind of a nice area, Geena supposed, to retire. The houses would catch the light off of the ocean in the mornings. But it reeked of age.

The house was full of age too. A ticking clock. A dog, a quiet spaniel. A litter of aviation trophies, slowly gathering dust. A bookshelf with a row of his science fiction books, skinny hardback volumes. In the middle of it all, on a walnut coffee table, there was a double picture frame: Jays as a kid, gappy grin and slicked-back hair; and an image of Jays the man in his brief prime, bouncing over the tan brown lunar surface, suit glowing in the sun, on his way to one checklisted task or another.

It was the home of an old man who had been alone too long.

Jays made her a cup of coffee. Full of caffeine and cream, it was all but undrinkable, but she drank it anyway. For himself, he cracked a beer.

"So," he said. "You're trying to help out your ex-husband. Kind of complicated." He smiled like a grandfather. "Not sure I ought to get involved."

"Well, he blames me for canning his project."

"The *Shoemaker.* Is he right?"

"I don't think so. I spoke out against it. But you know how this stuff works."

He nodded and took a pull of his beer. "You didn't do him any damage. But you weren't too smart about your marriage."

"I was speaking up for Man-in-Space."

"Sure," he said dryly. "Chewing the balls off of your husband had nothing to do with it."

"It wasn't like that."

"And now you want to make it up with him."

"No. It's done. I just don't want it to finish in bitterness. We've got our whole lives ahead."

He nodded. "Smart. A lot of sleepless nights to get through. Sometimes I wish . . . Well," he said, "you think we should go back to the Moon?"

"No. I heard what you said. But we ought to get on with Station. The space lobby is always divided. We should get behind the project we have."

"Bull." He crumpled the can, seemed to be thinking about another, then decided against it. "We've been fooling about in Earth orbit for too long. We didn't need Station to go to the Moon. If we want to go to the Moon then we should go to the Moon. Learn to live off the land. You can't do that in LEO." He eyed her. "Not that it would be easy. Some of the space buff types who come to see me seem to think it would be like the pioneer days, setting off into the western desert. It won't be. We got to the Moon for three days apiece, two guys for just three days, and we had to bend the national economy backward to do that. Up there, you have to haul along every drop of fuel you need to land, and the dust eats away at any equipment you have, and the volatiles in your seals boil away in the vacuum, and you have to bake the air you breathe out of the rock. Not impossible, but *not* easy.

"And all we got to work with," he nodded a head to the west, "is NASA. A Cold War museum. You ever think about that? What we'd actually do if some kind of *When Worlds Collide* situation came along, the dinosaur killer maybe, and we had to set up a colony off-world, fast? Hell, we wouldn't have a hope." He drained his beer. "People who say the Moon is easy are talking out of their asses. You can colonize a desert with Stone Age technology. On the Moon, you need to be *smart* . . ."

Sure, Geena thought. Sure, let's all dream about the Moon. That's fine, if you don't have to live and work in the space program as it exists, today, in the real world. Which means Station, like it or not.

"Can we talk about your rock?"

He was avoiding her eyes. He was reluctant—but also unwilling to show it.

There was something he wasn't telling her, she thought. Something he knew about that rock he wanted to keep to himself. She had no idea what that could be.

He sighed. "Okay, lady. I don't know what good it will do, but you got a deal. What do you want me to do?"

She got out her tape recorder, and replayed the voice transcripts of those remote moments when he'd found the rock that became known as 86047.

. . . Okay, Joe. It's a block about a foot across. I'd say it's an olivine basalt. It's almost rectangular and the top surface is covered in vesicles, large vesicles. It almost looks like a contact here between a thin layer of vesicles and a rock unit that's a little lighter in color with fewer vesicles. And I think I can see laths of plage in it, randomly oriented, two or three millimeters across . . .

So, in his living room, with a view of an ocean already tinted dark blue by the light of the setting sun, the old man listened to the words he'd once spoken on the Moon, and, as he descended in his mind once more into that lunar rille, he dredged up fragments of description and memory, which Geena noted down.

When she was done, Geena left Jays to his solitary peace.

On impulse, she drove on east and north through the darkening, faded grandeur of Seabrook, and it seemed as if maybe all the relics of the Space Age might one day end up here, washed along the coast by some intangible tide of time.

But when she went just a little farther north she entered industrial areas. The Dixie Chemical Company, the Graver Tank & Mfg. Co. Inc., and so on. Farther on still, on the Bay Area Boulevard, there were a lot of space-related industrial concerns: Lockheed Martin, Honeywell Space Systems, IBM, Hughes Aircraft, on roads called Moon Rock Drive and Saturn Road. Symbols that space wasn't yet quite dead, a sepia-tinted memory, an impossible dream of the generation of Heinlein and von Braun.

It was like coming back to the present, she thought, from a dismal descent into the dead past. She opened her window to let fresh air into the car, and turned the radio to a rock channel.

9

Constable Morag Decker swung her patrol car into Viewcraig Gardens and immediately ran into a jam.

She counted three sets of roadworks, a scene of wooden separators and flashing yellow lamps and hard hats and jackhammers. There were vans belonging to the gas company and British Telecom, and another from a private contractor that looked as if it was responsible for cable repairs, bumped up onto the curb on both sides of the road. The traffic wasn't too heavy, in the middle of this Monday morning, with the sun rising high above Arthur's Seat. But the tailbacks already stretched hundreds of yards to either side.

Maybe she should call the station.

It was unusual for more than one crew to be vandalizing the road surface at any one time. For now, the traffic was moving okay, but she could see the signs of frustration in the way the drivers edged closer together and glared at the crews as they passed. One accident, even something trivial, and the road would be blocked.

Today was April 1st. She wondered if this congestion was the result of some misbegotten joke.

She frowned as she thought it over.

At twenty-five, Morag had had her uniform for just a year. At her last appraisal her sergeant's most cutting comment had been about the way she refused to take responsibility on the ground. She was always too willing to pass the buck up the line, so he said.

She didn't entirely agree. She thought reporting up the line was generally pretty responsible, in fact; information to support good decision making had to be the key to any

reasoned response. So she'd been trained, and so she believed.

But her sergeant was of an older school, toughened in the English inner city riots of the early 1980s, when the police were essentially at war with a hostile public. *I remember my community policing training. A video shot through the back of a riot shield in Toxteth. My God, the looks on the faces of those yobs . . .*

Her own presence, gliding through here in the marked police car, was having a visibly calming effect. Maybe a copper on the spot wouldn't be a bad idea during the rush hour, later in the day.

She deferred the decision.

In the meantime she had a more immediate problem: nowhere to park.

She was in luck. Ted Dundas was out in front of his house, prodding vigorously at a garden verge. When she pulled alongside she opened her window and leaned out.

Ted straightened up, leaned on his hoe and nodded. "Morag. Come to see me?"

"No such luck. But I need to get this beastie off the road. Can I—"

"Use the drive?" He dropped his hoe and, with an alacrity that belied his years and beer gut, he hopped over a low wall and opened the wrought-iron gate.

That was Ted for you: helpful without pressure or hassle. He'd been one of the most helpful elements in the station when she'd joined last year; she genuinely regretted his retirement from the force.

She briskly reversed the car into the drive. She climbed out, carrying her peaked cap.

On impulse, she looked east, toward Arthur's Seat. The air was—odd. She thought she could smell ozone, like at the coast, or maybe before a storm. But the clouds were high and thin. And the light above the Seat seemed strange. Yellowish.

Morag reached out to lock her car. As her fingers

approached the handle, a blue spark leapt from her finger-tips to the metal; there was a tiny snap, and her fingertips burned sharply.

She snatched her hand back, involuntarily. "Shit."

"Language, Constable," Ted said. "I've been doing that all morning."

"Storm weather, you think?"

"Maybe. What are you up to here?"

"A call from a Mrs. Clark. Lost her cat. Insisted on a personal call."

Ted nodded. "Two doors down. Ruth's a widow. Be kind to her, Morag."

"I will." He calls her Ruth. Interesting. Gossip for the station canteen later.

She locked the car without any further static shocks, nodded to Ted, and walked down the road.

Ruth Clark, Ted Dundas's neighbor, was a slim, intense woman on the upper margin of middle age; evidently the cat meant a great deal to her.

Morag took the cat's description: a tabby, five years old, female. Unusually intelligent and sensitive. (Right.)

She looked around the boundary of Mrs. Clark's fairly shabby suburban garden. There was no sign of cat drop-pings—but then, said Mrs. Clark, Tammie was too smart to do her business in her own garden and she *always* used the neighbors', oh, yes.

On the other hand, there was no sign that anything amiss had happened to Tammie. No rat poison put down by a pissed-off neighbor, for instance.

Missing cats weren't a police priority. There wasn't anything Morag could do but assure Mrs. Clark that they would circulate the details of the cat, and suggest that she do her own searching—circulate notices to the neighbors, for instance—and then she endured a little routine vitriol at the general incompetence and apathy of the police.

"Even my phone's been off since I got up. I had to walk

down the road to the public phone box and you wouldn't believe the filth . . ."

Morag got out as quickly as she could, reported into the station, and walked back up the road to Ted Dundas's.

She sat in his kitchen—warm, smelling so thickly of bacon she could feel her arteries furring up just sitting here—and let him make her a mug of strong tea. He boiled up a pan on a battered camping stove, propped up on his gas hob.

"The gas is off," Ted explained. "You saw the repair crew in the road. Bunch of bloody cowboys," he said amiably. "I heard old Dougie at number fifteen complaining about it, and he said he'd heard someone else had called them in to look at a leak. Dougie heard that because they'd come to borrow his mobile phone; their phone was out."

Mrs. Clark's phone had been cut too. "Ted, what about your phone line?"

"Snafu. But I have a mobile. But you can hang the bloody phone; what bothers me is the cable TV. I was watching the baseball from Japan. Got to the fourth innings before it cut out."

"Um." Cable and phone lines and gas lines, all out. Morag turned over the possibilities. Was it possible one of those cack-handed crews, doing some innocent repairs, had cut through the other service lines? It wouldn't be the first time. Or what about deliberate vandalism?

"You own a cat, don't you, Ted?"

"The cat owns me, more like."

"I just can't see what people like about the bloody creatures."

"Aye, well, cats are unpleasant and unnecessarily cruel predators. And it's soggy and sentimental to think anything else."

"But you keep one anyhow."

"I told you. I think Willis keeps me." He poured her more tea. "We have a partnership of equals, me and that animal."

"Where is he now?"

He eyed her. "Not here."

The house shuddered gently.

Concentric ripples on the meniscus of her tea, like a tube train passing far beneath the foundations. Except there was no metro in Edinburgh. Or maybe like a heavy lorry rolling by, shaking the ground.

But Viewcraig Street was a cul-de-sac.

She glanced up at Ted. He was watching her carefully.

"Funny weather," he said.

"Yeah."

"Listen, do you have a couple of minutes? There's something I'd like you to take a look at."

They walked out to the back of Ted's house, toward Arthur's Seat. They headed up the slope toward St. Anthony's Chapel. Soon they were off the path and climbing over a rising rocky slope; the grass slithered under Morag's polished shoes. Once they'd risen twenty yards or so above the level of the road, the Edinburgh wind started to cut into her.

"I'm not equipped for a hike," she said.

"You'll be fine." Ted's grizzled pillar of a head protruded from the neck of his thick all-weather rad-proof jacket. His legs worked steadily, hard and mechanical, and his breath was deep, calm and controlled.

It was quiet, she noticed absently. There was the moan of the wind through the grass, the distant wash of traffic noise from the city. But that was about all.

What was missing?

She stopped. "Bird song," she said.

"What?"

"I can't hear any bird song. Can you? That's why it's so quiet."

He nodded, and walked steadily on.

A few dozen yards farther, Ted halted. He pointed up the slope, toward the gray, brooding pile of the Chapel, where it sheltered under the crag, still a couple of hundred

yards away. "There," he said. "What do you make of *that*?"

"What?"

"Don't they teach you observation anymore? Look, girl."

She looked, and stepped forward a couple more paces.

Under scattered fragments of broken orange-brown igneous rock, under green scraps of grass and heather and moss, there was a silvery pool. It clung to the outline of the crag, as if the rock had been painted.

"Now," said Ted, "this used to be solid rock. I wouldn't step much further."

"Why not?"

He bent and picked up a chunk of loose rock. With a reasonably lithe movement he threw it ahead of her, into the dust.

It sank out of sight, immediately, as if falling into a pond.

"Wow," she said. "How far does this go?"

"I don't know. There seem to be other pools, up around the summit, and then the odd outbreak like this one. Like something coming through the rock, somehow."

"Has anybody been hurt up here?"

"Sunk in the dust, you mean? Nothing's been reported, so far as I know."

She thought. "No, it hasn't." She'd have heard. "So what's caused it?"

"Well, hell, I don't know. I'm no scientist. I'm just an observant copper, like you. What else do you notice?"

She looked around, trying to take in the scene as a whole. Her skirt flapped around her legs, irritating her.

"I think the profile has changed. Of the Seat."

"Very good. On the slope we're standing on, which is no more than six or eight percent, I'd say there has been a slip, overall, of ten or fifteen feet. And in the steeper slope at the back of the Dry Dam, for instance, it's a lot more than that."

"You think so?"

"You can hear it. Especially at night. Rock cracking. Little earthquakes, that shake the foundations of your house."

She stepped forward, cautiously; she had no desire to imitate the fate of Ted's pebble. When she'd got to where she judged the edge of the dust pool to be—still standing on firm, unbroken basalt, maybe three feet from the lip of the dust—she crouched down.

The dust was fine-grained, like hourglass sand. It seemed to be shifting, subtly, in patterns she couldn't follow. It was more like watching boiling fluid than a solid.

She thought she could smell something. Perhaps it was sulphur, or chlorine.

Occasionally she thought she could see some kind of glow, coming from the dust where it was exposed. But it was sporadic and half-hidden. She'd once flown over a storm in a 747; looking out of the window, at lightning sparking purple beneath cotton-wool cloud layers, was something like this.

"Come on," Ted said. "I need to show you something else." He headed down the slope, and started walking around the pool.

She straightened up carefully, and went to follow Ted.

She said, "You think this has something to do with the loss of the lines? The TV and gas and phone—"

"I wouldn't be surprised," he said mildly. "Can't say how far underground it spreads, how far it has got."

"But if there are land slips going on, some kind of subsidence—"

"You could get line breaks. Yes. There have been scientists up here, poking and prodding away. There's an American chap my son works with . . . But they're just recording, measuring. I think someone should be *doing* something. Taking it a bit more seriously."

They climbed around the crag. They were paralleling the edge of the funny dust, Morag saw. It made for a rough circle, she supposed, patches of it draped across the breast of the land. But the edge of the circle was rough and irreg-

ular; in some places necks of the dust and broken ground came snaking down the hillside, perhaps carried there by some slip or a fault in the basalt, and they had to descend to avoid it.

Now, Morag heard singing. *I Wish I Was A Spaceman / The Fastest Guy Alive* . . . It sounded like a TV theme tune.

"Good Christ," Ted said. "I haven't heard that in thirty years."

"It sounds like kids' TV."

"So it is, my dear. But long before your time."

They entered the Dry Dam and came on a line of people. They were dressed in some kind of purple uniform, and they were sitting in a loose circular arc that embraced the hillside, and they were singing.

I'd Fly Around The Universe . . .

They were mostly slim to the point of thinness. They didn't seem cold, despite the paucity of their clothes, the keenness of the wind up here. They were singing with a happy-clappy gusto.

There was a boy standing at the center of the loose arc, age eighteen or so, skinny as a rake. When he saw Ted and Morag approaching he got to his feet, a little stiffly, and approached.

"Welcome," he said. "My name is Bran."

"Now then, Hamish," Ted said stiffly.

Morag glanced at Ted. "You know this gentleman?"

"Used to."

"Would you mind telling me what you're doing up here, sir?"

"Watching the Moonseed, of course," Bran-Hamish said.

"The Moonseed?"

"All this started just after that Moon rock was brought to the university. And Venus, of course. Fantastic, isn't it? Two thousand years of waiting—"

Morag walked forward. The members of the group, still singing, looked up at her. Before each of them there

was a small cairn, of broken fragments of basalt. When she looked farther up the slope, she saw broken ground, exposed silver dust, loose vegetation floating on the dust. Another pool. The smell of ozone was sharp.

"Every morning we mark it with a cairn," Bran said. "And every morning it has come further down the slope."

"You're a fruitcake," Ted said bluntly.

"Maybe," Bran said amiably. "But at least we're *here*. Where are the scientists, the TV crews, the coppers—"

Morag thought she could answer that. She imagined her own desk sergeant fending off nutcase reports from dog walkers, about an oddity no one could classify.

Morag frowned, pointing up the slope. "Where are the other cairns? The ones from yesterday, and the day before."

"Gone," Bran said simply. "Consumed, every morning. Like your fry-up breakfasts, Ted."

Morag straightened her cap. "Sir, I think you'd be advised to come away from here."

Bran spread his hands. "Why? Are we breaking the law?"

"No. And I can't compel you to move."

"Well, then."

She pointed to the dust. "But it's obviously not safe."

"We've never been safer. Not since the Romans came have we been so—*close*."

Ted pulled a face at Morag. "I told you. Fruitcake."

Bran-Hamish just laughed, and resumed his seat with the others.

Morag and Ted walked away.

"Well," Ted said. "Now you've seen it. What are you going to do?"

Morag hesitated.

She'd never faced anything like this before, in her brief police career.

She'd had some emergency training, at police college and since joining the station, with the council's emergency

planning people. It had all been rather low-key, under-funded and routine. Britain was a small, stable island. Nothing much in the way of disasters ever happened.

Morag had not been trained to handle the unexpected.

"I can't see this is any kind of criminal matter. And this isn't yet an emergency."

"It isn't? Are you sure? *What if it keeps growing?*" He eyed the horizon. "You know, cats are smart animals," he said. "Sensitive. Sometimes they react before the rest of us when something is going wrong." He hesitated. "I've not told Ruth, but I haven't seen Willis for a couple of days either."

"*Something going wrong? Like what?*"

There was a sound like subdued thunder.

Morag and Ted exchanged a glance. Then they began to hurry back the way they had come, around the shoulder of the crag. The cultists came with them, running over the basalt outcrops in their thin slippers.

They came around the brow of the hill. They stopped perhaps a hundred yards from St. Anthony's Chapel.

The old ruin was sinking.

The single large section of upright wall, two stories high, was tipping sideways, visibly, a ruined Pisa. But even as it did so its base was sinking into the softened ground. Its upper structure, never designed for such treatment, was crumbling; great blocks of sandstone were breaking free, and went clattering down the wall's sloping face, making the dull thunderous noise she had heard. One of the lower wall remnants, she saw, had already all but disappeared, its upper edge sinking below the closing dust as she watched.

It was like watching some immense stone ship, holed, sink beneath the stony waves of this plug of lava.

Around them, the cultists were jumping up and down, whooping and shouting.

Morag shook her head. "What does it mean, Ted?"

"I've no idea," Ted said grimly. "Ask these loonie buggers. I think it's time you made a report, girlie."

"Yeah."

She lifted her lapel radio to her lips.

10

Jane showed up in the lab, a little before noon. Mike actually escorted her into the clean room area. The staff had got the clean room procedures beefed up a little by now, and so Jane was wearing the regulation white bunny suit and cloth trilby, blue plastic overshoes.

"Hi."

Henry, with his hands inside a glove box, did a double take. "Oh. It's you." He fumbled the petrological slide he was handling, and tried to pull his hands out of the arm-length rubber gloves; he fumbled that too.

Her face didn't crack a smile. "Sorry. I'm disturbing you."

"No, no. That's okay. I just didn't recognize you." He studied her. "You look—"

"Different? Not so threatening in this male scientist disguise?" She wandered around the lab, passing between the stainless steel NASA glove boxes, the low fluorescent lights catching the wisps of hair that protruded from her hat. "I got Mike to sign me in for an hour. I wanted to see your world. I promise I won't touch anything."

"If you do, you'll be zapped by NASA laser beams."

"So these are Moon rocks."

"Yeah. Come see this." He led her to the center of the room, where the largest single isolation tank stood, on four fat steel legs. She followed him, and they stood side by side, peering into the tank.

Standing this close to Geena, he remembered, there had always been the faint smell of deodorants, shampoo, perfume. The chemicals industry of the late twentieth century. But with Jane there was only the autumn-ash scent of her hair. Like Moon dust, he thought absently.

They'd been seeing each other, on and off, for a month

now. Dinners. Walks, drives. A lot of gentle sparring as they picked at each other's old wounds. Goodnight kisses like he used to get from his aunt.

Maybe he could detect the stirring of some kind of attraction in her, on a subconscious level. The way volcano junkies could sometimes sense the stirring of magma pockets far underground, before the most sensitive of seismometers showed a trace.

After all, she was here.

Or maybe that was all self-deluding bull. He had been disastrously and persistently wrong about Geena. After a month he still wasn't sure.

The box contained a big, battered case made of aluminum. It was open. Inside the box was a series of dirty Teflon bags, some of them slit open.

Jane said, "What's this?"

"An Apollo Sample Return Container, in NASA-ese. A rock box, to you and me. This is one of the boxes Jays Malone and his buddy filled up on the lunar surface, with Moon rocks they put in those numbered Teflon bags. And it was left unopened in twenty-five years."

"You're kidding."

"More than half the Moon rocks have never been touched. We had to sterilize the box, with ultraviolet light and acid, dried it with nitrogen, punctured it to let out whatever trace of lunar atmosphere was in there—"

"Why? You can't think there is any danger of contamination."

"Of us, by the rocks? Hell, no. But they planned for it back in the '60s. They even sterilized the films the astronauts brought back from the Moon's surface. No, now we're more concerned with protecting the Moon rocks from *us*."

Jane leaned forward and inspected the Moon samples, where they nestled in the slit-open bags. "I'm not sure what I was expecting," she said. "Something—primordial. More glamorous. This looks like—"

"What?"

"Like jacket potatoes that got left too long on the bar-
becue."

He laughed. "The Moon is a dark world, Jane; it only
looks bright in the sky for lack of competition."

She pointed to an empty bag. It was numbered 86047.
"What happened to that one?"

"That's the most important rock in this box. The focus
of the study. It's lunar bedrock. Possibly . . ."

The work on the Moon rock was actually picking up
quickly—although Henry hadn't had much time for any
real science yet, as so much of his time was being taken up
with organizational stuff. He had to ensure the lab assigned
the right facilities for the preliminary studies he wanted to
run—emission spectrometry, X-ray crystallography, mass
spectrometry, X-ray fluorescence and neutron activation.
He wanted to push for a scanning tunneling microscope
study, but there was no STM here, and Dan McDiarmid
made it clear exactly where the boundary of his budget lay,
as if every STM in the world had been transported to the
Moon itself.

It put Henry in his place, and he spent a lot of time
fuming and fighting for turf.

But the work itself had soon gotten going well enough.

Mike Dundas was proving to be a good choice as his
lab manager, confirming Henry's hunch. Mike made sure
procedures and operations ran smoothly, and didn't get in
the way of the researchers, including Marge Case, who
were waiting to start their studies.

He told Jane, "I'm interested in finding fragments of
the Moon's primordial crust, the first that formed after the
Moon turned into a molten ball, after it accreted. *Global
melting:* if it happened to the Moon, it must have happened
to Earth, and other large bodies like Venus and Mars. But
we have to know how it all happened. And the Moon is a
natural place to study the process; the evidence is all buried
deep on Earth, by the continuing geology of the planet."

"And is that what your bedrock fragment is? A piece of primordial crust?"

"Unfortunately, no. We haven't found a large crust fragment in any of the Apollo samples. But in bedrock like this we can expect to find fragments in the breccias, recycled repeatedly from earlier ejecta blankets . . . That is, smashed up and stuck back together again several times." He eyed her. "Come see what I'm doing."

He led her to a bench, where he'd set up his petrological microscope. This was just a crude microscope, set up so you could look through a thin rock slice on a rotating stage, illuminated by a light source beneath. Jane squinted, trying to see.

"Your brother is good at producing slides for this, over in the rock cutting lab," he said. "You take a thin section of rock—say, five millimeters. You polish it with carborundum, take some thin chips, stick them to glass with optical glue, and then polish them in a grinder until they're no more than fifty microns thick. Thin enough to see through. The art is the finishing by hand that comes after that; you need better than five microns tolerance, and to get that you have to overcome faults in the jib you use, even in the glass slides themselves . . ."

She looked dubious. "I'm surprised they let you bring that thing in *here*."

He looked at the microscope, through her eyes. It was kind of battered, he admitted. He'd picked it up for twenty bucks as an honors student when his department had a clear-out, and it had been old even then. But the mechanism still ran sweet as a nut, and the Swiss optics were as bright and clear as the day they were ground, and the 'scope, worn smooth with use, had been all over the world with him.

Henry expected to be buried with his 'scope.

Still, Mike had banned him from bringing its wooden box in here, which was even more disreputable.

He stepped forward to check the alignment. The view

through the eyepiece was a disc of multicolored light, irregular shapes of bright color. He twisted the analyzer disc to show up the colors.

"Take a look," he said. "Try to keep both your eyes open. After a while, you won't see anything through your other eye."

She bent, and turned the analyzer as he showed her.

"What do you see?"

"It's like a view down a kaleidoscope." Jane straightened up. "Wow. I'm dizzy."

"That's your other eye cutting in. Forget it. The point of the 'scope is that you can see what minerals are present there, just by letting the thin slice filter polarized light."

"Just like that? At a glance?"

"At a glance. Neat, isn't it?"

"What am I looking at? Your bedrock?"

"No. That's a reference sample. A lunar basalt from another suite, closer to the norm of the Apollo samples. Tell me what you see."

She bent again. "Lots of small shapes, like a tiled floor. And, here and there, like pieces of stained glass window, rough discs and rectangles. Much larger shapes. Ships of glass, sailing among ice floes. As seen when on acid."

He laughed. "What you're looking at is a felted matrix of small elongate crystals of feldspar—that's the gray stuff—pyroxene, yellow—and olivine, all the bright colors you can see, scarlet and yellow and pink and blue. And stuck in the matrix you have those bigger crystals, phenocrysts of pyroxene and olivine.

"Now." He took out the slide, replaced it with another. "This is 86047. The bedrock. See if you can tell the difference."

She looked.

"No olivine."

"To a first approximation, yes."

She straightened up, frowning. "So what?"

He lifted his white hat and ran a hand through his hair.

"So, that's *wrong.* I can't figure out what process has taken out the olivine here.

"Look—rock is made of silicon and oxygen, and other stuff. The basic structure formed by silicon and oxygen atoms is a tetrahedron. An olivine molecule is built around a single tetrahedron, with iron and magnesium atoms stuck on. So olivine is the most basic form, the mother of all silicates.

"Deep in the mantle, at high enough temperatures, olivine is all you find.

"But when a lump of mantle material rises and cools, more complex molecules can form. You put together the tetrahedra like building blocks. First you get pyroxene, which has single chains of tetrahedra, then amphibole, which has double chains, and then mica—"

"I've seen mica. Flaky stuff, thin, papery sheets that you can chip off with a fingernail."

"Right. Mica is made up of sheets of the tetrahedra. But then, when the mica cools further, you have quartz. A three-dimensional lattice, a tough, hard crystal. So you are getting more and more complex silica structures, built of tetrahedra."

"So what happened here?"

"I don't know. It looks as if something has—accelerated the process, in this lump of Moon rock. Reworked the crystalline structure."

"Reworked? How?"

"I've no idea. One tack we're following is trying to replicate lunar mantle processes in the high-pressure labs."

In these, he told her, you placed a small sample of your rock in a foot-high stainless-steel block called a bomb, and then pressurized it hydraulically, as far as twenty thousand atmospheres, which corresponded to pressures in the Earth's mantle.

Sometimes the bombs failed, and lived up to their names. So the labs were run remotely, and had steel plates built into their walls, and blast chimneys.

But the high-pressure tests weren't showing them anything they didn't know already.

"In the meantime, we're ordering up other studies. X-ray fluorescence work, and time on the ion microprobe they have here. That lets us study the composition of very small samples of the rock . . ." He scratched his head under his hat. "I'll tell you something else odd. The samples I've been taking from the liquefaction patch, on Arthur's Seat—"

"I'd like my bottle back sometime."

"Yeah. I ran them through the 'scope, and a couple of other tests. They are deficient in olivine as well . . ."

She frowned.

"I can't see any connection either. Spooky coincidence, huh."

But she was hesitating. As if there *was* something, some connection, she wasn't telling him.

He said, "You know, if this—whatever—is consuming olivine—"

"What?"

"The Earth contains a *lot* of olivine, in the mantle. No wonder that patch is growing. And it isn't going to stop eating either."

"Eating?" She laughed, a little nervously. "You make it sound alive."

"I don't know what the hell I mean."

"Do you think we should tell somebody about this?" she asked.

"Like who?"

She shrugged. "The police."

He blinked. That hadn't occurred to him, that aspect of the situation. The *threat*. Maybe Geena was right that he had a one-dimensional mind.

"You know, I don't like the inexplicable."

"Oh, come on," she said. "Be honest with yourself. I know you people. You have a puzzle, and that makes you happy. Something you have to figure out."

He straightened up. "Buy me lunch and we'll discuss it."

She smiled.

"Listen, you want to see 86047 before you go? The bedrock sample. It's in the case over there by the wall."

She shrugged. "You've seen one Moon rock, you've seen them all."

They made their way to the door, and squeezed into the improvised airlock together.

Behind them, in the central glove box, sample 86047 sat in the lab's fluorescent light.

It had already been sliced in half and thin samples taken, by Houston technicians and Mike's careful hands. In the harsh illumination it would have been difficult to tell for sure, but perhaps a careful observer might have noticed something odd about its flat, new surfaces, exposed for the first time since the formation of the rock, billions of years before.

The surfaces were glowing, softly silver.

And, with a rustle rendered inaudible by the layers of glass encasing the rock, a rain of fragments was whispering down from the exposed face.

Jane drove Henry to a multistory car park close to Waverley Station, and they walked along Princes Street.

You could still make out the deliberate design of the old streets here, Henry thought: a neat rectangular grid pattern, almost like a U.S. city. But whatever character the street had once had was pretty much obscured by the encrustation of plastic and glass of the modern department stores and fast food outlets. There was even a McDonald's and a Dunkin' Donuts.

"This is what we call the New Town," Jane said.

"I know. 1760. You told me."

"The Old Town is the medieval town that grew up around Castle Rock. Narrow, windy streets, coming down the glacial tail there . . ."

"You've been building this city for a thousand years,

on top of an extinct volcano. I think you people are seriously crazy."

"Well, maybe. In the Old Town they burned witches; in the New Town they bred lawyers and scientists."

"Split personality."

"Yeah. Jekyll and Hyde."

"Right. Didn't Stevenson come from Edinburgh?"

"Yes. Maybe we do have a split personality," she said. "It was in Edinburgh that the crucial moments in the Act of Union were played out. Union with England."

"Let me guess. Back in 1672."

"Actually, 1707. It was the best for everybody. The alternative would have been civil war, or maybe war with England. What we gained was stability and prosperity. But what we lost was—something you can't define. Edinburgh used to be a capital. It never would be again. So, I think we've all gone slowly crazy."

"Conflicts in the programming," Henry said. "A city called Hal."

"Something like that."

"You Brits amaze me. The way you're so hung up on stuff that happened so long ago."

"And *you* guys *have* no history. History sticks around."

He glanced around, at Princes Street Gardens, the park which descended in the shadow of Castle Rock. "Was this a riverbed?"

"No. But it was a loch. Artificial. Used to dump their sewage in it—"

"And drown witches."

"Actually, yes. They drained it, to make the New Town."

"So, lunch . . ."

It was still early. After a debate they settled on a Seattle's Best Coffee outlet, which Henry was surprised to find here, and they drank lattes and ate immense chocolate chip cookies.

It was a relief to get in out of the cold.

"Your work seems to be going better," she said.

"You mean I'm not complaining so much."

"How come?"

He couldn't see any way to escape, so he pulled a package from his jacket pocket, and told her the truth.

It was a courier package from Houston. It contained a tape and a transcript of a conversation with Jays Malone, in which the old guy had evidently done his very best to ransack his memories, and provide Henry with the context he needed.

He tried to explain this to Jane. "Geology is about decrypting a tangled story: how a rock was formed, how it got where it was and what happened to it since is as important as what it's made of. That's what we call context. And that's what Jays has given me here." He scratched his head. "I'm no fan of Man-in-Space. Not when it cuts into good unmanned science missions."

"Including your own."

"Yes. But the astronauts weren't bad geologists, on the whole, when they tried. Pilots are trained to be observers, after all, and they all had strong, flexible minds. I suspect they competed with each other to turn in good performances as scientists."

Jane leafed through the little package, complete with a few sketch maps and diagrams in Jays's spidery old man's hand. There was a brief note in there, which Jane now found.

She eyed Henry. "So who's Geena?"

He winced. "My ex-wife."

She nodded, impassive, and handed him the note. "So what is this? Is she building a bridge?"

Henry glanced at the note again. Geena was about to go into purdah, working as a capcom on the current Station mission, and beginning the long process of training for her next flight . . .

"No," he said. "Not a bridge. This is Geena waving farewell from the far side of the ravine. *Good luck with your life.*"

"Sad," Jane said.

"History."

"I think I'm starting to understand you," she said, studying him.

He felt uncomfortable under the scrutiny. "You are?"

"You really are a true scientist. You like figuring out how the world works. You like the fact that it works logically at all. You find that comforting."

He rubbed his cheek. "I guess that's true. Take the Moon. The Moon is very different from the Earth, but the basic principles still apply. Like stratigraphy—"

"Like what?"

"On Earth, in general, younger formations lie on top of older formations. Think about the Grand Canyon. A big slice down through millions of years of sedimentary layers, older under younger, older under younger. And it's the same on the Moon. The big impact that created the Mare Imbrium, for instance, pretty much blanketed the Moon with debris—all of about the same age. So you can tell almost at a glance, anywhere on the Moon, whether a given unit is younger or older than Imbrium. When I learned for the first time that on the Moon, the logic of geology works just the same as in Arizona . . . well. Isn't it something?"

"It is to you anyhow. And you're talking too much again."

"I have the feeling," he said slowly, "you are diagnosing me as an anal retentive."

"I'm not diagnosing. I'm just trying to understand."

He ran his spoon around the crusted rim of his cup. "I guess we don't have much in common."

"I think you're wrong."

"You do?"

"I seem to be tuned in to patterns in the universe too. Trends and laws. The difference is," she said, "I don't take much comfort out of what the patterns tell me about the future."

They were silent for a while.

She leaned forward. "Do you have to go back to work?"

"Yes." He thought about it. "No, not necessarily."

"Maybe we could skip dinner."

He looked into her eyes. "Oh."

She said nothing.

He thought it over. "Let me pick up the tab."

"No. My shout."

They stood up.

They went back to Henry's hotel room, in the Balmoral.

It was . . . memorable.

She was tender, loving, funny. Whereas Geena had always had that chilling air of assessing his athletic prowess the whole time.

But it wasn't as if they were obvious soul mates. Jane was smart, and logical, but she was obviously coming to quite different conclusions about the world from his own.

Maybe they were complementary, somehow.

He remembered a story, he thought by Plato. How, at the beginning of time, human beings were split in two, by a malevolent god, into halves: male and female. They ran around the Earth thereafter, searching blindly, never happy.

Unless the two halves of a whole, by chance, met up and joined. Once joined, they were complete, and would never part again.

With Jane, it felt like that.

He hardly knew her, he realized. But he felt comfortable in her silence.

Later, lying beside her, he found himself thinking about the liquefaction patch.

He'd been up there, to the Seat, two or three times a week since they first found that puddle. And every time he'd found it had grown.

It was hard to be precise—much of the spread was sub-surface—and he was only measuring with shoe leather any-how. But he was pretty sure the growth was exponential. Doubling every few days.

He recalled Jane's question about telling somebody.

What the hell *was* this? And how, indeed, could it be stopped?

Because if it couldn't—

He started to worry.

He leaned over in bed, and picked up the phone. "Can you tell me how to get an outside line?"

He got out of bed, and padded to the cupboard where he'd hung up his jacket. In his wallet he had a card with the number of VDAP, the Volcano Disaster Assistance Program at the U.S. Geological Survey.

He dialed the number, and tapped the card on his teeth. "Never leave home without it . . . Hey." He checked his watch. "Sorry to disturb you so early. Could you put me through to Blue Ishiguro?"

11

Henry emerged from the lab's fluorescent harshness into bright afternoon daylight. In his rental car he drove the short distance to Holyrood Park, and, pulling on his rad-proof poncho, walked up the Seat, leaving the traffic noises behind. He drank in the warm, fresh air of this mid-April day. He was coming to like Scotland, he thought; there was something refreshing about the air here, the very light. Something northern.

He had now got into the habit of doing this, walking out to monitor the disfigurement of the Seat, every day.

Today he found the biggest dust pools had been cor-doned off by plastic police tape fixed to metal posts. Not far from the site where St. Anthony's Chapel used to stand—now just an anonymous patch in the glass-smooth surface of a dust pit—a young policewoman was standing. She

wasn't like the cops back home. She wore a blue sweater and tie, and the heavy equipment that dangled from her belt was just a radio. No gun. She didn't look like she needed it.

Henry walked up to her, introduced himself, and told her he was here to study the site. He offered to show her some credentials, but she waved him away.

"Go ahead, Dr. Meacher." Her accent was crisp and precise; she was cheery, dapper, competent, very Scottish. "I've seen you on the TV." That was likely; he'd featured, to his chagrin, as a strange-but-true item on the local news, the eccentric Yank here to study the Moon rock. "Besides," she said, "I can see the hammer on your belt. Just don't fall in."

"I won't."

"There are Government scientists coming up to study this. It's caused quite a stir."

"I'll bet it has."

She nodded. "We're going to need more cordon tape, aren't we?"

"That you are. Take care, officer—"

"Constable Decker."

He left her at her post.

He set himself to walk around the perimeter of the primary pool at the summit—as close as he could get, given the police tape—counting his paces as he went.

The pool lay over the craggy agglomerate like a silvery blanket, dimly reflecting the afternoon sun, like a splash of mercury paint. In some places it had actually adjusted the shape of the Seat; bits of the old plug had subsided into the spreading silvery pool, as if dissolved in some powerful acid.

He approached his starting point once more.

There was Constable Decker, standing relaxed, and a little farther down the hillside there was the patient group of cultists. Just like every day, they seemed happy; he could hear guitars, folk songs, raucous laughter. A TV crew was making some kind of report, a girl reporter being filmed

against the glimmering background of the Seat's wound. The reporter was in a radiation-proofed smock, but most of the other people here weren't.

The whole incident was turning into a kind of low-grade circus, he thought, an item for the end of the TV news, a little scary but too strange to take seriously, like skateboarding dogs and skydiving wedding parties and Moonstruck Yank geologists.

Henry had a palm-top computer in his jacket pocket; he pulled it out. He entered the paces he'd counted, made an adjustment for the fact that he hadn't been able to approach the rim of the pool as closely as before because of the tape, divided by pi on the assumption that the pool was circular . . . He entered the new data point onto a log-log graph he'd set up in the palm-top. The graph reduced the growth pattern to a straight line.

The new point was close to the line he'd established with his earlier data.

The growth he saw today was just what he'd found before. Steady. Relentless.

"I was right about the damn police tape," he muttered.

He expanded the scale of his graph. He would be able to figure out how far out this shit would reach, given time . . . It wasn't reassuring.

This was the easy part, of course. And he had already started to skew the work in the lab, focusing on this accelerating phenomenon, with studies of field samples, literature searches and phone calls to check on comparable cases (there were none). That was easy, too, all under his control, more or less.

The tough part was figuring out what the hell to do about this, how to tell people. From that, he found himself shying away. It wasn't any part of his career plan to become a prophet of doom.

But if his numbers were right—if the phenomenon wasn't self-limiting, if this inexorable growth continued— soon he wasn't going to have a lot of choice.

* * *

Afterward, Henry walked up the glacial tail of Castle Rock, toward the Castle grounds themselves.

The crest of the tail was topped by a chain of streets known collectively as the Royal Mile. The buildings here, the heart of the Old Town, were antiques, and some were imposing, like the uncompromising block of St. Giles' Cathedral; and it was startling to see, peering through steep alleys, a glimpse of the blue waters of the Firth. But to Henry the place was polluted by twee tourist shops selling junk, kilts and bagpipes and whisky marmalade and Scottish ancestry gizmos.

But some of the pubs were good. And he had to admit he had paid his dollar to go see the Camera Obscura, a Victorian sight-seeing gimmick that worked better than he had expected.

Castle Rock was another volcanic plug, smaller than Arthur's Seat but of the same vintage, sprouting from the same underground magmatic complex. The Castle itself was a sandstone mound of buildings, walls and turrets and battlements, looking as if it had grown out of the basaltic crag on which it was built.

He walked around the grounds, inspecting the basalt that underpinned the Castle—in some cases, rocky outcrops had simply been incorporated into the walls—but to Henry's relief there was no sign here of the contamination which had disfigured the Seat.

He climbed to the Upper Ward, and looked out from the cannon-platform terrace to the north. He could see the railway line and Princes Street, two great avenues stretching west to east, converging toward the odd structures on Calton Hill to the northeast. Between the rail line and Princes Street was the garden, that old drained loch. It was studded with trees, a little marred by a huge white marquee where— Henry had learned—a band played during the summer arts festival. Beyond that was the cluttered landscape of the

New Town, with its sandstone monuments—the Scott Monument, his own Balmoral Hotel, the banks and insurance companies on George Street—jutting out of the forest of roofs, and beyond that, serene and calm, was the blue surface of the Firth of Forth, and the rocky northern coast.

The lights were coming on, and in Princes Street the crowds were starting to bustle out of the shops and offices and making their way home, their radiation-proofed smocks and ponchos bright, bustling human activity at the heart of the ancient city.

He felt as if he was somehow opening up, as if walls in his head were crumbling. He wasn't used to feeling so engaged with humanity as this.

Maybe it was something to do with Jane.

This was Lilliput, small and crowded: a thousand years old, and beautiful. It seemed impossible that it should be under threat—a threat only he perceived.

Venus. The Moon rock anomalies. The Arthur's Seat dust.

The pieces of the puzzle seemed to be moving around in his head, colliding, trying to find ways to fit. But the essence of the future was clear to him; the inexorable growth of that stuff on Arthur's Seat would see to that.

Bad news.

Unless he, and those who worked with him, found a way to stop it.

"We have to, is all," he said to himself. "If not us, who else?"

For a while longer he gazed out over Edinburgh's bustle.

Then he began the walk back to the town, to meet Blue.

Henry had a little trouble meeting up with Blue Ishiguro, in the subterranean clamor of Waverley Station. Blue wasn't much over five five and was skinny as a rake, so it was hard

to spot him among all these heavy-set, overfed *gaijin,* as Henry always thought of Westerners when he was around Japanese.

But here Blue came at last, his pencil-thin frame all but overwhelmed by the giant, battered field rucksack he carried on his back, his button-small face split by a giant shit-eating grin.

Henry embraced Blue, and they went into a mock-boxing routine, what Blue, who had spent maybe too long in America, always called hoopin' and hollerin' mode.

Blue said, "It's good to see you, man."

"That's the truth. Let's get out of here."

They emerged into the center of the city. Blue hitched his pack on his back and looked around curiously. They set off west down Princes Street, which ran straight as an arrow toward the spires of St. Mary's Cathedral, to find the guest house Blue had booked for himself.

It was a little after eight in the evening, so the end-of-day crowd had subsided from its peak, and the light was starting to go. All the monuments of the city seemed to be bathed in yellow-gold floodlights: the Castle on its shape-less volcanic mound, the Balmoral Hotel, and the memor-ial for Walter Scott which looked, Henry thought, like a Saturn V launch gantry rendered in sandstone, turned black as coal by pollution, which the monument was too fragile to have washed off.

"So," said Henry. "What do you think?"

Blue gazed around, his rheumy eyes analytical. "Skinny," he said. "England has a lot of skinny buildings."

"It may do. But this is Scotland."

"Whatever. And it's kind of grubby from the pollu-tion."

"True enough."

"So where's the volcano?"

Henry clapped him on the shoulder. "Tomorrow, old man. You need to sleep off your jet lag."

Blue sighed. "I suppose you are right."

They arrived in a small, straight side street in the west of the city, not far from the shadow of St. Mary's. The guest house was a rambling, much-extended building next to a cobbled courtyard, entered by a narrow archway. The ground floor was pretty much a pub, a long bar gleaming with glass and leather, circular brass tables crowded with drinkers cradling pints in straight glasses; cigarette smoke hung like a volcanic pall in the air.

Blue grinned at Henry. "I think I will like it here."

He didn't object when Henry picked up his rucksack to carry it up the two flights of stairs to his room (no elevator, of course). The room, when they got to it, was just a box, not much bigger than a bed and a shower stall.

Back in the bar, which was still more crowded than before, Blue insisted on buying the drinks. They sat at a table in the corner, sticky with stale beer, and Blue waited patiently, until Henry had to explain that in a British pub you had to go up to the bar and order your drinks and bring them back. On the other hand, in cafés and restaurants you were supposed to wait for service . . . and so forth. Blue accepted all this serenely, went to the bar, and came back with two glasses full to the brim with heavy Scottish bitter.

"Here's to you," Henry said.

"Kampai!"

The beer was heavy, flat and warm; Henry was working at getting used to the stuff, but he had a ways to go yet.

"Your room's kind of small," he said.

Blue laughed. "So small that if I cussed a cat I'd get hair in my mouth. It's fine, my friend. I have my *tatami* mat and my happy coat and my portable family shrine, though I'm not sure where I will place it. The shower stall, perhaps. I think this place has a certain charm. Did you know it used to be a coaching inn? And you can see how old it is, so old it has had time to subside. Think about that, Henry. This place is probably older than all but two or three buildings on your whole continent."

"But not Japan."

"Not Japan, no."

"Well, these old Brit places are better than they used to be, I guess. At least you get a shower in your room now. But—"

"But you can't polish a turd."

Henry grinned. "I'm glad to have you here, my friend."

Blue eyed Henry. "I take it you don't want to talk about work."

"Not until tomorrow. I need you refreshed. I need your clear thinking."

"There are no live volcanoes in Scotland," Blue pointed out. "Not for three hundred million years."

"I know. And I don't think we have one now. What we have is—"

"What?"

"Something not right."

"It scares you."

"Yes, it does," Henry said.

Blue grunted and raised his glass. "But that is for tomorrow. For tonight, we will do what old men like us always do, which is to talk about old times. Tell me, do you still hear from the Pinatubo team?"

Pinatubo was a volcano in the Philippines. Henry and Blue had been part of a joint team of USGS and Philippine volcanologists who had gone out to assess the danger of eruption. Because of the accuracy of their characterization of the hazards and their prediction of eruption, more than fifty thousand people had been evacuated to safety, days before Pinatubo's devastating eruptions.

Henry, fresh from college, had done little more than carry the gear, but it had been his first exposure to real field work, and to a major geological event. And to what it could do to people.

So they gassed about that.

"Not that we were so smart about Pinatubo," Henry said. "You remember Sister Assumpta?"

Blue laughed. "Of course." This was the nun who had walked into the Philippine Institute of Volcanology to tell the assembled scientists, peering at their instruments in the artificial light there, that, begging their pardon, the mountain had just exploded. And so it had, clearly visible from her village; but that nun's soft-spoken message was the first warning anybody had.

So they talked about that for a while. Then Henry went up to buy some more drinks, and they talked about the time in Colombia when Blue had absentmindedly walked over terrain so hot that when he took off his boots his socks were smoking . . . and so on.

Blue kept up, but he looked thin and frail compared to the booming, bovine *gaijin* around him, and every now and again he would turn away and cough deeply into a huge handkerchief, the phlegm liquid in his throat. He had visibly crumbled in the few years since Henry had seen him last, and that was a true pisser.

Blue wasn't admitting to any of it, but the word was he had asthma, and maybe heart trouble. Which was why VDAP hadn't allowed him out of Vancouver and into the field for a couple of years, and—no doubt—why Blue had been so keen to come for a jaunt to Britain, on Henry's obscure and ambiguous invitation.

Blue was driven to keep working. Everyone who knew him knew that, and knew why. Kobe.

But that wasn't Blue's fault. Why the hell should he have to give up, to retire, to succumb to the betrayal of his body?

Henry felt a deep, unfocused anger boiling up inside him. *Age.* It was so damn medieval that they all had to submit to such a thing. He himself was already old enough to feel the weight of age descending on his own bones. It just went on and on, it seemed, wearing you down, taking out everybody from the best and brightest on down. And nobody got a reprieve, not so much as a day off from it.

He thought of the patch on Arthur's Seat, spreading

like the liver spots on the thin skin of Blue's bird-boned hand. Was that what it was?—a sign that even the Earth, in the end, grew old?

You've drunk too much of this British piss, he thought. The next time he went to the bar he came back with Becks, which was the nearest they had to a clean American beer.

12

He arranged to meet Blue up on the Seat the next afternoon.

In the morning, with a mildly banging head, he made his way to the lab.

He made a run around the building, checking on the progress of his samples in the various labs. Here was the X-ray fluorescence spectrometer, for instance, an anonymous gray box that looked like an industrial-strength photocopier, into which ground-up fragments of his rocks were fed in tiny platinum egg cups. X-ray fluorescence would tell him about elemental abundances in fine detail.

He was promised by the prep technician that his samples would be in place by the end of the day.

The ion microprobe was the department's million-pound pride and joy. It was set up in a gloomy lab crammed with humming electronic equipment. The heart of the probe was a chest-high complex of stainless steel tubing and chambers. Rock samples, coated in gold plate, were fed into a vacuum chamber and bombarded with fine beams of caesium or oxygen ions, focused by intense electromagnets. There was a little optical microscope you could use to watch the ion beam cutting its little crater into the surface of the sample, like a kid with a magnifying glass scorching his initials on the barn door. But the sample areas were just microns across, only a couple of atoms deep. The layers of atoms, sputtered off into a mass spectrometer, revealed the elemental composition of the sample, and such details as the temperature the crystal structures formed at.

It was an impressive piece of equipment—one of just four in geology labs around the world—or at least it seemed so until you realized that Motorola alone had *four* of the beasts, for use in their silicon chip quality control procedures. The academic community was undoubtedly the poor relation of business and government, and in Britain things seemed to be even worse than in the States.

Henry's work, it seemed, was next in the queue behind a meteorite analysis that was overrunning, after an all-night run. He argued, but got nowhere, and left fuming.

Anyhow, he suspected the composition of the samples wasn't nearly so important, in this case, as their structure. And that was going to be difficult to study here, without the right tools.

When he got to the clean room Mike was there, bright-eyed and depressingly keen, eager to go over the results of X-ray diffraction analyses he had run on samples taken from 86047. The results were simple traces, peaks and troughs. Mike had run the images through the computer already, and was compiling the results when Henry arrived.

But Mike looked flustered, and he was rushing to be ready; Henry had a sinking feeling he had been up all night with this.

At Henry's request, he had also run through some of the bizarre grains Henry had scooped up from the Arthur's Seat dust pool, or whatever the hell it was.

X-ray diffraction was a step beyond the use of polarized light. The wavelength of visible light was much bigger than atomic size. X rays had a wavelength just about the size of a typical atom, so they could show atomic structure: the crystal structure of silicates, for instance. The spacing of the peaks and troughs on Mike's results showed the crystallographic spacing of the sample. The trick was to map back from these simple patterns to figure what the underlying crystal structure must be.

It was complex. But diffraction results were unambiguous. And every so often you would run into a new crystal form.

And that, Henry realized with an odd stir of anticipation and dread, was what seemed to have happened here.

And not just with the Moon rock, which you might expect with such an exotic sample. There was, Mike said, something different about the Edinburgh sample, too.

They looked at the 86047 results first. Mike had prepared a summary diagram on a pc screen.

Inside the Moon rock's potato-shaped profile, roughly sketched with graphic software, Mike had marked layers, as if the rock was a misshapen onion.

"I took samples from all the way through the rock," Mike said. "You can see it has this structure—"

"*Structure?* What are you talking about? It's a *rock sample.* It ought to be a homogenized lump—"

"Nevertheless," Mike said. He sounded nervous, maybe pissed off, and Henry made a conscious decision to back off. Mike said, "This is predominantly olivine." He pointed to a band marked in red, just inside a gray band that made up the surface of the rock. "Then, going inward, we have, in order, layers of tourmaline, a pyroxene mix, amphiboles, mica, quartz." That took his finger to the core of the rock, which he'd left as white.

"So what's in there? And what's in the outside layer?"

"I can't say."

"You *can't say?*"

"Not from the diffraction results. But I know they are silicate forms. I did some chemical analysis to prove that. I can show you the results from the earlier optical emission and X-ray fluorescence tests which—"

"Later. I believe you."

"The stuff at the center seems to be hard and dense. Rigid."

"Some kind of super-quartz, maybe?"

"Maybe. Some very complex structure, anyhow." Mike hesitated, watching him. "Some of us are speculating it might fold up all the way into the fourth dimension. Ha-ha."

That didn't make Henry feel like laughing.

He tried to keep the frustration out of his voice. "Well, we still don't know what we've got here. We need to order more of these runs. Bump up the priority. I'm getting tired of queuing behind asshole grad students."

Mike made a note. "I'll call Marge Case."

"Don't let her give you any shit. And, Christ, this just isn't fine enough. We need some scanning tunneling microscope time."

Mike sighed. "Well, we don't *have* an STM. As you know."

"All right. What about the surface stuff?"

"It's a dust," said Mike. "Very fine. Almost no cohesion or adhesion. If you disturb the sample at all, layers of it just fall off."

Henry frowned. "That makes no sense. That damn rock was picked up by some galoot on the Moon, and then dropped from two hundred and fifty thousand miles into the Indian Ocean. That's what I *call* disturbance. Anything loose should have been shaken off long ago."

"I know," Mike said. "I'm just telling you what I found."

Henry pulled at his lip.

New forms of silicates?

It wasn't impossible. There were lots of ways to make crystal structures out of the silicon anion, the fundamental silicon-oxygen tetrahedral building block.

But 86047 was just a rock, a fragment of some larger body that broke off an aeon or two ago. Why should it have this neat internal structure?

It was, he mused absently, as if something was living in there. Working, burrowing deeper into the rock, chewing up the olivine and leaving behind these deeper, complex layers . . .

"Mike, I want you to repeat these tests. Keep on with the other stuff, the more detailed work, but go over this again. Every couple of days. See if there's any change."

"Change?" Mike frowned. "In a piece of rock billions of years old? How can there be any change? What kind of change?"

"If I knew, I wouldn't need you to run the tests."

Mike made another note.

Very fine dust. Almost no cohesion or adhesion . . .

"What about the Arthur's Seat samples?"

Mike had passed that work to another researcher. It took him a couple of minutes to retrieve the diffraction results from the intranet.

The diffraction pattern was unidentifiable. A silicate form nobody had seen before.

Nevertheless, to Henry, it looked familiar.

He had Mike call up the 86047 results again, and overlaid the two.

They were the same.

The diffraction results, of this sample of pulverized basalt from Edinburgh, and of the ancient Moon rock, were all but identical.

"Now," Henry said, "what the hell do we have here? What is the connection between this battered old piece of the Moon, and an innocent Edinburgh landscape?"

But Mike turned away, oddly reluctant to respond.

Mysteries on mysteries, Henry thought, puzzled by Mike's reaction.

When he went up to the Seat, he found Blue and Jane waiting for him.

"I see you found each other."

Blue was grinning so wide his teeth were twinkling. "I see *you* found each other," he said.

"Knock it off."

Jane said, "I was over with the cultists—"

Blue giggled. "She saw me sniffing the rocks."

"So I knew he had to be something to do with you."

"I'm glad you two are getting along," Henry said dryly.

"I've been telling her all about your past," said Blue.

"Oh, shit."

"Yeah," Jane said. "Blue tells me his hotel is okay, but they are—what did you say?"

"Skinning me like a country chicken." Blue cackled.

She said dryly, "So *which* part of Arkansas are you from?"

"Come on, Blue," Henry said. "We're here to work."

Blue nodded. "We need to get closer. The young lady—" he nodded at Constable Decker "—will allow us through the tape."

"She will?"

"I vouched for you," said Blue.

They lifted the tape and ducked underneath it. Cautiously, they approached the edge of the summit dust pool—which, once more, had spread since Henry last looked. It sprawled, ragged, over the lumpy rock.

Blue threw lumps of turf into the pool—they disappeared immediately, without so much as a ripple—and he kneeled down, a little stiffly, to sniff the air.

Blue said, "It might be liquefaction."

Jane said, "What's liquefaction, exactly?"

Henry said, "Where earth tremors shake up certain kinds of soils. Seismic shear waves passing through a saturated granular soil layer distort its structure, and that causes some of the void spaces to collapse—"

"In English."

"For a while, the soil acts like a liquid."

"But," Blue said, "liquefaction is only found when the sands and silts were deposited recently."

Jane said, "Recently?"

Henry shrugged. "Say, less than ten thousand years ago."

"Even then," Blue said, "you need ground water within

thirty yards of the surface ... This is an ancient volcanic plug. I can't believe this is liquefaction, as we understand it."

"Then what?"

He spread his frail hands. "I've never seen anything like it."

"Congratulate me," said Henry. "A new geological breakthrough."

Blue drawled, "Even a blind pig finds an acorn sometimes."

But the banter was, Henry thought, on autopilot. Blue seemed to share some of his own sense of dread, as he stood here and studied this unclassifiable phenomenon.

"So," Jane said, "what are you going to do now?"

"I think we should bring the portable lab out here," Blue said.

"What portable lab?"

Henry said, "He means the VDAP's. That's the Volcanic Disaster Assistance Program. A kind of volcano SWAT team run by the U.S. Geological Survey. They have a portable lab for studying geological disturbances which—"

"Oh, sure," she said. "Why don't you get your ex-wife to beam it down from the Space Shuttle?"

"Jane—"

"This isn't the Third World, you know. Even if it was, you would still be a patronizing arsehole American."

Henry eyed Blue. "Of course she's right. Everything we need should be here."

"Okay," Blue said. "So we wire the mountain. We need seismometers. A network of them, at the rim, on high-gain rock sites. They will have to be moved regularly as the pool progresses, I suppose ... We'll need volunteers for that. The seismos will be linked by radio telemetry to a central point."

"We'll use my lab," Henry said. "We'll need a war room."

"Why a network of seismometers?" Jane asked. "Why not just one or two?"

"Because we have to triangulate," Blue said with gracious patience. "We must locate the movements of the ground in three dimensions."

Henry said, "What else?"

"We should do some real-time and spectral seismic analysis, to understand the growth of this phenomenon."

"Deformation monitors?" To Jane he explained, "When magma builds up beneath a volcano the ground distorts."

"Yes," Blue said. "Whatever you can find. Ideally laser based EDMs—"

"Electronic distance meters," Henry told Jane.

"And GPS receivers."

"Global—"

"Positioning System?" she said with some satisfaction.

"A cospec for gas emissions," Blue said.

"Yeah."

"Henry, I'd really like BOB here."

Jane said, "Who's BOB?"

Henry smiled. "A VDAP computer program. For rapid analysis of time-series data in crisis situations. Okay. And I'd like to order up regular aerial surveys to map the changing extent of the thing. My shoe-leather metrics really aren't good enough. Later we should think about acoustic flow monitors if there are lahars, microbarographs—"

Jane said, "That sounds like it detects changes in atmospheric pressure."

"So it does."

"Why that?"

"Because it's a good predictor of a volcanic explosion."

". . . Oh." She was looking at the pool rim. "Look at this," she said. She pointed to a patch at the rim of the pool, where bare rock showed through the grass.

A foot-wide patch of rock was—Henry thought, shielding his eyes against the sunlight—*glowing*.

The rock flashed. Henry jumped back. He'd felt heat on his face.

When he looked again, the rock was changed. It had turned to the fine silvery dust, characteristic of the rest of the pool.

"Holy shit," Henry said. "Did you see that?"

Blue said, "At least we know how it spreads now."

Jane looked from one to the other. "I can't quite read you two," she said. "You are interested in all this. Fascinated, even. But, underneath that . . . You're afraid, aren't you?"

Henry and Blue exchanged a glance.

"Why?" said Jane. "*Do* you think this is a volcanic event? Arthur's Seat has been dormant for a third of a billion years. Do you think it's becoming active now?"

"We don't know. This isn't like any volcanic event we've faced before."

"Then what is it?"

"We don't know that either."

She nodded. "And that's what's frightening you."

"Yes," Blue said. "that is what is frightening us."

"The growth rate has been maintained for weeks," Henry said. "The pool is still pretty small now, but it's not going to stay that way." He regarded Jane. "We have to be ready to face that."

"I understand."

Blue was studying the air. "It is blowing away."

"What?"

"The dust. Spreading in the breeze."

Jane asked, "Is that important?"

"I don't know."

Blue was glaring at the dust, his face a sour mask.

"So," Henry said. "What do you think, old friend?"

Blue sniffed. "This is something which should not be here. It is like a cancer, on the face of a good friend."

Yes, Henry thought. That was exactly it.

Something new. And unwelcome.

Bad news.

They made their slow way down the Seat.

13

One more time to make love. Maybe the last time.

I have to stop thinking like this, thought Monica Beus. I'll finish up doing a countdown . . .

But still, here was dear old Alfred, as tender and gentle as he ever was, and, in the cool mountain air that filled Monica's apartment here in Aspen, they coupled like two elderly spacecraft gingerly docking.

Athletics, it wasn't.

But it hadn't hurt as much as she had expected. Maybe the quacks were right; maybe their new, "natural" chemotherapy regime really was a little less brutal.

And afterward, they shared the post-coital cigarette they were both too old to ever give up—and what would be the point anyhow?—and then they sat up in bed, blankets around their bony shoulders.

And they pulled their computers to their laps and went back to work.

Alfred got online to the International Astronomical Union nets, and Monica skimmed through the latest entries to the electronic preprints library being maintained by the National Laboratory at Los Alamos.

The papers on string theory, since the Venus incident, had become a blizzard. The excitement seemed to crackle out of the screen at her.

But Alfred had found something new on the astronomy nets and was becoming excited too.

Now people had started looking—NASA had hastily thrown up a couple of new satellites—they were starting to find signatures like the Venus event's all over the sky. Alfred tapped the screen to show her. "Like these. Gamma ray bursts. Called GRBs by those who study them. Flashes

of energy, emanating from explosions that lasted a few seconds . . . "

Huge explosions, he told her. By some estimates, radiating more energy in a few seconds than the sun does in ten billion years. There were lots of candidate explanations, none of them particularly satisfactory. Maybe asteroids were crashing onto the surfaces of neutron stars. Maybe neutron stars were colliding. Maybe giant helium stars were imploding.

"Or maybe," Alfred said feverishly, "some interstellar cousin of our Venus killer is at work . . ."

She found it hard to concentrate on what he was saying, given the buzz on the Los Alamos nets.

She tried to summarize for him what had been going on in the world of theoretical physics, galvanized as it was by the natural laboratory which Venus had somehow, magically, turned into. "Alfred, string theory is the best way we have to describe the kind of extremely high energy density events we're encountering inside Venus . . ."

String theory was a candidate Theory of Everything—which, if successful, would be a simple theory whose corollaries would describe a universe that was unmistakably *ours:* with quarks and electrons, gravity, nuclear forces and electromagnetism, three space dimensions and one of time, a universe of atoms and babies and stars.

"According to string theory," Monica said, "the most elementary object in the universe is a loop of string. Unimaginably tiny. Ten to minus thirty-three centimeters . . . The string has different modes of vibration. Like a violin string. Each mode corresponds to a particle, a quark or an electron. And the laws of physics correspond to harmonies between the strings' tones."

"Ah." He smiled. "The Universe as a symphony. Rather beautiful."

"But," she said, "there's a complication. String theory only works in a ten-dimensional space-time."

Alfred rolled his eyes. "I always hated theoreticians."

"Now, the missing six dimensions are there, but they are crumpled up. Like garden hoses, rolled around themselves."

Alfred struggled with that. "So these dimensions are there. But too small to see."

Monica hesitated. "Something like that. Yes. The trouble is, there are tens of thousands of ways for the six dimensions to crumple. Each of those different ways generates a different internal space, as we call it. And in each internal space, the strings adopt a different solution."

"A different solution?"

"One internal space describes our universe, with three types of electron, and one photon. Another might have two photons. Or something even more exotic. And so on." Monica leaned forward. "Now. The theoreticians are suggesting there is a—tear in space—at the heart of Venus. Or what Venus has been made into."

"A tear?"

"A way into another internal space. You see, when a string enters a new internal space, it adopts a different configuration." She cast around for an analogy. "Like ice. Take it from the Arctic to the Sahara, and it melts. Vaporizes. It adopts a configuration that's suitable for the environment."

"And so . . ."

"And so, at the heart of Venus, we think we're seeing strings being ripped apart. Literally. Maybe even being expanded to macro lengths before collapsing back down to new configurations."

"Hence, the exotic particles we've observed."

"Elementary particles as massive as bacteria. Yes."

"A tear in space, in the heart of the Solar System," he mused. "A pocket universe . . . Strange days indeed."

"Certainly we're looking at a release of energy more than enough to overcome gravitational binding energy."

"Umm. But *why?*" Alfred asked. "What's it *for?*"

"Since we've no idea how this is being done," she said, "we're nowhere near an answer to that."

She scanned through more preprints. A flood of them, a kaleidoscope of theory, scattered shards of calculation and insight and speculation. Too much for anyone to read, let alone review. "Makes me wish I was young again," she said.

"Umm?"

"The *excitement* out there. String theory describes the high energy stuff. Energies of up to ten to power nineteen giga-electronvolts. Which is ten million *billion* times higher than anything we could create in any conceivable accelerator. So much was hidden from us, in this low-energy world we inhabit. Like trying to deduce the nature of a lion, after being given a glimpse of his tail."

"And string theory is a description of the rest of the lion."

"With about as much guesswork involved. Yes. But now, it's as if Venus has conveniently transmuted into the biggest particle accelerator in the universe. We can *see* the stuff we struggled to describe before. Now, even the skeptical types are saying we might reach a true Theory of Everything in five, ten years at most. The excitement is extraordinary . . ."

But now Alfred had found something else on the IAU net. Evidence of more Planckian cosmic radiation, just a trickle of it, coming—not from a remote planet, not from exotic sources that lay maybe beyond the Galaxy itself— but a lot closer to home.

He pulled up a sketchy diagram from a new preprint: a circle centered on a schematic Earth, two points picked out on the orbit of the Moon. "L4 and L5. Gravitationally stable, like shallow pits in spacetime: the places in the Moon's orbit, ahead of it and behind it, where you'd expect debris to collect. Dust, whatever."

She looked at the closely printed text, tried to follow it. "What are they saying? That the Venus killer is there?"

"No. Just that, on a small scale, the processes we're observing on Venus are replicated there, on a much smaller scale."

She frowned. "How so? Something working on the raw material there? But what?"

"I don't know."

"And how did it get there? Did it start on Venus, and come here, to Earth-Moon? Or . . ." Or did it start here, on Earth or Moon, and spread out across space, to Venus?

There was, of course, no answer: merely new pieces of the puzzle, fragmentary glimpses, imperfectly described by the staid, passive language of technical papers.

Glimpses of something monstrous.

She wondered how she was going to express this to the Administration.

Something had turned Venus into a kind of giant particle accelerator, orders of magnitude more powerful than anything humans had ever conceived. But that great experiment had wrecked the planet, literally disassembled it, from the core outward, blowing its surface and atmosphere into space over a timescale, as far as anyone could tell, of no more than a few months.

Something had *done* this. Or someone.

But who? How? Why? And what, if anything, was going to protect the Earth from a similar cosmic visitation?

If, she thought bleakly, it isn't already here.

. . . And in the dark and warmth of an Edinburgh night, Henry tried to explain to Jane what they were finding, in the lab.

"There are two aspects to this. Two structures, if you like. 86047—"

"The Moon rock."

"—is coated in a layer of quicksand dust."

"The same as the Arthur's Seat stuff?"

"Presumably."

"Are they connected, then?"

"I don't know. It would be kind of a coincidence for

this stuff to show up in two places independently. We're not running a clean facility in there. Maybe there's been some kind of—breach of quarantine." *Quarantine.* The word disturbed her, and she tried to figure out why. He said, "Even the surface dust is like nothing we've seen before."

His matter-of-fact tone chilled her. "What do you mean?"

"Each grain has a structure. On the outside there's a shell of silicate—a rock—although even that's a mineral we haven't seen before. Super-quartz, we've been calling it."

"And inside the shell—"

"We don't know. Whatever is there is beyond the level of resolution of our techniques. Certainly subatomic. Its structure *changes* with time. Its primary resource is olivine. Mantle rock. Whatever is inside the super-quartz shell is presumably the active agent, whatever starts the transformation of the rock the dust settles on."

"You make it sound like a machine."

"Maybe it is. Lots of tiny machines, eating olivine, using forces we can't identify to tweak crystal structures."

"Machines, inside tiny eggs of rock."

"The Moon rock as a whole has a greater structure. Silicate again, at first, on the surface, but the density and complexity seems to increase, beyond what we can resolve, toward the center . . . It's a kind of funnel, I think. In three dimensions."

"A funnel?"

"Building regions of successively greater density and pressure, toward the heart of the rock. I think it has a purpose."

"What?"

"The compression of matter and energy. Jane, the way to make a new element, to turn matter from one element to another, is to go to high energy density. Atomic nuclei can fuse or fission—"

"Like in a nuclear weapon."

"Or the heart of the sun. Right."

"And that's what creates the miniature explosions," she said. "When the quicksand spreads."

"Yes. But they mightn't be mini fusion explosions. There are *higher* densities. You can go all the way up to a threshold called the Planck energy—"

Planck energy. "Where all the forces of nature unify. And the strings begin to vibrate in higher modes—"

"Yes." He studied her. "Where did you hear about string theory?"

She thought. "I heard a TV comment by an American scientist. A physicist called Monica Beus, I think."

"I know of her."

"She used string theory to explain the spectrum of the radiation from Venus."

His eyes narrowed.

She tried to read his face. "Henry, what does this mean? How can there be Planck energy levels in a chunk of Moon rock?"

He shrugged. "The energy itself isn't so great. It's about the same as the chemical energy in a tank of automobile gas. The difficulty is that to reach Planckian energy densities you have to focus all that energy on one proton or electron. That's what we try to do in our supercolliders, but we don't come anywhere near, not to within factors of hundreds of trillions. The Moon rock structure is a much smarter solution. I think the Moon rock is being turned, particle by particle, into a minicollider. An energy lens. It's elegant."

"How? Who by?"

"I don't think there's a *who*. Unless you call a virus a *who.*"

"A virus? Not a machine, then? You think this thing is alive? Like a plague?"

"Jane, I'm just a rock jockey. I don't know what *alive* means. I'm just speculating about what I'm observing."

"Henry, what does this mean? Is there a link between what's happening here, and whatever happened to Venus?"

She tried to make out his face, on the pillow beside her, in the dark. "Is the Earth under threat, like Venus?"

He was silent for a while.

Then he said, "You know, what we're doing, in the lab, isn't really science anymore. We're scarcely documenting." He looked at her and grinned, sheepishly. "It's kind of an emergency situation. I'm worried about the quicksand growth, which doesn't seem to be self-limiting. We're focusing on looking for ways to disrupt its growth. It's fairly easy, if you catch it early. Just flood it; the reaction with water under pressure stops the formation of the crystal structure. And hide it from the light. Solar ultraviolet seems to trigger the process: kick-starts it, before the energy density gets high enough to self-sustain. We think some kind of supra-molecules are forming there, trapping photons to rebuild themselves: change molecular shape, separate charges . . . But they are fragile. Hell, if you catch it early enough, you can just kick it apart. But—"

"What?"

"Once it gets into the mantle, out of our reach, there will be no way of stopping it."

And it's growing, she thought, every day spreading a little farther down the flanks of Arthur's Seat, and into its rocky heart. And then—

Kaboom, she thought. Like Venus. That's what Henry is thinking now.

Breach of quarantine; infected rock.

And she remembered a walk up Arthur's Seat, a vial of dust, scattered on basalt.

My God, she thought.

Mike.

Later, when Henry was asleep, she got up and looked into Jack's room. The boy was sleeping, his hair spilled on his pillow. She felt torn. She wanted to hold him, as if he was a baby again. But she knew she mustn't wake him.

Already, she found her tentative acceptance of what Henry had said was slipping away.

Denial, she thought. *I'm in denial.* Well, maybe. She just didn't want to believe in this stuff. Not with Jack in the world.

She went back to bed.

14

She was woken by thunder. Henry was already gone.

She lay in her bed, still only half-awake, the flat morning sunlight already warming the outside of her drawn curtains.

Thunder.

She thought it over. Like giant footfalls in the distance. Like a door slamming deep underground.

Thunder, on a morning that was obviously clear and calm?

Was it more than that? Had something actually jolted her awake?

She reached for her watch. Not long after 6:00 A.M.

Jack stood at the door, in his Hibs soccer-strip pajamas. "Mum?"

"Go back to bed. It was only thunder."

"Granddad's up. He says it was an explosion."

"Where's Uncle Mike?"

"I don't know. Should we get dressed?"

Now her father came to the door. He was already wearing his battered old donkey jacket, and he was pulling his trousers over his pajama bottoms.

"Dad, what was that noise?"

"I'm not sure. It came from Abbeyhill." The area just north of Arthur's Seat, a half-mile away. "I'm going over there." He glanced at Jack. "I think this wee fellow should have a day off school today."

"What are you talking about?"

"We'll pack our bags." He ruffled Jack's mop of sleep-

stiffened hair. "We'll go for a holiday on the coast for a couple of days, will we?"

"Dad, I can't just take him out of school. Where's Mike?"

"Not here." Ted glanced at her empty bed. "Neither is yer man, I take it," he said.

"No."

"I think you'd better find Mike," Ted told her. "We should be together."

"But the shop—"

Another thunderclap. Or explosion. Smaller, crisper this time.

She heard the distant, Doppler-shifted wail of police sirens, the throaty flap of a helicopter somewhere overhead.

"Dad, what's going on?"

"I don't know. I'll see you later."

Jack was left standing in the doorway, wide-eyed. "Shall I start packing? What can I take?"

"First things first." She swung her legs out of bed. "Go fix us some breakfast."

Still sleepy, eyes gritty after being disturbed, she used the bathroom. Mundane details, bright in the unreal daylight: yesterday's *Edinburgh Evening News* left folded on the window ledge by her father, a final shred of paper left clinging to the toilet roll in its holder, Ted's irritating little habit. The sunlight on the frosted glass of the window was midsummer bright.

There was no bird song, she noticed absently. No morning chorus, save for the discordant wail of the emergency vehicles.

According to the *News,* the patch of "quicksand" on Arthur's Seat had reached a thousand yards across by yesterday. The scientists were saying it was still growing, but it wasn't a neat circle; in some places it was burrowing away underground, following the seams of basalt that underlay the city.

It wasn't a big story. It was too slow and obscure and impersonal. There was more space given over to speculation about the transfer of a soccer player from Hearts to an English club, Liverpool.

Henry said it wasn't quicksand. On the other hand, he didn't know what it was, she reflected, and they had to call it something. *Naming something is the first step to understanding it.* Was that true? What if the underlying reality was so strange that it defied the neat labels, the metaphors and parallels, humans sought to justify it to themselves?

The bathroom was warm and peaceful. She felt reluctant to step out of here, to handle Jack's questions, to deal with the way her life was slowly tilting out of balance.

But she must. She splashed cold water on her face and went out to the kitchen.

Jack was eating a bowl of Coco Pops, the milk already stained a revolting diarrhea brown, and he had turned on the small TV that sat on the serving bench.

"Mum, look at this."

A train crash. Carriages tipped off their track, spilled and split over the ground. The picture, a little shaky, seemed to be coming from a helicopter suspended over the scene. The tipped-over carriages were long and sleek, shattered windows glistening as if moist. Fire was licking from a couple of the cars, bright despite the intensity of the early sun. She could see ambulances, police vehicles, emergency workers in fluorescent yellow jackets, bright in the sun, others in drabber everyday clothes. There were people lying over the broken ground, being covered by blankets, surrounded by buzzing helpers.

A reporter was shouting over the whine of aircraft noise, something about subsidence under the line causing the derailment.

Jack asked, "Will we see Granddad?"

"What?"

He pointed with his spoon at the TV. "On the telly. Will we see him?"

She looked again at the screen, and something still half-asleep in her snapped awake. This was Edinburgh. Abbeyhill, in fact, not a half-mile from the house. The rail line came out of Waverley Station and headed east, tracking the coast, toward Dunbar. The derailment must have been the explosion she heard. Unlike herself, Ted had known immediately what it meant, what to do.

The helicopter camera was taking wider-angle shots now. The bulk of Arthur's Seat was visible, a crude, grass-clad knot, surrounded by an encrustation of streets and buildings. She could recognize Holyrood Palace. Probably this house was in the image somewhere, if she knew exactly where to look.

On the Seat, the quicksand patches were clearly visible, rough circles shining a silver-gray in the morning light, like spilled paint. Millions of tiny eggs, she thought, waiting to hatch.

She wished Ted had stayed. She wished Henry was here now.

"Eat up and get dressed," she said.

"Have I got to go to school?"

"Listen. Get packed. Not too much. Pack for me . . . and for Granddad and Mike too."

"Pack what?"

"Clothes. Blankets." She frowned, thinking. "Torches. The camp stove. The tent. The canned food from the larder. A tin-opener. Blankets." She forced a smile. "As if we're going camping. Candles. Matches. The bathroom stuff—"

"By myself?"

"You can do it. Remember we've all got to fit in one car."

"What about you?"

"I have to go find Mike. I won't be long."

The image on the TV had changed. Now there was a picture of a fire at a petrol station. Fountains of flame leaping up from the cracked concrete, the sagging yellow-green

canopy of the station forecourt blistering. Another Edinburgh disaster: more subsidence, it seemed. The station's thin underground tanks had cracked, and there had been a spark . . .

She went to get dressed.

Outside, the light was strange.

The sky was a cloudless, mid-April deep blue; the last of the night's chill was already dissipating. But Venus was clearly visible in the east, a bright spotlight: a third light in the Scottish sky, neither Moon nor sun.

And there was something else, a silvery-gray texture to the air, as if everything was veiled by a fine smog, leaching out the colors. It was the reflected light from the quicksand, tinging the air gray: quicksand, rock chewed up and transformed by something from the Moon, glowing silver-gray by the light of the wreck of Venus.

This is a strange time, she thought uneasily.

She got in the car and snapped on the radio, flicking it to a rock channel. She started the car and turned south, toward Henry's lab.

If Ted can face this, so can I.

It was a little after seven. The early commuter traffic, heading toward the city center, was already building up. Men in suits, fewer women, strictly one to a car. More than usual? Less? She couldn't tell. But there were other vehicles: a lot of four-wheel-drives and people movers, Ford Galaxies and Renault Espaces, some laden with possessions and kids, moving in every direction, east, west, north—every direction away from the Seat, to the south. Early evacuees?

Evidently Ted wasn't alone in his intuition.

Of, course there were some who would relish this.

Perhaps there were survivalists, even here in respectable suburban Scotland, waiting for it all to fall apart—heading for the highlands with their cans of corned beef, ready to aim illicit shotguns at anyone who came begging. Or maybe

they just wanted some place more challenging to take their 4WDs than the car park of Sainsbury's. Riding out the cozy catastrophe, in Barbour jackets and Land Rovers.

"Fuck them," said Jane aloud. In a year such folk would be starving, chasing sheep around the highlands, and in two years they would be dead.

There was a queue of cars forming already outside the hypermarket. There was even a line of pedestrian shoppers forming outside the Iceland supermarket.

Frozen food. *Smart.* Not that she'd thought to exclude that from the list she'd given Jack. But the kid was brighter than she was, in many ways; he'd probably figure that out for himself.

She ought to make sure he put in tampons, though.

When she reached the Holyrood Road she found herself in a stationary queue of traffic. She got out of the car and walked a little way forward, until she could see to the head of the queue. There was a pair of police cars parked crudely across the carriageway, blocking the way, and a tape stretched more symbolically across the road. Some cars were already being turned around and were coming back; the drivers looked irritated, business types with meetings they needed to get to.

The queue was moving, slowly; she realized that it was simply compressing, drivers inching forward in frustration, as if they could clear the obstacle by sheer psychic pressure.

We're fragile, she thought. Everything is full, run to capacity, pared to the bone in the name of efficiency. The slightest disruption and everything freezes up.

The murky light of Venus was reflected from the roofs of the cars ahead of her, curved splashes of new light.

The wind changed, and blew in from the east, from Abbeyhill. There was a smell of burned meat. She could hear sirens. A helicopter flapped over her. She looked up. It was in camouflage green, Army or Navy.

Was this how it was starting? Was this the end of normality, of the routine of life? Would chaos and pain spread

out from here, growing like the rock infection Henry had identified?

Her father would be able to cope with such conditions. That silent strength had always been an irritation to her, as she'd moved through adolescence and upward. What use was a father who was a kind of heroic pillar? What could he do but intimidate her, make her aware of her own weakness?

But, she recognized, there were times when such strength was, simply, essential. Essential for survival.

The radio carried newsflashes. Incidents all over the eastern side of the city, fires and power outages and even collapsing buildings. She shivered.

The receptionist at the lab didn't know about Mike, and told her Henry hadn't come in that morning. "But you might try the car park."

The car park?

Jane suppressed her irritation, and went back outside.

In the car park, in one corner, she found a Portakabin, a squat cuboid, uncompromising yellow. A plastic packing case was being used as a step before the open door. A fat bundle of cables—power and data feeds, she supposed—snaked into the Portakabin from an open window in the main lab building.

She knocked on the frame of the open door. There was no reply. She stuck her head inside, shielding her eyes against the light. Henry was there, in the middle of clutter, with his back to her. He was sitting on a plastic chair, hunched over a workbench.

"Henry?"

He put down a soldering iron and turned around. "Hi."

She stepped inside. It was like an electronic hobbyist's den; there were circuit boards and soldering irons and oscilloscopes and meters of all kinds, scattered over the benches and the floor. On the bench where Henry had been

working there was a gigantic parts rack, row on row of little plastic drawers containing banana plugs, wires, leads, clips, resistors, capacitors, transistors. The glowing screen of a laptop sat at the center of the bench. And beside the bench there was a bizarre cairn of gear, a stepped pyramid of what looked like a car tire inner tube topped by plastic plates and Styrofoam sheets and lengths of hose, all topped by a clutter of electronic gear.

There was a complex smell here, she thought: over-strong coffee, the ozone-rich stink of electronic equipment and burned solder. And Henry, of course, the warm scent she had so quickly gotten used to.

She said, "Have you seen Mike?"

"What?"

"Mike."

"No. I—"

"Do you think he's in the lab?"

"He hasn't been around. What's wrong?"

"He didn't come home. Ted is worried." She told him about the train crash. "I'm worried too."

He stood up. "We'll find him. I think I know where he is."

She glanced around. "What the hell are you doing in here, Henry?"

"I'm building an STM. A scanning tunneling micro-scope." He looked at her. "It's a device that uses quantum effects to . . . Well. The point is you can study individual atoms. You can move them, even."

"Why? What for?"

"So I can study the Moon rock. Why else?"

"There must be STMs in the lab."

"Dream on, baby. But I need one, so I have to fall back on good old Yankee can-do . . . This pile of tires and Styrofoam is the shock absorber." He grinned. "Low tech but effective. I scrounged a piezo to fix the needle to. I use a loudspeaker coil to move the needle in toward the sample." He looked at her, to see if she was understand-

ing. "A coil from a telephone headset. I can move my needle to an accuracy of less than an angstrom. That's less than an atomic diameter. I can feel my way across the atoms on the surface of a sample, like working along a river bottom. I—"

"Henry," she said, "why are you in the car park?"

"Because the liquefaction is coming."

"The what?"

"The quicksand. Jane, it's coming this way. Running through the old igneous structures in the bedrock. The only uncertainty is when it gets here. The lab block over there is a warren. I don't want to get caught in that."

"But the university people—"

"—won't listen. So I'm making my protest, out here. This way, I might persuade more people to take this seriously." He stood up and held her shoulders. "Never mind. Let's go find Mike."

They considered taking her car, but the roads were impossible. The career types had gone to work, but now the survivalists in their laden 4WDs were mixed up now with the school run.

But still, Venus had set, and the light was a little more normal.

They walked, to Arthur's Seat.

She studied him. She said, "Aren't you freaked out too?"

"Sort of. This is spooky stuff. But the bigger part of me is—"

"Excited."

"Yes."

"By what? Nano-machines from the Moon? String theory? The end of the world?"

"Not really. Just about figuring stuff out. You were right. That's the thrill." He smiled. "Especially right now, when I have the excuse to skip the detail."

She felt the urge to punch his smug face.

"How do you know where Mike will be?"

"I don't. But I have a hunch." He turned to her, evidently gauging her reaction. "You know, he's kind of changed over the last few days."

"I know," she said. And I know why, she thought. Mike's figured it out too.

They climbed the Seat. Henry stopped a couple of times to inspect the grass, which had turned, in places, brown and wiry: dead, poisoned somehow.

They reached the dust pools, a ragged garden of them a thousand yards across. The police had given up trying to tape off the perimeter, but there were many of them here, in their fluorescent emergency-yellow ponchos, patrolling. Jane saw how the officers, many of them very young, kept a wary eye over their shoulders on the advance of the quicksand.

Outside the ring of police officers she spotted a group of scientists working close to the quicksand perimeter, with handheld probes and white-box lab equipment and flickering laptop screens. They were wiring the Seat, in Blue's term. A couple of them were preparing a small, turtle-shaped robot which looked as if it was going to be sent into the quicksand itself.

And there were TV and radio crews, with big fold-up antennae pointing at the sky. The tone of the broadcasts had abruptly changed, Jane thought; now that people had died, it seemed a great city was gathering itself in fear, and the earnest tones and body language of the reporters conveyed that, cartoon style.

Around the broadcasters and scientists there was a broader ring of sight-seers, mostly teenagers and young adults. Some were studying the quicksand, or watching what the scientists were doing, or listening soberly to the news people. Others were just, it seemed to Jane, enjoying a novelty in the sunshine.

It was, in fact, *crowded* here. There was a lively mood. Like a Bank Holiday crowd.

It wasn't hard to find the Egress Hatch encampment; it was at the center of the densest knot of sight-seers. The cultists were sitting around in their pajama uniforms in a rough circle, as close, it seemed, as the police would allow them to the quicksand puddle. At their center was the leader, Bran. He had on a Madonna microphone headset, and was strolling easily before the quicksand, his words amplified by a bank of ghetto blasters. He looked for all the world like a stand-up comic, she thought. His audience was no passive congregation; they laughed and whooped as he spoke to them.

Hamish Macrae had mastered the seduction of humor, she thought. He had grown up a lot since that lift shaft.

And here, as Henry had appeared to expect, was Mike, sitting among the cultists. He was still wearing a white lab coat, which stood out among the pastel colors of the cultists' pajamas.

Jane moved forward—she had to step over a few rows of cultists, who dipped out of her way with gentle smiles— and hissed until she had Mike's attention. He looked back at Bran as if wistfully, but he unfolded his legs, stood and climbed out to her.

Henry spoke first. "I was worried about you. We missed you at work."

Mike seemed surprised. "You did?"

"Well, Marge Case makes lousy coffee. Anyhow, you don't have the pajamas for this."

Mike smiled weakly. "Pajamas will be provided."

"When?" Jane snapped. "When you all beam up to the fucking mother ship?"

Mike wasn't reacting. "You can't mock this, you know. Bran mocks himself."

"Yeah," Henry said. "I noticed. He's smart."

"Dad thinks we should get out of here," Jane said. "Out of the city. We want you to come. We need you." She hesitated. "Jack needs you."

Mike frowned. "I think I'm needed here."

"Why?" Jane said sharply. "To atone?"

Mike wouldn't reply.

Henry touched her shoulder. "Let's get out of here."

She flared. "We can't just leave this little arsehole."

"What are you going to do, slug him and haul him over your shoulder? You know, these guys will have to come off this rock soon anyhow. The rate of progress of the dust—"

"*Moonseed,*" Mike said.

"What?"

"That's what Bran calls it. Moonseed."

Jane said, "Why?"

"Because it comes from the Moon."

She held Mike's arm, just for a moment. "We'll be waiting," she said.

He nodded tightly, already looking back at Bran.

"*Moonseed,*" Henry said. "It's a better word than quicksand. But it's still just a word."

"I think Mike's gone crazy," she said.

"No. You mustn't think that. None of them are crazy. Bran isn't crazy. I think Bran has looked at the same evidence as me and come to the same conclusions, in some way I don't understand. Now, given all that, how is Mike supposed to react?"

She felt herself get more angry. "This is all bullshit."

But Henry was still talking. "In a way Bran's thinking has gone far beyond mine; he isn't questioning the data he sees, or trying to construct hypotheses about it. He is already trying to deal with the consequences. He was brought up to expect a lack of disturbance. A stable world to live in. A long life. Hell, we all were. Now, that's gone. Bran is offering a way out. At least an explanation. Very skillfully presented. And Mike, and the others, are accepting that. I can't blame them for that."

"But it's all guff."

"I agree. But I don't have a smarter alternative to offer anybody right now. Do you?" He studied her. "So why are you so angry today?"

"Because of Mike. Because of *you*, you smug bastard."

"No," he said.

No, she thought. Because I don't want this to be happening. I want it to be yesterday, when I still had control of my life.

His hand covered hers. "I *know*," he said.

"What?"

"About Mike." He glanced at her. "That's it, isn't it? The quarantine breach. How it got out."

"Yes. And it's killing him."

"He couldn't have known. It wasn't his fault. If we can get him to—"

A soft warble came from his jacket pocket; he pulled out his mobile phone. He opened it up and listened. "Yeah . . . Shit."

"What?"

"Something at the lab. An explosion. I have to go." He paused a moment, unwilling to leave her. "There's nothing you can do about Mike now. Come with me. Then we'll go to your family, and get the hell out of here."

She hesitated for a second, looking back at the crowds at the base of Arthur's Seat, her brother among them.

And, visible at the heart of the concentric circles of people milling and laughing and arguing, there was the Moonseed pool, spread like parachute fabric over the Seat. It glimmered softly, the familiar contours of the Seat slowly dissolving into its silky, seductive smoothness; and the silent light-bursts at its perimeter came steadily now, as the Moonseed ate its way through the ancient basalt.

She grabbed Henry's hand, and they started to run.

15

When Ted Dundas got back from the train wreck, he found the house empty, save for Jack.

Jack stared at the blood and dirt on Ted's face. Ted let him get used to it. It wouldn't be the last blood he'd see.

The lad had done a good job of assembling the supplies his mother had asked for. They were stacked up in the hall, blankets and cans and camping gear and clothes. Good kid. Ted made a few suggestions. Anything run by battery, like torches and radios. Any batteries they had, in fact. His own old wind-up watch. Any kind of bottle or container they could find, filled up with clean water. Any medicines in the house. Clothes, for hot weather, cold, wet, snow. Towels, for Christ's sake.

Jack showed him his own stuff, a shoebox of toys and books he was taking. Some kind of spaceship, wings shaped like a black sycamore seed, so worn from play it had hardly any paint left at all. A book, some trashy thing about a virtual reality *Gulliver's Travels* theme park, the spine broken from rereading. And so on.

But the lad had only allowed himself this one box. He looked up at Ted seriously. *He understands.* Ted ruffled Jack's hair.

Ted gave Jack the keys to the car, and said he should start packing up. Then Ted went to his bedroom, stripped off, and ran a deep, hot bath. There ought to be time for this, and it might be a while before he got another chance. He showered first, to scrape off the worst of the gash, and then climbed in.

Lying in the tub, he made plans.

As near as he could make out, it was as if an earthquake was hitting the area. So: when the earthquake comes, what do you do? He dug into his memory, the emergency training he'd had as a copper.

Run for the hills. But first, prepare the home. Batten

down all loose objects. Fill the bath tub and the sinks with water. Switch off the electricity and gas. If he had time, put duct tape on the windows to prevent falling glass.

Find ways to mitigate the problem, not add to it.

He got out of the bath, toweled himself briskly, and pulled on fresh clothes.

He thought about Ruth Clark, a couple of doors down.

It would be murder trying to get Ruth to come away without her damn moggie. Well, he should try; there would be room in the car.

He walked out to the living room, drying his hair.

His relationship with Ruth had never exactly caught fire. And it had been inhibited further since Jane and Jack had come back home to live. Still, when he thought about the future, he'd always pictured Ruth somewhere in it. And he liked to think she thought of him the same way. And—

The floor was buckling, the carpet gathering in a fold.

Oh, Christ.

It happened in a second. It was as if the house had collapsed around him. Furniture fell, plaster showered down from the ceiling, his wife's collection of painted plates tipped gently off the Welsh dresser to the floor.

He found himself on his knees, as if someone had tugged the floor out from under him.

He heard the house frame crack, a window explode somewhere. So much for planning. Where was the lad? . . .

Later. He had to get through this himself. If he could get under the big dining room table—

The floor bucked, and he was thrown flat.

Jack was screaming.

Ted rolled on his back. Jack was somehow standing in the doorway, clutching his box of toys; he was crying.

Ted tried to sit up.

But here came the TV set, a great heavy box spinning away from its spindly stand, looming, filling his world, too big for him ever to avoid.

* * *

In the clean room, there was blood on the wall and floor. Sprayed there, as if with a fine hose, already drying to brown. An incongruous splash of human weakness, here in the damaged heart of this place of science.

The glove box which had held Moon rock 86047 was the center of it. The stainless steel frame was still intact, but the thick glass had been shattered and blown outward. Jane saw the remnants of one of the long-sleeved gloves the workers had used to manipulate the sample in its box, blown out and shredded, hurled into a corner. There was nothing left of the tools and trays the box had contained.

There were glass fragments on the floor, and punctures in the wall tiles which spoke of the ferocity of the box's bursting. A couple of the fluorescent ceiling light strips had been blown out, making the light here an even more dead gray than usual.

Henry was talking to the lab workers here, and to a young policewoman who was taking notes. The policewoman looked tired and harassed, Jane thought; it was surprising there weren't more police here, firemen.

Or maybe not. It was turning out to be a strange day.

Elsewhere, she saw that this lab had been turned into some kind of geologists' war room. Big Sun workstations had been commandeered; one was displaying weather satellite information, and another was scrolling what looked like infrared images of thermal activity in the area, more satellite images, multicolored and full of detail. There were big geological maps of the area taped hastily to the walls, and equipment, most of it unrecognizable to her, was being set up on the benches or floor, some items still in their foam-lined metal cases.

Now Henry came to Jane. He was followed by a young woman in a scorched lab coat, who seemed excited.

Henry said, "Nobody was badly hurt. We were lucky. Some lacerations and burns."

"Burns? What happened here?"

He grinned, his fascinated expression starting to

match that of the girl researcher. "The sample blew up."

"What sample?"

"86047. The Moon rock. It was just sitting in its box, and then—" He opened his hands in a popping motion. "Like a puffball fungus."

"It was incredible," the girl said. "We were monitoring the changes. Tee, pee, rho, all went off the scale—"

"Temperature, pressure, density," Henry said dryly. "Jane, meet Marge Case."

Marge Case just kept talking. "—and when we replayed the bang we detected gamma rays, X rays—"

"Like Venus," Jane said.

"Maybe," Henry said. "More like fusion products, from the layers around the very center."

Jane looked back at the case; there was no sign of the Moon rock. "Where is it now? Converted to energy?"

"Oh, no." The girl laughed, and Jane could have happily struck her. "Only a fraction of the mass was destroyed, we think. Maybe one part in ten to power eleven."

Henry thought about that. "If it was all hydrogen, that would be a sphere maybe forty microns across. At fusion temperatures and pressures."

Jane said, "And the rest of the Moon rock—"

"Is gone," Henry said grimly. "Converted."

"To Moonseed?"

"Some of it. We'll find it if we scrape the walls, no doubt."

"It's just incredible," said Marge Case. "Think of it. We probably had higher-order string modes, *here*, in this lab."

"For a squillionth of a second," Henry said.

"But why?" Jane asked. "Why does it do this?"

Henry shrugged. "To propagate. The Moonseed will go on to infect normal matter, create more puffball-fungus explosions, and propagate further still."

"Like what's happening outside."

"We think so," Henry said. "Although the growth isn't

even. Olivine-rich basalt is the raw material of choice . . ."

Jane looked from one to the other. "I don't understand you. You seem—excited."

"Exhilarated," Marge Case said.

"Really?"

"Of course." Her eyes were moist, shining in the imperfect light. "Don't you see? It's not just the high-energy physics. *This is the discovery of the century.* This may be life from another world. An utterly different mode of biology." She looked, to Jane, as if she hadn't slept for days, as if she'd been living on adrenaline.

"What I mostly feel is frustrated," Henry said. "We have no time to do the science. A study like this should take years. Teams all around the world. We're doing little more than guesswork, here. And—"

"What else?"

". . . Awe, I guess," he said. "Geologists get used to thinking big. Big timescales, huge energies, gigantic events. But I'm not used to seeing all that intrude into my own life."

"But we're talking about a threat to the city," Jane said. "Screw this guff about biology and science."

"Jane—"

"You think I'm being hysterical. But somebody needs to express what we're really saying, here. This isn't just some intellectual puzzle."

Marge smiled sadly. "Isn't it?"

Jane watched Henry. "I need to get out of here. I have to find my family." And, here was the unspoken thought, *I could use your help.*

He was meeting her eyes. But now there was hesitation.

What he has here is important. His work. Maybe more important than anything else. Not for me, though. He is going to have to choose.

But now Henry had turned away. He was looking down.

Then she felt it. The floor was shaking.

It was slight at first, almost imperceptible, but within seconds it grew stronger. There was noise, a deep bass rumble, with grace notes added by the rattling of equipment on the benches and shelves of the room. Glass tinkling. As if some gigantic eighteen-wheeler were driving past, shaking the ground.

The shaking stopped.

Jack Dundas stood in the living room doorway. Everything was smashed to pieces. The big patio doors had smashed apart. He saw his mother's collection of CDs spilled on the floor, the player smashed beside them.

Granddad, Ted, was lying on the floor. He was on his back, his hands over his chest. He had his eyes closed.

"Granddad? Are you dead?"

Jack took a step forward. Glass fragments crunched under his trainers. He looked down; it was one of his own school photos, a grinning geeky kid in a red sweater, the frame smashed.

He went to Ted. He put his toy box down beside his grandfather. Was he dead?

He had seen reruns of old hospital shows like *Casualty* and *ER,* so he knew what to do. He reached forward nervously, and touched Ted's neck. The skin was warm. There was a pulse.

Ted coughed, and gasped for breath.

"Granddad? Granddad?"

Ted's eyes were still closed. There was, Jack saw, blood soaking his shirt around his hands. Jack reached down and took his grandfather's wrists. They were thick and coated with wiry hair. He pulled Ted's arms away from his chest, exposing a ripped shirt, and a bloody wound.

The wound was grisly. There was a piece of fractured rib protruding from the chest wall, surrounded by blood. The blood was bubbling.

Jack sat back, helpless, shocked.

"Jack."

The voice was a croak, and it made the lad jump. His grandfather's eyes were alert, on him.

"Help me. You can do it, lad. Make me sit up."

Jack put down his box, crawled around behind Ted, and helped Ted to half-sit up, resting his head against his lap.

"That's it . . . now put your hand over the wound."

"I can't."

"Do it, Jack!"

Jack reached out and put his palm tentatively over the wound. Ted reached up and covered the lad's hand with his own, pressing the hand into the wound. The feel of bone and broken flesh and *bubbling* made Jack want to heave, but his grandfather's hand was warm and solid and steady.

"Good lad. Now seal the wound."

"What?"

"Or else my lung will collapse. Find something that won't leak. Anything."

Jack looked around, scraped around in the litter on the floor. He found a clear plastic magazine envelope. *New Scientist,* he saw; his mother's subscription.

"How about this?"

"All right. Now. I'm going to breathe out. As hard as I can. Push me forward."

The breath came out in a wheeze, and Jack pushed at his shoulders, trying to help.

Ted's words were a gasp. "Put the patch over the wound."

Jack slapped the plastic envelope over the hole in Ted's chest, gratefully taking his hand away from the bloody wound.

"Good lad. Bandages. You need bandages. In strips. Quickly. The bathroom . . ."

Jack gently lowered Ted's head to the floor—guiltily wiped his bloody hand on the rug—and went to the bathroom.

No bandages. He'd packed them already in the car.

He went to the front door, which had come off its hinges and was hanging drunkenly in its frame, so he had to step over it. The tarmac of the drive was cracked, but the car seemed intact. The boot was still open, and he quickly found the rolls of bandage where he'd packed them.

He looked around the street. There were no cars on the road. All the houses were—ruined. As if stomped by a giant. One of them, where Pete McAllister lived, was on fire. But he couldn't see any fire engines.

He hurried back to the living room with his bandages.

"Good lad. All right. Around my chest—fix the patch in place—"

Jack started to wind the bandage around Ted's chest, over the patch. Under Ted's whispered instruction, he made sure each layer overlapped the others.

Ted watched calmly, his head resting against a tipped-up armchair. "You're saving my life, lad," he said. "Don't you ever forget that. A hell of a thing to do when you're ten years old."

"Ten and three quarters."

"And three quarters. Don't forget your shoebox when we leave."

In the lab, people were standing silently, as if hypnotized. A polystyrene coffee cup was edging its way across a bench surface, neat concentric ripples marking its surface.

It's unnatural, Jane thought. That's why we're transfixed. The floor isn't supposed to move under us.

"Those are harmonic tremors," Henry said. "Magma moving."

Marge Case said, "It's consistent with what we've been monitoring. Swarms of shallow microquakes." She turned to Jane. "Shallow because this isn't some deep tectonic movement, but a movement of magma close to the surface . . ."

The shuddering subsided.

"If VDAP were here they would already have called a Level D alert," Henry said. "At least. And—"

"If there is some kind of eruption," Jane said, "what will it be like? Arthur's Seat is old. Surely—"

"It won't do much damage?" Henry looked glum. "Jane, we don't know what to expect. The best guess is that the old magma, broken up by the Moonseed, will be viscous, with a lot of trapped superheated steam."

"So very explosive," said Case. "And—"

There was a jolt, and a sharp crack.

"The building frame," said Henry.

"I have to get home," Jane said. "Christ, if it's come this far—"

She started toward the door. It was like trying to walk in a moving subway train.

"Look," said Marge Case softly.

A wave was passing through the floor, through its substance, a neat sine wave a few inches high. The floor tiles buckled, or popped away from where they were glued. "Good God," said Marge, and she giggled. "Floor surf."

It happened in an instant.

The floor lurched under Jane, like a plane in turbulence, and she was thrown to her knees. She landed hard, her knees and the balls of her hands taking the impact. She felt as if she had been punched. The shock of it, the physical power, was like a violation.

And now the floor *tipped,* and she was sliding. Someone screamed. She looked for Henry.

Suddenly equipment was flying off the shelves on the walls, electronics boxes and tools and glass dishes, raining down. And the people were clinging to the floor, or skidding down the sudden slope, trying to stay on their feet.

She saw a heavy set of weighing scales come tumbling down in a neat parabola, and hit a lab-coated man in the back of the neck, evoking a sharp, clean snap. He fell for-

ward, arms and legs loose, and rolled down the tilted floor.

The lights flickered. One of them exploded in its housing in the ceiling. Then they failed, and she was in darkness.

Jane was still sliding down the floor, in pitch darkness. It was a childhood nightmare, a mundane world turned monstrous, dragging her down into some pit she couldn't even see.

Everyone seemed to be screaming now. More explosions from above. A crash, a stink she couldn't recognize, and she found herself coughing. Christ alone knew what chemicals they kept in here; there had to be a danger of toxic fumes, fire.

She scrabbled at the broken floor; her fingers closed around the lip of a dislodged floor tile, and she hung onto that. The tile ripped her nails, but she wasn't falling any more.

Somebody came skidding down the floor, and hit her side. The impact was huge, uncontrolled; a thick hand scrabbled at her clothes, trying to get a grip. She knew she couldn't hold this new weight, and her own.

She should kick this guy away. She knew that's what she should do.

He didn't get a hold. He fell away into the dark, sparing her the decision.

Now there was a new series of deep, grinding cracks. Light from below; a throaty explosion of collapsing brickwork, the grind of tearing metal. She risked a look down. The wall beneath her had broken up, and huge chunks of it were falling away, letting in the daylight. Glimpses of the car park, maybe fifty feet below, the cars still parked in their mundane rows.

And, silhouetted before the light, people scattered like dolls, trying not to tumble any farther. Marge Case was clinging to the square leg of an analysis table, bolted to the skewed floor. One hand was bloody, and flapped at her side like a broken wing; she was holding on to the table with her other hand, one set of fingers.

The whole building had tipped up, Jane realized. Like that movie. *The Poseidon Adventure.*

A fat man lost his grip, went rolling down the floor, and fell neatly through one of the holes in the wall. He fell screaming. Jane could see him for a couple of seconds, suspended in the air, still clawing monkeylike for a grip on something, anything, before he fell out of sight.

When he reached the car park there was a meaty punch, a sack of liquid breaking open on an unyielding surface.

"Jane! This way!"

Henry had climbed to the comparative sanctuary of the doorway, with the policewoman and others. Henry was reaching down to her.

She looked up at him, calculating. She could reach a table leg no more than inches from her, push herself up on that, then half-stand on the leg to get to Henry's hand.

Marge Case was screaming behind her, begging for help, almost incoherently.

Perhaps Jane could reach her. But she might fail. This is ridiculous, she thought. I don't have time for this. I have to get to Jack.

She thought about the unseen man she'd been prepared to kick away. Not yet, she thought. We haven't come to that yet.

She turned to Henry. "Help me get to her."

They formed a chain. Henry braced himself in the doorway and held the policewoman's hand; she reached down and gripped Jane's wrist, with surprising strength, Jane got a couple of footholds in the broken tiles, and reached down herself, and caught hold of Marge's hand. Marge was sobbing, and just hung there.

Within seconds, the weight was too much for Jane.

"Marge, I can't lift you. You'll have to climb."

But Marge seemed frozen, and Jane had to coax her into it, step by step. "Put your foot on that table leg. There. Now push up. Good girl. Okay, grab my waist . . ."

So Marge climbed to Jane, and Jane climbed to the

policewoman, and they all clambered out to the corridor with Henry, where they could rest.

There were others here, lab workers and students, mostly young, looking bewildered. Marge Case was in floods of tears, and was starting to react to the pain of an arm which looked broken. The policewoman got hold of her and started to apply some simple first aid, strapping the arm to the girl's side.

Henry held Jane, just for a moment.

And all the way through, Jane couldn't help herself thinking, over and over: I don't have time for this.

Ted, as a kid, had once got his ribs bruised playing football. He hadn't been able to get out of bed for three days.

But bed rest wasn't an option now.

It took him an age, and excruciating pain, just to stand up.

Well, he was able to walk, if he leaned on his little helper. But it felt as if someone was grinding a sharp fist into the center of his chest, over and over.

"We should wait for mom."

"No. We have to go before the quakes come back. We'll find your mum."

That was true; if they managed to get onto any of the A roads, there would surely be reception centers; that was police procedure in eventualities like this. It shouldn't be impossible to find Jane and Mike.

Always assuming he could drive.

Ruth Clark's house seemed to have taken a still worse beating than his own. It looked as if the roof had simply fallen in, leaving the outer walls standing in broken spikes, delimiting the debris.

We ought to just get in the car, he thought. I have to take responsibility for the lad. And I sure as pish can't do any heavy lifting.

But he couldn't just leave her.

With Jack's help, he stumbled up the drive to Ruth's house. Her front door was a heap of match wood, blocking the hall.

He limped around to one of the intact sections of wall. There was actually a window here, still unbroken, that let into the living room. He couldn't see anything inside. He surely wasn't going to be able to climb in there.

There was a soft whimpering, from inside the house. Crying, like a baby's.

He got Jack to fetch him a towel. Ted wrapped it around his arm, turned away, and smashed open the window. Then, with the towel still in place, he pushed out the remaining shards of glass—

A tan brown blur hurtled out of the window. Tammie. He got a single clear view of the beast, as it looked into his eyes.

Then it dropped to the ground and was gone.

The crying had been the cat, then.

Jack said, "Should we chase Tammie?"

"No. She'll look after herself."

"What about Mrs. Clark?"

Ted ran over what he'd seen, in his mind, in that brief confrontation.

The cat had blood all around its mouth. It had been chewing something. Eating into it—

"I don't think Mrs. Clark is home, Jack. Come on."

He leaned on Jack again, and they limped back to the car.

Somewhere, a siren wailed.

The lifts were all out, and there was no light in the corridors. But they were able to push open the doors on the uppermost side of the building, and reach the fire escape. This was a red-painted staircase, bolted to the side of the building; but it was tipped now at maybe thirty or forty degrees to the vertical. Jane had to slither down the stairs and the face of the wall.

The building continued to tilt.

The noise was immense, cracks and grinds from the frame and brickwork as they sought to relieve the impossible tensions on them. Windows popped out of their frames, sometimes intact, sometimes in a shower of shards, glittering in the bright April sun. Once a whole section of wall simply exploded outward, a few feet from her, a brief fountain of brickwork and concrete.

It took an age to reach the ground. Henry was waiting for her; he grabbed her hand. "Let's get out of here." His palm was slick with blood.

They ran out of the car park and into the West Mains Road.

The road was cracked, right down the middle, as if along a neat seam. Jane could see that houses had collapsed, or fallen to pieces. Taller buildings were sometimes intact but were leaning precariously. In one place, water was gushing up from a crack in the pavement.

The pavement was broken, rippled, in some places subsided. The Moonseed was here, she realized: right here, in the bedrock, under her. The ground could give way under her any minute, dropping her into hell.

But there was nowhere else for her to go, nothing for her to do but run over this unsafe ground.

They ran east, trying to reach the main road that would take her home.

The road was packed with stationary cars, all crammed with luggage. Most of them were still occupied, drivers and families waiting patiently for a break in the jam, waiting for someone to tell them what to do. As he ran Henry shouted at them. "Get out! Get out!" But he didn't stop running. The car passengers, many of them children, stared out bewildered at the stream of ragged and bleeding refugees running past them.

After a hundred yards, they came to a woman trapped under a fallen tree. She was screaming.

Henry and Jane hesitated. Then they bent to help.

The tree was thick, mature, immensely heavy. Impossible to move. They tried anyhow.

Jane looked back, toward the lab. It dominated the horizon of the street, as it had yesterday. But now it leaned impossibly, like a sinking tanker; for now it was still intact, though its upper levels were crumbling, its windows and fascia cracking and falling in great leaves, exposing its steel and concrete frame.

There was no fire here, she realized. They had been spared that, at least. But there was a smell of burning, a pall of smoke rising from somewhere to the east. There was no sign of the emergency services. No police, no fire brigade—nobody save for the lone police constable, running with the rest of them, trying to raise her station on her lapel radio.

And now an immense groan emanated from the falling lab building. Jane looked back. There was a crack like snapping bone, and the building exploded, lengthways, its upper levels hurling themselves forward as if trying to escape the betraying ground. But they fell, inexorably, fragmenting as they went.

The building lost coherence and collapsed, in a cloud of billowing dust. There was a fresh explosion, a sharp, almost beautiful flower of flame, at the base of the building.

The woman, still trapped under her tree, was no longer moving. She was unconscious but probably still alive, Jane thought. But how could they help her?

"We have to keep going," said Henry. "When these cars start going up, there'll be a chain reaction."

Jane looked down at the woman. "The first we are leaving to die."

"She won't be the last," Henry said grimly. "Listen, I have to go with that cop."

That startled her, although she should have anticipated this.

His face was full of doubt and anguish. "I need to get to the authorities, somehow. Yes. That's what I have to do. She's my best bet—"

"No. We have to reach Jack." She looked into his face. "You have to help me."

His expression was complex, unreadable. "I have to do this."

"Why?"

"Because they have to evacuate the city. And then I have to tell what I know. To someone who can do something about it, on a global scale."

"Like what?"

"Like find the source of this."

She thought that over. "You mean *the Moon?*"

He peered up at the sky, as if seeking the Moon, then looked at her. "Listen to me," he said. "We saw what happened to Venus. Maybe this is all somehow linked. And right now we don't have any way to stop it, here on Earth. No way to stop it, until it goes all the way to its conclusion."

That chilled her, more than she would have believed possible, after what she'd already gone through, what she still had to face. But the most important thing, the central realization, was unchanged.

He's not going to come with me.

She felt more frightened than ever.

When she was with Henry, she felt as if she could do anything, go anywhere. Live forever. *My head knows we're in trouble, but my body needs educating. Like a dumb old dog. It doesn't understand.*

But I barely know him. Am I investing too much, in a relationship that barely got started? Could I have expected anything more?

Hell, yes, she thought.

If there were people on Venus, did they feel the same as I do when it started there?

"I have to get to Jack," she said. "It's all I care about." And it was true; she could feel the pull to her child, like a cable attached to her chest, dragging her, a primeval force.

"I understand."

"But you won't help me."

"I can't," he said.

"I thought you cared about us." Christ, that sounds weak.

"You know I do," Henry said. "Jesus." He turned away, his shoulder muscles hunching with the tension. "It's what I want. To be with you."

One last try. "Then come with me!"

"I can't. I have to go find a way to stop this. I'm sorry."

She held his gaze for one, two seconds.

Then he turned away, and ran toward the city center.

A helicopter flapped over her, silhouetted against the sun, so she couldn't see if it was here to help the people, or to watch them die.

16

In support of the general evacuation of the eastern city that had been ordered, Morag Decker was assigned to assist at the Queensbury Hospital, off the Holyrood Road.

The area immediately around Arthur's Seat remained chaotic and uncontrolled, because of the suddenness and scale of the devastation, the collapse of the roads, the inability of the emergency people to penetrate.

The wounded and dead still lay as if dropped from some other planet onto these quiet Edinburgh streets.

But here *she* was, a police constable, running past the casualties, making for the hospital as fast as she could manage.

She knew the drill, the work that ought to be done here: *Attach a waterproof numbered disc or label to the remains. Each body or part of a body must be numbered. Mark the position of the remains with a similarly numbered peg or stake. Use yellow wax crayon on hard surfaces. Place the remains in a body bag and label with the same number. If during this procedure items or body parts fall from the remains they should not be replaced but put into a separate*

*container and labeled to indicate the probable association
with that body number . . .*

She wanted nothing in the world so much as to go off
duty, to go home, to shower away all the shit she'd been put
through already today. That wasn't an option right now.

She reached the hospital.

The car park was crammed. There was a queue of buses,
cars, taxis, ambulances both ways at every exit. There
seemed to be patients wandering everywhere: some com-
plaining, some apparently enjoying the break from hospital
routine, some actually pushing their drip bottles on portable
stands. At the exits, hospital staff were chasing their patients,
trying to get their details before they became lost in the
crowds. A policeman was trying to ensure a one-way traffic
flow through the grounds, but the system wasn't working.

A cry went up when an ambulance, reversing, knocked
over a wheeled stretcher. Fortunately the stretcher was
empty.

She heard the hospital managers conferring with each
other, and the consultants and senior nurses. Where the
hell were they going to put all these patients? The Health
Service had gotten very sleek and efficient, it seemed, but it
didn't have an ounce of spare capacity . . .

She found a senior police officer, a superintendent,
trying to bring some order to the chaos; she told Morag to
help out with room clearing.

Morag went into the hospital.

Away from the reception areas, the building had
already mostly been cleared. *The National Health:* bulk-
bought green paint on the walls, echoing corridors, metal-
framed beds, the all-pervasive stink of disinfectant—as a
child Decker had had an unhappy time in hospital, an
extended stay to treat a badly fractured leg. Being here
brought all of that back. Especially the *smell*.

But still, in here she was away from people for a time,
the car horns and shouts of the exit areas were receding to

a background wash of noise, and the loudest sound was the click of her heels on the polished floor.

She could feel herself starting to unwind, just a little. Was that wrong?

The doors to the wards were closed. When she looked along the corridors she could see pillows propped up against each of the doors, their fat cotton bellies protruding from the door frames. The pillows were a mark that the rooms had been cleared. It was standard procedure. You couldn't go back into one of these rooms without knocking over the pillow, and you couldn't prop it up again from inside the room. Fail-safe, supposedly.

She heard something from inside one "cleared" ward. A low mumbling.

She kicked the pillow out of the way, opened the door and went inside.

Bright sunlight streamed into the room, dazzling off the polished floor. There was a row of beds, roughly abandoned, sheets and blankets pulled aside and crumpled. She searched, quickly. Medical charts, clothes lockers, a trolley with medication.

The whimpering was coming from under one of the beds.

Morag went over and looked under the bed. There was an old woman huddled there, in a thick flannel nightdress. Bright, rheumy eyes stared out of the dark at Morag. "Who are you?"

"It's all right, dear. You need to come out now."

The woman clutched birdlike arms to her chest.

Morag straightened up and checked the name on the medical card fixed to the bed. "Mrs. Docherty, is it? I'm the police. It's safe to come out now."

Those rheumy eyes turned again, distrustful. "The police?"

"Yes." She showed Mrs. Docherty her warrant card.

"I didn't hear the all-clear."

Morag made herself smile. "How's your hearing, Mrs. Docherty?"

"Not what it was ..." Mrs. Docherty reached out a thin hand.

It took some time and care to get Mrs. Docherty out and on her feet.

Together they began to shuffle to the door. Mrs. Docherty wouldn't go anywhere without her handbag.

"That's what we had to do in the war. Stay under the bed."

"I know. You did the right thing."

Mrs. Docherty's hair was a tangle of white, her body a sagging sack, pulled down by gravity; she could barely walk. But, Morag noted absently, she had good, high cheekbones. A beauty, in her day.

She thought of the people she'd walked past in the street, before coming here, in the end, to assist this old lady. Which of those others might have been a better choice to spend her time on? Which a better investment, for the human race? Was there some lost Einstein, someone who might have figured out the truth of this disaster? Or even somebody who might have been able to go on and help someone else in turn?

Someone, in short, she admitted to herself, who was of more use than this old dear ...

But even if that was so, who was she, Morag, to choose? What did *useful* mean? To a husband or daughter or grandchild, this old lady might be the most valuable person in the world.

So she held Mrs. Docherty's arm as they made their slow, difficult way along the corridors.

"... I rather enjoyed the war," Mrs. Docherty was saying. "Old Winnie. Bit of a lad, we always thought. One of us. Of course I was only a girl ..."

They reached the exit, and Morag handed her over to a nurse.

* * *

The traffic lights were either out altogether, or scrambled. The pain in Ted's chest, as he tried to control the car at speeds of no more than a few miles an hour, was blinding.

Jack sat in the front seat beside him, belted in, clutching his box of books and toys. The boy was silent, Ted thought. Too silent. But there was nothing he could do about that for now; the lad was going to see a lot more nasty stuff before they were done with all this.

If, he thought through his pain, they ever were.

Ted called by a camping gear shop, but it was as empty as if it had been looted. Same with an Army surplus store.

He queued at a petrol station. Fifteen minutes; not as bad as he'd feared, and there was still some supply. He got Jack to fill the tank while he limped inside. He tried to pay with a credit card. The tills were working but the operator wouldn't take his card; there was no line to the card operators. No phone lines either; it sounded as if a telephone exchange had gone down.

Christ, he thought. Lose a telephone exchange and suddenly you can't buy petrol. Everything has got too complex. Too interlinked. We're too fragile.

He paid in cash, and through the nose too, the sharks.

The traffic moved a little more easily once they reached the A1 past Duddingston, heading east. But at the roundabout at Bingham they ran into a queue of traffic, all of it heading east. It was like holiday traffic, cars crammed with kids and grandparents and pets and luggage.

The westbound carriageway was kept empty, save for fuel trucks and emergency vehicles which raced into the city. The traffic inched forward, so slowly he wasn't sure if it was really moving, or just compressing.

A couple of cars ahead, he saw a driver, a fat middle-aged man in a suit, get out to look up the road for the obstruction. He slammed his fist into the roof of his car with frustration, and yelled at somebody in the car. His wife, maybe.

The day was getting hotter.

The western horizon, in the rear view mirror, was

turned orange by a smudge of smoke and dust, underlit here and there by the crimson glow of fires.

Ted tried the radio, looking for some guidance from the police. But there was only a stream of lurid on-the-spot reports from the trouble spots in the city, which didn't do either of them a damn bit of good, so he pressed buttons until he found what sounded to his antique ears like a modern pop station, and left the radio there.

It took an hour to move the half-mile or so to the next roundabout. There were police in yellow ponchos, he saw, walking into the traffic stream and directing it; all the exits from the roundabout save one had been blocked off by police cars, their lights flashing.

A tall black policeman—just a kid—reached the car.

"What's going on, officer?"

"When you get to the front of the queue, follow the diversion signs, sir—"

"What diversion?"

"To the college at Brunstane, the Jewel. That's designated as the Evacuation Assembly Point."

"What?"

"You can park your car in the side streets there. You have to register with the Police Casualty Bureau, and transport will be laid on to take you to the Rest Centers."

"Transport laid on?" He slapped the steering wheel. "What do you call this?"

The copper looked strained and tired. He'd clearly been through this spiel a hundred times already, and no doubt had the same reaction from every driver.

Ted said, "Let me talk to your commander."

"The super? I don't think that's necessary, sir. If you'll just—"

From his chest pocket Ted dug out his old warrant card, now—melodramatically—stained by blood. "I can help, son. I won't cause you grief."

The copper hesitated. "Come with me."

Ted beckoned to Jack, and then clambered out of the car.

So they walked through the traffic, Ted leaning on the copper's arm, clutching Jack's hand, all three moving at the stately pace enforced by Ted's weakness. There were coppers everywhere, trying to get irate drivers to cool down and be patient.

. . . You're telling me I've got to leave my car up there? What gash is this? I've got three kids here. How am I going to carry this luggage? Are you going to help me? . . .

. . . Why do I have to go to the Rest Center? I have a sister in Prestonpans. If I can get to her house . . .

. . . You guys don't know what you're doing. Do you? You don't fucking know . . .

The control center had been set up on the roundabout itself, in the back of a police Land Rover which had been bumped onto the grass, leaving untidy scuff marks. The local commander turned out to be a superintendent, a thin, forty-ish man surrounded by a ring of officers, and beyond that by a wider, untidy crowd of irate drivers. There were maps of the area opened over the back of the Rover, Emergency Procedures Manuals spread out on the grass.

The atmosphere was tense: the crackle of lapel radios, officers watching the crowd nervously, eyes sharp.

Ted knew that look well. *Trouble brewing.*

With an effort, Ted's tame copper got him through to the center of things.

Finally the super made eye contact with Ted.

"Billy MacEwen," Ted said.

The super's thin face creased. Ted knew what he was thinking: *I don't need this complication.* "Ted Dundas. I haven't seen you since—"

"Since you were a buck-toothed copper on the beat. You've done well for yourself."

"Is Murphy here trying to get you to the Rest Center? Ted, you should—"

There was blackness around the edge of his vision. Just a little longer.

"Listen to me," Ted rasped. "You're not going to be able to keep this up."

"What?"

"Christ, boy, this isn't 1940."

"The Procedure Manuals—"

"—are out of date. Just look around. This is how people behave now, Billy. They have their cars. They aren't going to get out to be processed by us, and herded onto buses. Get out of the way. Let them leave. Back off, and just keep the roads open. Manage the traffic, Billy, not the people."

"But the registration—"

Ted sighed. "We always assume people are going to panic, and have to be herded and registered. Bullshit. I tell you, if you bottle people up here you'll have a riot on your hands, Billy boy."

As if on cue, there was a tinkle of glass somewhere. Raised voices. The coppers around Ted straightened up further, peering out like meerkats. Some of them bustled off toward the disturbance.

"I mean it," Ted said gently.

Billy MacEwen was thinking hard. Evidently this wasn't the first time he'd had advice like this. "Ted, you know how the command structure works. I'm only a silver commander. Gold says—"

"Gold isn't here," Ted said wearily. The blackness was closer, like a curtain closing. "Just do it while you still have control."

MacEwen didn't respond.

Ted closed his eyes, and let himself lean a little harder against the young copper, Murphy.

"I think it's the Rest Center for you anyway, sir," Murphy said.

Christ, he could barely see. Taste of iron in his mouth. The sunlight seemed remote, and at least the pain was gone.

The vertical, marked out by these pillarlike young coppers, was tilting sideways.

Where was Jack? Still here. Safe.

He didn't fight it. He'd made his point. MacEwen wasn't going to lose face by changing his strategy in front of him. Not a bad time to pass out.

Not Billy's fault anyhow, he thought. They just weren't ready for this. None of them were. How could they have known?

Time to leave the stage for a bit, he thought, and he smiled, and gave himself up to the darkness.

The policewoman gave Henry directions to the police authority headquarters in Fettes Avenue, on the north side of the New Town.

Traffic was snarled everywhere, and Henry had to walk. So he stomped his way north along the Mayfield Road toward the city center.

Close to Arthur's Seat the smell of smoke, the wail of sirens, the clatter of helicopters filled Henry's sensorium, masking the outlines of the familiar world. But away from the zone of the immediate disaster—just a few hundred yards—normality seemed undisturbed. True, the traffic was clogged, but there were people walking, coming to and from work—they were even carrying shopping, for God's sake. In his torn and bloodied clothes, he felt out of place. Ill-mannered. People stared at him.

Only the smoke rising from the east of the city served as a reminder that all was not well, here.

It took him two hours to reach the Lothian and Borders police authority headquarters.

The desk officer stopped him, of course, and Henry resorted to a mix of persuasion, string-pulling, ranting and bluster to penetrate the layers of bureaucracy which, inevitably, surrounded the decision makers here. He even produced his passport. But ultimately it was his physical

state, the filth and blood, that bore testimony that here was a man who had just walked out of the heart of it all, that lent him the authority to bamboozle these low-ranking cops.

Actually it wasn't the first time he had had to bully his way through obstructive organizations: a career at NASA had trained him in that.

Even so, he was kept waiting on a hard-backed plastic chair, cradling a polystyrene cup of what might have been tea, for more than an hour. Then, at last, he was ushered into the big incident room that was, he was told, serving as the command center for the response to the emergency.

The control room was chaos, on first appearance.

Police officers and civilians moved from area to area, desk to desk, shouting and gesturing. Mobile phones and pagers sounded continually. The walls were coated with white boards, on which were listed cryptic notes, contact numbers, lists of areas and actions. There was an immense map of the east of the city, cluttered with color-coded stickers: bright primary colors, red and green and yellow and blue. There were yellow emergency jackets and hard hats, some scorched, hanging on pegs and draped over the chairs. The desks were covered with yellowed Home Office procedure manuals.

On one desk he saw a document marked "Evacuation Plans 2 and 3." It was dated 1938. It was the plan for evacuating the city that had been used during the Second World War.

Holy shit, he thought.

At last he was brought to the Chief Constable.

"Yes. I'm Romano. Who the hell are you?"

The Chief Constable was a woman, fifty-ish, with strong Italian-extract features, hair that was thick and black though streaked with gray. She stood before the big area map, hands empty, an island of stillness amid the bustle of the pot-bellied male cops around her.

"Henry Meacher. I'm from NASA."

Romano laughed. "NASA. That's all we bloody need."

"Yes, you do," Henry said seriously. "Are you the decision maker here?"

"For now."

"Then I need to understand what you're planning."

Romano eyed him. Henry thought he could read the calculation there, the mind of a senior officer accustomed to using her time efficiently. *This guy is different. He might have something. Or he might not. He has thirty seconds before I throw him out.*

Romano said, "We're evacuating the area in the vicinity of the disaster." On the wall map a rough chinagraph-pencil circle, diverting to follow the lines of the streets, enclosed Arthur's Seat and the Moonseed surge area, to a radius of about a mile. "We're setting up assembly points and Rest Centers here and here." Points on the roads leading out of the marked area, and outside. She raised an eyebrow at Henry. "Does that meet with NASA's approval?"

"Hell, no," Henry said. He looked around, at the circle of officers around Romano, watching him. "Don't you guys get it? It's not going to stop here. You need to evacuate on a much bigger scale, or you're facing major losses."

Romano rubbed the bridge of her nose; for an instant she looked immensely tired, but when she straightened up her command was returned. "Do you know what you're asking? Do you know the difficulty and cost of mounting such an evacuation? We have to consider the elderly, the ill; we have to think about the needs of businesses. We have to think about where all those people will go. Sanitation. Shelter. Food."

"I know," Henry said gently. "It's just that I don't think there's a choice." Talking rapidly, he summarized his researches.

"Exponential growth starts slowly. One, two, four. But then it breaks out, eight, sixteen, thirty-two—"

Romano laughed. "So Edinburgh is being destroyed

by a rock-eating bug from the Moon. I've never heard such rubbish in all my puff. If we were to order an evacuation because of that, the public would laugh in our faces."

Henry shrugged. "Then tell them something else. That's your problem. There really isn't a choice."

Romano stared at him for long seconds. Then she turned to one of the civilians near her, a tall, upright, silver-haired man who looked as if he might have once been a soldier. "Archie . . . Dr. Meacher, this is Archie Ferguson, the Emergency Planning Officer."

Henry nodded.

"I don't have the authority to evacuate the city, do I?" Romano asked.

"No," Ferguson said. His accent was soft, almost anglicized. "That's a lot bigger than us. We'd need to establish a REC."

"A what?"

"A regional emergency committee. The old civil defense arrangements would come into play. Regional government, involving the military, police, health, transport, environment. And the utilities—electricity, telecoms, water. Whoever. We'd need the power to requisition and raise funding—"

"Christ," said Romano wearily. "You're talking about the Emergency Powers Act."

"Yes. We'd have to get it through Parliament."

Romano shook her head. "Which Parliament? Westminster, or our talking shop here?"

Ferguson looked unhappy. "It's not clear since devolution. Both, probably. It would take two or three days anyhow."

Henry exploded. "Two or three *days?* What bullshit is this? Why the hell don't you guys call in FEMA—the federal emergency guys—whatever your equivalent is here?"

"We don't have a FEMA," Ferguson said coldly. "We don't work that way. On the scale of the disasters Britain generally faces, it's not necessary, or appropriate. We have

a system of flexible response, where the most appropriate agency—"

"Jesus." Henry took a couple of paces in a tight circle, trying to stay cool. "So nobody's in control."

Ferguson said, "This isn't Hollywood, Dr. Meacher."

"It sure isn't. Call in *our* FEMA."

More laughter, shaking heads, the crazy Yank. Romano said, "Dr. Meacher, I'm not sure if a parachute drop of Hershey's bars is quite what we need right now."

"It's not even clear how we'd handle a major evacuation," Ferguson was saying ruefully. "We were geared up for major disturbances—particularly nuclear strikes—during the Cold War. But that's all gone now. We sold off most of the regional bunkers. The military hospitals have closed. The Army is a lot smaller, a hundred thousand professionals, and most of them are tied up in Ireland or the peacekeeping zones." He looked at Henry, almost apologetically. "We just weren't expecting this."

"No," said Henry, more restrained. Take it easy, Henry. These people are trying to do their jobs, as best they can, and they're listening to you. "Nobody was expecting it."

"And we have to think about litigation," Ferguson was saying unhappily.

"What?"

Ferguson said, "It's happened in America. We have powers to act during an emergency, such as an evacuation. But does that imply a duty of care? We're in a cleft stick. We'll be liable if we don't attempt to evacuate, but also liable if we do and we cause unnecessary suffering."

Henry shook his head. "Believe me. The lawyers are going to be the least of your worries."

Romano said, "Well, I can't make the decision alone. I have to consult. The senior fire officer, who I bet will back an evacuation. The local authorities, who probably won't." She eyed Henry. "You know not everybody agrees with you. The geologists assigned by the Department of Environment, for instance. They're putting out briefings. They

say this is liquefaction. Just an earthquake. Localized. A couple of days it will all be over."

"Bullshit," Henry said.

"Maybe." She eyed him. "But if you want me to act on what you say, I need you to press your case."

I'm winning, Henry thought. *She's going as far as she can.*

He said, "I'll talk to your superiors, whoever. But that's not enough. There's no reason to think this incident is going to confine itself to Edinburgh. Even Scotland. I need to speak to your central government. The U.S. government also . . ."

Romano arched an eyebrow. "Because you're the only person who knows the truth. The man who can save the world."

He closed his eyes. *I wish I had some smart way to say this. And I wish I'd tried to get the word out before the shit hit the fan.* "That's about the size of it."

"And you have to walk into *my* office." She was silent a moment, visibly making her decision. "All right, Dr. Meacher, we'll see what we can do for you."

"Good. Thank you."

"I'll make arrangements to get you to London. I'll talk to RAF Leuchars. Might take a day or two. Do you want to find somewhere to clean up, to rest?" Romano turned to one of her officers. "You'd better get me the Home Office. And I'd better speak to the silver and bronze level commanders again . . ." And now Romano was distracted by a junior officer who had some pressing message, and with a last nod to Henry, she walked off.

Henry closed his eyes, rested for a second. But all he could see was Jane's face.

He was still covered in blood and grime, some of it his own. Maybe he ought to find a paramedic.

Ted and Jack were directed to a Rest Center in Musselburgh.

Musselburgh was a small coastal town a few miles east

of the city center. Ted had only ever been out here for meetings at the race course, and to take the misty sea air, and to walk along the river gardens. *The Honesty Town,* was the local motto. On the lampposts there were flags to attract the tourists' eyes, garish splashes of color, mussels and anchors and lengths of rope.

Now, it seemed, the Honesty Town was going to have to soak up half of eastern Edinburgh. Already there was talk, he overheard, of setting up a tent city on the race course, soldiers laboring to install power lines and dig sewers and lay temporary roads on the turf.

The Rest Center itself turned out to be set up in the Brunton Theater, maybe the biggest and most modern building here, a 1970s sprawl of concrete and glass that seemed out of place in this small, quiet, respectable old town.

Ted and Jack were directed into the foyer of the theater. This was dominated by a huge, unlikely sea horse sculpture, around which people, weary and bewildered, were trying to find a place to rest, somewhere to go. The theater also, it turned out, doubled as the housing department offices. There were signs directing Ted where to go for Payment of Rents, Rates and Accounts, and there was a big notice board for house swaps. Now, the foyer was getting cluttered with blankets and chemical toilets and fold-up cots.

Ted made a discreet choice. He pulled his jacket tighter to hide his bandaged chest, and he hoped there was no blood on his face or hands. He could pass himself off as a "survivor"—at worst a walking wounded who could look after himself for now—and take charge of Jack. It had to be for the best; Christ alone knew what would happen if they got split up in this mess.

They had to queue up, in a long, tangled line at the door, to register. Jack clung to his hand, as he hadn't since he was a small child, wide-eyed but silent; Ted felt proud of him.

He was surprised by the way the people around him endured this wait with stolid patience, even good humor—remarkable when he considered what had happened to them, the untimely ejection from their home, the catastrophe that was overwhelming the city barely six miles away.

There were mobile phones scattered along the lines of people. He heard people trying to contact family members, offices and business contacts, trying to rearrange meetings, talk about being delayed for the next few days. People didn't seem to be grasping what was going on. Was this what the trick cyclists called *denial?*

After more than an hour he reached the front of the queue.

"I'm looking for my daughter. Jane Dundas. Is she here?"

He was speaking to a dumpy woman, no older than thirty, with a WRVS armband. Women's Royal Voluntary Service. She was sitting in what usually served as the theater box office. She had a stack of forms, hand-drawn and evidently hastily photocopied, in front of her on a rickety foldaway desk. "I need to take your details. Is this your son?"

"No, it's my grandson," Ted railed, "and today's already been a very, very bad day, and now you have already kept me and the lad waiting an hour to go through this registration bureaucracy gash. Why can't you just help me?"

The woman looked weak, her face round and soft, and—Ted noticed—she might have been crying earlier. But now she was all cried out, and at Ted's tirade, she just looked weary. "Right now the only way I can help you is by having you fill in this form."

Ted leaned forward, ready to attack once more.

Jack touched his arm. The lad looked up at him, solemn, making him think again.

She's just a volunteer. Not very smart, not very capable, out of her depth. Just trying to do the job she's given, in impossible circumstances.

Besides, she's right. Registering here, letting The System know where he was, was likely the only chance he would have of finding his daughter.

He felt shamed. *I should be helping here. Not making more trouble.*

"I'm sorry," he said, and he bent forward to fill out the form.

The woman nodded, without real reaction. It looked as if she'd had her fill of apologies, too, today.

When the form was done, the woman passed it on to a runner, a school-age girl, who took it over to a bank of pcs for entry at the back of the office. The woman started pointing out features of the theater, like an air hostess. "You're in the Survivor Reception Center. On the first floor there is a Friends and Relatives Reception Center, in the theater bar."

"The bar."

"Yes. You might find your daughter there. We have a rest area for the emergency personnel, a transit area for people to be passed on to other centers . . . We're very busy."

"I'm sorry," said Ted again. *For being such an arse.*

But the woman had already moved on to the next in line, a heavily overweight man with a small, unhealthy-looking dog under his arm.

Ted moved away. "That went well," he said dismally.

Jack squeezed his hand. "You'll get used to it, Granddad."

"Maybe."

"What do we do now?" Jack asked.

"We find a toilet," said Ted firmly.

Even that wasn't so easy. The theater's regular toilets were closed up—no running water, and the drains were blocked. There was a single chemical toilet in a Portaloo on the patio outside the entrance, with another immense but patient queue, which Ted joined; at the door there was a Red Cross official, a burly man.

"How about this," Ted said wearily. "A toilet with a bouncer. Never in all my puff."

The elderly man behind him grunted. "I hear they've got lads digging latrines on the beaches. Just like the bloody war." And he stared with stolid, resigned patience at the yellow wall of the Portaloo.

When they reached the front of the queue, Ted found the toilet flushing but it smelled clogged, and the floor was slick with drying, dribbled urine. There was a small sink with a faucet that supplied a small amount of very hot, very high pressure water. He used it to get the worst of the blood and dirt off himself, and off Jack: Ted's own blood, in fact, sprayed over the clothing of his grand-son.

He felt newly shamed, that he hadn't been able to pro-tect the kid even from this.

On impulse he found a clean T-shirt in their single suit-case and got Jack to put it on. He stuffed his bloodied shirt in a waste disposal slot, despite a pricking of conscience. You don't know how long these clothes will have to last.

The hell with it.

The theater was getting steadily more crowded, with adults, kids, babies, some sullen teenagers. There were just *so* many kids, for now sticking close to their parents, but with plenty of potential for trouble later.

All these people. And all of them would need feeding, and watering, and toilets. Young, old, thin, fat, good, evil, smart, dull. And yet it was the purpose of all human endeavor, as far as he could see, to preserve every last one of them, as if he or she was the last human on the planet.

And they would all, he supposed, want dignity.

Not only that, they had their pets with them: there were a *lot* of dogs, rather fewer cats, a handful of birds in cages and fish in bowls, even a few rabbits and gerbils and hamsters in cages or shoeboxes. The animals were already making a hell of a row, and much as he approved of the principle of keeping family units together—and pets were

part of the family—he could see there was going to be trouble later; animals and humans, generally speaking, did not mix.

All these people. And this was just one refugee station, of perhaps dozens, hundreds being set up, as the city became a leaking balloon, spilling its people across the countryside, the authorities trying desperately to mop up that sad flow in sink holes like this, trying to get some control again.

When what they should really be doing, Ted told himself, was getting the hell out of the way.

There were volunteers from all over, the British Red Cross and the St. John Ambulance Brigade and the Salvation Army and the WRVS and the RAF and the Army, even from the local Rotary Club. They were carrying blankets and sheets and camp mattresses and pillows, packets of food, plastic tubs of water, but they looked a little lost about where to put them.

The RAF types had a job-lot of storm lanterns with them, and at that Ted glanced up at the light fittings. Not a flicker; no sound from any PA. No power, then; that was going to be fun later . . . though he wondered how those pcs were being made to work.

Ted found the family reception point, as the woman on the desk had described it. It was crowded with lost-looking people, some of them injured. But there was no sign that this place had been set up to serve its new purpose. Not so much as a bulletin board with a box of tacks.

He found a ballpoint pen in one pocket, and he scrawled his name and Jack's on a painted wall. *Jane Dundas. We'll find you.*

An anxious-looking young woman begged the pen from him, to add her own message—*Mum's here*—and then another after her.

A queue started forming.

Ted turned to Jack. "Nothing but queues," he said.

"Yes."

"Don't suppose I'll see that pen again."

"No."

"So what do you think, lad? This place is a mess. How do you fancy a little work?"

Jack nodded seriously. "I think they need our help."

"That they do."

Ted led the way downstairs again.

Back toward the entrance there was even more of a crush to register than before. The lengthening, folded-back queues looked less patient than before, and there seemed to be a large number of wounded and their families being carried straight past and into the theater.

Ted put down his case and leaned to talk to Jack. "Now then," he said. "I know I complained at that lady."

"But you were wrong."

"Yes, I was wrong. Logging everybody in is one of the most important things that can happen here."

"Without that, mum can't find us."

"That's right. Are you any use with a computer?"

"What model? What language? I know C++, mark-up—"

"Never mind." He pointed. "You see the wee girl over there." It was the teenage runner he'd noticed before, carrying registration slips to a pc. The table where the pc was set up was piled high with unentered slips.

Jack nodded uncertainly.

"Say I sent you. Say you'll help her with her forms. If she'll let you type in the stuff, fine. If she just wants you to bring her the forms, well, that's fine too."

"All right, Granddad." The lad looked dubious. Probably he was more doubtful about the prospect of approaching a fourteen-year-old girl, Ted reflected, than getting involved in the greatest evacuation exercise in Britain since wartime. At that, Ted envied him.

"But the first thing you can do is bring her a cup of tea. Or a Coke, or whatever. And the lady on the desk there too."

"Where will I get the tea?"

"Do I look as if I know? You'll find it, lad."

"What about you?"

"I'm going to see the manager." He bent, painfully, and looked Jack in the face. "But you listen. I'll be right here, in this theater. You'll be able to find me any time you want me."

"And you can find me too, Granddad."

He nodded. "I'll take you up on that. And your mother will be along soon. But for now, we've got work to do."

Ted ruffled the lad's hair and, taking care not to look back, he turned and limped off to find the manager's office.

The door of the theater manager's office was open; a small, harassed-looking woman was shouting into a phone about how she didn't have the resources to handle this, not to mention a complete lack of training, and if something wasn't done about it soon . . . First bad sign, Ted thought. Should be a line of people at this door, waiting for instructions. This woman isn't running anything but a phone bill.

"Excuse me," he said.

She put her hand over her phone and scowled. "Who are you?"

"Ted Dundas." He flashed his old, now blood-stained warrant card.

"Retired," she said wearily.

"But not deactivated."

"Mr. Dundas—"

"Ted."

"I think I have all the help I can handle right now."

"You do?" Ted turned, as if to go. "That's good. You'll need it. Because I was wondering what percentage of the population of Edinburgh you were thinking of lodging in this establishment. And for how long."

"What?"

"You've got people streaming in. I don't see too many streaming out." He studied her. "You haven't been trained for this, have you?"

Her mouth turned to a thin line. She was near the edge, he realized. She was just the manager of a small provincial theater, a place that was a one-line backup on some local authority contingency plan that had never been expected to come to pass. And now, *this*. And everybody stretched thin, nobody around to help. Except an old arse like me.

Tact, Ted. Never your strong suit.

"Mr. Dundas, I'm in charge here."

"I know you are." He held up his hands. "But I can see you don't have what you need. No training. No emergency box. No call-out list. It's all just been dumped on you."

She hesitated.

"Yes," she said. "Yes, it has."

He nodded. "You don't need to keep everybody here, to begin with. Billet them. Find volunteers here, with their cars, waiting to take people away, to put them up in their homes. It just takes a little organization. Maybe I could help with that."

"But the registration—"

"You can register them going out as easy as coming in. Maybe there will be some who won't have to pass through the center, physically, at all."

"We won't have enough volunteers. Hosts."

"Get some more." He pointed to her mobile phone. "Use that. Find a ham radio operator. Start tapping into the communication networks that already exist. Are there media people here?"

"Media?"

"The telly. They are *going* to be here, and in your face. Use them. Find somebody to be a media spokesman."

"Spokesperson."

"Whatever . . . If a local radio station is still operating—"

The manager frowned, then scribbled a note.

He ought to speak to whatever copper was in charge here, probably a bronze-level commander. The sooner they

could be persuaded to let the mobile and self-reliant pass on and out of here under their own steam, the better.

"What about resources?" Ted asked now.

"We have the social services and the volunteer agencies—"

"You never have enough blankets and warm clothing," he said sharply. "Start an appeal. The local people. The ambulance service, the RAF . . . How about food?"

"Well, we have a canteen in the theater. And I've been on to the school meals adviser for the town."

"Good. What about cutlery? Paper plates? What about special needs? Vegetarians. People with medical requirements. Ethnic diets. Whatever."

She said nothing.

"You know you have some unattached kids here, don't you?" he said. "They may be orphans, I suppose. Even they don't know yet . . ."

She was looking at him, her eyes wide.

He said gently, "I think you ought to get your senior staff in here, don't you?"

17

Sweating in his heat-resistant space suit in the late spring sunshine, laden with cameras and seismometers and thermocouples, Blue Ishiguro climbed the east flank of Arthur's Seat.

Here, the uneven spread of the Moonseed had not yet turned the rock to flour, and the ancient basalt plug persisted. But the grass and heather were dying back, he saw, poisoned by emissions of gas. The ground underfoot was distinctly warm, even through the thick soles of his boots. From small depressions in the ground, gas and steam seeped.

Blue bent to collect samples in glass bottles, which he tucked into pockets in his suit. He steadily described what he saw into a throat mike; his words would be captured by

a miniature tape recorder inside the suit and transmitted to his colleagues, safely removed from the area.

Sweat pooled under his eyes, and he wished he could reach inside the suit. He was sandwiched, he thought, trapped between the hot May sun and this burning ground. *And if I don't get out soon, I will fry like a chunk of fish in a tempura grill.*

Of course, it might already be too late. There was no reason to suppose normal volcanological wisdom would apply here.

But that wisdom was all any of them had to go on.

And besides, the fact that this was a new phenomenon increased its attraction for Blue. The chance to study something new—to collect data from a genuinely new phenomenon, to push out the boundaries of understanding . . .

To atone, he thought. *Because I could not, in the end, do anything to save Kobe.*

Was that his motivation, as Henry Meacher believed? Perhaps. It scarcely mattered; for now the job was the thing, the only objective reality.

Blue moved on, cautiously, taking his samples and readings, toward the heart of the disturbance, the primary Moonseed pool itself.

He felt a tremor, a deep shifting in the ground. *The catfish is stirring,* he thought, *deep in the mud.*

. . . *Wish I was a Spaceman / The Fastest Guy Alive* . . .

Singing, coming from over the crest of the Seat. There were people, still here.

He increased his pace.

Over the summit and there they were: the cultists, the followers of the Scottish lunatic Bran, gathered on the agglomerate. None of them wore protective gear of any kind, not so much as a handkerchief over the nose, and Blue could see how they coughed and wiped their streaming eyes. There seemed to be fewer of them now—evidently the resolve of Bran's followers had been tested to the limit—but still, many remained, perhaps a dozen, all of

them in their ludicrous purple pajamas. They sat in a circle around Bran, oddly asexual, and they sang their absurd sci-fi songs to each other.

And they were *smiling*.

The Seat appeared to be otherwise deserted. Just this single ring of cultists before the unearthly steel-gray glimmer of the Moonseed puddle, the smoking ruin of the Edinburgh suburbs beyond. But a single policeman had stayed with the cultists, standing patiently with his hands behind his back, showing no sign of fear.

Remarkable, thought Blue. He knew the British police had no powers to evacuate people forcibly. This young man must know his own life was forfeit, and yet he stayed to do his duty, giving himself up to defend a foolish law.

Mike Dundas was here, among the cultists. His head was shaven, and he had somehow acquired the cultists' oddly asexual look. Perhaps it was the pajamas.

Blue walked up to the cultists. He waved to the policeman, miming that he would stay here only two minutes.

He reached Mike. He took a deep breath, and pulled off his hood. It was difficult to grasp the dusty material with his heavily gloved hands.

The air was heavy with sulfur, and his eyes stung immediately.

Mike's eyes, he saw, were glowing like jewels.

Blue squatted beside him. "You must come with me."

"I'm staying here. I'm in no danger."

Blue shook his head. "The signs are unmistakable. You understand this. The Moonseed has been eating down into this basaltic plug. Working its way to the old magmatic chamber that powered this volcano in the first place. We're expecting a major event. The deformation has increased, in some places, by two yards *since yesterday*. Kid, when you see a turtle on a fence post, you know it didn't get there by accident."

Mike looked up at him, puzzled. "I understand what's happening."

"Then you are a fool, Mike Dundas."

"No." Mike's expression was peaceful, despite his streaming eyes. "I've made my choice."

And, Blue thought, maybe it was a rational choice after all. Mike would find peace, he supposed, whether his space aliens came to beam him up or not.

"I do not know what has driven you here," he said gently. "I do not know what you're trying to escape."

"No," said Mike. "You don't. Anyhow, there is no escape. For any of us. But we don't need it. We have to put aside our fear, and accept." He smiled. "Isn't it beautiful?"

Blue looked at the landscape, the scar of metal-gray Moonseed that was pushing aside the green blanket of Scotland.

"No," he said. "I do not think it is beautiful at all. I will remember you to your family."

"Just tell them I love them. And I'm sorry."

Sorry? For what?

Blue said, "I will tell them."

The ground shuddered again, a stirring beast.

Blue pulled on his hood, and walked back the way he had come.

Morag Decker walked steadily along George Street, knocking on doors.

This was the heart of Edinburgh New Town, lined with banks and shops and churches. Today, the day after the first Moonseed surge, twelve hours after the evacuation was ordered, the street was empty save for a couple of abandoned cars, an old newspaper blowing down the center of the road. The emptiness was eerie in the middle of the day, the sun bright overhead, the light splashing from the buildings.

The smoke clouds were still rising from Abbeyhill.

There was no reply to her knocking. The evacuation of the city was all but complete, as far as anybody could tell; this was the final sweep.

The evacuation, though fast, had been a mess. She'd been surprised how difficult it had turned out to be to get people to *move*.

There had been broadcast warnings in the media—national and local TV and radio, even the Internet—with details of evacuation procedures, assembly points, Rest Centers. But the messages had been confusing, and mixed up with a lot of lurid misreporting. People were fragmented; there was no one channel that everybody listened to, no one time when everyone tuned in. And besides, nobody sensible believed what they heard on the radio anyhow.

So the police had resorted to more old-fashioned methods. There was a mail-shot campaign, aimed at house-holds and businesses affected, thousands of them. That had worked, even if it hadn't made people move immediately; Morag had seen many people clutching the flyers, carrying the information with them.

And at last, in the small hours, there had come the blunt approach: police cars with loudhailers patrolling the streets, one-way road blocks, coppers going from door to door telling you to get packed up and get out *now*. It had been that, it seemed, the sight of police on the doorstep giv-ing direct commands, that finally forced compliance.

That, and the sight of the fires on the eastern horizon, the mess around Arthur's Seat that was visible from most of the city: this is *real,* and it's coming *this way.*

Morag's briefing, from the local authority emergency plan-ners, had been rudimentary, but effective.

For instance, how to tackle looting. Looting was rare—bad guys flee too if the danger is real—but the fear of looting, whipped up by inaccurate reporting, was some-thing you had to deal with. People wouldn't have their houses marked as empty, for instance, for fear of making them targets. So you had to reassure. It was one reason she was still here now, a bobby on the beat in the empty heart

of Edinburgh: to reassure the thousands who had gone.

The most heart-rending moments had been dealing with people who couldn't move themselves. The elderly. The disabled. A team of interpreters had combed the Asian communities, to make sure the message got home there. Once Morag had found a house occupied by a deaf couple; she'd had to call out a sign language interpreter.

There were a *lot* of people on the margins. She'd never realized how many. Like the people dumped out of homes and hospitals under the Care in the Community program. It had reduced the nation's welfare bill, and no doubt done some kind of good in many cases. But, by God, it had added to the strain in this situation.

The gold police commander, the Chief Constable, had estimated that fifteen percent of the population had needed direct attention and assistance of some kind. Fifteen percent.

Anyhow, now it was done; as far as she could tell, George Street was empty of human life—empty, at any rate, of anybody who wanted to move.

She studied the eighteenth-century buildings that studded the street. There were two great churches, St. George's and St. Andrew's, the latter with its spire rising out of a Pantheon-like neoclassical building. The monumental banks and insurance houses were a blizzard of porticos, pediments and pilasters. But this was no museum, but the heart of a working city; many of the buildings had modern frontages of glass and plastic grafted on to them, sometimes with a brutal lack of grace.

She reached the intersection of George Street with Frederick Street. She stood at the feet of the statue of Thomas Chalmers, founder of the Scottish Free Church, and looked north. Monuments everywhere to the great men of the past, who had looked for immortality in stone and bronze.

Beyond a line of trees she saw blue sky, a hint of the waters of the Forth. The fresh light, still untainted in that direction by the smoke from Arthur's Seat, drenched the prospect in loveliness.

It was so beautiful, the world was so beautiful, and she had seen so little of it.

Maybe she should go find her family, her mother and father. They had headed west out of the city; she knew where they should have got to by now.

But she still had her duty.

She turned away from the sunlit trees. She walked south, and turned into Princes Street, and continued to knock on doors.

A helicopter flapped over her head; she stared up to see its rotors glittering in the sun.

The Chinook set down in the center of Princes Street Gardens. It was a crude chunk of military hardware in the middle of this Georgian garden, its runners crushing ornate flower beds, the noise of its rotors clattering rudely from the elegant buildings.

Henry, clutching his petrological microscope, lumbered up to the chopper, looking for somewhere to sit.

The interior of the Army Air Corps Chinook was spartan, just a bare hull with plastic coating over the frame. There were no seats. There were soldiers here in field kit, a patrol on their way to some assignment of their own. The men were hot, sweating, sitting in the roar of the engines on a non-slip flooring littered with dirt. Their packs were strapped down to the floor, with cyalumes—lamps— around them. The men were rooting through the crew's kit they found there, pinching chocolate bars and Coke with a practiced thoroughness.

And I complained about British Airways, Henry thought. Well, there wasn't a lot of choice. Maybe if he padded his jacket under his ass—

A loadmaster tapped him on the shoulder. "Not here, sir. You can ride upfront, in the cockpit."

"Is that any more comfortable?"

The loadie shrugged. "The company's better."

So, with an effort, Henry climbed into the cockpit, and took a jump seat behind the pilot and copilot. The pilot was on the left—no, he was the guy on the *right*, damn it, these Brits took the wrong side of the highway even in the air. He nodded to Henry, a crisp "Sir." The pilot seemed young, an NCO; Henry would have said he was working class if that hadn't become, he'd learned, an outdated analysis of British society.

The cockpit was a cave of switches and dials and screens; the pilot and copilot were working through their take-off routine.

"Pedals in neutral."

"Pedals."

"Cyclic centered, collective lever down."

"Got it."

"Clear left and right."

"Go for it."

"Rotor brake off. Wind up rotors."

"I got it . . ."

The noise of the rotors rose.

The Chinook lifted with a surge that made Henry's stomach sink a little deeper inside his frame.

Thanks for the warning, fellas.

Edinburgh turned into a glowing map spread out beneath him, a folded blanket of green cut through by the blue of the Forth, the gray-black of the buildings, the lumpy outcrops of volcanic rock. The road network, clean and well maintained, was a black thread like a kid's toy track, its markings clear and bright. Today the roads were empty, save for a few scattered and stationary vehicles.

In the middle of the rectangular, oddly American grid that was the New Town, someone was standing, alone, looking up at him, face a bright white dot.

"One hundred feet . . . eighty feet . . ." the copilot said.

"Roger, eighty feet. Ninety knots." The pilot turned, his eyes insectile behind big tinted goggles. "So you're from NASA, sir?"

"Yup."

"Always glad to give you Yanks a flying lesson. Staying at eighty feet, ninety knots."

The Chinook dipped sharply to the right. Henry looked for a sick bag; there was nothing that qualified.

"This is a little slow for you, I suppose, sir."

"I'm a scientist, not an astronaut."

Now the Chinook was flying low over Arthur's Seat.

The plug looked extraordinarily ugly from the air, a crude knot of basalt protruding from the ground, old and stubborn, somehow magnificent. Its several ancient vents were easy to make out, the basalt outline clear beneath a thin coating of heather. The Seat had, thought Henry, already seen off three hundred million years of weather, the titanic scraping of the ice, the pinprick depredations of man. But it wasn't going to be able to see off the Moonseed. And there, indeed, close to the summit, was the central pool, obscured a little by the smoke from the ruin of Abbeyhill, shining like a coin in the ashen light.

And elsewhere, there were signs of magmatic activity: the blur of steam and smoke, perhaps a fissure near the crest of the Seat. He wished he had a cospec up here. A camera, even.

Incredibly, there were people on the Seat: still, even now, with the whole damn city evacuated, right at the heart of the thing.

Then, as the Chinook completed its second orbit of the Seat, Henry thought he spotted landsliding, on the south face, away from the ragged patches of Moonseed.

It was beginning.

He tapped the pilot on the shoulder. "Could you circle a few times? I'd like to take a closer look."

"Surely, sir. Break my right now. That's nice . . ."

The Chinook dipped to the right and hurled itself into a dive.

The copilot intoned, "Seventy feet, ninety knots. Sixty feet, one hundred knots."

Arthur's Seat approached, like an obstacle in a Disneyland ride, and the Chinook soared, following the ground's blunt contours.

The pilot whooped. "Raw sex!"

It came more abruptly than Mike Dundas had expected.

There was an earthquake, a single jarring shift sideways, that sent them all sprawling, even Bran.

Mike sat up. His arm was bruised, but nothing was broken.

The ground shuddered. Aftershocks.

But Bran was sitting up. He looked around the group, locking each of them in turn in eye contact. "Not long now," he said, his voice thin and clear. "The EVA is almost terminated. All that remains is for the controllers to choreograph our reentry. We must accept, and be prepared."

Be prepared. Accept. Yes.

A tall, older man broke out of the group with a kind of sob. "Christ, I don't want to die. Not for a fucking junkie like you." He ran, stumbling.

Bran just watched him, his calm undisturbed.

The ground cracked. There was a sound like thunder emanating deep from within the earth. Another jolt.

A fissure opened up, stretching back toward the peak of the Seat; it was just a few inches wide, and the earth around crumbled into it. From a hole at one end of the fissure, smoke, steam and bursts of red hot cinders broke into the air.

The policeman stepped forward. His blue trousers and yellow jacket were stained green where he'd been thrown into the grass. "Who else? It isn't too late yet. I'll do all I can to get you down from here in safety."

There was a stir among the cultists, and a stir in Mike's heart. *Not too late.* Could that be true?

People were getting up around him, brushing off scuffed and torn suits. Sheepishly joining the copper.

But it is too late, Mike thought. It had been too late for

them all, for the whole city maybe, from the moment he had brought those Moon dust grains to this place.

He had let Henry down, betrayed a trust. He had killed the city, even his family, and he deserved to suffer.

. . . Or maybe, as Bran expressed it, all he had done was to open the door, the hatch to the Airlock that was waiting for them all. And in that case, he deserved the peace and joy and endless light that would follow.

So he ignored the people losing their faith, scurrying down the rock after that copper like frightened rabbits. Perhaps there was nobody left but himself and Bran, but that was okay too. There would be room for them all later. Room for a planetful of lost souls.

He looked for Bran. But Bran had gone.

That was puzzling. But even that didn't seem to matter.

"One hundred feet . . . eighty feet . . . eighty feet."

"Roger that, eighty feet."

"Power lines a quarter mile."

"Roger, power lines. Pulling up."

The surge upward caught Henry by surprise. His attention had been fixed on the evolution of the Seat; suddenly he was pushed down in his jump seat, his consciousness forced back into his fragile body, hurled around inside this clattering contraption.

"One twenty . . . one fifty . . . one eighty . . . five hundred feet now."

"Five hundred feet. I have the lines visual. Over we go."

Henry saw the power lines pass seemingly feet below the Chinook.

"Okay, going lower—"

The Chinook orbited over the south face of the Seat once more.

In the last few seconds, the landsliding had become intense. As Henry looked down, it was as if everything south of a line drawn east-west from the Salisbury Crags to the

Dunsapie Loch was beginning to move. The nature of the movement was eerie—like nothing he had seen before—not truly a landslide, for there was no lateral movement; rather, the whole mass was rippling and churning up, basalt shattered and turned to a crude fluid by the immense forces stirring within.

And now, at last, the whole south side of the Seat began to slide southward along a deep-seated plane. Already outlying billows of dust and ash were reaching Duddingston Loch and Prestonfield, the suburb to the south of the Seat, mercifully evacuated—

That was when the explosion came.

Red-hot stones were hurled yards into the air. They came down hissing on the grass. Ash was hosing out, black outside, red-lit within; a cinder cone was already building up around the aperture.

The ground shuddered. There were more deep-throated cracks and explosions: Mike was hearing the voice of the ground coming apart, new fissures and vents opening up.

Mike repeated one of Bran's favorite mantras. "Christmas Eve, 1968. *In the beginning, God created the Heaven and the Earth . . .*"

He heard people join in. *"And the Earth was without form and void, and darkness was upon the face of the deep."* He was not alone, then. *"And the spirit of God moved upon the face of the waters—"*

The ground shuddered, and he was thrown flat again, his face pressed into the grass. The first stones had become a fount of boulders, incandescent bombs hurled so far into the air they passed out of his sight, into the ash cloud that was gathering above him.

Lightning sparked in the cloud. The sunlight was blocked out. He was enveloped in heat.

Mike was sure there was nothing like this in the literature, this sudden and spectacular opening up. But then,

there was nothing in fifty thousand years of human history, nothing in five billion years of Earth, like the Moonseed.

The noise had merged into a roar now, continuous, the shuddering unending. But still he could hear his own voice.

"And God said, 'Let there be light.' And there was light."

The ground split again, gas and steam rushing all around him. He heard a scream, unearthly; he was scorched by the heat, but still, it seemed, uninjured. He could scarcely breathe, the air was so hot and thick with the ash.

The ground subsided under him.

In the darkness, he seemed to be falling. Perhaps he would fall all the way to the center of the Earth, hollowed out by Moonseed.

But now the ground returned, slamming up under him, and he fell on his back, the soil and grass and rock and heather and moss rubbing against his flesh.

He was rising into the roiling ash cloud. It rose up above him, lightning sparking. Remarkably, he still felt no pain, no real discomfort.

There could be only seconds left, though.

Far above, a glint of metal against a square inch of blue sky. A helicopter?

He tried to shout, but he had no voice.

And God saw the light . . . That it was good . . .

But now the ash descended on him—oh, Jesus, it was hot, it was burning—and there was no more light.

The cloud of dust and steam billowed upward, thrusting like a fist toward the Chinook.

"Get us out of here," Henry said. *"Now."*

The pilot didn't need telling twice. He opened up his throttle and the Chinook dipped, its big rotors biting into the turbulent air.

Henry looked back. The cloud, a black wall, hundreds of feet high, seemed to be catching them up.

The Chinook lurched; the pilots fought for control.

There was an explosion nearby: a crackle of acoustic shock waves, a blast of light, as if someone was shooting at the chopper.

"What—"

"Hold on!"

The Chinook rocked violently.

"Break left! Break right!"

The Chinook banked; Henry grabbed the frame, but even so he was thrown from side to side.

Thick and viscous magma, he thought. Undisturbed for three hundred million years. Heavy with dissolved gases. Suddenly the Moonseed takes the lid off. The magma tears itself into hot fragments, that jet upward or tear out of the new/old vent. Hurling volcanic bombs into the air, even high enough to threaten this Chinook.

Understanding it, he found, was no reassurance right now.

The rocking began to reduce.

"Take it easy," the pilot said.

The Chinook leveled out.

Henry looked back again. The cloud was still expanding faster than they could run, probably three hundred miles an hour or better, close enough now to turn the day dark.

There was a patter of ash particles on the windscreen.

"North," he said. "Go north."

The pilots hurled the Chinook into a sickening wrench to the left.

Henry looked back. The cloud was still expanding, but mostly southward; the north was shielded a little by the topography of the Seat, what was left of it.

The cloud was separating into distinct mushroom-shaped clouds, thick and black, heavy and pregnant with ash. There were lighter cirrus clouds arrayed above. He could see the ashfall beginning already, a black rain; it would turn what was left of Edinburgh into a new Pompeii, he thought.

The Salisbury Crags, at the western face of the Seat, had given way. He could see what looked like a pyroclastic flow, a heavier-than-air mix of gases and hot volcanic fragments. From here it looked like a smoke ring spreading down the battered western flank of the Seat. The flow would follow the contours of the ground, and pool in the lower areas: the heart of Edinburgh, the old loch that had been drained to build the New Town.

Already the Seat itself, what was left of it, was scraped bare of life. And, through the clouds, he couldn't see any sign of the Moonseed pools.

Lightning bolts shot through the clouds, extending to tens of thousands of feet.

For Morag, it started with a low rumble, like a train deep underground. But there were no trains running today.

Then a series of buffeting jolts. Jolts that grew stronger.

She stood in the middle of Princes Street, in the roadway away from the buildings.

Then she was down, her face slammed against the tarmac. It was as if a rug had been pulled away from beneath her feet.

She tried to get to her knees. There was blood on the tarmac, a deep sting down the right side of her face, where the skin had been scraped away.

The noise was suddenly enormous, the crashing and roaring of the buildings overlaid on the deeper rumble of the ground. There was a muddled stink, of gas, steam, ozone, soot.

The street, still shaking, was turning into a battlefield. The facings of the buildings were coming away and crashing to the pavements, sheets of stone and bright plastic and metal and glass, smashing and splintering as they fell, as if the street was imploding. Billboards and neon light tubes turned themselves into deadly missiles, showering shrapnel over the pavements below. Some of the older buildings

seemed to be collapsing already, the breaking of their beams like gunshot cracks.

To the east, toward Arthur's Seat, she could see red flames rolling and leaping, a growing pillar of black smoke. Sometimes the flames seemed to pause, to weaken, but then they would find new vigor and hurl themselves even higher than before. There was a constant muffled roar. It was like watching some immense oil refinery burning up.

She sat down in the middle of the road, keeping her hands away from the glass fragments skidding there. The road surface was cracking open—to her left, a great section of it was tilting up—but she seemed to be in a stable place, here, and far enough from the cracking facades of the buildings to survive that, with a little luck.

Hell, she thought. She might actually live through this. If she found somewhere to report in she would have a tale to tell . . .

But now there was a new explosion. A sound like a thousand cannon.

A wall of flame—taller than any of the buildings, laced with black smoke and steam—poured into the eastern end of Princes Street. It was almost beautiful, like a moving sculpture of smoke and fire and light. At the cloud's touch buildings exploded like firecrackers, a blizzard of stone and metal and glass.

Oh, shit.

Time turned to glue; she seemed to be able to make out every detail.

The flame hit the big old buildings at the end of the street. She saw the Register House's portico and clock towers burst outward, before fire erupted from within, white and hot, overwhelming the Wellington statue, the old Iron Duke on his horse, in the instant before the cloud enveloped them.

Now a fountain of flame and smoke erupted from the entrances to the Waverley Market, the underground mall built around the Station, and the panels of its roof flut-

tered into the air like so many leaves. A brilliant light enveloped the Scott Monument, two hundred feet of carved Gothic foolishness, magnificent in the flames' underlighting for one last instant, before it too erupted into shards of stone.

A wind buffeted her, blistering hot.

The cloud poured along the street, more like a fluid than a gas. It must be full of ash, heavier than the air. Lightning cracked within it. It was carrying rocks, irregular, glowing boulders and sharp-edged fragments that probably came from buildings. Carrying all that stuff, she thought, was actually going to make it more efficient at scouring the city as it progressed.

This thing was going to scrape Edinburgh down to the bedrock, she thought, and then the Moonseed was going to eat *that.* But maybe it would be beautiful, in its way.

So much for reporting in.

She stood tall, facing the heat. She had time for an instant of regret before the cloud reared before her, and—

Soon, it seemed to Henry, the ash had reached a huge altitude, maybe fifty thousand feet. Ash, laden with Moonseed dust.

It obscured the view of Edinburgh, and maybe that was a mercy; he glimpsed the fiery hell of Arthur's Seat, the husks of burning buildings all around.

The pilot said, "We couldn't have outrun it, could we, sir?"

"I don't think so. No."

"We'll have to go back to Leuchars. I don't trust this bird after inhaling all that shit from the air."

"That's fine."

"We'll find another transport to get you to London."

Henry looked back at the high ash. It would inject itself all the way up to the tropopause, ten miles above the Earth, where the decreasing temperature of the thinning

air was inverted, making the tropopause into an invisible lid on the lower atmosphere. But such was the violence of the eruption, the ash from the Seat would surely break through the tropopause into the stratosphere beyond. There was no rain up there, nothing to wash the debris back down again.

The ash from the Seat would form a thin veil that would spread all the way around the planet, the heavier fragments slowly drifting back down to Earth. He thought he could see, as it reached toward the stratosphere, the steel glitter of Moonseed dust amid the ash.

The genie was out of its bottle now.

"Welcome to Mars, fellas," he said.

EARTH

18

Monica Beus was exhausted by the time Scott Coplon, her USGS guide, had led her to Kanab Point, here on the north side of the Grand Canyon. And that after a (reasonably) gentle one-mile hike from the off-road vehicle that had brought them almost all the way from the North Rim entrance station.

It was close to sunset—probably one of the best times of day to view the Canyon—and the light, coming in flat and low from a cloudless sky, filled the Canyon with dusty blue shadow. The layers in the rock shone yellow, orange, pink and red, the colors of fire.

Scott was a kid of thirty or so, his face hidden by a bushy black beard and thick Buddy Holly glasses. He was dressed, as she was, in a bright red survival suit and woolly hat. He asked now, "Are you okay?"

Now that, she thought, was a spectacularly dumb question, and she sat on a ledge of ancient, eroded sandstone and considered it. Not only was she being eaten up from the inside, not only had she become, without noticing it, a decaying old lady, but, according to the best of her information, some kind of dreadful global catastrophe was coming down. So: no, she was not okay, and never would be again.

Even if the quacks did say the bone disease she had contracted was a really "good" form of secondary cancer; even if the quacks still, absurdly, gave her a fifty-fifty chance of survival, despite the startling acceleration of her anatomy's failure.

But it didn't make a piece of difference as to what she had to do, to be the eyes and ears and scientific brain of the President of the United States, just a little longer.

Anyhow she let the kid off the hook. "I'm fine. Just let me catch my breath."

He took a couple of steps closer to the rim. "You can smell it, even up here."

"What?"

"The sulfur. And the ash. If you're asthmatic—"

"I'm not asthmatic. Help me up." She lifted her arm. "Give me a minute."

"For what?"

She smiled. "To sight-see. I've never been out here before, to my shame." *And I sure as hell never will again.*

He grinned and backed off. "Sure. I understand. This is why I got into this game, you know."

"The scenery."

"Uh huh. I get *paid* to be up here. Take all the time you want."

She stepped forward, alone, her feet crunching on basalt fragments.

Jesus Christ, this was the *Grand Canyon.*

From here, on the northern rim, she could see the sweep of the land. She was in the middle of the Colorado Plateau, thousands of feet of rock laid down by the shallow seas and deltas that had once covered much of North America. On the horizon, to the south, she could see the smoothly swelling surface of the Plateau, flat and undulating, reminiscent of the sea which had given it birth. It was speckled with green, what looked like blades of grass spilling over the plateau walls. But each of those blades was a tree, a juniper or a canyon pine, each of them twenty or thirty feet tall.

That was the Plateau, magnificent in itself. But the Colorado River had just cut through the whole thing, as clean as a knife gouge, dynamic and unstable. And the complex channels and incisions had exposed, in the out-

crops and walls, the layers of sedimentary rocks laid down in that vanished ocean. Looking around the fragmented landscape, her gaze could complete the lines of distinct layers, invisibly spanning the Canyon's channels. And she could see where the eroding river waters had met stiffer resistance, from the older, deeper rocks; scree piles flared against the base of surviving plugs.

It was inhumanly vast. And yet she could *see* that this was a canyon, a channel cut into the softly swelling Earth. If this had been the Valles Marineris on Mars—compared to which the Canyon would have been just a tributary—it would have been so huge as to make its nature incomprehensible, and it wouldn't have been nearly so striking. It was as if it had been placed here, this great wound in the land, with exactly the right dimensions to force a response from the human soul.

As the sun set, the colors in the Canyon walls turned to gold.

The sky up to the zenith was already stained pink. The sun was scattering light from haze layers fifteen or twenty miles above sea level. LIDAR measurements, pulsed laser beams scattered from the haze layers, had confirmed that the Edinburgh event had spread dust and aerosol particles throughout the stratosphere, all across the middle latitudes of Earth.

The ozone layer was taking a beating from the chlorine injected up there. The meteorologists and climatologists and oceanographers were having fun predicting the impact on the atmosphere's heat balance. A global cooling of maybe a half a degree. Acid rain, from all the sulfuric acid being created up there. Disruption to El Niño, in the equatorial Pacific, over the coming summer and fall.

Droughts in Australia. Heavy rain and waves on the coast of California. And so on.

And this, she thought, is evidently just the start.

The first star was already out, low in the east. Maybe it was Jupiter.

She knew if she dragged herself out of bed in the morning, she would see Venus, still bright enough to dazzle and cast shadows, surrounded by a halo from all the shit in the upper atmosphere.

Beautiful. Deadly.

Scott was pointing out some of the Canyon features to her. ". . . The peak over there is Mount Sinyala." A crude cylindrical plug, with a flared skirt of smashed rock. "The channel that lies between Sinyala and these pinnacles in the foreground is the Colorado itself. The plateau you can see at the foot of Sinyala is called the Esplanade." A cracked and shattered sheet. "It's an erosional feature resting on one of the more resistant members of what we call the Supai Group of rocks. You can clearly see the contact between the Coconino Sandstone—that's the lighter colored stuff on top—and the Hermit Shale, the deeper red below."

"Yes."

"This is the western end of the Canyon. We're a goodly way away from where the tourists come to roost, at the resort areas on the South Rim some way to the east of here. The landscape here is different. Older." He pointed. "You can see cinder cones over here. Lava cascades." He looked at her. "You know, you can tell the nature of the rocks, just by looking, just from the way they have eroded. The shales form slopes. The thick beds of limestone and sandstone form steep, almost vertical cliffs. And the Inner Gorge, at the very base of the Canyon, is a V-shaped groove that reaches down maybe a thousand feet to the river itself. Those are ancient rocks, igneous and metamorphic . . ."

She could see, now he described it, how the Canyon was a complex structure, channel cut within channel, Canyon within Canyon, each inner valley chiseled into harder, older rocks, all of it centered on the Inner Gorge, the narrowest valley cut into the oldest rock of all.

"Enough of the tourist stuff." Now it was Monica's turn to point. "Tell me about *that*."

It was a plume of black smoke, rising from one of the incised channels.

Scott grinned. "You can see for yourself. One of those old cinder cones has just cracked open and started belching ash. We think a more significant event is on the way. We've recorded more seismic activity in the Canyon area in the last few weeks than in the previous couple of years. It's actually very exciting; there are a couple of dozen guys from the Survey working the area right now . . ."

She let him run on. Right now the Administration was keen to keep enthusing scientists off the screens, but if this kid's excitement was what motivated him to be up here and keep working and studying and gathering data, that was fine by her. The fact that what he was studying was liable to kill him, ultimately, was neither here nor there.

For it was clear that the sudden, unexpected rash of minor volcanism in the Canyon, like that in a dozen other sites around the world, was directly related to the particle cloud that had spread around the planet from Edinburgh: what Henry Meacher called the Moonseed, the alien infection that—for weeks, it seemed—had been raining down out of the stratosphere and was eating into the very rock beneath her feet.

The precedent of Edinburgh for what would follow was not encouraging. And what she needed to find out was what would happen when the Moonseed got into those deep old rocks.

On the way here, she'd had another E-mail, from Alfred Synge.

> Here's what we think is happening in Venus. And I'm sure you can express it, not to mention understand it, far better than I can.
> Take one of your rolled-up ten-dimensional string objects. Pinch it, like compressing a garden hose. As you approach zero width, you generate quantum-mechanical waves, membranes wrapped around the

scrunched dimensions. The waves are extremal black holes . . .

Actually Monica didn't agree with the nomenclature here. These "black holes" were nothing like the collapsed stars of astrophysics. They were just solitons, clumps of string fields; the physicists preferred to call them black bubbles or black sheets.

But arguments about nomenclature weren't the most important thing right now, she reflected.

> The black holes are massless, so they flee at the speed of light. But, like massless photons, they aren't without momentum. So they exert a push.
> Monica, we think that inside Venus there's an organization of mass and energy that is working as a generator of extremal black holes. Maybe that's what the transformation of the planet is "for," if you can think of such events as having anything like a single purpose. There is a fountain of black holes streaming from where Venus's north pole used to be. And it is pushing what's left of the planet out of its orbit, away from the plane of the ecliptic. It's like a rocket, Monica, a black hole rocket . . .

It was fanciful, abstract. The whole Venus event had become a kind of theoretical toy to be kicked around by the young and/or over-enthusiastic, including Alfred, and the hypotheses just got wilder. It was impossible to connect to the grubby reality of a cracked cinder cone, here in this great chasm.

And yet, it seemed, connected they were.

Alfred's mail ended in rambling, a rant about NASA's post-Edinburgh decision to destroy its remaining forty-billion-dollar Moonrock stock. *The genie is out of the bottle! The horse has bolted! This is vandalism.*

No, she thought. You don't understand. It's a symbol. Appeasing the gods.

"Tell me about the Inner Gorge rocks," she said to Scott Coplon.

"Yeah. They're primarily schists and gneisses. The rocks were formed from pre-existing igneous and sedimentary rocks during mountain-building events in the deep past. A gneiss is what we call granitic rocks which have been exposed to later episodes of metamorphism, and—"

"I know. Go on."

"Sorry. Well, we know that what's exposed here is just the top of a much deeper layer. The rocks extend thousands of feet down from the surface and form the basement of the North American continent."

"The basement?"

He nodded. "Rocks of that age and character underlie most of the continent. But it's only where they have been exposed, like here, that we can study them . . ."

Monica knew a little about plate tectonics. She knew that the continents rode like rafts of granite, on the plates that slid on currents in the viscous molten rock that lay beneath. The younger rocks of the ocean floors, gabbro and basalt, were in time subducted—dragged back into the interior of the Earth, to be melted and reborn. But the ancient rocks of the continents, riding above, survived.

And now it looked as if, here and elsewhere, the Moonseed might reach those foundation rocks, the granite core of the continent itself, through this immense wound of rock and strata.

This is not good, she thought. Not good at all.

Well, then, we must do something about it. But what the hell she had no idea.

Scott took her arm, and led her back toward the car.

Scott started talking to her about the river ride she was

going to have to take if she wanted to get any closer to those old Precambrian rocks. It meant a descent of five or six thousand feet, a rise in temperature of maybe twenty degrees. She calculated whether she would have the strength to undergo such a trip. And at the same time, she started to figure what she should tell the President, and how.

A black hole rocket engine, firing wildly in the ruins of Venus. Now, what was the meaning of that?

Strangeness. Too much of it, for one lifetime.

The sunset crept on them. The colors deepened to rust, mile-long shadows flooding at perceptible speed across the land, and they walked back to the car.

19

Henry was flown, mostly at low altitude under the ash clouds, the length of Britain.

Once, most of Britain was covered by a shallow ocean, which deposited gigantic chalk layers over the whole country. But then Britain tipped up. And the ice came, scraping most of the chalk off the top half of the island.

Now, as he traveled south from Scotland, he traversed younger and younger landscapes: billion-year-old gabbros and granites and basalts in Scotland, belts of successively younger sedimentaries as he came down through England, until he reached the youngest of all, the marine Pleistocene clays and sands around London, less than sixty million years old.

He could see the old buildings—churches, houses, pubs, even railway stations—which stood like geological markers, constructed of their area's native rock. Britain was a small island, crammed with ten thousand years of history, a billion years of geology.

The sheer size of London surprised Henry. He'd come to think of everything in Britain as being miniature scale.

Even a place like Edinburgh was—*had been*—pretty small by the standards of many American cities.

London, though, was different. He flew over mile after mile of gray suburbs, knots and twists of terraced houses and semis, spread like blankets over the gentle topography of the chalk landscape. His RAF pilot pointed out some of the logic, if you could call it that, that underlay the sprawl of outer London. It was really a collection of old villages— like Brentford and Harrow and Ealing and Richmond— that had been overwhelmed by the flood of building that had come after the war, but their identities were preserved in their names and the topology of the roads, which curled around the old village centers.

The Thames coursed through the heart of the sprawl, a silver-blue thread, and as they flew over central London it was easy to use the river as a guide to pick out tourist highlights: the big ugly glass developments at Canary Wharf, where the old docks used to be, and ships from Britain's global empire had once called; the tiny, jewel-like sandstone perfection of the Palace of Westminster, the seat of Parliament; the surprisingly elegant bridges that laced across the water; the spectacular cowl shapes of the Thames flood barrier.

Traffic crowded the streets and highways, the metallic carapaces of cars and buses and lorries glimmering like so many beetles in the sun. Life was, obviously, going on here. It was as if the bad shit that had come down in Edinburgh, a bare four hundred miles away, had never happened.

They landed at a floating heliport on the bank of the Thames, near a bridge the pilot said was called Blackfriars.

Incredibly, he was taken to a hotel for the night; even more incredibly, he was going to have to wait until the next day—in fact, for twenty-four hours—before meeting members of the Government.

So he arrived in an anonymous BMW in Soho, an area of tight, crowded roads, the cars cruising inches from the elbows of cappuccino-sipping customers of pavement

cafes. Most of the population here looked young, sleek, dressed well if sometimes bizarrely; Venus protection had been subsumed into fashion, and the girls in their ponchos looked like butterflies.

The car pulled into Frith Street, just off Soho Square. Henry got out with the holdall full of spare clothes and bathroom stuff that he'd requested on the way down from Edinburgh. His hotel was a neat little converted eighteenth-century house, another corner of Britain that was, no doubt, older than his entire country.

His room turned out to be a box, a typical city center room, no doubt ruinously expensive, but His Majesty's Government could worry about that. His escort, a couple of bullshitting squaddies, were booked in the hotel, down the corridor.

He threw his holdall down on the bed, shucked off his filthy clothes, and climbed straight into the shower, which was a modern fitting with a hot and powerful jet.

Ash-gray shit soaked out of his skin, and made little whirlpools at the plug at his feet. Bits of burned Edinburgh, rock just a day old, the youngest rock on the planet.

Drying off, he turned on the TV. All the regular programs were suspended, save for one channel that was carrying children's TV—he saw five seconds of it, weird little aliens that bounced around and spoke gibberish, Christ, bring back *Sesame Street*—and on all the other stations there was, of course, only one story.

Images of Arthur's Seat, before and after the explosion. *Before:* waving cultists in their purple pajamas, upturned faces like daisies, maybe one of them Michael Dundas's.

And Arthur's Seat *after,* a smoldering crater, still pumping out ash and steam.

And all of the people, as volcanologists say, part of the sunset now.

Here was the New Town after the pyroclastic flow, like an image of Hiroshima after the bombing: stumps of build-

ings, shorn off at little more than knee-level, surrounded by smashed and strewn rubble and covered by a ghostly powder-gray layer of ash, nothing left of the great Georgian design except the rectangular layout of the streets.

There were people already picking through the rubble, some in volcanologists' protective suits, others, heroic, in nothing more than regular emergency gear. The scientists were recording what they could, pyrometers and thermocouples measuring the dwindling heat of the smashed ground. The rescue workers were using microphones and other gear to search, forlornly, for survivors, maybe people who had ridden out the ash storm in cellars. So far, the news guys said, not a one had been found.

Henry could see how the heavy ash cloud, seeking the lowest points to pool like the sluggish liquid it was, had swept like a transient river around the other bony basalt outcrops, Calton Hill and the Castle; in fact most of the structures on those hilltops were still standing. But both plugs were marked, distinctly, by the cancerous gray scars of Moonseed pools. It would only be a matter of time before they went the way of the Seat, and added to the destruction of the area.

And all the time the Moonseed was spreading, chewing up the Earth, disrupted briefly by the destruction it caused, but always returning, stronger and more widespread than ever.

The cameras focused on the human misery, the scenes on the roads and assembly points and Rest Centers, improvised from schools and hospitals and leisure centers, most of them all but overwhelmed. People were crammed into whatever shelter could be found, bereft of their homes and belongings, lucky if they kept their families with them, stripped by the intrusive cameras of the last of their dignity.

It was impossible to believe he was looking at a Western city, Henry thought uneasily.

He needed to talk to Jane.

He used the hotel phone to try the contact number

Chief Constable Romano had given him in Edinburgh, a direct line to the Police Casualty Bureau. It took a while to get through even so, and when he did there was no record, on the improvised database the young man on the other end was consulting, of Jane or her family.

But then, looking at the televised chaos of the evacuation, he wondered what percentage of the refugees had finished up on any kind of official record anyhow.

The Brits just weren't ready for this.

Why should they be? Britain floated like a rocky raft in the stable center of a tectonic plate. It should have happened to us, he thought. Americans. We'd have been ready.

Up to now, anyhow. In the long term, if the Moonseed could not be limited, no experience with disaster management was going to stave off the bad rain that was coming down on them all. Maybe his instinct to get to the center of things, to figure out a way to propagate his bad news, was mistaken. Maybe it was all futile anyhow.

He should have stayed with Jane.

He called Blue Ishiguro. He got Blue's mobile; Blue had evacuated himself, along with Marge Case and the rest of the department.

We are intending to continue our studies, Blue said. *We will continue to go back in to the site as long as it remains stable.*

"What about McDiarmid? Where the hell is he?"

Your esteemed leader. Nowhere to be seen. The smart money is that he long since decanted himself to London or maybe farther afield.

"Asshole," Henry said.

You never know how far a frog will jump until you punch him.

That got a laugh out of Henry.

Blue remained serious. *Henry, we have nothing but bleak hypotheses here. Now that the Moonseed has got into the mantle, as it surely must have—*

"Yeah." Even now it must be breeding down there, in

the slushy layers beneath the continents. Building its fat lit-
tle superstring bombs.

Although we may contain the surface effects—

"Hell, we can't even do that."

It is difficult to see what can stop it.

"I know," Henry said.

We can't evacuate forever, Blue said. *Eventually we will
run out of planet.*

The light in his window was fading. The end of the day.
Eventually we will run out of planet.

Of course it wouldn't come to that. They'd find some
way to combat this thing, or else it would self-limit. But
still, maybe somebody should be thinking about extreme
contingencies.

Now, what the hell was stirring at the back of his mind?

"Blue, I'll call you back."

Henry—

He put the phone down.

He lay on the bed, as the light deepened, and tried to
let the thought coalesce, in the recesses of his head.

An official car came to pick him up the next morning. A
black Daimler, for Christ's sake. He sank into soft leather in
the back. His escort, one of the squaddies, followed him,
looking even more uncomfortable.

A police escort, two outriders, took them at a brisk
pace through the London traffic.

They turned off Whitehall into Downing Street,
through heavy steel barriers. Henry got out of the car, in
front of what was maybe the world's most famous front
door: in fact just a polished black door set in a mundane-
looking terrace.

There were press ranked up on the other side of the
road, behind a cordon. There was an explosion of flash
bulbs, a bank of TV lights that glared despite the brightness
of the day.

"Henry!" "Henry Meacher!" "What are you going to tell the Government, Dr. Meacher?" "Is Britain doomed?" "This way, Henry!"

A policeman at the door saluted him. "Christ," said Henry, unnerved. "How did they get my name? You'd think I was the Prez come to call."

The copper, a grizzled forty-year-old who looked as if he had seen it all, just nodded, face stern and blank.

The door opened, as if automatically, and some kind of butler let him into a pretty impressive hallway. The butler was a big, balding, well-muscled guy. A plain clothes cop, no doubt.

A young suited man shook Henry's hand. "Dr. Meacher? My name's Pearson. I'm the Prime Minister's PPS—uh, political secretary."

"The *Prime Minister*?"

"Didn't you know you were seeing him? He's waiting for you upstairs in his study. I'll tell him you're here."

The aide ran off up the narrow staircase. Henry was left standing with the Bruce Willis butler.

It was just a smart old town house, on the surface. But Henry knew there was more to it than met the eye. For instance there were corridors that led to the other houses in the row, such as Number Eleven, the residence of the Chancellor of the Exchequer, the finance minister. So, behind the facade, this was all one big house, like the Beatles' shared home in *Help!;* he half-expected to see John Lennon playing a Wurlitzer come ascending from the floor.

It was hard to believe you could run a modern country from such a place, but evidently the Brits managed.

"So this is Number Ten," he said to Bruce Willis.

"How true, sir."

"It seems kind of—poky. What's that big place down the corridor? The pool room?"

"We call it the Cabinet Room, sir."

The political secretary returned, and escorted him up the stairs. The walls were lined with portraits of what

looked like previous Prime Ministers. Henry recognized some: Churchill, Thatcher, Major, Blair, Portillo.

The Prime Minister was standing in front of the window.

Over the PM's gray-suited shoulder was a hell of a view, of what looked like Horse Guards Parade. A couple of other people—a man and a woman, both sweating in heavy suits—were sitting in hard-backed chairs before the desk. The desk itself was a mess; its green leather top was covered by loose papers and scribbled notes and a big map of Britain. There were plates of abandoned sandwiches on the window sill, and a half-drunk bottle of red wine and three glasses leaving stains on the desk. It looked as if meetings had been going on here through the night.

The Prime Minister turned and came forward. He looked tired, his face slack, his thick hair grayer than Henry remembered from TV. "I'm Bob Farnes," he said. "Dr. Meacher, thank you for coming."

"It's, umm, an honor."

Farnes introduced the others. The man, so fat his belly strained the buttons of his off-white shirt, was called Dave Holland, and he was the environment minister. The woman, a thin, intense Asian, was called Indira Bhide. Her title was Home Secretary, which meant, as Henry understood it, she was the most senior interior minister.

Farnes said, "We have projections from our own science advisers. But Professor McDiarmid tells us you're the best qualified to brief us on this phenomenon."

Henry wasn't expecting that. Was McDiarmid uncharacteristically avoiding the credit for Henry's work on the Moonseed—or, more likely, trying to avoid the heavy shit?

"Tell us what we're dealing with here, Dr. Meacher," Farnes said.

Henry spread his hands and summarized what he'd found out about the Moonseed. "It eats rock. It prefers igneous rocks—basalt, for instance. Volcanic rocks. It is spreading across surface rock, subsurface rock, and down into the mantle. Also, after the Arthur's Seat incident, it is

also spreading through the mantle itself, and through the stratosphere in the form of dust."

"I'm told it slowed down, after the Edinburgh eruption."

"Yes. I expected that."

"You did?"

"It doesn't just grow. It builds things. Structures in the rock. Now it's into the deeper rock, we think it is busy building. But its spread will resume."

Holland pulled his lip. "So you say."

"Yes."

"Not everyone agrees with you."

He'd been expecting that. "They haven't had time to study it the way I have."

They were staring at him, their faces grave—Christ, they'd already lost a city, they'd already presided over Britain's biggest peacetime disaster—but, even so, not grave enough.

He turned to the desk, and pulled the Britain map toward him. "Look. Here's Edinburgh. Right now, we think the outbreak is around two months old, and it's maybe four miles across. In another couple of months it will be out as far as *here*." He stabbed at a point twenty miles to the east of Edinburgh. "What's this? Some kind of nuclear plant?"

"Torness," said Bhide quietly.

"Okay. A few weeks after that, it will reach here." An urban sprawl at the western end of the Midland Valley. Glasgow. "And you won't get the slow burn you had in Edinburgh. It will sweep over the city in a day." He studied them. "Somewhere about then, it's going to be moving faster than most people can walk. After that it will dig through the crust and—"

"Dear God," said Holland. "What about the rest of Britain? North England—even London—"

Henry shrugged. "The projections are chancy. And we have to expect more incidents as it eats into old magmatic structures—dead volcanoes, weaknesses in the crust—and, given time, the Moonseed will attack the crust itself. The

ocean floor is about five miles thick; the Moonseed will take a few weeks to get through that and down to the asthenosphere. The continental crust is more like fifty miles thick—"

"What happens then?"

Henry looked for the right expressions. "The scale of the eruptions is going to increase."

"Beyond anything we've yet seen?"

"Beyond anything in recorded history."

Farnes withdrew to his window, and the sunlight streaming in there silhouetted him, masking even his posture.

Holland said briskly, "So how can we stop this thing?"

"We don't know. We're trying to find a way. It can be inhibited. The Moonseed has to form, umm, certain crystalline structures before it can spread effectively. If you disrupt those structures, we think it can be slowed down."

Holland looked confused. "What do you mean, disrupt?"

"Mechanically. Break it up. Bomb it."

"Nuclear weapons? We couldn't sanction—"

"No," said Henry firmly. "The radiation from a nuke would probably feed it more than inhibit it. Carpet-bomb the infection sites with conventional weapons. Water helps."

"Water?"

"Under high pressure. Flood it wherever you can. The earlier you can catch a new infection site the better your chance of disrupting its growth, we think."

"You think?" snapped Holland. "Damn it, man, don't you *know*?"

"No, sir, I don't. At Edinburgh we did some lab tests but we didn't have time to test any of this in the field."

"But at least we can slow it down."

"I think so. You can buy some time."

Holland said, "What about further afield? Beyond the sea. Ireland, the continent—"

"We think it will be inhibited by the ocean. The Moonseed likes dry rocks and sunlight. But it will migrate eventually, even if it has to go through the mantle."

"Evacuation," Bhide said. "That's what we're looking at, if Dr. Meacher is right. First the Scottish Midland Valley towns. We can send people to the highlands and islands in the far north, to northern England, and out of Britain altogether. To Northern Ireland. Eire. France."

"We'll have to think about the royals," Farnes said abruptly. "Get them to Canada maybe. Christ. The bloody royals. The King will hate it; he despises the Canadians . . ."

Holland stepped forward, angry. "Oh, this is all rot. Do you have any idea what you're talking about?" he snapped at Bhide, and Henry saw old rivalries tense between them. "These are all short-term palliatives. If this gentleman is right, inside a few months, we would have to evacuate the *country*. It's impossible. The capacity of the airports, the sea ports, the Channel Tunnel . . . Dr. Meacher, we're talking about moving *sixty million people*."

"Of course it's impossible," Bhide said gently. "But we have to try. What else can we do?"

"But where would we go?" the Prime Minister asked softly. "It would be a new diaspora. The British, without Britain."

Holland took a glass of wine and gulped it down. "Christ, here we go," he muttered to Henry. "He went catatonic like this when the Euro collapsed."

Bhide said nothing.

Farnes said, staring out the window, "I have to go on TV tonight. A message to the nation. If you were in my shoes, what would you say, Dr. Meacher?"

Henry took a breath. "Sir, you have to look at the probability that the machinery of government in this country isn't going to last for much longer."

Bhide nodded. "We still have regional government contingency plans from the Cold War days—"

"You have to go beyond that," Henry said. "You have

to plan for a time when you will not be able to govern *at all*. People must understand that ultimately their lives, the lives of their families, will be their own responsibility."

"My last act," Farnes said, "will be abdication."

"No, sir. Education."

"And," Bhide said, "we have to keep trying. We must buy time, as Dr. Meacher says. And if the scientists can come up with some solution—" She looked to Henry.

"As soon as I'm done here I'm going to America to keep working on just that, ma'am. But—"

"Yes?"

"Right now, we're nowhere near a solution."

Farnes was silent, gazing through the window.

Holland took another glass of wine; he dribbled spots of it down his shirt. "Catatonic," he mumbled. "Bloody catatonic."

When they let Henry go, the butler character led him out through a back way, through the basement which led past the ruins of an old Tudor tennis court; he didn't want to face the press again.

20

At the end of their first day in the Rest Center, Ted didn't make it to bed until one in the morning.

He had a little trouble finding Jack. But the lad had not only put himself to bed, he'd *found* a bed in the first place: in a remote corner of the theater's main amphitheater, a couple of fold-up cots that looked as if they'd been supplied by the RAF, along with National Health Service blankets and International Red Cross sheets. The cot was a little sharp-edged but comfortable enough, even for an old codger like himself.

Ted had even had some food, a bowl of thick soup served by a stern-looking woman from the Women's Institute.

If it wasn't for the presence of dozens of other people

in the room—and their pets, including one snoring Alsatian—he'd have been happy.

Sleep came easily, and was disturbed only a couple of times by the dogs barking.

And when he woke, in the light that marked another day, Jane's face was before him.

He sat up—his chest sent pain shooting through his frame—and he reached out and cupped her face. "You found us."

She was sitting on the edge of Jack's bed. "It wasn't so hard. Although I looked for you in the medical area. You old bugger."

He shrugged. "Too much to do. Michael—"

She caught his eye, and shook her head, subtly.

The day felt a little colder.

"What about Henry?"

Her face turned hard. "He's not here. He has his own agenda."

Ted didn't press the point.

He glanced down at Jack. The boy was awake, and looking up at them with big, wet eyes.

Jane frowned, and bent over him. "Jackie? What is it?"

At first he shook his head, but she pressed him.

"I wet the bed! I wet the bloody bed . . . "

The Alsatian started barking, and pulling at its short lead.

The days after that were both better and worse than the first.

There were more volunteers now, in place to do more useful things. Registration was slick and smooth, with older schoolkids able to take details down straight onto their computers, which were linked in some way Ted utterly failed to understand, and the kids were able to retrieve immediately data on friends and relatives.

For all that, there was no sign of Michael, on any system.

The billeting process went well. Ted's first thought had been to have the refugees meet the Musselburgh people, and see if they paired off. He was especially keen to find stable homes for the unattached children.

But it didn't work. The Musselburgh population seemed predominantly elderly, and they were good-hearted. But the human dynamics were all wrong. *Cherry-picking;* it was really quite obscene. The pretty girls and the youngest kids were always requested first. Nobody wanted the older boys. Even now—and Ted found himself to be utterly naive about such things—there was a lot of concern among the professionals here from the social services about the dangers to the kids of lodging them with strangers.

The cherry-picking was repugnant anyhow, so Ted broke that up, and started to allocate the refugees on a more random basis, matching up on the basis of needs rather than individuals. The billeting was restricted to families with kids of their own, or people who were known foster parents. Only family groups, with an older male or two, went to volunteers unknown to the social services. If they'd take them, anyhow.

It all helped to reduce the pressure on the Rest Center itself. But there weren't enough hosts to go around. And there were some people who were just not suitable for billeting: large family groups, the elderly, people who had been undergoing "care in the community," and the plain irascible who didn't want to be billeted anyhow—under which category Ted would place the old guy with the yapping Alsatian, and himself and his diminished family. Ethnic-minority families attracted scarcely any help from outside their own communities, a phenomenon which made Ted feel ill with frustration.

Ted's own informal estimate was that maybe ten percent of all those who arrived at the Rest Center couldn't be

billeted. And you had to add to that, he supposed, the pop-
ulation of the hospitals, the prisons, the remand centers for
the young, the long-term care facilities, old people's homes.

On it went: a *lot* of people.

Some things got worse, as time went on.

Like hygiene. Dog shit seemed to be everywhere. He
found himself spending much of his mornings organizing
volunteers on clean-up squads, and issuing warnings about
the danger of children getting eye infections from the stuff.

More food arrived, canned stuff from the local super-
markets. Ted wondered how long that would last. But he
heard of fleets of Army choppers bringing in supplies from
Glasgow and north England, and when it arrived it came in
boxes marked prominently with the name of the supplying
store, big black letters to display for the TV cameras.

There were cameras everywhere, in fact. He found
one crew filming a grinning care worker handing a sack of
used toys sent from Boise, Idaho to some kid who was sup-
posed to act grateful, a Scottish kid with her own life and
dignity, in order to please the hearts of some beer-sodden
asshole on the other side of the planet, a kid who would for-
ever be scarred by the experience. Ted had to be restrained,
by Jane, from throwing the crew out.

The theater manager—her name was Siobhan Reader—
was soon wrestling with longer-term problems. Like
finance. It seemed the theater would have to recover its
costs from the local authority, who in turn would have to
get it back from central government, all retrospectively,
and all within the provisions of something called the Bell-
win scheme which covered emergencies like this.

And some of the residents here were actually asking
for cash loans. With cash they could buy stuff from the local
shops, which were still open, to tide them through the crisis.
Many of them had left home with only electronic money,
credit cards and Switch cards, which, when the telephone
exchanges went down, had suddenly become useless.

So Reader had obtained some money, twenty thou-

sand pounds, as a loan from the theater's own bankers in Musselburgh, and was now trying to figure a way of accounting for the small handouts she was making to the families.

But there were good things too. The *Edinburgh Evening News* was published every day, without a break, though Ted suspected it was being run up on a desktop publishing package on somebody's home pc. It carried some news, mostly stale rehashes of the TV and radio bulletins, but it also ran long lists of personalized messages from the displaced people of the city. *To Mary McClair from Vicky Norman. If you need a place to stay, please call* . . . The mobile phones prevalent in the Center were being used less for personal messages, and more as part of an informal communications network, spreading low-level news about the fate of people and places, even pets. One of the volunteer groups brought in printed T-shirts. *NO WATER. NO FOOD. NO POWER. NO PROBLEM.* They became a fashion accessory among the volunteers.

They had a VIP visit. It was Dave Holland, a London politician, the environment secretary, a fat English bastard whose accent seemed to disappear down his throat. Trailed by two camera crews with glaring lights and gigantic boom mikes, he strode through the theater, shaking hands with photogenic kids and care workers and volunteers. Ted couldn't believe how much time and resource was taken up by catering for Holland, the security and route planning and all the rest of it.

But it was good for morale, he was told.

Holland made one substantive announcement. "There's a wave of sympathy around the world for what you're going through," he said. "Everyone's eyes are on you. There will be a rock concert in Wembley Stadium to raise relief funds. And we're flying out the Hibs and Hearts squads—" A ragged cheer; they were Edinburgh's two principal soccer teams. "—to play an exhibition game."

Rock music and soccer, Ted thought sourly.

He actually got to meet Holland. The man came along a row of volunteers, introduced by Siobhan Reader, shaking hands and sweating heavily. When it was his turn, Ted asked, "When are you going to start evacuating Glasgow?"

Holland laughed nervously and moved on.

Later, Ted found himself in a huddle with Reader and Jack.

Jack said, "I'd have asked him if Willie MacLeish is playing." MacLeish was Hibs' star striker.

"You're right," Ted said seriously. "I would have got more sense."

"And I'd have asked him," Reader said stiffly, "if there's any word of my husband." The first time she'd mentioned him. And with that she turned and walked to her office, to start another sleepless night of work.

Ted stared after her. She was, he'd first thought, just an ineffectual worker, and he'd treated her with contempt. The wrong person in the wrong place at the wrong time.

But she was, of course, a woman with a life of her own. A family maybe. And he'd never thought even to ask.

The evenings were long.

Just a day or two from near death, and boredom was becoming their biggest enemy.

On Ted's advice, Reader had banned alcohol, but allowed in TV, powered by a portable generator. The reception of the terrestrial stations was poor—local transmitters knocked out, lousy conditions because of the volcano weather lingering over Edinburgh—but satellite dishes seemed to work reasonably well. Reader had intended to show a steady diet of game shows, pop and movies—she even wanted to run videos—but Ted suggested that, except for kids' programming in the area set aside as a nursery, she simply run the news. People here wanted to *know*, after all.

The news, the images from Edinburgh, worked to

keep people quiet. Ribald cheers whenever somebody in the Rest Center was shown.

The Hibs-Hearts soccer match attracted the biggest crowds around the TVs. The game itself was played at Ibrox Stadium, the home of Glasgow Rangers, and the teams, depleted by the disaster, were reinforced by loan players from other clubs, in England and Scotland. There seemed a genuine warmth as the stranded people watched their teams battle it out, fans of the two clubs mingling without self-consciousness or conflict.

When the game was done, the mood was subdued, it seemed to Ted: subdued, but somehow deepened. As if the televising of a soccer match, two scratch teams chasing a ball around a park, had moved people on a level the destruction of a city never could.

Even the news of alcohol-fueled rioting among Glasgow fans that followed the match didn't seem to mar the mood.

At the end of the fourth day, as the light was fading, Ted realized he hadn't taken any air. So he walked out through the foyer, still crowded with new arrivals, and stepped into the comparatively fresh air of the patio outside.

There was a pall of smoke to the west, over whatever was going on in Edinburgh. Helicopters flitted, their lights winking brightly. Some of them appeared to be dumping water or some kind of chemicals into the continuing inferno; others were dropping crates of supplies under blossoming parachute canopies to the pockets of survivors that remained. The small human activity, probing and challenging the work of the Moonseed, warmed Ted's heart.

Somehow, watching that, he found it easier to believe that Michael might yet have lived through all of that.

He found a purpose, coalescing within him. He had to return. I'll go in for Michael. And if I don't find my son, maybe I'll find the asshole who lured him in there. Then we'll see.

He told Jane what he planned.

"What? That's ridiculous."

"But if it was Jack—"

"I'd go. I'd go without hesitation."

And above their heads, the ash and smoke and steam merged into one hell of a sunset, a curtain of flame that reached to the police-blue zenith.

The Rest Center was actually quieter that night. Many people had found billets, or had been allowed to leave to find accommodation in hotels, or with relatives.

Sleep again came easily to Ted. But he was woken at 3:00 A.M., by yelling voices.

A middle-aged man—still dressed in the rumpled suit in which he'd arrived at the Rest Center yesterday, straight from his job as lawyer or bank manager or accountant—had strangled that yapping Alsatian with his bare hands.

21

The journey into Tokyo was an ordeal for Declan Hague.

May was the season for the school children to be taken in parties to the nation's show places. Venus and the volcano ash hadn't put a stop to that, and they seemed to be everywhere: on the trains and the stations and the streets, with their mobile phones and their laughing faces and their fashionable rad-gear and their electronic toys. And everywhere he went, they seemed to home in on *him*.

Well, he could understand why. He was a combination of two rarities for these kids: a *gaijin*—a foreigner—*and* a monk. Here they came in little groups of three or four, boys and girls alike in their ankle socks and navy or black uniforms and ties, grinning and giggling and holding up their disposable cameras.

The kids pursued most of the few *gaijin* on Tokyo's crowded streets. But he thought there was more to it than

that. About him, they probably sensed weakness, on some subliminal level.

Weakness. Fear.

Or even a whiff of danger.

After all, it was because of children younger than these teenagers that he had been forced to leave Ireland, leave the Church, and come all the way around the world to this place, to immerse himself in the placidity of another religion.

But he got through the day somehow, smiling and nodding and waving away their requests for photographs. And besides, his determination to complete the mission he had set himself would carry him through.

He walked the mile or so south from the Tokyo J.R. station to Ginza, the most famous entertainment and shopping district in Japan—so he had been told; he'd never been here before. What he found was an oddly American-flavored district of glittering, high-rise buildings laid out on a rectangular street pattern, neon signs bright enough to dazzle even by day.

Everywhere was crowded, of course, but without the sense of crush and bustle he'd grown up with in Dublin, even London; that, of course, was because of the Japanese habit of politeness and deference, all that smiling and bowing that had seemed so odd to him at first, but which now he understood as a vital social lubricant, the only way so many people could get along on this cramped little island chain.

Politeness and deference—from everyone except the school kids, attracted endlessly by the *gaijin* mask he could never take off.

And it was in Ginza—in a small (but expensive) shop near the Sony Building—that he found what he was looking for.

In among the trashy Buddhist charms and plastic fans and pictures of twelve-year-old pop stars, there was row on row of vials of ash-gray dust: rock from Edinburgh. Each vial, he found, came with a certificate of authenticity from

some geology institute he'd never heard of, and a list of the uses to which people were putting this stuff. Scattering it over their Zen gardens. Putting it in their Shinto shrines. Even mixing it with milk and drinking it.

For this anonymous-looking volcanic ash had been—if the stories were true, if the ash were genuine—transformed by the ghostly touch of the Moon itself.

Declan bought three vials. Then he turned and, without hesitation, made his way back to the J.R. station.

Home for Declan, for the last decade, had been a small Shinto shrine called Futaarasan, which stood on the north bank of Lake Chuzenji, some hundred miles north of Tokyo. Now he retraced his journey to Futaarasan, taking the Shinkansen bullet train from the capital to Nikko, and the bus to Chuzenji.

At last, cradling his vials, Declan made his patient way back along the lake's north shore road toward the shrine.

Chuzenji was once, probably, an attractive area, he thought. But the town had become a trashy resort, feeding off the cable car that took visitors down the river gorge to see the Kegon Waterfall. Through the trees that lined the lake, he could see pleasure boats made absurdly in the shape of swans, Disney style, plying back and forth.

If they had done this to a site in Britain or Ireland, he thought, everybody would have said it was a typical desecration. But the Japanese were, maybe, a little more mellow. This was a culture where monks would quietly earn a living from charging for entry to their temples and shrines—even for services—as well as rake off hundreds of yen apiece for ridiculous little charms, like something out of the Middle Ages.

With relief, he returned to the shrine itself.

The shrine was modest. Its main buildings—vermilion-painted wood topped with blue tiles—were grouped around a central square. Facing the lake was the *haidin*, the

hall of worship, and on either side were the *honden,* the main hall, and the *homotsu-kan,* the treasure house. Declan hurried through the square to the *torii* gate which stood at its rear, a plain affair of gray wood, two uprights topped by two crosspieces. Beyond the *torii* stood a narrow vermilion archway, and behind this a steep flight of steps soared up the hillside.

Declan paused a moment to gather his strength; he still felt exhausted from his unwelcome encounter with Tokyo. But he set his sandaled feet on the first of the steps, and began the familiar climb.

Futaarasan Shrine nestled at the feet of Mount Nantai, a green-clad volcanic cone which rose above it, reaching all of a mile and a half above sea level. *Futaara* was actually an old name for the cone, and the true center of the shrine was set at the lip of the caldera at the summit. Each August pilgrims would come this way, through the old *torii* gate, leaving behind the absurd world of charms and plastic swans and tourists, and climb up here to the violent, quiescent heart of the volcano, just as Declan now climbed, alone.

He knew he couldn't wait until August; he knew he must do this now.

The climb was long and arduous, and by the time it was completed he was sweating hard, his breath coming in gasps. But the view from the lip of the caldera was magnificent: the old volcano mouth itself, the numerous mountain lakes and volcanic cones, rounded and furred over by trees, and Lake Chuzenji, blue and sleek and beautiful from this distance, a vista too remote to be spoiled by the foolishness of its visitors.

Japan was built on the junction between plates deep in the Earth, and was plagued by volcanism and earthquakes. And so everywhere you went, rounded volcanic hills stuck out of the landscape. It gave the landscape a sense of impermanence, he thought, and also a human scale.

The Japanese had been shaped by their landscape. It seemed to him you just couldn't build a giant Gothic cathe-

dral in the middle of all this. Japan was about continuity and reflection and calm. The Japanese even had two religions, Buddhism and Shinto, working side by side without a hint of conflict, which was quite a contrast with Ireland.

And that sense of calm had been what he'd sought when he'd come out here.

He felt a sense of that old panic, of enclosure, as unwelcome memories of the past stirred in his hind brain. But he had *done* those things, hurt those children, and, even a decade later, he could never remove that scar from his soul—as they would, surely, never forgive or understand, and as those in authority would never hesitate to punish him, if they could identify and trap him.

But then he was already trapped, by his own addled personality. For he knew he would do those things again, given the opportunity, the chance of secrecy. Even as he encountered the schoolchildren in Tokyo, he had felt his aging loins stir, unable to dispel the endless calculations, the intricate maze of actions that might lead to a new release of his lust.

So he must never give himself such opportunities again.

He took out his little vials of Edinburgh dust, and smiled.

He descended a little way into the caldera, past the trodden paths and platforms, until he was walking on bare volcanic rock. Then he opened his vials of Scottish dust— they smelled, he thought, of autumn bonfires—and he spilled them, carefully, on the ground. Delicately, with his fingertips, he rubbed the ash into the rock, as if applying some gentle unguent.

The ghost touch of the Moon, brought to Mount Nantai.

When it was done, he felt a great peace. He stayed for a while, as the evening gathered, and the spectacular volcanic sunset crept over the sky.

Perhaps this offering would propitiate whatever gods resided here. Or perhaps it would destroy them.

Perhaps it would destroy *him*.

And that would not be such a bad thing, if it reduced the number of future days he would have to face, the days he would have to wrestle down the monsters that lay inside him.

In the caldera, where he had delivered the dust, the rock surface glowed softly.

22

In his London hotel room, waiting for transport to the U.S., Henry tried to nail down the thought that Blue's remarks had sparked.

Okay, address the worst case. The Moonseed was already spreading globally. What if it *couldn't* be stopped? What then?

Eventually we will run out of planet. But not, he thought, of planets.

What was he thinking of? Evacuating the world, when they ran out of planet? Like *When Worlds Collide?*

It was, of course, impossible. And even if you evacuated a handful of people, you needed somewhere to go, somewhere you could live off the land and not in a spacesuit.

Ideally, somewhere immune to the Moonseed.

. . . The thought coalesced, like crystals forming in supersaturated solution.

Damn it, maybe there was such a place. But it was a hell of a long way away. And he might be wrong anyhow.

The only way anyone would know would be by sending someone there . . .

Suddenly, he realized he had to talk to Geena.

From memory, he called the number of her new apartment in downtown Houston. He got an answering machine, saying she wouldn't be back for days. Dumb, Geena. An open invitation to the bad guys.

He tried JSC, but the receptionist there didn't seem to believe who he was, and wouldn't put him through.

He tried the press office.

He got nowhere trying to prove his identity. If he wanted to hear an astronaut, they said, he should log onto the World Wide Web in a couple of hours, to watch an online chat between a group of astronauts, in training for upcoming missions, and a bunch of schoolkids from Iowa. It sounded to him as if the NASA guys had been fielding a lot of shit all day, no doubt the usual end-of-the-world demands and queries and accusations of cover-up that NASA always got when something bad came down.

He thought about that online chat. Maybe there was a way he could break into that.

But he'd left his laptop in Edinburgh. Part of the sunset now. Besides, this hotel room wasn't exactly geared up for the information age. The telephone cord literally disappeared into the wall rather than terminating in a regular point.

Shit.

He found a telephone directory under the bed. *Yellow Pages.* It took a while to figure the classifications, but he found what he needed quickly.

He got dressed. He pulled on the jacket the Army guys had given him—a little tight but expensive, smart casual—and stumbled out of the room.

He was carrying his shoes, so he could get down the corridor without a sound, and give his military escort the slip. Apart from the creak of antique floorboards, he did pretty well.

In the hotel lobby, he pulled on his trainers. He pushed his way out of the hotel, into what was left of the daylight.

He called into a news store and bought a Central London map. He directed himself through side streets to Charing Cross Road, and then south, toward the river.

On foot, London seemed overwhelmingly strange. Red pillar boxes. Traffic that was snarled up everywhere

you looked, but which still stopped for you at pedestrian crossings, one hundred percent of the time. Churches and statues and blue plaques telling you who lived in this or that anonymous-looking old house, five centuries ago.

The sun was still up, visible above the clustering rooftops. It was surrounded by a fat opalescent corona, sprawling and misshapen. What volcanologists called a Bishop's Ring.

Charing Cross Road was lined with bookstores, though they were mostly small and cramped compared to the big mall and out-of-town stores he used back in the States.

He reached Trafalgar Square: Nelson's Column, the triumphalist stone lions growling at his feet, odd echoes of what the British thought of as their great days, the mock-classical front of the National Gallery looming over everything. The Square was crowded with tourists and hucksters—not an Anglo-Saxon face in sight—and fat, waddling pigeons for which you could buy feed from the hucksters, should you so choose.

There were shoppers and browsers and people hurrying to and from work, wrapped up in their own concerns, not even seeing Henry unless he all but collided with them. Homeless guys, curled up in the doorways in their sleeping bags, repeating their endless mantras, "Spare some change please . . ." More of that than he'd expected. He had to step *over* them sometimes, so crowded were the pavements.

It seemed unreal.

Except for lurid headlines on the stands of the local paper, the *Evening Standard,* and the shimmering rad-ponchos everywhere, there was no sign of what was coming down in the north of the country. As if the Earth was flat and infinite, the stars just lights in the sky, the future endless and unthreatened. As if some kind of alien nano-bug wasn't eating up the country.

It struck him that Britain was an alien country—he was a true foreigner here, common language or not. Britain was geologically placid, hadn't been seriously invaded since

1066, hadn't suffered a civil war since the seventeenth century, and had been at peace since 1945. It was hard for him to empathize with what that calm history must do to shape the psyche of the people here.

For sure, they weren't going to start panicking just because of a little geological excitement in Scotland.

He cut down the Strand and found the place he was looking for, a cyber cafe in a side street off the main road. It was a small place but clean and bright and crammed with terminals, but only full to half of its capacity. Maybe all the cybernauts had their own equipment now.

He bought a coffee and credits and sat down. As he drank the coffee, he realized he couldn't remember when he'd last eaten.

He got right back up and went to the counter, and came back with a plateful of sandwiches in plastic boxes, a bag of the potato chips the Brits called crisps, a slab of cake laced with chocolate. As he logged in, he crammed the food in his mouth, chewing mechanically.

He tried Geena's E-mail, but she'd evidently changed it again. So that left the chat room.

Geena and her buddies were already talking to the schoolkids from Iowa or Ohio or wherever the hell it was.

> My name is Amy Im asking for my brother whose in a diferrent class but hes like whats it like in space
> This is Brett. It's hard to answer that question, Amy. You look down at the Earth, and you think, good Lord, how small it looks. You feel strangely the whole time, because there's no gravity, and you're confined in your ship or your space station or your space suit. You feel very close to the people with you, your team, even if they aren't Americans. You miss your family. Amy, you'd even miss your brother,;-).
> This is Geena. You pass from light, brilliant unfiltered sunlight, into darkness, spangled with stars, and back again, every forty-five minutes. It's magical.

When you come down, that's what you remember, I think. It's like going to a magical place, a secret place, that you want to share, that only a few people know about . . .

And so on.

Henry broke in. It was easy enough; NASA only used a few passwords on such occasions.

> My name's Henry. I have a question for Mrs. Meacher.

There was a blank period in the chat room. He, her ex-husband, was the only person on the planet who had ever called Geena that, and then only to needle her.

> Geena, I'm all right. I'm sure you'd want to know that.
> Who is this? This is Mrs. Bates. You aren't in my class.
> This is Geena. Yes. Yes, I'm glad to know it. Call me. I tried. You won't believe how these Brits are keeping me dangling. I need your help. How would you put together a mission to get back to the Moon?
> Who *is* this?
> This is the Administrator. This session is closing.
> This is Mrs. Bates. See what you've done, you ass-wipe cracker?
> What time period? A couple of years? This is Geena.

How long?

He tried to think it through.

The propagation of ash and dust in the stratosphere was well modeled, and they had a good handle now on the surface propagation of the stuff. But he didn't know how the Moonseed would spread in the mantle.

If they were going to the Moon, they would have to go while they still could, before the launch gantries at Canaveral sank into the sand or tipped into the Atlantic . . .

> Try a few weeks.
> Impossible. I think. I %33%
> This session is cl&-%$£$#

. . . and he was out of it; the chat room emptied.

Maybe that was enough. Geena would find a few bright back room guys, see what kind of straw men they could come up with, let the naysayers throw their rocks.

This was the stuff NASA was good at. Responding to an emergency. It was an organizational tic that irritated the balls off him when he was trying to push his projects through, but now it might be useful.

If there was a way to get to the Moon fast, NASA would find it.

He finished his food and stepped outside. The sky had turned pink-gray.

On a whim, he cut down a couple more streets and walked to the Embankment that lined the northeast bank of the river. The Thames was broad and placid and clean. There was a garden here, cut through by a roadway, and he found a place he could sit and look at Waterloo Bridge and the big modern concrete buildings squatting like toads on the south bank, the Queen Elizabeth Hall and the National Theater.

The sun had set to the southwest, behind the rooftops of London. The horizon was tinged with a silvery luster. Above that a yellowish haze, like L.A. smog, filled the western sky. The haze changed in color and extent, ranging from a greenish yellow through orange and deep scarlet.

As he sat there and watched, the dusk crept on, and orange and olive tints washed through the whole of the

sky—even to the east, over the river, which shone like cop-per in the light. Deep scarlet was gathering in the west now, even as the first stars started to appear, directly above him.

The sunset colors faded for a time, and the deep summer blue filtered down the sky, making it look almost normal. But now a new surge of bloodred seeped into the western sky, and looked set to linger long after the conclusion of a normal sunset.

Volcano sky. Shit. He'd seen nothing like it since Pinatubo.

He was getting cold, and he was tired as hell, and he got out of his seat to look for a cab.

He was due to leave the next day, for Washington. He wondered if he'd ever see Britain again.

23

Geena set up a meeting at the Outpost, with Jays Malone and the young missions-operations whiz he knew called Frank Turtle. When she arrived Jays and Frank were already here, sitting at a table with a couple of empty bot-tles apiece; she ordered a fresh round, with a Diet Coke for herself.

After introductions the guys resumed their conversa-tion.

". . . We were planning a shit-load of weird stuff before *Challenger* blew," said Frank Turtle, talking rapidly, a little nervously, perhaps overawed. "We were going to launch *Galileo* and *Ulysses* on Shuttle. Because both of those ships were going to Jupiter—and because the launch window was tight—we'd actually have had two Shuttles on orbit at the same time.

"Not only that, you'd have had both of those ships with liquid oxygen/hydrogen loads in the payload bay. And we never truly figured how we were going to handle that. We didn't know how to keep the load topped up on the pad. Would you run cryogenic lines *through* the skin of the

orbiter? And we couldn't figure out a way to dump it fast enough in case of an abort. For instance you might be flying an RTLS abort, which is a powered fly-around back to the Cape, a hell of an aerobatic maneuver which we've never, in fact, tried. And in the middle of this you'd have to dump your forty thousand pounds of LOX and hydrogen, separately.

"Or what if you do a transatlantic abort and finish up at some airfield in Africa? How are you going to process the stuff there? It takes three days to get the C–130s out there, and in that time you could get an explosive build-up of gases in your payload bay. Well, hell, after *Challenger* we just never looked at that again . . ."

Geena was content to listen for a while, absorbing their personalities, the bar's atmosphere.

The Outpost was a beat-up old bar off NASA Road One, not far from the Johnson Space Center. The NASA folk held launch parties and postmission parties here. It was just a low-roofed wooden shack, its walls plastered with aging Shuttle crew signed photos, crew patches and other memorabilia. One of the photos had been airbrushed Soviet-style to remove an unpopular female astronaut from her one and only spaceflight. There was a scuffed shuffle-board deck and a pool table.

But not everybody was a NASA nut. There were plenty of good old boys who looked like they had their heads on upside down, sitting in a wall around the bar and glowering at strangers, cradling Buds and watching basket-ball on the noisy TV.

Geena didn't particularly like it here. The Outpost was a close, dark wooden box. It was photogenic, and a lot of times you couldn't move in here for the TV crews. But what depressed her was the sense of antiquity, the walls encrusted with layers of yellowed photos lying over older pictures, like Henry's geological strata. The Space Age reduced to a nos-talgia object.

But it was inevitable, she supposed; after decades the

space program had developed its own history and peculiar human traditions, like everything else people ever did, from baseball to religion to politics.

Or maybe she was just sour because she didn't want to be here, that somehow her life was *still* tangled up with Henry's.

Geena studied Frank Turtle. She realized belatedly that Jays's description of him as "young" was entirely relative. Frank had to be forty-five at least. But he dressed young, which she thought was a good sign, in a crumpled denim jacket and jeans and open shirt, and with a tangled mop of graying black hair over thick Coke-bottle glasses.

He wore an electronic button-badge showing the Venus explosion, cycling through that startling burst of light every few seconds.

As he talked, she learned Frank Turtle had done a series of jobs at JSC, getting hands-on experience of space operations by working on Shuttle operations as a mission designer and flight controller. In common with a lot of people here, she suspected he had applied for some of the astronaut recruitment rounds, in his early days. But for the last few years—hell, she realized, more than a decade—he had worked for a department called the Solar System Exploration Division; and, with his buddies, Frank's job was to blue-sky the future. *If you had to get to Mars in a decade— how would you do it?* NASA had to be positioned to answer questions like that, when the call came, and that was Frank's job.

Of course NASA had been waiting for that call since 1969, and it hadn't come yet. But Frank and his like were still prepared, constructively dreaming, ready to respond.

A lot of careers got kind of stuck at NASA. There was a shit-load of recruitment back in the early 1960s, when NASA ramped up for Apollo, and a lot of those guys were still around now. They liked to work for NASA, and there was really nowhere else for them to go anyhow, and even

with all the downsizing over the years it was still difficult for the federal government to shed people from a place like JSC. So here they all are, aging Boomers, getting older and grayer and using up space; and here was Frank's generation, in the line behind them, no doubt creating their own logjam in the resource pool.

". . . So," Frank said to her now, wiping a spume of Coors from his mouth. "You want to talk about going to the Moon. Why the hell?"

Because my ex-husband thinks the world is going to end.

"I can't really say right now," she said.

"It's something to do with the stuff they're calling the Moonseed, isn't it?" Frank smiled. "We ain't dumb, you know."

"I'm sorry—"

"That's okay." He held up his hands. "Frankly I'm more interested in getting us back there than why the hell we go. If you came up with a reason, good for you. Now. Jays said you're looking at a fast return."

"Yes."

"How fast? Ten years, five?"

"Try five weeks."

Frank held her gaze for a few seconds, letting that sink in.

"You think it's impossible," she said.

"Have I said that?" He sat back and studied her. "I do wonder if you know what you're asking for. With all respect."

"You know," Jays Malone growled, "we're farther from the fucking Moon now than we were in 1961."

"There are certainly a lot of barriers," Frank said. "In a way Apollo fooled us. Apollo wasn't a lunar exploration system. All Apollo could do was deliver two guys to a place on the near side of the Moon, not too far from the equator, for three days, at a certain time in the lunar morning. And that was it, and even for that you had to fire off a Saturn V

every time. There was no real expansion capability, no logical follow-up."

"Von Braun was right," Jays grumbled. "They should have built the fucking Nova. Forty million pounds of thrust, six times the Saturn V. So big you'd have had to launch it from a barge in the Atlantic. If we had the Nova we'd have been on Mars by now."

Oh, Christ, Geena thought. Back to the Sixties.

"We had it all," Jays went on, "and we threw it away. You know, even when Armstrong landed on the Moon, Nixon was ripping apart the space program. NASA worked up a plan that would have had fifty people on the Moon by 1980, Americans on Mars by 1985. Instead it took twelve years after Armstrong to get the Shuttle to orbit, and NASA could start campaigning for the next step, the Space Station."

"A reason for us all to keep our jobs," Frank said dryly.

"Well, Reagan said it should be built by 1994. And there would have been an orbital transfer vehicle—"

"Yeah, the OTV," Frank said to Geena. "Now if we had *that,* we really would be able to get to the Moon quickly. The OTV would have ferried people between low Earth orbit and geostationary, where they put the comsats." He smiled. "You know, I was there when Michael Duke and Wendell Mendell had their epiphany, as they called it. They figured it takes almost the same energy to go from LEO to GEO as it does to go from LEO, all the way to the Moon. So if we had the OTV, we'd be able to get back to the Moon. That was the start of the Lunar Underground . . ."

Geena had actually been part of that: she'd attended a workshop in Los Alamos in 1984, and then a symposium in Washington, D.C. The bright-eyed enthusiasts there, mixed in with a few Apollo-era vets like Duke and Mendell, didn't attempt to justify a lunar return. They just *assumed* it would happen, probably by the mid–90s, when Station and the OTV gave the country the capability again. It was a lot

of fun, even if, to Geena, most of it was utterly unrealistic.

Still, she remembered now with an odd tug of nostalgia, it was at the Washington symposium that she'd first met Henry. A wild-eyed geologist with some kind of sketched-out scheme for extended lunar colonies, self-sufficient cities of lunar glass big enough for thousands of people, fueled by all the ice he believed existed at the Poles. Even then he talked about terraforming the Moon.

Those eager youngsters lobbied hard, and got NASA to set up an Office of Exploration which looked at ways to return to the Moon and push on to Mars.

"We spent years devising mission architectures," said Frank, nostalgically. "All those imaginary voyages. Christ, we could have piled up the vu-graphs we generated and just *climbed* to the Moon."

"But then came *Challenger,*" Jays said brutally. "And that was the end of that."

"Yeah. We didn't even fly again for two years. And all the plans we had were frozen . . ."

"I was there when Bush made that speech at the Air and Space Museum," Jays said. "Twenty years after Apollo 11. The Space Exploration Initiative. We'd finish the Station, go back to the Moon, on to Mars. But we screwed ourselves. NASA came up with a report that said it would take half a *trillion* dollars to get to Mars. And Congress killed it, zeroed out the budget by '91, '92. The OTV was canceled—"

"They even killed off the Lunar Polar Orbiter," Frank said. "An unmanned probe, that we'd been studying for twenty years. What a waste."

"Which is why I say," Jays said to Geena, "we're farther away from the Moon than we were in 1961 . . ."

Geena leaned forward. "Okay. I heard how cruel life is. I heard how hard it is to achieve this. Now tell me how we do it."

Frank looked up at her. "Five weeks?"

"Five weeks."

His eyes, hooded by his thick spectacles, narrowed.

* * *

"The logic of how you get to the Moon hasn't changed since 1969," said Frank Turtle.

Frank started sketching on the back of a napkin: schematic mission profiles with the Earth shown as a flat floor, the Moon as a ceiling above it, and little rockets and landers clambering between the two, like medieval angels flying between Heaven and a flat Earth.

"You need some way to get to Earth orbit, or beyond. Then you need some kind of transfer vehicle, to drive you to the Moon. You need a habitat to sustain you on the journey. And you need some kind of lunar lander, like Apollo's, to drop you to the surface and bring you back up again. For an extended stay you probably need to double all that, to drop a shelter or surface-stay resources in place.

"Now, Earth's gravity well is *deep*. If you want to send a ton to the Moon, you need to throw *seven* tons from Earth's surface, most of it lox propellant. Which is why we needed a Saturn V for Apollo.

"But today we don't have a Saturn V, a heavy-lift capability. The Shuttle's payload capability is a fraction of Saturn's. You'd need four Shuttle launches for every lunar mission, or some similar number with low-payload expendables. Like our Titan IV, the Russians' Proton, the Europeans' Ariane—"

Jays said, "If we'd built the National Launch System, we'd have heavy-lift *now*. But they canned that in '92."

Geena said, "Maybe the Russians' Energia—ninety tons to LEO—"

"Junk," Jays said bluntly. "The Energia was a piece of shit, even before they closed down the production lines. Believe me, I went out there for an Apollo-Soyuz anniversary event, and I saw what's left of it. Energia is not an option."

"Okay," Frank said. "Well, alternatively we have those old studies of Shuttle-derived vehicles . . ."

Geena knew about some of that. There might have been the Shuttle-C, an unmanned throwaway variant of the Shuttle, capable of orbiting seventy or eighty tons. But the cost advantage would have been minimal compared to existing systems like the Titan IV, so that too got canned in 1990.

"But," said Frank, "there was another baby I worked on called Shuttle-Z. Looked like the Shuttle on steroids: your regular solid rocket boosters and external tank, but then a cargo element that was fatter than the external tank, with four Shuttle main engines. Could have sent a hundred and thirty tons to LEO. One hell of a bird. But that would have meant a lot of changes to the processing and launch facilities, so it wasn't economical either."

Jays said, "If we got to sit around and wait for Shuttle II—VentureStar, or whatever the hell they call it now—"

"Yeah. We'll never get anywhere. But what about reviving the Saturn V production lines? Have you seen those studies? . . ."

"Enough." Geena held up her hands. "Let's get real, guys. In a few weeks we aren't talking about a new heavy-lift vehicle, or rebuilding the Saturns, or Shuttle-derived vehicles, or any of that. And we ain't going to get an OTV. We have to think in terms of what we've got. We have to develop an architecture based on Shuttle and the available low-lift expendables."

"Off the shelf and to the Moon." Frank grinned.

"And what," Jays said quietly, "about cost?"

Geena took a deep breath. What she was about to say went against years of ingrained NASA cultural orientation.

"Forget about the cost."

Frank spluttered. *"What?"*

"I know. It's hard. But cost isn't going to be a factor here. Timescale is all. It's a mind game, guys. The rules are, assume you can spend what you like, but all you can do is requisition existing components."

"Umm." Frank pulled at his lip. "Your mission, should

you choose to accept it . . ." He pulled over another napkin, and sketched Earth and Moon, this time as two spheres. He drew tight circular orbits around each of Earth and Moon, then a figure eight around the two worlds.

"Let's be specific about what we have to achieve here. If we are restricted to the current fleet of medium-lift vehicles, we have to consider Earth orbit rendezvous. Several launches, by the Shuttle and other vehicles, carrying up the components of the mission, to be assembled there. Probably using Station as a refueling shack.

"First of all we need propellant for the TLI burn." He drew a little arrow, at the Earth end of the figure eight. "Translunar injection. We coast for three days to the Moon. We need our habitat vehicle to keep us alive. Then LOI: lunar orbit insertion, another burn, which we have to carry fuel for, to place us in orbit around the Moon. Next, into the lander. A deorbit burn, descent, soft-land standing on your rockets. More fuel, of course. Ascent back to orbit, maybe using the same engines—maybe not, like Apollo. Rendezvous in lunar orbit. Then the trans-Earth injection, coast back to Earth, probably aerobrake to orbit and have Shuttle come pick you up."

"Pretty much like Apollo," Jays said.

"Well, the rules of celestial mechanics haven't changed. Almost certainly this architecture is going to provide us with the minimum-weight configuration. You could consider direct-ascent, for instance, where you take your whole ship, transfer habitat and all, down to the surface . . . But we ran some studies a few years ago along these lines, about how light, how cheap you could get. It wasn't encouraging."

"Stick to what you have," Geena said.

"Let's start with the lander. Everything else is going to scale to that. Now, the old Apollo Lunar Module was around sixteen tons, full up weight. But that included a surface shelter for six man-days on the Moon, effectively. And there were a lot of structural costs in the mass estimates,

because of the split between ascent and descent stages, and the nature of the design. We did some studies that showed you could cut that to maybe a quarter."

Jays snorted. "Bull hockey. Believe me, that old LM was just a bubble of aluminum. Those Grumman guys shaved it thin."

Frank grinned. "Old man, that bird will look like a Chevy compared to what I'll show you now." He quickly sketched an Apollo LM, the familiar spidery descent stage, the bulbous ascent stage. "The whole thing stood maybe twenty-three feet tall. Now look at this." Alongside he sketched something that looked like a scale model of the Apollo descent stage. "There," he said. "Six feet tall. Nothing but fuel tanks, legs and a rocket engine. The structural integrity is actually expressed through the tanks themselves."

Jays looked closely. "No ascent stage?"

"You use the same engine for ascent as for descent. You refuel on the surface, from an unmanned tanker."

Geena, looking at the blurred little sketch, said uneasily, "Where's the cabin?"

That wolf grin again. "What cabin?" And Frank sketched on two stick figures with space helmets, side by side, standing on the platform, holding onto some kind of rail. "We call it the open cockpit design."

"Jesus," Jays breathed.

"Well, we had to keep the weight down," Frank said. "It was a strong, closed design." He sighed. "But we never got to build it, of course. And we couldn't do it now in a couple of weeks. So I guess we can't use any of this." He made to crumple the napkin, but Geena covered his hand to stop him.

"Hold it. What about the *Shoemakers*?" Henry's unmanned sample-return probes. Two flight models and a fully functional test model, now sitting in a white room at JPL, unused, canceled, requirements deleted.

Frank put her through another of those long silences of his.

Then he said, "In fact, the *Shoemaker* design bor-

rowed from some of the conceptual work we did on the manned lander. Building the structure around the tanks, for instance. But now—shit, you're talking about using the *Shoemakers* to put humans on the surface?"

"Why not? Those sample-return packages must be heavy. The mass estimates are—"

"Comparable." Frank pulled his lip thoughtfully.

"But," Jays said, "those robot probes are designed to land themselves. What's the pilot going to do?"

Geena took a deep breath. Here I go breaking another piece of NASA conditioning. "Jays, *it doesn't matter*. Not for this mission. If this would work, if the *Shoemakers* would get us there, we should accept giving up control."

"Oh, sure. And would *you* fly this thing?" Jays asked. "Would you risk your ass on some hacked-over piece of shit that was meant to be unmanned, ride it down in your space suit, without even *piloting* it, for Christ's sake?"

Geena thought it over. Realistically, if I push this through, then this isn't an academic question. It really could be me. With no abort options or training or—She forced a grin. "Hell, yes. Wouldn't you?"

Jays was thoughtful. "I don't know," he said at last. "That's the honest truth. I don't know. And I've been there."

"We could probably give you some control," said Frank. "I'm not too familiar with the *Shoemaker*'s specs . . . some kind of override option during the final powered descent. Just in case you found yourself coming down on a crater wall or some such. But—" He shook his head. "I got to tell you I don't see any way we could get those crates man-rated. Not in the timescales you're talking about."

"Well, I accept that," Geena said. "Here's another break with the culture. This isn't going to be a safe mission."

"That's for sure. Just figuring out the abort options will be—"

"There may be *no* abort options, for long stretches of

the profile," Geena said. "But it doesn't matter. Not this time."

Frank eyed her. "It seems that somebody wants to go to the Moon, real bad."

She said, "We're all going to have to think out of the box on this. If you can make this fly, we'll go anyhow, and accept the risk."

Jays thumped the table. "Damn it, I've waited since 1961 to hear someone say that. If we'd been grown-up about the risks, accepted our casualties, we'd be orbiting fucking Jupiter by now."

Geena saw Frank blanch. It was a common enough view, but Frank had spent a working lifetime being coached in the opposite direction. She leaned forward to cut Jays off.

"Suppose we can make the lander work. What about the rest of it?"

Frank looked warily at Jays, before turning back to Geena. "Well, we're still in trouble. We never did build that handy Orbital Transfer Vehicle, so we got nothing to push us from Earth to Moon."

"But we do have the PAM-Ds," said Geena. "And the IUS." The Payload Assist Modules and Inertial Upper Stages were small boosters carried into orbit in a Shuttle's payload bay, to boost satellites to geosynchronous orbit, or send interplanetary probes on their way.

Jays laughed. "The 'I' in IUS used to stand for 'Interim,' because it was only supposed to be operational until the OTV came along. When they found out they would be flying it in the 1990s, they figured they'd better change the name."

Frank said, "The PAMs won't work. Sorry. They're spinners. That is, they depend on spinning for stabilization and thrust-vector control."

"And we couldn't modify them—"

"Not quickly. Besides, the performance of those solids sucks. It would make for a huge translunar injection propellant load. You'd need a *lot* of IUSs to—"

Geena said, "What other upper stage could we use?"

Frank eyed her skeptically. "That's the spirit. But I think we have a hole here. What we need is a Service Module like Apollo's, or an OTV, but we don't have either of those."

Jays growled, "*We* don't."

"What do you mean?"

"We aren't the only players here. I remember the security briefings we got during Apollo. I'm talking about '67 or '68. The CIA got worried the Russkis were getting close to a manned circumlunar flight, because they launched this thing called a *Zond* and reentered it. That was why we bumped Apollo 8 up to a lunar orbit mission; it was slated as an Earth-orbit flight."

"Oh," Frank was nodding now. "Oh, you're right. The Russians were testing an upgraded lunar-mission Soyuz, complete with a new Service Module stage called a Block-D. They launched it on a Proton booster. It all fit in with their lunar landing plans, that they scrapped when their N–1 booster kept blowing up on them."

Geena smiled. "And the Block-D—"

"Is still flying. They use it as an upper stage on their commercial Proton launcher."

"And so—"

Frank started to sound quietly excited. "And so we could use that, along with a beefed-up Soyuz, as the equivalent of the old Apollo Command Service Module. In fact, since the Block-D is a kerosene-oxygen, it should have a better performance than Apollo did. For the old *Zond* missions the stage must have imparted about ten thousand feet per sec. With the added mass of our lander outbound—" He scribbled on another napkin. "You're looking at plenty of gas for both the lunar orbit insertion and Earth-return burns." He looked at Geena, eyes wide. "What are we missing? Suddenly this is too easy."

Jays nodded vigorously. "Soyuz to the Moon. Has a ring to it, doesn't it? Of course they're still flying that baby

up to Station, but it's an Apollo-era ship. Shit, I think it predates Apollo." He laughed. "And believe me, if you find yourself flying one of those, it will make riding down to the Moon without a cockpit look like a cakewalk."

Geena said, "So now we just have to figure how to get that combination on the way to the Moon."

Jays said, "The highest performance stage we've got is the Centaur."

Frank shook his head. "Won't work. Liquid hydrogen. It would take a couple of them—and we'd have to launch on Titan IVs—but anyhow the LH2 on the first one would boil away before we could launch the second. Those stages are only designed for a couple of hours on orbit."

"How about the IUS?" Jays asked. "They can go up on Shuttles or Titans."

Frank pulled his lip. "Their performance is poor compared to the Centaur."

Jays grinned. "So take more. Four, maybe?"

Frank scribbled quickly. "Actually, three would do it. Hmm. I guess you could launch the first on a Shuttle, second on a Titan, and the third on another Shuttle, then use that orbiter to assemble the stages."

Geena said, "And the Soyuz—"

Frank put down his pen. "Easy. Send it up unmanned with the Block-D on a Proton, like they did with *Zond*. Autodock to Station—"

"We'll need the Progress autodock module, then."

"Yeah. Transfer the crew from Station. Then haul over to the IUS assembly, dock—and go to the Moon . . ."

Geena asked, "You think the Russians would agree?"

Jays said, "You told us you could command the resources this would need. Anyhow," he said, eyeing her, "I hear you have contacts of your own over there. Maybe that could, umm, smooth the way."

He was right, of course. Although it added another layer of complication. Not only was she going to have to campaign for this ridiculous lashed-up lunar mission, but

she was also going to have to get her ex-husband and her Russian lover to work together on it . . .

Frank, frowning, started to sketch in a Soyuz on his napkin: a pepperpot, with fragile solar wings.

"Holy shit," he said respectfully. "Maybe it will work. I think we could do it."

"Hell, of course we can do it," Jays boomed. "Makes you think, though. What did we learn in all those years of flying Shuttle, all those billions of bucks, to help with this, when the chips are down? I'll tell you. Diddley."

Geena said to Frank, "Can you turn this into some kind of formal recommendation?"

Frank said, "For what audience? . . . Never mind. We can cover that when we have the material. We have a lot of studies to do. The conversion of the *Shoemakers*. Looking into the IUS. Figuring out the Soyuz option. Confirming the mass estimates. Figuring out what you'd need on the surface—what about EVA suits, for Christ's sake?—and then there's the operational stuff. Assembly at the Station. Who and how? Looking at the launch manifest for Shuttle and Titan and Proton, figuring out what can be bumped . . ." He looked at her nervously. "You know, it doesn't pay to go into these things just one chart deep."

"I understand. I'll start pulling strings. If," she said heavily, "you think you can do it."

"Oh, I can do it." He grinned. "After all, everything's off the shelf."

Jays said, "You say you put forward this kind of proposal a few years ago."

"Yeah," said Frank. "An internal study. A little less improvised, of course—"

"What happened?"

"It was too expensive. We aimed to get back to the Moon for less than a billion bucks. We still found we came in at nearer two billion."

Jays belched. "Hell," he said. "Speaking as an old Air Force man I can tell you that's the cost of *one* B–2A Spirit

bomber. A return to the Moon, for that. What a waste. What a fucking waste." He grabbed the empty bottles. "Where's the waitress? You want another?"

They all did, and before the waitress could clear the tables, Geena took the napkins Frank had sketched on, and folded them carefully, and put them away.

They stayed for more beers, long into the night, and the Outpost got steadily more raucous.

24

. . . There was a quake in Seattle, in fact, on June 1st, the day before Joely Stern moved there.

For a vet of L.A. like her, it sounded like no big deal: Richter five or six, hardly enough to slosh the water in the bathtub, even if it did send enough dilute mud out of Elliott Bay to flood the Waterfront Park and knock out the streetcars. But it sent the locals into a spin, coming so soon after the Rainier eruption.

And anyhow just then Joely had bigger problems on her mind.

Like negotiating her pay at Virtuelle, which still hadn't been settled even when the company's big eighteen-wheeler had turned up at her apartment block in L.A., and the movers had loaded up everything, right down to her *car,* for God's sake.

She had gone in pitching at eighteen hundred bucks a week, but the executive who hired her, in the end, managed to lowball her to fourteen hundred. And on top of that she would lose twenty percent to the employment agency Virtuelle were recruiting her through, which in turn meant that she was engaged not as a staff employee but as a perma-lancer, no health benefits or pension or stock options. And by the time Uncle Sam had taken his cut she was left with little more than eight hundred a week, which felt like a defeat, even if it was more than she had earned in her twenty-seven years . . .

But she went to Seattle anyhow.

She spent a day exploring, and she immediately fell in love with the place.

She liked its topography, the way it was folded over the compact hillsides above its bay. She liked being able to drive from snow-capped mountains to a yacht-filled Sound in half a day. She liked the Elliott Bay Book Company, whose boast to stock every book in the world she was not able to invalidate with her standard three-title test set.

Work was a little iffy, though.

Virtuelle's campus—all paid for by the unexpected profitability of the world's first successful virtual reality E-zine—was a carpet of neat quadrangles of grass, separating three-story office buildings like children's blocks, gleaming blue glass, identical save for their red numbering. The bottom story of each building was an open car lot, so that the buildings were fat, top-heavy boxes held up there by skinny little beams of reinforced concrete, all of it a little rickety in the eyes of a Californian.

She spent most of her first day sitting in a cubicle before a blank screen, waiting for her magnetic photo-ID key and her E-mail address to be allocated her, without which, as far as she could tell, she didn't really exist here, and she certainly couldn't go anywhere or *do* anything.

The cafeteria—where a kindly security guard bought her coffee and a sandwich for lunch pending the day her IDs arrived—seemed to be the centerpiece of the campus. It was a spectacular multilevel glass cylinder built around a chunk of bona fide Berlin Wall, laden with graffiti, and giant posters of happy customers, overlooking a sparsely populated food hall. There was, bizarrely, a stream running right through the middle of the hall, with little stone bridges spanning it.

White security vehicles openly toured the campus. There seemed to be video surveillance in most office areas. She couldn't receive faxes; these arrived at a central drop point and were distributed throughout the campus. A

notice over her desk reminded her that even her E-mail could at any time be subpoenaed by the Justice Department.

A slow start, then.

On her third day, though, once her E-mail alias had been allocated, she arrived to a blizzard of mail, almost all of them utterly irrelevant.

She met her boss once, a pushy New Man who insisted on bringing his three-year-old kid into work every day: fun, but it made serious progress impossible, although he didn't seem to recognize that.

Still, he gave her a first assignment: a major feature on the Rainier blowout.

There was no shortage of material, of course, a lot of it gripping and dramatic, much of it in IMAX or 3-D formats. Here were the first ash eruptions, small, but sufficient to shroud Rainier's snow-capped peak with black streaks. Here were the geologists earnestly studying the bulge that had grown out of the hillside at a rate of yards a day, in a time-lapse sequence visible to the naked eye.

Then came the sharp earthquake that dislodged the giant avalanche of ice and rock from the northern face of the mountain, releasing the pressure on the superheated groundwater and magma beneath the volcano.

And the explosion. Half of the remaining peak was torn off, like a cork popping, hurling the fragments across five hundred square miles of forested ridges, the biggest seismic event in the Cascades since Mount St. Helens.

A whole set of last words, distorted and stark.

Here was the geologist from the USGS who had been measuring the bulge, and when the explosion came, just had time to radio his headquarters: *Vancouver—Vancouver—I think ...* Here was the old Navy guy who had been manning a Department of Emergency Services volunteer warning station a mile north of the avalanche,

who had coolly described the avalanche, and how it over-whelmed his partner a half-mile away, and even how, in the end, it came to get him too.

Great pictures, of course. Gas, billowing out of the exposed magma body for twelve hours, jetted ash high into the sky and sent ash flows down the shattered north flank. Rivers of mud flowed down the miniature valleys that drained the mountain. A little town called Orting was over-whelmed with ash, but not before heroic feats of evacuation led by the guys from VDAP, lots of human interest stuff.

Volcanic ash even rained down on the Seattle-Tacoma area, in some places inches thick, covering cars and pedes-trians and sidewalks, tire marks like snow.

Well, it was a hell of a thing, and even given the cover-age it had already, would make a great virtual feature.

And of course the most interesting aspect was how this was all connected to the Edinburgh explosion.

She tapped into the buzz about the volcano plague that was spreading around the world. But she couldn't get any responsible geologist to comment on that.

Most of them said they weren't too surprised by Rainier's eruption. For hundreds of years Rainier had been subject to erosion from the weather outside, and from sim-mering magma inside. The magma had cooked the innards of the mountain to unstable clay. Rainier had, they told her, gone rotten, and the big bang had just been waiting to hap-pen; it hadn't taken much of a seismic jolt to kickstart the eruption.

But why now?

Of course the volcano plague was the world's biggest story: a string of disasters, big and small, widespread and localized, following in the wake of Edinburgh. In addition to those directly affected—including the injured and the dead, already too many to count—*everyone* was feeling the knock-off effects.

Air flights and shipping had been disrupted. The ash in

the air worsened what Venus had already done, and disrupted crops worldwide. In the U.S., prices in the stores were sky-high on some items. Elsewhere, people were already starving. Or rioting. Or going to war.

Right now things—the world—seemed to be holding together. National governments were handling their local emergencies—but the services were stretched. International cooperation was collapsing. Peacekeeping troops were being flown home. Trade was crumbling, and some nations were threatening protectionism.

There were already politicians calling for a "Fortress USA" mentality.

It was bad, and getting worse, steadily.

But what interested Joely was Rainier. Was its eruption part of the plague? If it was, could they expect more of the same?

Just coincidence, the geologists said. *Probably.*

Some of them admitted to her they didn't know enough about the plague to be sure.

Of course there was always the nutty fringe, who held that the whole planet was doomed, like Venus.

Still, when you thought about that, the assumed geological stability of the Washington region was kind of odd. After all you had Alaska up the coast and California to the south, both plagued by devastating quakes. Why should Washington be spared? The locals just assumed it was so, despite Rainier. Not *here,* not in Seattle . . .

She spent some time digging a little deeper into the online libraries. And, slowly, she began to piece together an answer.

Seattle-Tacoma was sitting on top of an area where one tectonic plate was diving under another.

An ocean floor plate called the Juan de Fuca Plate was spreading out from a center somewhere in the Pacific. When it hit the North American Plate, a little ways offshore, it dived beneath it, back toward the mantle. Subduction, this was called.

So in the place where the plates were in contact, they rubbed over each other.

But not smoothly.

Part of the fault that separated the two plates remained locked. So the continental plate was *bending,* like a board bent over a table, folding under itself to follow the ocean plate.

The continent could bend so far, as if it was made of rubber. But eventually it would snap back into place. And then—

Well, the technical journals were a little light on detail on what would happen at this point.

There were few severe earthquakes in the area's historical record, she found. But then it was only two hundred years since the first Europeans, including Captain Cook, visited the region, and "history" began. And there were plenty of earlier disasters reported in the oral histories of the region's original inhabitants. Such as the big quake that struck Pachena Bay, on the west coast of Vancouver Island, one winter night: in the morning the village at the head of the bay had gone . . .

After a couple of days, the work even started to get to be fun, as her mix of 3-D video clips, sound and prose scraps started to assemble itself into something resembling content.

But every time she called somebody, even internally, to discuss the project, she had to sign a non-disclosure form. After a week, Joely was seriously wondering how long she was going to survive here.

Still, she found herself a nice apartment in Bellevue, with a fine, if distant, view of the Sound, and she had the eighteen-wheeler unload the rest of her stuff.

After her first week, though, there was another quake, and a childhood memento—a snowscape of Disneyland that had survived three decades in L.A.—fell off a shelf and smashed, spilling plastic snowflakes all over the carpet.

It was irritating. If the big quake hit before she filed

her feature, she would lose her angle, and probably her job . . .

She worked faster.

25

Henry called Jane.

The truncated family were still in the semi-private little nest they'd carved out for themselves in a corner of the theater—three cots and a cupboard—and they were settling down to sleep.

Ted held his mobile phone out to Jane.

Jane answered it, and then held it away from her ear, as if it was hot.

"How did he get my number, Dad?"

Ted just grinned, of course, a look that had infuriated her since long before her fourteenth birthday, when the old fool had first started to meddle in her love life. He turned away on his cot, and picked up the dog-eared copy of *The Day of the Triffids* that was doing the rounds of the Rest Center's informal lending library.

Jack was already asleep.

She didn't have much choice.

"What do you want?"

And how are you? I'm amazed you're still there.

"Your pet the Moonseed hasn't been doing too many of its tricks recently."

It's working subsurface.

"That's it, look on the bright side."

You've only gone six miles in three weeks. You're crazy.

"But things have calmed down here, Henry. You ought to see it. The evacuation has become a lot more orderly. There are even classes for the kids. The Government seem to be thinking long term now."

Long term?

"Where to locate the thousands—hundreds of thousands—who had to flee Edinburgh, how to feed and house

them, how to find them new jobs. How to rebuild the businesses that were lost. We've been helping to run the Rest Center." She ruffled her sleeping son's hair. "Even Jack." Maybe especially Jack. "You learn things about yourself." Like, I've learned I can stop a fist fight over a smuggled-in bottle of booze. "Ted doesn't want to leave until he's sure about Michael."

You should have gotten farther away.

She shifted, folding her legs on the bed and propping her chin on her knees. "You're getting irritating, Henry."

At least you're not paying for the call.

Anyway, she hadn't wanted to go further. She was comfortable here. If she was honest with herself, she knew that if she moved, she would have to face the bigger picture again, and she was reluctant to do that if she didn't have to. Here, she was in control, at least of the small things in her life.

The psychology of disaster: *denial, anger, withdrawal, acceptance.* It dismayed her to look into her own heart and find herself working her way through the textbook.

"So where are you? The Moon?"

Might as well be. I'm heading for Washington. Trying to get them to take me seriously.

"Any success?"

I'm getting tired of meetings with people in suits. Decisions. Directives. None of it is real, Jane, compared to what's happening out there. The physical reality of the Moonseed, in the rock. You can't executive-order all that out of existence.

"I understand."

. . . And people always want to believe it's going away.

His voice was flat. Something had changed him.

"Henry, what are you trying to tell me?"

There was silence for long seconds, digitally perfect.

I've been working on the science out here. Options to stop the Moonseed. Short and long term. Teams of us, across the planet. And I've become convinced.

"What about?"

That we can't stop it.

She tried to take that in. "There *must* be a way."

No. No happy ending, Jane. No neat solution. It doesn't work like that, it seems. The Moonseed is implacable.

"Is this why you called me?"

No. Yes. I suppose so. It's difficult. Jane—do you believe me?

She massaged her forehead. "I don't know."

The trouble is, we have no one to surrender to.

"I'm not joking, Henry."

Neither am I. I'm sorry.

"How long—"

The math is uncertain. Earth is big. Decades, probably.

"This wasn't the future I expected when I was growing up."

You, the great prophet of environmental doom?

"I think on some level I believed we would be able to do *something*. We were making a mess of the planet, fine, but it was within our capabilities to stop. All we needed was the will. And then there's the movies. Science fiction. Disaster films. The world is ending, but the heroes can always *do something*."

Yeah. But in real life the future was always finite, Moonseed or not.

"Not this finite. We used to talk about a billion years, Henry. Now you're talking about decades . . ." Not even long enough for Jack to have kids of his own, and watch them grow, and grow old himself. Whatever years he does have, he'll spend on the run. Fleeing from the bloody Moonseed.

Henry said, *All any of us can do is our best, by each other, by whatever duty we perceive.*

"Not much comfort."

I'm sorry, he said.

"It's not your fault. It's not anybody's."

No. Not even Mike's.

"Are they going to send people back to the Moon?"

That's what I'm campaigning for. I suppose it would be another one in the eye for astrology.

She laughed, softly. "Tell me your birthday."

He told her.

She thought for a while. "Well, there you are. Your sign is Sagittarius, the sign of exploration. The sign that's linked with spaceflight. And your dominant planet is Pluto. Planet of transformation. So the omens are good."

Gee. How spooky.

"Of course I don't believe in astrology. But then I'm a Scorpio, and Scorpios are always skeptical."

A long pause, transatlantic crackles.

For a while I'm not sure if I cared if it ended or not. But now I've met you. And—

"What?"

His voice was hesitant. *Do you think we could have had a future together?*

"Hell, I don't know." She laughed. "I suppose it's possible." She thought it through more carefully. "Yes. It's possible. We would have had some incandescent arguments."

I'm sorry I walked out on you, the way I did.

She took a breath. "I understand."

The truth of it was, she did understand. It was as he'd said. *All any of us can do is our best, by each other, by whatever duty we perceive.*

It tore me apart.

"But you can't expect a mother to see it your way. Right then I'd have mobilized the resources of the planet to unite me with Jack if I could, for one more day, and to hell with the rest."

I understand. Anyhow, that's the reason.

"What?"

The reason I care. It's you, Jane. You, and Jack, and even Ted and Mike, damn it. It's you. It took me a while to figure it out . . . The world can end, but not if it takes you.

Henry's voice, accent enhanced by the phone's tiny

speaker, was a dry whisper, from a million miles away. Dust blowing across the dry bottom of one of those lunar seas, she thought.

"For Christ's sake, Henry," she said, "you're the nearest thing to a hero I've got. If you feel like that come up with a better option."

I don't feel like much of a hero.

"Listen," she whispered. "Here's something to protect you. *I see the Moon, / The Moon sees me, / God bless the priest / That christened me . . . / I see the Moon, / The Moon sees me, / God bless the Moon, / God bless me.*"

Pretty.

"Yeah. Now you try it."

The words came drifting back to her. *I see the Moon, / The Moon sees me . . .*

26

As it turned out, Frank Turtle responded quickly, and, using some of the material from his failed return-to-the-Moon pitch, Geena and Frank worked up a convincing-looking presentation within a few days.

They had Jays and others dry-run them, and then they presented to Harry Maddicott, JSC director. He sat, sleek and replete with lunch, as Geena and Frank worked through the spiel tag-team style. But Maddicott was more supportive than Geena had expected. He advised them to take it to at least one more center before going to the NASA Administrator, however.

So the next day they flew down to Alabama, to the Marshall Space Flight Center at Huntsville. This was the center which had originally been built up around von Braun's core team of German rocket engineers; this was the center which believed its engineers had pulled off Apollo-Saturn despite the dead-weight of the rest of NASA, and in their approach to engineering they were as conservative as all hell.

The review was tough, confrontational, detailed, laced with that conservatism. *Von Braun didn't fly to the Moon that way, and we sure don't need some kid from Texas coming here telling us how to fly to the Moon now.* Soon Frank was sweating, trying to cover questions to which he hadn't had time to assemble answers.

But Geena kept pushing. She had the group break into study forums to thrash out issues, and had Frank make conference calls to Houston and other centers, and soon Frank's rough sketch was being worked into something credible. And, once the Marshall guys started to believe that, hey, this was something they could actually *build,* they got remarkably enthusiastic. They even started to advise Geena and Frank on how to present to the other centers.

Jays told her she shouldn't be surprised by the speed of all this. "Hell, we did this before. We've been to the Moon. The Moon is a walk around the block. And we've been waiting thirty years to be asked to go back . . . These Marshall folks are tough on bullshit, but they *want* to make this work."

And then, only four days after that brainstorm in the Outpost, Geena found herself in NASA Headquarters in Washington, briefing someone called the Associate Administrator for Exploration, and at last the NASA Administrator herself.

The Administrator, a tough woman of fifty with a helmet of steel-gray hair, made a decision after thirty minutes. "She has kind of a lot on her mind right now. I'll take it to the President myself."

27

Monica Beus distrusted Henry Meacher from the moment he stood at the lectern in front of the OSTP.

She knew he'd just come from giving testimony over in the Russell Senate Office Building on Capitol Hill, before the Senate committee on commerce, science and transport.

And now here he was in Room 476 of the Executive Office Building to give a briefing to this subcommittee of the Office of Science and Technology Policy, which reported to the President herself.

Monica was at one end of a long conference table with Henry's lectern at the far end, together with an overhead projector and a laptop computer, and three members of the President's science team, boosted today by a suit from the Pentagon: Admiral Joan Bromwich, Vice Chairman of the Joint Chiefs of Staff. The Building was next door to the White House itself. In fact, when Monica looked past the small window-unit air conditioner and out the window she was looking along Pennsylvania Avenue.

So it was a big day for Henry, maybe the biggest in his career, the clearest sign there could be that Washington was taking him and his dire warnings seriously. And yet here he was standing at the lectern in dirty jeans and a shirt that looked as if it had been slept in and his thick black hair like a mop: the picture of disrespect, or independence of thought, or unconventionality, or whatever the hell other Hollywood-scientist clichés he thought he was projecting. How were the suits sitting around the table *supposed* to respond to him?

And how was *she* supposed to get through today, before she got back to her apartment, found the blessed oblivion of a few hours sleep?

Just don't embarrass me, she thought. She, and many others, hadn't forgotten how Henry had shot his mouth off on TV and the Internet and in the newspapers to campaign, over the head of NASA management, for his doomed *Shoemaker* missions. It didn't help his credibility, today. She'd had to put her own reputation on the line to bring this meeting together. She would be very damaged if Henry fouled up today. Just don't embarrass me.

She was surprised, in the circumstances, how much that still mattered.

And she was glad Alfred was here. She'd even, on his

advice, consented to wear a hat, so the attendees could con-
centrate on the matter at hand rather than her latest
chemotherapy Bad Hair Day.

She gathered her strength. "Let's start."

A rumble of assent from around the room.

"Dr. Meacher, have you prepared a formal briefing?"

Henry tapped at his laptop, and images filled the pro-
jector screen. Maps of Earth, molecular structure charts
and equations, energy expressions. He began without pre-
amble. "We established conclusively that the Edinburgh
outbreak flowed from the Moon rock, Apollo sample
86047."

"Fucking careless handling," Bromwich growled.

Henry wasn't fazed. "We were doing geology. Not epi-
demiology."

Monica said, "I don't think apportioning blame is
helpful right now, Admiral."

Bromwich glowered.

"Anyhow," Henry said, "that was the primary source.
We've been able to trace secondary outbreaks, in the U.S.
and elsewhere, to the ash cloud that spread out from Edin-
burgh, through the stratosphere, around the planet."

An animated image of the Earth. Lurid red pimples
appearing everywhere. First they came in a belt at about
the latitude of Britain, spreading westward, across the U.S.,
Asia; and then more pimples and scars in most of the world's
geologically unstable regions: the Ring of Fire, the subduc-
tion volcanoes around the Pacific basin; the rift volcanoes
in the middle of the Atlantic and other midocean ridges;
the hot-spot volcanoes, like Hawaii. In other places, more
usually stable, the Moonseed seemed to be making its own
volcanism by just digging its way toward the asthenosphere
through old flaws in the crust, such as at Edinburgh itself.

Henry said, "The data here comes from worldwide
sources, including our own USGS Earthquake Information
Center in Colorado and the Large Aperture Seismic Array
in Montana—"

The Admiral said, "Dr. Meacher, tell me what's going to happen to us from here on in."

He started to pull up charts. They showed the past records of cataclysmic geological events: volume of eruption, in cubic meters, plotted against repose time, in thousands of years . . . "Even for what's likely to hit us in the short term, we have no precedent in historical times. The larger the magmatic event, the less frequently it occurs. But we have evidence that many eruptions in prehistoric times were larger—ten or a hundred times—than the huge eruptions we know about, like Thera and Tambora."

Thera destroyed a civilization. Tambora was the greatest ash eruption of the current geological period; it caused the Year Without a Summer, in 1816. *Ten or a hundred times as large.*

"Are you saying," Admiral Bromwich said, "that some of this stuff is—normal?"

"Yes. We've lived, as a species, through a quiescent period in Earth's geological history. The Moonseed is a lubricant. Enhancing the problem. But what's hit us so far is the violence of Earth itself, Admiral. A lot of this stuff could have happened at any time.

"Beyond this near-term stuff we're predicting a timetable of escalation."

"A timetable?"

"Depending on the thickness of the crust. In a month the Moonseed will penetrate oceanic crust—the sea bottom—where the plates are thin. Six weeks, a couple of months beyond that, we expect major events in plate boundary regions. Subduction zones, mountain-building areas, like the Pacific rim. And a month or so beyond that we'll see the first breaches of the continental crust itself."

There was a brief, shocked silence.

Henry delivered this with a chilling calm, Monica observed. He looked overworked, but calm. Hollow. He's already accepted the logic of his argument. And its ultimate

conclusion. That all this is just going to get worse and worse, until—

I hope to God, she thought, he has a plan.

Bromwich shook her head. "What do we tell the President?"

"Aside from the direct damage, expect climate changes," Henry said. "All that ash in the stratosphere, blocking out the sun. The injection of so much heat, greenhouse gases, destruction of ozone—we have to model this. Figure out what it means for crops, this year and next."

"Shit," said the Admiral, and she scrawled notes on a pad in front of her. "Refugees. Crop failure. Starvation."

"We'll be lucky to avoid war," Alfred said.

"The British are already dealing with this," Monica put in.

"We're not the damn British," Admiral Bromwich growled.

Henry said, "The point is, we're only seeing the start. This isn't going to go away. We're going to have to expect a movement of populations, from the more geologically unstable areas of the world, and from the areas most impacted by the Moonseed itself, like Scotland."

"A movement? Where to? Where is the safest place to be?"

"Shelters," Henry said. "Like greenhouses. Maybe subsurface. Maybe off planet."

"Off planet?" That surprised Monica. "How? To make a colony viable, you'd have to sustain a breeding population—say, several hundred—independently of Earth." Even the Space Station, which in its present form could hold all of three people at a time, depended on almost continual resupply from Earth.

The Admiral said, "Where the hell? Mars?"

Henry shook his head. "Not Mars. Too far. Too difficult."

Monica said, "Mars or not, we don't have the technol-

ogy to sustain a colony off planet. If we had another century—"

"But we may not have another century," Henry said evenly.

"Australia," Alfred Synge said.

"What?"

"Australia. The oldest place in the world. All the mountains worn down to a nub. That's where I'd go."

That didn't help, Monica thought, watching Henry. He has some recommendation. Some case he's building, carefully. He isn't ready yet.

I can't read this guy. I wonder what the hell he wants.

Henry pulled up another chart. "That's the short term. Further out, we have to expect something like an extinction event."

Bromwich frowned. "I thought it was some big rock from space that killed the dinosaurs. I seem to remember listening to one of you assholes pitching for a Star Wars system to blast the rocks out of the sky. Like the one that's coming in 2028—"

"The Cretaceous extinction was actually relatively minor," Henry said. He pulled up more data from his laptop. "The Permian event was maybe the most significant Earth has suffered. Two hundred and fifty million years ago. A single giant continent, Pangaea, dominated the planet . . . Half the number of known marine families disappeared. Only two out of a hundred and thirty genera of brachiopods survived. All forty genera of the large fusulinid foraminifers were—"

"Enough," Monica said.

"All told," Henry said, "we lost eighty-three percent of marine invertebrate genera, three-quarters of the amphibian families, eighty percent of the reptilian."

"A fucking big rock," Bromwich said.

"Probably not a rock," Henry said. "Violent volcanism is the best hypothesis."

"You say," David Petit said. Petit was a Nobel Prize

winning chemist, a thickset man with a Brooklyn accent. "Others don't agree—"

Bromwich snapped, "And is this where it will stop? With this—Permian shit?"

"No," Henry said. "Ultimately, the mantle infestation will be the most serious. When the Moonseed is spreading *under* the crust."

"Why?"

Monica saw that Bromwich still didn't understand.

"Because," she said, "it will blow the crust off the planet."

"Like Venus."

"Yes, Admiral. Like Venus."

Silence, briefly.

Henry brought up molecular structure charts and scanning microscope images. "We think we have a handle on how the Moonseed works. If not why. It primarily attacks basaltic rocks, particularly those rich in olivine."

"Like the Earth's mantle material." That was Alfred. "And comet dust, and primordial debris."

The Admiral asked, "Primordial?"

"Left over from the formation of the Solar System," Alfred said. "Admiral, this thing feeds on the most basic rock suite in the universe. It is well adapted to conditions in this universe. More so than we are, in fact. We should have suspected the existence of this thing. Even logically deduced it."

Henry said, "It appears to reassemble the crystalline structure of a mass of rock in a recursive form which—"

"In English, doctor," Monica said.

He brought up another image. A slice of rock, the crystal structure picked out with false color. A maze of dwindling tunnels, disappearing beyond the resolution of the 'scope into some invisible center, a heart of darkness.

"It is changing the structure of the rocks it touches. Building something." It was a kind of bootstrap process, Henry said. The manipulation of the outer layers of a crystal

structure enabled the more detailed rebuilding of inner layers, which in turn enabled changes on a still smaller scale . . . and so on. Like waldos, Monica thought, each layer of miniaturization building the next level down, on to invisibility.

"There is a certain logic in this," Alfred mused. "Between planets, where resources are scarce, one might expect an evolutionary drive of this type. Toward the very small—the utilization and building-in of complexity into even the smallest grains of matter available."

David Petit, the chemist, locked his boxer's hands behind his head. "Your qualifications are all in geology, Dr. Meacher. True?"

"Yes."

"Not in chemistry or particle physics or biology."

"That's true." Henry was quite unfazed.

Petit stopped there, satisfied he had made his point. For now.

Alfred Synge said, "Of course maybe this isn't some kind of geological thing, or even biological. Maybe this is nanotech. By which I mean the manufacture of materials and structures with dimension less than a billionth of a meter. Molecular machines—"

That started an argument.

"Nanotech is on our own horizon," insisted Alfred. "We can manipulate atoms with microscope probe elements, we can use the amino acids to make new, non-natural proteins. We can posit self-replicating assemblers that can take inexpensive raw materials—any hydrocarbon feedstock would do—and produce anything from a rocket ship to a disease-fighting submarine that would roam your bloodstream—"

David Petit slammed the table with the palm of his hand. "Nonsense," he said. "Sure you can manipulate atoms. You can even get them to hold still for a while. But only by cooling your sample down to liquid helium temperatures. At room temperature, the atoms of your assemblers will start combining, with the ambient air, water, with each

other, whatever medium your assemblers are floating in.

"And what about the laws of thermodynamics? What about information flow? How do these assemblers get their information about which atom is where, in order to manipulate them? How do they know where they are themselves, to get from their tiny supply depots to wherever they are supposed to be working? How do they get their power for breaking up material, and navigating, and computing?" He turned to Bromwich. "Admiral, this is just more nonsense. Nanotechnology is cargo cult science. A plot generator for lazy sci-fi writers. Nobody has demonstrated *any* of this, outside computer simulations, where of course you can do anything you like."

Evidently, Monica thought, watching him, the good doctor has a beef against nanotech. She wondered which grant application of his had been turned down in favor of some sexy nano-proposal.

Henry said mildly, "I'm not here to defend nanotech. The Moonseed, however, is doing one simple thing: building inward, and smaller. The structure, in fact, seems to be similar on all scales. You don't need much stored information, or computation, or materials transfer to achieve that."

The Admiral frowned. "I wish you scientist types wouldn't argue with each other. So the Moonseed is some kind of artificial phenomenon. We're looking at tiny machines here. Is that what you're saying?"

Henry said, "Maybe they are artificial. Maybe they are alive. It may be that when a life-form is sufficiently advanced, there is no difference. It may not matter anyhow."

Bromwich shook her head, visibly angry, dissatisfied at the speculation and lack of clarity. "Continue with your analysis," she told Henry. "What's this thing *for*? What's the point of rebuilding a rock?"

"Concentration of energy," Henry said.

"What?"

"There is enough chemical energy in a tank of gasoline

ficulty reaching the surface of a planet, from space. They burn up in atmospheres, or are smashed by simple impact, on an airless body like the Moon."

Alfred said, "But if they do get to a planet—"

"If they do," Henry said, "then they transform it. Like Venus."

Petit said dryly, "Explain something else to me. You say the planets are shielded from the Moonseed, by atmosphere and gravity. We brought it here, from the Moon. But how did it get to Venus?"

"We've developed a theory about that too," said Henry.

Petit said dryly, "I thought you might."

"We took it there," Henry said.

"What?"

"You need a soft landing to deliver Moonseed to a planetary surface. The only objects which have soft-landed on the planets are our probes."

"You're saying *we* did this?"

Henry shrugged. "It's a hypothesis. The probes collected the dust from the Lagrange clouds in near-Earth space. Specks in the paint work. And then delivered them to the planetary surfaces."

Petit pulled Henry's laptop toward him. "Give me a minute . . . Ah. The first probe to soft-land on Venus was Soviet. Venera 7. Landed in 1970." He looked up.

"So," Alfred said softly, "it takes a few decades to destroy a world the size of Venus."

The Admiral snapped, "How big is Venus?"

"Similar to Earth," Alfred said. "Eighty percent of the mass."

"Jesus H—So there's our timescale."

"Oh, this is just bull," Petit protested. "For God's sake. There are holes in this you can drive a Chevy through. We've also been to Mars. Mars is only eleven percent of Earth's mass. How come we didn't destroy Mars too? And we know it's on the Moon. How come the Moon hasn't burst like a party balloon?"

"I don't know," Henry said, looking determined. "But I think that's the key, Professor Petit. *The Moon.* The Moon is the key."

Monica asked, "The key? To what?"

But Alfred was speculating again. "You know, you're right, Dr. Meacher. The only way the Moonseed can get to a planetary surface is through the action of intelligence."

"Which means—"

"Maybe that's the purpose of intelligence. Maybe we were *meant* . . ."

There was a moment of silence.

Petit laughed. "Alien nano robots manipulating history, eh? Is that what you're going to tell the President? Should she go on TV with that? Admiral Bromwich, I intend to disprove this absurd scaremongering hypothesis, point by point."

Henry nodded. "Do it. I'll be there to applaud you."

"But in the meantime," the Admiral said, "we have to consider how to advise the President. And Dr. Meacher, for all he's a little swivel-eyed for my taste, is the only one coming up with any scenarios here."

"Thank you," Henry said dryly.

Bromwich said, "I think we have to work on a worst-case assumption."

Petit laughed. "The worst case being the end of the world. In an election year, too."

Admiral Bromwich turned to Henry. "You've told me how bad this is going to get. Now tell me what we should do about it."

"Three things," Henry said. "We know we can slow the Moonseed down, if not stop it altogether, at least before it gets into the mantle."

"How?"

"The structures it forms are fragile. They can be smashed, to put it bluntly."

"We'll bomb the shit out of it," the Admiral said.

"And," Petit said, "when you run out of bombs?"

"Then I'll be on the White House lawn ripping it apart with my teeth and bare hands," the Admiral said. "Where will you be? What else, Dr. Meacher?"

Henry said, "Maybe we can come up with some kind of nano counter-agent."

"I thought you said there was no hope of that."

"I might be wrong. We have to try. But, no, I don't think there is any hope."

He let that hang in the air, for long seconds, maximizing its impact.

Monica studied Henry anew. He was the first to understand this, she thought. There must have been a time, right at the beginning, when only he knew this. Only he, of all the billions on the planet, could see the future. The unfolding of Moonseed logic: Christ, the end of the world. How must that have felt?

Probably, she thought, much like the moment when the doctor, an absurdly young man, had told her, in cool, compassionate terms, that she had such a short time left to live.

If it had been me, would I have had the strength to act as Henry has done? To communicate, to risk mockery and ridicule?

After all, she wouldn't live to see the end, whatever happened.

There is no hope. Yet we must act as if there is.

Yet there was still something in Henry's manner she didn't understand. Something he didn't want to tell them.

Or something he wanted to achieve.

She said, "Dr. Meacher, give us your third recommendation."

"We need to go back to the Moon. To Aristarchus, where Jays Malone picked up that rock."

The Admiral frowned. "Why?"

Because the Moon is the key, thought Monica. That's the center of his case.

Henry said, "We have the question Professor Petit

raised. We know the Moon is infected with Moonseed—*but the Moon hasn't been destroyed*. Why not? We've learned all we can here. Something on the Moon must be inhibiting the Moonseed. We have to understand what."

Monica watched him. This is what he wants, she realized, on some deep intuitive level. The Moon mission. This is what he's seeking from us, today.

But, she sensed, there's something he wants to achieve up there beyond what he's telling us.

But he fears ridicule, obstruction, if he tells us about it . . .

"I agree," she said immediately.

Henry looked at her, surprised. He said, "We have to go quickly. While we still can. Before we're overwhelmed. It may be in a few months we won't be capable of mounting a Moon mission, whether we want to or not."

The Admiral nodded. "How the hell? I thought we smashed up all the Moon rockets, or put them in museums."

"We did," Henry said. "But NASA has a way."

Monica said softly, "When can you leave?"

He looked startled. "Me?"

"Who else?"

"Dr. Beus, I'm a rock hound, not an astronaut."

"Difficult times," the Admiral said. "We all have to think out of the box, Dr. Meacher."

Henry subsided, looking confused, calculating. But he leaned forward again. "There's something else."

"What?" the Admiral said.

"Weapons. We need to take weapons."

Petit gasped. "You can't be serious."

The Admiral considered. "I suppose the premium will be on compactness, lightness. A battlefield nuke, maybe. Lasers—"

"My God," said Petit. "If you were a man, Admiral, I'd say this was turning into a testosterone fest. Nukes to the Moon? We signed the Outer Space Treaty in 1967. If I

remember my history, we undertook not to place in orbit, or emplace on the Moon or any other body or station in space, nuclear or other weapons of mass destruction. We pledged to limit the use of the Moon and other celestial bodies exclusively to peaceful purposes. We prohibited their use for establishing military bases or testing weapons—"

Monica said bluntly, "We signed that treaty primarily with the Soviet Union. A country which doesn't exist any more. We shouldn't let that stand in our way."

"I'll dissent from the recommendation," Petit said.

"That's your privilege, sir."

"You space buffs make me sick. History can be torn up, just so you have your Buck Rogers dreams back again. The Russians—"

Bromwich smiled comfortably. "Who cares about the Russians? What can they do? Think about it. We're now the only superpower on the planet. The Russians can't stop us. So fuck them."

Monica noticed that, as Henry let this dispute run on, he wasn't volunteering what he wanted his weapons *for*.

Alfred Synge was smiling at Henry. "To return to the Moon. You know, I envy you . . ."

The Admiral looked around the table. "Dissenting voices or not, I think we have our recommendation for the President. We back Dr. Meacher's proposal for a Moon mission, if it can be mounted. But in parallel we set up programs to mitigate the effects of the Moonseed, here on Earth."

Henry was nodding.

"And," said the Admiral, "we should continue to study the basic science of the thing, see if we can come up with an antidote. Whatever."

Nods around the table.

Monica was content to let the Admiral take over. She'd expected it anyhow, and she didn't disagree with any of her conclusions.

The Moon mission, though, was going to be the key,

she sensed. That was what Henry Meacher had wanted when he walked in here, and it was what he was walking out with: a manned lunar flight, with a weapon.

Maybe he is smarter than he looks.

As the meeting relaxed into break-up informality, the Admiral drummed her fingers on the table. "Tell me this, gentlemen. Just what in hell are we dealing with here? Underneath all the science. Is the Moonseed here to destroy the world? Like some kind of Berserker?"

"I have a theory," Henry said quietly. "Off the record."

"Off the record," said Bromwich.

"Think about a starship," Henry said.

Petit laughed, sat back in his chair, and folded his arms.

Henry went on doggedly. "It's a slow affair. Restricted to low velocities by relativity, by lightspeed and energy requirements. Maybe it's driven by some kind of low-tech thing, like a solar sail. Whatever. It reaches a star system. Like the Solar System." He closed his eyes. "It's surrounded by a cloud, of something like the assemblers the nanotechnologists talk about."

"The Moonseed," said Bromwich.

"Yes. As it passes through the System, the assemblers hit on local resources. Principally small rocks, floating in space, asteroids and comets. There's an awful lot of that stuff floating around out there; no need to go all the way down into a planet's gravity well to retrieve it. It takes the rocks apart, and makes—"

"What?" Petit demanded.

"I don't know." Henry spread his hands. "Starship parts. I think, if we go back into the Moonseed pools, that's what we'll find."

Petit just laughed.

"But if it does reach a planet," Henry said, "the Moonseed goes further."

Alfred spread his hands. "That's true. Venus now seems to be some kind of black hole factory. Extremal

black holes, which flee at the speed of light. I know it sounds implausible, but—"

"Good God," Bromwich said. "I hate this sci-fi stuff. *Why* the hell?"

Alfred said, "Maybe it's a starship drive. How about that?"

Henry smiled. "Even I never thought of that. A black hole rocket. Well, why not? The exhaust velocity would be lightspeed. The specific impulse—"

Admiral Bromwich was shaking her head. "So where is this fucking starship?"

Henry shrugged. "I don't have all the answers. Maybe the starship has gone. Maybe it was destroyed. Perhaps the Moonseed have been here a long time. It could be the starship got here when the Solar System was forming—lots of debris just floating around, the planets not yet stabilized. The System would be a dangerous place back then—but better adapted for the Moonseed, no planets yet, just a thin cloud of rock flour. The kind of system such a ship would aim for. But dangerous. Maybe it suffered some kind of catastrophic accident."

"And," said Synge, "if the Moonseed has been around that long—"

"Maybe it has evolved, somehow. Or devolved. Maybe it forgot how to make anything except itself. Maybe it forgot how to make a starship drive properly."

"So Venus is a screw-up," said Alfred.

"If there was a ship," Bromwich said doggedly, "where did it come from? Where was it going?"

". . . Maybe there was no ship," Monica Beus said. "Maybe the 'ship' was a hive. Then you don't need to speculate about motive, or destination: nothing above survival, reproduction, propagation."

And as she framed the thought, she shuddered. On some deep level, she felt she had stumbled on a truth, in this insight. My God. A hive. What are we dealing with here?

Or maybe her own morbidity was polluting her thinking. Projecting the cancer that was eating her up onto the whole damn universe.

They talked further, and the speculation, mostly led by Alfred, got wilder.

Perhaps, it was posited, in all this evolution, the imperatives of the Moonseed had got lost, or warped beyond recognition.

Perhaps the Moonseed was actually a *message*, of some kind. Perhaps it would rebuild the Solar System, if it was allowed, into some new information-bearing form. Perhaps the Moonseed was trying to reconstruct the world it came from, or the people who lived there. "Like a transporter beam," said Alfred. A distorted beam, with the information it contained lost or transmuted, into which Earth had strayed. "I think this is just an accident," Alfred said. "We are lucky—"

That was too much for Bromwich; she snorted. "*Lucky?* You scientists really are fuckers." She picked up her papers. "I'll tell you this, though. If this is what we meet the first time we put our foot out the farmhouse door, we're going to find it a tough old universe out there."

David Petit shook his head, disgusted.

The meeting broke up.

28

The day began badly, and got worse.

Ted even had trouble putting on the thick heat-resistant suit Blue Ishiguro lent him. When he bent to haul on the tight trousers and boots, and wriggled into the one-piece tunic, the stitched-up hole in his chest seemed to gape wide open. And when he pulled on his gloves and the hood with its big glass faceplate, the heat immediately began to gather.

Blue—already suited up, a heavy pack of equipment strapped to his back, cameras fixed to his hood and chest— was watching him skeptically.

"Kind of hot," Ted said.

"Yeah. Here." Blue handed him a heavy box, the size and shape of a cat box.

Ted tested the weight. "What's this?"

"For samples. This is science, remember. How many can you carry?"

Soon Ted was laden with four of the boxes, suspended over his shoulder on leather straps; where the straps dug into him he could feel the heat build up further.

Blue was still watching him doubtfully. Questioning his strength, or commitment.

Ted glanced up at the sun, which was climbing the sky. "Are we going, or what?"

Blue hoisted his pack, picked up tools and sample boxes of his own, and set his face to the north, towards the center of Edinburgh, the city of ash.

As he toiled over the rubble-strewn ground, Ted kept re-running his last encounter with his daughter. Their last argument.

". . . What are you talking about, Dad?"

"They say there are still a few hundred people alive in there. Maybe more."

"Dad." It was hard for her to say it, he sensed, as if saying it might make it true. "Dad, Mike is dead. You know Mike is dead. You just want revenge. But revenge against what? The Moonseed?"

No, he had replied. Not the Moonseed. Something more specific than that.

Saying good-bye to her, and Jack, had been harder than he had imagined. But it had to be done. He had a job to do, and he had never shirked from duty before.

Anyway he was too damn old. They didn't *need* him anymore. It was better this way.

Blue and Ted had been dropped off at the city bypass, a deserted motorway-class road, a couple of miles south-

east of Arthur's Seat—or rather, of the hole in the ground where the Seat had been. They walked along the Gilmerton Road toward the city, through the residential areas of Gilmerton and Hyvot's Bank and Inch.

At first there was little sign of damage. Here, the evacuation had been complete: the houses and shops were closed up, and the road was reasonably clear, save for a couple of burned-out wrecks. There was barely a sign, Ted thought, of the calamity that had befallen the city, save for a few inert lumps of rock—lava bombs, said Blue—and the pervasive layer of ash. The ash gave the mundane suburban streets a strange, unearthly tinge, Ted thought, as if the colors had been washed out, only the discarded outlines remaining. And the silence was eerie. No traffic noise. No bird song. No insects.

Only the sounds of the suit, his own noisy breathing, the scuff of the heavy fabric at his armpits and crotch, the soft crunching of his footfalls in volcanic ash.

Like walking on the Moon, he thought.

But the air was still and hot and smoggy, a yellow dome that obscured the sky. There were fires burning somewhere, threads of black smoke that snaked into the sky. And when a road junction gave them a clear view of the Braid Hills, the site of a golf course Ted had played a few times, he could see the steely glint of Moonseed dust.

Blue was dismissive. "That's a new infection," he said. "We want to get into the primary nest, where the Seat used to be. See what the hell the Moonseed becomes when it matures." So he stomped on, setting a tough pace that Ted had trouble matching, even more trouble pretending it wasn't causing him any distress.

They passed the Cameron Toll, and now, barely half a mile from the Seat itself, the signs of damage suddenly became apparent. Volcanic rubble lay everywhere, rocks and pumice and ash; the housing stock was mostly standing, but with shattered windows and roofs, crushed cars littering the silent streets.

And now, around Mayfield, they reached a place where the damage was much more severe. The buildings had been effectively razed, down to their foundations. The area looked something like a schematic street plan, in fact.

Blue grunted. "The pyroclastic flow came here. Hell on Earth, for a few minutes or hours."

The ash was still warm underfoot.

In some places fires had caught, and some of the wreckage was scorched black. The fires had evidently burned themselves out without effective response.

But it was the surviving fragments of normality which were most heartrending.

Here was a scrap of carpet, lingering beneath a stub of wall, scorched at its fringe, thick with ash. The carpet was strewn with little glass beads. At first Ted vaguely thought this was some kind of volcanic effect, but the beads turned out to be marbles, with the pictures of soccer players embedded inside. *Collect all 265!* And here was the skeleton of a carefully designed garden, a layout of gravel and a square of scorched earth that had been a lawn. There was no sign of the flowers that might have flourished here, the trees—fruit perhaps—were no more than charred stumps.

Some of the ruins bore pathetic messages, scraps of paper already discolored by the sun and the billowing ash: notes pleading for Moira or Donald or Petey to meet Janet or Alec or William, at St. Giles' or Waverley or the Meadow Park.

The clearing away of the housing here provided a new, uninterrupted view of Arthur's Seat itself, off to the northeast. But it was no longer the blunt outcrop Ted had grown up with; now there was little left but a few spiky basaltic spires, cracked and scorched, with a final venting of ash and smoke still curling into the air from its heart.

And everywhere was the cold, unearthly glint of the Moonseed, like a poison that had infected the Scottish earth, emanating from this broken-open old basaltic scab.

Up to this point they had been surrounded by the

props of emergency rescue efforts: bulldozers, backhoes, tunnel borers, earth movers, some of them still working. But now they came to a place where no heavy machinery moved: where, amid the Moonseed's silvery glow, only people picked their cautious way.

Blue had a map tucked into a plastic pouch at his waist. Now he pulled it out and showed it to Ted. It was a large-scale Ordnance Survey, marked by highlighters and pencil. "Listen up," Blue said. "This is going to be no stroll in the country."

"I know."

"I bet you don't. Here's what we think. The Moonseed is everywhere: in the ash that coats everything, digging into every exposed chunk of bedrock, working through the subsurface layers. But there are still places we can walk. Places where the surface layers have held together. But they may be—" He was searching for the right word. "Fragile. You have meringues in this country?"

"Yes."

"Like that. We're going to be walking over a meringue, a thin crust of rock. Take a wrong step, and *poof*." He snapped shut his fingers. "That's why there's no heavy equipment here. We'll follow these routes." He indicated the highlighted trails. Other areas, Ted saw, had been sectioned off by hand-drawn blue hatching. Moonseed outbreaks.

"So how do we know where is safe?"

Blue shrugged. "We can't be sure. We do aerial surveys, every day. Debriefs from the soldiers and police and fire boys who work in here." He eyed Ted. "We spend human lives, the lives of civilians or scientists or emergency workers doing their duty. That's what this thing is. A map bought with human lives." Blue faced him, his face a broad round mask behind his scuffed and dirty faceplate. "Now, you listen to me, old man," he said.

"I'm not much older than you."

"Bullshit. I'm taking you in as a favor to Henry, who likes you because he's porking your daughter."

"I wish you'd say what you think," Ted said dryly.

"Only fools like me should risk going into such places. And for sure a dinged-up old fucker like you is just a liability."

Blue's mix of Japanese accent and cowboy phrasing was, Ted thought not for the first time, bizarre.

Blue leaned forward. "Now, I don't give a rip what Henry says. Henry isn't here. If you start coughing and spluttering and wheezing and doing other old-man stuff, you're straight out of here. I want that clear right from the git-go. You got that?"

"I got it."

"Okay. Then let's get it over."

Blue folded his map, and they walked on.

Ted wanted to get as close to the Seat as possible. That was, he reasoned, where he would find what he sought. But Blue skirted west, heading toward the New Town, and he had to follow.

In the rubble of the west of the city, there were more people than he had expected.

Many of them were civilians, poking through the ruins of their homes, business suits and summer skirts stained with ash. Some of them were filthy, their faces grimed by layers of mire; they looked as if they hadn't washed or been properly fed for days. Evidently not everyone had made it to the comfort of a Rest Center.

But there were provisions for people, even here. They passed a Red Cross tent complex, beds and a simple field hospital, and what looked like a morgue. Human life and activity, slowly intruding, here on the surface of the Moon.

A squad of soldiers went by. They wore grimy fatigues, cloths bound over their mouths. They looked exhausted, but they were carrying spades and body bags, on their way to another clean-up. None of them spoke. They looked inordinately young to Ted: probably younger than both his children, not much older, in the greater scheme of things, than poor Jack.

The Army crews had been working here since the volcanism had died away. But there were still many bodies. Ted could see that, just walking here.

Some of them lay where they had been trapped in the rubble of their shattered houses, their limbs splayed, under roofing timbers or steel joists. The corpses were already bloated and discolored, faces swollen to a youthful smoothness, freed of the contortions of pain, the bloody reality masked by the thin painting of ash. In Newington there seemed to have been a more major fire—the buildings were uniformly razed—and in the main road that threaded through the suburb, they came across many bodies, apparently unburned, men, women and children alike, lying scattered across the road surface.

He saw a mother with a baby. The mother had been trying to hold her baby up, away from the road surface. And in that posture they had been petrified.

Evidently there had been some kind of miniature fire storm here. The road tarmac had melted. The people, fleeing the fires, had gotten stuck, like insects on fly paper, and, suffocating, had fallen. Now their corpses were glued in place, cemented to the road surface which had betrayed them.

How must it have been? Ted wondered, staring at the corpses. Not the fact of death itself, but those few seconds, knowing its inevitability: knowing that today was the day, now was the hour, death bursting out of the mundane background of these quiet suburbs; and suddenly there was nothing you could do to protect those you loved, not even the most innocent. How must it have been?

Edinburgh had become a city of tableaux, he thought, of tiny fragments of immense and undeserved suffering, such as this.

Ted and Blue inched around the bodies, trying not to get too close. Flies swarmed, and the stench was powerful enough to penetrate Ted's protective suit.

They walked on into the heart of the city. The heat of the June day climbed.

* * *

At St. Leonard's, Blue cut right, and headed through the few blocks of housing directly toward Arthur's Seat. Ted followed gingerly.

The damage was so extensive here it was impossible to make out even the outlines of the streets. Everything had been smashed and burned and shattered by the ash flow, so that rubble lay everywhere in heaps that looked, from a distance, almost smooth. Easily negotiable. But close to, much of it was actually hot to the touch and unstable, eager to collapse to a more consolidated profile.

Ted found the going much more difficult, with jagged edges of wall eager to trip him, or rip his suit, or send a miniature landslide down on top of a foot or leg. In some places the rubble was smoothed over by layers of pumice and ash, making it still more treacherous, and even Blue was forced to slow right down, and move forward with much more caution.

From the air they must have looked like two silvery bugs, inching their way across the shattered, transformed landscape.

That wasn't the worst of it, though. Here, Ted could *tell* he was close to the Moonseed.

The air was so still. And there was a tinge, a silvery glow, as if the sunlight was being scattered by a smog of iron filings.

At last, the world was reduced to its essentials. Moonscape below, silver-stained sky above, himself and Blue and this rubbly plain, his own breathing, the steady thump of his old heart, the tug of pain at his wounded chest. And as his faceplate grew opaque with the mist of his breath, the fine layer of ash dust he had to keep wiping away, his universe narrowed further, became simpler still.

It was almost peaceful.

He wondered what he would smell, if he raised his hood.

He thought about the Moonseed, and meringues, and the unknown pit of alien forms somewhere beneath his feet. It was as if the Moonseed had turned this place into an alien landscape, not Earth anymore.

Blue mounted a thick slab of wall, breathing hard, and looked back at Ted. "You are doing well."

"Thanks."

"For a geologist this is not so strange, this landscape."

"What?"

Blue waved a gloved hand. "No life. Nothing but minerals. The world reduced to its essence, by the burning power of the alien among us. Come, my friend. Not much farther." And he stepped forward and continued his progress.

After a time, the housing remains ran out. They had reached the western edge of Holyrood Park, the old garden which had contained the Seat, overlooked here by the Salisbury Crags.

The Crags had gone. The Moonseed pool had come spilling out from the Crags in great silvery tongues. But the turf survived, in narrow bridges pushing a few yards more into the Moonseed, evidently fragile. Ted could see the burned and fallen trunks of trees, gray and lifeless on the scorched, ash-strewn turf.

Farther to the east, toward the heart of the Seat, there was only the silver-gray glow of Moonseed light, all the geology and structure there—a billion years of Earth history—reduced to alien smoothness.

"Come on," Blue whispered. "We can go a little farther."

Blue stepped forward, onto a wider neck of ground. He tested every step, as if he was walking onto an ice floe. Ted followed a few yards behind, trying to stick to the footsteps Blue had left in the ash. Fixed to his hood Blue had a chest-mounted still camera and a small video camera—the kind they put in cricket stumps, Ted thought irrelevantly. Blue was working the still camera now, and talking patiently into a microphone inside his hood.

After maybe fifty paces Blue stopped.

Ted came to stand beside him. The neck of blackened turf went on some yards farther, but Ted could see how cracked and fragile it was becoming.

"Notice how it's not advancing," Blue said.

"What?"

"The Moonseed."

"Why?"

"Who the hell knows? Come on. Open your bottles and let's make like we know what we're doing."

Blue crouched and, leaning as if reaching out of a boat, began poking at the Moonseed debris with stuff from his equipment pack. He had probes of metal that he scanned over the pool surface or pushed into it, taking data through wires into his backpack, muttering to his tape the whole time.

Ted squatted down beside him, his knees and calf muscles protesting. He got hold of Blue's belt at the back, near where he had tucked his heavy geologist's hammer. It was like holding a child, leaning over a rail. Blue didn't protest.

Ted looked around, back the way they had come. He was on a neck of land like a spit protruding into a silvery sea. At the "shore" he could see the rubble, the ruined Moonscape suburb through which he'd had to clamber. It seemed a long way away. The closest intact building was a ways away to the west, halfway up Castle Hill, a squat pile of sandstone that looked like it might once have been St. Giles' Cathedral; the old church poked out of the landscape like a beached wreck.

He could see no other humans, in any direction.

In his gloved hand Blue had cupped a small sample he'd taken from the Moonseed surface. "Look at this now. Be careful. It is very delicate."

Ted bent. He had to wipe the ash from his faceplate to see.

It was like a spiderweb; or an autumn leaf; or the skin stretched over the bones of a child's hand. A fragment of

structure, with the finest of membranes stretched between hair-thin spars.

He grunted. "Like something the Wright Brothers might have dreamed of."

Blue laughed. His hand shook, just slightly, but it was enough to shake the fragment to pieces, to silvery Moonseed dust, which fell through his fingers and back to the pool. "It is all but impossible to retrieve such structures intact. They are like sculptures of dry sand."

Ted straightened up painfully; it felt as if there was no blood at all in his lower legs. "Structures?"

"Yes." Blue shifted his position, looking for more samples. "From the aerial shots and samples taken on the ground, it appears that the Moonseed is endeavoring to *construct* something here. A kind of dish, with a parabolic profile, half a mile across—"

"Covering most of Arthur's Seat, then."

"Yes."

"This Moonseed is a rock-eating germ. How can it construct anything?"

"It does not eat rock," Blue said, "and neither is it a bug. It moves atomic particles, sometimes molecules, to build structures from the subatomic level up. As far as we can tell, these structures are perfect. Without defect."

"Not so perfect. That thing in your hands just fell apart."

"It's true we can disrupt the structures if we catch them early enough. But I don't think whatever the Moonseed is building *here* is meant for this world."

"What do you mean?"

But Blue wouldn't answer.

He bent again, trying to collect more samples of the Moonseed structure, which he preserved in clear, fast-setting plastic.

When they were done, they walked gingerly back along the neck of land.

Ted pointed to the Cathedral on Castle Rock. "We go there."

Blue looked at him curiously, face masked by the layers of dust and dirt on his faceplate. "Why?"

"Something I'm looking for."

Blue shouldered his equipment. "Henry told me about your son."

"In between porking my daughter."

"I understand why you have come. I feel a certain— responsibility—for bringing you here." He looked into Ted's face. "So I feel I have to tell you this. *Smell the coffee*, Ted. Your son is dead. I saw him here, just before the great eruption. He is lost, here in the ruins of Edinburgh. At best you will only find his body. Probably not even that."

"I know," Ted said softly. "I've known that from the beginning."

"Then what are you looking for?"

Ted said, "Are you coming with me, or do I go alone?"

Blue sighed. "If I abandon you, Henry will squeal like a pig stuck under a gate. Come."

With Blue leading, they worked steadily over the shattered cityscape toward the building.

St. Giles' was a great sandstone block, atypically low and squat for a Gothic cathedral, but that had evidently helped it survive; the pyroclastic flow, washing over Castle Rock, had heaped up against the eastern wall, but had not breached it. Still, the stained glass windows had shattered or, it looked like, melted; and the ornate crowned tower, the Scottish equivalent of a spire, was gone.

They paused for breath.

"St. Giles," Ted said. "Patron saint of cripples, lepers and tramps."

"Very appropriate," Blue said. "I am impressed it has survived at all."

Ted pointed. "Those pillars holding up the tower are nine hundred years old. Even survived the English burning the bloody place down. They'll last a wee while yet. Come on."

The big wooden doors of the Cathedral had been smashed in, the shards burned. Ted and Blue picked their way over the wreckage, the scorched wood crunching under their thick-soled boots.

The roof was destroyed—debris was scattered over the aisles and altar and the rows of pews—and silvery, alien daylight streamed into the dusty interior through the gaping roof and the empty window frames. Ted stood in the doorway for a few minutes, letting his gaze follow the soothing geometry of sunbeams. As if one part of the world still worked. The Cathedral was full of light, in fact, probably brighter than it had been since the day the roof was put on. The uniform gray and black was oddly pleasing, like a charcoal sketch.

He moved forward. He had to push through the ash layers, climb over the cold lava bombs which lay beneath it, like pushing through a shallow stream.

There were *people* in the pews, he saw.

Some were sitting, some had been kneeling, some seemed to have fallen. Their bodies were barely visible, all but drowned by the ash. Here was a woman—he couldn't tell her age—her face tipped up to the ceiling, he supposed toward God, her mouth open and clogged with ash.

"The roof probably gave way immediately," Blue said gently. "The ceiling rubble came down on them, and then pumice, hot ash, steam, gases. They must have died very quickly. Probably of suffocation."

"I suppose they came here for shelter."

"I suppose so. Perhaps we will find the priest at his altar. If they are undisturbed, perhaps this will form another Pompeii, for future archaeologists."

Ted stopped beside another woman. "They are not undisturbed."

Blue bent to see.

A necklace had been ripped from the woman's neck. There were fingermarks, cut deep in the layers of ash.

"He's here," Ted said.

* * *

It didn't take long to find him. There weren't many places left in the Cathedral intact enough to hide in.

He was in the Thistle Chapel, an ornate, heavily ornamented twentieth-century annex of the Cathedral. The windows had blown in, but its roof had survived, and so had most of the Chapel's ornamentation: carved animals, angels playing musical instruments, including bagpipes.

He was hiding under a pew. He was thin, in rags, filthy, wide eyes staring out of a sketch of a face, patchy stubble over the spittle-splashed chin. Really no more than a boy, Ted realized. He had a little food—cans and packets and bottles of water, detritus around him—and a pathetic stack of valuables, jewelry and wallets and cash.

Ted pulled off his hood. There was a stench.

"You have fouled yourself," he said softly. "Even an animal does not foul itself. Are you, then, less than an animal?"

Blue was frowning at him, but Ted kept his gaze on the boy.

"I don't know you." The lad's voice was thin, breaking, from fear and disuse.

"I know *you*," Ted said. "You are Hamish Macrae. The one they called Bran."

Bran said nothing. He shrank back beneath his pew, folding his legs against his chest.

Ted reached forward and collared him, as simple as that. From a renewed, sharp stink, it seemed as if Bran had fouled himself once more.

"Who are you?"

"Don't you remember me, Hamish?"

"No . . ."

"A father, of one you led to the Seat. One of many. To his death."

Bran was trembling, but he spoke up bravely enough. "So you found me. So what?"

Blue asked, "How did you know he would be here?"

"He stayed as close to the heart of it as he could. He was scared to run too far. There are others looking for him."

"Too fucking right I'm holing up here," Bran said. "Have you not heard the troopers? In the Highlands they're already burning witches." He looked at Ted, calculating. "I didn't mean it. The Egress Hatch thing. I mean, I did. And I was right, wasn't I?" He glared at Blue. "It did come from space."

Blue rubbed his neck, through the thick fabric of his suit. "It is possible."

"That mirror thing the Moonseed is building. It's a solar sail," Bran said. He smiled. "It's obvious."

Ted turned to Blue. "A *what*?"

Blue was wheezing; maybe the concentrated dust here was getting to him. He said, "A sail, to catch the sunlight and so drive a spacecraft. Perhaps that's the purpose of the large parabolic structure the Moonseed is struggling to assemble. Others have speculated like this. The Moonseed seems to be making spaceship parts. But it is stranded, here, at the bottom of this gravity well, under all this air."

Spaceship parts. For a few seconds, the strangeness of the thought threatened to overwhelm Ted.

"Stuck at the bottom of a well." Ted frowned at Blue. "You sound as if you feel sorry for it."

Blue looked up. "In a way. After all, it's possible it means us no harm."

"I was right," Bran said, as if crooning. "I knew I was right. But I went a little crazy. And then, as soon as the ground started to give way—"

"You had your fun," Ted said evenly. "Money. The girls. Didn't you? And it cost my boy his life."

"Are you another witch burner, old man?"

"I don't know. I haven't decided."

That seemed to renew Bran's fear. He looked in desperation at Blue. "Who the fuck are *you*? Can't you stop him?"

"I am a scientist," Blue said. "I am here to study the Moonseed. That is all."

Bran searched Ted's face, his eyes huge in the dark, his face thin and weak.

"Story time's over, laddie," Ted said softly.

There was noise outside: whistles, shouting.

Blue looked out into the main body of the Cathedral. "I think the light is changing," he said.

Bran tried to wriggle from Ted's grasp. "What does that mean?"

"It means," said Blue, "we should get out of here."

A sound like gunfire. Deep-throated coughs.

"*Now,*" Blue said.

Bran seemed dazzled by the daylight. Perhaps he hadn't been outside for days, Ted thought. With his hand still clamped on Bran's collar, he looked around.

A party of soldiers was running, to the west, away from Arthur's Seat, jumping over rubble. One of them looked hurt; his mates were helping him hobble along. When they saw Ted and Blue they waved. *Come on.*

Smoke was rising from among the ruins atop Calton Hill.

"It is the Moonseed," said Blue. "It has started again. The secondary vents of the old magmatic complex—Calton Hill and Castle Rock, here—we are expecting them to give way in the next cycle."

Still grasping Bran, Ted climbed up onto a section of wall, and looked east, toward the Seat, the Moonseed pool.

The pool was glowing. Light sparked from its rim, like flashbulbs popping under a blanket. He could see the ground cracking and dissolving, sinking into the Moonseed as he watched.

"It's spreading," Blue said.

"Jesus," Bran said, and he squirmed harder.

"It has been immobile for days, but now . . . We go," Blue snapped. "We must get off this vent."

"Here," said Ted. "Take your bottles."

For one second, two, Blue looked into Ted's face, then Bran's.

Then Blue nodded, evidently understanding. He grabbed the sample bottles, and ran to the west, with surprising suppleness.

Bran started shouting. "What are you doing? Shit, man, what are you doing?"

Ted shook the lad, not hard, until he stopped squealing.

When he'd turned in his results, Blue Ishiguro stripped off his Moon suit and walked back into the city. This time he walked to the east, the far side of the Seat, where the Moonseed had yet to spread.

Here, in the suburbs of Duddingston and Bingham and Northfield and Restalrig, the work of clearing the corpses hadn't advanced so far as in the west. So he joined a party of soldiers, with little protection but their improvised cloth facemasks, as they made their way along the ruin of a street. There was no way of telling what the housing stock had been like here, but there were a lot of cellars and underground rooms, some of them new additions— Venus shelters—where people had tried to ride out the explosion.

Stiff pits, the soldiers were calling them.

They dug into the rubble. It was loose, and so there were constant falls of dust and dirt, tiny avalanches. There was no machinery, because the scientists could not guarantee that the meringue surface would support the weight of any vehicle.

So the soldiers had to use their muscles and hands. They removed layers of shattered masonry, plaster and roof beams and glass shards, all under a layer of ash and

pumice, gingerly exposing an entrance. As soon as the new pit was opened, fetid air came billowing out, thick with insects. A stench, like rotting roses; after so many days, the bodies were liquefying, turning to mush down there.

In the early days, the soldiers had had to drag out the corpses, bag them up, try to identify them, take them away for burial or burning. Now, though, the solution was simpler: a corporal stepped forward, with glass face mask, and a flamethrower to hurl down a tongue of fire, the ultimate flame which these poor souls had, Blue supposed, sought to escape.

Blue Ishiguro had survived Kobe, a disastrous earthquake his science had failed to foretell. Many of his family had died there. And now, here he was, surviving again, hale and healthy, even well fed, where so many others had died.

He was, he thought, cursed with life.

So he labored with the soldiers for hour on hour, burying himself in the dirt and stench of it, pausing only when his body betrayed him, and dry heaves racked his stomach.

29

The Prime Minister, Dave Holland was told, was up on the roof garden.

So Holland had to wheeze his way up the stairs past the Strangers' Gallery, then through a fire door to the roof. His thick gut gurgled as he climbed, laden with a good dinner and a couple of beers, and he was wheezing and red-faced by the time he stood in the glow of the central skylights that illuminated the chamber of the House of Commons below.

He took a minute to recover himself, and he dabbed at his sweating face with a huge, discolored handkerchief. The House was working, even so late, as the members forced through one package of emergency legislation after another.

He could see Bob Farnes standing by the balustrade at the far end of the terrace, looking north. The Prime Minis-

ter was alone up here—save for the discreet presences, in the shadows of the garden, of his PPS, Pearson, and a couple of Special Branch men.

Holland knew the roof garden well. The view was spectacular, even so late at night. To his right he could see the Thames, the crammed pleasure boats like bubbles of light on the black stream of the river. There were a lot of boats, in fact, reflecting the mood that seemed to be sweeping the country, like a rerun of the millennium.

To his left he overlooked the tiled roof of Westminster Hall, the oldest part of the Palace of Westminster, mostly shadowed now. And before him was the tower of Big Ben, its carved sandstone fascias glowing golden in the light of the spots at its feet, and the big translucent clockface shining from within. The traffic of London sent a subdued, continuing roar into the air, a river in itself.

He'd often used this spectacular place, high above the seat of British sovereignty, to host functions—the cocktail party for MPs he held when he was running for the Party leadership against Farnes, for instance—and for more private conjunctions, with two or three of the prettier research assistants who still flocked to the Commons, attracted like moths to the fat old drunks who worked here.

But tonight, it wasn't the same.

The garden itself, the spectacular architecture beyond, were bloodied by the volcanic sky above, a dismal crimson glow that covered the stars all the way to the zenith. It was the curse of the Scots, he thought gloomily, entirely typical that their passing should be marked in such a melodramatic style, by the banishing of true midnight for everybody else.

The Big Ben clock tower looked full of air and light, he mused, as if it were some immense Gothic spaceship, fueled and ready to go, ready to lift off from this sorry old world, and he wished it bloody well would, and take him with it.

He coughed and walked forward.

Farnes didn't turn. "Hello, David. Do you think—"

"What?"

"Do you think there's a *glow* up there? To the north?"

Holland looked out over Whitehall, the Foreign Office and Treasury and Home Office: the great houses of the state, pompous as wedding cakes, and, as events had proved, just about as powerless.

Farnes stared past it all, to the far north, looking for the glow.

The light of Scotland burning, Holland thought bleakly.

"No, I bloody well can't see any such thing, Bob," he said bluntly, "and even if I could it wouldn't make a damn bit of difference."

"No," Farnes said. "I suppose not."

Holland tried his best to project the bluff boyishness that—even if fake—had got him so far in life.

"Now then, Bob. The preparations are going well. We're gearing up to receive a flood of evacuees in the south, from the most threatened areas. All the emergency powers are in place now, and the police and the military are being briefed on various contingencies. We've got the Green Goddesses out." A fleet of emergency fire engines, dating from the war. "Those bloody things. We only have a thousand or so left operational. And they are so old now you can't get spares, and the rubber parts have perished . . . Well. There've been a few oddities. The police have had to assign men to patrol church services, would you believe. Riots, by people locked out. They say it's like managing football matches used to be."

Farnes didn't react.

"Further out—well, the scientists are floundering, I think," Holland said. "They don't agree on what this Moonseed bugger is, or how fast it will spread, or whether it can be stopped. In the best case, perhaps we can contain it in Scotland. Perhaps it's already contained, in fact. Somehow exhausted."

"Do you believe that?"

"I don't know. I suppose the next few days or weeks

will tell. But if it can't be contained, if it's going to spread further—"

"Then what if it does? What do we do then?"

"Then we continue to make plans."

"Plans?"

"We've already got the airports geared up." Heathrow and Gatwick and Stansted and Manchester and Birmingham and Luton, all of Britain's great terminals. "The air traffic boys confirm we can handle up to a million passengers a day. A 747 in the air every three minutes, packed to the gills.

"As to destinations, we can load as many as we like into Northern Ireland in the short term, of course. It's going to be important to keep the ferry ports in Liverpool and Wales functioning as long as possible. The Scousers are organizing volunteer squads to break up any Moonseed infection, to keep the ports and roads open. Heroic. The bloody French are being no help at all, as you'd expect; they say we can take people out through the Chunnel, but they'll be sent straight on somewhere else.

"All of the ports are ready, of course. We're going to ask you to front an appeal to small-boat owners to come to the aid of the party."

Farnes, in profile, smiled. "Dunkirk in reverse."

"That's it. That's exactly the note to strike. Spirit of the Blitz. I'm glad your instincts are still with us, Bob."

But the flattery did nothing to disturb the ominous calm within which Farnes seemed locked.

Holland went on, "But we'll never be able to get everybody out. The chronically ill, the very old, perhaps. The awkward squad who just won't move anyhow. The emergency planning boys estimate perhaps fifteen percent could never be evacuated no matter how much time we have."

"Fifteen percent, of sixty million."

Holland blustered on, "We've already moved the bulk of the gold reserves to Belfast. The Arts Council have pulled together a committee on works of art to be exported.

There are architects who want to set up an archive some-where of plans and photographs of the finer buildings." He coughed, and glanced around, for eavesdroppers. "On your instruction we're working on the Ireland option."

"Ireland?"

"The military option. Invasion. It's feasible, though diplomatically it would be—"

"Disastrous. We would be pariahs."

Perhaps, Holland thought. But needs must. He didn't want to say any more, even here.

"We're setting up alternate seats of government, in Belfast and the Scillies. We have to think about moving ourselves, sooner rather than later . . . Bob, are you taking in all this?"

"Oh, yes," Farnes said. "Every word." He stared into the north. "We've already lost so many lives. How many more?"

Holland hesitated.

"Just too big," Farnes said. "Just too bloody big. *Sixty million.* We can't conceive of such a number. In our hearts, we're all still in some Stone Age village, where everybody knows everybody else. Sixty million. It's beyond us.

"And yet here they all are, Dave, all sixty million, crammed into this fragile little country of theirs, and all of them looking to me for guidance. Maybe there is no such thing as government." He looked at his hands. "No such thing as *power*. Look at us. We couldn't even manage the economy, if truth be told. And now, this plague from space, this natural disaster, has shown us up for what we are. Pos-turing puppets."

"But we carry on," Holland said. In fact he understood how Farnes felt. He'd had to wrestle with this in his own demons, and he'd stiffened his resolve, and he'd come to believe every word he said now. "We do what we can. We keep on trying until the ground opens up under Whitehall."

"Like Churchill. At the gates of Buckingham Palace, facing off the Germans with his tommy gun."

"That's the spirit. We save what we can. We govern. We let the country carry on in an orderly way, as long as we possibly can."

"But what's the point, Dave? What's the point if this—" He waved a thin hand into the darkness. "—if this bloody black meteor is heading straight for us?"

Holland hesitated, considering a morale-boosting, upbeat answer. But Farnes was clearly beyond that.

At last he said: "Dignity."

"What?"

"Dignity. When you come down to it, what else is there, for any of us?"

Farnes reflected on that for a long time.

Holland found himself shivering. The traffic noise was dying to its minimum, as the small hours approached.

Holland hated to be awake at such a time, the dead of night when the horrors arose, the fears of powerlessness and mortality which seemed to be overwhelming Farnes now, which could be banished during the day with its illusions of light and movement and control . . .

Farnes said, "I'm planning to resign, Dave."

That startled him. "You can't. Not now."

"I must. This is all too—" He waved his hands again. "—too big for me. I'm done for, Dave. You take it, if you want."

Despite himself, despite the circumstances, Holland felt a deep, atavistic thrill at the words.

Power, real power, at last. He became intensely aware of where he was, poised above the chambers he could soon command, surrounded by the machinery of state, as if he was the huge, ugly Victorian mechanism which drove Big Ben itself.

He tried to focus his mind on Farnes, the suffering man before him.

"There will have to be an election," he said.

"You must do as you see fit."

"It wasn't your fault," Holland said. "How could it have been?"

"But it was on my watch."

There was a sound like thunder, or distant guns, far to the north.

Both men clung to the balustrade, staring toward Scotland, trying to pick out a change in the light.

30

To Ted's surprise, they survived the night, the two of them crouched in the ruins of St. Giles'. No food or water, but that scarcely mattered now.

And with the dawn came the sound of thunder. Ted went outside, with Hamish's collar grasped in his hand—Hamish-Bran seemed passive, beaten—and he climbed a ruined wall, looking for a vantage.

The Moonseed was on the move. The Moonseed pool was spreading like a silvery stain across the ground. The remains of buildings, of homes, with whatever tokens and bodies and memories they held, were cracking and falling, subsiding into the glowing mass. Ash was rising in diffuse clouds. There was a stink of ozone.

Inexorable. The word might have been coined for the stuff.

Where Holyrood Road used to be, a man, a soldier, was running before the spreading, flaring pool, somehow separated from his mates. He was far enough away to be reduced to a stick figure, his face a white blur.

He wasn't running fast enough. The Moonseed was faster.

Ted pointed. "Look."

"What? For God's sake, what?"

"Did you ever see anything like that? The fox that couldn't outrun the hounds. The child caught by the tide. Jesus, Jesus."

In the last moment, that white point of a face turned to Ted, as if imploring.

"Nothing I can do," Ted murmured. "Not any of us. It's a tide of death. Come all the way from the stars, to wreck our homes, and kill us . . . And there are always little bastards like you, out to make it worse for everybody else."

The Moonseed pool, hissing, overwhelmed the soldier. It was mercifully brief, from Ted's point of view. One minute he was there, the next, in a flail of limbs, he was falling, and gone.

And now Ted turned to face east.

It was coming, crackling, bursts of light like a second dawn, the sound of rock breaking open like eggshell, washing up Castle Rock in a tide of light. Seconds left, no more.

"What do you think?" Ted asked gently. "Still expecting a great beam-up to that party in the sky?"

Bran was begging now. "Let me go. Oh Jesus, oh shit, let me go."

Ted tightened his grip on Bran's collar. "Burning witches in the Highlands, eh. Good for them. Maybe the Highlands will survive. Maybe the Highlanders will come back down here, like William Wallace, and stuff the bloody Moonseed back where it came from. Eh? . . ."

The smell of ozone was stronger. Just like the beach, he thought. He remembered what Henry had told him, nuclear fusion or fission or some damn thing going on as the Moonseed spread. He smiled.

"Maybe we'll get a suntan," he said to Bran.

Bran, panting, his trouser legs stained wet, turned a dirt-streaked, tearful face up to him. "What? You crazy old fucker. *What?*"

The tears made him look young, the calculation and cunning gone from his face. He was younger than Michael had been, Ted remembered suddenly.

But Michael would never get any older. And neither would this boy.

. . . And now, after all this, he suffered an instant of

doubt. This is only a kid. What right have I got to be judge and jury?

But there was no time. For now the Moonseed swept on him like a wave, buildings cracking and bursting into debris and falling, that fusion light bright all around him. All choice was ended, and that, for Ted, was a huge release.

He had time to see the Cathedral collapse. Big sandstone blocks just exploded out of the walls, as the church's structural integrity vanished at a stroke, nine hundred years of building and preservation wiped out in a few seconds. There were massive blocks flying through the air toward him—Bran was screaming again—the Cathedral would kill them both, if it got the chance.

But before the blocks arrived, the wall he was standing on crumbled and collapsed. He was dropping, into a surging, silver-gray pool.

He closed his eyes, and fell into Moonseed.

It was soft and warm. Not like rock at all; like something alive, moving over his skin, exploring.

Something was grabbing at his hand. Bran.

He shook him loose; a creature like Bran should die alone.

The pressure built up around him. He was trapped, a fly in amber.

He opened his mouth to breathe. Something forced its way in—softly scraping, neutral temperature—scratching his mouth and throat as it pierced him.

No more air, then.

If Bran was right—*Christ, the pressure on my chest*—if Bran was right after all, he would be with Mike in a moment.

There was light beyond his closed eyelids, shining pink through the flesh. Streaks like meteors in his vision.

Michael, Jane, Jack. He'd done all he could for them. There would be no room in whatever was left of the world for an old fool like him. His doubt was gone now; to rid the world of a blight like Hamish Macrae was a worthy price for the remnant of his life.

A single instant of heat, unbelievable pressure, as the ancient volcanic plug gave way, and the surviving Castle buildings were blown apart, the fragments hurled high in the air.

31

So here was Henry back at Johnson Space Center, the heart of NASA, which he'd fled with such ill feeling. The old Saturn V still lay beside the entrance drive, as it had for decades, its most recent refurbishment leaving it sparkling white, like a Disney mockup. The mid-June air was heavy and humid, particularly after the clarity of Scotland, and the sky even here was an oppressive blue-gray dome, laden with ash.

From the security building, Henry was escorted to the Astronaut Office. He walked across the campus, the blocky buildings of oyster shell and glass, a solidification of a 1960s future that had never quite come to pass. Concrete paths crisscrossed between the buildings, lacing across bristly, bottle-green grass; the paths, Henry had observed in the past, never seemed to take you where you wanted to go, and he had developed a habit of jaywalking over the lawns, something that had not improved his popularity around here.

Today, following the girl from security, he stuck to the path.

There seemed to be a lot of people around, groups of them running between the buildings, carrying laptops and vu-graphs and folders of mission rules and procedures. There was a sense of urgency, in fact, that hadn't been apparent in the time he'd spent here before. JSC, the center of the nation's space effort, had with time become just another place where big government work was done, with the nine-to-five schedules and leisurely pace that entailed.

Not now, though. Now, there were things to be done, missions to be mounted, a sense of urgency the place hadn't known since the Apollo days.

All because of me, he thought. Jesus.

But then, it was as if NASA had been waiting for this call to arms since the curtailing of Apollo.

It seemed to Henry that once he had gotten through Monica Beus's OSTP review, the official initiation of the scrambled Moon program had been extraordinarily fast.

He had to make another presentation, more formal, to the National Space Council: another presidential advisory group, this one chaired by the Vice President himself. And away from his own involvement, support built up. He read of Congressmen being hauled into the White House to be pressured into supporting the emergency bill authorizing the release of federal funds to NASA to implement the program. Opponents in the Senate, who appeared to think this was just another NASA job-creating publicity stunt, tried to filibuster the bill. But the White House orchestrated public opinion and concern, focusing on fence-sitting senators, who soon started to feel the heat from their home districts.

Maybe it shouldn't have been such a surprise, Henry thought. This President had emerged from Congress herself; she was said to be the most skilled Chief Executive at dealing with Congressmen since Johnson. And that was just as well given the sexual harassment charges still being laid against her.

And when she went public—as, of course, she must have anticipated—she found herself, as the first President since Kennedy to approve a start-up Moon program, riding on a wave of popular approval. The language of the commentators was helpfully blunt. *This is America. We aren't going to sit here and let some nano-bug screw us over like in Scotland. Let's go to the Moon and kick butt . . .*

The comforting myth of American can-do, Henry thought: the idea that we can *do* something, President and military and nuclear fleets and spaceships, act to save ourselves just like in the past. Maybe it was all a delusion, wish fulfillment. But when it was harnessed behind a coherent project, the can-do myth was powerful indeed.

And the approval ratings it was giving the President didn't hurt either.

So NASA had been given the funds and go-ahead to assemble the mission. But the decision was being made in stages; the approval to launch was still being withheld. It seemed to Henry that there was still a component of the public's thinking—and hence of the Administration's—that wished for this problem to go away. More rationally, the President was being urged to wait until the results of attempts to disrupt the Moonseed—with conventional bombs, nukes and other methods—were known. Maybe it wouldn't be necessary to risk the lives of astronauts in this jaunt to the Moon.

So the Prez was hanging fire, waiting for the news to get worse, as it surely would.

. . . Here was Henry, delivered to the heart of the Astronaut Office. It was just a plain-looking briefing room filled with hard-backed chairs. It could have been a briefing hall in any large corporate or government building, he thought, anywhere in the country. All there was to betray its true nature were the rows of Shuttle mission plaques on the walls, nearly a hundred of them dating back to 1981, the bold, patriotic designs and rings of crew names commemorating forgotten missions, strangely old-fashioned.

Henry had never been here before, inside the lair of the hero jock pilots; his interest had always been solely in unmanned space exploration, and he would never have come to Houston, center of the manned effort, at all, if not for the location of the extraterrestrial samples facility here.

And here, waiting for him in a grubby blue Shuttle astronaut's coverall, was Geena, his ex-wife, with others he didn't know. Geena had a look he'd come to recognize. *I really, really don't want to be here, with you, Henry . . .*

"Henry," she said, "we're going on a little trip together."

He frowned. "The Cape?"

"Farther than that," she said sourly.

And then he saw it, and his heart sank. "*The Moon.* You're going to the Moon, with me."

"No," she snapped. "*You're* going with *me.* I'm the fucking mission commander." She eyed him. "It isn't my fault. Thanks to you I've been involved in this from the start. Championing it. Who else would they pick?"

"Not the kind of scenario you generally have to think about in marriage guidance counseling sessions, huh."

"Just as well we didn't have any," she said heavily. "As long as we're both professional about this we'll get through it."

"Maybe." He grinned. "It sure does appeal to my sense of irony."

"Henry—"

"Aren't you going to introduce me to your colleagues?"

With Geena was a mission designer she introduced as Frank Turtle, a skinny, owlish, bearded guy in bell-bottom jeans who was probably older than he looked. And there were a couple of astronauts: both men, both aged around forty, both with hard-muscled arms folded across their sports shirts. They regarded Henry with evident distaste, and said as little as they had to.

Turtle, it turned out, had been at the heart of devising this improvised lunar mission from the start, and so had found himself catapulted upward in terms of responsibility—if not, Henry suspected, in such tangibles as his salary, the size of his office, and the color of his carpet. He looked as if the responsibility was crushing him.

Frank Turtle coughed. "Dr. Meacher, we've tried to devise a training program to get you through as much as possible in the time we've got. There are three main phases. Suitability, where the medicos assess if you could survive a space mission at all. Generic training, in emergency procedures, weightlessness, so on. Finally crew training, where you'll be taken through the launch and docking procedures." He scratched his receding hairline. "It's going to be a scramble; I

don't know what resources we can offer you. I don't think NASA personnel have ever been so stretched. For instance we're going to have to force through Shuttle launches to take up the spacecraft components. We're all working double shifts . . . equivalent to a pace of sixteen Shuttle launches in a year, if we had to keep it up that long . . ."

Geena said to Henry heavily, "Guys like Frank in operations and Mission Control, and the engineers at the Cape, and the flight crews, are the true heroes of this, Henry. The greatest pace we achieved in the history of the Shuttle program was nine launches, in the year before *Challenger*. I have guys working their asses off, doing double or triple shifts. Just don't forget it. This mission isn't about you. It's about them."

The astronauts eyed him coldly.

He wondered what to say. "I'm grateful."

None of them was comfortable. He sensed anger. Frustration. Henry could see conflict in Geena's face, and Frank Turtle's.

It wasn't hard to understand why.

NASA tended to think of itself as a heroic agency, capable of taking on whatever challenges were thrown at it. But the truth was, all the way back to Mercury, they had never launched a manned mission without every aspect of it being timelined, checklisted, simulated and rehearsed, over and over, until every possible glitch had been identified and contingency-planned, until the crew knew the mission so well they were actually desensitized to its dangers.

Running a mission like this—making it up as they went along—was alien to a NASA culture that went back half a lifetime. Culture shock for us all, he thought, with a certain relish.

Geena was still talking. "Your suitability training will be performed here, in the U.S. Your crew training will take place in Star City. The generic training will be at a mixture of locations; we're agreeing the objectives with the Russians now, and—"

"Woah. *Star City?* Isn't that Moscow?"

Turtle said, "Our launch manifest is full, in the window we have. You'll be taken to orbit in a Russian Soyuz." He smiled, weakly. "The Russians are working with us. Planet in peril. Hands across the sea. All that stuff."

"Oh." Oh, shit.

Geena grinned, with relish of her own. She said sweetly, "Didn't anyone tell you? And by the way."

"What?"

"I'm running your training."

He was to be flown to Brooks Air Force Base in San Antonio, to report to the School of Aerospace Medicine there. And Geena was going to take him there, in a T–38, flying from Ellington Air Force Base close to JSC.

The T–38s were supersonic jet trainers which the astronauts used to maintain their flying proficiency, and they used them as personal taxi cabs, taking themselves and their colleagues back and forth between NASA sites at Houston and the Cape and Alabama and elsewhere. The pilots had been flying the little planes since the 1960s, and they were a familiar sight in the skies over Houston.

But Henry had never flown one before. And certainly not one piloted by his ex-wife.

It took him an hour just to get suited up, in a flight suit, helmet, boots, parachute, survival kit. The tech had to walk him from the personal gear room to the runway, because Geena was already in the cockpit.

Close to, the T–38 was, he conceded, an elegant piece of engineering, a sleek white cylinder with a vanishingly small wingspan, barely wide enough to accommodate two adult human beings under tiny blister canopies.

Geena didn't acknowledge him as he walked up. The tech helped him climb into the cockpit, and he closed his canopy, and found himself staring at the back of Geena's helmeted head.

As soon as he was aboard she taxied the jet to the end of the runway. Dials and sticks moved back and forth in his cockpit, a baffling choreography. The jet roar was too loud for him to hear anything through the intercom, if anybody troubled to speak to him, and in his helmet he was sweltering in the cockpit, trapped in a bubble of Houston heat.

When he breathed through his oxygen mask he could smell burned rubber.

The jet accelerated suddenly, throwing him back into his seat. The T–38 was in the air in seconds, and then took off like a dart, tipping itself up and rising almost vertically. The needle nose shot through thin cloud, and when he looked back the ground was turning to a faint gray-green, interspersed with cloud shadows. Ahead, the sky was fading to a rich purple, and—if he read the dials right—they were already at forty-five thousand feet, higher than any commercial jet.

Geena leveled off, and looked back at him.

Suddenly, unexpectedly, *exhilarated* by being hurled up here, into this bowl of height and speed and light, he gave her a jaunty thumbs-up.

Her voice crackled in the intercom. "So you haven't upchucked yet."

"I won't upchuck."

"There's a bag in your flight suit leg pocket."

"I won't upchuck."

"We ought to be sending pilots to the Moon, not scientists with their heads up their backsides. It's an old argument."

"Geena, *all* our arguments are old arguments," he said.

"This flight is part of the training. Part of your familiarization with the forces you'll be experiencing during the launch and reentry. Did they tell you?"

"Geena, there is no *they*. You are *they*."

"Remember where that bag is."

And she threw the plane into a snap roll, a one-hundred-

eighty-degree turn in seconds, and then barrel rolls and a parabolic arc and a steep dive over the Gulf of Mexico. Henry's helmet was bumped against the canopy, and his body strained at the harnesses restraining it, and sunlight and shadows wheeled around him.

Ultimately, he was proud he lasted all of ten minutes before using the bag.

The medical testing, run by Air Force and NASA doctors, struck Henry as brutal and invasive. Hospitals were mostly a mystery to Henry, who had been spared illness save for popped shoulders and busted fingers, the work hazards of the field geologist. Now he found that such exotica as barium meals and enemas and endoscopic probes of the intestines were not just exquisitely painful but also utterly humiliating.

It wasn't even as if he was genuinely ill, in which case he'd have to endure one or two such tests, and even then they'd be spaced apart. Henry was hit by one after another.

For instance the endoscopy was going to be so painful, he was told, he'd normally be given a shot of Valium in advance. But he'd already had Valium for the gastroscopy, so he had to do without it. And when he went in for his chest X rays he still had the electrodes over his chest which had been fixed there to monitor his heart, and so the X rays were marked by small black dots. And so on.

Some of the tests were more relevant to spaceflight. The medicos checked the balance mechanism in his ears, by pouring hot water into one ear, or cold water, and then swapping over. By watching his eyes, seeing if they flickered, the doctors claimed to be able to tell if the temperature differential made him dizzy, and how much.

He was put into a spinning chair, and told to close his eyes and tip his head up and down, from his knees to the head rest. A few minutes of this was enough to make him want to throw up, which, it turned out, was the idea.

Back at JSC, he was put through altitude chamber tests.

The chamber was a big metal box with thick glass portholes, through which protruded TV lights and cameras. It turned out that some of the cameras belonged to the doctors, and some to the press; such was the public interest in the mission he was already a reluctant media star.

He was taken up to a simulated forty-four thousand feet, and the air bled out of the chamber slowly. When the air was down to a quarter sea-level pressure, his lung sac expanded so much it ached; his bowels distended, making him fart explosively. Eventually the air pressure got so low he was forced to pressure-breathe into his oxygen mask: when exhaling, he had consciously to force air out of his lungs.

He had never in his life had to control, consciously, his breathing. It scared him.

They took him back to sea level. And then, without warning, they hit him with a rapid decompression test.

Suddenly he was at twenty-five thousand feet, and in the middle of a simulated bail-out. The air was sucked out of his lungs, and pain stabbed in his ears; when they returned the air, the room filled up with a cloud of condensed vapor.

He wasn't sure what the surgeons were learning from such things. But he was learning, brutally, a lot more respect for his ex-wife and the other pilots.

The tests got tougher.

Sealed inside a dummy spacecraft he was slammed into deep pools so that he could practice unhooking his harnesses, opening the hatch, swimming to the surface and activating his survival systems. He was sent up in the Vomit Comet, a converted transport plane which followed elaborate parabolic loops through the sky so that, falling freely inside the aircraft, he could experience weightlessness for twenty or thirty seconds at a time. During the first he was made to sit still, to find out how it was going to feel: like, it turned out, going over the lip of the world's biggest roller-

coaster, and never coming down. On the second loop he was allowed to move around, floating from ceiling to floor, wall to wall. At the end of every loop he had to make sure his feet were on the floor before the plane went into its recovery. He practiced moving large masses, throwing a medicine ball to Geena, feeling the reaction as he was pushed backward. Henry learned how to brace himself, to get the reaction he needed, and to judge the center of mass of a complex object, to learn to shove and control without sending it rolling.

Then he was put through another flight where he had to do the whole thing again, but wearing a spacesuit.

The next day Geena flew him to Johnsville, Pennsylvania, to the Navy's Acceleration Laboratory, for a ride in what the technicians here called, cheerfully, the County Fair Killer. It turned out to be a centrifuge, a cage with a seat and other equipment that got spun around inside a circular room. During the launch he would be given a protective G-suit to wear, but for now he had nothing to protect him, save exercises on tensing his muscles and holding his breath, to make his blood pressure well up.

When you thought about it, he realized, a centrifuge was a symbol of the high frontier. Only pilots of high-performance aircraft and astronauts would be accelerated to the rates that kind of centrifuge could provide. He found out later that NASA didn't even have any centrifuges of its own anymore. The Shuttle ride to orbit was so gentle the astronauts were subjected to no more G than you'd suffer on a moderate switchback ride.

On the other hand, during the most crucial stages of launch and reentry, Henry would not be in the hands of NASA.

It didn't seem so bad when it started. A mix of fairground ride and James Bond torture chamber. But the force was eyeballs-back, as the pilots called it, an intense pressure on his chest, as if a ton of bricks was being piled on there. Breathing got more difficult, and he could feel his

face distending. He felt oddly self-conscious; there was a closed-circuit TV camera fixed on his pancaked face through the whole experience.

They ran him up to five Gs. That wasn't so bad; he ought to be able to withstand as much as fifteen Gs. But it was enough to keep his chest pressed against his backbone, and he felt he had to force his rib cage open just to take a breath.

Stopping, he found out, was the worst part. When he slowed the sideways forces started to kick in, Coriolis forces, and he felt as if he was tumbling, and threw up heavily before they could haul him out of the cage, his vomit probably laced with barium.

To familiarize him with the Space Station, now being used as an orbital construction shack for the Moon spacecraft, he was taken to the Sonny Carter Neutral Buoyancy Laboratory. This was located up near Ellington Field.

The weather that day was clear after some days of cloud, and the sky was streaked by toylike T–38s, astronauts anxiously keeping up their flying hours. Henry suffered a corny NASA moment, when he found himself at the entrance plaza of the facility looking up at a slab of blue July sky framed by a Stars and Stripes, while a T–38 flew past a milky Moon.

But Venus was already rising, a malevolent smear of light.

The Carter facility turned out to be a gigantic rectangular pool, all of forty feet deep. Henry was kitted up in a bulky, multilayered pressure suit, with a heavy backpack to keep him alive. Inside his bubble helmet, enclosed, he could smell lint and metal and the hiss of air; his own breathing was noisy.

He was lowered into the pool on a frame elevator. Divers took his arms and helped him into the water. The color of the water was a deep blue—just because of its

depth, not because of any additives—and it was so deep the divers who accompanied the astronauts on their dives had to undergo decompression procedures. The astronauts, in their pressure suits, were pretty much immune to pressure changes.

He could feel the resistance of the water, see its bluish haze extending around him, but in his bubble of air he was as dry as desert dust, cut off. Beside the graceful, seal-like divers, he felt clumsy, stiff, barely able to move. He wondered if he would feel so isolated in space.

The pool was full of gigantic toylike trainers: an open Shuttle payload bay so he could practice hand-cranking the big doors closed, and huge pieces of Station, through which he swam.

Sonny Carter, it seemed, was an astronaut who had died in a plane crash. This facility seemed like a good memorial to Henry. The pool afforded him moments of peace, of slowness and relative control, little oases in the chaos that had overtaken his life.

And a day later he was called away to make a parachute jump. He resisted this, but Geena insisted he had to do it once, under controlled conditions, so he knew he could hack it if he had to do it for real.

He was given a couple of hours' familiarization, and then he was taken up in a Chinook. Geena, of course, went first. She didn't hesitate in the open doorway but stepped straight out, her static line cracking sharply behind her.

When it was Henry's turn, he leaned out of the doorway—it was impossible to believe he was standing here, on a platform in the air, with *nothing* separating him from the ground—but he could see Geena's parachute, bleached white against the pale green of the ground. Somehow that sight dissolved his own fears, and he jumped without hesitation.

A few seconds of free fall, of the wind plucking at him as he approached terminal velocity, and then the chute opened behind him, and he fell into his harness like a doll.

The descent was tranquil. He could hear sounds from the ground, cars and sirens, though they were muffled, and he thought he heard bird song.

He didn't want it to end. It was like being back in the pool again.

But it didn't last.

In the middle of all this he tried to keep up with the developing science of the Moonseed, and the bad news from around the planet, and to work on the mission itself: at least, that limited part of it he could control. The surface EVA schedule. The detailed science objectives. Where he wanted to land. The equipment he needed to take. How it would be deployed on the lunar surface.

He demanded, but didn't get, some practice time implanting seismographs wearing a spacesuit.

Frank Turtle looked miserable. "We haven't had time to work up anything on those lines," he said. "They mothballed all the old Apollo facilities, like the Peter Pan rig."

"We're just going to have to wing it," Geena said grimly.

Henry wondered what a Peter Pan rig was.

But it was academic, because there was no time to pursue this before he was dropped in the Nevada desert, close to Reno, with Geena and a couple of cohorts from the Astronaut Office, for three days of survival training: what to do if your spacecraft comes home off course.

They had nothing but a little water and basic survival gear. They made a tent of parachute fabric, and waited out the heat of the day. At night they had to hunt lizards and snakes. Here was one situation where Henry, veteran of hundreds of days in the field, was able to fare a little better than the rest. The astronauts looked enviously at his knife, for instance, inside the hollow handle of which he had stored matches and fish hooks, held in place with candle wax, and he showed them how to make frying pans from pieces of aluminum foil, and so forth.

On the second night he spotted Geena hoarding her water. He came to sit with her.

"Rationing the water doesn't help," he said.

"Huh?"

"Try that and you'll pass out. This is the desert. You need a certain amount of water to keep from dehydration. You should drink the water you have until it's gone, and if you have not been picked up by then, well, you die of thirst."

She glowered at him, but made no move to comply. "Some people are blaming you," she said.

"What?"

"For the Moonseed. The way it got out, at Edinburgh."

The truth was, nobody knew how it had got out, save himself and Jane—and Mike, who couldn't atone anymore. He eyed her. "Do *you* blame me?"

"I don't know. You're Henry. I knew you were an asshole long before any of this stuff." She glanced at him, then away. "No. I guess not. You aren't cast for the role of cosmic villain. Or hero. You aren't big enough."

"I don't think anybody is."

They sat in silence.

"How's Rocky?" he asked at last.

"With my mother, in San Francisco," she said. She stood up. "As if you care."

She stalked away to her sleeping bag.

"Drink your water," he said softly.

On his last day in the U.S., he was taken to the Cape to see a Shuttle launch, probably one of the last there would ever be, its payload bay crammed with final pieces of equipment and fuel pods, a half-billion dollars' worth of firepower aimed at getting him to the Moon.

He stood on a beach with Geena, to the south of the launch complex. To the west, toward inland, the sunset was volcanic, tall and colorful. And in the southeast there was a

blue-black sea, a bruised purple sky. And the Shuttle was picked out by floodlights, the orbiter a graceful white moth against the rusted brown of its gantry.

The Cape was crowded. It seemed a million people had turned out here to watch the spaceships that symbolized the nation's fight-back against the creeping geologic menace. It was like Apollo, said the old-timers.

Geena stood with him. She said, "Do you know what has gone into this launch?"

"What?"

"Ball-breaking work. Henry, *Columbia,* over there on the pad, was turned around from its last mission in two *weeks.* We already have two orbiters in space right now. We only have two simulators; we're sending this crew up untrained. We think the operational safety of the Shuttle system was pegged at ninety-five percent after *Challenger.* But that's thanks to the safety checks. We have no *idea* what risks we're running now. We don't even have time to calculate them."

So it's my fault if *Columbia* blows on the pad, today?

But he let her talk. He understood how hard it was to overcome a generations-old culture; if this was her way of working it out of her system, fine.

. . . Despite the countdown, the launch was somehow unexpected.

There was a flare of dazzling yellow flame, liquid and vibrant, from the solid rocket boosters, and then the whole unlikely stack lifted smoothly off the ground, twisting as it rose. It trailed a cloud of white smoke, illuminated from within by yellow-red fire, and a throaty, crackling noise that seemed to ripple down from the sky.

The energy was palpable, like a seismic event. But it had been made by human hands. All around him, people were whooping, laughing. Crying.

Geena looked at Henry, her face shadowed by booster light. "*Now* do you see what it was all about?"

Moved, he said, truthfully, "Yes."

"We could have been on Mars by now," she said. "On the moons of Jupiter. We could have had colonies big enough to survive off the planet."

"Maybe we could have. But we don't. And now—"

"And now, we have to struggle like hell just to get back to the goddamn Moon, which we abandoned in 1972. You still sure you want to go through with this?"

"I don't think I have a choice."

The Shuttle rose on its stack of billowing smoke, and a warm wind pulsed over them as rocket light glimmered from the patient Atlantic.

When he got back to his room, there was bad news from Scotland, and elsewhere.

32

Jane was woken by the gentle tone of her mobile phone.

She propped herself up on her shoulder, and took the call in a whisper. Then she folded up the phone and put it away.

It had been Henry, calling from NASA.

The surge which had killed her father had subsided. But now, it seemed, the Moonseed's spread had started again: out of Edinburgh, and elsewhere.

She gave herself one second, before letting that sink into her consciousness. She closed her eyes and relished the warmth of the Red Cross blankets wrapped around her, the soft, untroubled breathing of her son a few feet away.

Time to move on.

If they could never be comfortable in this lashed-up Rest Center, at least, with all their efforts, they had made it into a kind of home, efficient and clean. She'd become unreasonably proud of Jack, the way he'd coped with the disruption to his life and settled down to work here. After the first few days informal schooling had started up, but Jack and the other children had still been expected to help with the adult work. Doing his bit.

But he shouldn't have to "do his bit," she thought bitterly. He should be able to grow up untroubled, like every other British kid since 1945. She ought to have been able to protect him.

But that wasn't possible. It never had been.

Maybe she had been lucky to have had this interval of peace. But now, it was all starting again.

She opened her eyes. The last of her peace was gone, her warmth disturbed. She pushed back the sheets.

She shook Jack awake, silenced him with a fingertip to his lips. He nodded and reached for his shoes.

They'd talked about this. Slipping out into the dark. Getting a lead on everybody else, the unfortunates who didn't have boyfriends in NASA.

Betraying them, maybe even leaving them to die.

We discussed this. We've done all we can here. Now things are going to get worse, a lot worse. Now's the time to think of ourselves. The family. That's what counts now.

With their bags, they slipped out to the theater car park.

To the west, over the heart of Scotland, the sky was glowing red. There was a distant sound, like thunder.

And it was raining: a thick, sticky black rain Henry had called tophra, laden with soot and ash.

They hurried to the car. She had been careful to leave it close to the exit. Jane let Jack into the back, loaded the bags into the boot, and put the key into the ignition.

"We're going," said Jack, ten years old.

"Yes."

Go east, Ted had said, the last time she saw him. *Follow the coast. Get past Dunbar and you'll be out of the Midland Valley, and you ought to be home free.*

For a time, anyhow.

There was the sound of a siren somewhere. Lights were coming on in the theater.

And then there were two, she thought.

They climbed into the car. Being here, her hands on

the wheel again, was strangely comforting. The car was a
piece of home, of the old life. A haven.

She started the car, pulled out of the car park, and
headed east.

The outskirts of Musselburgh were already congested with
pedestrians, mostly, it seemed, fleeing as she was to the
east. The tophra fall, thick now as a black snow, made it
gloomy, and people were groping their way along with
flashlights and umbrellas. Most of them had shirts or pieces
of cloth fixed over their faces. She passed one woman who
looked to have been overcome by an asthma attack; a doc-
tor was attending her with an inhaler and what was proba-
bly a steroid shot, something to keep her moving.

Out of town, the traffic moved freely at first, and as
they achieved more distance from the city, the tophra fall
thinned out. But the A1, the road east out of Musselburgh,
was a car park.

So Jane swung north at Tranent, and hit the coast at
Port Seton. The power station here, chimneys and boxes of
corrugated iron and glass, was still working.

Then she followed the coast road to Longniddry, and
then through Aberlady across the bay to the A-road that
led to North Berwick.

The traffic was moving on the coast roads, but it was
almost solid. One bad accident, a single burst radiator,
would clog up the whole damn thing. Her son's critical path
to safety was littered with the dodgy cars and lousy driving
of thousands of panicky strangers. Terrific.

Every radio channel was given over to news and evac-
uation instructions, and she turned it off. There was one
music tape in the car which she played over and over, as the
car limped on.

She knew the coast well from her own childhood. It was
a peaceful place, beaches and caravan parks and golf
courses, a place where families came to spend time together.

Day trips, sausage sandwiches and tea and cake in little cafes.

Here was Jack's childhood: grimy, underfed, in mild shock, huddled into a car seat, clutching a battered sycamore-shape spaceship to his chest, eyes as wide as saucers. It worried her that he'd barely said a word for days. But she would have to think about that later, when she had secured his survival.

It wasn't so far. Fifteen or twenty miles to Dunbar. She had plenty of petrol. If she could do it she would run as far as Berwick-upon-Tweed, the first big coastal town to the south, inside England. Surely they would be safe enough there.

But they had to get there first.

She tried not to look back, at the orange glow and palls of smoke and lightning that played to the west. She tried not to think of her father, or Mike, or Henry. There was nothing she could do for any of them now, or they for her. Time enough for them later.

For now, Jack was her whole world.

The ground shook, every few minutes; she could feel it through the car's suspension.

The car edged forward.

Going through Berwick, she got a good view of North Berwick Law, a tight volcanic cone, six hundred feet high. It seemed to be smoking.

Past Berwick, the traffic stalled completely.

A man—fortyish, thin, in a grimy business suit—clambered onto the road from rough ground beyond. He glanced up and down the row of cars, evidently selected Jane's, and walked up to it.

Before she could react, he had yanked open the driver's side door. "Out of the car," he said, and to make his point he grabbed her sweater at the shoulder and pulled

her sideways. She wasn't wearing her seat belt, and she
spilled sideways onto the road, grazing her knees; the pain
was startling.

She got to her feet stiffly.

In the middle of the road, traffic all around, the man
confronted her. "I'm taking your car," he said bluntly.

But he was hesitating.

Here was a man who was not used to this, to highway
robbery. She tried to think, to size up the situation.

In the scrub on the far side of the road, beyond the
crawling traffic, was a fat woman with a couple of suitcases,
and a kid, a sulky-looking teenage girl. Jane tried to figure
what minor disaster had befallen this family. Maybe their
car had broken down, or simply run out of petrol. Maybe
they had been robbed themselves.

She could offer to give them a ride.

But now the man, with tongue protruding, grabbed
her arm; he pushed his free hand inside her sweater, search-
ing for her breast. He was doing this thing in front of his
family, and hers. Just because he thought the rules were all
gone; just because he thought he couldn't be stopped.

Jane stepped back, breaking his grip easily, and threw
a punch at his nose. She put all her weight behind it. Blood
spurted, bright crimson, and he fell backward.

"Fuck off," she said.

She got back in the car and locked the doors from the
inside. The car edged forward—given the traffic she could
hardly get away—but she didn't trouble to look back.

Jack was clapping her slowly, a grin on his lips.

Jane waved her hand in the air. "It bloody hurt. And
don't let me hear you use language like that."

The traffic crept forward.

The air was strange. The sky was tinged orange. She
could smell ozone and ash.

By evening, they'd come no more than ten miles, and
they had to sleep in the car.

It was now 3:00 A.M. in Chuzenji, an hour or more since one of the monks had woken him with the news of the Pacific volcano. Declan Hague sat in his cubicle, pondering events.

Waves.

In Declan's mind, the future was simple: it was a question of waves, and wavelengths and speeds, the simple physics he remembered from school.

On his small, hand-held TV there were the images of destruction, brought to him in a fraction of a second, bounced around the world by the satellites: the boiling ocean, the glowing, cracked sea floor, the new island-mountains thrusting into the air from the depths of the Pacific. It was the Moonseed, the scientists said. It hadn't taken long to chew through the five-mile-thick crust under the oceans, to open up new vents to release the swarming fire of Earth's interior. Some of the scientists seemed pleased with themselves. *Right on schedule,* they said.

These electronic images came to him on the first wave, at the speed of light.

Next would come the sound, the great shouts of the quakes and eruptions, carried through the perturbed and increasingly murky air of Earth at some six hundred miles an hour, directly to his ears. The second wave. He would need no technology for that, and that was pleasing.

... And at last, one more wave, of more uncertain velocity, that would come rearing out of the perturbed ocean. And that, he thought with relief, would finish it all.

There was a tsunami watch which sought to monitor and predict the great waves, like seismic weather stations, scattered across the Pacific, run by many countries. So the coming event was not unanticipated. On his TV the experts pronounced solemn warnings to prepare, exhortations to stay calm.

Japan had been struck by at least fifteen great waves in

the last three centuries. In 1896, a tsunami was reported to have killed twenty-seven thousand people. More than a thousand died in 1933. And so on.

Tsunami.

It was a word which meant "tidal wave," but the waves were nothing to do with the tides, the pull of the Moon.

Right now, in the open ocean, the wave caused by the ocean floor crack would not be so spectacular to look at. Perhaps three hundred miles long, but no more than a few feet high, with a hundred miles or more between crests, traveling at somewhere between three and six hundred miles per hour. Unimpressive—except in terms of the energy stored by such a vast formation, crossing the world ocean at such giant speeds.

As it entered the shallower waters along the edge of a continent, the wave would reduce in speed and gather in height, to perhaps two hundred feet, three. And then when it reached the land, friction with the shallow bottom would reduce the speed to less than a hundred miles an hour—but the wave height would be magnified tremendously.

No structure could withstand its force. As it uprooted trees and smashed buildings, it would become laden with debris, and its ability to scour the land bare would be magnified. Sizable ships might be carried miles inland.

Then would come a rapid retreat back to the ocean, and then, every ten to twenty minutes, a fresh surge, until the energy was dissipated.

Sometimes the first surge would deposit fish, swept inland and left to suffocate. Fools would hurry forward to take the fish. But the wily Japanese knew that more surges would come, and ignored the apparent bounty. That was the folk wisdom, the common experience. The Japanese were, after all, used to tsunamis.

But he wondered if they really understood what today would bring.

There would, of course, be no one to help. For, as the

flickering TV images showed, the Moonseed was surging in many places, and the world was, evidently, starting to come apart.

He had no desire to sleep again. He pulled on his habit, slipped out of the main hall, and walked through the soft quiet to the staircase cut into Mount Nantai.

He took nothing but the clothes on his back, the sandals on his feet. Not even a light, a lantern or a torch, to guide his way on the rocky steps. The sky was so bright now, glowing a thin red like a sunset, all the way through the night—thanks to the volcanic dust being injected into the air, from Britain and Italy and the Philippines, and a hundred smaller eruptions—that he needed no light anyway.

It would have been nice to see the stars, he thought. But then in an hour or so the baleful countenance of Venus was due to rise, and he had no desire to witness that ill omen again; let the dust blot it out for good.

He reached the caldera rim, and was greeted by the stink of sulfur and ash and chlorine. There seemed to be new fissures in the ground here, and he suspected he could see the vent of steam.

Here and there, the rock burst into subdued silvery light. It was the mark, he had learned, of Moonseed growth. His creation.

He smiled.

He found a place where he could sit in comfort, with his back to the subtle warmth of the reviving volcano. Here he could look out over the lake, to the south and east, toward the ocean, and Tokyo.

There were twelve million people in Tokyo, an incredible number. One quarter of the population of the country lived within thirty miles of the Imperial Palace there.

He wondered how many had already fled. But, as the light of a new dawn seeped into the sky, many more would even now be making their way *into* the city, by car and train and bus, for another day's work, regardless of the warnings.

The Japanese were used to tsunamis, after all.

The sun was high, but it was a pinprick, a wan disc in an ugly gray sky. He was cold, despite the thickness of his robe.

Unseasonal weather.

Declan knew he would have to wait most of the day, until perhaps the early evening, before the wave arrived.

By now, Hawaii must already have suffered.

Hawaii, stranded in mid-Pacific, was surrounded by deep water, submarine trenches outside its harbors. The water shallowed rapidly near the land, and the waves, coming out of the western ocean, would pound down on the islands with virtually no warning. The sun was high; the destruction must already be over there. Scoured down to the bedrock, he thought.

But even the tsunami would not be the end of it, no matter how destructive.

A major earthquake was, said some of the experts, overdue for Japan. Statistical projections said it would be on the scale of the great 1923 quake which killed a hundred and forty thousand people. Hitting modern, crowded Japan, such a quake would destroy industrial production, and lead to a massive worldwide recession.

That was the projection, the common understanding. Declan knew that the calamity that was coming would far exceed such measly predictions.

Perhaps the approaching tsunami would trigger it. Or perhaps it would be the destruction of Nantai, fed by the Moonseed: perhaps it would be necessary for the Moonseed to work deep into the magma under Earth's skin here, as it appeared to have done in Scotland. Perhaps, even now, other great calderas—even Fuji itself—were opening up, feeling the ghost touch of the Moonseed, the stirring of the magma in the deep chambers within.

Eventually, though, it would all let rip.

He imagined the near future, when the whole ring of fire went up: tracing down the western seaboards of North

and South America, scrawled over the ocean past China and Japan and Australia, almost a perfect ring around the Pacific. What a sight it would be, from space! It would be as if the Pacific, the world ocean, was trying to pull itself free of the poisoned and battered Earth which spawned it, perhaps to sail free into space to join the Moon.

He would like to live long enough to see that. But it wasn't essential.

Probably Declan hadn't needed to do anything to speed the decline of Japan. It was all, really, inevitable; you only had to glance at the polluted sky to see that, the poison that had wrapped itself around the planet.

But it pleased him to have played his part.

He was destroying his home by his own actions. Just as he had destroyed one earlier home, lost his wife and baby daughter because of what he'd done, and the awful revelations he hadn't been able to forestall or buy off.

But this time, he would have nowhere to flee. Nowhere to shelter his sorry soul; nowhere to eke out the days, as he imprisoned himself.

He smiled. Call it time off for good behavior.

There was a wind from the ocean. A spattering of rain. It was salty and muddy.

Declan Hague laughed, celebrating his freedom. He let the salty rain run into his open mouth.

Scoured down to the bedrock.

34

Debbie Sturrock was actually coming off duty when it happened; that was the irony of it. And strictly speaking she wasn't even a firefighter at all, since she hadn't yet completed her training in the Scottish Fire Service Training School, down the road at Gullane.

She just happened to be in the way.

Torness, the modern nuclear power plant just outside Dunbar, meant little to Debbie. She drove past it every

day on her way to her training assignment at the fire sta-
tion in North Berwick. Torness was just an anonymous,
slightly sinister collection of blue cylinders and boxes and
piping, hiding behind a row of immature fir trees.

But today, as she drove toward it on the crowded
road, alarms were sounding, and people were fleeing out
of the gates, and there was black smoke billowing from the
big structure of steel and glass at the heart of the compound.

She pulled over to look more closely.

A pillar of flame. Sparks. Bits of concrete, metal struc-
tures, tumbling in the air.

She drove up the broad main drive and got out of the
car. She had her yellow hard hat and her jacket in the boot;
she pulled them on, running to the gate.

A security man was here, holding his position despite
his obvious fear, directing others, office workers and engi-
neers and managers. Debbie approached him.

"I can help. Which way?"

He looked her over, evidently recognized her as a fire-
fighter, and pointed. She hurried into the compound.

The big, boxlike building at the heart of the compound
seemed to have exploded; the thin metal frame was ripped
open at the roof, like a tin can. Above the damaged build-
ing there was a bluish glow, and pockets of fire on the sur-
rounding buildings.

She found herself walking across a neat lawn that was
littered with glowing debris.

Despite herself, her pace slowed. This was, after all, a
nuke plant. Dear God. What have I walked into here?

Well, she'd already been in a lot of fires, and she'd
never hesitated before.

Without thinking, she pushed herself forward, toward
the blue glow.

The heat was enormous, like a wind, crowding through
the layers of her clothing.

She came to a maintenance crew, trapped in a tool
bunker maybe five hundred yards from the explosion's

core. The bunker wouldn't last long; Debbie Sturrock could see a bloodred liquid seeping from the walls as they started to melt in the massive heat. The maintenance guys had no protective gear.

A fire crew was pushing in toward the tool bunker with a fire hose. They were trying to keep the water playing on the door.

Debbie joined them. The crew leader waved at her, miming at her to piss off out of here. She ignored him, and lent her strength to the efforts of the crew as they kept the hose directed at the door.

When it was cool enough, the door was opened from the inside. The workers there threw out singed sandbags, which they'd evidently been using to seal the door, and made a run for it.

By the time they were gone, Debbie was vomiting. But still she held onto the hose.

The ground shuddered.

Earth tremor?

She wondered if that was what had triggered the explosion. She knew the two reactors here were cooled by pumped carbon dioxide gas. What would happen if a tremor knocked out the coolant pumps, or broke a feed line, or . . . ?

Really, she knew nothing about nuclear plants. Nothing, except that you shouldn't go near one at the best of times. And this was not the best of times.

When the maintenance guys were out, under the leader's gestured command, the fire crew dropped the hose and ran toward the center of the blaze. Debbie followed.

Her vomiting was over, but she was still dry-retching even as she ran.

There were fires everywhere. It looked to Debbie as if the stuff raining down from the central explosion—the reactor?—had ignited whatever it could find, like the tar on the roofs. She had some breathing apparatus now, dropped by an injured firefighter, but as they worked to the center of

the complex she found it progressively more difficult to battle through the intense heat, the acrid air, the molten tar that stuck to her boots, a black graphite dust which seemed to be everywhere.

She felt *hot*, inside and outside, a feeling she'd never known before.

They were met by a man in shirtsleeves and a Scottish Nuclear tie. He was the deputy station manager; he was wearing a badge that turned out to be a radiation dosimeter. His boss, the station manager, wasn't here; she was crowning the Gala Queen in Dunbar five miles away. Local-friendly PR for the area's biggest employer.

Gradually, as the deputy manager and the fire chief argued about what to do, Debbie figured out what had happened here.

"We're protected from quakes here. The founds go down to bedrock. But we're designed to withstand only up to a certain Richter. When the big tremor hit, the sea water conduits cracked . . ."

"What does that mean?"

The manager struggled to explain. "The reactors are cooled by carbon dioxide gas. The hot gas is passed through a boiler that turns water to steam, and the steam runs the turbine. The steam is in a closed loop. It passes through a condenser, where it's cooled by sea water."

"What happens to the sea water?"

"It's dumped back in the ocean. The radiation levels are low, and we monitor—"

"Never mind that. So without the sea water flow there's no way for heat to get out of the system?"

"And on top of that we had a total loss of power. The cee-oh-two pumps failed—"

"Shit, man, you must have backups."

"Oh, yeah. We draw power from the National Grid to keep the coolant pumps going. And failing that we have eight diesel generators on site. But the quake was too severe. We lost *everything*. Even so there are failsafes.

When the power failed, the damper rods should have fallen into the reactor cores by gravity."

"Don't tell me. They didn't."

"The core was distorted. We couldn't get the rods in. And we had carbon dioxide trapped in the core because the pumps had failed, and the gas got hotter and hotter, until there was an explosion that disrupted the pressure vessel—"

"Hold it. *What* exploded?"

"Reactor Number One."

"Oh, Jesus . . ."

There was a small fire team here, Debbie learned, but only one of them had worked for the Fire Service.

There were two nurses on site. Nobody knew where they were.

The chief was still arguing what to do with the station manager when the one experienced firefighter tapped a couple of buddies on the shoulder, pointed, and ran toward the big central building, which was still burning.

Debbie hesitated for one second, then followed.

The leader took the crew up an appliance ladder to the roof of a building which, Debbie learned, was the turbine hall. Here, a couple of crews were already plying hoses onto the burning building below.

It looked—to Debbie, in her ignorance—like the central reactor hall itself.

The central building was just a shell of metal and glass, pretty much blown apart, a shell that had been wrapped around a massive concrete cube: the reactor block.

She was looking down at the roof of the block, which was littered with equipment and protective clothing, hastily abandoned. There were three big discs of black tiles, set in the block roof. The centermost of these covered a store for spent fuel, and the two others were the two reactors themselves, in their forty-feet-high pressure vessels of concrete and steel, buried inside the block.

There was a huge lime-green crane-like machine that ran on rails along the roof; this was the fuel charging machine, designed to lug seventy-feet-long fuel assemblies to and from the reactor cores. But the charging machine was crippled, its iron frame bent out of skew.

Number Two Reactor, to her right, looked intact. It was Number One that had suffered the explosion.

Its massive lid had been blasted off—black tiles were scattered around the building—and its concrete shell was broken outward, reinforcing bars flailing upward wildly. She could actually see into the heart of the reactor, the exposed core, which was a mass of flame and smoke.

The firefighters were hesitating before this, arguing about what to do.

To Debbie it was obvious. The fire in that reactor core had to be put out, before any more radioactive products were vented into the atmosphere.

And there was only herself and the other firefighters to do it, by hand if necessary.

She'd heard about Chernobyl, the heroism of the firefighters there. The casualty rate later.

She'd never expected to encounter such a situation herself.

When she looked into the exposed core, she felt its warmth, on her face and chest and legs. She wondered if she ought to ask for a dosimeter badge.

She fixed her helmet and oxygen mask. With the others, she pushed forward, into the heat.

The traffic crawled through Dunbar, and beyond.

Farther east, there was something going on. Jane could see a pillar of smoke, blowing inland. Helicopters were flapping over, dumping tons of what looked like sand.

Five miles past Dunbar, close to the source of all the smoke, somebody came blundering into the road in front of her, and Jane braked sharply. It was a fireman—no, a

woman—singed donkey jacket, blackened hair, what looked like a bad case of suntan darkening her skin. She looked around blearily, focused on Jane, and came staggering to the passenger door.

"Please," she said. "Help me." Her voice was a hissed whisper.

She was just a kid.

Jane nodded. She got out of the car, and bundled the firefighter into the back. The woman lay down, her legs drawn up to her chest, shivering. Her face looked swollen, and she seemed to be trying to protect her hands. Around her neck, her skin had burst and was hanging in strips. She was bleeding through her nose, perhaps hemorrhaging. There was a name badge on her jacket. STURROCK.

Jack just stared.

Jane realized where she was. Torness. Jesus. I should have thought of this. I have to get Jack out of here—

There was a thunderous roar overhead, startling Jane enough to make her brake. "Jesus Christ. What now?"

She looked out of the window. Planes: fleets of them, huge black shapes, sweeping in from the north.

"They're coming from RAF Leuchars," Jack said.

Jane stared at him. It was the longest sentence he'd uttered in days.

"There are Vulcans. See, the British ones. And B–2As. The Americans. Look, that's a B–52. And I think that's a Tupolev, the white one. Russian . . ."

The sky was black with the bombers, the growl of their jets filling the air. All around her people were climbing out of their cars to see, or peering out of their windows into the sky.

They were whooping, clapping. One woman was crying.

Henry had told her about this. The start of the counter-measures. Now we fight back, Jane thought brutally.

In the car, the firefighter groaned.

Jane pulled onto the road's central reservation, and put her foot down, ignoring the blaring horns around her, putting as much distance between herself and Torness as she could manage. She tried not to hunch her shoulders against the invisible radioactive sleet that must be drenching them both.

In the back, Jack gave the firefighter water.

From the heart of Scotland, behind the fleeing car, came boiling clouds and a continuous roar of thunder. More planes flew overhead, and she imagined the fight against the Moonseed, all over the suffering planet.

35

Garry Beus stepped out into the flat California sunlight.

Edwards Air Force Base was a chunk carved out of the western desert, marked only by Joshua trees, twisted and arthritic and sinister. The land that time forgot. It was early, but already heat haze was shimmering off the flat, pale salt lakes on the horizon, obscuring his view of the giant aircraft hangars here.

And there was a muddy brown color to the sky. Volcanic shit. The reason he would be earning his hazardous flight pay today.

It had started off as a normal morning. Shower and shave, a pass on breakfast. But when he climbed into his flight suit, an ugly sonofabitch in olive green with a zipper from balls to neck, and he took his wallet and log book, and he pulled on the thick socks he always wore in case of a cockpit heating failure—well, his heart had started to pump.

Edwards had always been the place to be for a pilot, a place you could come burning down out of the sky and always find a place to land on those broad salt flats, where you could touch down faster than some airplanes could *fly*. Chuck Yeager flew here. This was the home of the X–15. They even landed the Space Shuttle here. But in truth Edwards was a place for test pilots, like Garry himself.

Today, though, Garry had some real work to do here.

He walked to the squadron building. Here was the ops desk where he had to check in to confirm his mission, and his wing man for the morning's two-ship flight, Jake Parrish.

The briefing between the two of them took a solid hour, led by Garry. He covered the mission objectives, and the motherhood stuff, the basic principles for every sortie: operating standards, radio procedures, contingency plans, SAR—search and rescue procedures—and the weapons, though today that just meant the two laser-guided bombs each F–16 would carry on its underwing pylons. There was some special briefing material on volcanic effects they might hit: hot updrafts, microbursts, ash in the carb, toxic gases, other shit.

Then it was back to the ops desk. There were no maintenance delays, no clouds, and the volcanic shit in the sky shouldn't cause any hold-ups.

But here was Garry's mother.

She was reduced to a shriveled little husk, hair a wisp of gray, probably only half his weight. It just wasn't damn fair, Garry thought. But she was smiling at him, so he smiled back and hugged her.

"My God, mom, what the—what are you doing here?"

"Well, it's my fault you're going," Monica Beus said.

"Your fault?"

"The whole mission was my idea, I'm afraid. I wasn't best pleased when you called and told me you'd been assigned to the flight."

He grinned. "So, you want to split the hazardous-duty pay? It's all of a hundred and fifty bucks."

"I think you're going to earn that today," she said quietly.

Jake had joined them. "Don't worry, Mrs. Beus."

"Doctor," Garry said.

Jake said, "I'll watch his ass, pardon my French, and bring him home safely."

"Make sure you do that." She looked up at Garry, as

once he'd looked up to her, and he felt his heart break once more.

"Mom, how's . . ."

She let him off the hook. "The brain tumor?" She smiled thinly. "Not so bad as you'd think. I get sickly headaches. Wiggly lines at the edge of my vision. If I had your job, they'd ground me."

He wanted to hug her. "Mom—"

"Now, Garry, if I can handle it you can. Things can't get any worse, after all. And I'm not ready to have a child die ahead of me. But you know how important this is."

". . . I know."

"We need some good news here." And she talked briefly through some of the issues that were coming across her desk.

The breakdown of government and society, the great swathes across Africa, Asia, even parts of Europe. Massive population movements. Deaths from geological events, and simple crop failure and breakdown of trade, on such a scale nobody dared estimate. *The die-back* they were calling it.

Even in Fortress USA the problems were immense. Rationing was already breaking down. The survivalist types had made some parts of the interior ungovernable. Lethal force was meeting refugees from Mexico and Cuba and *Canada,* for God's sake.

It was worse than Garry had heard. Worse than had been made public. Somehow the censoring of the news was the most striking thing.

"We have to make a stand against this Moonseed. *You are an American, fighting in the forces which guard your country and your way of life. You are prepared to give your life in their defense.*" She was quoting the servicemen's code of conduct. "That's never been more true than today."

Jake nodded gravely. "We'll do our jobs, ma'am."

When they walked off to the life support room, Jake nudged his arm. "Was she always so serious?"

Garry thought about that.

His mother had seemed a plump, warm giant to him throughout his growing-up years. Despite her high-powered jobs, as her academic career took her to a variety of universities around the world—and, at last to Washington, where she had, it seemed, got the ear of the President herself—she had always made time and space for Garry, never been less than a mother. Something he appreciated even more now he was thirty, and he thought about his own young family in L.A., Jenine and young Tommy . . .

"Yeah," Garry said. "She was always serious."

When they were kitted out, they hopped into the van that would take them to their aircraft. The crew chief—a round, glum man of around fifty—showed him the aircraft forms; everything looked good today.

Garry's F–16 stood waiting for him: fifty feet of sleek gun-metal gray, its color darkened by the muddy sky. Garry walked around the bird and kicked the tires, made sure the right weapons were loaded, and checked the oil. The weapons pods were two fat, sleek torpedoes slung under the wings.

He climbed the ladder that dangled from the cockpit, and perched for a moment on the canopy rail. He held onto the ledges and swung his legs into the foot wells, like James Dean hopping into a convertible. He finished up semi-reclining in the hardened seat pan, with his legs straddling the instrument console, his feet planted on the rudder pedals.

The F–16 was his idea of an airplane: a single-seater, single-engine bird in a tradition that dated back to the P–51 from the Second World War. And its primary mission was air-to-ground, which would give him the chance to fly at five hundred feet, the ground rushing by, the sensation of speed startling.

Garry thought his blood must be fizzing in his veins, loud enough for Jake to hear.

The preparations continued. He snapped an air hose to his G-suit, to swell the bladders that would keep his blood from pooling when he pulled Gs. He fixed clips at his shoulders and hips to his parachute risers and the seat kit with its survival gear, all of it contained within the seat pan. He pulled tight his lap belt, lifted on his helmet and fitted his oxygen mask.

The crew chief called up. "Rail clear?"

Garry gave him a thumbs-up.

The canopy came down, a clear polycarbonate bubble that slid down over him and locked into place, smooth as something out of *Flash Gordon*. He activated the seals to pressurize the cockpit, and set the climate controls to a little cooler than the flat desert air outside. He was in his own world, already cut off from the ground, the cockpit so tight and cramped around him it was as if he had donned the bird like some immense Batman suit.

He strapped on his knee clipboards, and set his switches to their start positions.

He called the crew chief. "Fore and aft clear, fire guard posted, chocks in place?"

Roger that, Garry. Ready for run-up.

He turned on his electrical power, and hit the jet fuel starter, the small engine that would turn over the main motor, the GE–100. He advanced the throttle from off to idle; the engine surged with a throaty roar.

When he was ready to taxi, the fire guard removed the chocks from his landing gear. The crew chief directed him forward, waving his hands back behind his head.

Garry pushed the throttle past idle, and led Jake out toward the runway, steering with his rudder pedals. The end-of-runway crew gave them a final systems check, and the weapons crew pulled the safeties on the bombs. He kept his hands in the air, where the crew could see them, just so the crew knew he wasn't about to flatten them with a careless touch of a flight control.

They were cleared for takeoff, and he taxied onto the

runway. He pushed the throttle to ninety percent power. He ran one last check, cycling the flight controls. All was in order.

He took his feet off the brakes and pushed the throttle to military power.

The engine rose in pitch to a scream. He turned on his afterburner, injecting neat fuel into the hot exhaust stream, generating huge thrust.

The plane kicked him in the back, and the runway was ripped out from under him.

At three thousand feet he reached his takeoff speed, two hundred miles an hour. He touched his stick back, stroking the fly-by-wire, the plane's nervous system.

The plane just leapt into the air, and he followed the flight-path marker on the head-up display into the sky.

Below him, the Earth closed over on itself, turning into a dome littered by the blocky buildings of the base—airplanes sitting in the washed-out sun like kids' toys—and he could see the desert beyond, etched by roads, scarred by the smooth sheen of the dry lakes.

Monica saw the takeoff from the ops building.

It was a burn and a roar, as Garry bore down the runway at full thrust. His engine nozzle opened with eerie mechanical grace, and a sheet of flame shot out. There was a rumbling, and the air seemed to shake, or perhaps it was the very ground.

Then he was in the air, and receding quickly, the flame becoming little more than a red dot. She watched until she had lost him, in the blur of the volcanic sky.

Then she went indoors, wondering how much more of this marrow-sucking heat she could withstand.

The doctors said she had a full house of mets now: secondary sites, lungs, and liver . . . She knew what to expect. The pressure in her skull was giving her the headaches. She might get speech or movement disorders, or epilepsy.

Maybe even dementia, if she lasted so long. But the liver or lung stuff would probably collapse on her first.

The only good thing about her illness, she was finding, was that it took her mind off her worry about her son, the fighter pilot.

Aviate, navigate, communicate.

Jake checked his relative position by radar. *Two is tied. Two is visual.*

Garry craned his neck; he could see Jake's bird in the muddy sky. "Clear to rejoin."

The wing man came skimming in, sliding through the air until he was in fingertip formation, within five feet or so of Garry's wing tip, every detail of his bird visible sharp and clear. They ran an eyeball leak and panel check of each other's planes, and then they slid apart to a standard formation, tactical line abreast, a mile and a half apart.

Garry was sitting at the front of his plane, cushioned by ear plugs and ear cuff pads, surrounded by a crystal clear bubble of plastic. He was in a cocoon of sunlight and sound, everything at his fingertips and under his control, at home.

Garry turned the formation to the northeast, toward Arizona.

They flew over Las Vegas. The city was a splash of glass and concrete in the middle of a crumpled, arid landscape. He could see the pyramid of Luxor shining in the washed-out sun, utterly unreal. And then over Lake Mead and the Hoover Dam, and across the Shivwits Plateau . . . And now, here was his first, thrilling glimpse of the Grand Canyon.

Here at its western end the Canyon was a knife-gouge in the Colorado plateau. He was flying east now, into the low sun, and he could see how the light picked out sedimentary strata. In the deepest section of the Canyon he could see the Colorado River itself, a stripe of silver-blue painted over the land. There was a greenish stubble over

the plateau and the upper slopes of the Canyon, the asparagus green a strong contrast to the crisp red of the old rocks exposed beneath. The stubble was a covering of trees, he knew, junipers in a sea of sage, diminished to specks by the scale of the Canyon.

He dipped low, and imagined the sound of his passing washing over the empty land. But a soft warning from Jake made him lift his nose, and gain a little more altitude. A smudge of volcanic shit, ash and dust, covered the ground here, emanating from the cracks that had opened up in million-year-old vents. Best to keep his engine intakes clear of that.

He looked into the Inner Gorge, the oldest rocks. He could see where the Moonseed was eating into them, silvery patches like scars amid the volcanism.

They headed farther east. He passed Lava Falls, where rapids turned the river white, and he was flying over the Havasupai Reservation, the home of the People of Blue Green Water, who had lived here for a thousand years. But today, of course, the People had been evacuated. Despite the peril they had stuck to their traditions; they had insisted on walking out, all the way to Tusayan.

They flew on over the tourist areas around Tusayan. He could make out the tiny, scattered towns and lodges, the dusty trails along the South Rim, the fine black lines of the metaled roads. And then he followed the Colorado to the north, skirting the Navajo Reservation, soaring over Marble Canyon, until he reached Lake Powell itself.

Lake Powell was flat, like some kind of engine oil spilled into the valley, its Mediterranean blue a striking contrast with the sunlit red and ochre of the high desert. He could see at a glance the lake wasn't natural. Its shoreline was sharply ragged, like a fractal pattern: no time for erosion to smooth away the edges here.

Maybe some day—if the kooks, like Alfred Synge, that his mother used to bring home had been right—Mars would look like this. Terraformed, by American hands and

energy and ingenuity, blue against the red dust. He grinned. Even if all we do with the world we build is put up plastic pyramids.

Anyhow, today the Moonseed was soon going to find out just what Americans were capable of. For better or worse, for them all.

He turned away from the sun, with Jake on his tail. He scooted low over Lake Powell.

And there, at last, was Glen Canyon Dam. The target.

Garry was going in first. "Target in sight. Ten seconds to the drop."

Copy, Garry. Your pickle is hot.

"Master Arm on . . ."

The LANTIRN targeting pod, fixed to the forward fuse-lage of the airplane, fired a short laser burst at the dam, to establish the range to target. A grainy image on his head-up display, generated by the pod, told him what was going on.

The time-to-drop clock counted down to zero.

The two bombs fell away from his wing pylons. They lit up and accelerated away quickly.

When the bombs were fifteen seconds from impact, Garry fired his guidance laser at the base of the dam, as close as he could get to the water line. A clock in the multi-function display counted down to zero.

He could see the missiles slam into the face of the dam: small puffs of masonry dust, in utter silence.

After that, nothing.

He peeled around, and stood off as Jake completed his own run.

The bombs were "Deep Throat" penetrator bombs, officially designated GBU–28/B, complete with Paveway laser guidance kits. The first of these babies—improvised from old, rusting Howitzer gun barrels—had been put together by Lockheed in haste in the build-up to Desert Storm, to dig out Iraqi command and control bunkers.

When all four bombs were emplaced, their tail-mounted fuses caused them to detonate, simultaneously.

It happened in an instant.

Concrete erupted from the face of the dam, hailing over the water of the Lake, which turned white. Garry imagined a shear wave slamming into the structure of the dam, weakening it fatally.

The first cracks appeared, even as he watched.

Jake whooped. "We're the new dam-busters, boy!"

They turned into CAP—"combat air patrol"—even though they weren't on combat duty today; they'd trace a series of long, skinny ovals in the sky, like following invisible racecourse tracks, while the camera pods they carried recorded the results of their handiwork.

It wasn't particularly usual for a pilot to do his own follow-up spotting like this. But then, this wasn't a *usual* mission. There were no hostiles. But the sky was full of volcanic shit, which nobody was quite sure of what it would do to the airplanes' engines, and so there was a reluctance to risk launching off more guys than necessary.

All of which meant, Garry thought wryly, that all of the risk today was being bought by himself and his wing man.

But he patiently settled into his ovals, each of them taking fifteen or twenty minutes, scooting over the tortured scenery of the Grand Canyon. It was no big deal. He was comfortable here, in this armchair in the sky, with the world's greatest view; he could do this all day, or at least until he had to take a dip, a refuel, on the airborne tanker, the big 707 they had lined up on the ground.

Over the dam, the sight was spectacular. Already he could see the angry water, brown-white and swirling, smearing itself across the landscape of the Canyon, washing out Highway 89, pounding at the Navajo Bridge, ramming its way deeper into the Canyon.

Since the damming in 1963, the Lake had been storing up two hundred and fifty tons a day of sediment—the sand and silt and smashed-up rocks which had enabled the river to scour out the Canyon in the first place—and today, all that good stuff was going to come pouring down the Canyon, taking decades of pent-up revenge, the mother of all mud slides.

He took another tour over what he was coming to think of as the badlands, the bleaker western end of the Canyon, laced with clouds of ash and steam, lair of the Moonseed. It was going to be a hell of a sight when the floods rammed into the Inner Gorge—

His headset rang with an alarm.

Acquisition radar. It was so unexpected it took him a couple of seconds to recognize it.

But he confirmed it on his threat warning screen. Right on top of him, out of nowhere.

Working on automatic, he called Jake. "Mud six. I got mud six."

What?

It had to be a malfunction.

Closing up, Jake said.

The sound went off, but the visual alarm continued to show.

He turned his head, scanning through his bubble window through a hundred and eighty degrees. He was looking for the plume of a surface-to-air's rocket motor. What if some crazy *was* shooting at him? Some eco-freak, maybe . . .

He saw nothing.

Jake was screaming. *Shit, man, it's right under you!*

Counter-measures. Radar chaff—

But there was no more time.

There was a slam, the loudest noise he had ever heard.

He was thrown up, like a punted football, and then he fell away to his left. Whatever had struck him had come from beneath, his blind spot, and hit the F–16 in the belly of the fuselage.

He glanced back.

His plane was *gone*.

The F–16 had been broken in two; his nose and cock-pit had broken away, and were falling through the sky, powerless. He couldn't even see the rear section.

There was flame lapping all around him. His instrument console was breaking up, splintering and warping, glass dials popping and smashing. The flames dug into a gap between his oxygen mask and his visor, and the nape of his neck, behind his collar.

Slam, fall, flames, pain, all within a fraction of a second.

He looked down. There was a hard rubber handle jutting between his legs: PULL TO EJECT. He reached down with his left hand and pulled.

The seat pulled his restraints in, back to the parachute risers, dragging him back against the seat frame. The canopy popped, and was gone; air rushed over him, cool and clean, dousing the flames. The seat slid up its glide rails, and a rocket catapult hurled it into the air. A kick in the back: ten or twelve Gs, for maybe half a second. Garry thought he could feel it all along his vertebrae.

The air slammed into him like an ocean wave.

Then he was upside down, still strapped to the seat, shards of debris fluttering around him. The seat stabilized itself quickly, and there he was: face down, stranded in the air, five miles high.

The crumpled Arizona landscape was rising toward him, so slowly it was almost imperceptible. It would take five minutes to free-fall to Earth. He was supposed to ride out four minutes of that, until the seat opened at fourteen thousand feet.

He could see the wreckage of his plane, two big chunks surrounded by a cloud of smaller fragments of debris. He watched the nose section hit the Canyon wall, and it exploded there, and a pall of black smoke rose from the crater. His own miniature volcano, to go along with his earthquake.

There was no sign of whatever assailant had struck at him.

The air up here was cold and empty and silent, after the explosive shattering of the airplane. As the adrenaline shock receded, he waited for the wave of pain to hit him.

He'd never tried this before.

You didn't practice ejections; they were too dangerous, not to mention expensive. You just studied the manuals and made sure you knew where the yellow lever was and hoped you never had to pull it. For sure, he didn't feel as badly as he always imagined he would, after being hurled out of his safe, bubble-wrapped armchair in the sky, into this position of complete nakedness and exposure.

You're in shock, he told himself.

He could even recognize where he was. The western end of the Grand Canyon was laid out below him like a National Park tourist map. There was the skinny sheen of the Colorado, bright blue against the Mars-red of the high desert into which it had cut. He could see the tributary canyons, cut by their own rivers, Prospect and Mohawk to the south, Andrus and Parashant to the north. Even now, there was no sign of the flood water that was forcing its way along the Canyon from the east. The Canyon was *long* . . .

There was a fiercely black knot of cloud, right about where Lava Falls should be. He was, in fact, drifting over the Falls, and so looking down, right into the cloud.

He could see the glow of red, inside the cloud. He heard distant bangs, like cannon fire, disturbing his peace. He saw sparks fly out of that red scar.

Sparks?

If he could see them from here, then they had to be the size of houses. Rocks, then. Probably lava bombs, freshly birthed from the Earth, cooling even as they sailed up from the mouth of the ground.

He knew about lava bombs. After the Moonseed, everyone was a volcanologist.

So now he knew what had hit him. Maybe he and Jake

had indeed made the Earth quake. But the Earth, or at any rate the Moonseed, had struck back.

It wouldn't take another lava bomb to kill him, now he was out of the airplane. Just a fragment, an ember of red-hot rock, might be enough to torch his canopy. And if he fell through the cloud his lungs were going to be filled with searing hot ash and dust and steam.

And he was falling right into that spreading cloud of black, fiery shit.

Garry got hold of the manual override handle in the right side of his seat, and pulled it.

He heard a light pop as the drogue chute emerged. There was a jerk as the drogue filled up, and then a billowing, like huge wings over him. It was a wonderful noise, the sound of his main canopy opening up.

Now there was another jerk, much harder.

Suddenly he was falling much more slowly, now at an angle to the ground, still strapped to his seat.

It was going to be twenty-five minutes before he touched down.

He would have to lose the seat at some point. A seated landing would be hazardous. But for now, it made him feel secure. Hanging in the air like this, it was hard to let go of *anything*.

At twenty thousand feet he pulled off his oxygen mask and dropped it earthward. His cheeks and neck immediately felt better.

He heard the roar of a jet over his head. It was Jake. The gleaming F–16, stunningly artificial against this barren, inhuman landscape, waggled its wings.

Then Jake fell off to the east. He must be low on fuel, and for all Garry knew had taken some kind of damage from the volcanism as well. But he knew his wing man wouldn't rest until Garry was picked up.

He reached to the front of his seat and found the toggle switch that activated his distress signal.

At fourteen thousand feet his seat fell away, as it was designed to do. He looked up. For the first time he could see his canopy, a broad ceiling of orange and white and green, as visible as all hell.

He started to think about where to come down.

Even if he avoided that volcano, and any little brothers and sisters it might have, he didn't want to land in the Canyon itself. Certainly not in the Inner Gorge, waiting for the giant flood he'd initiated to come scouring away the walls. He needed to look for a place on the plateau, then, either to north or south.

The wind hit him again, harder, and he found himself drifting through a neck of fierce volcanic cloud. Suddenly he was immersed in darkness, and his mouth and nose were full of hot, gritty dust. The buffeting got worse. There was hot air all around him, roiling and turbulent. It was possible that even if he wasn't burned or suffocated to death, the damn turbulence could tip him upside down.

He had to get out of this. Like, now.

He reached up to the four-line release, a set of red handles either side of his head. He tugged at them sharply, to open panels to the rear at the canopy. He could feel himself shoved forward, as the air gushed out of his canopy.

In a few seconds he had come out of the cloud, into relatively fresh air. He was coughing, eyes streaming, but he was intact.

The air was carrying him a little more to the east than he would have liked, but he was able to correct that with tugs on his harness lines, and keep his heading to the north.

A thousand feet, less. He could see a lot of detail now—too much—trees and sage everywhere, scattered over a landscape that didn't look nearly so smooth and featureless as from the air.

He'd done his time at jump school. Keep your feet

together or your legs might snap—head up, and land into a roll, with contact at the balls of your feet, legs, hips and back, to disperse the energy of impact . . .

The landscape opened out, the horizon receding around him, the trees foreshortening, as if reaching up toward him. There was a patch ahead of him, clear save for a little sage. He had his landing area.

He hauled on the harness lines and got a little more northerly push. He kept his feet and knees together, legs slightly bent.

The ground was hard, and he fell to his left, hard enough to knock the wind out of him, and his head slammed into the exposed rock.

Quick-release the harness strap clips. Release the seat kit . . . No pain. Shock again?

He could see his parachute, billowing and collapsing, and, bizarrely, his rubber life raft, bouncing over the scrubby ground.

It was turning into one lousy morning.

He didn't come to until they lifted him off the ground, wrapped up in some kind of silver emergency blanket. He heard the whup-whup of chopper blades.

Here was Jake's face, hovering over him.

"You're okay, buddy," Jake was saying. "You're a hero."

"Bullshit." Christ, his voice was a croak.

"It's true. The whole damn Canyon looks like a dried-out river bed," said Jake. "Ledges, buttes of bedrock, gravel bars, teardrop hills, like a piece of the Mississippi delta. And you should see the IMAX images taken from the Space Station. We're famous, man. We're on TV."

Garry grabbed Jake's sleeve. "But the Seed, man. The Moonseed."

Jake's face split in a grin. "We stopped it. NASA said so, those sensors they have up there. It stopped spreading.

Listen, you get yourself fixed. I got two shots of Jeremiah Weed lined up at Edwards already . . ."

Garry thought about the new volcanism he'd witnessed from the air: the deep wound the Moonseed had dug into the continent's oldest, hardest rocks, that even the Colorado could only scratch, the silver patches there.

Maybe they had bought some breathing time, at least.

He knew his mother said efforts like this were only superficial. More about making people feel good, feel they were fighting back, than about canning the Moonseed.

But hell, maybe that was all anybody could do.

He wished he could do as much, by analogy, for his mother.

In the oily interior of the Chinook, he stared at the metal frame ceiling, until the rotors roared and he was lifted, and he closed his eyes.

36

Henry and the mission planners were receiving a briefing, by a quiet young military officer, on the systems they were installing to support the nuke.

"We removed the code box, the permissive action link. For your purposes we engineered a time fuse and detonator and matched them with the warhead. You will have a timer, but you will be able to abort the detonation at any time up to the final moment." The young man, earnest and soft-spoken, referred to the bomb as a "monkey."

The nervousness this topic roused in the program managers and controllers and astronauts intrigued Henry. These were hardened, experienced people; why should the idea of carrying a weapon into space spook them so much?

Unless it was the very fact that a weapon was now deemed to be necessary.

Since the 1950s, if not earlier, the Solar System had been assumed to be an empty, barren place, a wilderness of gas and rock and ice, a stage on which man's drama could

be played out. A place to take a camera, not a gun. Now, suddenly, it looked as if that assumption was not true.

And they were *scared* . . .

That was when Henry got the message about some kind of problem at Torness.

He ran back to his quarters. There were several messages waiting for him, from academic contacts, the Scottish authorities, Blue Ishiguro.

Torness. He remembered the map he'd inspected with the Prime Minister. Twenty miles from Edinburgh, to the east; exactly along the route Jane said she was going to follow.

Since he told her to get out of Musselburgh he'd tried a slew of ways to get in touch with her, and had failed every time.

Torness wasn't the only nuclear installation to have suffered a catastrophic failure, as the quakes and fissures and volcanism and floods hit, all around the world. *Nuke stations going up like firecrackers. All we need.*

It was the peculiar fortune of the human race, he thought, to have encountered this problem just when it was smart enough to build such things as nuclear reactors but not smart enough to shut them down safely.

He had to do something for Jane.

He contacted Geena, and called in some more favors.

By the time he was done he had a guarantee. If Jane made it out of Scotland, if she was found, she'd be flown out of Britain, to the relative safety of the States.

It was all he could do for her, as it turned out, because the latest blocking moves, in House and the Senate, were overcome, and the authorization came for them to be shipped to Russia.

On his last day in America, Henry received two packages. One was a cancellation of his life insurance policy. The other was an olivine necklace, a string of bottle-green beads.

He tucked the necklace into the little pouch of personal effects he was being allowed to take, all the way to the Moon.

A USAF transport plane took them into Moscow. Henry tried to sleep, during the long haul over the North Pole.

He woke up during the descent into Moscow. He glimpsed green-clad hills below, an ancient landscape where Nazi and Soviet soldiers had fought to the death: humans sacrificed in waves in the cause of nations which no longer existed, offerings to vanished gods.

He didn't know what was in the minds of the Administration that had made them progress their decision this stage further. Some of the attempts to disrupt the Moonseed had worked, like the cataclysmic flooding of the Grand Canyon. Elsewhere, they had failed.

Like the backpack nuke that had, against his advice, been dropped on a Moonseed patch that had been set up in Nevada.

The nuke had made a predictable mess, but basically the flood of gammas and X rays had *accelerated* Moonseed propagation. Monica Beus led a study that showed, taking into account the energy returned by the accelerated activity of the Moonseed in those Nevada rocks, that the gamma-fired Moonseed had delivered an energy return in a feedback factor measured in the *billions.*

As Henry had suspected. In fact he was counting on that, for his secret plan to save mankind, although when he put it like that he found himself staring in the mirror and wondering exactly how crazy he was.

Anyhow he contacted Monica, asking for more specific measurements.

He suspected it was the failure of the nukes that had triggered the Administration, finally, into acting. Henry never expected a nuclear attack to succeed—quite the opposite—but he supposed it had to be tried. And its fail-

ure resonated like the failure of a god, like the death of Superman, confirming their worst fears.

After the Nevada failure, in fact, there had been questions asked about the need to carry a nuke on the Moon trip. Henry had insisted; and everybody seemed too busy to argue with him.

Still, though, the Administration's step-by-step commitment to the project wasn't complete; it wasn't yet confirmed that they would actually be allowed to launch. As if, Henry thought bleakly, they still expected things to somehow get better.

He managed to sleep through most of the bus journey out of Moscow to Star City.

Star City, more formally known as the Gagarin Cosmonaut Training Center, was the place the cosmonauts lived, along with the instructors, administrators and mission planners. It was a purpose-built town of four or five thousand people; its atmosphere, to Henry, was somewhere between a university campus and a military barracks.

They were greeted with a lunch banquet in a building called the recreation center—and it was literally a banquet, Henry found to his amazement, with cognac and champagne; the Russians were treating their contribution to this mission as a cause for celebration. Henry joined in enthusiastically, despite frosty glares from Geena. He figured that if he got stoked enough there would be no more training today, at any rate.

He was introduced to Arkady Berezovoy, a tall, dour, strong-looking cosmonaut who, it seemed, would be riding to orbit with them, and so would be joining in the training from now on. It turned out that Geena and Arkady knew each other already; they had worked on Station assignments.

When Henry was introduced, Arkady grasped his hand firmly and looked into his face, searchingly. Henry was left puzzled.

After lunch they were taken for a tour of Star City.

Everything seemed built on an immense, heroic scale, a legacy of the Soviet days. He was shown a giant mock-up of the old Mir station, a spacesuit display, and a hydro pool where the Russians planned their spacewalks. There was a culture center, and a giant memorial to Gagarin. The first cosmonaut of them all stood heroically, one hand behind his back, looking up at the stars.

There was even a planetarium, intended, Arkady told him seriously, for the cosmonauts to learn interplanetary navigation for the Soviet mission to Mars which had never come. In the planetarium foyer was a mock-up of the spacecraft which could have achieved the mission, perhaps in the early 1990s, assembled from hauntingly familiar components: Energia heavy-lift boosters, a Mir-based habitat module, a Mars lander built around Proton booster rocket stages.

But those dreams were long gone.

He was taken to gladhand the staff at TsUP, Russia's mission control at the unremarkable little town of Korolyov, outside Moscow. The control room looked like a small cinema, with a big screen to show the Station's trajectory curving over Earth's surface, and four rows of consoles dating from the 1980s. Under the screens there were two big sponsors' banners, one from a U.S. computer firm which had supplied the latest set of pcs that supplemented the older equipment, and one, bizarrely, from the Red October chocolate factory, with a slogan about celebrating "shared Russian traditions of quality." The most useful piece of equipment looked to be a plastic model of the Space Station, which got more attention from the controllers than the screen images.

The cosmonauts still earned a decent wage, but even that was mostly funded by American money funneled through the Station project, and many of the engineers and controllers, bringing home less than a couple of hundred bucks a month, worked as cab drivers and cleaners in Moscow to cover their bills.

It seemed to Henry the disparity between space dream and reality was even harsher here than in the U.S.

Most of the training forced on him here, it turned out, was in emergency procedures.

Henry was heavily briefed on what to do if a Station module was slow-punctured by a micrometeorite, and what would happen if there were a failure of the booster in the early stages of launch (an escape rocket would haul the manned capsule clear—a lot of noise and shaking, high Gs, probable unconsciousness, a spell in hospital). It wasn't that there was anything for him to *do* in such an eventuality, but it was thought better for him to know what would hit him.

Henry, exhausted, disoriented, overtrained and bewildered, didn't agree.

He was trained for emergency landing. The Soyuz was designed to come down on land, somewhere in the Soviet Union, and there would be choppers to pick him up. In theory. But he was taken to the bush in Kazakhstan, a place the capsule might come down where helicopters wouldn't be able to land, and he practiced getting into a recovery chair lowered from a helicopter.

And he underwent what the American managers called water egress training. With Arkady and Geena, he was dropped in a mocked-up Soyuz entry module into the Black Sea. It was a July day and it was hot—around thirty Centigrade—and the three of them, stiffly noncommunicative, struggled in the hot, cramped capsule, bobbing in the sea, to change out of their spacesuits and into survival gear. It took three hours to get ready, and when Arkady finally opened the hatch, steam gushed out, and briny sea air replaced the stink of vomit that had come to dominate in the capsule.

They had to float in the water, holding onto each other in a triangle. The rescue crews left them there for another hour before fishing them out, and barely a word passed between them.

And in the middle of all this robust Russian training, they were visited by Frank Turtle and his team, red-eyed from jet lag and overwork, with bundles of charts and vugraphs and laptops, who took Geena and Arkady through the procedures they were working out in such haste: procedures for the real mission, beyond the technicalities of Soyuz and Station—the flight to the Moon itself.

But still, final approval for launch didn't come.

Then, one August morning, Henry was woken, to see the new images, of fire and ash and flood coming out of the west coast of America, and he knew there would be no more hesitation.

37

The editorial review was *not* going well. And, Joely Stern thought with dismay, it was only 9:00 A.M.

Cecilia Stanley, her editor, read from the copy glowing on her screen ". . . *And from there Earthquake and Thunder went south . . . They went south first and sank the ground . . . Every little while there would be an earthquake, then another earthquake, and another earthquake . . . And then the water would fill those places . . . 'That is what human beings will thrive on,' said Earthquake . . .* Shit, Joely. Earthquake and Thunder. What is this, *Sesame Street*?"

Joely kept her temper. She'd already lost it once too often in this job.

As an insurance, though, she had her ID in her pocket, in case she was fired on the spot.

"It's a Yurok myth," she said evenly.

Sitting behind her desk of expensive dressed stone, Cecilia was a severe, toothy woman of thirty-five. A classic corporate climber; a devourer of souls, thought Joely. "And just what," Cecilia said in her cool way, "*precisely* is a Yurok?"

"They're the natives of this region. The Pacific coast. The legend seems to be a reference to a massive quake in

this region in prehistoric times. 1700. A folk memory."

"If it's prehistoric, how do you know it was 1700?"

Smartass. "Because they cross-correlated it with a tsunami that washed up across the Pacific, in Honshu."

"Where?"

"Japan. And that *was* recorded. And, look, the legend describes what *should* happen. When the fault gives way the edge of the North American plate slips forward, and what used to be an upward fold in the plate catapults into a downward fold. The sea rushes in, and brings in sediment. And that enriches the land, like the man said. It's happened several times. They've found layers of sea bottom mud and sand over ancient peat."

Cecilia rubbed her eyes. "Sea bottom mud. Native Americans nobody heard of. Look, Joely, this just isn't what we're looking for." She glanced at Joely. "I'm expecting anger from you here."

Joely thought it over. She said carefully, "I think I used up my anger. I used it up on all the times you undermined my authority by sending out my copy to those shit-for-brain buddies of yours scattered around the corporation, and having them blind-side me with their E-mails."

"Joely—"

"All this after you said I had autonomy. At least now you're being straight with me."

"This isn't personal," Cecilia said. "It's editorial. Don't you get that? I don't want nursery school songs about *peat,* for Christ's sake. I want NASA and the USGS and FEMA. Now, if you could have gotten hold of that guy Meacher, the one who's been shooting his mouth off about going to the Moon, we might have something—"

There was a boom, like remote thunder.

They stared at each other.

Cecilia said, "What the hell was that?"

Joely laughed. It can't be. Not right on cue.

They went to the window. Cecilia, as a permanent employee of Virtuelle, had a corner office, of course, up

here on the third floor. The biggest window faced west, toward the Puget Sound.

The day was clear, if oddly smoggy. They had a good view of the campus. On one of the neat squares of grass a cat was standing. It was facing north, standing oddly, with its legs apart . . .

Far to the west, over the ocean, there was a giant electrical storm raging. It was a bank of thick black cloud, roiling, spread right along the horizon.

There was sheet lightning, cracking in the gaps in the cloud, and what looked like fireballs, tossed into the air like popcorn. Ball lightning, maybe.

"I think it's a quake," Joely said. "A big one."

"Oh, you're an expert," Cecilia said.

"That black stuff could be dust, thrown up by the quake. The rock shears, the water vaporizes . . . You get a build-up of electricity . . ." She glanced around the campus. "These buildings—they conform to the California building code. Right?"

"This isn't California." Cecilia looked confused. "How would I know?"

"Well, they look like tilt-up construction to me."

"Is that bad?"

The thunder was replaced by a low rumbling noise overlaid by a crackle, a series of short bangs that sounded like gravel on a tin roof.

Joely listened intently to the low-frequency rumble, fascinated. She knew what that was. She was *hearing* the shortest-wavelength seismic waves, listening to the vibration of the Earth itself. The longest waves, with a period of an hour or so, corresponded to the whole Earth's resonant frequency, and were much too low-frequency to hear.

The planet was ringing like a bell.

Now, above the storm, there was a strange cloud formation. Something like a smoke ring, Joely thought, a loose band of fluffy white. Maybe that was the acoustic pressure wave, rising up toward the stratosphere. The satellites

would detect it later, a displacement of the atmosphere's layers by a mile or more.

Now Cecilia was starting to sound nervous. "What's going on? Are we safe here?"

"I don't know. That storm front must be hundreds of miles long."

"But we're safe, right?"

Of course not. ". . . Yes. I guess so."

Cecilia was silent.

On impulse, Joely reached out and took Cecilia's hand.

Joely thought of the cat. Animals knew how to brace themselves like that, standing with their legs apart, cross-ways to the shock.

That cat is smarter than I am, she thought.

Now there was movement.

A couple of the pine trees at the edge of the campus tipped up, locking their branches together like clasping hands. When they sprang apart, their trunks cracked, and burst into showers of matchwood.

Another line of trees, closer, popped out of the ground, roots and all, like wooden rockets.

Incoming, Joely thought.

"Holy shit," said Cecilia.

. . . And then it hit.

It came in a second, without warning. The floor just disappeared from beneath her, and she was thrown into the air—like a kid in her father's arms—her nose was inches from the ceiling . . . Then she fell, landing heavily on her back.

An instant of stillness. Something falling to the floor with a soft explosion, maybe Cecilia's pc monitor. Glass, she thought, and she closed her eyes.

She'd had Cecilia's hand wrenched out of her grasp in that first moment. She opened her mouth to call her.

Slam, under her back.

Again she was thrown into the air.

She landed with a grunt, on her front this time, mercifully clear of furniture.

And now the ground was pitching. She lay flat, spread-eagled, trying not to be turned over. It was like being on a violent sea, she thought—but not quite, for the motion was compound, shaking her up and down and side to side. More as if she was a flea on the back of a dog, shaking after a swim.

She was surrounded by explosions. The window burst, creating a new hail of glass fragments over her neck and head. The wall cracked with a report like gunfire.

Then the whole building *fell*, just like that, dropping through several feet, and she landed hard on her front again.

There was a grind of metal, the soft crump of fresh explosions. That open car lot on the ground floor must have collapsed. The building was now a storey shorter than the architects had planned it.

More booms. Smoke, curling into the window. That would be gas tanks going up, in the crushed automobiles beneath.

Cecilia's Toyota 4Runner. Her pride and joy, paid for by the company. Even now, lying here in her own blood in the middle of the greatest damn earthquake since Cecil B. de Mille, Joely found room in her head for a touch of spiteful joy at that.

The floor was still shaking, but maybe not so violently. She got to her knees. She turned, looking for Cecilia.

Cecilia's pc lay smashed on the floor.

It occurred to Joely that with the intranet destroyed, so was all the work she had done here; she had no hard copy, anywhere. Nothing to say why she had made her way here, today of all days. All those E-mails, lost like dreams, forever unanswered.

If this is the end of us, she thought, we will leave less behind us than the citizens of Pompeii. So much of what humans had created in the last few decades had been, when

you got to it, just electronic patterns, stored on some tape or chip or disc somewhere. And when the power failed . . .

She saw a pair of legs, dimpled with cellulite, protruding from a too-short skirt. The edge of the stone desk top, still in one piece, had come down just above that skirt. Joely could see there was only a couple of inches clearance between the sharp rim of the desk and the floor.

Just a couple of inches, into which a human torso had been crammed.

There was blood seeping out under the desk, thicker and darker than Joely had imagined. Jesus. She felt bile rise at the back of her throat.

She looked for the door. It was on the other side of the desk, and she wasn't sure if she could make it that far. And even if she could it looked as if it had buckled in its frame. No way to get that down except with a fire ax.

She made her way to the wall, and grabbed onto the window frame. A shard of glass stabbed her arm, but she ignored that. She stood, the floor still trembling beneath her feet. She looked out.

The campus was demolished. Most of the buildings had simply fallen apart, she saw, like card houses, their prefabricated walls lying smashed on the neat patches of grass. One other building, still intact, had tipped over.

She wondered if the ground had dipped already, the way the scientists' models said it would. Was she below sea level yet?

The horizon was just a blur of smoke and fires and electrical sparking, against a continual crackling noise. There was a kind of dome of a greenish luminosity, she saw, gathering in the air above the cloud.

There were wide ravines, scratched at random across the ground. From a couple of them, fire was spurting. Gas mains, maybe. One of the fissures was *closing* again; and somehow that was more disturbing than anything else.

She couldn't even tell where the level was, so broken up was the ground.

She could see nobody moving. There were a few splashes of color that might have been people, or might not. No sign of rescue, not so much as a TV news heli.

And the quake wasn't done; she could see a *wave*, maybe twenty feet high, passing through the ground itself, its crest sending chunks of shattered tarmac feet into the air.

But the shuddering of the building seemed to be subsiding.

My God, she thought. I might live through this yet. What a story I'll have. Book deals, syndication, TV movies flashed through her imagination. She wondered if there was a webcam in the office.

The dominant noise changed, to a whooshing like a wind blowing through trees.

And now there was something emerging out of the smoke bank, to the east. Like a new cloud, wide and dark and rolling, laced with fire.

Oh.

It was water. A wave, surging out of the Sound, as if Puget was no more than a tipped-up bathtub. Burning oil had spilled over its surface, probably from the storage tanks at the docks. Earthquake cocktail, she thought.

The wave had to be a hundred feet high.

Waves like that could travel a hundred miles an hour; she could never outrun it. Not even in Cecilia's Toyota.

Blood dripped into her eye from a wound she hadn't noticed. She was lucky as hell to have survived this far, she thought, and then she laughed at herself. *Lucky?* She was the girl from LA who had to move to Seattle in time for the Big One.

The floor started to move again. She clung to the window frame, trying to stay on her feet. This was an up-and-down whiplashing that no building was going to be able to withstand. More cracking sounds, as the walls broke open, letting in the daylight—a stink of sulfur—and she was thrown to the floor, which was splintering under her.

The ceiling came crashing down at her.

. . . But, before the ceiling debris reached her, the floor fell away.

She was falling through the stories, arms and legs limp, pursued by a shower of debris. Maybe the building itself was falling, even as it fell to pieces all around her, as the ground flexed, giving up its stored energy.

A last moment of daylight, before a rush of heat, and a wall of water that slammed her sideways—

In Star City, Moscow, Russia, Henry Meacher watched the destruction of Washington State on CNN.

There were few pictures coming out of the area itself. Nobody left alive to send any, of course.

The best images came from the satellites and the Space Station: the band of smoke and flame laced along the western seaboard, the sea churned to mud and froth for hundreds of miles from the coast. You could pick out the cities by their dull burning glow, Seattle and Tacoma and Olympia and Vancouver, as far south as Portland. The experts said it was a series of firestorms that would not burn themselves out for many hours.

It would be a spectacular sight at night. *Keep tuned, folks.*

The economists speculated about the impact on the world's economy of the loss of the Seattle region, Boeing and Microsoft and . . . The tame scientists, gabbling at each other, blamed the explosion of Mount Rainier for setting off an earthquake which had been overdue anyhow. And the wilder ones blamed Rainier itself on the bizarre infection the commentators were calling Moonseed.

Evidently, the whole of the locked subduction zone had given way.

There seemed to have been sympathetic earthquakes in Chile, causing severe damage there. The rest of North America seemed to have been spared, but unusual wave motions had been observed on the Great Lakes and other

large bodies of water, in some places violent enough to tear boats from their moorings.

And in Alaska, hit by two earthquakes, the Yakutat glacier had changed its direction and was spilling ice slabs into the sea.

Henry wondered how much longer news like this would remain free and uncensored.

Henry pulled out his laptop, and checked the data against his predictions. The spread rate of the Moonseed, from both primary and secondary infection sites, had reduced drastically as the Moonseed had sunk into the crust. Nevertheless events were unfolding much as he'd expected.

It had taken some thirty days for the ocean crust to be breached, around seventy for the first deep breaches at the continental margins to be achieved, like the one which had caused the Seattle event.

But this was just the start. There would be an escalation of such gigantic seismic events, from now until—

Well, he thought, until the end.

Time to act, Henry thought. If not now, never.

The telephone started to ring.

And when he put the phone down again, he knew that, finally, there would come a day—in mid-August, just a week from now—which would be his last on Earth, perhaps forever.

38

He slept badly, with disturbed dreams.

There was a knock at the door, repeating gently.

He didn't know where the hell he was, or what time it was.

He looked for his watch, and couldn't find it, but it was useless anyhow as he hadn't reset it since Houston. He pulled a towel around his waist and padded to the door.

Standing there was a doctor—it was obvious that was what he was, a little guy in a white coat with a black bag—

and Geena, his ex-wife. Geena was wearing some kind of blue coverall and carried a little bag of groceries.

"You didn't used to have to knock," he said hoarsely.

"Different days, Henry. Can we come in?"

"Oh, shit," said Henry, remembering. "You're wearing a flight suit, aren't you? It's *the* day."

Geena grinned, perhaps with a little malice. "The Russians say we are to share a great honor, this day," she said.

Geena and the doctor bustled into the room. Henry backed off, and retreated to the bathroom. A last refuge of privacy.

He had spent his last night on Earth in Leninsk, the city that had grown up on the back of Baikonur Cosmodrome. They had arrived late. This was what they called the cosmonauts' hotel, the *Kosmonaut,* a low, modern building screened by what looked like elm trees—*karagach,* a young Russian told him. His room was a tiny suite, a doll's-house Hilton of a thing, with a living room, a bedroom and a bathroom.

The room was like something out of the 1950s: carpets, net curtains, a fridge. Nothing inside the fridge but Diet Coke, labeled in Cyrillic. The bath had taps and a shower-head. But there was no plug—not in the hand-basin either—and the ceramic was cracked and stained.

Now, when he lifted the toilet lid, the ancient ceramic was so dark he couldn't see the little puddle of water at the bottom. He had to admit it took a little willpower to lower his butt once more to this cracked Russian po.

When he flushed there was a sluggish trickle, of dirty brown water.

He tried the shower. It ran cold. There was a small sign in Cyrillic which apparently told him for which quarter-hour of the day he could expect hot water.

Farewell from Earth, he thought.

He toweled himself down. When he emerged, the doctor was waiting for him.

"Ya pravyeryoo daulyeniye."

"Huh?"

The doctor, miming what he wanted, pulled out a blood pressure cuff and wrapped it around Henry's arm. Then came a stethoscope, lung capacity measures, an eyepiece for peering into his mouth and ears, other simple tests. The stethoscope disc was cold on Henry's chest.

Geena stalked around the room. She looked down on Henry's discarded socks and underpants, as if from a great height.

The doctor backed off. *"Vi nye balni. Odivaitis, pazhalsta."*

Henry looked at Geena.

"You are healthy," said Geena. She shrugged. "I speak astronaut pidgin. He says you may get dressed. There are clothes in the closet."

Henry went through to his bedroom. Hanging up in the wardrobe there was a blue NASA flight suit—it had a little U.S. flag stitched to it, but not his name—and there were long johns, socks and T-shirts in the dressers. He washed again—the water was still cold—and when he emerged the doctor was waiting for him, here in the bedroom, his last sanctum. With mimes, the doctor insisted he had to be rubbed down with an alcohol swab.

Henry submitted. The alcohol was cold on his flesh.

When the doctor had gone Henry got dressed quickly. All the clothes fit. There were light training shoes, and he slipped those onto his feet.

He picked his own clothes up from the floor. He considered putting them into the trash. Then, carrying the clothes, he walked back out to the lounge.

"I look like a tour guide at Disneyland," he said to Geena.

"You look fine."

Henry held his clothes out to the doctor. "Will you look after these for me?"

The doctor nodded; his round, Moonlike face split into a smile. *"Da."*

"It's just shit, but it's all I have left."

"I think he understands," Geena said. "He has been around cosmonauts a long time."

"I'm not a cosmonaut."

"By the end of today you will be. Now." She lifted her grocery bag, and inside there was heavy Russian bread, and little packets of salt and water. She laid out the stuff on the crude coffee table that was the centerpiece of Henry's living room. She poured the salt into a depression in the top of the loaf. Then she broke off a piece of the bread, dipped it in the salt, and bit into it.

Henry took some bread and bit off a piece. It was heavy and strongly flavored. "An old Russian custom?"

"That's right. They do this tradition stuff better than we do." Geena slapped her thigh. "Into the saddle!"

She really has gone native, he thought.

"Hi ho Silver."

Geena put down the bread. "Look, Henry. I know how you must be feeling. I know you've had no real time to prepare. But I'm trained for this. Some of it, anyhow. I'm with you all the way; you won't come to harm."

To his chagrin, Henry found he was reassured. "Thanks."

The doctor said, "*Schastleevava pootee! Nye nada peet alkagolya.*"

"Have a good journey," Geena translated. "But drink no alcohol."

"There goes my plan for the day."

"Here." Geena handed him a pencil.

"What's this?"

"Sign your name on the door."

Henry did so, adding his signature to a patina of graffiti here. "Another cosmonaut ritual?"

"Dating back to Gagarin himself." Geena smiled.

Henry picked up his polarizing microscope.

* * *

He was taken for breakfast, in an opulent dining hall. The food was meat drowned in butter and sour cream. Henry was hungry, but when he bit into the meal he could almost feel his arteries furring up. This was no place to be a vegetarian, it seemed.

There were others here, mostly men, some in uniform: cosmonauts, doctors, managers, engineers. They ate breakfast too, but largely in silence. He could sense them staring at him, but when he looked directly toward them they looked away.

Heavy cutlery clinked on thick china plates.

He leaned to Geena. "What's with these guys? Are they jealous?"

"Some are. The other cosmonauts here. Some have waited years for a flight into space, and now they have to watch two Americans fly their ship—"

"I know, I know. Here I am, taking their berth. Just like JSC. What about the rest?"

"Only the most senior managers are here. It's an honor for them."

"Why? What's the fascination? The fact that we're going into space?"

Geena turned to him, pale blue eyes as empty as church windows. "No. The fact that we'll probably die."

When he was done he was led, with Geena, from the building, into the fresh air. It was midmorning now. The sky was high and blue, the air hot with a billowing breeze. This was Kazakhstan. He was far to the north here—farther north than Chicago, for instance—but he was still in the heart of the world continent, and it was a land of hot, parched summers and glacial winters.

They walked down a little path that wound between rows of elms, to a car park that might have been located outside any mall in any city in America. There were buses, police cars, what looked like press vehicles with TV cameras stuck to their roofs.

Cape Canaveral, it was not.

There was an air of casual cheerfulness, of slow progress to their ultimate destination. People came up to Geena, and offered comments, backslaps and jokes. It was very different from the way he'd followed Geena through launches at Canaveral: informal, as if this was some huge family vacation.

But nobody spoke to Henry. It was as if, he thought, he had left the planet already.

They clambered aboard a bus. An Orthodox priest stood by the door and blessed them, mumbling incomprehensibly. Henry bowed back, more for the benefit of the old priest than himself. He stowed his polarizing microscope under his seat.

The bus pulled slowly away. There was a convoy of police cars around them, lights flashing.

They were evidently still in the outskirts of Leninsk. The town looked like 1930s Chicago. A lot of the money the Americans had put into the Russian Space Agency, to finance the Russian contribution to the International Space Station, had flowed into Leninsk and got stuck; and now the town was, according to Geena, like a Wild West city.

Soon the low apartment buildings were giving way to the open scrubland beyond. Local people turned out to see them go, glum-faced peasant types, short and solid, lining the road, their faces following the bus like flowers following the sun. They wore improvised-looking Venus hats, or carried parasols.

All of them, thought Henry, here to watch the Americans go to their deaths.

Then there were no more people. He blinked around fuzzily at a huge, empty plain.

Glimpses of semi-infinite steppe.

They passed a river bank: green, blue, spring, everything very earthy. On the bank there was a kind of teepee, a squat tent of what looked like sheepskin. The word *yurt* floated into Henry's mind. Some old guy was moving around it, dressed in heavy furs despite the spring temper-

atures; he glowered at the bus, looking like Genghis Khan's uglier brother.

This was an old, rusty country, he thought. People had been living like this for centuries before anybody in the west even knew Henry's continent existed, and maybe they would prosper here long after the more fragile Western culture collapsed.

Ten miles out of Leninsk, they came to what looked to Henry like an aging industrial park, a complex of factories and laboratories that stretched away over the plain, with lox tanks and lines of cabling and pipes. Geena said this was the MIK assembly area, where the Russians manufactured and assembled their spaceships. Henry could see how the rail links and roads and scattered buildings and launch pads of the complex stretched for miles across this immense plain. This cosmodrome was a Cold War relic, built in the 1950s; it was much bigger than the American equivalent at Canaveral.

Geena pointed out some of the sights. The Russians put together their boosters lying on their side, and then hauled them out by rail to the launch pad, to be erected by hydraulics. At launch the boosters actually sat on turntables; the rockets were much dumber than American designs, and had to be *pointed* like July 4 firecrackers to hit the right azimuth.

Most boosters, built by whatever nation, were launched to the east, the way the Earth rotated, to pick up a little extra energy. In case anything went wrong and the booster fell back, you needed a clear area to the east of your pad. That was why Canaveral had been built on the U.S. east coast, with the whole Atlantic to drop rockets into.

Here, though, it was different. The Soviets had built *their* pads in the heart of their continent, with the empty belly of Asia stretching hundreds of miles to the east, a waterless ocean of rock and scrub.

But the place had seen better days, Henry learned.

Baikonur was guarded by army recruits who were sometimes not paid for months on end, who had rioted several times, and who had been reduced to supplying their needs by looting the supplies for the cosmonauts loaded aboard the Space Station's Progress resupply ships.

Reassuring.

They came to a small, insignificant building that turned out to be the cosmonauts' preparation block.

Henry got down from the bus. There were more people here, waiting to greet him: pad rats, he supposed. Geena nodded, smiled, quipped and shook hands. The pad rats were all wearing surgical-style facemasks, over which they stared at him. Even so he could tell not one of them was smiling at him.

They were led to a big room, something like a hospital ward. There were strip lights in the roof, and a gleaming tiled floor, and two couches; amid piles of equipment, more technicians in lab coats and facemasks waited for them.

With gentle tugs, the pad rats showed Henry he should strip naked once more. He unzipped his NASA flight suit and pulled off his underwear; it was crammed unceremoniously into a bag and removed, taking his human warmth, leaving him feeling shriveled and exposed.

Now came another standing bath of alcohol, and he was handed more underwear to put on. A medic pulled a heavy belt closed around his waist, thick with equipment. He guessed there was a cardiograph in there, maybe something to measure his breathing.

And now a garment was lifted toward him by three pad rats.

"My God. It's a spacesuit," he said, wondering.

The pad rats looked back at him blankly.

The spacesuit was a floppy white mannequin, its limbs held stiffly out, as if it was already half-alive. Henry watched it approach, feeling a deep reluctance to climb inside. But the pad rats lifted and manipulated him as confidently as if they were packing a souvenir doll in Styrofoam.

The suit was open at the front, and the pad rats helped him slide his legs down through the stomach. There seemed to be two layers to the suit, an inner layer of some tough, rubbery material and an outer layer of a rough artificial fabric, coated with flaps, zippers and pockets. The rats lifted up the back and chest part of the suit, and he had to struggle to push his arms into the heavy sleeves.

When he was inside they lowered a helmet over his head, its visor open, and when it was locked at his neck they sealed up the hole in the suit through which he'd entered. The material at the front of the suit was pulled into a bunch, tied with a fat rubber band, and tucked inside his suit, which was then sealed up by two thick zips. It felt as if he had a cushion tucked under his shirt.

All this took place before a big glass window. Beyond the window there were rows of seats, filled by people with notebooks and cameras and tape recorders. The apparatus of the press. But there was little sense of urgency, and the seats were half-empty.

Maybe these weren't really pressmen, he thought, but historians.

Or obituary writers.

He was helped to his feet, and he tried walking around. The suit was stiff, and every step required a conscious effort. Evidently the suit was internally wired for strength.

Geena, wrapped up in her own suit, was grinning at him.

Now he looked at Geena, he had to admit these Russian spacesuits looked pretty cool. They were basically all white, including their boots, with copper metal rings at neck and wrists for helmet and gloves, and the zippers making a neat V-shape at the front. They even had handy little pockets in their legs where you could store your gloves.

Geena said, "How do you feel?"

"Like John Glenn."

"Don't insult your suit," Geena warned. "In space, it is your only true friend."

A pad rat took hold of him now, and closed down his helmet. He felt it settle into the seal at its rim. The voices outside became indistinct murmurs, his own breathing sounded like a rattle. He felt as if he had been excluded from the outside world, shut away into this shell by the pad rats.

By contrast, they seemed to be swarming over Geena, touching her and beaming up into her smiling face, as if they were trying to root her to the Earth.

The pad rats connected his suit to an air pipe, and he heard a hiss as air was pumped in. He felt his ears pop; a pressure test, then. As the suit filled up the limbs became stiffer. Experimentally he tried to move an arm; it was like wearing a car tire inner tube.

The pad rats, miming, showed him a knob on his chest. When he turned it, the high-pressure air hissed out, and he was allowed to flip up his visor.

He picked up his battered microscope box—it looked enjoyably unhygienic in this operating-theater atmosphere—and he was led out of the building, to a kind of parade ground.

There were small white squares painted on the ground, like cue marks in a TV game show. Geena took one mark and pointed to the other, where Henry went to stand. There were people all around, pad rats and suited managers and technicians. Geena's square was marked "KK," and Henry's "KI"—acronyms for mission commander and researcher, as it turned out.

Henry looked down at himself. His white spacesuit gleamed like snow in the sunshine.

A military man walked forward, decorated with ribbons and medals. Evidently an Air Force general. Geena saluted, spoke in Russian, and repeated in English. "My crew and I have been made ready, and now we are reporting that we are ready to fly."

The general nodded, and spoke in thickly accented English. "I give you permission to fly." He glanced at Henry, but seemed to look through him.

Geena nodded to Henry, and led him toward another bus, this one silver and blue. He had to walk past ranks of silent workers. Close to, many of them looked gaunt, underfed, dressed shabbily. Maybe they would normally cheer, he thought. Maybe they somehow resent me being here.

Or maybe they're as scared as I am.

It was difficult to sit down on the bus in his stiff suit, but he made it. The bus pulled away with a lurch.

It wasn't long before the rocket came into view.

The booster was a pillar, squat and solid: coal gray, save for an orange band at its midsection, and a bulge at the top, a white-painted faring which hid the Soyuz capsule he would ride to orbit. At the base the booster flared gracefully, where four liquid-fuel rockets were strapped to the pencil-slim core stage.

It was a hundred and fifty feet tall. White vapor slid down its flanks, as if the booster were already rehearsing the great leap upward it would take in just a few hours.

Its three big supporting gantries had already been tipped back, resting close to the ground, so that it was as if the rocket stood at the heart of a metal flower. He could see a slim tower with an elevator to carry the crew to their capsule. The whole stack stood on a sky-blue platform—it looked like some kind of mobile launcher—and a flame pit, a channel cut in the Earth and lined with concrete, stretched away around it.

This was fifty-year-old technology. The booster was a derivative of an old ICBM design. The first Sputnik had been flown aboard a booster basically the same model as this. So had Yuri Gagarin. He couldn't work out whether that was reassuring or terrifying.

The bus lurched to a stop at the base of the booster. Henry followed Geena out. People stood around, watching them: technicians, managers, generals, politicians, wives,

even a couple of kids running around between the legs of the adults. Henry clutched his microscope box to his chest. He couldn't believe they let so many people get so close to what was basically a liquid-fuel *bomb*.

Geena led him to a short flight of metal steps, which were set right against one of the fat first-stage boosters.

Henry looked up at the booster. Foreshortened, it was like a busted-off piece of the Kremlin. But the booster was uncompromisingly real, dominating its flat surroundings. There seemed no doubt, at last, that these guys were serious: they really were going to lock *him* into that little capsule at the top of this thing and fire him off into space.

He took his first step on the metal stair. One foot in the dust of Earth, one on metal. This is the moment, he thought, when I leave the Earth. All the rest is detail.

He wondered where Jane was, right now, what she was thinking.

He lifted his other, spacesuited foot, and climbed the stair.

Geena led him to the elevator cage at the base of its tower. A single pad rat stood in here. When Henry and Geena had crowded in, their pressure suits billowing, there was barely room to stand without touching.

"Penthouse, please," Henry said. Nobody laughed.

The elevator lifted up with a clatter. Henry looked out through the bars of his cage. A few pad rats remained, their faces turned up to his. The bus was already pulling away.

So here he was, rising past the flank of an ICBM.

It was like climbing the spire of some huge metal cathedral. White mist billowed around him—the cryogenic fumes smelled, oddly, like wet dust—and he could see ice, great sheets of it, condensed and molded against the smoothly curved flanks of the rocket. The ice shone in the sunlight, but beneath the surface sheen, the metal of the booster was cold and dark. He could have touched the damn booster, run his gloved hand over that metal flank.

The elevator clanked to a halt alongside the heavy far-
ing that shielded the Soyuz. More pad rats were waiting on
a small platform that led to a round hatch cut in the side of
the faring. Geena strode forward, and climbed in first.

Henry looked down. The booster flared gracefully
under him, two cone-shaped strap-on boosters clearly visi-
ble. The flame pit was a concrete scar in the ground, but it
was dwarfed by the immense flatness of the steppe, the
land coated with a dull green, flattened by a heavy blue sky.

He heard the wind moan, and the booster swayed,
creaking.

Following the pad rats' mimed instructions, he turned
and sat down on the lip of the hatch. The pad rats pulled a
protective cover off his helmet, and hauled outer boots off
his feet.

The last pad rat, a heavy-set older man, looked him in
the eyes. *"Ni pukha, ni pera."*

"Huh?"

"May nothing be left of you, neither down nor
feather." He grinned. "I am wishing you luck. Now you
must tell me to go to hell."

When in Rome . . . "Go to hell."

The pad rat took his hand, and receded slowly, over
the metal platform; Henry, unexpectedly, found himself
clinging to this last human contact, his last hold on Earth.

The fatherly pad rat let go.

Henry swung his legs inside. He had to climb through
the faring to get to the spacecraft, which was completely
enclosed inside its protective cover.

And so he entered the Soyuz.

He was in the orbital module. It was a cramped cabin,
like a small box-room, its walls lined with storage compart-
ments and handholds. It was just about big enough for one
person to stretch out. The hatch behind him was a circle of
bright daylight. Another hatch, open, was set in the floor,
leading to another compartment called the descent module.

He lowered his feet through the floor hatch and

twisted down into the space below. It was cramped in here, with three upturned frame seats in a fan shape, side by side. The inner walls were lined with yellow insulation blankets, and there were bundles of equipment: a life raft, parachutes, survival clothes.

Geena was already in the left-hand seat, working through a checklist. Stiff in his suit, Henry wriggled until he had lowered himself into the right-most seat.

And so here he was, lying on his back, tucked up inside an antique Russian spacecraft that had been assembled by guys who probably hadn't even been paid for half a year . . .

39

As Henry had predicted, the Moonseed dug through the continental crust beneath the Midland Valley of Scotland, the primary infection site, and things rapidly got worse.

Jane picked up what she could, from the news broadcasts and her limited contact with Henry.

It sounded as if the ancient volcanic plugs all over Scotland were breaking open. There was some kind of event at the Binn of Burntisland, across the Forth from Edinburgh. That cut off the northern escape routes, then. To the west, closer to Glasgow, more vents were going up in strings, from Fintry to Dumbarton and along the Campsie Hills.

In the open air, she could hear it, feel it. Explosions, floating on the air. Shudders transmitted through the ground. As if the Earth itself was waking.

Time to leave.

Jane and Jack had reentered the national database of refugees at the Rest Center they stopped at in Berwick. If you could call it a Rest Center. The second-wave evacuation camp was a crude tent city, hordes of people clustered around medic tents and food trucks, malnutrition and disease and open sewers. A Third World scene, in prosperous Scotland. It took twenty-four hours after they arrived there

for a policeman to come find them, and drive them out to a field on the edge of town, where an Army Air Corps helicopter was waiting for them.

They were to be flown to the U.S., thanks to some obscure string-pulling by Henry, and, she suspected, his ex-wife. She wasn't about to argue.

But air traffic, even the military stuff, was utterly screwed up, because of the pressure the flood of refugees was putting on the requisitioned commercial fleets and military transport, and because of the mess the Midland Valley disturbances had made of the air space there.

So Jane had found herself hopped over to Prestwick by an Army Air Corps Gazette—actually, that had been rather fun, especially for Jack—and now here she was on an aging 747, a British Airways airliner crammed with Scottish families, part of the great flood of refugees fleeing Britain, eight hundred of her fellow citizens seeking succor in a foreign land.

She got a seat in First Class, and, remarkably, the crisp, rather snooty BA stewardesses in here were still serving champagne before the take-off.

But even here, the cabin was crowded with refugees, adults and squalling infants and grumbling, distressed old people; the overhead lockers overflowed with hastily packed suitcases, even carrier bags. There was great distress, in some cases from injury, more often because of what had been left behind: family members, mothers and sons and grandparents, even pets; homes that had been the focus of lives for, in some cases, decades.

Waiting for take-off, Jack buried his nose in a book, and Jane receded into herself.

She ran a poll of her anatomy, her stomach and breasts and throat; surreptitiously she checked the moles on her legs.

She hated being so aware of her body. So frightened of it, in fact. So far she'd found little to concern her, little she couldn't dismiss as hypochondriac overreaction. But nevertheless she had been exposed, with Jack, to whatever foul

sleet had come pumping out of Torness, when she had taken them both blundering past so carelessly.

Maybe she deserved to soak up the hard rain, for her stupidity. Not Jack, though. Not Jack.

She watched him while he slept, inspected him too. She didn't want to voice her concerns, for fear of frightening him—or perhaps, she thought, for superstition, as if the evil when uttered might become real.

At last the jet surged down the runway, and Jane glanced out at the tarmac, sliding off beneath the wing. The take-off run was unusually long, she thought. Something to do with the heat of the air, probably. The plane lifted, and banked right before settling on its airway, its invisible track across the sky.

When they were airborne, Jack asked to be taken up to the cockpit; a smiling stewardess complied. When he was gone—out of her sight for the first time in days—Jane closed her eyes. She felt safe here, in the hands of professionals; she felt she could relax.

She sank into the seat, and a small chorus of aches rose from her body . . .

She slept for a while.

There was a flash, visible even through her closed eyelids, coming from the window to her right. Lightning. She turned and watched absently. There it was again. Roiling black clouds, too distant to be any threat.

Jack wasn't here, presumably still up in the cockpit.

There was hazy cloud outside the window now.

Sparks flashed across her window, miniature forks, like scale model lightning bolts. St. Elmo's Fire, she thought, discharges from an electrically charged cloud.

She leaned in her seat so she could look forward to the wing.

The whole of the wing was enveloped in a cold glow. St. Elmo flashes broke out across the metal, and flecks of light streamed beneath the leading edge like tracer bullets.

She could smell ozone. Puffs of smoke, of some kind,

were seeping out of the air conditioning nozzles above her.

The seat belt light came on with a soft chime.

"Jesus," somebody said. "Look at the engines."

Jane looked.

The two engines on the wing were illuminated from within, as if by a magnesium flare. Shafts of lights shone forward, like searchlight beams, flickering as the fans turned and strobed the light.

One engine flared more brightly. There was a brief impression of the strobing reducing in pace. Then the electrical fire-light died.

The plane tipped to the right, subtly.

"Jesus . . ."

There was a thumping noise. The other engines were surging. Dying.

Acrid smoke was curling across the cabin floor. The cabin lights had dimmed, but bright electrical light was shining in through the windows; it was as if the whole wing had caught fire.

The sounds of subdued distress had been replaced by a chatter of concern.

But under the chatter, Jane could detect an eerie silence.

No engine noise. All four must have gone.

And now, beyond the wing, she could see a cloud, an ash tower that looked as if it was reaching to the sky, black and shot through with lightning.

She stood up. A stewardess came to force her down again, but Jane insisted. "Get me to the flight deck. My son's there."

The stewardess led the way.

The Soyuz was shaped like a pepper pot. Its main body was a squat cylinder called the instrument assembly module, which housed fuel tanks, oxygen, water supplies, ancillary equipment, and the big retro-rocket that would, in a normal

flight, be used to return them from low orbit to the Earth. On top of this sat the descent module, a dome-shaped tent of metal, where Henry would sit to ride to orbit. And over this was fixed a bulbous misshapen sphere called the orbital module, with equipment for operations on orbit.

The Soyuz had been designed, all those years ago, as the core of a system that should have taken Soviets to the Moon. It had never gotten that far. Instead the Soyuz had become an orbital ferry, carrying cosmonauts to three generations of space stations: the old half-military Salyuts, the Mir, and now the International Space Station. When it was time to return to Earth, the orbital compartment and the service module would be cast off to burn up, and only the descent module would reenter and parachute to the land, somewhere in the echoing heart of Asia.

The descent module was unbelievably cramped, even compared to the Apollos he'd seen in museums. It was just a crude stretched hemisphere of thick metal, so small your legs would be jammed up against the next guy's, and it was impossible to straighten them out.

The ship's main controls were here. But there was a disturbingly small number of instruments fixed to the walls. Some of them had even been hand-lettered with Cyrillic characters, or fixed on top of other components. The windows were small, circular and featured big heavy panes of glass and rings of bolts, like portholes from Captain Nemo's *Nautilus*. But he could see no daylight through the windows right now; that big white faring saw to that.

Geena struggled out of her seat, and pulled closed the hatch in the roof. Soon after, Henry heard a muffled thud, as the techs shut the outer hatch.

And so he was sealed up in the ultimate enclosure: a cell within which he couldn't even stand up, and yet which would carry him away from the Earth.

He searched for some reflection of this in Geena's eyes. But there was none; Geena's expression was cloudy, distracted. After a couple of seconds she turned back to her

checklist, and worked through instrument settings, exchanging messages with the crisp Russian voices of the ground control in their bunker.

Jane understood the problem. In the last couple of weeks she'd heard about other planes which had run into this difficulty. But knowing didn't help; she knew, in fact, that the outlook for their survival wasn't good.

The volcanic debris, silicate ash suspended in the air, fused when it came into contact with the hot metal of an airplane's combustion chambers and turbines. It was like damping a fire with sand. Engines just flamed out.

Through the windows she could see how the hot grit had sandblasted the 747's leading edges. The paint was stripped, the windscreen and landing light covers opaqued. The dust got into the aircraft's pitot tubes—airspeed sensors—and caused conflicting information on the flight deck. The engine nacelles, intakes and fans looked as if they had been shot-blasted.

The crew allowed Jane onto the deck—Jack was here, wide-eyed—but they barely reacted to her presence.

The cabin was filled with a bluish, acrid mist, sucked in by the compressors before the engines died. There was only gray cloud ahead of the aircraft, dancing electric light on the windscreen.

The crew were following their procedures, the drill Jane recognized as preparing for an in-flight start-up of the engines.

They all looked incredibly young.

". . . Mayday, mayday, mayday. Our position is forty miles west of Glasgow. We have lost all four engines. We're descending and we're out of level 370."

Prestwick here, have you got a problem?

"We've lost all four engines."

Understand you have lost engine number four?

The Senior First Officer—a thin, nervous young

man—groaned at his captain, a competent fifty-ish woman. "The fuckwit doesn't understand."

Jack's eyes got rounder.

"Then tell her until she bloody does," the captain said. "Tell her we want radar assistance to get back to Prestwick. What about number four?"

"Fully shut down."

"All right." The captain checked the position of that engine's fire handle and thrust lever. "We'll go for a restart. Begin the checklist."

The crew struggled through their checklists and drills—*start levers to cut-off, standby ignition on, start levers back to idle*—and Jane felt for them, forcing themselves through their complex procedures, mastering their own fear.

Kerosene ignited in the engine, and a huge flame shot from the jet efflux. But the engine didn't restart.

The silence was eerie. Jane could hear the crew's scratchy breathing.

The captain was using her autopilot, Jane saw. Five hundred feet per minute descent. She picked up a little of what was happening from the crew's terse conversation. They were trading height for speed; their airspeed was two hundred and seventy knots, somewhere near the speed for minimum drag for the present all-up weight. And the pilot was turning back toward Prestwick. Good, Jane thought, somebody who knows what she is doing. Even after total engine failure, the aircraft was still under control. In fact it could glide for another twenty minutes or more from this height, and surely the engines would restart at a lower altitude.

But still, a dead stick unpowered landing back at Prestwick—or worse, a ditching—would be no fun.

A warning horn sounded in the cockpit. Cabin pressure was dropping. No air was being pumped into the aircraft.

Oxygen masks dropped before the crew, and they fitted them to their faces. There was none for Jane and Jack,

where they stood at the back of the cabin. The flight engineer's mask didn't fall properly; he had to get out of his seat and pull it down, but when he did so the supply hose just fell to pieces.

"Shoot," the captain said softly. She disconnected the autopilot, dropped the aircraft's nose and pulled on the speed brake lever. There was a rumble, and Jane braced herself. The captain was throwing away her precious height, the height which could be traded for speed and distance, which might save all of their lives. But now she had no choice.

The altimeter dropped steadily. But Jane could see that the electrical garbage in the atmosphere outside was playing hell with the instruments. The inertial navigation systems showed random digits and patterns, and the distance measuring equipment was blank altogether. Even communication with Prestwick was disrupted by bursts of static.

The SFO said, "We might have water contamination in the fuel tanks. And in that case—"

"There's no way the engines will start again. Oh, shoot." The captain looked ahead steadily. "All right. We'll head toward Prestwick, and then turn westbound to ditch. You know the drill. Land along the line of the primary or predominant swell, and upwind into the secondary swell, or downwind into the secondary swell . . ."

"My God," Jane whispered.

She felt a stab of anger. To have come so close, to have survived so much. And now, even as they were escaping from the blighted country, *this*.

The wounded plane flew on as the crew worked steadily.

"Five minutes," Geena told Henry. "Close your helmet."

Henry pulled down his visor. His breathing was loud.

Geena reported, "We are in the preparation regime.

Everything on board is correct. And everything is correct in the control bunker."

A reply, in Russian and English.

"Shit hot," Henry said quietly.

"Two minutes," Geena said evenly.

He looked across at her. "This is one hell of a strange divorce we're having, Geena," he said.

She ignored him.

Still there was no countdown.

And a little after that—

There was a rumbling, deep below, beneath his back. It was like an explosion in some remote furnace room.

An analog clock started ticking on the control panel. It was the mission clock.

Oh Christ, oh Christ. They were serious, after all. They really had fired this thing, with Henry and his ex-wife stuffed in the nose. And now—

"One minute before the turn," the SFO said.

The aircraft had been without engines for twelve, thirteen minutes, Jane estimated. She had lost count of the number of restart attempts while she'd been up here, and there surely wouldn't be time to restart now. There were maybe five minutes left before the ditching.

Jane listened to the crew's diagnosis and projection. With only battery power, there would be no radio altimeter for precise height indication. Not even any landing lights. The captain wouldn't be able to lower her flaps, so the ditching would be fast—faster than the stall speed of a hundred and seventy knots—the engines would surely break off on impact; the wings and structure would be damaged . . .

The cloud cleared; low sunlight poked into the cabin, briefly dazzling Jane. The play of electrical light over the windscreen dissipated.

The flight engineer cried out. "Number four has restarted!"

Now Jane felt the roar of the engine; she could see the engine gauges rising, the power settling. Gingerly the captain advanced the thrust lever, and the engine was running at normal power.

They had ducked under the ash cloud, she realized; that was what had enabled the engines to start.

"Here comes number two," the captain said.

"Prestwick," the SFO said, "we seem to be back in business. We have diverted back to Prestwick and will land in fifteen minutes."

"Number one. Number three."

The captain pulled the plane into a shallow climb. Immediately the cabin was swamped by the dark, smoky cloud once more, St. Elmo's Fire dancing on the windscreen.

"Good God," the captain said. "Bugger this for a game of soldiers."

She dropped the nose, and the plane dipped beneath the volcanic cloud and into the light once more.

An engine surged violently, recovered and surged again. The bangs were audible on the flight deck, and the aircraft shook.

"We're going to have to nurse this poor old girl home," the captain said. "Shut down drill, number two engine."

Jane peered through the windscreen. There seemed to be mist lingering there, or perhaps spilled oil, but the busy wipers were having no effect. It was sandblasting, she realized, scarring by particles of volcanic ash.

Even inside the cabin there was black dust on every surface. Jane picked it up between thumb and forefinger. It was gritty, with a sulfurous smell.

When she looked out, through the murky windows, she could see a new ash cloud, miles wide, still higher, black as coal, reaching into the air from some new geological horror.

If that cloud had been a little lower, if the base of the ash had dropped to ground level, the plane wouldn't have got out.

Cautiously, leaning to see through the remaining clear patches of windscreen, the captain nursed her craft to the ground.

... And now, three seconds in, the rumbling got louder, and the cabin started to shake. Henry knew he must already be off the ground, but the booster was poised there, burning up its fuel just to raise its mass through these first few yards.

So here he was, locked into a cabin on top of a Soviet-era ICBM, which was balanced on the rocket flames jetting from its tail.

But the roar built up, and so did the vibration—every loose fitting seemed to be clattering around him—and now came the sense of acceleration he'd expected, almost comforting, pushing him hard into his couch.

The bunker spoke to Geena, and she responded, her voice deep and shaking with the vibration.

Henry wished he had a window, or a periscope. He wished he could see Kazakhstan falling away as if he was in some immense elevator; he wished he could see the great plains of central Asia opening up beneath him.

The acceleration continued to mount. He closed his eyes. Simple physics, Henry told himself. Acceleration equals force over mass. As the fuel load decreased, the mass went down, the acceleration had to grow ... But knowing what was going on didn't help relieve the pain in his chest, the heaviness of his limbs.

When he opened his eyes again he could hardly make out the instruments, so severe was the vibration.

There was a series of clattering bangs on the outside of the hull.

Geena shouted, "There goes the escape rocket. And now—"

And now another jolt, much bigger, fundamental. Henry knew that must be the clustered first-stage boosters

dropping away. Now only the centrally-mounted main engine was burning.

The thrust built higher, smoothly.

"Thirty miles high," Geena said.

Another clatter from the cabin hull, and suddenly the faring was gone. No longer needed, Henry realized, because they were already above most of the air.

The windows were clear. There was a shaft of yellow sunlight, lying across his spacesuited lap.

He looked right, through his Captain Nemo window.

There was a loose snow, drifting past his window: ice, breaking off the hull of the capsule. They were so high now there was no air friction; only the ship's steady acceleration carried him away from the ice fragments as they spun.

The second stage rocket died with a bang.

The acceleration vanished. Henry and Geena were thrown forward against their restraints, two puppets, helpless in this steel fist. A second of drifting. The ticking of the cabin instruments, the cooling creak of the hull.

Then came another bang as the final stage lit up, and they were slammed back into their seats. The acceleration soon built to the most ferocious of the launch.

There was nothing smooth about rocket flight, Henry realized, nothing gradual. It was all or nothing.

He glanced at the clock. Less than eight minutes ago he was still sitting on his back on the pad—

The third stage cut, in an instant. Henry was thrown forward against his restraints. He gasped. His chest was sore, probably bruised. His back hurt.

One instant the stage had been burning as hard as it ever had, the next it was dead.

But there was no more rocket fire, no more lurches of acceleration. It was, it seemed, over.

The light shifted across his lap.

Through his window he could see the Earth: the curving blue breast of an ocean that had to be the Pacific, laced

with streamers of cloud, like a slice of day. And above a blurred horizon there was a jet-black sky, the sky of space.

The launch was over. This was Earthlight on his lap. He was in a spaceship, and it was rolling, and he was on orbit.

Holy shit, he thought.

40

For two and a half hours after launch, they had to stay strapped in their couches. Geena worked through more checklists, ensuring the comms, solar panels, computer, pressurization, propulsion and other systems had all survived the launch and were working correctly.

Henry could loosen his straps. He felt his body float a little way above the seat, so his layered suit wasn't sandwiched under his back any more. The ventilation was working the way it was supposed to, and he started to feel pleasantly cool; the sweat that had gathered in the small of his back dried up quickly.

If he relaxed his muscles, he found his hands rose before him, as if raised by invisible threads, as the muscles of his arms reached a new equilibrium.

Floating: no pressure points on his body, the temperature neutral. If he closed his eyes it was as if he was suspended in some fluid, in a sensory deprivation tank maybe . . .

But by his right-hand side, through the stout little *Nautilus* porthole, he saw the Earth.

White clouds, curved blue sea: his first impression. The clouds' white was so brilliant it hurt his eyes to look at the thickest layers too long, as if a new sun was burning from beneath them, on the surface of the Earth. And the blue was of an extraordinary intensity, somehow hard to study and analyze.

It was easier to look at the land, where the colors were more subtle, grays and browns and faded greens. Cultivated areas seemed to be a dull sage green, while bare ground was a tan brown, deepening to brick red.

But Henry was struck by how much of the planet was empty: all of the ocean, save for the tiny, brave lights of ships, and great expanses of desert, jungle and mountain. To a first approximation, Earth was a world of blue ocean, baked-brown desert, and a few boundary areas.

And the Earth was immense. The Soyuz, for all the gigantic energy of its launch, was trivial, circling the planet like a fly buzzing an elephant, huddled close to its hide of air.

The sense of motion surprised him. No feeling of acceleration, of course; but still the Earth unrolled beneath him, new features washing steadily over the horizon, littered with clouds that were strikingly three-dimensional. Here came the Florida peninsula, for instance, like a raft of land suspended on the royal blue waters of the ocean, its coast fringed by a delicious electric blue, the shallower ocean floor of the continental shelf. A little way out to sea, over the Atlantic, a bank of cloud was gathered in great three-dimensional ripples, like scoops of ice cream layered over the pondlike air. On the land itself, he could make out the spit of land that marked Cape Canaveral. Straight inland from that, surrounded by the central lakes, he could see the Disney World complex, splashes of white and gray. On the other side of the peninsula he made out Tampa Bay, and Miami in the south. The cities were bubbly gray, their boundaries blurred. The whole thing looked like a map— but in three dimensions, with that visibly thick layer of air above it.

He was struck by the land's flatness, the way it barely seemed to protrude above the ocean's skin. In fact Florida was indeed a karst topography, a bed of limestone laid down in a shallow, ancient sea, and the lakes were just hollowed-out sinkholes in the limestone. Little separation between land and sea.

But his view was never stable. The spacecraft turned, slowly, so that its big, winglike solar panels caught the sunlight. If Henry craned his head he could see the panels, jut-

ting out like an airplane's wings from the hull of the ship, the solar cells gleaming gold, as the Soyuz turned like a flower to the light.

They flew into darkness: what Geena called the shadow, the dark half of the orbit. Reflections from the cabin lights on the windows made it hard to see out at such moments, but still Henry could make out continents outlined by cities, chains of them like streetlights along the coasts, and penetrating the interiors along the great river valleys. The strings of human-made light, the orange and yellow-white spiderweb challenging the night, were oddly inspiring.

Over the Pacific's wrinkled hide he saw a dim glow: it was the light of the Moon.

And then they flew toward the sunlight once more. It was quite sudden: a blue arc, perfectly spherical, suddenly outlined the hidden Earth, and then the first sliver of sun poked above the horizon. The shadows of clouds fled across the ocean toward him, and then the clouds turned to the color of molten copper. The lightening ocean was gray as steel, burnished and textured. The horizon brightened, through orange to white, and the colors of life leaked back into the world.

He had the feeling he could spend his life up here and not tire of this.

But then, over North America, he saw a high, swirling stream of smoke. It seemed to flatten out at some high atmospheric layer, then plumed out toward the horizon. It was from the ruins of Washington State: steam and smoke and volcanic ash, disfiguring the face of Earth itself.

Eventually Geena told him he was free to leave his seat and get out of his spacesuit.

Helmet, gloves, zippers: he had to wriggle to get his arms and body out of the upper section, and then shove hard at the tight leggings to free himself. But as soon as he

did, there he was floating in the air, dressed in his white T-shirt and long johns, in a freedom he'd never imagined.

The closed-over walls of the cabin seemed roomy. With a push of a fingertip he made himself float up to the control panels fixed to the roof, and with a gentle shove he could spin in the air, so he was looking down on the couch, and the spacesuit which lay there like a beached whale. He tried making himself twist further, but he found that if he moved his head too quickly nausea washed over him.

Geena, moving with the slippery grace of a dolphin, opened up the hatch to the orbital module and beckoned him. Henry used his hands to pull himself after Geena through the tunnel, but—unlike Geena—he caught his knee on a control box, his foot on the lip of the hatchway. Two bruises already, and he hadn't even gotten to Station yet. Anyhow, legs didn't seem too much use up here, save as obstacles to movement; already his hands and arms, which would have to do most of the work in zero G, ached vaguely.

In the upper orbital module, he felt disoriented. The little boxroom, its walls lined with equipment, seemed much bigger than on the ground. Not only that: it looked *different,* its layout subtly altered, as if some unknown engineer had replaced the compartment he'd clambered through on the ground with this distorted twin.

Geena was working the equipment. "Lunch time," she said.

Henry shrugged. "I'm not hungry. I'm not even thirsty."

"Bullshit," Geena said precisely. "I'm dehydrated from the launch, and so are you. You have to learn to live up here." She had pressurized the water tank, and now she pressed open the valve.

A sphere of water emerged—a little thumb-sized liquid planet, shimmering and wobbling, complex waves crossing its surface, the cabin's floodlights returning a mesh of highlights. It swam toward Henry; he watched, fasci-

nated. There were bubbles of air, trapped inside the blob of water, like so many tiny jellyfish, showing no desire to rise to the surface. When they touched they merged, little silvery meniscuses gleaming.

He opened his lips and let the blob just sail in; the surface broke against his back teeth, and his mouth was flooded with crisp cool water. Half of it went down his air pipe, and he coughed, expelling a haze of tiny droplets.

Geena laughed.

Henry went back to the water valve and practiced, until he could suck a ball of water into his lips without wasting a drop.

Geena dug out a plastic bag of grain. She shook it before Henry. "Buckwheat porridge," she said. She squirted hot water into it, kneaded it, then pulled it open. He dug his spoon into it, but when he pulled out a spoonful, the porridge sprayed out of the bag and began floating around the cabin.

"Not enough water," said Geena. "Time to feed the fish."

She began pushing herself around the cabin, gulping mouthfuls of the porridge out of the air. Henry followed suit. It was fun to chase down the little crumbs, but the porridge was very dry.

After that, there was an awkward moment. How *do* you ask your ex-wife how to go to the bathroom?

Geena was predictably brisk. She opened up a panel in the wall, revealing a small, conventional-looking privy. There was no partition, no place to get privacy.

Henry said, "I'll wait."

"Like hell," Geena said. "You have to learn how to do this. Come here." She turned a switch; a fan started up with a clatter.

And so Henry found himself floating around with his dick in his hand, forcing himself to pee into a suction pump, while his ex-wife looked on, murmuring encouragement.

A cute stream of golden globules swam into the bowl

and were whisked away, like something out of a Disney cartoon.

Geena said, "And later, the solid wastes—"

"Much later, Geena. Much, much later."

For twelve hours the Soyuz, in a lower orbit, chased the Station around the curve of Earth. Geena worked through the rendezvous maneuvers with care and skill. She was patient but tense, Henry saw; he sensed there wasn't much time to spare.

Two hundred and fifty miles out, Geena switched on a system she called *Mera,* a long-range scanner. The docking was to be pretty much automated, it seemed. At twenty miles another short-range system called *Igla* turned itself on, and the Station showed up as a blob in a little TV screen.

The Station was the greatest construction ever assembled by humans off the planet. But it looked trivial, like a party favor, suspended over the blue curve of Earth.

The Soyuz worked its way smoothly through its final series of burns. Each thrust was a smooth, sharp push in the back, a rumble of the big engine behind. The smaller attitude thrusters sounded like hollow punches, like someone hitting a barrel with a sledgehammer.

And now the Soyuz turned again, and the Station swam back into Henry's view, close enough now to make out detail.

It was a rough L-shape. Its spine was a string of modules, blocky cylinders joined nose to nose. Out from the final module sprouted an open spar—Henry could see Earth clouds through its structure—and there were delicate, purplish solar panels fixed like wings to the spar, and to the other modules.

It looked, Henry thought, more Soviet-era Russian than American.

Geena leaned toward him. "The tourist guide," she

said. "That spine of modules is the heart of the Station. There's the Service Module, and the FGB. Both Russian-built, similar to Mir core modules." They looked like two fat Soyuz craft, joined nose to nose. "Next we have the Resource Node, which links the Russian and American halves of the Station, and then the U.S.-built Laboratory Module . . ." The last was unmistakable, with its giant "USA" and Stars and Stripes. A black-painted Soyuz was stuck nose-first to one port, like a suckling pig to a teat.

Henry knew he was looking at the Station's so-called Phase II configuration. The Station was still only partially built. It would have taken all of twenty-six more flights—by American, Japanese, European and Russian carriers—before the Station was complete, and able to host six people permanently. Even before the Moonseed, the Station was so far behind schedule, and so far over budget, that the first components were already starting to show their age.

The Soyuz nudged closer, like a lion stalking a deer. They would dock at a port on the Service Module.

Henry thought about the physics of docking, of joining two immense masses in Earth orbit. This wasn't like bringing a boat home to harbor. For one thing, a boat was constrained to two dimensions, and the harbor didn't move; here both Soyuz and Station could move in any of the three dimensions, and at different rates. Eight degrees of freedom, then. And on Earth there were damping forces: friction, air and water resistance, the restraining forces of rails and cables, all helping to kill the craft's relative motion. In space, all the excess kinetic energy would have to be absorbed and damped out within the vehicles themselves . . .

But the Americans and Russians had been docking craft in space for four decades already. He decided to stop worrying about it.

The Soyuz swam closer to the Station, and the great structure slowly turned in space. It was like a toy, brightly lit, shining green, gray and white in the sun, and underlit by soft blue Earthlight. The modules were coated in powder-

white insulation blankets, into which portholes had been cut. Henry could see now how the blankets were pocked by micrometeorite scars, big fist-sized craters. The blankets were a patchwork of colors, in fact, because some of them had already been replaced during the Station's life. The paintwork of the once-bright logos had faded. Around the nozzles of the attitude thrusters mounted on the FGB he could see scorched, blistered paint.

He could see a face, sunlit in a porthole, peering out at him, human pink against the engineering dullness of the Station, the blue of Earth.

As the Soyuz's nose nuzzled into its docking port, struts and shadows and powder-gray blankets filled his window.

He could feel the moment of docking: a slow grind of metal, a hard thump, a noisy rattle of latches. Then the Soyuz swung back and forth, gently, for long minutes; he heard metal creak around him.

They swam up into the orbital module. When Geena opened the hatch, Henry could smell hot metal: the Soyuz hull, which had been exposed to vacuum.

Jesus, he thought. This is *real*.

And when he looked into the Station, at human faces grinning at him, Henry felt an unexpected gush of emotion. It really meant something, he found, to fly up through all that rocket energy and rattling metal, and *arrive* somewhere.

Here was Arkady, waiting on the other side of the hatch. He was hanging with his head down, his body disappearing into the dimness beyond. He was wearing a Green Bay Packers T-shirt, cut-off jeans and thick socks.

Geena reached out a hand to him. He pulled her up, and they embraced. But they broke when Henry came blundering up behind.

"Pay the cab fare," Henry said to Arkady. "I got no change."

Neither of them laughed. Henry looked from one to the other. Suddenly, unexpectedly, he felt like a gooseberry.

"We do not have much time," Arkady said gravely.

Geena checked her watch, a big Moonwalker's Rolex strapped to her arm. "TLI is minus fifty."

"What's TLI?"

"Trans-lunar injection. When we leave Earth orbit, for—"

"The Moon. Minus fifty what? Hours?"

She grinned. "Minutes."

He gaped at her. "You guys are crazy."

"The launch window is complicated, Henry. It will last about a day—after that the plane of our orbit will drift and we'll have to wait a month—and we have pushbutton opportunities of a minute or so, once an orbit—"

Arkady put a hand on his shoulder. "We will take care of it. If you need to defecate, I would recommend you do it here, in the departure lounge, so to speak. It will be rather more comfortable than later."

Henry shrugged him off. "What is it with you astronauts and my toilet functions? I'll take my chances."

"As you wish." Arkady floated off.

Henry struggled after Geena, through the Station. He hadn't got his sea legs yet, and he kept getting his elbows or his clumsy feet hung up.

It was *dark* in here. The habitable compartments made up a kind of cramped corridor, strung out together, patchily lit by floods. There was a constant rattling of machinery, thumps and bangs and whirs. Oddly, he couldn't smell anything at all, save a little sparky ozone. That made a certain sense. The air was recycled, with carbon dioxide absorbent and contaminant filters. It must be dry, clean, healthy. And it must be irradiated by the raw uv coming in the windows, ionized to ozone.

The windows were small, well-separated portholes. They were grimy, coated with dusty fingermarks. Any dirt

in the air up here was going to stay there, he supposed, until it stuck to some surface, or got sucked out by the filters.

After all you couldn't open a window to let out the fug.

The walls were covered by thick insulation blankets. Every square inch of usable surface seemed to be crammed with equipment: boxes of electronic gear, pipes and air ducts lashed together with silver tape, crudely lagged. Cables were strung about everywhere, floating like seaweed. It was like some old geezer's home workshop, he thought, encrusted by years of make-do-and-mend, pieces of equipment crudely taped to the walls, instrument panels and air scrub cartridges and exercise gear sticking out at every angle, and towels hanging like flags from color-coded holders on the walls.

This wasn't so much a science platform as a survival shelter, he thought. It was strange to think of humans struggling to survive in all this dimness and clutter, while the silence and beauty of space, of the Earthscape itself, hung beyond the scuffed walls.

Right now there were five people up here, in a Station built for three: himself, Geena and Arkady plus two regular crew. Everybody was working but himself, it seemed, hauling equipment and supplies back and forth along the cramped modules. Less than an hour to TLI, Henry thought, and they were still loading. So much for checklists. He wondered what crucial item was being forgotten, what key mistake was being made, right this minute . . .

He saw Arkady carrying his petrological microscope, ugly wooden box and all, and he felt obscurely reassured.

Geena introduced the crew briefly. There was a tough, competent-looking woman of about fifty called Bonnie Jones, and a guy called Sixt Guth. Sixt had to be at least sixty, Henry thought: fit and lithe, his head totally free of hair, as if it had worn smooth. He was struggling with a pack of consumables, but he stopped to shake Henry's hand. That left something on his palm, Henry realized, a kind of gray sheen.

Sixt saw him looking. "Sorry. Metal dust," he said. "From the Progress."

"The Progress?"

"The supply ships the Russkies use. Like unmanned Soyuz. Pieces of shit. Half of them are looted for food by the ground crews in Kazakhstan." Sixt winked at Henry. "So you're going to the Moon. I envy you."

"Maybe I should be envying *you.*"

"You know, the thing of it is, you get tired of watching the Earth, from orbit. After two or three months up here, you want to *go* some place."

"And now we are."

"You, anyhow. I just hope there's somewhere for you to come back to."

Geena drifted past, beckoned Henry, and he followed.

Bonnie pushed past them, hauling equipment. She barged into Henry's back, knocking him aside.

He took a moment to recover. "What's eating her? Jealousy?"

"No," Geena said. "Well, maybe a little. Mostly she resents your being here. The interruption to her routine."

"Wow."

"You get a little cabin fever up here."

They came to another tunnel, set in the floor, with an open hatch.

He said, "And what's down this rabbit hole?"

She said softly, "*The Moon . . .*" And she pushed him through the hatch.

It was just another Soyuz capsule, another crude ball of earthy Russian metal. Geena pushed him through the orbital module to the descent module, pointed at the right-hand seat and told him to buckle up.

For a few minutes longer the hatch above his head stayed open, and he could hear the crew frantically jamming last-minute cargo into the orbital module above him.

The Soyuz was basically the same design as the one in which he'd ridden to orbit. But there were some differences in the instrumentation: a small laptop computer, duct-taped to a wall, English labels hand-printed and stuck over some of the Russian gear. He got the sense of improvisation, of beat-the-clock preparation, of this simple little craft being hastily upgraded to be capable of taking three humans to the Moon, and back again.

The sense of hurry was *not* reassuring, right now.

Geena came swimming down. She wriggled over to the left-hand seat and pulled a checklist from a plastic pouch stuck on the wall.

Arkady followed, muscular limbs in a blue jumpsuit, crowding into the center seat.

So the crew was complete, thought Henry. Geena was trained to fly the lander; Arkady would handle the Soyuz; and he was Mister Moon. Given the circumstances they were a well-matched crew. Complementary.

So why, then, was the atmosphere so stiff?

"Fifteen minutes to TLI."

Radio voices responded to Geena, from the mission controls in Korolyov and Houston, English and Russian voices ticking through checklist items. Geena responded in kind, her Russian tinged with California.

"Shouldn't we be wearing spacesuits?"

She turned to him, distracted. "The launch window is kind of tight here."

"So, shut up, Henry."

"Shut up, Henry."

Arkady's knees were jammed up against Henry's. Try as he might, Henry just couldn't get away from that gouging physical contact. The Soyuz seemed *much* more crowded with three than with two.

And now Sixt's Moonlike face loomed briefly in the open hatch, and he nodded gravely, before he slammed the hatch shut.

Once more, Henry was sealed in.

* * *

Henry heard a hiss as the short tunnel between Station and
Soyuz was evacuated. Then the clamps that held the craft
together were released, and a spring connector pushed the
Soyuz away. The undocking was a small symphony of
thumps, bangs and obscure jolts.

Then the light in the porthole beside him started to
change.

He could see the great powder-gray structure of the
Station once more, drifting away from him. The Station
was lined up so its long axis pointed down toward the cen-
ter of the blue Earth, and its big solar panels trailed after it
in its orbit. He wondered dimly if the Station's position had
something to do with stability: maybe the orientation was
tweaked that way by the Earth's faint tides, and the solar
panels felt the soft breeze of the remnants of the atmo-
sphere, even so high, so that the Station sailed like some
immense ship through this silent ocean.

Arkady saw him looking. "When Station is opera-
tional we will line it up with the long axis in the direction of
flight. That eliminates tidal effects, from our zero-G manu-
facturing experiments—"

"When it's operational."

Arkady smiled sadly.

The checks continued, in English and Russian. Henry
could follow maybe half of what was spoken, pick up
maybe ten percent of the sense.

*. . . Roger, Geena, this is Houston. We're all set here.
We're even ahead of schedule.*

"Rog."

*Green lights here. Your attitudes look like they're on the
nose . . .*

The basic Russian systems seemed to have been aug-
mented by American electronics, to handle the extra func-
tions required of the ship on this Moon flight. Arkady mostly
worked at the basic Soyuz controls, while Geena tapped on

her laptop. They worked pretty smoothly, all things considered, but sometimes they stumbled, and they had to repeat what they were doing in English and Russian.

The Soyuz turned in space, firing its attitude thrusters. Every clattering thruster pulse felt like a punch in the back. Henry could feel the shove of his couch and the hull wall, physically swinging him around.

Now there was another clatter he recognized. "We docked with something."

"Very good," said Geena dryly. "We just picked up our booster stack, Henry."

They flew into Earth shadow. When Henry peered through his window he could see fans of crystals spewing out in geometrically perfect straight lines from the attitude thrusters: rocket exhaust, in Moonlight.

Geena said, "The five-minute light is on. We should have the thirty-second light in—ah, five seconds—coming up—two, one, *light.*"

Very good. We got TM confirmation. Timing is perfect, you guys.

"Roger that."

I'll count you down to autosequence and you'll call at five . . . Confirming, flight directors have been around the horn at Houston and over in Korolyov, and we confirm you are go for TLI. Geena, you are go for TLI.

He asked, "What's an autosequence?"

"The program for firing the rockets," Geena said.

"The rockets that will take us to the Moon?"

"You got it," she murmured.

"Yes." Arkady's voice was somber. "But the ship is smart. It has aligned itself with the horizon and with the stars, and is ready to fire the new engines strapped to it. I am not concerned. The ship is much wiser than we are . . . "

"Umm," said Henry. "I just wish they'd had time to test this stuff."

"You can't have everything," murmured Geena. "Henry, this is going to be eyeballs-out."

"What the hell does *that* mean?"

Here we go. Countdown to autosequence. We've got—ah—ten, nine, eight, seven, six, five—

Geena flipped a switch. "Arm."

Three, two, one, sequence.

"Got it," Geena said. "Right in the groove. Green on the attitude. She's holding like we're locked in cement."

"Copy that."

Here we go. Coming up to the five count.

"Roger."

Coming up—now—five, four, three, two—

Henry gripped the frame of his chair, and braced his back.

—one—

"Oh, shit."

Zero.

He heard a low, deep rumble. Henry felt himself fall forward into his straps, as if he was falling into the nose of the cabin. The push was sharp, initially, then settled down to a steady thrust, a little more than Earth-normal gravity.

"Eyeballs-out, hell," he said.

"Didn't have time to design it out," Geena shouted back. "Sorry."

Henry turned and looked out his window.

He was flying over the Pacific night. He could see the light of the engine, a pale orange spot, reflected in the wrinkled Moonlit hide of ocean. Anybody down there, looking up, would be able to see the burn, see the first Moonship in a generation veering off into space.

But already Earth was sliding past his window. He could *feel* the craft sliding sideways, pushing out of Earth orbit, heading for the Moon.

You're looking good here. Right down the old center line.

"Thirty thousand feet per second," Geena said. "Thirty-three. Thirty-four. Thirty-five . . ."

After a couple of minutes the thrust shut down, without warning. Henry watched the others, but they didn't seem concerned. There was a series of metallic bangs.

"Second stage," Arkady said evenly. "Three, two, one—"

Another jolt from the ship's nose, eyeballs-out again, a thrust that lasted for two more minutes. Then that died— and the ship flipped over—and a final meaty push in the small of his back.

The computer shut down the engine. The push died in an instant, and Henry felt himself pitch up out of his couch.

So it was done, so quickly. He was moving at more than twenty-four thousand miles an hour, fast enough to coast all the way to the lip of Earth's gravity well, and then downhill to a rocky Moon. But inside the little descent module, with its homely clatter of vents and fans and generators, there was no sense of speed.

Arkady cut loose from the booster stack. Working the Soyuz's attitude thrusters with two handheld joysticks, he turned the spacecraft so the windows were pointing back toward the Earth.

The discarded booster stack looked immense, glowing in the unfiltered sunlight. Henry saw it was made up of three fat, squat cylinders, bound together in some kind of rough framework. Geena told him what he was seeing: the upper stages of three American-built boosters called IUSs, which had been docked to the Soyuz's nose. The final push had come from a Russian engine called a Block-D, strapped to the back of the craft. The Block-D, incidentally, would deliver them to the Moon. The booster stack was dumping exhaust, spewing sheets of sparkling ice particles into space, sheets which spiraled out as the stage turned. It was like some immense lawn sprinkler, Henry thought.

And beyond it, Henry could see the whole Earth,

already small enough to fit into the frame of the little window. For the first time he could see the object of his life's study, not as fragments of landscape, but as a planet, complete and entire, folded over on itself.

From out here, Earth's dominant color was blue, the deep, mature blue of the oceans, with clouds laced over them dazzling ice white. Where the land showed, he could make out the bright oranges and browns of the desert, but the softer greens of the temperate zones were washed out to a bluish gray. A world of ocean and desert.

But it was streaked with black. Even from here, the damage done by the Moonseed was visible.

And beyond its edge, only utter darkness.

As he watched the Earth got smaller.

They were receding so fast—he hadn't expected this—that the Earth visibly shrank, even as he watched, as if he was riding some cramped elevator car.

Arkady pulsed the hand controllers once more. The booster stack receded, still rotating slowly, turning at last into a starlike point surrounded by a dim haze of vented propellant. And there came a time when Henry looked away, just for a moment, and when he turned back he'd lost the booster in the blackness.

The light of Earth and sun was so bright out there he couldn't see the stars. The little craft was alone in space, sliding unpowered through the dark; and all the universe was either inside this little metal bottle, within a few inches of his outstretched hand, or thousands of miles away.

The three of them looked at each other, wondering what they had done, in such haste.

A little later, they flew through the shadow of the Earth.

The eclipse took more than an hour. They could see their home planet as a hole in the stars, ringed by a rainbow of sunlight refracted through the atmosphere. And in the center of the planet, they could see a faint gray-blue glow:

it was the light of the Moon, shining down on the belly of the Pacific. It was an eclipse of the sun by the Earth, a sight no human in all history could have seen before the Apollo adventure, and no human had seen since. A hell of a thing, Henry thought.

41

It was going to take them three days to get to the Moon, just as it had Armstrong and Aldrin.

Three days. There was really no other way to do it, as long as you were constrained by chemical rocket engines: a hard push that burned up your fuel to launch you out of Earth orbit, a slowing climb up to the point where the Earth's gravity balanced that of the Moon, and then a steady fall down to the Moon itself, where you would have to slow again to enter lunar orbit. Like climbing up one hill and down another, Henry thought.

And as long as humans flew this way, it was going to take them those three days, just as it always had.

Henry tried to sleep.

Geena had hung up three light sleeping bags in the orbital compartment of the Soyuz, where there was just enough room to stretch out straight. Henry climbed into one, and Geena zipped him up, with a reasonable amount of tenderness, and so there he hung, suspended like a bat.

He had supposed that sleeping in zero G would be like the most comfortable bed imaginable, but it didn't seem to be working out that way. He missed the pressure of a pillow under his head, the security of a heavy duvet over him. Even field trips weren't like this. He was missing Earth's heavy gravity field, gluing him safely to that big ball of rock.

And the damn bag was too big. If he'd been Arkady's size it might have been okay, but he wasn't. He was rattling

around in here, and every time he moved the neck gaped open and cold air rushed in.

Besides, whenever he felt himself drifting away, some deep part of his brain warned him that he was falling, and he clutched at his sleeping bag.

He burrowed deeper into the bag, shutting out the light and noise.

His heart, powerful enough to withstand a planet's gravity field, was too strong up here. His pulse boomed in his head.

And the cabin was full of noises—the clatter and whir of pumps and fans and extractors—and every so often some mechanical gadget would change its tone, startling him awake once more. It was like trying to sleep inside some huge refrigerator, with the added frisson of knowing that on these rattling Russian machines depended his *life*.

He wasn't aware of drifting off.

. . . He came to when Geena reached into the bag, grabbed him under the chin and hauled his head out by main force. He found himself coughing, gulping at cool air.

"Are you okay?"

"I think so." His head felt stuffy, as if he had been standing on his hands. But he was the same way up as when he'd gone to sleep. He shook his head, and *that* was a mistake; the cabin started to move around him. "Oh, wow."

Geena stood before him, looking into his face. "Think about it. No convection, right? So if the carbon dioxide builds up in your sleeping bag you choke yourself."

"Much you care."

"A corpse in a Soyuz is about as welcome as a fart in a spacesuit, as we say." She was looking into his eyes. "How do you feel?"

He took an inventory.

The left side of his head hurt. For some reason, he found that if he pressed the back of his head it helped a lit-

tle. His feet felt numb, as if there was no blood at all down there. His nose was stuffy.

He reported all this to Geena. She laughed.

"Your eyes are red as shit, too. It's just the blood pooling in your head; your fluid balance hasn't adapted yet."

Gingerly, he started to push himself out of the sleeping bag. Strangely, the experience of zero G seemed still more bizarre than it had yesterday.

"Where are we?"

"Eleven hours since TLI. Seventy thousand miles from home."

The light was shifting. He looked out the porthole.

Earth and sun swung gently around the craft, as if the Soyuz was creating its own tiny sunrise and sunset. Geena had put the craft into barbecue mode, a slow hour-long roll in the sunlight to even up the heat load.

Everything was rolling.

"Oh, shit."

Suddenly he was retching.

It was just a spasm, barely painful. But suddenly here was a greenish sphere, the size of a tennis ball, floating in space in front of him. It was oscillating slowly, thick and languid, pea-green and quite beautiful.

Geena was scrabbling in a locker. "Christ, Henry." She handed him a plastic bag, and he held it before his face, catching most of the rest.

Under some complex combination of surface tension and air currents, the loose sphere of puke split in two. One half headed for the wall, the other for Geena.

Henry ventured, "Kind of pretty, isn't it? And look at the way they are moving. Equal and opposite. Conservation of momentum, I guess. And—"

Geena was watching in horrified fascination. She didn't seem able to move out of the way.

The blob hit her square on her chest. The magic of zero G dissipated instantly, and the puke spread out over her white T-shirt, viscous, sticky and lumpy.

She started dabbing at it with wet towels. "Henry, you asshole."

"I never said I was a spaceman."

The other lump of vomit reached a locker door now. Instead of sticking, it broke up into a dozen smaller globules, that rebounded and set off over the cabin.

Arkady came floating up from the descent module. "I could smell—oh." He laughed. "Time to hunt butterflies, I think."

He took a handful of wet wipes, and he and Geena started to chase over the cabin, snagging the vomit spheroids out of the air. Henry just hung there being still, trying not to worry about which way was up.

Twenty-eight hours out; a hundred and forty thousand miles from home. A day after TLI, they were already more than halfway to the Moon.

Wrapped in a blanket, Henry hung before a window, staring out.

He could see the Earth every once in a while, as it slid past his window. He could tell it was a fat round world, floating in space, much more three-dimensional than the Moon; the huge highlight cast by the sun from the oceans ensured that, as if the Earth was a huge steel ball under a spotlight. Every time the planet came by, it dwindled. He couldn't see the change if he watched, but if he turned away from it and looked back, it was a little smaller and more distant.

Now, with the planet reduced to the size of a baseball, he found he'd lost his sense of what he was looking at. He was supposed to be a geologist, for Christ's sake. But the real Earth was no map: it was swathed in cloud, and the countries weren't color-coded.

Geena laughed at him when he told her this.

"Start from the beginning," she said. "What's that big white patch at the edge? Ice or clouds?"

Henry thought about it. "Looks like ice," he said. "And if it's summer in the northern hemisphere, and that patch is in sunlight—"

"It has to be the Arctic."

"Okay. But how can that be right when it's at the bottom?"

Geena, reasonably gently, took hold of his long johns at the hips, and swiveled him around, handling his mass as easily as if he was some inert piece of payload.

When she'd turned him upside down, everything fell into place. There was Antarctica, and above it there was South America, Chile to Brazil, from forest to desert swathed in clouds. The whole of North America was drowned by gray, unseasonal cloud, although he could see Florida peeking out through a rift. There was a cyclone over the mid-Atlantic, like some immense pinwheel. In the Caribbean, he could see the Bahamas, the shallow ocean there shining green-blue as if lit from within.

Monica Beus had e-mailed him with extracts from newscasts, some still uncensored.

—French government have announced that their nuclear strike against a deliberately engineered Moonseed patch in the South Pacific has not been—
—hard to believe that these hollow-eyed, malnourished children are English—
—the Internet shutdown may indeed be purely from technical issues. But civil liberties groups are saying this is too convenient an excuse for a Government which is demonstrating increasingly illiberal instincts in this time of crisis—
—relocation of crucial high-tech companies from the Washington coast has been complicated by the grounding of many aircraft by volcanic ash—
—we should talk to it. It's a living thing. This is first contact, for God's sake. What does it want?—

—so this thing chews rocks. Well, so does my ex-wife,
and I lived with her for three years before—

He deleted the mail before he got to the end.

It was hard to reconcile the geometric calm and silence
of space travel with the clamor of voices on Earth, crying
for help. He couldn't help a guilty feeling that—despite the
unknown dangers he faced ahead—he had already escaped.

He wanted to be able to pick up the Earth and turn it
around, view it from the other side, witness an African
night. But he would have to wait for that; the Earth would
turn in its own sweet time, as it always had, and by the time
Africa was brought to face him, he would be too far away to
be able to see.

Arkady showed Henry the food store.

The Russian-cuisine food was kept in boxes in the
lockers of the orbital module. There seemed to be a *lot* of
soup. Some of it was freeze-dried—*kharcho,* for instance,
spicy lamb and rice—and some was natural liquid, such as
borscht, which seemed to be cabbage and beet. There was
cottage cheese, pork with potato, canned fish, coffee, tea,
milk. There were *eight* different kinds of bread, cut up into
little chunks, and then candied fruits, plums, chocolate,
cookies. To drink there was fruit juice, in tubes, and coffee
and tea. It was a regular snack bar up there.

It took Henry a day to get his appetite back—he still
didn't feel too hungry even so—and he took to taking what
he wanted, when he wanted, and stuffing his pockets with
snacks for later.

He got in trouble with Geena, for scattering crumbs
around the capsule. The Soyuz, it seemed, didn't have a
decent air filter system, and he had to go around the cabin,
scooping the drifting crumbs out of the air with a handheld
vacuum cleaner.

Geena showed him how to wash, Russian-style. You

just had to wipe yourself down with wet napkins. You could even wash your hair that way: Geena wrapped a brush in another napkin, and scrubbed over his head for him. It was a soothing, relaxing feeling. Grooming rituals, he thought, a hundred and forty thousand miles from the nearest chimpanzee colony.

Shaving was just an electric razor; he had a little vacuum cleaner standing by to collect his spare whiskers. He cleaned his teeth with a napkin wrapped around his finger. It was loaded with mint-flavored toothpaste; it got rid, at last, of the taste of vomit from his mouth. Geena said it was actually good for him because it meant his gums got a massage too.

Besides, toothbrushes would be impractical up here. After all, where would you spit?

Ultimately, he had to face it, he needed a dump.

Once again he faced a 1960s Soviet-era privy, mounted on the wall. He stripped off his long johns, switched on the fan, held himself in place and pushed.

He had to strain harder than he'd expected; it seemed that Earth gravity even helped with this simple act.

It wasn't so bad. One little floater escaped the air flow, and he was able to chase it down with a wet wipe.

At that, Geena told him, it wasn't as bad a system as what the first Moon voyagers had to endure on Apollo, which was after all the same era as this Soyuz design. On Apollo, a crap involved stripping stark naked, and climbing into the storage bay under the three metal-frame couches. Then you took one of a collection of plastic bags, with adhesive coatings on the brim, and finger-shaped tubes built into the side. You had to dig into the bag with your finger— nothing would *fall*, after all—and hook your turds down into the bag. And afterward you had to break open a capsule of germicide, drop it into the bag, and knead it all together.

Things, Henry realized as he chased down his turds, could be a lot worse.

He drifted down into the descent module. Arkady was working through a checklist at the control panel. There were crackly voices singing in lusty Russian on the ground-to-air loop, and Arkady was singing along, his voice booming in the confined cabin, working as he sang.

They finished up with a ripple of applause. Henry realized dimly that Arkady's voice, time-delayed, would have been out of synch on the ground; they must have compensated for that somehow, a small act of interplanetary kindness.

Arkady said to him, "*Vam panravilas?* You liked it?"

"It sounded like an anthem. I kept expecting some shotputter to step up for her gold medal."

Arkady laughed. "It is a dashing Russian song we call *From an Island into a Deep Stream.*"

"Oh, yeah. Lieber and Stoller, right?"

"Pardon?"

"Never mind."

Arkady studied Henry. "Your face is swollen like a balloon. You move stiffly. Your back is sore."

"Yeah. How could you tell?"

"It is a hazard of spaceflight. Your spinal column is stretching. This will not become easier. Your back muscles will weaken, your discs will stretch. You must go back to the orbital compartment and brace your legs against the walls, and press your head against the opposite wall, and stretch. You will feel much better."

"An old cosmonaut trick?"

"Born of long experience." Arkady worked at his list. "I have been able to observe the differences in approach by Russians and Americans to this business of spaceflight. You Americans build fine machines, but pay little attention to the fragile bodies crammed inside. To us, however, spaceflight is an affair, not of machines, but of humans. We sing. We joke. We speak to our families."

"Smart guys."

"You like music?"

Henry shrugged. "Not much. Geena played a lot of jazz."

Arkady snorted. "Jazz makes me tired and irritated. Jazz does not reflect any of the feelings of our everyday lives. Jazz is a music of idleness. It is for young people, flinging, hectic, impetuous. As they grow up they will come to appreciate art that brings relaxation and enjoyment."

Henry wondered if this guy was taking a rise out of him. "So what *do* you like? Songs about tractors?"

Arkady didn't rise to that. "Russian folk music. Tangos, foxtrots. Sentimental songs by Ruslanova, Shtokolov, Kobson. These songs evoke warm feelings in me, and banish disquieting thoughts."

"I'm happy for you."

Arkady studied him. "Are you adjusting to weightlessness?"

"I guess so. I'm not throwing up so often. I guess I missed the training—"

Arkady snorted. "My training was begun by my grandmother."

"You're kidding."

"No. At night we would go to the swings in the park, to train me against motion sickness. She pushed the swings and checked my endurance with an alarm clock."

"*My* grandmother knitted me sweaters."

"She was a sweet woman and a hard worker."

"So you always wanted to be a cosmonaut? Did you follow the guys on Salyut and Mir?"

"Not the cosmonauts. I grew up in the military town of the Kantemir division, in which my father was serving. I had a happy childhood. My dream was born when I was in school. I read books and watched films about the Patriotic War. I idolized the pilots I saw there.

"But it has not been easy. I became a test pilot at the Moscow Institute for Aviation. I applied to serve as a cosmonaut. I was rejected three times. I remember the fourth time. I walked to the train station through a field of rye. I

took off my boots and slung them over my shoulder. A golden field of ripening wheat was swaying around me; there were skylarks in the blue sky. I was overwhelmed by the thick aroma of Earth's bounty. Thus, in my military uniform with the stripes of a sergeant, I walked barefoot to become a cosmonaut."

I don't believe this guy, Henry thought. He's a Russian Jimmy Stewart.

". . . I worked in the designers' office. I flew jets from Noviy Aidar. I flew helicopters in Viazniki. I trained; every morning I exercised, and jogged five kilometers. I became much stronger.

"But I had to wait for my first flight. After *glasnost* the money which was made available for spaceflight in Russia was much reduced. There were few seats, hotly contested. It was the advent of our joint project with the Americans, first on Mir and then Station, which gave me my doorway to space . . . But I never doubted it would come."

He worked as he spoke, his blue eyes flicking over the checklists, his voice level. His eyes were the same color as Geena's, Henry noted absently.

Behind Arkady, unnoticed, a baseball-sized Earth slid past the window.

"And now here you are."

"Here I am, having traveled farther than any cosmonaut before me, farther even than Gagarin, flying between Earth and Moon."

"Lucky guy."

"No. Not luck. It is the faith of others." He studied Henry. "I have found that many times in my life, friends and strangers alike have been prepared to help me because they believe in me. I am very happy because of this, and I am always careful not to betray their trust."

Henry thought Arkady was the most serious person he had ever met.

Henry drifted back up to the orbital module, and tried

Arkady's back-compressing trick. It took a little practice to lodge his head and feet—he kept slipping and bouncing away, like a compressed spring—but after a time he got it and, he was not surprised, it seemed to help.

Geena, too, took the time out to look back at the Earth. But the experience seemed unreal to her; she was unable to take in the reality of the immense distance she was traversing.

She had spent a lot of time in space, but all of it, before TLI, in low Earth orbit. Always she had had the Earth, a huge, barely curving blue wall, outside her window, as if she was flying low over some huge map of the world. On orbit, the Earth was still the anchor of her sense of place, her sense of self.

Out here, it was different.

Out here, the features of Earth were so compressed they were hard to distinguish, and anyhow the planet itself was already so remote you could cover it over with the palm of your hand. When she looked out the window, when she thought about it too hard, she felt lost, a dust mote drifting around, a fly in a cathedral dome.

She had to find a new frame of reference.

Well, there was the Earth, a blue ball over *there,* the Moon a gray disc off thataway, and the sun, a glaring white torch: three beacons, enough to fix her in three-dimensional, interplanetary space.

And beyond those references, visible when her eyes were shielded from the sunlight, she had the stars.

Already she'd come an immense distance in any reasonable human terms, but the stars were so remote that they hadn't shifted in perspective from when she'd lain out under desert skies, in California and Nevada, and tried to count them. The stars were still there, and they would guide her, as they had sailors on less strange oceans than this for millennia.

The stars, and Venus, of course, an ugly gray smudge, like a stain on the pristine darkness.

Distance: endlessly accumulating as they slowly climbed away from Earth.

What made it all seem real, at last, was not the changing view, but the lengthening moments of silence that punctuated every exchange when she spoke to Houston. She had come so far, at last, that even light was taking its time to reach her.

She felt her sense of space and time shifting and flowing, oddly. Here, in this timeless submarine of a capsule, without perspective beyond the windows, she lost her sense of how big they were—reduced to atoms, adrift in the cosmos, or inflated to the size of giants, able to reach out and enclose the Earth itself. Even time seemed to dissolve away from the steady clockwork of orbit, the ninety-minute dawns and sunsets. Sometimes it was as if her heart raced, other times as if it was pumping sluggish lava through her veins, as if she was losing her grounding in the frame of the universe.

For the first time, she understood what the old guys like Jays had been telling her, all these years. Being an astronaut wasn't supposed to be a career step. It was about *going* someplace.

I really have come a long way from home, she thought.

It was in this mood that she cornered Arkady, in the descent module, when Henry was asleep.

They didn't need words. They pulled off each other's coveralls and underwear, until they were surrounded by a drifting cloud of clothing, like Jane Fonda in *Barbarella.* Then they found places to anchor themselves, with hands and feet, thrusting their mouths and bellies together.

It wasn't their first time in zero G. In the Space Station they had usually been driven to hide themselves away in some module or other—sometimes a Soyuz, in fact—to

find privacy. Sex in space, they had found, was a matter of engineering ingenuity, of anchoring and leverage points, and of some athletic ability. Both partners had to work at it; it was no use relying on Earth's sticky gravity to pull you down.

Of course there was the usual problem of fluid imbalance. Arkady's body fluids had pooled above his waist; he didn't have the hydraulic surplus down below he was used to. But as usual, she discovered to her pleasure, testosterone overcame microgravity.

And this time it was more delicious than ever for Geena: to float here inside the metal walls of this little egg in space, a hundred thousand miles of vacuum all around her, but with Arkady's strong warmth inside her, his mouth pressed against hers, like two blobs of the primeval ocean come together here, defying the void—

"Holy cow."

They broke, swearing. Geena grabbed coveralls out of the air—they turned out to be Arkady's—and held them before her.

It was Henry, of course; his head protruded out of the descent module's hatch, upside down, his hair tousled with sleep.

"Oh, God," Geena said.

Henry shook his head. "The fucking ship was *shaking*. I thought we had a leak." He looked from one to the other, as they scrambled into their clothes. "So. The two of you. East meets west; astronaut athletics. Of course. How come I didn't see it before?"

"Henry, I'm sorry—"

"Do what you want. I've no hold over you." And he ducked back into the orbital module, slamming the hatch behind him.

After that, the silences grew very long. Three people tucked into that confined place couldn't have got farther apart or communicated less, Geena thought; it was like the solution to some geometrical theorem.

* * *

Two days and seven hours out, all of two hundred thousand miles from Earth, they went over the hill.

They had climbed past the point of gravitational equilibrium, and entered the Moon's sphere of influence. Up to now they had been slowing down, like a stone thrown up from the surface of the Earth; but from now on they would accelerate, all the way down to the Moon.

Henry marked the moment, watched as the timer ticked past the nominated mark. Of course he felt nothing, no sense of speed or acceleration; he was inside the same old enclosed submarine, and there was no marker post here, or anywhere else.

But they'd clambered all the way out of Earth's gravity well. Somehow it didn't seem right, that such a gigantic milestone should pass unmarked. But it did.

The Soyuz carried a small telescope, of sorts. It was a monocular, designed to be used as part of a sextant, for interplanetary navigation by the stars. Now, Henry used it to study the Moon.

He swept his gaze along the terminator, the line between night and day, and the long shadows there; he could see terraces in the collapsed walls of the bigger craters, as if they were cities designed by some intelligence, walls which curved over the close horizon. And littered over the walls and some of the crater floors, he could see boulders, pinpoints of brightness sending long, needle-fine shadows across the dusty ground.

If the dinosaur killer comet had hit the Moon, it would have left a crater like Copernicus or Tycho, with ejecta rays stretching around a hemisphere.

After a time, he abandoned the telescope, and just looked.

In the window, the Moon was still small, no more than the size of a golf ball held at arm's length. *But he could see craters,* with his naked eye: a sight denied to every human who ever lived, before Galileo raised his telescope.

He stared into the Moon's gray light until his eyes blurred with tears.

They passed through one major crisis.

Henry knew almost nothing of the systems that would take him down to the Moon's surface, and keep him alive there. There hadn't been time to explain it all, and Geena suspected he didn't want to know anyhow, until he had to.

But then he started asking how they were going to carry their nuclear weapon down to the surface.

Geena drifted in front of him. "Henry, we can't do it. We didn't design the mission that way. We don't have any spare carrying capacity. The mass estimates—"

"Then we have to leave some mass behind."

"Like what? The air? The water? We can't do it, Henry."

Arguing was difficult in microgravity. They tended to drift around the cabin, colliding with the walls and each other; it screwed up their body language.

"Then," he said, "how are we supposed to use the nuke anyhow?"

Arkady said gravely, "The nuke has a small rocket pack which can drop it out of orbit, directly to its target. We can bomb Aristarchus, or any middle-latitude site, but—"

"It's my fault," Henry said. "I should have been more open."

"Yes, you should," Geena said. "The story of your life, Henry. What the hell do you want, anyhow?"

He hesitated. "Suppose I told you I needed to drop the nuke on the South Pole. How could you do it?"

"It's impossible," Geena said. "We don't have the delta-vee for the orbit change. And if you're talking about delivering it to the surface, rather than dropping it at orbital speeds—"

"Yes. We might have to use the bunker-buster effect."

"Again, we don't have the delta-vee," Arkady said.

And he drifted away, and began a conference, in Russian, with the ground controllers.

"There is no way," Geena said, irritated. "Henry, this is your fault. This is your damn *plan*, isn't it? If you told us up front what was on your mind we could have prepared for it."

He laughed. "That's impossible. They wouldn't have let me out of Edinburgh if I had. I guess I thought there would be more—flexibility. More options."

"Well," she said heavily, "you guessed wrong."

He backed off, troubled.

When Geena tried to sleep, she wasn't disturbed by the noises of the ship's equipment, the sensations of zero G. She was used to all that. What got to her now were the flashes inside her closed eyelids: loops and meteorite streaks and starbursts, some of them so bright she felt dazzled. The flashes were caused by cosmic rays, heavy particles which had emanated from some ancient supernova, and had crossed light-years to pass through her head.

Even in low Earth orbit you were protected from this shit by the Earth's arching magnetic field. Not out here. And every time one of those ancient little wasps passed through her, it caused a little more damage to her body's structure.

Slowly but surely, space was killing her . . .

"I see the Moon, / The Moon sees me, / God bless the priest / That christened me . . ."

Henry was whispering, but even so it woke her up. She turned in her sleeping bag, and cold air pushed in at the neck.

Henry was hovering by the wall, holding loosely to a stanchion. He was staring out the window, looking at the Moon.

Arkady was curled into a ball, snoring softly.

The Man in the Moon had changed. It looked as if he

had turned a little to the right, bringing his left side forward, obscuring Imbrium, his big, dark right eye . . .

She had come so far, already, that she was looking at a new part of the Moon.

Its light flooded over Henry's face, shadowless and stark.

"*I see the Moon, / The Moon sees me, / God bless the Moon, / God bless me.*"

"Henry, what are you doing?"

"Something I learned in Scotland," he said. "I'm protecting you." He turned to the Moon; half his face entered shadow, so that there was a terminator down his profile, picking out the shape of his eye ridges, nose and lips.

"What's she like?"

"Who?"

"Whoever taught you the poem."

"Is it that obvious?"

"Yes."

"She's called Jane. She has a kid. A boy."

Geena grunted. "Different from me."

He thought about that, studying her. "No. I don't think so. Not fundamentally. She's strong, like you. She's no astronaut, though."

"Will you go back to her?"

"If there's somewhere *back* to go to. What about you and Leonid Brezhnev over there?"

"Yes. I think so."

"I should have guessed. He's your type."

"What do you mean?"

He shrugged. "A straight arrow. No complications. Everything I'm not."

She didn't reply.

"Well," he said. "I'm happy for you. I just wish this thing had a garage I could go sleep in to give you privacy . . . *Look* at the Moon. You can see it's covered in dust, even from here."

She stared at the smoky plains of the Moon. "How so?"

"Think about it. Suppose it was made of bare rock. From here, mountains and craters or not, it would look pretty smooth. A big, fat bowling ball in space. And you'd get a specular reflection at the subsolar point."

"A what?"

"A bright spot of light, right under the sun."

"Oh." She looked again at the Moon's diffuse glare. "No spot. So, dust everywhere."

"Yeah . . ."

A hail of dust-sized motes hit the airless Moon constantly. The motes were tiny, but they were moving at interplanetary velocities—greater than ten miles a second—and they packed a lot of energy. The micrometeorite flux was an eternal sandblaster, grinding the Moon's surface to dust and smashed-up rock.

"Dust, everywhere. Even on the highlands?"

"Even on the highlands," he said. "It's why, from the Earth, the Moon looks like a disc, rather than a ball. It's too dusty to reflect the sun." He studied her. "You mean that never occurred to you? To wonder why the Moon doesn't give off highlights?"

"I guess it never did."

"Well, there you go," he said dryly. "You learned something new already."

She snuggled down into her bag. "Go to sleep, Henry."

"Yes, ma'am. *I see the Moon, / The Moon sees me . . .*"

Thus, bathed in Moonlight, they sailed between worlds.

42

Suspended in cislunar space, Henry followed the news from Earth. None of it good. All of it in line with his predictions.

Around Ayr on Scotland's west coast—near the airport at Prestwick—about fifty old volcanic vents opened up, in an area bounded by West Kilbride in the north, Muirkirk to the east and Dalmellington in the south. Far-

ther east many of the Earth's folds and faults were giving way, from the Pentland fault to the south of Edinburgh to the Tay north of the Forth, and the Campsie Dusk Water faults around Glasgow . . .

Gradually, the weaknesses in the crust spread through the Midland Valley, toward Glasgow itself. An immense event was approaching.

Henry knew Jane was out of it, safely in the U.S. He felt ashamed how much that mattered to him, how much it diminished his sense of the tragedy to come. It made his efforts here seem small, absurd. And yet, trapped in the clockwork of the mission, he had to continue.

Soyuz was freefalling toward the Moon. The gravity field of that rocky world would make the craft fall around the Moon's far side. But, without intervention from its strapped-on rockets, Soyuz would skim through the Moon's shadow, pass through a zone of occlusion from Earth's radio signals, and then whip around to the sunlit side—and back toward Earth. To enter lunar orbit, the craft would have to burn its Block-D booster to shed some velocity, slow down sufficiently to be captured by the Moon's feather-light gravity field.

. . . Soyuz, Houston. You're go for LOI. You're riding the best bird we can find. Godspeed, Soyuz . . . Soyuz, this is Korolyov. Do not rush to hell ahead of your fathers . . .

LOI: lunar orbit insertion, the burn of two of their three remaining booster packs to put them into lunar orbit. Maybe the most crucial moment of the mission so far. The irony was, it would happen the first time they were out of contact with Earth, on the far side of the Moon.

And since, with characteristic caution, Arkady had already turned the stack to the precise orientation for the burn—that is, ass-backward—none of them could see where they were heading.

Henry said, "You know, we've come a quarter of a mil-

lion miles across space, and we're aiming at a world two thousand miles across, and we're going to go into orbit sixty-nine miles above the surface. Not much room for error. And we can't even see where we're going."

Geena grimaced. "Every pilot hates not to be able to eyeball the target. That's why LOS is so important."

"LOS?"

"Loss of signal. When we go around the corner of the Moon, and into radio shadow."

Arkady found a place on his checklist. "They can calculate our trajectory to the second, in advance. And if LOS comes when the list says it should, at sixty-five hours, fifty-four minutes, five seconds, we'll know we're on course." He grinned at Henry. "Trust me."

. . . And, as the craft turned in response to Arkady's touches, the Moon came into Henry's view: only eight thousand miles away now, less than four diameters, it was a gigantic crescent bathed in sunlight, pocked with craters, wrinkled by hills.

And it was *growing* in his view, even as he watched.

"My God," murmured Geena. "It's like a dive-bombing run."

But they were approaching the Moon's dark side, and as the Moon neared that sunlit crescent narrowed, even as it spread across space.

Henry leaned into the window and craned his neck to see the sweep of the Moon, from horn to narrowing horn.

Jenny Calder packed her two kids off on the train with her sister. She watched as it pulled out of Glasgow Central Station, at the start of their long journey to their aunt's home on the south coast of England.

It broke her heart to do it.

She hadn't even felt able to tell her husband, William, who was on the Northern Channel exploratory rig. Not until he got home. But she'd wait here in Glasgow for him

until he returned, just a few more days, and then they would go south together, and be a family once more.

She patted the bulge of her stomach. Soon be a bigger family, in fact; another thing she hadn't felt able to tell William while he was working so hard, desperately trying to get them a stash of money before the rig work finally disappeared.

The rest of the day stretched before her, empty.

She could go back to the flat. It was on the edge of the Gorbals, where she and William had both grown up, but their flat was one of the better conversions that had been done in the 1980s to attract the yuppies, and now a lot of their money was tied up in it, and of course they couldn't sell it for love or money since the Edinburgh stuff started happening on the TV. Well, now it was going to stand empty. The police said it would be secure until they were able to return, when the Government got this volcano stuff under control.

There was still some packing to do. But the flat would feel very empty without the kids.

And there was something she had promised herself for a long time.

She went out to the taxi rank. Soon she was in the back of a cab, whizzing along the motorway to the southwest, through Clydebank and Oban.

She reached Pollok Park, and here was the Burrell Collection, airy rooms with a woodland backdrop, stuffed full of the art gathered by William Burrell, a dead ship owner.

There were figures and statues and heads from Greece and Rome and Mesopotamia and Egypt. She especially liked the porcelain flower girls—the pieces which would fit best in her own flat, she thought, if she was allowed to take something away. And the place was full of surprises, for instance the old doorways and lintels and jambs that had been built into the fabric of the museum.

There were notices saying there had been pressure

from the Government to crate up the collection and ship it south, or abroad, until the emergency was over. But the city council had resisted. And Jenny was glad.

She'd lived all her life in Glasgow without seeing this. William would never have been interested in coming here, bless him, and the kids were still too young. Well, it would always be here, in the future.

Being here, it was as if all the volcano and earthquake stuff didn't exist, as if life was just going on as it always had. But there was hardly anybody here, and on some of the surfaces there was a fine layer of pale gray grit, the same stuff that had come drifting out of the sky all over the city.

When she was done, she spent a while wandering around the Park itself. Just three miles from the city center, it was like being in the country.

But, though the light was sharp, there was a stink of ash, or smoke, in the air, and an odd orange tinge to the sky, like smog.

After a few minutes, she went to find a taxi back to the city.

The taxi carried her over the Kingston Bridge, the big motorway bridge that crossed the Clyde.

The Clyde was low. Very low, surely lower, in fact, than just a couple of hours before. She could see watermarks in the banks, high above the rippling surface of the river itself.

She thought she could see the water recede further, in the couple of minutes it took to cross the bridge. She'd never seen anything like it. Some kind of tide?

She had the taxi drop her at George Square. From here she could walk up the hill along North Hanover Street to the Buchanan, the big mall at the end of Sauchiehall Street.

. . . There was a sound like an explosion. The ground rippled.

She was lifted up, thrown into the air, and landed flat, face down on the ground.

The air was filled with shrieking sounds. Car alarms.

Dazed and confused, Jenny tried to get up, cradling her bump. Her knees were grazed, bleeding, as if she was a ten-year-old kid.

The buildings around the Square were *swaying*. Some of them had collapsed—the masonry and brickwork and glass just seemed to explode outward—and the air was brown with clouds of dust and smoke. A couple of buildings to the north were on fire, sending up pillars of black smoke.

On the horizon were flashes. Electricity generators shorting out, perhaps.

Now she could hear the wail of sirens, police cars and fire engines and ambulances. She could hear people screaming and shouting. They were emerging from what was left of the buildings, blinking in the sunlight, and then they began picking their way back into the ruins.

Another shock, that jerked her onto her backside on the tarmac.

There were pillars of black smoke all around the sky-line now. An awful lot of fires.

The *speed* of it struck her. Everything had just come apart, shaken to bits, in a few seconds.

No traffic was moving. There wasn't anything she could do to help. The Square was open, and she decided to stay where she was, far from the buildings; at least here she wouldn't be crushed by falling bricks.

One minute to LOS. You're go all the way.

"Copy that."

Soyuz, Houston, ten seconds.

"See you round the corner . . ."

Henry watched the clock, intently. At precisely 65:54:05—two days and seventeen hours from Earth—static filled his headset.

"My God," he said. "Right to the second."

Geena laughed. "Aw, they probably just turned off the radio to make us feel better."

Henry felt awed by the careless accuracy of the moment. To think that human beings could dig out this shell of metal and plastic, of Earth materials, wrap it around themselves and hurl it across space all the way to the Moon and arrive *to the second*.

Arkady and Geena began the checklist for the burn, working carefully and slowly, swapping languages all the time. They seemed doubly careful not to make any mistakes now, out of sight of the Earth.

The celestial geometry adjusted smoothly, the two great beacons of Earth and sun shifting steadily around the sky, illuminating the battered Moon. Through Henry's window, the crescent of sunlit Moon ground grew, narrowing still, until it dwarfed the fleeing craft; and at last it narrowed to invisibility.

. . . And, quite suddenly, the craft was enveloped in darkness, in the shadow of the Moon.

It was the first time in three days Soyuz hadn't been bathed in unfiltered sunlight. He craned toward his window. As his eyes dark-adapted, he could see stars, emerging from the gloom, each of them shining with a steady, gem-like brilliance. And, where the sun had been, the Moon was a giant, perfect hole in the star field—no, he saw now as his eyes adapted, not complete darkness: Earthlight played here, making the craters shine blue-black, like ghosts of themselves.

But, ahead of him, maybe a third of the lunar disc was in true darkness. It was the double shadow, the place neither Earthlight nor sunlight reached, as dark as any place in the Solar System.

Only the Apollo astronauts had known this experience before.

The hair stood up on the back of his neck.

". . . Translation control power, on."

"On, Geena."

"Rotational hand controller number two, armed."

"Armed."

"Stand by for the primary TVC check."

"Three minutes to the burn. We are still go, Geena . . ."

The ventilation hummed, the fans whirred, the machinery gleamed, mundane sights and sounds, as if he was in the guts of some immense pc; after three days they were enveloped in a persistent aroma of Russian cabbage and stale farts.

But there was nothing mundane about where he was, a warm pink body, sailing through the shadow of the Moon.

Come on, Henry, he thought. You aren't supposed to feel like this.

There was an explosion of light. Henry craned to see.

Far ahead of the craft, the sun was rising over the Moon.

It was a dawn of sorts, but it was bony and stark, with none of the richness and fleeing colors of an Earth-orbit sunrise. This was an airless world with no atmosphere to refract sunlight, to bend it up from below the horizon, and create a pre-dawn glow in the sky. So sunrise was instantaneous: one moment it was night, the next a line of fire had straddled the horizon, poking through the mountains and crater rims there.

The light fled across the bare surface, casting shadows hundreds of miles long from mountains and broken crater walls. The smaller, younger craters were just wells of darkness in the flat light. For the first time, the Moon looked jagged and exotic, a craggy, romantic alien world; but he knew it was only an artifact of the light, giving the old, eroded Moon a rugged grandeur it didn't merit—

The engines lit.

For a couple of weeks the rig workers had noticed strange happenings.

The sea water here in the North Channel, not far from

the mouth of the Clyde, was sometimes so warm it steamed. And there was that prevailing stink of rotten eggs. Hydrogen sulfide, the lab boys said.

William Calder didn't think much of it. Aged twenty-seven, with a wife, Jenny, and two kiddies in a tenement block in the Gorbals back in Glasgow, he'd always known the work on this exploratory oil rig was going to be hard and dirty and dangerous, even before Scotland started bloody blowing up. Twelve hours on, twelve hours off, weeks or months away from home; William just kept himself to himself and got through his work, like serving a sentence, which, if truth be known, William had done once or twice in his younger days.

But now it was nearly the end of his tour of duty—nearly the end for everybody, as the rig was going to be evacuated in a few days because of the volcano stuff—and William would be going home with his bank account stuffed with money, more than enough to get his young family out of Glasgow for good, and into some safe bolt hole in England, as far south as they could bloody go without falling into the English Channel.

So he was sitting with a six-pack in the cinema, watching *Independence Day* for the fourth time, when the first explosion came.

The rig shuddered, and there was a wail like a scream.

"Jesus Christ, that's a gas leak," said Jackie Brown, one of the blasting foremen.

Everybody stood up.

The film jammed, and burned through with shocking suddenness, a black circle just gushing outward across the screen.

Then the plastic walls of the room started to melt, and the workers, men and women alike, started to run.

In the corridor outside, William saw people grabbing at metal railings. There was a sound of sizzling, like bacon, and people screamed. The railings were too hot to touch.

William tried to get to the heli-deck, but that was a

waste of time. The stairwells were jammed with people, and the heat was already intense. So Jackie Brown turned and said, "Come on, boys," and he started to push his way deeper into the rig.

Eventually they got out through the drill deck, to a lower level which took them out to the foghorn platform. William blinked in the sudden light, breathed in fresh air. The sea was calm, the day bright. People were running everywhere.

There was no sign of rescue, no choppers. There was a gigantic pall of black smoke, though, hanging over the eastern horizon.

"Shite," somebody said. "They must have nuked Glasgow."

William could see the gas flare, the system that burned off the inflammable gases produced by the thimblefuls of crude oil that was all they had managed to dredge up, here in the Channel between Britain and Ireland. The flare was burning furiously, much more intensely than usual.

And then, as William watched, the flare exploded. The light was dazzling, brighter than the sun, and you could feel the energy pouring out of it.

The bang was followed quickly by heavy, mortarlike crumps coming from the heart of the rig.

Jackie Brown was standing beside him. "That's the bloody diesel tanks," Jackie hissed. He was nursing burned hands.

. . . And now a fireball rose with a kind of majesty through the heart of the rig. It was the central gas jet. William could hear the tearing of metal, the cracking roar of explosion after explosion, as the rig tore itself to pieces.

The deck beneath him tipped—the whole rig was coming apart—and now, oh God, some of the deck plates were buckling.

The flames were towering over his head.

Jackie Brown clapped William's shoulder. Jackie, in his fifties, had seen it all before. "Fry and die, or jump and

try," he shouted, and he jumped without hesitation off the tipping side.

There was oil burning on the surface of the water, which was all of a hundred feet below. The heat was already unbearable—

William thought of Jenny, and wondered where she was now.

He wondered if he should take off his boots first.

He jumped.

Henry was pressed back into his couch.

The ignition was a sharp rattle, the engine noise a dull roar, transmitted through the fabric of the Soyuz. Suddenly Arkady's knee, pressing against his, felt heavy, unbearably bony.

He heard a clattering noise from above as some loose piece of gear fell through the orbital module. The pressure was heavy; he knew it was only a fraction of Earth-normal gravity, but, after three days of weightlessness, it felt like five G.

Arkady and Geena scanned their controls. "Pressures coming up nicely," said Geena.

Time seemed to stretch, flowing like mercury. Henry knew that if the burn was too short, they would finish up on some weird, perhaps unrecoverable orbit. But if the burn was even a few seconds too long then instead of missing the Moon by that crucial sixty-nine miles or so, they would drive into its eternal surface, creating one more crater among billions.

It was the longest four minutes of his life.

"Burnout coming up," Geena said. "Chamber pressures dropping to fifty psi . . . three, two, one."

The engine thrust died in a snap; the vibration and noise disappeared, and Henry was thrown forward against his straps.

* * *

The fires around George Square seemed to be growing, not diminishing, and still the jolts and aftershocks came. Jenny sat squat on the ground, her hands spread out, not daring even to stand.

In one place, in the west of the city, there was a kind of fountain, of steam and fire, that reached hundreds of feet into the air. Great glowing rocks shot out of it, and where they landed, like bombs, new fires started. A volcano, she guessed, right here in the middle of Glasgow.

People were gathering in the Square, in ones and twos or small groups. Some were burned, or were nursing damaged limbs or heads, crudely bandaged, or were carrying other injured.

Some of them had stories, and Jenny listened in horror.

There was the woman who had come across the Glasgow Bridge, to flee the fires on the south bank. The bridge had collapsed, and the woman, with dozens of others, had ended up creeping across a single iron beam. But there had been a panic, a rush, crushing and suffocating, and fifty or sixty had been sent headlong into the waters of the Clyde. When she looked down, the woman saw maybe a hundred people in the water, some swimming or clinging to flotsam, some already dead. There were small boats trying to pick up survivors, but their task seemed hopeless.

Here was a man who had seen Argyle Street crack right open, and fill up with a bizarre mix of rushing water and a wall of fire, from burst mains; the crowds had fled through streets that, even where intact, were jungles of downed power lines, bricks, rubble, shattered glass and felled lampposts and burning cars.

Another woman barely escaped when the motorway bridge collapsed, steel reinforced concrete twisting like plasticine.

An elderly woman had been asleep in her bed, when her high-rise block collapsed. Her first floor flat had become the ground floor; the lower level had telescoped down to eighteen inches. When she clambered out, dazed,

she found people trying to mount a rescue operation, shimmying down fire hoses, people screaming and crawling over each other.

There was the tale of a man who was buried up to his neck in the ruins of the City Chambers. When they dug him out, the whole of his lower body was crushed flat, like a tiger rug, and he had time to see it that way, before he died.

Another woman had been trapped by her legs under a beam. Her son had tried to free her by, good God, amputating her legs. But he could only remove one before the flames beat him back.

. . . And so on; everybody had a story to tell, it seemed.

More and more people crushed into the Square. The fires were still growing, all around the skyline. New arrivals said the big fires on the south bank had leapt the Clyde. That big explosion was the fuel depot at the Central Station going up.

And while all that marched up from the south, another great blaze was licking its way down from the wreckage of the Buchanan Center to the north.

She waited. There was nowhere to run. She just had to hope it would die back before it reached her. She cradled the bump in her stomach, shielding it with her hands.

While Geena and Arkady worked through their post-burn checklist, the craft left the land of shadows and sailed over brightening ground. The Moon filled his window now, a montage of pale tan and black, the edges and rims of the craters sharp and stark. Sometimes he lost his sense of perspective and the landscape seemed to flatten out, and the shadows looked like streaks of oil, sliding past his window.

But those streaks of light and dark were the mountains of the Moon.

Without air, compared to Earth from orbit, the view was remarkably clear. He flew over a landscape of craters: young, smooth, perfect bowls; random gouges; gentle hol-

lows; tiny buckshot wounds; craters on top of craters. Here was a big old basin, with an eroded mountain at its center, and on the smooth floor—and on the flanks of its mountains, and its rambling walls—he could see the pockmarks of younger impacts.

Craters on craters, everywhere: everything he saw, it seemed to him, was made of the rims or basins or central peaks of craters. It was like flying over some ghastly World War One battleground. It was a world of death, a world whose life had been smashed out of it.

The clarity was incredible, though. When he peered down into the craters, especially when the shadows were long, he could see boulders, even broad scars in crater walls that had to be landslides. He could even see details by the milky blue of Earthlight; the landscape disappeared only when they flew through the double shadow of Earth and Moon. The view was so clear, in fact, that his vision kept playing tricks on him. The smoother craters seemed to reverse, popping up into domes or blisters, then sinking back to depressions. He couldn't tell if he was sixty-nine miles up or six, and every so often, as some new mountain passed below, his heart would skip a beat, as if the Moon was clawing up into the sky.

Now the jokes by those old Apollo guys didn't seem so funny. *Sixty-nine miles high? Watch out for the seventy-mile mountain on the Moon's backside . . .*

He craned to see more. This module had been designed for survival, not as a viewing platform, and it was unbelievably frustrating to be so close and not to be able to *see* properly. Like driving through a national park, he thought, in a Sherman tank.

As he skimmed around the rocky limb, passing from shadow to light, he learned that shadows—the angle of the sun—were the key to seeing, on the Moon. When the sun rose, other features would become more prominent, like the brighter ray systems. They looked, he thought, like the marks left where a pickax had dug into concrete.

But when he was subsolar, with the sun behind him, the shadows were flattened, or disappeared altogether, as if he was looking down at the bleached floor of some dead ocean.

In fact, when the sun was right behind him, the lunar landscape seemed to brighten suddenly. *Heiligenschein,* the lunar scientists called it. The saint's halo: some obscure effect of the dust.

But navigation using landmarks was going to be difficult, at high lunar noon. He conceded the wisdom of the old Apollo planners, who had sent all their guys in to land at lunar morning, when the low sun would send forward nice long crisp shadows for seeing . . .

While he analyzed, Geena and Arkady were sightseeing.

"It's colorless," Geena said. "Basically shades of gray. Like plaster of paris, or maybe a deep, grayish builder's sand."

"Or pumice stone," Arkady said. "Or a beach. Perhaps after a picnic. All churned up by a volleyball game, embers of the bonfire everywhere . . ."

"Bullshit," said Henry, angrily. "Arkady, you spent too long on Cocoa Beach. This is why they made a mistake sending you guys, you aviators, in the first place, on Apollo. You tourists can't even describe what you're seeing."

"What's to describe?" Geena said grimly. "It's just a ball of rock. Christ, it looks bleak. A huge expanse of nothing—"

Henry, irritated, shook his head. "That's because you don't know how to look at it—"

"Oh, my," Arkady said now. "Will you look at *that.*"

Henry and Geena crowded to see.

Here she was, right on cue, as they completed their audacious orbit out of her sight for the first time in their lives: Mother Earth, right where she should be, rising above the surface of the Moon, a blue crescent hanging in the black sky.

Even from here, you could see volcano smoke.

". . . Oh, man, that's great," Geena said. "Wow, is that pretty."

Arkady started taking pictures of Earth with his Hasselblad. "I hope these come out."

"You sure you're getting it?"

"I think so . . ."

And so on. Henry sank back into his couch. It was Apollo 8 all over again, he thought, the astronauts ignoring the unexplored wastes below them, for the sake of a few tourist snaps of a place they'd spent their whole lives. It was such a cliché . . .

But he found a lump in his throat.

This is ridiculous, he thought. What am I, a salmon dreaming of the birthing river?

He tried to focus his attention on the Moon. But some part of him, buried deep in his hind brain, made him look up at the rising Earth, again and again, as Geena and Arkady crowded to take their pictures.

The sea was sharply cold, but when William's head was out of the water he could feel it being cooked by the heat of the skeletal, smoldering wreck of the burning rig, so he had to duck under the surface as much as he could manage.

There were no lifeboats, but there was buoyancy foam here from a smashed boat, and he and four others were clinging to it, including Jackie Brown. William couldn't get to a foothold, and his arms were getting weaker, but he didn't want to drag some other guy off and back into the water.

There were people just floating in the water, screaming from the pain of their burns. There was nothing William or anybody else could do for them. There were bodies, too, strips of flesh peeling off them.

The air stank here, that rotten-egg sulfide smell.

And now there was a new explosion, *behind* him, from the ocean.

He turned in the water, clinging to his scraps of foam.

There were explosions coming toward him, in a line maybe five hundred yards long. Ash and steam plumed into the air, and fell back into the water. The steam was gathering into a cloud that soon drifted over the five of them, heavy droplets, hot and damp, that clung to their skin, and made it impossible to breathe without sucking in moisture.

William screamed. Not from pain—from bewilderment. Wasn't the rig explosion enough? How could there be more? Wasn't that one thing *enough?*

. . . But now there was something under his booted feet.

Surprised, he looked down.

Rock. Lumps of it clustered together, the size and shape of pillows, just four or five feet under the surface. And a little farther out he thought he could see more of these pillow rocks forming. It was some kind of lava. A sack-like skin would form over a lump of red-glowing, sticky rock. The skin would solidify, then burst, and the lava would squeeze out like toothpaste, and start to form another pillow.

Volcanic stuff, he supposed. The kind of thing that had knackered Edinburgh. It must be what had wrecked the rig, this crap bubbling up from the ocean bed.

But now, maybe, he could use it.

Cautiously, he rested his feet on a white pillow boulder. The rock was hot, but his heavy boots protected him. He was able to loosen his grip on the foam fragment, and his arms ached with release.

He reached out to the others. Here came Jackie Brown. One of the younger men had given Jackie his life jacket, but even so, Jackie was exhausted, ashen-faced, barely awake.

William stood on the new rock, clinging to Jackie, holding him up.

The steam cloud cleared.

On the rig, he could see men on the heli-deck. They were waving their arms amid the smoke and flame, pleading to be taken off, but there was nobody to respond. Even if choppers had been near, they couldn't have approached through the heat and smoke.

He saw men and women climbing down the legs into the water. Badly burned, terribly burned—some had their faces burned off—but still moving. The rig was tipped through thirty degrees, and looked as if it would fall over any minute.

There were more explosions in the water behind him, as this weird volcanic stuff rebuilt the sea bed. But he was, incredibly, standing on stable ground here.

He might live through this. Stand here, literally stand in the sea, until the choppers came, get himself saved by the volcano stuff that had destroyed the rig, costing probably a hundred lives.

Incredible.

William was alive, where so many had died, and he knew he would take a long, long time to come to terms with that.

In the far distance, he saw the glint of helicopter blades, bright against the huge pillar of ash and steam that hung over Glasgow, and he thought of Jenny and the kids.

The walls of fire broke through the line of ruined buildings to the north.

People started to panic, to push to the south. Jenny struggled to her feet. But the heat from the south was also blistering.

And now the fire gushed like a fluid, from the north, and swept across the ground.

Ash and cinders rained down on Jenny, and she screamed, and tried to keep it out of her hair. Bags and parcels, dumped on the ground, burst into flame. People were running everywhere, but they were falling, popping

into flame before they stopped moving. But she seemed to be alone, with nowhere to run.

The fire rushed at her, a glowing fist. She was knocked onto her back by a red-hot wind.

Oddly, she found herself relaxing.

Her fear was gone.

The kids were safe. William would look after them. And the one in her belly was with her; it would never know suffering.

She was looking up into a cyclone; she could see a pillar of fire, laced with flame and debris, reaching high into the sky, dragging the flames together.

She held her hand up before her face. It burst into flame, just like that, her fingers burning like the candles on little Billy's cake.

There was an instant of glowing pain.

Henry, in lunar orbit, studied the summaries on his laptop.

Something immense and restless was pushing out of the Earth, disturbing the thin blanket of rock and life that overlay the hot interior.

The Moonseed had devoured a goodly portion of the asthenosphere, the mushy semi-solid layer that contained the hotter magma of the deeper mantle. A magma plume seemed to be starting up beneath the Midland Valley, a fountain of liquid rock like the ones which had built Hawaii, Iceland.

But if that was true, it was a plume of a volume and extent and speed of efflux that nobody had modeled before. Already there had been disturbances all over the Valley: the cracking of extinct volcanic plugs, the slippage of faults that had been stable for millions of years.

The destruction of the cities had caused human misery on a biblical scale.

All of it, Henry knew, would be dwarfed by what was to come.

Henry, sailing through black and white celestial geometry, felt like a detached god, unable to imagine the human suffering, souls as transient as sparks in a fire.

He was glad, as they prepared for the landing, there was little time for reflection.

43

Blue Ishiguro—wheezing, asthmatic, lungs full of ash—made his camp at the top of Dumfoyne. With relief, he set down his seismometers and miniaturized cospec and pyrometers, tiltmeters and cameras, and connected them up via a laptop pc to a satellite transponder.

Dumfoyne was a lumpy volcanic vent. The hilly country of the Midland Valley, stained green and purple with heather, rolled away around him. He could see the little town of Strathblane perhaps a couple of miles away, compact and green and nondescript, cupped by the hills.

In his brief time here Blue had come to appreciate the Scottish landscape, even away from the more spectacular scenery of the Highlands. This land, shaped by the ice sheets and punctuated by stubborn igneous outcrops, was built on a scale that was almost human, a scale that reminded him of Japan, and it seemed to him that the character of the people had been shaped in the same way. Modest. Robust.

But already the landscape was marred by the events of the last few weeks.

That little town was deserted, for instance: no vehicles moved there, no smoke curled into the air, no children played. And the blue sky was overlaid by thick black clouds, ash-laden. The clouds gave the place the tinge of autumn, of decline.

And that was surely appropriate, for winter was drawing close for Scotland now; little of this panorama would survive what was to come.

. . . The ground shook, subtly.

The catfish was stirring. Blue could smell sulfur, and it

seemed to him that the ground under his buttocks was a little warm.

Not long, then.

He unfolded a small package containing smoked salmon sandwiches—his favorite Scottish delicacy—and a bottle of Tennent's lager, the beer to which he'd taken an unreasonable liking.

ISS, Ishiguro. You're right at the epicenter, Blue, so far as we can tell.

Blue adjusted his Madonna headset. "Thank you, Sixt. If 'epicenter' is the appropriate word."

We don't really have the words, I guess, said Sixt Guth, in orbit on the International Space Station. *The Moonseed is taking us into new territory.*

"I am atop the vent called Dumfoyne," reported Blue. "I have a good view of the western Campsie Fells from here. I can see how the Clyde Plateau lavas, contemporaneous with this vent, form a steep scarp over Lower Carboniferous sediments, though this is partly obscured by a landslip—"

Fuck the context. You should be getting your sorry ass out of there.

"Watch me run, when it comes."

But the argument was ritual. Sixt knew Blue wasn't going to move from this spot.

Radar mounted on the Space Station had shown that the ground was uplifting, slowly but steadily, all across the Midland Valley of Scotland. False color images showed a bulls-eye shape, ragged circles of increasing altitude. And, as ancient cones belched fire, the deformation was increasing in scale and rate.

And Blue was right at the center of things, right at the eye of that NASA false color storm of new contours.

Like most geologists, Blue had often chafed at the absurd rapidity of human attention spans, even lifetimes, compared to the slow grandeur of the geological processes he studied. He'd been attracted to volcanism because at least it enabled him to see things *happen.*

And today, something strange—even unprecedented—was going to happen. On such a day, with such an event impending, this was the only place to be.

They made Henry put on a POS, a portable oxygen system, for all of twelve hours before he entered the all-oxygen atmosphere of the EVA suit. The POS was just a face mask, an oxygen bottle, a pressure regulator and a lith hydroxide cartridge to scrub out carbon dioxide. The idea was to flush the nitrogen out of his system, to save him from the bends. After the first couple of hours it was as uncomfortable as hell.

They were, it seemed, going to have to spacewalk to reach the lander.

"Spacewalk?" Henry remembered movie images of Apollo astronauts, guys casually swimming through pressurized tunnels to their spacious and comfortable two-stage LM, with its big descent engine for landing, and smaller ascent stage to bring them home, and a cabin big enough to support two men for three days . . . "This isn't Apollo, is it?"

Arkady grinned. "It has been rather necessary to—improvise certain elements."

"How reassuring."

"But this is how *we* planned to reach the Moon: a space walk from a Soyuz derivative to a lightweight lander." Arkady shrugged. "It is not impossible."

"But you never tested it out in practice."

"Since our launch rockets blew up on the pad, we never got the chance. To my eternal regret. Now. You must suit up."

Geena and Arkady began swimming briskly around the orbital compartment, pulling pieces of spacesuit from lockers. These suits were an American design and they looked bulkier and more rigid than the Russian design he'd worn to Earth orbit. There were inner coveralls of what looked like Spandex, and chunky outer suits that came in

two halves, top and bottom. The halved suits swam fitfully around the cabin, as if half-alive.

Arkady helped him prepare. "These are Space Shuttle EVA suits," he said sternly. "They are called EMUs, for extravehicular mobility units—"

"How did they know my size?"

"They don't," Geena said stiffly. "One size fits all."

Arkady said, "The suit is like an independent spaceship. It will keep you alive for seven hours. Long enough to reach the surface of the Moon, all the way to the old Apollo site, if all goes well."

Henry had to strip to his underwear, and he switched from his oxygen mask to a scuba-diver mouthpiece. Arkady helped him climb into his Spandex mesh cooling garment. It was a one-piece affair, with water pipes woven into the fabric, and air ducts fixed to the limbs. It was a struggle to squeeze his legs down through the tight neck.

When he was done, he had to hook a little rubber loop over each thumb, to stop the undergarment riding up his arms later.

When he moved, he squeaked. "I feel like the Man from Atlantis."

Arkady looked blank. Geena didn't react, her face white and set as she struggled with her own suit.

Next came the outer suit. First there was the Lower Torso Unit, so-called, a bulky set of trousers with built-in boots. Arkady held the trousers steady while Henry swam into them.

And now Arkady held up the Upper Torso Unit, the top half of the suit, complete with built-in backpack and chest computer, lacking only gloves and helmet. Henry had to hold his arms up—the thumb loops dragged at his hands—and slither upwards into the suit, threading his arms into the bulky sleeves. The suit was filled by a stiff polyurethane pressure bladder; it took a real strain before he managed to pull his arms down by his side and force his head through the steel ring at the neck.

Arkady swam behind him, connecting umbilicals from the backpack to his undergarment. Then he showed Henry how to lock the two suit halves together; steel rings joined with faint clicks, and he pulled a fabric flap down over the joint.

Arkady lifted a Snoopy-hat communications carrier onto his head, and showed him the instruments mounted on his chest. "This is your display and control module. You see it has a LED display which will warn you of any malfunction. Here is how to adjust the oxygen flow inside your suit . . ."

Here came his gloves. There was a range of pairs in the lockers; he tried three or four before finding a pair that fit comfortably. The gloves fitted to his sleeves with a neat little snap-and-lock ring system. There were little rubber fingerpads, evidently to allow him to feel something of the world to which he was about to descend.

Last came the helmet, a plastic bubble with a snap-on gold-plated visor. There was a sound of closure as Arkady lowered the bubble over his head and snapped it into its place at his neck. He found himself looking out through a wall of plastic that was, he noticed, scuffed and starred, evidently by long use in Earth orbit.

Arkady showed him how to set the oxygen control switch on his chest to PRESS, and the suit built up an overpressure, so they could check for leaks.

His ears popped.

"The suit will preserve you," Arkady said. Arkady's face, peering in at him, was subtly distorted, the sound of his voice muffled, his words subtly masked by the gentle whoosh of air around his face. "It is good, mature technology, much better than the old Apollo suits. But you must anticipate problems. Remember the EMU has been designed for spacewalks in Earth orbit, not for Moonwalks. You may find the limbs stiff. And the suit is rather heavier than the Apollo design . . ."

Locked in here, it was hard to focus on what Arkady

said. He flexed his joints and fingers; they seemed to move
well.

He found he liked the suit, with its little glowing LED
display and its snap-and-locks and flaps and zips. It had
something of the feel of the interior of a quality car.

But he wondered if he'd feel the same way after a cou-
ple of days inside it.

He watched Geena. Her motions seemed stiff, a little
hurried. But her face was already hidden by her gold visor,
and she had become an anonymous snowman in the bulk of
the suit, dwarfing Arkady, and Henry couldn't read her.

Arkady embraced Geena, and then came to Henry.
After a moment's hesitation, he wrapped his long Russian
arms around Henry's chest and squeezed. Henry could feel
the hug, strong human muscles compressing the pressur-
ized bubble he was sealed inside; the human contact was
oddly reassuring, even considering who it came from.

Then Arkady closed up the lockers, grabbed a few
pieces of loose equipment, and swam down into the descent
module and sealed the hatch behind him.

Geena turned to a control panel crudely welded to the
cabin wall, and twisted a switch. "Pressure to five psi." Her
voice was a flat crackle on the radio loop. He heard a
remote hiss, dying rapidly. She turned the switch again.
"Press to zero. Put your oxygen switch to EVA."

He obeyed. "So," he said into his microphone.
"Where's the airlock?"

She said, "We don't have one." And she turned to the
wall hatch through which, just days before, he had climbed
into the Soyuz down at Baikonur, and she twisted its han-
dle, and opened it, to space.

It was like opening the door of a log cabin on a bright
spring day.

The brightness was extraordinary; the sun was like a
thousand-watt spotlight glaring into his helmet. For the

first time he understood just how poky and dark the Soyuz had been.

Geena fixed a thin tether to a loop at her waist, and swam, without speaking, out of the airlock. Henry watched her feet disappear from his view.

He pushed his head out of the hatch. A spray of metallic, glittering dust swarmed out around him, along with a couple of screws, a sheet of paper, a pencil.

The curved green wall of the Soyuz was beneath him, a comforting anchor. Beyond that he could see the Moon, its cratered surface curving away from him in every direction, its details as sharp in the low sunlight as if it was a model just a few feet away, as if he could reach out and touch it.

Away from that, there was *nothing*. The sky was utterly black, save only for the tiny blue splash of Earth. He couldn't look directly at the sun; it was a mere source of light that failed to dispel the blackness beyond, a blackness, he realized, that went on *forever*. After the enclosure of the Soyuz, the change in scale was profound.

He felt his lunch rising in his throat, and he really, truly did not want that to go any further in a pressure suit helmet. So he closed his eyes and hugged the wall of the ship, and tried to tell himself he was safe and snug, inside the stinking interior of the Soyuz, crammed between the wall and Arkady's bony body . . .

Geena could feel the oxygen blowing across her face, hear the warm hums and whirs of her backpack. She looked down at the bottle-green skin of the Soyuz. She could see— a mundane detail—that here and there the paint was bubbled, from the heat of the attitude thrusters.

And when she looked along the cylindrical length of the Soyuz, she could see at one extreme the big, soft-looking contour of the strapped-on heatshield that was supposed to airbrake them back to Earth orbit, and at the other,

strapped to the hull, the angular, spidery form of the little lunar lander.

She began to make her way toward the lander, hand over gloved hand, following holds built into the hull of the Soyuz. A tether trailed behind her. She felt her legs dangle behind her, inert and useless in the pressurized suit; the exertion sent a familiar warmth spreading through her arms and hands as she pulled herself along.

It was just like the three EVAs she had made from Station in Earth orbit, she told herself. Or just like the sims she had done in the Vomit Comet, or the big weightless training facility, the pool at Ellington AFB . . .

Except it wasn't.

There was no Earth looming alongside the craft like a blue wall of ocean and cloud, huge and enclosing; nor was there the feel of water around her, the murky forms of swimmers to assist her.

When she raised her head from the metal surface before her, when she looked around, there was *nothing.* And if she let go, she felt, she was going to fall, all the way back down to that blue floor far below, like a trick diver aiming for a bathtub from a telegraph pole.

"Hey."

She looked down. The upper half of Henry's pressure suit, sharply lit, was protruding from the hatch; with his gloved hands he was paying out her tether.

Henry said, "You look as if you're going to leave fingerprints in that handrail."

When she looked to the hull before her, she could see how her hands had wrapped themselves around a rail.

With an effort of will, she released the tension in her hands. The stiff gloves made her fingers pop open, as if spring-loaded.

She turned to the blackness. It was just so damn *dark* out there.

There had been no real training for this mission. None of the endless hours in the sims she'd endured during her

Shuttle and Station training, so much simulation that the real thing had seemed somehow a disappointment by comparison.

But she'd always understood the real purpose of all those sims. It wasn't to train her. It was to beat the unfamiliarity out of her, to destroy her fear.

For this mission, there hadn't been the time for that. And here she was, exposed. More alone than she had ever been.

She raised her right hand and, just for an instant, raised her gold visor.

The sunlight was dazzling, glaring directly into her helmet and bouncing off the module's sheer hull, and she screwed up her eyes. But the stars were still there: the sky crowded, the constellations immediately familiar.

Somehow she felt reassured, anchored in the universe again.

She closed up her visor and waited for her eyes to clear. Then she turned to her work.

Henry and Geena were loosely tethered to the Soyuz, inspecting the lander.

The *Shoemaker* was, Henry supposed, about the size of a small car. It was just a platform, with four spindly, open-strut legs protruding beneath it. There was a single rocket nozzle sticking out from under it, surrounded by four fat tanks containing propellant and oxidizer. And at the corners there were four little clusters of smaller rocket nozzles, attitude thruster assemblies, with flaring shields behind them. The whole thing was maybe six feet tall, from pads to the table surface, and on top of the table there were a couple of open metal rectangles, the size and shape of door frames.

And that was all: no more than the prototype unmanned craft he'd inspected at JPL, before his program was canned, minus the elaborate sample-return stage on top.

Henry's training, which had focused on the hazards of launch and reentry, hadn't covered this. He looked around. "Where's the rest of it?"

Geena's voice was tight. "You're not helping, Henry."

"No, I mean it. I see the landing stage, but where's the cabin? Where are the seats? Where's the ascent stage?"

"Come here."

With one hand anchored to a strut, she grabbed his shoulder and spun him around. She guided him backward, into the right-hand door frame. The metal rectangle neatly encompassed his backpack; Geena snapped latches, and the pack was secured, and so was Henry. He was stuck there, like a turtle glued by its shell, his arms and legs dangling.

"Put your feet down here." She guided his feet to a little sloping shelf on the top of the platform.

He placed his feet where she showed him. There was a handrail in front of him, and he grabbed onto that, and he felt a little more secure. Not much, though. And in fact, the little foot platform made him feel as if he was tipping *forward*, about to fall off the damn thing.

Geena swam into place beside him, in the left-hand frame, and locked herself in. There they stood, side by side. There was a small control console in front of her, with a couple of simple hand controllers.

She turned a switch, and there was a gentle shove beneath his feet. Latches had opened, releasing the platform, and some kind of spring-loading pushed it away from Soyuz.

Henry was suspended in space: just him, Geena, and a dining-room table with a rocket mounted beneath it.

"Oh, my God."

"Don't bend the handrail," Geena said.

"You have got to be kidding. This *is* all there is. Isn't it?"

"It's called the open-cockpit design concept."

"Jesus Christ, Geena." The whole craft, Henry thought, would probably have fit inside the ascent stage of the old

Apollo LM, which was, in Henry's memory, starting to look luxurious. "What idiot designed this thing?"

"The idiot who was trying to show how he could bring your samples back from the Moon for under a billion bucks."

"By leaving out the *spaceship*?"

"Look, the bright guys at JSC studied the open lander concept. In fact the *Shoemaker* design was based on the concepts they dreamed up then. It's feasible. It's all about saving weight. There's hardly anything of this craft but the rocket and its fuel . . ."

Henry looked down, at the pocked face of the Moon sliding beneath his feet. He was naked, he thought, about to fall to another world, utterly defenseless.

Geena tested her reaction control thrusters. She closed her hand over her little controller, and the engines banged, rattling the platform and swiveling it this way and that. Henry could see little streams of exhaust crystals, gushing out in perfect straight lines, glittering briefly in the sunlight.

The old LM ascent stage cabin had just been a bubble of aluminum, he reminded himself. But right now, even a canvas tent around him would have been better than *nothing*.

With no warning, Geena worked the thrusters again to tip the *Shoemaker* up. Now its engine bell faced the way they were traveling, and suddenly Henry was flying over the mountains of the Moon, face down, feet first.

"God damn it, my sphincter just clenched. I never felt that before."

"Take it easy," Geena said tightly.

They sailed into the shadow of the Moon.

Sunset was sudden, like a light turning off. His bubble helmet cooled, and started to get a little damper; as the temperature dropped, the environmental control system was having trouble removing all the moisture from the air.

* * *

Shoemaker, *Houston, you are go for DOI, over.*

"Roger, go for DOI. Do you have AOS and LOS times?"

Roger, LOS at 103:16 and AOS at 103:59, over . . .

DOI, AOS, LOS. More acronyms, Henry thought. Well, DOI must be descent orbit initiation. And LOS and AOS referred to loss and acquisition of signal; for, like so many of this mission's most crucial moments, the descent burn would take place on the far side of the Moon, out of sight of Earth, and far from assistance.

The descent orbit burn would put them into a lop-sided ellipse of an orbit with a high point of sixty-nine miles, kissing Arkady's circular orbit, and after skimming for three hundred miles around the Moon's lighted face, they would reach a low point of nine miles: just fifty thousand feet high, close enough to touch the mountains of the Moon. And there they would burn their engine again, and fall all the way to the surface.

That was the plan.

There was no air on the Moon. Air would have made it easy, he thought. With air you wouldn't need all this fuel. You could glide down, like the Space Shuttle returning to Earth, or even batter your way in with a heatshield and fall into the ocean under parachutes, the way the Apollo astronauts used to.

On the Moon, there was nothing to help you down. All you could do was bring along a rocket motor, and all the fuel you needed, and stand on it as it descended, all the way to the surface of the Moon. Like riding an ICBM back down into its silo, Henry thought bleakly, and about as stable. And expensive as all hell, considering the fuel load it took to bring an ounce of payload here . . .

Shoemaker, *on my mark you'll have twelve minutes to DOI ignition.*

"Roger, Frank."

Shoemaker, *Houston, stand by for my mark. Mark. Twelve minutes.*

"We copy."

Shoemaker, *Soyuz, this is Houston, three minutes to LOS. You guys look good going over the hill.*

Geena said, "*Shoemaker,* roger."

Arkady chimed in, "Roger from Soyuz."

Geena called, "Arkady, have a good time while we're gone."

"Yes," said Arkady. "I won't get lonesome."

"And don't accept any trans-Earth injection updates."

"Don't you worry," said Arkady.

And so on.

It was, Henry knew, the kind of bull pilots always exchanged when hanging out their hides. But, he had to admit, right now he could see it had its purpose. After all, here he was strapped to this tabletop, on a craft that couldn't take him back to Earth. If anything went wrong before the landing, Arkady was going to have to come down and get them, if he could. And after the landing, if the *Shoemaker* engine failed to restart, there was *no* way home.

At such a moment, what were they supposed to talk about?

The Moon was starting to reappear as his eyes opened wide: a tableau of craters, ridges and plains, worked in blue and soft gray. He could see *shadows,* cast by Earth itself.

As he sailed on, the shadows stretched out, and the Moon became a maze, a geometric essay in darkness and blue light. He thought he saw shapes in that unrecognizable surface: cities, artifacts, even gigantic human faces peering up at him, skulls with eye sockets made of dead lunar craters. It was an encounter with the Moon, he thought, but also with himself, with the deep reptilian core of his brain, which truly, really, could not understand where he had brought it.

There was a burst of static in his headset. Loss of signal. *Shoemaker* and Soyuz were sailing alone over the far side of the Moon.

* * *

It was *dark:* darker than Earth ever was, even over its night side, where you could see the sparkling cities at the rims of continents, and fires in the forest, and the lights of ships on the oceans—even, sometimes, the phosphorescent wakes of the ships, the evidence of tiny living creatures giving up their light to space. Out here, by comparison, there was nothing; and it hit him with a gut realization that there really was *nobody* out here, nobody to look up and see him crossing the night sky, nobody to help him should he fail.

After a half-hour of utter darkness, he could see fingers of light, gushing across space, obscuring the stars. It was the corona, streamers of gas from the outer atmosphere of the sun, which was itself still hidden by the Moon's rocky curve.

Slowly the luminous coronal streamers thickened and brightened. They were three-dimensional, he saw, shafts and curtains of light, spread across space. And then he made out waves of light: thin bands of light, snaking around the rim of an invisible circle, suspended between the stars, and the pit of darkness that was the Moon. He was seeing the peaks of the mountains of the Moon, shining in the light of the rising sun.

The band thickened until the sunlight returned without warning, in a fingersnap, turning night to day. Long, spectacular shadows fled across the surface toward him.

Now he was flying over the far side of the Moon. And it didn't look like the near side.

There were no maria here: at first glance, anyhow. There were basins, just like on the near side, but you had to pick them out from their mountainous ring walls, for they hadn't filled up with basalt lakes. Nobody knew why.

It was like one giant stretch of highland, craters piled on craters, their overlapping rims like wave crests frozen on a rocky sea. There wasn't even a sense of scale. It was an unsettling experience. He couldn't tell where he was, or how high he was, or even what size he was anymore. It was as if his sense of space and time was softening, drawn out of

him by the ambiguous Moon far side, this land human eyes hadn't evolved to see.

But here came giant Tsiolkovsky, the most distinctive crater on the whole damn far side of the Moon. Once, NASA had talked of putting an Apollo down, here in Tsiolkovsky, in the middle of the far side, with some kind of superannuated military relay satellite in orbit above it to keep the hapless astronauts in touch with home. Looking down now, he could see how dangerous that would have been, how treacherous Tsiolkovsky was.

"Forty seconds," Geena said.

"Rog."

"Press the switch over there. To your right."

It was mounted on his back frame; he had to reach to get it. "What's that?"

"The movie camera for the landing. IMAX. Twenty seconds. Engine armed. Pressed to proceed." She grabbed the handrail. "Two, one."

Ignition.

Henry could feel the thrust of the engine, silent and invisible as it was; it was like some mysterious gravity field, pulling him down to the surface of the *Shoemaker.*

The engine, he noted absently, had started up by itself.

"Hey," he said. "Who's flying this thing?"

"Autoland," Geena said tightly.

The engine roared to full thrust, and the *Shoemaker* platform shook with a soundless, high-frequency vibration. His feet came to rest hard against the *Shoemaker*'s deck, and after five days in microgravity he welcomed the feel of acceleration.

"We're burning, Arkady," Geena said.

"I can see the glow in the engine bell. Godspeed, my friends."

"Yeah. You too . . ."

* * *

. . . The ground lurched under Blue Ishiguro.

He'd been up here for hours. He had, he realized, been dozing.

He heard the growl of cracking rock, and he was thrown onto his back. Suddenly there was smoke everywhere, and the air was burning hot. He could see the clouds venting from new fissures, the white of superheated steam, the blue of sulfuric acid and fluorine. The stink was foul, like, he thought darkly, a high-school chemistry lab.

He straightened himself up, and surveyed the new situation.

Fissures had appeared on the flanks of the Campsie Fells. Lava fountains there, curtains of red flame following the lines of the fissures, rock droplets hurled meters into the air. As he watched, the fissures were spreading and merging.

A main vent, a broad crater, opened up in the hillside, facing Strathblane. More lava fountains, and now a major surge of sticky, viscous lava poured out. The heather on the hillside singed and burned in brief flashes. The cooling lava was already building up levees, and the molten material gushed down channels between the levees, heading toward the abandoned town.

Another, broader vent opened, and vomited lava.

Blue could smell sulfur and methane. Near the edge of the flow, loud cracks marked the explosion of methane gas. The fume clouds above the vents glowed orange against the blackening sky.

Blue?

"Sixt, I think it is starting. It was very sudden."

He checked his cameras and instruments were stable, and that his data was indeed reaching orbit.

Then he pulled up his protective hood, and patiently described all he saw, as the Scottish ground—under intolerable strain—broke apart.

* * *

As it receded after its separation, Arkady had kept the spindly lander in sight through the eyepiece of the twenty-eight-power sextant. With its bright colors, white and gold and black, hanging in the shadow of the Moon, it looked something like a tropical fish, angular and unlikely.

But there were Geena and Henry in their snow white suits, perched on top of the *Shoemaker* platform. He could see them move as they worked their controls, or turn to each other and gesture: human beings, interacting as humans always had, here in lunar orbit.

When Geena fired the descent engine to drop out of circular orbit, Arkady was looking into the *Shoemaker*'s engine bell. The craft seemed to become a glowing ball, like a jet plane on afterburner, and it moved away from him as steadily as if mounted on rails.

The engine glow lasted a half-minute, then died, and he could no longer see them. Soyuz sailed on, through light, through darkness.

The engine throttled down, and cut. Suddenly Henry was falling again, and once more he felt his lunch rise up his throat. He swallowed hard.

Geena said, "Right on the nose." She looked across, and he could see her face framed by her helmet. "We're still breathing, Henry."

"Maybe you are . . . Oh, *shit*."

For now they were falling, tracking their ellipse, all the way down to the orbit's low point at fifty thousand feet. And he could *sense* their diminishing altitude. The tightly curving edge of the Moon seemed to flatten, quickly. The features beneath him fled behind him, like shadows on an ocean.

He felt as if he had fallen over the lip of some giant, invisible roller coaster.

"And I always hated roller coasters," he muttered.

Geena looked across at him. "I know," she said. "Hold onto your ass, kid."

"I'm holding."

Earth rose ahead of them, unnaturally quickly, its blue making a contrast with the tan and gray lunar plains that was almost painful to Henry's eyes.

. . . Shoemaker, Houston. We're standing by.

"Houston, Shoemaker, reading you loud and clear, do you read me?"

Copy, Geena, good to have you back. That's AOS, reading you five by. Coming up on twelve minutes to next ignition. We're waiting for your burn report.

"The burn was on time. Residuals are minus point one, minus point four, minus point one. Frank, everything went swimmingly, just beautiful."

The horizon closed in. Mountains hove over the edge of the world, chains of them, that curved inward until Henry could see they formed a crater rim, and then, as soon as the far side was visible, the rim fled beneath him. Sometimes they flew over fields of boulders, immense, round-shouldered, their shadows long and flat.

"Look at that," Geena said. "Some of those babies must be five stories high."

No, Henry thought. Probably ten times that . . .

It was strange to remember how he'd griped about the restricted viewing from the Soyuz. Now he could see too *much,* a three-hundred-and-sixty-degree span of Moonscape and sunlight and bare, clutching rock.

Under the control of the computer the thrusters fired. There was no noise, but Henry could see little showers of exhaust crystals venting into space, feel the punch of the burns through his feet and hands. The *Shoemaker* rocked from side to side, fore and aft, sharply; it was a stomach-jolting feeling, like turbulence in an airliner . . . but there was no turbulence here.

They reached the center of the Moon's daylight face, and passed beneath the sun. Giant pumice gray lava plains fled beneath him. Briefly, at the subsolar point, the shadows disappeared, and the surface detail washed out.

Coming up on five minutes to ignition.

"Five minutes, copy."

You're heading right for the guidance box at perilune.

"Copy that."

Shoemaker, Houston, you're go for powered descent. Your signal is breaking up. Recommend you yaw right ten degrees and reacquire.

Geena pulsed her thrusters once more, and the *Shoemaker* swiveled, pointing its main antenna more squarely at the blue sliver of Earth.

Three minutes to PDI. Two minutes forty seconds . . .

"Forty-seven thousand feet. The laser altimeter has locked in. It agrees closely with the trajectory."

Good to hear it, Geena. You're looking good at three minutes. You are still go to continue to powered descent.

"Copy that . . ."

Now they flew deeper yet, over a mare, a lava plain. It looked smooth as wet clay, pocked here and there by small round craters, fleeing beneath them. This was the Mare Imbrium, he thought with a thrill of understanding: he was flying over one of the Solar System's greatest impact basins, the right eye of the Man in the Moon.

Forty thousand feet high: back on Earth, even Concorde flew higher than this. No big deal.

But this was no airplane ride.

Tracking around the airless Moon, they were still following an orbit, and by dipping down from the peak of their ellipse they had actually picked up speed. They were moving at all of three thousand seven hundred miles per hour, more than a mile a second, five times the speed of sound. No pilot in history had flown so fast, so close: at orbital speed, hugging the ground.

Henry felt as if he was bare-ass naked, strapped to his table. He shut his eyes, clung onto his restraints, and tried to forget where he was.

"We're drifting off."

He snapped open his eyes. "What?"

"Something spooky. It's as if the *Shoemaker* is trying to line itself up toward the radius vector." Geena turned to him, her face mirrored. "It wants to point straight down."

"I can't feel anything."

"It's too subtle to see. The instruments know, though."

"The mascons," he said. "Mass concentrations. The Moon is a lumpy old world. It's plucking at us. Playing with us."

She grunted. "I wish it would leave us the hell alone. I sure wasn't expecting turbulence out here."

"Turbulent gravity . . . Oh my," he said, looking ahead. "Oh, my."

Aristarchus himself was shouldering over the horizon.

The crater's walls were a great rampart, visibly circular, which rose out of the Imbrium plain like the walls of some impossible city. And already Henry could see Jays Malone's rille: Schröter's Valley, a dry valley gouged into the sandy surface of the Moon by a brief, late spasm of lunar volcanism.

The crater stunned him with its magnitude. The energies that had gouged out this monster—shattering the rock and melting the very floor—had been truly stupendous, far beyond human capability, as far ahead in the future as he cared to look. And yet, he knew, even this great impact had been a pinprick compared to the gigantic, primeval events which had gouged out the great basins, the final formative bombardment that had shaped the geology of the Moon.

It was as much as humans could do, he thought, to send them this far, two tiny people, encased in air and water, descending cautiously on their candleflame. How could they hope to shape events here, on this cosmic battleground?

The whole exercise, his grandiose, half-formed schemes, seemed futile before they even started.

But now the Powered Descent burn began, this toy lander's rocket engine jarring to life once more.

Henry was tipped toward the vertical. He could *feel*

how his center of mass was swung through space. Now, the *Shoemaker* would stand on a tail of rocket flame, all the way to the surface of the Moon.

Twenty-one thousand feet. Velocity down to twelve hundred fps, Geena. Still looking very good.

"Copy."

Seven minutes into the burn.

"We're only about ten miles from the landing site," Geena said now. She looked down past her toes. "We ought to see the landing site soon."

Shoemaker, you're looking great. Coming up on nine minutes.

And then, at seven thousand feet, the *Shoemaker*'s engine throttled down.

"High gate," Geena said.

"Wow!"

Henry could feel the sharp reduction in thrust, as if the brakes had suddenly come off. It was momentarily exhilarating. He was, after all, riding a rocket ship to the Moon; there *ought* to be moments like this . . .

The long brake was over now, and the *Shoemaker* pitched up for the final descent; now it would come down on its rocket tail.

Henry settled gently against the platform. The lander was still supporting him, but the Moon's gentle gravity was tugging at him now: he could feel the Moon, for the first time.

And there was the Moon itself: a ghostly, black-and-white panorama, not much more than a mile under his feet, flying past at unreasonable speeds. But he was so close, now, that the glow of the engine bell was reflecting back up at him from the flanks of the taller peaks. Human fire, reflecting from the Moon.

"Oh, shit," said Geena.

"Yeah. That maneuver—"

"No, not that. *Look* at this place. Where the hell's the Apollo?"

The Moon was a thousand craters, a thousand pools of shadows. Henry felt an instant of panic. How could they map-read, how could they find their orientation in a landscape like this?

. . . But suddenly he picked out the rille again, a scar in the Moon, sinuous and twisting, a trowel trench dug into wet clay. And there—a needle-point, glittering brightly, its morning shadow stretching behind it—was the old Apollo lander.

He pointed. "We got it."

"I see it," said Geena. "Holy cow. Right ahead of us. The computer is taking us straight in."

"I guess those geeks at NASA knew what they were doing after all."

"I guess."

It was essential to use the Apollo site as a beacon, because that was the site from which Jays Malone had traveled to pick up the fateful rock, 86047; and because that was where Houston had sent their supplies, on the second *Shoemaker* lander, unmanned. If they couldn't find the second *Shoemaker* they wouldn't even have the fuel to return to orbit.

The *Shoemaker* turned, its thrusters banging, tipped up through about fifty degrees now. Henry's viewpoint changed, and he realized the *Shoemaker* was flying *beside* a mountain. They were already so low that its rounded flanks shouldered all of five or six thousand feet above him, pale brown curves bright against the black sky.

For a moment he lost the sense of powered flight, and it seemed to him he was drifting, weightless, among these huge shapes.

Looking good, Shoemaker.

"Five thousand feet high, a hundred feet per second," Geena said. "Right on the nose."

Shoemaker, you are still go for the landing. Four thousand feet. Three thousand. Descending at seventy feet per second.

A lot of Apollo astronauts had burned up their fuel by coming in along a stair-step pattern. Maybe they hadn't trusted their landing radar data; maybe they hadn't trusted the evidence of their own eyes. But the autoland, blindly confident in the thirty-year-old maps in its computer memory, was just going to bring them on down. And so it did, in a smooth steep nerveless glide that brought the ridges and craters and hummocks exploding into unwelcome relief.

The Apollo site was still a long way ahead.

"Something's wrong," he said.

"No." Geena was staring at the little bank of instruments before her, concentrating on the *Shoemaker*. She was looking internally, he realized, thinking about the machine they were riding, not externally, at the *Moon*.

And the Moon was not behaving as it was supposed to.

"Look up, Geena. We're coming down short. Maybe you should take over and bring us in."

"No. I told you. We're autoland all the way to the ground."

"Neil Armstrong did an override."

"Neil Armstrong hadn't been here before. We have. We have maps, Henry. We have photographs. Now shut up and let this thing land itself."

A thousand feet above the Moon, and he was flying toward a bright field of craters, their shadows stretching away from him across the Moon. The *Shoemaker* was coming in at a low angle, unreasonably quickly, like an artillery shell lobbed across some ancient battlefield; and Henry was riding the shell, feet first.

Let Geena do her job, he told himself. Trust her.

But they were still coming down *hard,* and now there wasn't even a sign of Apollo.

It seemed to Blue, now, that he was actually rising into the air, as if Dumfoyne was a raft which he was riding in a swelling lava sea.

Perhaps he should have brought an altimeter.

Lava from the main vent overwhelmed Strathblane, it seemed in moments. The neat buildings, the rich green fir trees, exploded and burned, as the lava, enclosed in a stretching sack of cooling rock, surged through the streets.

There were faults everywhere now, fissures and lava fountains. Already most of the vegetation had burned off. As if the whole area was turning into one giant caldera.

For now he was safe, here at the summit of Dumfoyne. The hill, and its nearby twin Dumgoyne, were little islands of stability, in a sea of fissures and vents and lava fountains.

Dumfoyne was a raft he was riding to the sky.

His voice transmission was still getting through, although his sky was covered, now, by an ugly, roiling cloud of steam and ash, through which lightning sparked continually. But the reception was too poor for his instruments' telemetry to penetrate, and, regretfully, he folded up his instruments and collapsed his laptop.

. . . *incredible, Blue. We can't believe these radar readings. There must be a magma volume production rate of millions of cubic meters a second . . .*

That compared to hundreds of cubic meters, Blue knew, in an eruption of the size of Mount St. Helens.

. . . *as if we're seeing a million years of geology compressed. Mauna Loa, built in a day.* Mauna Loa in Hawaii was Earth's largest volcano, stretching seven miles above the ocean floor.

"But this may be bigger than Mauna Loa," Blue said, unsure if Sixt could hear him. "Bigger than anything on Earth."

There had been no volcanism on Earth on this scale for a hundred millennia. Twice as long as humans had existed.

Perhaps this was Olympus Mons come to Earth, he thought. The giant Martian shield volcano, so huge its caldera poked out of the thin atmosphere. Mars, come to Earth.

The ground lurched, swelling further.

* * *

"Geena, we're coming in short."

"The autoland is—"

"Going to bring us down in the wrong damn place! Can't you see that?"

Now, he could see, she actually closed her eyes. "You don't know that."

He thought furiously, trying to figure out how this could have gone wrong . . . "Mascons," he said.

"We know where the mascons are. We mapped them with *Prospector*. We allowed for them."

"We know where they *were*. Geena, if we're right about the Moonseed—"

"Oh. Maybe the mascons shifted."

"Right. Geena, if we land right but in the wrong place, we've failed. You know that."

"Henry, I can't handle this—"

That wasn't Geena.

Abruptly he realized she was descending, deep into some unexpected funk. He felt irritation rise; he felt like screaming at her, rerunning the breakup of their marriage.

But right now, she was the only pilot he had.

It's the lack of training, he thought. They didn't have time to desensitize her. She's not used to being in a situation she can't anticipate, control to the last degree.

But that's where we are now.

He tried to concentrate on the altimeter, to read off their diminishing altitude. There could be minutes left, no more.

"Tell me about piloting," he said. "If you don't like where you're landing—"

"You have four alternatives. You can go left, right, short, or go over. Going left or right is a hairy thing."

"Good. And landing short—"

"You got to come down dead. You can't see what you're going into."

"Like a copter. So—"

"You land long."

She opened her eyes and looked at him, and he could see a kind of desperation in her face.

"That's it, Geena. Land long. Go ahead."

She looked forward, as if seeing the fleeing surface of the Moon for the first time. She grasped a switch with her clumsy gloved hands, and flipped it to ALTITUDE HOLD.

The *Shoemaker* pitched forward, sharp enough to jolt him. Now it was almost level, and it skimmed forward, over unfamiliar, empty terrain.

"All *right*," Henry whispered. "Five hundred and thirty feet," he said. "Looking good."

"Kind of sluggish," she muttered.

"You're doing fine . . ."

But the Moon rushed up at him—it was like riding a glass-walled lift—and new terrain swept over the horizon. A young, fresh crater slid under the *Shoemaker*'s angular prow. Henry made out details inside the crater: a square, blocky shape, a few scattered pieces around it, all of it casting long angular shadows at the center of a rough disc of discolored land.

The attitude thrusters pulsed, making the *Shoemaker*'s frame shake. When Henry looked down he could see his restraints rattling silently.

The silence of the flight was eerie. Unnatural. No engine noise, no wind whistle. Not even a plume of smoke erupting from their engine. Just this platform, the two of them, and the sun and the Earth and the Moonscape wheeling past them, under a black sky.

The craft responded sluggishly, but the 8-ball in front of Henry tipped sharply, and the cratered landscape tilted, before righting itself again. He tried to help Geena, to follow the readings on the little computer screen. "Three hundred fifty feet, down four feet per second. Horizontal velocity pegged . . . Three hundred thirty, down six and a

half . . ." He was Buzz Aldrin, he realized suddenly, relaying information to her reluctant Armstrong; it was all just as it had been before.

And suddenly the blocky lunar-floor shapes before him resolved, and there was the old Apollo site, right in front of him. He could see the boxy shape of the abandoned LM descent stage, little glittering packages around it.

The Moon's surface was discolored, in a rough circle centered on the LM stage. At first he wondered if that was some kind of raying from the LM's ascent and descent engines. Then he understood.

The marking was footprints from American boots: after thirty years as fresh in the lunar regolith as if they'd been made yesterday.

And he could see a shadow, fleeing across the textured ground: it was a platform bristling with antennae, set on four spindly legs, elongated by the low sunlight—and there were two skinny forms, side by side, his own shadow and Geena's, sailing across the surface of the Moon itself. The *Shoemaker* shadow was surrounded by a kind of halo, sunlight reflected brightly straight back the way it had come.

Henry smiled. "I do believe we have found what we came for."

And now there was a surge, upward, that threw Blue onto his back; ash particles spattered his face. He could actually feel the acceleration this time, as if he was being carried aloft in a high-speed elevator.

But it wasn't like a quake; the motion didn't have that sharp, characteristic suddenness. Basic Newtonian physics: nothing moved a mass of rock like this *suddenly*.

Storm clouds gathered above him, turbulent, agitated. The air was being displaced, rammed upward toward the tropopause.

The end game must be close.

The ground stabilized again, if briefly, and he got to his knees. He was starkly alone here, now, on this chunk of rock; his instruments had gone.

The Earth below was deformed, bulging upward.

He was riding a plug of rock, somehow held stable here, riding the flank of a new mountain that was pushing out of the ground, its sides still glowing hot from their new birth, lava rivers coursing, overwhelming levees even as they formed. Layers of steam and dust and smoke prevented Blue from seeing the original ground level, if that term had any meaning any longer.

He wasn't even close to the summit of this sudden bulge, he saw; the glowing flank continued upward above him to a peak, a new caldera, lost in more layers of steam and mist.

The noise reached a crescendo, then seemed to die away; he kept talking, but he could no longer hear his own voice, still less Sixt's.

His hearing was gone, then. He doubted it mattered.

It looked as if all of Henry's predictions were being fulfilled.

The plug of rock he was riding was tilting. Soon, it would tip him off. Even if not, the streams of lava gushing down the wounded flank of the higher hillside would surely overwhelm him soon; it was only the absurd expansion of the mountain which had saved him from that fate so far.

He wondered which peril would administer the final butt-whopping—

Slam.

It felt like a punch from a giant, deep in the base of his spine, and he was flying in the air, literally flying, among fragments of the rock which had, moments before, comprised the modest summit of Dumfoyne.

He couldn't feel or move his arms or legs. Perhaps his back was broken, or his neck. He couldn't even tell if he was still breathing.

The human body was, in the end, remarkably fragile.

He seemed to be riding a new fire fountain; without the rock to shield him he was surely burning up, yet he felt nothing.

Perhaps a god was smiling on him, even now, undeservedly sparing him the punishment dished out to others.

And, remarkably, he was *still* rising, high into the ash clouds, picked up like a rag by some thermal current. Lightning flared above, and the clouds parted.

And, for a brief moment, he saw the stars, so high had he risen.

Just a few seconds more, he thought. Let me see the new mountain from above, the greatest geological formation in a hundred thousand years. Olympus come to Earth.

But now even the gods, at last, failed him.

". . . Two hundred feet," Henry read. "Coming down at three. We're going to make it. One hundred. Leveling off. *Woah.* Look at that."

Suddenly they were kicking up dust, great bright streaks of it, rushing to the horizon over the ground. His view of the surface grew blurred, and he felt a tingle of new alarm. What if Geena couldn't see the surface? How would she know where to set down the *Shoemaker?*

"Ninety-six feet, coming down at six. Slowing the descent rate," Geena said.

He looked around, seeking the Apollo lander. A sheet of dust swept over the boxy LM. He hoped their kicked-up debris wouldn't mess up the landing site.

Now all Henry could see was a streaked layer of dust, with a few of the taller rocks sticking up here and there, like low mist.

"Fifty feet," Geena said. "Shit, we're going backward . . . Henry, how much fuel do we have left?"

The fuel indicator was a little ticking clock. "Sixty seconds flying time."

"More than Armstrong," she muttered. "Thirty feet.

Coming down at two. No lateral movement now." Her voice was thin, but she seemed in control.

A blue glow lit up on the instrument panel, startling Henry. "What's that?"

"Contact light!"

Geena slapped the ENGINE STOP OVERRIDE button on the panel. The slight vibration of the engine died immediately.

The *Shoemaker* fell the last few feet, into dust that was already settling.

The four legs hit the ground with a firm thump, that transmitted up his legs to his spine, the Moon itself punching up at his animal bones for his audacity in being here.

Geena went into a flurry of post-landing checks. "Descent engine command override is off. Engine arm off. Control stick out of detent . . ."

And the dust settled, falling out of the airless spaces around him like so many tiny projectiles, and the stillness of a billion years returned to the Imbrium plain.

Craters and rocks, just a few feet below him now; and under a thin layer of kicked-up dust, he could see footprints, a generation old. He was on the Moon.

"Houston," Geena said, "this is Aristarchus Base. We have come home."

IV

MOON

The sky was dominated by the sun, a white spotlight too bright to look at. The Earth was there in the blackness, bigger than a full Moon but smaller than Geena had expected, just a thumbnail of blue light in the sky. The brightness of the sun made it impossible to make out the stars, and, away from sun and Earth, the sky was just a jet black, empty.

Standing here on the lander platform, she could see all the way to the horizon, clearer than the finest day on Earth. The sculpted hills of the Aristarchus ejecta blanket rose above this puddle of pitted, frozen basalt, their slopes bathed in sunlight, shining like fresh snow.

But there were no visual cues—no trees or cars or buildings or people, not even haze, to help her judge the distance. And beyond the brightly lit hills at that horizon there was only blackness, like the space at the edge of a map.

She could see the horizon was close, for it *curved,* gently but noticeably, the way the Earth looked to curve from fifty thousand feet or so. And in fact she could even see how the land before her curved away, dropping like the brow of a hill, out to the horizon. On this lander platform, she could tell she was standing on a ball of rock and dust, suspended in space; the roundness of this world was no intellectual exercise.

She felt lost.

It just didn't look the same place as from orbit. Most of the shadows she'd used to guide the landing, particularly those pooled at the bottom of the craters, were invisible now. Not only that, she couldn't see even the larger craters

beyond a hundred feet or so, so flattened was the landscape by her perspective.

Maybe there was just a hint of color. Golds and tans. But it was washed out, as if poking out from under a layer of dust. Shades of concrete, she thought. It was a little like looking out over her driveway, back in Clear Lake, under the glare of the security night lights.

She didn't share these nongeological thoughts with Henry.

She looked at the sunlight bathing her gloved hand. The fabric of her sleeve glowed with an intense brightness, as if it had just been manufactured. She thought she could feel, in fact, a ghostly trace of the sun's warmth, seeping through the layers of cloth surrounding her.

But she shivered, under the black sky. She could feel her heartbeat rise, and hoped it didn't show up on the monitors on the ground.

For it was *wrong*. How could so much light be falling on her, and not dispel the darkness above? Some ancient part of her brain, adapted for billions of years to life in the pondlike atmosphere of Earth, seemed to be rebelling against these new conditions.

Going to take some getting used to, she thought. That's all.

She looked past her feet, the way she now had to climb down, in her role as mission commander, to step on the Moon. The *Shoemaker*'s footpads had settled barely an inch into the ground, and the little ladder, just two or three steps, was resting neatly against the dust.

Geena released her restraints. They rolled themselves up silently into their holders.

She took a step forward, to the edge of the platform. She was at the center of a radial array of streaks and stripes, the disturbance they'd made in the ancient dust of the Moon as they descended.

She felt giddy, vertiginous. Ridiculous. She'd ridden down from orbit on this contraption, and now here she was

three feet above the dust, and she felt dizzy. But even so, she had to hold onto the control post before she got over it.

She turned to Henry. He was still in his restraints, standing calmly, watching her. His oversuit glowed brilliant white in the unfiltered sunlight. He held out a gloved hand to her.

She took it. Their gloves were so thick she could only feel the bulk of his suit, not his flesh and bone within.

Holding on to Henry, she turned, got hold of the handrail, and bent forward. She put her foot on the top rung of the ladder, then the second.

Her suit was stiff. In this Shuttle EMU it was hard to bend, to lower her feet from rung to rung. She found it was easier to push off and just drop down to the next rung, and the next.

She let go of Henry's hand.

She pushed away one last time, and her hands slid along the rail . . . and her feet thumped into Moon dust.

A little spray of dust—ancient pulverized rock, charcoal-black—lifted up around her feet, and settled back. Where it touched her clothing, it stuck.

She said: "We're back. My God, we did it. We've come back to the Moon."

She heard the sounds from Houston, whooping in her headset, some kind of broken-voiced response from Frank Turtle. But the words were remote and didn't register.

She moved her foot around over the surface. The dust was soft, queasy, but she wasn't sinking in too far. She took a few steps. A little cloud of dust tracked around her feet, falling back with neat, liquid grace. The dust seemed to have an affinity for her suit, for it clung to her blue overshoes and the fabric of her leggings, as if she was a magnet attracting iron filings.

She looked around.

She was standing on a textured plain—like a piece of the high desert around Edwards, she thought—and the ground glowed in the sunlight. But the sky remained

utterly, unnervingly black. Nothing moved here. There was utter silence. She fought an impulse to turn around, to look to see who was creeping up behind her, in this horror-movie stillness.

She took a few more steps, experimentally.

She couldn't walk, exactly; her legs wouldn't bend far enough to let her. This Shuttle suit, meant for zero-G EVAs, was even worse than the old Apollo suits for stiffness. She could move in a kind of jog, rocking from side to side, but the low gravity let her travel farther than she wanted to go.

And her balance was off. Her backpack pulled at her, and to compensate she leaned forward as she walked; she felt as if she might fall at any moment. She was somewhere between buoyant and heavy. Weight and mass had been redefined for her. It was more comfortable than either a full gravity or zero G: it had much of the buoyancy of micro-gravity but without that disconcerting lack of up and down. One-sixth G was weak, but enough to anchor her to the world.

But, when she was still, it was hard for her to tell when she was standing upright. The land was full of gentle rises, and there were no verticals here, no telegraph poles or trees or buildings. Something to do with the gentle tug of the Moon's gravity on her inner ear, maybe.

The backpack's pumps and fans whirred, and she could feel the soft rush of oxygen over her face. The pack was a reassuring mass on her back, replete with energy, supplies for heat and cooling, water, air; she was a little bubble of Earth life, she thought, bouncing around on the surface of the Moon.

Maybe fifty yards from the *Shoemaker,* she turned to face the sun. The light glared through her gold-tinted face-plate. There stood the *Shoemaker,* Henry on it watching her, a little gold-colored platform with a white snowman perched on the top. The lander looked strangely light, as if it might blow away. Its gaudy gold and black and silver looked ludi-crous: overdesigned, for this gentle, subtle landscape.

Behind the *Shoemaker* she looked across the width of a big crater, a bowl bigger than a football stadium, shadows stretching across the ground toward her from rocks and craters. She could see the old Apollo lander, nestled close to the crater's shadowed far wall, a squat, boxy structure, unmistakable.

And there, only a hundred yards from the Apollo, stood the second *Shoemaker,* laden with the supplies that would keep them alive.

"How about that," she said. "Can't be more than six hundred feet away." She felt elated—the first lunar landing for more than thirty years, and it was pinpoint accurate. "Outstanding."

"You got the job," Henry said dryly. "Now, will you help me down from here?"

So here was Henry, unbelievably, standing on the Moon, a geologist on the ultimate field trip. He turned, slowly, trying to understand where he was.

The sun dominated seeing on the Moon, he realized immediately.

The sun was like a giant, intensely bright searchlight, pure white, overwhelming everything, and the mental picture he built up of the landscape here depended completely on the angle to the sun.

At zero phase angle—if he looked down-sun, with his own shadow stretching across the untrodden surface—it was difficult for him to make out shadows. Most objects were visible, but the contrasts were washed out. But he could see shadows if he looked cross-sun, so the trick was to look from left to right, to pick up the shadows, and shapes and sizes and glints, and he could orient himself that way. And if he walked up-sun, with the shadows stretching toward him, the sun was very bright, glaring in his visor.

When he looked at his own shadow the sunlight around it came bouncing straight back at him. The shadow

of his body was surrounded by a glow, a halo around his helmet.

He inspected the mineral ground. *Cinereous,* he thought. The color of ash . . .

But there *were* colors here, he realized suddenly.

He stopped and looked around more carefully.

If he looked in the direction of the sun, the ground looked a pale, golden brown. It was the same if he looked away from the sun, beyond his own long shadow. But to left or right the colors got darker, to a richer deep brown. If he looked under his feet, or at a handful of soil in his hand, the color was a deep charcoal gray, sometimes even a black.

But anyhow the Moon colors looked pale and lifeless when he looked at the blue armbands on his suit, his blue lunar overshoes, the brilliant black and gold and silver of the *Shoemaker,* and especially the ice-blue of the Earth, when he looked up.

He knew he would have to learn to take account of all this, learn to read the landscape on its own terms, in its own conditions of light and shadow.

He did a little geologizing.

He was standing on a dark plain, its surface evidently sculpted by craters, of all dimensions, craters on craters. There were rolling hills, almost like dunes, their form softened and fluid, their flanks littered with boulders thrown out of the larger craters. And close by he could make out smaller craters, almost rimless pits in the soil, and the center of each one was marked by a spot of fused glass, a remnant of the punch which had dug out that particular pit.

It was a landscape unlike any he had seen on Earth.

The mountains—foothills of the Aristarchus crater rim walls—rose up like topped-off pyramids into the black sky, their sides dauntingly steep. There was no easy comparison with terrestrial features; the hills were neither as crag sharp as the granite of the Rockies, nor as smoothly rounded as the ice rivers of Norway.

And besides, almost all of Earth's features—certainly

all of the mountains—were *young,* at any rate by comparison with what he would find on the Moon. Some of the mountains of the Moon were almost as old as the Solar System itself.

But the shadows of the mountains were not the wells of darkness he had expected, for light, reflected from nearby slopes and plains, softened the shadows. The light, reflected from the rocky ground, was, of course, Moonlight: precisely that, the very light which illuminated Earth's night sky.

He'd ridden through Moonlight across a quarter of a million miles. And now, standing here, he and Geena were bathed in it.

He shivered.

He took a step forward, over dust and broken rock. The Moon gave him a firm footing, beneath a layer of looser dust that compressed like unpacked snow.

The loose stuff varied from place to place, from maybe a few inches thick to perhaps a foot. He knew the reason for that: the regolith was created by a hail of micrometeorite bombardment, and it deepened and matured with time.

So when he walked into a patch of softer dust, he was walking somewhere older.

Anyhow, nowhere did it cause him a problem; the Moon, as a geological field site, would, it seemed, be an accommodating place to work.

In fact, he felt an odd ache as he looked down at the dust billowing around his feet. He wanted to take off his gloves and run his bare fingers through the soil, connecting with the Moon. But that was, of course, impossible; he was the alien here, encased in his bubble of Earth murk, and he must stay that way.

He walked farther.

He bent and, with both hands, pulled a big rock out of the ground. He had to push his fingers into the crackling surface, smashing up agglutinates, rock fragments glued

together by solar wind particles, to get his hands around the rock.

From above the rock looked smooth, almost flat against the ground, like a glacier deposit. But when he dug it out he found its underside, buried in the regolith, was sharp and angular, and maybe ten times as bulky as the portion that had shown above ground, like an iceberg. And the buried surfaces were sheer, lacking the sheen of zap pits and impact glass of the exposed section.

This rock, casually dropped here after some ancient impact, had been eroded flat by an aeon of micrometeorite rain.

He brushed off the dust and held the rock up to his faceplate.

This was a breccia, a compound lump of rock whose fragments had been crushed, ground, melted, mixed and then bound together in a shock melt. When he turned it in the flat sunlight he could see the sparkle of glass, the recrystallized minerals that were holding this lump together.

This rock, in fact, almost looked like a vesicular basalt—a pumice, riddled with bubbles left by gas. But the heat that formed it came not from volcanism but from the energy of the catastrophic fall of a giant impactor. And he thought he could see that this breccia was in fact itself made up of earlier breccias, breccias nested in breccias like biblical generations, remnants of still earlier impacts. In this one chunk there might be pieces of ancient anorthosite crust, mare lavas, even solidified dregs of the original magma ocean.

He weighed the lump of breccia in his gloved hand. Its weight was barely discernible in the feeble gravity. And yet, just looking at it, he felt echoes of the almost inconceivable violence which had shaped the Moon's early history, sensed the processes which had formed this rock since, processes unlike any on Earth.

And now Geena was calling him, telling him to come with her to the Apollo site.

He put the rock back where he had found it, back where it had lain for a billion years, and loped away through the morning sunlight.

Side by side, Geena and Henry crossed the few hundred yards to the Apollo site. They kept quiet, concentrating on learning how to walk.

Walking, in fact, took more of his attention than he expected, distracting him from the geology.

His suit would have been too heavy for him even to lift on Earth. And, being pressurized, it was about as stiff as a rubber tire. But because of the low gravity, his mobility wasn't much reduced from what he could manage on Earth.

He found that trying to walk heel-to-toe, as he did on Earth, was difficult and seemed to eat up energy. He kept tumbling away from the surface, as if he was walking across a trampoline; he didn't feel as if he was stuck down properly to this light little world, and his overpowered Earth muscles kept throwing him off.

The best way to move was something like a lope. He would push off with one foot, shift his weight, and land on the other foot. It seemed to him he was covering ten feet or more with every step. But that couldn't be right; the Moon must be fooling him again.

However far it was, however long he was up, every step kept him off the ground for several heartbeats, and he had to watch where he came down, on a rock or in an ankle-snapping crater. The trick was to anticipate each next step as he flew across the ground, shifting his weight and pushing off as soon as he landed, working rhythmically, like loping across a stream. It was demanding, and he couldn't take his eyes off the ground for long. But he could relax in mid-step, unlike a runner on Earth, and it was amazing how that simple thing conserved his energy. It seemed to him he would take a long, long time to get tired.

He could sense his inertia, though.

It was hard to get moving; he had to thrust his body forward to get underway, as if he was walking into a wind. And to stop, he had to dig in his heels and lean back. He felt as if he was scuffing at this pulverized surface to which he was lightly bonded, trying to move his massive Earth bulk.

It was the separation of mass and inertia; the gravity here was so weak the effects of his mass were reduced, and inertia dominated. Sir Isaac Newton, you should have been up here. *You* understood all this, without having to fly to the Moon.

When he got tired, the stiffness of his suit actually helped. He could stop where he was and just slump inside his suit, and if he gave up the effort of trying to move the damn thing he could just rest against it.

When he looked across to Geena, she was loping along in much the same way. With her body dipping, stiff-legged, at every stride, she looked like a giraffe running across some Godforsaken piece of veldt, dipping into the swelling crater pits. He stifled a laugh.

. . . The surface was nothing but craters. Emphasize that: *nothing* but craters.

The main craters ranged in size, mostly from a foot across to maybe twenty yards, and from a few inches to maybe ten yards deep. It was like the frozen surface of some ocean, shaped by wavelike swells of a characteristic length and spacing.

But there were smaller pits as well, right down to zap pits on every rock he picked up, and he knew that if he took a glass to the fragments of regolith he'd find more craters right down to the limits of visibility, the rocks themselves like little Moons, as if this was a fractal landscape.

After four billion years of incessant pounding, there wasn't a square inch that hadn't been pulverized and racked up into a saucer-shaped dip of one size or another, not a footfall but where he crunched on regolith, a flour of pulverized rock. The terrain was just saturated, like the desiccated remnant of some Civil War battlefield.

He focused on the experience: the soapy feel of the fresh regolith, the gentle swell of the surface. As he loped across the land he might as well have been on the surface of some ocean, rolling quietly.

. . . And at Aristarchus Base, Rover tracks and footprints converged on the truncated base of the abandoned Lunar Module. The LM formed the center of a circle of scuffed regolith, littered with gear.

Geena walked respectfully up to the old LM. It was a squat box on legs, a little taller than she was. There was a ladder fixed to the front leg; when she ran a gloved hand over it she found dust clinging to its rungs, left by departing feet, more than thirty years ago.

The gold-colored Kevlar insulation on the descent stage was discolored, and in some places it had split open and peeled back. Geena tried to smooth it back with her gloved hand, but it just crumbled under her touch. The bird was evidently thoroughly irradiated. The paint had turned to tan, and where she looked more closely she could see tiny micrometeorite pits, little craters dug into the paintwork. Another million years of this erosion and there would be nothing left of the Apollo.

She looked for Henry. He was studying the ALSEP science station that the astronauts had set up. She loped over to join him.

The instruments were laid out in a star-shape over an inert patch of the Moon, and connected by gold-colored cabling to a central telemetry transmitter and a power plant—a thermoelectric nuclear generator, now long inert. Henry pointed out the sights like a tourist guide. Here was the seismometer, like a paint can on top of a silver drop cloth. This irregular ball in a squat box on legs must be the solar wind spectrometer. Three booms, spread out like the petals of a flower, made up the lunar surface magnetometer. And so on. All the instruments were boxes covered by gold-

colored insulation and white paint, covered with dust from long-gone astronaut footsteps, now blistered by years of sunlight.

There were packing brackets everywhere, dumped on the closely trodden ground.

When she turned away, she tripped on an ALSEP cable. She didn't even know it; Henry had to tell her. She couldn't see her own feet as she walked, because of the chest-mounted control unit in her way, and she couldn't even feel the cable through the inflated layers of her suit. The cable itself hadn't unrolled properly. It seemed to have kept a kind of "memory" of being rolled, and once unrolled it wouldn't lie flat, in one-sixth G.

Near the LM was much evidence of departure. The surface was littered by exhausted lithium hydroxide canisters and LM armrests, two abandoned backpacks, urine bags and food packs: garbage thrown out of the LM, the detritus of three brief days of exploration.

And the LM was surrounded by glittering fragments, for its foil insulation had been split and scattered by the blast of the departed ascent stage's engine. There was a new ray system, streaks of dust which overlay the footprints.

On a rise three hundred feet away sat the Lunar Rover, with its camera blindly pointing to a sky into which its masters had disappeared.

Perhaps fifty yards from the LM, a U.S. flag stood on its pole, held stiffly out on the windless Moon by a piece of wire. It had fluttered only once, as the brief blast of the LM's ascent stage engine had rushed over it, and now it was tipped over, at an angle of thirty or forty degrees to the vertical.

Geena loped over to the flag.

She got hold of the staff, raised it straight, and tried to push it into the regolith. The staff would go in four or five inches easily, but then she came up against stiff resistance. Still, she managed to balance it, almost upright.

The relentless beating of sunlight had worn away at the fabric, and its colors—the red stripes, the blue star

field—were no longer factory bright. But the flag was the most colorful object on the Moon.

When she turned away from the flag, she saw a pattern in the dust. In the low sunlight she couldn't make out what it was, and she walked around it.

A single line of footsteps led to this patch in the regolith, then turned back. And here was the object of that minor expedition: a name, written in the lunar dust, by a gloved finger. TRACY. A name written up here so it would last forever, on the unchanging lunar surface. He—Jays or Tom—had thought nobody would ever see this.

She shivered. Maybe it was a feeling she was walking through a graveyard. Or maybe it was exultation. After all, she was here. We can still do it, by God. We got here, just like before.

She turned, taking care not to spray dust over the scrawled name, and walked away.

The second *Shoemaker,* with their supplies, had come down clumsily. One of its four legs had settled into a nasty pit of a crater, and the whole thing was tilted at maybe ten degrees to the horizontal. But when Geena hopped up to the platform to check its systems, it looked otherwise intact.

The *Shoemaker* looked identical to their own, except that its upper surface was covered with a glittering Kevlar insulation blanket. Geena pulled that away; it fell oddly— low gravity, no air—it was stiff as molded steel until it hit the ground, where it crumpled softly.

There were no crew standing frames here, Henry saw. Instead there was a pair of big, clam-shaped discs, maybe two yards across, pressed up against each other, with some kind of fabric compressed between them. There were equipment boxes and fuel tanks crowded around, black and white and gold.

Geena started to undo restraints on the boxes. "Help me," she said. "We have to unload all of these."

Clumsily, Henry hopped onto the platform, and bent to help her.

So, here he was, working on the Moon. It was harder than he expected. His Space Shuttle inner tube suit was unbearably stiff at the waist and knees, and it took a lot of perseverance to lean over and bend. And the stiffness of his gloves made it hard to close a grip; he had to fight a monkey impulse to pull his gloves off and use his bare hands.

When he picked up a box, because he couldn't bend his suit, he had to hold it out in front of him. That meant he was constantly fighting his suit, like a weight-training exercise. Like that, he tired quickly, and had to take frequent rests.

The gravity was a sixth of Earth's, but, oddly, when he hefted something heavy, it felt less than that—maybe a tenth. And when he got something moving, it just kept on going, but the motions were slow.

At that, Geena was making better progress.

"I don't remember you as a fitness freak," he said.

She grunted as she worked. "In space the hard work is done not by your legs, like on Earth, but by your arms and hands, which have to do all the work of hauling your mass around, gripping things, moving equipment. So in between missions I did a lot of upper body training."

Henry could hear his breath rattling in his bubble helmet, his pulse pounding in his ears. "Smartass."

At length they had the *Shoemaker* unloaded, their equipment scattered around. By now their Moon suits were coated with gritty charcoal-colored dust, up to and beyond their knees.

"Now for the fun part," Geena said. She reached up to the nearer of the clam dishes and pulled a lanyard.

Latches popped open all around the clam dish, which released its twin. The concertina-style fabric contained inside filled out to a cylinder. The clam dishes moved apart, wobbling slightly, in utter silence.

When the habitat was fully opened it made up a rough

cylinder maybe three yards long, sitting like a pale fat worm on the *Shoemaker* stage. It had a big U.S. flag and the NASA roundel etched into its side.

Henry grinned. A typical NASA gadget. "Woah," he said. "The world's biggest squeezebox."

"Shut up, Henry."

"Another prototype?"

"You got it. Home sweet home. Here." She handed him an equipment box. "Now we got to get all this stuff inside."

He took the box, and turned to the hab.

They squeezed through the tight fabric hatch in their Moon suits, like two soot-covered bugs trying to get back into their chrysalises. Geena pushed buttons, and air hissed into the shelter. The Moon dust which had stuck to their clothing with such determination sprang away, filling the new air with a grayish cloud. The dust scattered over equipment boxes and the fabric walls of the hab. Henry hated to get Moon dirt all over everything, but there really wasn't a choice.

His polarizing microscope, in its battered wooden box, looked utterly out of place here, a jarring piece of familiarity in this alien place, as comforting as he'd expected.

Geena got to work setting up an oxygen generator. Adapted from Space Station kit, it was a Russian design, a cylinder four feet long that worked by separating water into oxygen and hydrogen.

When Henry uncracked his helmet, he could smell the dust. It smelled like gunpowder.

It made Henry sneeze.

The dust in this shelter had never before been exposed to oxygen. So every grain was chemically active, like gunpowder just after it had been set off, and it was busily oxidizing, rusting away, not to mention reacting with his nasal passages.

Geena took her helmet off. Her short hair was plastered to her forehead.

They sat for a moment, breathing hard, facing each other, huge and clumsy in their pressure suits.

It was—awkward. Eight years of marriage, and here they were on the damn Moon, and he couldn't think of a thing to say.

Looking into Geena's ice blue eyes, he sensed she felt the same.

They got on with their chores, and their conversation stuck to the equipment.

They took off their gloves and helmets. Then, helping each other, each in turn stepped into a big stowage bag and pulled it up, and began to dismantle and shuck out of the suits. The stowage bag was needed to catch the rain of sooty Moon dust.

The hab module seemed smaller than it had looked from the outside, and it was tipped up by the *Shoemaker*'s awkward landing. There was only just room for a suited human to stand upright. Every time Henry rolled against the fabric wall the whole thing shook like a kid's inflatable bouncer; he just hated the thought that this was all that stood between him and the high-grade vacuum outside.

They piled up their opened-out suits in a corner of the shelter. They would have to leave them to dry out before they would be usable again. The pressure suits, irradiated by the sun, smelled of ozone. And Henry found his faceplate was scarred, in several places. Tiny zap pits, from the invisible interplanetary sleet within which he'd been walking, micrometeorites laboring to wear away his protection. If he stayed out there long enough, he supposed, the hail of dust would wear him down, grind up his suit and flesh and bones, leaving nothing of him but a strange organic trace in the thick regolith layers, a part of the eroded-flat Moon.

Out of his suit for the first time since leaving lunar orbit, he inspected his own damage. His face, armpits, chest

and crotch were pooled with sweat. The sweat didn't drip down, as it did on Earth, but clung in place; he could scrape it off with his fingers but it stuck there too, wobbling like a viscous jellyfish.

His hands and forearms ached, and his fingers were sore—he even found blood underneath the nails of his right hand—and his wrists had been bruised where they bumped up against the seal rings on his suit.

By comparison, his hips and knees felt stiff from underuse; it was a pleasure to do a little stretching, to touch his toes and squat down, bending his knees, to flex his body in ways his encasing pressure suit never allowed. There was no doubt, though, that Geena was right; the Moon was a world for the hands and arms and upper body.

Geena opened a spigot on one of the boxes, and poured water into a shallow bowl. "Here. Wash. But go easy."

The water poured slowly, and curled gracefully against the side of the bowl, licking upward in a slow tide, as if trying to escape.

Henry dipped his hands in. The meniscus bowed, reluctant to wet him. Geena had a little vial of liquid soap, and when he added that the water ran more easily over his hands. When he lifted his hands out of the water the liquid clung to his skin in a sheath maybe a half-inch thick. He held his hands over the bowl, and the water dripped back in fat globules.

The languid motion of the water was surprisingly pleasing, easy on the eye muscles. As if, he thought, this was the pace our systems were supposed to work at all along.

They pulled on blue Space Shuttle flight suits.

Geena showed him the hab's systems. The life support was open-loop. There was no attempt to recycle any of it. The hab could support the two of them, Geena said, for maybe six days. The atmosphere in here was low-pressure oxygen; there were filter beds to take out carbon dioxide, which they would have to reload.

The power came from hydrogen-oxygen fuel cells, built into the *Shoemaker,* which would also supply more water. Their waste would go into bags or tanks, to be dumped over the side when it was time to leave. There were cold plates and radiators to control the temperature. There was a simple medical kit, germicidal wipes, some tools, equipment for the EVAs.

Cramped, dusty, fabric walls, tipped-up, crowded with gear: the hab was, he thought, like a tent in the Antarctic. Except for the two huge space helmets stacked in the corner.

Geena started to dig out food.

"Station rations," she said. "In fact just the rehydratable stuff. You can add hot water, but we don't have an oven."

Henry looked at the rows of labeled plastic bags in dismay. "Fit for a king. Okay, what do you recommend?"

She dug out two packets. "Chicken, cashew nuts, rice."

"Ah. You always preferred Chinese."

"Henry, for Christ's sake."

"Sorry."

"The hot spigot is over there."

"Right."

He found how to inject the bags with water, and knead them up until they were mushy. Geena slit open the bags with a pocket knife, and dumped the contents into bowls. Then she dug again into the food locker and produced chopsticks.

"Wow," Henry said. "You think of everything."

"Just something I always wanted to try."

In one-sixth G, the chopsticks worked better than on Earth; the food seemed to fly in a steady stream to Henry's mouth, and with pretty good accuracy. But the portion lasted just minutes, and as for the flavor, he had the feeling he should have eaten the plastic packet.

The walls of the hab were vaguely translucent. It was, of course, still lunar morning outside. As he ate, Henry was

aware of the gross features of the landscape: the sun a daz-
zling, blurred disc, black sky, bright ground.

Geena seemed to be trying to come up with something
to say, to fill the silence. "You know, the Chinese have a
Moon legend. They say a beautiful girl called Chango has
been living up here for four thousand years. She was sent
up here because she stole the pill of immortality from her
husband. And she has a companion, a big Chinese rabbit
which—"

"What if we get punctured by a meteorite?"

"You know that's not likely."

He punched the walls with his fist, making the fabric
wobble around them. "Okay. But what about cosmic radia-
tion?"

"Actually, the biggest risk on a six-day stay is a solar
flare."

"So where is the six-inch shell of lead plate to pro-
tect us?"

"You can't design out all the risk, Henry. And the risk
of dying because of some act of God up here is low com-
pared to some of the other risks we have to take."

"Such as?"

"Principally, launch from Earth. Reentry is no Disney-
land ride, either."

"So tell me how you handle this *low* risk."

"Management waivers. A NASA specialty. You want
some dried strawberries?"

After they'd cleaned up, they did some work on their suits.
They turned away from each other, seeking a little privacy.

. . . The cabin was still full of Moon dust. Henry could
actually see it in the air, hanging like a fine gray mist. If he
breathed in deep it scratched at his throat and hurt his
chest.

It was very clingy stuff. It got all over his hands. It
stuck to everything: metal, fabric, painted surfaces, clothes

and skin. The stuff had low conductivity and dielectric losses, and it had been pounded incessantly by ultraviolet from the sun, and so it had built up a charge. It stuck to him electrostatically, the way he had once, as a kid, made pieces of paper stick to his comb.

But knowing the process didn't make it any less of a pest.

He worked on his suit. He tried a pocket-sized whisk broom to scrub the dust off of his suit. But it only seemed to work the dust deeper into the fabric.

The dust itself was very fine. It was basically ground-up lava bedrock, which made it abrasive as all hell. There were probably shards of pure iron, and perhaps glassy spheres and dumbbells in here, produced by major impacts, droplets which had been thrown into space and fallen back. And he could see the soil contained larger fragments: agglutinates, particles welded together by the glass produced by the much smaller impacts of micrometeorites.

Out on the surface, the regolith matured, subtly, the rain of micrometeorites welding it into such agglutinates, the solar wind implanting volatiles—hydrogen, for example—into the surface. Maybe recoverable, by future colonists.

He could feel the glass pricking at his fingers. And, as he rubbed it between thumb and forefinger, it was working its way into his skin, he saw. It seemed to be smoothing out his fingertips, taking away his individuality under a surface of lunar debris. He suspected it would take a long time, a lot of washing, before he could get himself clean of this stuff.

He started greasing his suit's zippers and neck and wrist ring seals.

The toilet was waste tubes and plastic bags. Embarrassing intimacy.

When it was time to sleep, they slung fireproof Beta-cloth hammocks across the shelter, one over the other. Henry elected for the bottom bunk.

Geena gave him a sleeping bag, and a length of hose.

"What am I supposed to do with this?"

"Pump your bag full of water."

"Are you crazy? . . . *Oh.* So this is NASA's plan for protecting us from radiation."

"You got it." She dumped her own sleeping bag onto her bunk, and ran a tube from the water tank. When her bag lining was full she hung a blanket over the sun's blurred image, darkening the hab, and clambered into her bunk.

Henry climbed inside his own bag and tried to lie down. It was like settling into a wraparound water bed. Every time Geena moved, she gurgled; and, he supposed, so did he.

Just above him, Geena barely made a dent in her own hammock, but he could see the curve of her hips, the way she'd tucked her legs up a little way toward her stomach, just like she always used to.

He tried to sleep.

The shelter was full of noise, the bangs and whirs of coolant pumps and ventilation machinery.

He'd read that the old Apollo guys had trained for sleeping on the Moon by camping out in Lunar Module simulators, with a tape of LM noises playing in the background. They should have just slept in a boiler room, he thought.

. . . There was a creak. He had a sense of falling.

His eyes snapped open.

"Geena," he hissed. "Are you awake?"

Geena's voice was hushed. "Hell, yes, I'm awake."

"Did you hear that?"

"Hell, yes, I heard it."

"Do you think we're tipping?"

"I don't know."

"You don't suppose this damn thing is going to roll over altogether?"

"Can't you tell?"

"No. I can't tell for sure which way is up. This low gravity—"

"Henry."

"What?"

"Why are we whispering?"

Henry pushed his way out of his hammock. He collided softly with Geena, who came tumbling down from the top bunk; he held onto her upper arms, to keep them both from falling over.

For a moment they stood there like that, in the milky gloom of the shelter. Geena's face was only a few inches from his, outlined by the subdued stand-by lighting. Her eyes were pools of darkness, her mouth a shadow. But her breath was warm on his face, the heat of her flesh in his hands tangible; for the first time he realized how deeply, utterly cold he had felt, how much he needed to be held by another human being.

They were, after all, alone on the Moon, the only living creatures on a planet.

She said, "You feel horny, don't you?"

He grunted. "I haven't felt so horny since my father's funeral. But—"

"But it wouldn't be wise," she said.

"Damn right it wouldn't," he said; and when he looked into her eyes, he saw they both meant it.

They stepped apart. She began to cast around, in the piles of equipment loosely stacked on the floor.

"What are you looking for?"

"A weight."

"What for?"

"A plumb line. If we can't tell which way is up we need an attitude reference. We don't have an eight-ball in here."

She dug out one of Henry's smaller geology hammers, and tied a piece of string to it. When she hung it up from a loop in the roof of the shelter, it hung straight down.

"So we aren't tipping," Henry said.

"No. That damn thing knows which way is up, even if we can't tell."

"Yeah."

She reached up and, with an easy low-G bound, pulled herself up into her hammock once more. "Good night, Henry."

"Yeah." He clambered back into his own hammock, and pulled his sleeping bag up around his neck.

He tried to settle his mind.

He listened to Geena's soft, even breath. When he thought he was tipping, he looked up, and he could see the hammer dangling there, calm and rational, a link to a world where the laws of physics continued to work.

He closed his eyes, determined to sleep.

To his surprise, he succeeded.

45

Alone in lunar orbit, Arkady set his alarm to wake him during a period when he was on the far side of the Moon: invisible to all mankind, to remote blue Earth, even to the two humans scrambling through the Moon dirt near Aristarchus, here he could enjoy the ultimate privacy.

He lay for a moment in his sleeping bag. He was surrounded by equipment, bags and containers and documents, fixed to every square centimeter of wall surface. It was like being in the middle of a busy railroad station, he mused, luggage scattered everywhere.

The craft's noise was a miniature orchestra: the whirring of different electrical devices, fans, regenerators, carbon dioxide absorbers and dust filters, gadgets which were never switched off. The noise rattled around him, echoing in this compact metal barrel. It was, he supposed, about as noisy as a busy apartment—with one difference: these were only mechanical sounds; there were no human voices here, save his own.

Once, for an experiment, on the far side of the Moon, he'd turned everything off. Just for a moment. The silence

was oppressive: in his ears there was only the susurrus of his own breath, his rushing blood, and beyond that a stillness that stretched a quarter-million miles. It gave him an unwelcome sense of perspective: noise seemed to make the universe more friendly.

Loose objects—pens, paper, food wrappers—swam through the air past his head. They moved languidly in the gentle air currents from the fans, sometimes darting this way and that in the random flow of the air, like improbable fish.

Here, *everything* floated: dust, pieces of trash, food crumbs, juice drops, coffee, tea. None of it would settle out, and all of it ended up suspended in the air. This enhanced Soyuz was fitted with a jury-rigged air circulation system, and a lot of stuff would end up collected on the intake grill of fan ducts, which he kept covered with cheese cloth. Once a day, he would wrap up the cheese cloth with its assorted trash and replace it with a fresh one.

Most things, if he lost them, ended up on the grill. If he needed something in a hurry he had a little rubber balloon that he kept in his coverall pocket. If he blew this up and released it, it would drift with the prevailing air currents and he could just follow where it went.

If he was thinking about chores, it was time to get up.

He clambered out of his sleeping bag. He started his day with bread, salt and water.

He spent some time cleaning up the Soyuz.

He had some napkins soaked with katamine, a scouring detergent. He wiped down the wall panels, the handrails, the door hatches, the control panel surfaces, the crew couches. And, with a little hand-held vacuum, he cleaned all the tough places where dirt built up. He opened up wall panels so he could vacuum the bundles of pipes, cables, fan grills and heat-exchanger ducts there. When he did that he found a pen he'd lost right after the launch; he tucked it in his pocket, unreasonably pleased at this little triumph.

He had grown used to life in microgravity.

When he'd first arrived on Mir, he remembered, he could barely move a meter without catching his feet on side panels and banging his legs on anything fixed there: documents, cameras, lenses, control panels. Now he could fly through hatches and compartments, wriggling like some lanky fish, neatly avoiding the equipment and obstructions. If he had to cross some space without handholds, he had learned how hard he had to push. When he had to maintain a position at some work station, he had learned to find a post around which to wrap his legs, or else he would find somewhere to lodge his elbows, feet, knees or even his head, thus holding himself steady; sometimes he would use his legs as clamps, to hold maps or other documentation.

He had come to depend heavily on the advice and experience of other cosmonauts who, for nearly thirty years now, had been learning to survive long-duration assignments in space.

There had been that time, for instance, when the Progress resupply ship was late and he and his crewmates had been reduced to burning lithium perchlorate candles to sustain their oxygen. And then the recycling plant that connected to the toilet had failed, and the sewage tanks had filled up. The crew had been forced to open up the tanks and simply stir the sewage, to reduce the volume. That had worked, but the stench had been awful and did not seem to dissipate, as the days wore on; after all, they could not open a window up there to let in fresh air.

Still, there had been some comedy as their American guest, brought up there in air-conditioned comfort on Shuttle, had tried to cope with all this; she had looked on with horror as the sewage tank was opened, antiseptic wipes over her face to protect her from week-old Russian shit— or, as she had comically put it, "human post-nutritive substance . . ."

There were two E-mails for him today, transferred up via Houston to the IBM laptop fixed to one wall by Velcro patches. The first mail was relayed from Korolyov. It

seemed his coefficient of errors was up to point three five, an unacceptably high level by historic standards.

Arkady sighed and discarded the mail. It was a peculiarity of the Russian system—seen by Geena's American eyes at least—that every error he made, on this or any other mission, was recorded by his controllers on the ground. Basically, after a mission, he was evaluated not by what he did or how much he accomplished, but by how many mistakes he made.

If he saved the world, he thought wryly, maybe they would overlook his unsatisfactory error ratio.

The second mail was more pleasing. It was from workers at the Krasnoyarsk Hydroelectric Power Station in Siberia. One summer, as a student of the Moscow Institute of Aviation, Arkady had worked at Krasnoyarsk on a dam construction project.

> To celebrate the first Russian lunar flight, by the joint decision of the workers and the MIA student construction workers in Sayany, Arkady Berezovoy is nominated as an Honorary Concrete Worker in Dmitri Syroyezkho's work team. His salary will be transferred to the Russian Peace Foundation. We wish you Siberian health, happiness, successful completion of your mission, and a safe return to Earth. We embrace you as a friend. Come and visit us in Sayany . . .

Arkady was moved. He was sorry Geena was not here to see this—though he was glad her American ex-husband Henry was not here to mock. Americans would never understand such a gesture as this, and would deride it.

But to Arkady, it was like an echo of the past. It seemed to Arkady that since the implosion of the Soviet Union—whatever the rights or wrongs of that "liberation"—the Russian people had had precious few heroes to celebrate. This message from the power workers wasn't the

first such he had received. It warmed him, here orbiting the cold wastes of the Moon, to think that his countrymen, even in these dark times, were following his mission. Arkady had always believed that the true value of a hero was not to himself or herself, but to others, as an example of the heights to which humanity can aspire.

He drifted before the laptop keyboard, and composed a reply.

> >Dear friends, I thank you for your mail, and for the great honor you do me . . . I can assure you that by my hard work on the Soyuz I will represent the hydrocon-struction workers with honor . . .

That done, the Honorary Concrete Worker continued with his duties, in lunar orbit.

When he passed over Aristarchus, he looked for Geena and Henry. If Arkady told the computer where to look, it was able to point the navigation sextant, with its low-power telescope, right at the rille; and when he looked in the eye-piece, just within the rim of the crater, there was the lander: a point of metallic light trailing a needlelike shadow.

He peered into the eyepiece, willing himself to pick out more details. Maybe he could make out the four land-ing legs of the old Apollo Lunar Module . . . Perhaps that fuzzy oblong was Geena's inflatable shelter.

But the 'scope wasn't powerful enough for that, and he was starting to see what he wanted to see, not what was there; and so, he knew, he must put aside the telescope.

No Russian had ever visited the surface of the Moon. Perhaps no Russian ever would. It was an exercise in futil-ity, therefore, to gaze on its surface like Moses at the Promised Land.

It might have been different, though.

Arkady would, he admitted to himself, relish the

chance to be a hero, to be another Gagarin to inspire future generations, to help his country climb its long ladder to a better future.

But he would do nothing to jeopardize the mission.

He sailed once more into silence.

He liked this experience, sailing through lunar orbit, of being alone on the far side of the Moon. To a pilot it was the essence of flying: to be alone, in control of your craft. As he was now. It was, he thought, the purest form of freedom.

And there were lonelier places than the far side of the Moon. He had flown sorties over Afghanistan; he knew; he had been there.

When he came into view of Earth, the radio static turned to voices, and he was connected to humanity once more, strained voices that betrayed the grimness of the planet.

46

Houston woke them up with a burst of Louis Armstrong singing *What a Wonderful World*.

Henry snapped awake, disconcerted. He'd woken up to news—bad news—every day for three months before the mission. But then it wasn't NASA policy to pass on news, bad or otherwise, even when the world was coming to pieces around them.

For a while they lay in their bunks, staring at fabric walls illuminated by tan backlight from the Moon dust.

Good God, Henry thought. It's real. I'm still on the Moon.

He'd slept well. He felt good.

Even the soreness in his arms had disappeared. The doctors on the ground had speculated that the cardiovascular system was so much more efficient, here in one-sixth G, that it cleansed the muscles of lactic acid and other waste

products before they had a chance to do any damage. He hadn't believed them; but now, he could feel the results.

How strange, he thought, that humans, four-limbed primates, should be so well-adapted to conditions on this sister planet. It looked as if those millions of years spent swinging around tree branches hadn't been for nothing after all.

In the end, how easy it had been to come back to the Moon. They'd just decided they wanted to do it, and they'd done it. We wasted thirty years of exploration time, he thought.

But then Geena started to move, and it was time to begin the day.

A day in which, he realized, he was going to have to confront the Moonseed at last.

He struggled out of his sleeping bag.

When Henry peered out of the shelter's little window, the Moon looked strange.

He knew from yesterday how far away the various instruments and craft of the Apollo astronauts were. He could even see the tracks of his own prints in the scuffed regolith. But when he looked out of the shelter's window, it looked as if the instruments were right outside, as if they had come huddling closer to the shelter's warmth.

None of it, the swimming perspective of the Moon, made any sense to him.

He turned to his suit and donned it, working steadily through its checklist.

When they were done they decompressed the shelter and climbed out, one by one, like fat gray-white grubs pushing out of a discarded shell.

He felt as if he was in some immense darkened room, where the light didn't quite reach the walls, so that he was suspended in a patch of light in the middle of a darkened floor.

A morning that lasts a week. They'd first landed at something like 6:30 A.M., local time. The twelve hours they'd spent inside the shelter were equivalent to something like a half-hour in the lunar "day": enough to shrink the shadows a little, but not by much.

Even so, all the pooled shadows were different, changing the feel of the landscape. Even the *colors* had changed, Henry saw, because the colors depended on the angle to the sunlight; the grays and browns, changing as he looked around, seemed to him a little more vivid.

He kept thinking he saw features, rocks and craters, he hadn't noticed yesterday; but he soon realized they were the same rocks under different lighting, like a movie set that had been reassembled. The slopes of the crater walls and ejecta hills looked much less severe, almost gentle: not nearly the challenge they'd appeared yesterday. Maybe that was true. Maybe he was being fooled in the other direction.

The Moon was full of optical illusions, he thought. Given there was nothing here but bare rocks and flat sunlight, that was kind of surprising. It was a stage set put together by a master illusionist, a minimalist.

Maybe, he thought moodily, the Moon really is a magic world, a world of dream or nightmare, a world where distances and times can shift and swim, like a relativity student's fever dream.

The Moon was, undoubtedly, a stranger and more interesting place than he expected.

He started to collect the equipment they would need for the day: tools and a couple of batteries for the Rover, his geological gear.

Reaching to lift a bag, he leaned too far, and fell.

When the fall began, his balance was lost quickly, especially when he tried to back up. The ground was uneven everywhere, and he kept treading on rocks and crater holes that made him stumble further. Besides, the heavy pack at his back gave him a center of gravity aft of his midline, so

he was always being pulled backward.

But he fell with a dreamy slowness, like falling underwater. He had time to twist around, the stiff suit making him move as a unit, like a statue, and he could catch his footing before he fell. He just spun around, bent his knees and recovered, scuffing his feet to get them under him again.

Then he felt his ears pop.

He had to be losing pressure. He felt his heart pounding. Maybe he should call Geena.

He stood still. He leaned forward and checked the gauge on his chest. There was no change, and he didn't *feel* any difference. Just that one pop.

Maybe he had bumped against the oxygen inflow port, or the outflow. If he obstructed the flow, that would cause a momentary transient; it might even have been a slight increase in pressure.

His monitors stayed stable. A glitch, then.

The incident was enough to brush him with fear.

Sobered, he went to work.

Side by side, carrying tools and equipment, they walked away from the *Shoemaker,* toward the Rover.

The Apollo Lunar Rover was a home-workshop beach buggy: about the size of a low-slung jeep, but with no body, or windshield, or engine.

"Oh, shit," Henry said. "Have we really got to ride this thing?"

"Better than walking. You know what the Apollo guys called it?"

"Hit me."

"Chitty Chitty Boeing Boeing."

They bounced around the Rover, inspecting it.

The Rover was an aluminum frame, ten feet long, maybe six wide. It had four fat wheels—actually not quite wheels, but wire mesh tires, with metal chevrons for tread. There were fenders, of orange fiberglass. There were two

bucket seats with plastic webbing, and a minimal controller—just a gearshiftlike hand controller between the seats, and a display console the size of a small TV. No steering wheel. At the back of the buggy there were bags for storage of equipment and samples.

The front of the thing was cluttered up with cameras and comms equipment. The TV camera still pointed at the sky, where it had followed the final departure of the astronauts in their LM ascent stage. The camera was coated in insulation foil, which had split and cracked. The umbrella-shaped high-gain antenna still pointed at Earth, where the Apollo astronauts had left it, for the Earth had not moved in all the years since.

This Rover was a working vehicle. He could see how the straps on the backs of the frame chairs were stretched and displaced from use. There were still dusty footprints on the foot rests fitted to the ribbed frame, and the mark of a hand, imprinted in lunar dust, on the TV camera's insulation. And one fender at the rear had cracked, and had been crudely patched with silver wire and what looked like a checklist cover, though the text and graphic had long since faded. The Rover looked as if it had been used just yesterday, as if its original drivers would come back in a couple hours for a fourth or fifth EVA.

Tracks, crisply ribbed, snaked off back over the ground, diminishing into the distance.

The Rovers had been built from scratch by Boeing in just two years. There had only ever been four of these babies, and all of them had been flown to the Moon, and all of them had been left up here, in the clean airless sunlight. Two million bucks apiece.

At that it was a better fate, he thought, than to finish up in a glass case in the Smithsonian or some NASA museum, slowly corroding in Earth's thick, murky air while generations of successively more baffled tourists came to stand and gawk . . .

He said, "What makes you think this old dune buggy is

going to work anyhow? It was built to last three days, not thirty years."

She shrugged. "It was built to last three days, not thirty years."

She shrugged. "It was built for temperature extremes and vacuum. What is there to go wrong? Neighborhood kids stealing the tires? They built better than they had to, in those days. Look at those old space probes from the 1970s. Pioneer 10 lasted twenty-five years . . . Anyhow, you better hope. Otherwise, it will be a long walk."

Geena left the original batteries in place at the back of the vehicle, and set replacements on top of them. The new batteries were an advanced lithium-ion design. She started to hook them up with jump cables, and Henry loped around to help her. It was stiff, clumsy work; the Rover hadn't been designed for this sort of maintenance, and Henry's fingers were soon aching as he fought the stiffness of his gloves to manipulate leads and crocodile clips.

They bolted a lightweight TV camera to the Rover's big, clunky 1970s original, and a new miniaturized comms package. The old antenna still seemed to be serviceable, however. Then they loaded Henry's gear into the panniers in back of the Rover.

When Henry moved past the camera, a red light glared at him, steady and relentless. Back on Earth, they were already watching him.

Let them. For what they were going to do today, there had been time to prepare no checklists, no simulations, no training. Maybe for the first time in the history of U.S. space exploration—the first since John Glenn anyhow—he and Geena were, truly, heading into the unknown. And there wasn't a damn thing any of those anal retentive characters at Mission Control could do to help or hinder them, except keep quiet.

Happily, they seemed to know it.

Henry lowered his butt cautiously onto the right-hand of the two bucket seats, and swiveled his legs over the cor-

rugated frame. The pressure in his suit made it starfish, and he had to use a little force to keep his arms by his side. He pulled restraints around his chest and waist.

Half-sitting, half-lying, he tried to relax.

The Rover was noticeably light; when Geena dropped into the left-hand driver's seat, the whole vehicle bounced, and little sprays of dust scattered around the wheels.

She flicked switches on the console, and dials lit up.

"Left-hand drive," Henry said.

"What?"

"If the first people on the Moon had been Scottish, you'd be sitting where I am."

She lifted her gold visor to stare at him.

Then she dropped her visor, put her right hand on the joystick control, and jammed the control forward.

The wheels, each spun by an independent electric motor, dragged at the dust. The Rover bucked like an aluminum bronco, bounding out of its thirty-year parking spot, throwing Henry against his straps.

Following Apollo tracks as fresh as if they had been laid down yesterday, they headed east, toward the rille.

It was an exciting ride.

The turns were sharp. Every time Geena steered, all four wheels swiveled. The ground here was all bumps and hollows, an artillery field of craters, and every time they hit an obstacle one or two wheels would come looming off of the ground.

Henry, strapped to his lawn chair on top of this thing, was thrown around, especially when Geena took a swerve to avoid a rock or a crater.

"Holy shit," he said.

"Don't be a baby," Geena said. "It's only eight miles an hour. We'd be beaten by a San Francisco cable car."

"Yeah, but how many hummocks per hour are we hitting?"

Geena pushed up the speed. The Rover bounced high off the ground, and threw up huge rooster tails of black dust behind them.

"Let me explain something to you," she said as she drove. "Our consumables are being used up all the time."

"Sure."

"So at no point are we going to drive farther than our walkback limit."

"Which is the distance we can walk back to the shelter, with the oxygen in our backpacks. In case the Rover breaks down. I know. That makes sense to me."

"Yes. But because our consumables go down steadily, that walkback limit gets tighter and tighter with time. And we are going to stay within that limit, all the time."

"Sure," Henry said.

"If that means we have to leave the rille before you're ready, we do it. If it means we have to miss out on interesting-looking detours, we do it."

"Geena—"

"And I'm going to be conservative, because the navigation computer on this thing doesn't work anymore. As far as walkback is concerned I'm the boss."

He shrugged, a clumsy gesture in his suit. "Sure. You're the boss."

If she wanted to feel in control, if that was her way of avoiding the funk she suffered on the way in, it was fine by him.

. . . There were, Henry realized afresh, craters *everywhere.*

Some of the craters were subdued depressions, almost rimless, as if dug out of loose sand. They were easy to traverse; the Rover just rolled down a gentle slope. But others—mostly smaller—were sharper, with well-defined rims, the classic cup shapes of story books. The younger craters were full of rubble, like builders' slag, concentrations of angular blocks, and they had littered rims. Geena had to drive around those babies.

They couldn't avoid a big crater, maybe two hundred yards wide. As they approached the rim Geena slowed down; they had to thread their way through an apron of ejecta a couple of hundred yards deep, sharp-edged, scattered blocks up to four or five yards in size, dug out of the Moon and thrown up here.

From above, Henry knew, this blanket would form the crater's ray system, the scattering of ejecta around the central wound, like a splash of blood around a bullet hole. It gave him a thrill to know that he was here, actually driving among the rays of a lunar crater. A hell of a thing.

Here at last was the lip of the crater. They went over the rim into the basin. It was strewn with blocks ranging from a yard across to maybe fifteen yards, with a few yards separating the blocks, wide enough for them to drive through, as if passing through some miniature city block.

Crossing the crater floor there was an ejecta ridge, a rough, loose structure made of highland dust and mare basalt fragments, churned up together. It must be part of the ray system that came radiating away from the impact that created the younger Aristarchus. He noticed a piece of rock that sparkled with glass beads. It was possible that after the impact, so many billions of years ago, this chunk had been thrown thousands of miles into space, smashed, molten, cooling, before falling back to the Moon, to land here, and, after waiting as long as it had taken for life to evolve on the Earth, here it was for him to see.

Now they drove through a dune field—as he thought of it, in defiance of lunar geology—pitching over a uniformly corrugated ground, ridges and troughs. Here, he thought, was a place they could easily get lost. But the sun hung in the sky above them, unmoving, a beacon.

He thought about that. Morning would be a week long, on the Moon.

For seven days that sun was going to climb up the black sky. For seven days the shadows, of rocks and craters

and two human beings, would shrink, vanishing at local noon. The rocks would get as hot as two hundred degrees Fahrenheit. Then the sun would start to sink, sliding at last under the western horizon, and the two-week-long lunar night would cut in. The temperatures then would get down as far as two hundred degrees below zero.

Four hundred degree temperature swings, every month.

On Earth, on a field trip in the desert, you could get swings of more than a hundred degrees, and at night you would sometimes hear distant, muffled crumps: rocks, exploding under the pressure of the endless contractions and expansions.

But there would be no shattering rocks here. Maybe there had been such incidents once, but every rock that was going to shed layers had done it a hundred million years ago, or more; and there was no volcanism to push up mountains and deliver fresh rocks to the air, no frost to work into rock cracks.

After aeons of erosion the Moon was *smooth*.

The mountains of Aristarchus, on the horizon, were like fluid sculptures, rounded and smooth, set out under the black sky, majestic in their own way. If he looked toward the sun's glare, they were partly silhouetted, their forms delineated by smooth crescents of sunlit terrain, like sand dunes at dawn.

And the mountains weren't gray or brown as he had expected, but a pale gold, in the low lunar morning light. Rounded, dust-covered, they reminded him of ski slopes— maybe in the mountains of Colorado, high above the timber line. And that golden sheen gave them a feeling of warmth, for him; they seemed to cup the Rover like an open hand.

He could, he realized, get to feel at home here. You could set down your lander almost anywhere on the Moon and expect to find a reasonable surface to work with.

And it had its own antique beauty, he found, subtle

and unexpected. A place where time ran slow, where morning was a week long.

But he wished he could see the stars.

He imagined walking here in the lunar night, with the stars above: a huge canopy of them, reaching down to the horizon, undiminished by even the slightest trace of dust or mist.

But it would take all of twenty-eight days for a star to circle around the sky—and the stars here didn't turn around Polaris, that great hinge in the skies of northern Earth, because the Moon's axis was tipped compared to Earth's.

. . . But, even as the stars slowly worked around the sky, the Earth would hang above you, fixed forever. That unmoving Earth would *spook* you, hanging there in the sky, blue and white, forty times as bright as a full Moon: winding through its remorseless phases, like an immense, blinking, unwavering eye.

To an inhabitant of the Moon, Earth was the blue eyeball of God, he thought.

They stopped every few hundred yards, so Henry could emplace seismometer stations. The little moving-coil devices, jug-shaped and trailing wires, were placed three at a time, to pick up the ground's movement in three dimensions. He even had some experimental lightweight gravi-meters, little stainless-steel cans, that were capable of getting down to an accuracy of ten milligals or so.

Henry was wiring the Moon.

Here and there, he also laid down small explosives. His intention was to do a little active seismography, using the explosives to send shock waves through the Moon's interior, to be picked up by the seismos. The larger the net of sensors he could cast, the better the image of the interior of the Moon he would be able to build up; in a way the messages of the little seismometers were likely to be more significant than anything he would see, at the rille.

* * *

As they approached the rille, still following the old Apollo tracks, they had to drive up an incline. It was an outcrop of Cobra Head, the old volcanic dome here, the source of the lava which had gouged out the rille.

The thirty-year-old Rover performed impressively on the slope, seeming to carry them without effort. But, a hundred yards short of the edge of the rille, they stopped. The old Rover tracks snaked on farther up the incline, but Geena was reluctant to risk taking the aged car any farther.

When Henry tried to get up, he could barely raise his suited body out of the seat, and when he got to stand, he felt as if he might slip down the slope. The steepness here was deceptive.

"Henry. Help me."

"What?"

"I think this damn thing is going to run downhill."

Geena was holding onto the Rover. Henry could see one of its wheels was lifting off the surface.

Henry grabbed onto the Rover; it was so light he felt he could support it easily.

He pointed out an eroded old crater they could park in, and when Geena drove forward, they found the Rover was left almost level.

Henry turned to look back. He was three hundred feet high now, and the view was staggering. The sloping land swept away, obviously a sculpture of craters: craters on craters, young on old, small and sharp and cup-shaped on old and eroded and subtle. And he could see that big rubble-strewn crater they had driven through, looking as fresh as if it was dug out of the plain yesterday. Its sharp rim was a ring of dazzling white, and rays of boulders, black and white, clean and sharp, were scattered across the landscape for miles in all directions.

Farther out the slope's broad flank swept down and merged with a bright, undulating dust plain that was pocked with the gleaming white rims of craters, all of it diamond sharp, under a black sky. It was a wilderness, sus-

pended beneath that starless interplanetary sky above.

And it was crossed by just two, closely paralleled, human-made car tracks.

Geena was already working on the Rover, carefully wiping Moon dust from its new batteries.

Henry took his equipment from the sample bags in back of the Rover, and from beneath its seats. They both had big Beta-cloth bags they loaded up with gear, and then slung over their shoulders. Geena had a coil of nylon rope she looped over one arm. And they both had torches, taped to their helmets.

Thus, laden with their gear, they loped away, toward the rille.

Henry stopped periodically, setting in place miniature acoustic flow monitors and seismometers, sensitive to high-frequency vibrations. This was part of the monitoring network he was going to build up around the rille, and whatever lay within it.

For a while they were still tracking the Apollo astronauts' exploration. But now they came to a point beyond which there were no Rover tracks, only footprints: two sets, tracking up and down the incline. Henry could see how the Apollo astronauts' tracks had diverged, as they loped about the hill, taking what samples they could in their haste. But he and Geena had only one purpose now.

They marched directly up the slope, ignoring the meanders of their predecessors, following the line of steep-est ascent.

It was a difficult climb. The dust was thick: the slope was almost bare of rock, and the dust and rubble was churned up, mixed and messy dust that gave the mountain its smoothed-over shape. Maybe it looked attractive from afar, but on foot it was difficult terrain. What it meant was that with every step he took dust fell away from his feet, like soft sand, as if he was climbing the side of a dune.

He was out of breath in a few steps.

Still, he persisted.

He paused for a breath. He turned and looked back at the skeletal Rover. It looked like an ugly toy: squat and low, sitting there in a churned-up circle of dust. Its orange fenders and gold insulation were the brightest things on the surface of the Moon. A few yards behind him, Geena was laboring up the slope after him, her arms full of gear, her red commander's armbands bright.

. . . *He was on the Moon,* he remembered suddenly; this was no routine hike.

The return of perspective was unwelcome.

He remembered some of the early, now lost, theories of the Moon's surface. One geologist called Thomas Gold had warned that the Moon would be covered in a layer of fluffy dust dozens of feet thick. Armstrong and Aldrin would have to drop colored weights to the surface before they landed; if the weights sank, they would have to abort their landing immediately, before their LM was swallowed. Gold had clung to those views even after unmanned craft had safely settled on the surface, but happily for Apollo 11 he had been proven wrong . . .

Maybe.

Now that he was approaching the nest of the Moonseed, Henry wondered whether Gold had been more correct than he knew. What if the layers of basaltic strata beneath his feet, infested by Moonseed, were indeed Gold's dust?

He continued.

He reached a flat crest, and came suddenly on the rille: Schröter's Valley. It was a gap in the landscape in front of them. It wound into the distance, its walls curving smoothly through shadows and sunlight.

As he walked farther, the surface of the mare sloped gently toward the rille rim, and the regolith was getting visibly thinner. The rille walls themselves sloped at maybe twenty-five or thirty degrees.

He stopped, where the slope was still gentle.

The sun was behind him. The far walls were in full sunlight, and Henry could see *layers:* distinct layers of rock,

poking through the light dust coating. They looked like layers of sedimentary rocks on Earth, sandstones or shales, laid down by ancient oceans, the myriad deaths of sea creatures. But what he was seeing, here, had nothing to do with water, or life. The story of the Moon, laid out for him here, was different.

These layers were lava flows. Over hundreds of millions of years, a succession of outpourings had flowed out of the Moon's interior, covering and recovering the valley floor, building up the ground here.

But then, pulsing out of Cobra's Head, a lava river had coursed down the slope of the older landscape, a brief band of light cutting savagely into the older layers. The flow cooled from the edges, the hardening rim confining the central channel. Eventually the channel even roofed over with hardening rock, and the lava stream cut deeply into the underlying mare basalt.

But the brief eruption of heat subsided rapidly. The remnant of the lava drained away and cooled, leaving a tunnel in the rock. Along much of its length the roofed-over tunnel collapsed, exposing its floor to the sunlight.

This will do, he thought.

Henry walked along the rille edge, until he came to a place where a boulder, four or five feet tall, was embedded in the inner wall of the rim. He sat down in the dirt, resting on his hands; the regolith crunched beneath his butt. He put his feet flat against the rock and started to push. It was hard to get any traction; the friction between his butt and the ground was so low he kept sliding backward. Eventually he found a way to brace his arms at an angle behind him, and get more purchase.

Geena joined him. "What in hell are you doing?"

His exertions weren't budging the rock, but they were lifting him up off the ground, to which the low G only casually stuck him. "Help me. It's a tradition."

"More science, Henry?"

"Hell, no. Come on."

She sat down beside him. She pressed her feet into the face of the boulder and pushed, alongside Henry.

"Rock rolling," Henry said between grunts of effort. "No geology field trip is complete until you've sent a boulder crashing down into a caldera, or a forested hillside—"

The boulder came out of its regolith socket with a grind he felt through his knees. With an eerie grace, the rock tipped forward. He tried to keep pushing, but it was gone, and there was no pressure under his feet; he slid a little way down the slope.

He leaned forward to see. As the rock started to fall it was a little like watching some huge inflatable, on Earth, bounding slowly down a hillside; but at length, as the low gravity worked in the resistance-free vacuum, the rock picked up speed. He watched it until it had plunged out of sight, in the deep shadow of the rille. It left a trail in the regolith, a line of shallow craters that looked as if they had been there for a billion years.

He listened for a while, but there was, of course, no noise, no crack as it reached that remote bottom.

"Um," said Henry. "Kind of fast. Suddenly I feel vertiginous."

On his butt he worked his way back up the slope, and stood up, yards from the eroded rim. He had left a track like a sand worm in the regolith. When he stood up his butt and legs were coated with dark gray dust; he tried to beat it out but only succeeded in grinding the stain deeper into the fabric.

Geena was surveying the area. She pointed. One set of tracks continued from this point, deeper into the rille.

The ghost of Jays Malone was close here, he thought.

She said, "You ready?"

"Let's get it over."

She took the rope from her shoulders, and knotted it professionally around Henry's waist, taking care not to snag his backpack or his chest controls. Then she wrapped a length of it around a Chevy-sized rock, and took some slack herself.

For a moment they faced each other. Henry could see himself reflected in her gold visor, slumped forward in a simian pose under the weight of his backpack. But he could not see Geena's face.

Behind her, he could see the camera on the Lunar Rover fixed on them, watching analytically.

He ought to say something. But this was Geena, for God's sake. They were *divorced*. In full view of the world, what were they supposed to say now, as he prepared to confront an alien life form?

She said: "I'll be here."

"I know." He licked his lips.

He thought he could see her nod, inside her helmet.

He picked up his tools and turned.

He walked forward, toward the rille. He went over a smooth crest, and started descending into the rille itself. But there was no sharp drop-off; like every other surface here the rim was eroded to smoothness, and the footing was secure. The rope trailed behind him, reluctant to uncurl and lie flat in this weak gravity.

Just to be sure of his footing, he clambered back up the slope. There were no problems.

He turned, and bounded several yards back down the slope. Even from here he couldn't see the bottom of the rille; it was still hidden by the broad shoulder of the valley.

The footing was good here. The Moon, shaped by impacts, was littered with rocky rubble. But this close to the edge, a lot of those fragments would have tumbled into the rille, carrying off the dust, and that had left the regolith here very thin—

Suddenly his left foot disappeared, out from under him.

"Shit."

He looked down with surprise. His leg was just sinking into a pit of soft dust, softer and deeper than any other place he had come across, anywhere on the Moon.

He brought his right foot forward, but he caught it on

a rock, and he fell with some force onto his hands and knees. His leg came loose of the dust pit, but his momentum rolled him forward, and the roll carried him over on his right-hand side.

"Henry. Are you okay?"

"Just a little soft here. I caught my . . . I stumbled over that rock."

"You need me to help you?"

"No."

He pushed his way to his feet, bouncing upright like a mannequin. He stepped back a little way from that patch of soft dust. It was a rough disc, he saw—and it *swirled,* gently.

Just as he'd seen in Scotland, on another planet, just as he'd predicted, he had found it here.

"Henry?"

"I'm fine."

He carried on down the slope, following the tracks of Jays Malone as he had searched for his piece of lunar bedrock.

. . . And then he saw it, sheltering beneath a hummock in the regolith: an irregular-shaped crater in the regolith, scuffed by footprints. It was the original resting place of sample 86047, here on the Moon, a rock that had traveled a quarter-million miles from this spot, to his lab in Edinburgh.

He bent sideways, awkward in his suit, and ruffled the surface of the regolith with his fingertips, with reverence.

Then he straightened up. The tracks didn't go any farther, any deeper into the rille. The ghosts of Apollo couldn't help him anymore; and when he passed out of line of sight of Geena he wouldn't be able to speak to her. Now, at last, he had to go where no human had traveled before.

He raised his gold sun visor. For now, he wouldn't need it.

Clutching his equipment, trailing the rope behind him, he marched on down the slope, into the shadow of the rille wall, alone.

* * *

It was dark here, the only light scattered from the far side of the rille.

He lit his helmet torch. It cast an ellipse of light on the regolith surface before him, and back-scattering illuminated a short way beyond that. He had to keep his head down so the light showed him where his feet would come down, so he could see only a few feet ahead of himself at any time.

He was truly, he thought, approaching the heart of darkness.

At first he moved cautiously. But the slope here, sand-blasted by micrometeorite rain, was still gentle. Walkback limits, he thought; he could afford to go a little faster.

He lengthened his stride. Soon he was bounding in slow-motion leaps, sailing over the rocks and dust. When he landed he sent up sprays of dust which collapsed back immediately to the surface, like handfuls of gravel.

The trick with the light now was to keep it focused on the spot he was likely to land, rather than directly under his feet; it took some coordination, but he was getting the hang of it.

He allowed himself a moment of exhilaration. Hot shit, he thought; this is the way to do a field trip.

But now the ground was getting steeper, the regolith layer thinner; the sprays raised by his footfalls were diminishing.

He tried to slow. But he'd underestimated his momentum; old Sir Isaac was pushing at his back, and the surface under his feet was slithery. He leaned back and tried to dig his heels in, but that succeeded only in tipping him over backward.

He slid six, ten feet on his butt, deeper into the rille. In his stiff Shuttle suit it was like sliding down a ski slope in a box.

He tumbled to a halt.

He sat there in darkness, breathing hard, his torch showing him only a few yards ahead, so close was the rille's horizon now.

His rope gathered itself up, went taut, and he got a good hard tug on the chest. Geena, telling him to behave himself.

Well, she was right. It was going to be a lot harder coming back up.

He got up and slapped ineffectually at his thighs, trying to dust himself off. He held onto the rope, and stepped cautiously, ever deeper, his feet scraping now over almost bare basalt.

He came to a place where the slope was steeper than one in one. There was a basalt ledge here, a place where one of the lava strata had become exposed; it made a place to stand. When he looked up, his torch showed him the rille wall tipping up and away from him, dauntingly steep and tall.

He wasn't sure he could go any farther in. This would have to do.

He took his instrument bag off his shoulder, and placed it carefully at the back of the ledge. Then he got to his knees, and crept forward to the lip of the ledge. The suit fought him the whole way, but he crawled determinedly.

He stuck his head over the edge.

His torchlight splashed down over the steepening rille wall. More basalt layers. He inspected them briefly, noting their thickness, their difference in composition.

The whole history of mare volcanism was laid out here, clear as a road map. He longed for a couple of grad students, a truckload of sample bags. Maybe just by visual inspection, a couple of samples, he could achieve some good science here . . .

But he knew he mustn't. His objective lay farther on, and he must hurry to achieve it before his life support limits cut him short.

He lifted his head, and let his torch beam play farther down the slope.

It looked as if the base of the rille, here, was no more than thirty or forty feet below him. The surface was smooth, silvery and flat.

It looked as if a river of some fluid had been dammed here.

Moonseed dust.

He raised his head further. His ellipse of light lengthened, until the glow became too attenuated to make out. As far as he could see, across the width of the rille, and to left and right along its length, the Moonseed dust lay, shimmering in his torchlight. It looked as if a river of mercury had come lapping through the rille's dusty walls.

He found a loose rock, a fist-sized pebble an arm's-length away. On impulse, he picked it up. He looked at the big astronaut's Rolex on his wrist, set its timer, and dropped the rock.

He watched the rock fall, at first with dreamy slowness, and then with greater, more Earthlike velocity as the slow gravity had time to work. If he got the timing right he would be able to calculate pretty accurately how far below him that surface was . . .

In the light of his torch, the rock hit the surface, and disappeared. The Moonseed dust closed over it without a ripple, as if it had never existed.

He checked his watch. Four seconds. The Moonseed was forty-two, forty-three feet below him.

He knew he had to wait for the results of his seismic analysis. But already he knew what he would find out.

The whole damn Moon was rotten with Moonseed, just as he'd suspected.

And yet the Moon was still here, unlike Venus.

He crawled to the back of the ledge. He worked his way along the ridge, setting out his instruments, little tin can boxes containing sensitive seismometers, shrouded in thermal blankets. The seismometer signals would be analyzed as real-time data and in terms of frequency to record the ground's vibration. He set up combinations of theodolites

and electronic distance meters that might give some clue as to the deformation of the ground, even here on the side of the rille. And he deployed, close to the rim of his ledge, a small cospec, a correlation spectrometer, that would be able to measure emission rates of any gases it could detect. The instruments would be connected to a central data collection and communications unit and batteries by multiplex cables, that he plugged into the backs of the boxes.

All these instruments were improvised from light-weight gear deployed by VDAP to gather real-time data on volcanic events. It was true that what he was investigating here was no volcano, but even volcanology was a young science; he hadn't had any smarter ideas on what to bring here, to this infestation on the Moon.

He actually enjoyed setting up the science gear: plugging cables into their sockets, testing power couplings and data transmissions. It was simple work, no more complex than putting together a backyard barbecue. Yet it was good for his soul to have some familiar tasks to get through, here amid all this strangeness. He moved between the instruments, the fans of his backpack whirring, the oxygen blowing cool over his face.

When the science station was set up, he stepped back from it, toward the edge of the basalt ledge. He ran his eye over the connections one more time, making sure he hadn't missed something dumb, checking all the power lights were switched on. He didn't want to have to come back down here and fix anything.

However, it all looked fine. Now all he had to do was climb out of here, trailing a comms link cable behind him, so the station could talk to the surface, and so to Earth and the shelter.

But there seemed to be a softness, beneath the tread of his right foot.

He looked down sharply. He was maybe four feet from the lip. But suddenly the rock surface was crumbling like wet sand.

The last three or four feet of the ledge just disappeared, in a half-circle extending maybe a yard around him. Under a surface of some kind of duricrust, he realized, this whole ledge was rotten with Moonseed dust. Suddenly he was falling, amid a cloud of dust, and there wasn't a damn thing he could do about it.

Moonseed sparkled in the light of his torch.

Falling on the Moon:
Dreamlike slowness.

In the first second—the first one or two rattled heartbeats—he only fell through a couple of feet. He fell stiffly, his suit starfishing around him, as if he was in some body-shaped coffin.

Two seconds, and, picking up speed inexorably, he had fallen ten feet. The rope was coiling behind him, still fixed to his waist. How much was there left? Enough to stop him hitting the Moonseed river?

Would he just drag his anchor rock off the lip of the rille after him?

Three seconds, maybe twenty feet, and at last his speed was becoming respectable. No air here, so no terminal velocity; if there was a hole all the way to the center of the Moon you would just keep on falling, accelerating steadily, until—

His feet hit the surface of the Moonseed river.

It worked its way up his legs, to his waist, sluggish ripples spreading out from him. His speed slowed rapidly as the resistance of the dust built up. He could feel the pressure of the dust on his legs, crumpling the inflated pressure suit.

Now he was sinking slowly, as if into treacle. He tried to keep his arms out.

Up to his waist. He couldn't move his legs.

He would presumably reach some level at which he would be buoyant. The dust was all but a fluid; Archimedes' principle would work, even here. How deep would that be?

So deep that the pressure of the dust would crack his visor, ramming itself into his mouth and nose and eyes? Or maybe the end would be less spectacular: eventually, the heat trapped by the dust would surely kill him . . .

The dust was up to his chest now. But his rate of descent was slowing. He tried to kick at the dust; maybe if he could lie on his back he could float like a swimmer on the Dead Sea. But he couldn't move his legs, not so much as an inch; it was as if his pressure suit was embedded in concrete.

But the rope was taut, pulling at his waist. *Geena.* She was trying to drag him out of here.

He lifted his hands, and grabbed at the rope which snaked out from his waist like an umbilical cord. He could feel the tension; he imagined Geena at the surface, hauling, digging her feet into the regolith.

It was working. He could feel the dust falling away from his legs. Maybe he was out of it already.

He kept pulling, and Geena kept hauling, and he could feel himself rise with dreamy grace. Maybe he was going to live through this after all . . .

But now he became aware of a new problem.

He couldn't hear the pumps and fans of his backpack anymore, nor feel the breath of oxygen over his face.

When he looked down at his chest panel, there was nothing but red lights. The heat, the pressure of the dust had killed it.

But right now he felt fine. Better than fine, in fact. He felt alert, confident. When he looked up above, he could see a line of white light, the sunlit upper face of the rille.

Actually, he felt a little high.

He had no doubts, suddenly, that he would live through this; in a couple of minutes he would be with Geena, and then back to the shelter, and Earth, and in a few years it would be no more than a sea story he could share with Jane . . .

He was flat against the rock face, being dragged upward, almost passively.

Now he was approaching daylight. He was being hauled up the shallow upper slope of the rille, like a swordfish being landed on some Greek island beach.

He seemed to be lying on his back. The sun, a ball of white light, flooded his helmet. He turned his head toward it and let all that pure light pour into his open eyes. It was really quite beautiful. And there were colors, like the kaleidoscopic sparkle of a granite thin slice in his petrological microscope, all around him, the colors of the Moon.

But now there was somebody before him, a snowman figure loping around him as if in a dream. He—or she—reached down and closed something over his face, and the world turned to gold.

He closed his eyes.

Gold, gray, black.

Henry's backpack was just a ruin. Crushed and overheated. Even his emergency oxygen supply, from the purge tanks, seemed to have failed. He was clearly suffering hypoxia. A few more minutes of this and he would suffer permanent brain damage.

Geena dug hoses out of her backpack. She coupled her own emergency air supply to Henry's. That would be enough for an hour or so. Then she hooked up more hoses so Henry could share her supply of cooling water; he'd broil before they got back to the shelter otherwise.

She was tempted to peer into his helmet, to see if he was breathing, if he was responding. But it wouldn't do any good. What could she do, take off his gloves to see if his fingernails were blue?

She pulled him up. He half-stood, inert, like a statue, so stiff was his suit. She managed to get his arm over her shoulder, her arm around his waist. Under lunar gravity he only weighed a couple of pounds, but he was awkward, a stiff, massive shape. As she hauled him back toward the Rover, his feet dragged in the regolith.

It was going to be a race back to the shelter, to get Henry inside before that emergency pack expired. At least driving back would be easier. They only had to follow their own tracks back, to be sure of their destination.

But if anything else went wrong—if a fault developed with her own backpack, or the thirty-year-old Rover—it was quite possible neither of them would live through this.

She tried to hurry, forcing Henry forward, across the slippery regolith.

47

Henry became conscious again, long before she got him back to the shelter.

"We have to get back," were his first words.

"I know. We're going."

"I have to start analyzing the data." He looked at the hoses which snaked between their backpacks. "Thanks for saving my life."

"Pleasure."

"I don't think my fall affected the station I set up."

"You checked as you fell to your doom, did you?"

"Yes," he said, without irony.

They bounced across the surface of the Moon, back to the shelter.

She parked as close as she could to the shelter. It wasn't easy to get inside; linked by the hoses with their fragile couplings, they had to move like Siamese twins, taking care over every step.

Once inside, she checked the shelter's air and took off her helmet and gloves. She could feel a gush of moist heat escaping from the joints at her wrists and neck; it was a relief to shuck off the suit and move freely.

Henry went straight to work. He set up his pc, checked the data link to the remote station he'd set up in the rille, and

started tapping at his keyboard. And he prepared some of his samples on slides for his ridiculous high-school microscope.

He worked feverishly. She knew Henry of old; in this mood, whatever his physical state, he wouldn't be dissuaded. It used to irritate her. In fact she thought of Henry as a workaholic. Well, maybe he was. But right now, she realized, whatever understanding Henry achieved today, here on the Moon, might be crucial for them all.

So she let him work, and contented herself with a health check; he didn't seem to have been permanently harmed by his brush with the Moonseed.

She tended to her equipment. That pesky Moon dust had continued to etch into her gear, she found. It was now ground deeply into the fabric of her suit, and even when she tried to scrape it out with her fingertips she only succeeded in working it into her fingers and under her nails. The metal seals at wrist and neck were getting quite badly corroded. And the handle of Henry's geology hammer had had its rubber coating worn away to bare metal.

She recharged her backpack. She took a look at Henry's, but it was ruined beyond her capability to repair it here. When they next left the shelter they would have to do it bound together once more.

She made some food. A hot drink: chamomile tea, one of Henry's favorites. She made him drink and eat, and he complied, but he didn't seem to notice what he was being fed.

She sipped her own tea. Even freshly made, it didn't seem hot enough. One of the old clichés of lunar travel, she thought: water boils at lower temperature in low pressure. Well, it was a fact of physics, and here she was living it out.

Still, the tea was a comfort.

Afterward, she pulled on her sleeping bag and lay down. She ought to try to get some sleep, she knew; God alone knew what the next day was going to bring. She considered filling her bag with water from the tank. In the cir-

cumstances, though, the drizzle of radiation seemed the least of her worries.

She closed her eyes, and listened to the tapping of Henry's fingers on the keypad of his laptop, his characteristic, soft, under-the-breath mutterings—frustration, surprise, satisfaction. Just like old times, she thought. As she drifted, the drizzle of key taps seemed to stretch out, as if Henry was some scientifically-minded robot, slowly running down.

Maybe she slept.

Henry tapped her on the shoulder. He was hollow-eyed, but he seemed healthy enough. He was chewing on a rice cake.

"You okay?"

"Yeah," she said.

"But you're wide awake."

"I am now."

"I'm sorry," he said.

"You aren't working."

He shrugged. "I think I'm done for now. Monica Beus sent me another E-mail. Smuggled it past the NASA smiley-face censors."

"And?"

"And what? The world is coming to an end. Where do you want me to start?"

The event in Scotland, its scale unprecedented in the lifetime of the human species, had shaken the world on every level—physical, political, economic. Governments were collapsing all over. Someone had taken out the U.N. building in New York with a backpack nuke. Britain had invaded the Republic of Ireland, seeking living space.

The NASA satellite pictures were scary. White infrared blurs that were whole populations, running. Black scars showed where thousands, millions, had died. People were fleeing in herds, seeking safety where none existed anywhere on Earth, all dignity gone.

After the collapse of the international order, wars had flared all over, in every troublespot you could think of, nuclear, chemical, biological, conventional. But it hadn't taken long for the collapse and general chaos to reach a point where large-scale warfare was impossible, and the conflicts descended into low-level, low-tech—but nonetheless bloody—local brushfire.

"Good news," Henry said humorlessly. "Famine is killing more people than war. Oh, and NASA centers have been coming under attack."

"Why, for Christ's sake?"

He shrugged. "You got to blame somebody."

He was talking too fast, his mood strange.

She pushed her way out of her sleeping bag. "Show me what you have."

He brought over his laptop. The screen showed a sphere in false colors, yellow, orange and red, slowly rotating, semitransparent so she could see to its core.

He asked, "What does this look like?"

Under a near-intact crust, the sphere was riddled with pockets and chambers. The core was picked out by a hard, dark blue knot. "A rotten apple."

"It's the deep structure of the Moon."

"Right."

He explained how he'd produced this image.

The Moon was a quiet planet.

It wasn't just the lack of air. The Moon had some seismic activity. In fact the heaviest quakes were imposed by the Earth, every month, "deep forming Moonquakes" caused by the dark tides Earth raised in the rocks of the waterless Moon. And there were occasional "shallow Moonquakes"—smaller, isolated events, of which nobody knew the cause. There were even occasional landslides, caused by impacts or quakes.

But the Moon's seismic violence was only a hundred-millionth part of the energy that racked the Earth.

On the airless Moon there could be no sound, of course.

But the Moon, paradoxically, transmitted sound well, through its solid structure. The Moon had "high Q," Henry told her. That meant that when you hit the Moon, as he had done with his implanted charges, it would ring like a bell. And if you set a seismometer on the surface, it could pick up your footsteps as you lumbered away in your spacesuit.

What all this meant was that Henry's networks of seismometers were a powerful tool for unraveling the meaning of the rocky waves that passed through the Moon's interior.

"... I have a database and analysis program here called BOB II," he said. He brought up lists of commands. "A neat piece of work. Command-drive, interactive. It's adapted from the data analysis suite VDAP uses—the volcano disaster people—for the real-time analysis of time series data of seismic events in crisis situations. And—"

"Henry, I don't care about the software. Tell me what this means."

For answer he reduced the Moon's image, and paired it with another. "This is what we called a puffball rock, from Edinburgh. Just a couple of feet or so across. Rotten with Moonseed, ready to blow."

It was an irregular elliptical shape, something like a potato. But it showed the same pattern of pockets through its structure as the Moon.

"You're telling me the Moon is a puffball rock."

"I'm telling you the Moonseed has infested it, as it did rocks on Earth." There were differences of detail, but the patterns of the two infestations were the same. "You can see the relative scaling of these chambers—the way they cluster, like bubbles butting up against one another. We find the same in smaller rocks. Even dust fragments."

"... The Moonseed is all the way through the Moon," she said. "That's what this means."

"Yes." He rubbed his eyes. "I'm sorry. I guess that isn't so obvious, unless you study this stuff. Yes. The Moonseed is all the way through the Moon. I kind of knew it would be," Henry said sadly. "The assumption of mediocrity. Jays

Malone wasn't looking for Moonseed, so from the point of view of the Moonseed he landed at random, but he found it anyway. If it was here, at Aristarchus, it was going to be everywhere . . .

"Geena, the Moonseed works in a fractal way. The same structure regardless of scale. Whatever rock it settles in, it sets up the same kind of infestation pattern through the structure. And if you slice off a small piece of that rock, you'll find the same structure repeated on the smaller scale, and if you slice off a piece of that, the same again . . . Right down to the microscopic." He shook his head. "You have to admire the design. Cold, simple, logical. Yet with time, with the most minimal of resources, it allows the Moonseed to infest a world. The Moonseed is adapted to the universe. Perhaps the Moonseed, not we, is going to be the true master of the future . . ."

"You know, I hate it when you talk like that. It's a sign of your morbid personality."

He looked surprised. "Morbid?"

"Sure. How often would you wake me at three A.M. full of angst about death and futility? Morbid, Henry, that's you."

"Well, I guess I have a lot to be morbid about."

She studied the Moon image once more. "Here's something not in your puffball rock." She tapped the dark center of the image.

He rubbed his eyes. "It's a mass anomaly at the center of the Moon."

"A mascon?"

"No. More dense, relatively, than that. More regular."

"Regular?"

"It shows plane surfaces. Evidence of internal structure. It's tens of miles across; it must be very dense. The data's a little patchy . . ."

"What is it?"

He paused before replying. "Geena, I didn't come to the Moon just to find if the Moonseed is spread right through it. I knew that must be true, if a galoot like Jays

Malone could land at random and pick up a sample at his feet. All this is just confirmation."

"Then why?"

"I had to find out why the Moon continues to exist at all. *Why doesn't the Moonseed destroy the Moon, as it did Venus?* Something here has to be suppressing it. Making it inert. Oh, probably the stuff near the surface went off long ago, under the action of sunlight, but the reaction, the spread of the Moonseed, was stopped. Like everything else on the Moon, the Moonseed infestation here is old; the surface activity finished long ago."

"Are you saying that this thing, at the core of the Moon, is suppressing the Moonseed?"

"I think so." His eyes were fixed on nothing. "It's the Witch in the Well, Geena. The demon at the heart of the Moon."

"But what is it? Some geological thing?"

"No . . ."

He told her his hypothesis.

It came to Earth when the Solar System was young.

One day, human scientists would call it the Impactor.

It had about the mass of Mars, a tenth of Earth's. Humans would later speculate that it was a young planet in its own right.

But they were wrong. It was not a planet.

Its heart was a dense block of matter, complex, its surface shifting, silvery. It was a hundred miles across, extraordinarily dense.

This core came trailing a cloud of silvery motes. Where the motes touched, worldlets were transformed. Raw materials rained down on the surface of the core.

It was heading for the sun. There, less than a solar radius from the young sun's roiling surface, a great sail would be unfurled—or rather assembled, from the materials leached from the young Solar System. The sail would be

almost perfectly reflective, so much so that it would have been cool, to a human touch. Humans would one day speculate about such objects, as designs for craft to cross the gulfs between the stars.

But this was no craft. To a human eye, the sail would have looked organic, its surface as structured—and as beautiful—as a young leaf.

The flood of raw sunlight would hurl the core, the sail and its attendant cloud out of the Solar System, and on to a new destination, another young system, pregnant with resources.

Perhaps that was the plan. Or perhaps the intention was different. Or perhaps there was no conscious intention.

From without, it was impossible to say.

Whatever its purpose, the object barreled through the dusty plane of the Solar System, heading for the sun.

But there seemed to be something in the way.

"Earth," Geena said. "You're saying the Moonseed hive—ship, whatever—was the Impactor that hit the Earth—"

"And created the Moon. *And it's still here,* deep inside the Moon." He laughed. "Ironic, isn't it? Without that impact—without the Moonseed—life on Earth wouldn't even exist. But now it's going to destroy us."

She studied him. "Let me summarize. A massive Moonseed hive crashes into the Earth. The impact forms the Moon. The hive becomes trapped at the core of the Moon. Its cloud of, umm, nano manufacturer insects, is trapped in the Moon's fabric. They stop their destructive behavior because of some kind of asimov inhibitor . . . It sounds like something your dippy girlfriend would come up with."

"Jane's too sensible for this stuff. Look, it's a consistent hypothesis. This mass concentration at the heart of the Moon, the wreckage, is actually a confirmation."

She said, "But what about Venus? All that stuff about a black hole rocket—"

"I think that fits. If a hive gets trapped in a star's gravity well, for whatever reason, it needs a more energetic propulsion system to escape than a solar sail."

"But in this case—"

"In this case, the hive got itself more deeply trapped than that." He stretched out on the floor; there were bruises on his neck, where his suit had caught him during the fall. "So I figured it out. I found what I came to find. The trouble is, it's no use to us."

"Why?"

"Because what is suppressing the Moonseed is something inside the wreck of a five-billion-year-old hive at the core of the Moon. Kind of out of reach, don't you think?"

He bit into his rice cake, and chewed slowly, his expression neutral.

"So what now?"

"Now," he said, "I do some thinking."

"Thinking? What the hell is there to think about?"

But he wouldn't reply. He turned back to his screen, and its light filled his eyes.

His plan, she thought. He is figuring out his plan, the one he won't tell anyone. Whatever the hell it is, it had better be good.

She persuaded Henry he should sleep.

She watched over him, listening to the whir of the fans and extractors.

She looked out at the Moon's molded plains. Alone on the Moon, the only conscious mind in the world, she was driven in on herself.

Time stretched out here, in the Moon's shallow gravity, she thought.

She touched her face, the lines there, the stiffness of her graying hair. She was, of course, aging, as was every other member of the human race. Falling helplessly into a

black future, hour by hour. And you don't even, she thought, get a day off for good behavior.

She checked her watch. The Rolex ticked slowly, steadily. It was 3:00 A.M., Houston time. The morbid hour.

Their human activities were regulated by the constant heartbeat ticks of their Rolexes and timers, the limits of their consumables, the working of their equipment. The chaotic clamor of Earth's bad news. But that busy human ticking was irrelevant to the grand, slow timescales here, the time of the Moon. A day here lasted a month; she had worked for six or seven hours on the surface, and there had barely been a change even in the angle of the sunlight.

And beneath that there was a still grander timescale, of the slow evolution of the Moon itself. She thought about all she had seen—the ejecta hills, the rille, the crater-sculpted plains—and she knew that she could have come here a billion years before, or a billion years from now, to find basically the same scene.

The Moon cared nothing for time. And the longer she stayed, the more her own busy schedules came to seem irrelevant. She felt as if her sense of time was dissolving, stretching like melted candle wax. Perhaps she could sink down into the Moon's rhythms. Perhaps if she kept still, she could lie here long enough for the Moon to turn beneath her, and carry her into the night.

Henry seemed to be sleeping peacefully.

In a way, he had what he wanted. And there was the paradox of a scientist. On one level Henry was satisfied. What had driven him in his feverish efforts earlier—what had driven him all the way to the Moon—wasn't so much fear for himself, a desire to save those he loved, as simple curiosity. Now, Henry had his answer.

But that was too simple. Henry was no one-dimensional Brainiac. She suspected he understood the Moonseed on a level that defied her. And when he contemplated it—its simplicity of operation, its immense timescales, its tenacity, its capacity to destroy worlds—it seemed he felt genuine awe.

She suspected he *envied* the Moonseed its lack of the complexity that bedeviled human life. Maybe Henry would like to be a half-machine, like the Moonseed.

But even that wasn't the bottom of the truth, she thought sadly. Because, plumb in the middle of Henry's life, there you had dippy Jane, his relationship with her based on nothing but—she forced herself to admit it—*love.*

Maybe she'd never really understood Henry, she thought. Or vice versa. Probably they'd never stood a chance.

She probed at her own feelings. She felt—numb. Bewildered. Maybe she had gone through too much; maybe she was in shock.

How were you *supposed* to feel, when your ex-husband says your species is doomed?

Geena had grown up, in San Francisco, without religion. She'd never felt the need of what she thought of as its ersatz, manipulative comforts. So she had never had the expectancy of surviving her own death.

More than that: she'd grown up with the message of science, which was that humanity had a finite tenure on the planet, come what may. If nuclear war didn't get you, the eco-collapse would, or the dinosaur killer, or the return of the glaciers, or the extinction of the sun, or . . . The doom scenario depended only on which timescale you chose to think about.

She was an advocate of space travel. Colonies off the planet would have boosted mankind's chances of survival. If NASA's more grandiose plans had come to pass and there were now, say, three or four hundred people living in some kind of Antarctic-type research station on Mars, right now, they wouldn't have to worry so much about this Moonseed thing.

The Earth might die. Even the Moon. Mankind wouldn't have to.

But it was too late for that.

The fact was humans just weren't adapted to living anywhere away from Earth—the deep gravity well and

thick, complex atmosphere they'd evolved in—and there was nowhere else in the Solar System for them to go.

She was glad she didn't have a kid . . .

"What are you thinking about?"

Henry's voice made her jump. He was lying in his sleeping bag, eyes wide in the dark.

"Sorry," he said.

"I was thinking about the Moon."

He scratched his couple of days' growth of beard. He never could grow a beard, she thought; it came up comically patchy. He said, "Plutarch said the Moon was a way station for our souls. Humans have to die twice. First on Earth, where the body is severed from the mind and soul, and returned to dust. And the mind and soul travel to the Moon. There, a second death occurs, with mind and soul separating. The mind flies off to the sun, where it's absorbed and gives birth to a new soul. But your soul stays here, on the Moon, sinking into the Moon dust, clinging onto dreams and memories . . . Maybe all that stuff about rocket ships and Cape Canaveral and Baikonur was a fantasy. A false memory. Maybe we died, you and me. Maybe we're just clumps of memories, sinking into the regolith."

She was shivering, despite the warmth of the hab.

"Shut up, Henry."

"Sorry." He rubbed his face; his patchy beard looked to have grown a little denser.

She felt she couldn't stand the stillness any longer.

"Henry, for Christ's sake."

"What?"

"Tell me your plan."

He hesitated.

"I haven't shared this with anybody," he said.

"Not even dippy Jane?"

"Not even Jane."

"I promise not to laugh at you. But I could use some good news right now."

"... I think there's maybe a way out. It's risky. The math is chancy; it depends on a lot of assumptions."

"Like what?"

"How much ice there is at the South Pole. What happens when you drop a nuke on lunar Moonseed; what kind of energy amplification factor you can achieve here, in the presence of the hive remnant—"

"Why didn't you tell me about it before?"

"I had to get here to be sure. I had to confirm the Moonseed is as extensive as I suspected. And—"

"What?"

"I had to sleep on it."

"Why?"

He sat up. The sleeping bag fell slowly away from his chest, exposing his long johns. "There are a lot of costs. Suppose I told you it might be possible to save some of mankind."

"Not all?"

"Not all. A handful. Maybe enough to start again."

"Right now, I'd take it."

"Okay. Now suppose I told you it would mean wrecking the Moon, as it exists now, before we have any kind of chance to study it, to learn from it. Gone forever."

That made her pause.

"Go on."

"Suppose I told you it might cost us our lives." He grinned tightly. "In fact, probably. That's the part I've been sleeping on."

She closed her eyes. "I guess we're all soldiers now," she said. "And this is the front line."

"Suppose I told you it will *certainly* cost Arkady his life."

She kept her face still. "Why?"

"We talked about this. Because somehow Arkady is going to have to deliver that nuke of his to the surface, at the South Pole. It's kind of hard to see how he can do that with-

out at least stranding himself in orbit. Look, Geena, when I came out here I didn't know what Arkady meant to you."

"Would that make a difference now?"

"I don't know," he said. "Let's face it. It's complicated."

"Then we must ask Arkady how he feels."

"Yes," he said. "Yes, we must."

"Tell me what you got."

He opened up his laptop, and started to explain.

And that was how it started.

They got into a complex four-way discussion, involving Houston, Korolyov, Arkady up in orbit, the two of them huddled in their shelter.

The mission planners in Moscow and Houston came up with a way for Arkady to deliver the bomb as Henry asked. It was actually Arkady's idea. They chewed it over from every which way.

It lasted hours. It involved geologists, orbital mechanics specialists, NASA managers, even politicians.

The plan was wild, implausible, resting on a lot of unproven assumptions. And none of them—Arkady, Geena or Henry—had a hope of living through it, to see if it worked.

But, she slowly realized, they were going to do it anyhow.

Eventually they got the go-ahead. The consensus was, they had little, after all, to lose by trying Henry's outrageous idea.

Arkady, of course, agreed immediately, as Geena knew he would.

When she thought about it, his proposal was entirely in line with his character. Because it would allow him to become a hero at last: a new Gagarin, transcending the old, the savior of the planet.

And as they talked on, the sun climbed imperceptibly

into the sky, and the slow lunar morning wore on toward its long noon.

48

The procedures for the final operation were rather intricate. Arkady copied them down by hand, on the backs of checklists for the trans-Earth injection burn and Earth-return aerobraking maneuver, neither of which would be required now. And when he had transcribed them he read them back to the ground controllers, in English and Russian.

He was forced to perform a brief space walk.

He opened the forward hatch, in the nose of the Soyuz's orbital module, and thrust his head and shoulders into space. Then he clambered out, hauling the laser package after him.

The laser was an American Star Wars toy. Developed at Phillips Labs for the USAF, it was designed to be carried by a 747 aircraft, and used to shoot down short-range missiles. The technology was simple, light and robust, and no doubt inordinately expensive.

Still, the technology was remarkable. The laser was fueled by hydrogen peroxide which was mixed with chlorine to produce oxygen atoms. At hypersonic speeds, the oxygen was forced with iodine into the lasing cavity, which was a container no bigger than a breadbox, with mirrors at either end. When the oxygen reacted with the iodine it emitted light which was bounced between the mirrors, before being released . . .

The power generated by this miniature contraption was more than a megawatt.

It had seemed absurd when Henry Meacher had requested this system. What was he expecting, dogfights with the Moonseed in orbit around the Moon? But now, it seemed, its true destiny was becoming clear.

It was a simple matter to fix the laser in place on the outer hull, with silver wire and tape, so that its blunt nozzle

pointed ahead of the Soyuz. Arkady used his sextant to check its orientation; it must point directly along the axis of the craft.

When he closed the hatch and pressurized, he found the compartment filled with the sharp scent of space, the tang of scorched metal.

Next, he considered the nuclear weapon, the B61–11 bunkerbuster, stowed here in the orbital compartment.

The laser could be controlled from a laptop computer, which he would have close to him during the landing. He ensured that the nuclear weapon could be triggered from the same device.

It was, thought Arkady, at heart a simple problem.

Henry insisted that his nuclear device, the bunker-buster, must be delivered to a precise point, at the very center of the South Pole-Aitken Basin. But the nuclear device was in lunar orbit, on board Soyuz, and simply dropping it, at orbital speeds, would not suffice.

But to leave orbit and land took energy to remove the velocity with which a spacecraft circled the Moon. The two landers used in the mission had expended that energy in the form of rocket fuel.

Now there were no more landers available. And, just like the Apollo Command Module, Arkady's Soyuz was not designed to land on the Moon.

Nevertheless, it had been decided, it would have to, in order to complete this new mission.

In the 1980s NASA had actually studied this mode of landing, if briefly. It opened up a new area of knowledge, tentatively called "harenodynamics," which was a fancy Latin-derived term for "sliding." Arkady had once attended a conference on lunar bases, industrialization and settle-ment, which had touched on the subject; when he raised it now with NASA's Mission Control at Houston, it had not taken long for the back room people there to dig the mater-ial out of their archives.

And even less time to express their disbelief.

The trouble was, a Moon landing required a dispro-
portionate amount of fuel. Because it had no air, either for
frictional braking, or for supporting gliding or parachuting,
the Moon gave its visitors no help on the way down.

But harenodynamics was a way of forcing the Moon to
help after all. *If* it could be made to work, it could provide
a way of landing that would need just ten percent of the fuel
of a conventional landing.

The trouble was, nobody had ever tested the idea,
even on Earth, let alone the Moon. And Soyuz wasn't built
for it anyhow; there was a consensus that you'd need signif-
icant advances in a number of material technologies to
make the technique reliable, if it was possible at all.

And besides, all pilots who looked at the papers hated
the whole idea. If it was ever applied at all, surely it
would be only for unmanned cargo drones.

But—as Arkady had immediately realized when he
heard Henry's request—in the current circumstance, there
was really no choice at all.

He would go through with this because he had faith in
Henry, and because he trusted Geena; her relationship with
Henry had finished unhappily, but she would not select a
fool.

And besides, as far as he could see, it was only Henry
who had fully understood the implications of the Moon-
seed infestation from the beginning, and so Arkady must
do what was necessary to implement his plans.

But on Earth, arguments raged on.

There were hardly any scientists who were prepared to
validate Henry's grand proposal. The Americans' greatest
concern seemed to be allowing a Russian access to their
prized weaponry.

The Russian authorities were rather more focused on
the humanity of it. TsUP at Korolyov at first flatly refused
Arkady permission to proceed with this scheme. Breaking
with custom, his personal physician was brought on the
loop to try to persuade him to return to Earth. If he came

home, perhaps some alternative plan could be found—for instance, perhaps an unmanned missile could deliver a nuclear weapon as Henry desired.

But Arkady knew that could only cause delay. And it was self-evident that launches of any kind might soon become impossible from the surface of Earth; already many facilities at Canaveral had been destroyed in terrorist actions, and were in any event under threat from tsunamis. This might be the only chance.

In an attempt to persuade Arkady to desist, they even flew in his sister to TsUP, and had her talk to him on the ground-to-air loop.

It was never easy, Arkady had found, to talk to family and friends from space. Life in space—even on a routine Earth-orbit mission—was rather like a commercial airline pilot's: hours of tedium, punctuated by moments of extreme terror. If you tried to describe the tedium, it was simply dull; if you talked about the terror, you sounded melodramatic—worse, you might finish up frightening the person who cared about you enough to call you.

It made for awkward conversation.

But his sister knew him, and was wise. Nor would she play the part demanded of her by TsUP.

She spoke to him of simple family matters. *Vitalik asked me to say hello,* she said. Vitalik was Lusia's son, Arkady's nephew. *He is at summer camp. He is getting happier. He swims in the sea, he rehearses plays, he is doing arts and crafts. It was different in our day.*

"Yes." At the Soviet pioneer camps when Arkady was a boy, the children had been subject to meetings and political training, so much so they were sometimes deprived of sleep. Not everything about the breakup of the Soviet Union, they agreed, was necessarily so bad. And so on. Lusia spoke further of Vitalik's small projects and achievements.

She said nothing of his intentions, the fate of the world. She was simply saying good-bye, on behalf of the world, the family he had left behind.

She knew, as he did, that his proposed course of action would mean the final sacrifice. Even if, by some miracle, he survived the landing itself, he could not hope to live through what followed.

But then Henry and Geena were making as big a sacrifice.

There was really no choice.

It was a duty; it must be done.

After a time, they fell silent, and he listened to the soft hiss of the static on the air-to-ground loop.

And eventually, after much debate and protest, official permission was granted to proceed with the mission.

First, Arkady had to change the plane of the orbit of his Soyuz.

At present, the orbit was a ground-hugging circle, angled at some twenty-five degrees to the Moon's equator, a shallow tilt. Now, Arkady needed a ground track that would take him over the Moon's South Pole. So his orbit must be tipped up at a more jaunty angle, eighty degrees or more, so that he looped over both poles.

Steering a spacecraft to a new orbit was not a question of turning a wheel, like a car. The Soyuz's main propulsion system would have to burn at an angle to its present velocity vector, gradually pushing it sideways, like a tug hauling at a supertanker.

The velocity changes required were well within the capabilities of Soyuz with its Block-D booster—which was, after all, capable of returning him all the way from lunar orbit and to the Earth—and it was a neat exercise in three-dimensional orbital mechanics, which Arkady conducted in conjunction with the ground, to calculate the rocket burns required.

But the maneuver would absorb most of the fuel reserve put aside for the return of Soyuz to the Earth, whether Arkady proceeded with the landing or not.

And so it was that when Arkady felt the gentle push of the propulsion system at his back, he knew he was, already, committed.

Arkady allowed himself a complete orbit, in his new polar orientation, before he began his descent.

As he passed over the Earth-facing hemisphere of the Moon, he spoke to Geena.

. . . Are you lonely up there? Do you miss me?

"Yes," said Arkady. Yes. But I cannot tell you how much. Not when the whole world, including your ex-husband, is listening in. "I even miss Baikonur."

Baikonur? The steppe?

"The steppe has its beauty. At this time of year the grass and flowers have burned off, and the steppe has turned gray, save for the green of the camel thorn and the pale pink of the saxifrage flowers. Sometimes after the rain, puddles form, like little lakes, in the middle of the salty desert. Swans come to breed there! . . ."

It sounds beautiful.

"It can be."

Now, unexpectedly, Geena sang a song for him. Her voice was hesitant, not very tuneful, her Russian accent poor. But he recognized it immediately. It was a favorite from his childhood, *On the Porch Together.* Her voice was nervous and thin, reduced to a scratch by the radio loop, and it all but reduced him to tears. She had learned this song from his family, and had now brought it to the Moon for him. And she was filling his heart. Most Americans could never understand the importance of such simple human moments.

And when she was done, Geena sang one of Yuri Gagarin's favorites—so it was said, anyhow—called *I Love You, Life.* All the cosmonauts knew this one, and he joined in, but his voice was weak and he feared he would lose control.

At last, without warning, he sailed around the rocky limb of the Moon, and the radio signal turned to mush, cutting short her song.

He turned off the receiver, and drifted away into the empty, ticking cabin.

In solitude once more, Arkady watched the shadows lengthen, and, for the last time, he sailed into the shadow of the Moon.

It was necessary for his craft now to perform the final burn. As so often happened with the key events of this mission, it seemed, it must be done here, in the radio shadow of the Moon, when he was alone and out of touch with the Earth.

But if it must be, it must be.

He ensured that all the loose equipment in the craft was stowed away. Then he swam through to the descent module and sealed shut the hatch behind him.

He climbed into his pressure suit. He fixed his gloves and helmet in place. He made to close his visor.

He paused.

He clasped his hands on his lap, closed his eyes, and intoned, "Help us, God." It was just as if his family was with him, here in the sphere of the Moon. Then he straightened up to begin his work.

He closed his helmet, and settled into the contoured couch at the center of the descent module. He pulled his restraints around his body, adjusted them, and locked them in place.

Now, he need only wait for the computer to count down to the final burn.

Arkady sailed over the Moon's North Pole. The flat sunlight picked up particles swimming along with the Soyuz— flakes of paint or insulation—and if he banged his fist on the wall a whole shoal of them would be born. They seemed to sparkle as they moved away from Soyuz, but some of them floated nearby, as if tracking a current through water.

Three, two, one.

There was no noise. Not even a vibration. Just a gentle, steady, push in the back.

Good engineering, he thought.

Soon it was over.

He had lost velocity, and the orbit of the Soyuz had become an ellipse. As he sailed around the Moon, he would come gradually lower, until—as he approached the South Pole, all of halfway around the Moon—he would reach his new orbit's lowest point, which would graze the surface itself.

So he was committed. His only regret was that he would die alone, without so much as touching another human being again.

But then he would not be alone, on the Moon. Geena was there.

In the dark, the attitude system fired. He could hear the hollow rumble of the vernier rockets, like somebody dragging a chain across the hull of the ship. The Soyuz was automatically turning itself around, for it must come down nose-first. Through his portholes he could see flashes, a pinkish spray of particles from the reaction control nozzles, like sparks from a fire.

And then he flew into sunlight, without warning, as he had every two hours since entering this lunar orbit. As the light flooded over him, and the sun's heat sank into the fabric of the ship, making the hull tick and expand, he felt a surge of renewal, of rebirth. He basked in the light, like a cat on a *zavalinka,* the earthen wall of a peasant's house.

Coupled by the emergency hoses like Siamese twins, moving awkwardly, clumsily, constantly fearful of breaking their contact, ever aware of the way their time on the Moon's surface was diminishing . . .

Thus, Henry and Geena labored to collapse their shelter, their only home on the Moon, and to load up the old Apollo Rover with their survival gear.

When they were done the Rover was piled high with equipment. The collapsed shelter, a big pie dish, was tied to the back by nylon rope.

"Like something out of *The Beverly Hillbillies*," said Henry.

"I always hated that show."

They clambered onto the Rover, and Geena pushed at the joystick.

The Rover lumbered forward.

It was a rocking and rolling ride, all the way to the rille complex. Every time it hit a mound or a depression or a crater rim—which was every few seconds—the Rover teetered precariously, obviously top-heavy.

Geena followed yesterday's tracks, but today they rolled right past the point where they'd parked.

They approached the rim of a side rille, much smaller than Schröter's Valley.

"That's it," Henry said. "Pull over." Henry got out of the Rover even before they stopped, but his hoses yanked him back, and he tumbled back into his seat.

She rapped his helmet. "Do *not* do that again, asshole."

"Sorry."

They went through the complex and embarrassing ballet of getting themselves, as a joined pair, off the Rover.

Together, they walked to the rille. Geena held Henry's hand, to ensure they didn't separate too far. She couldn't feel his hand, inside the thickness of his glove. It was difficult to Moonwalk, joined like this; they had to synchronize their loping.

The rille was small—only twenty or thirty yards wide, its walls deep-cut. Henry had picked it out from old low-orbit Apollo photographs. In the low sunlight, with the regolith's tan sparkle, its eroded walls looked like a small mountain valley, she thought, somewhere above the snow line.

"*There,*" said Henry. He pointed along the rille. "You see that?"

She looked where he pointed. A few hundred yards along, the rille terminated; but she could see a kind of bridge of rock beneath which the valley continued, as if it entered a tunnel.

"What is it?"

"A lava tube. Our salvation. I knew there had to be one here. Maybe we can live through this after all. Come on. We haven't much time."

This was Henry's latest plan. She thought it was crazy. But she had to admit, now she'd slept on it, the idea of sacrificing her life without *trying* was less appealing than ever.

So, with Geena clinging on to Henry's hand, watching they didn't foul the tubing that joined them, they loped back to the Rover and began to unload it.

He fell inexorably from the empty lunar sky, every minute dropping five thousand feet and covering sixty more miles, the shadows lengthening as he rounded the curve of the Moon.

He must fly down the visible face of the Moon, all the way to the south, before landing. His altitude would drop steadily, sixty miles, forty, twenty, ten. He imagined his trajectory unwinding, a smooth curve shaped by gravity, kissing the surface of the Moon at just the point he intended, fifty miles short of the place he intended to deliver his nuclear weapon.

He was still flying at orbital speed—three thousand miles per hour, about Mach Five—and he would keep up those speeds, accelerate in fact, all the way to the surface of the Moon. Nobody in history had ever flown so fast, so low, not even Geena.

Certainly nobody had tried to achieve a touchdown at such speeds. And yet that was what he must attempt, today.

Through the tight portholes of his Soyuz, he caught glimpses of the surface of the Moon. It was a spotlit bombing range under a black sky, fleeing under his prow, fresh craters and basin rim mountains and undulating mare plains crowding over the close horizon with an unwelcome eagerness.

His view was completely sharp, of course. There was

no cloud, no layer of muddy air, to obscure his view; and at times he would lose his sense of altitude. At such moments he turned away from the windows and trusted to his instruments, his infallible electronic senses, and to the precise mathematics that had guided him here.

And now, as Arkady flew farther south, a new series of mountains—a ring of them, folded and eroded—came shouldering over the horizon toward him. They straddled the Moon, as if striving to block his further progress toward the Pole.

This was, he knew, the mountainous rim of the great South Pole-Aitken Basin: the huge impact crater that straddled the South Pole of the Moon, the largest and deepest such crater in the whole of the Solar System, a walled plain as wide as the Mediterranean Sea.

His Soyuz, like a little green bug, flew over the immense, eroded shoulders of the rim mountains. The mountains stretched before him and to either side, obviously ancient, colorless as plaster-of-paris models, a five-thousand-mile-long ring of shattered and folded Moonscape.

He checked his clock. Fourteen minutes to his touchdown. He was still seventy-five thousand feet high, with almost a quarter of the Moon's face still to traverse; yet he was already inside the great Basin.

The land beyond the rim walls was revealed now. It was battered and scarred even beyond the norm he had come to expect for this small, ancient, rocky world, every square inch of it crowded with craters and rubble. The biggest craters here were major complexes in themselves, huge and eroded, many miles across, their giant flanks punctured by smaller, brighter newcomers.

In the shadows of the mountain ring, there were places where the sun could not have shone for a billion years—perhaps the coldest places, Arkady thought, in the Solar System.

It was there that Henry predicted water droplets from Moon-smashed comets would collect, snowing once into

the shadows, and forever lying still. And it was there that Arkady must descend.

Ten minutes left. Fifty thousand feet: as high as he had flown, above Earth, before his first flight as a cosmonaut. And still he dropped, five thousand feet per minute, his descent as steady as aging, and the fleeing Moon rose to meet him, as inexorable as death itself.

His controllers at Korolyov were silent. There was, it seemed, nothing more to say.

And now, as the land fled beneath him, at last—for the first time, and utterly unwelcome—he felt the brush of fear.

The lava tube was maybe ten yards wide. Its entrance was strewn with rubble, evidently cracked off of the roof. When she shone her helmet lamp into its depths, it extended farther than her beam could reach.

"Good grief," she said. "It's *long.*"

Henry was moving into the tube, stepping carefully over the rubble-strewn floor, pulling their shared hoses behind him. To Geena, he was just a silhouette before the elliptical puddle of light cast by his helmet lamp.

She was forced to follow, reluctantly.

She was *spooked* by this place.

Of course she was being illogical. There could be nothing here to hurt her, not so much as a lunar rat. Nothing, in fact, had walked here since the tube's formation, perhaps a billion years ago.

But even so . . .

"Look how sharp the rocks are," Henry said. "No meteorite weathering here. Watch your step, Geena; this stuff could cut your suit to ribbons."

"And you watch out for the damn hosepipe."

"Yeah."

"You know, the tube is bigger than I expected."

"Well, this is the Moon. The last time I was in a lava tube was Hawaii. A couple of miles long . . . The lava on the

Moon flows much more freely. That's why you have the maria, great frozen puddles of the stuff. This tube might be ten miles long, maybe more."

"Henry, help me with this damn shelter. If we don't recharge our packs in the next couple of minutes, we're screwed anyhow."

"Yes, ma'am," said Henry. He loped across to work with her.

When they had the shelter set up, they crawled inside.

They sat there in their EVA suits, fully pressurized, within their grimy inflatable shelter, sheltered by the rille lava tube, talking by torchlight.

Geena said, "How long before we see anything?"

"Maybe three hours after the detonation. The math is chancy."

"That's a long time to wait."

"Not so long."

"Tell me a story, Henry."

"I don't know any stories."

"Tell me this is going to work. *How* much water is there at the South Pole?"

"I don't know for sure. But the Moon is old, Geena. Enough time for a *lot* of volatiles to collect in the cold traps, where the sun never shines. Water and carbon dioxide. My models suggest there might be the equivalent of a thousandth the mass of a large cometary impactor, delivered by one process or another."

"I'll give you your thousandth," she said. "So what?"

"Geena, a thousandth of a comet—if you melted it— could cover the Moon in water to a depth of a meter or so. A thousandth of a comet would contain enough carbon dioxide to form an atmosphere."

The fans of her suit whirred patiently. She was sitting on a folded-up blanket, her suit stiff; now she came a little closer to him, as if seeking the human warmth trapped inside the layers of his suit. "So how come *Prospector* detected so little?"

"Because it's logical. A working-out of the laws of physics. Solar System processes. It has to be there hidden in the deep regolith."

"Right. And your nuke is going to melt it all."

"Oh, no." He sounded surprised. "Don't you get it? To melt all that ice would take the energy of . . ." He thought about it. "Maybe ten times Earth's whole nuclear arsenal."

"So how is the bunker-buster going to work?"

She could hear the grin in his voice. "Judo."

Suddenly, she felt weary. She just wanted done with all of this, all these schemes and plans, one way or the other.

She closed her eyes.

"You've got to be a believer," he whispered gently.

Arkady checked the controls set out before him. There were instruments and switches for the main systems, a TV screen, and an optical orientation viewfinder set up on a small porthole next to the panel; there were orientation controls on his right, and maneuvering controls to his left. His small laptop, with its weapons controls, was fixed to the couch to his right.

For the nuclear device, he had rigged a simple dead man's switch. If possible, he would set the timer after a careful emplacement. But if power was lost, the device would detonate anyway.

His craft was prepared, and the weapons it carried.

He closed his hands around the joysticks that controlled the spacecraft's systems. There was no computer program to control what he was going to attempt, with this poor Soyuz; he must lead it perhaps to its destruction himself.

He was ready.

Two minutes left. Just ten thousand feet now. The Moon ground fled beneath him, flattening, bellying up toward him.

His descent was actually very shallow—just ninety feet

in every mile, much shallower than even a civilian airliner. His path, in fact, was almost tangential to the Moon's surface. But his speed was gigantic. The pocked ground fled beneath him, like a scarred runway in the last few feet of a descent.

One minute.

Five thousand feet up, and he was still sixty miles from his goal.

The land seemed to flatten further, the close horizon receding.

And then he flew *past* the flank of a round-shouldered lunar mountain, gray, pock-marked. Its shadowed far side was limned by a graceful, powdery curve of sunlit regolith, and its summit was lost above him.

As soon as he perceived the mountain, it was gone, lost behind him, as unreachable as his childhood.

Twenty seconds. Less than two thousand feet. The craters ahead were foreshortened to ellipses, pools of shadow in the sunlight, flattening.

He flew into shadow, and he could see no more.

And so, in darkness, Arkady—still moving at a mile a second, sitting up in his couch—hit the surface of the Moon.

Arkady's life, the success of his mission, was utterly dependent on Henry's theories.

At the moment of touchdown—the instant at which the rounded belly of the Soyuz impacted the lunar dirt—two things happened.

First, the attitude thrusters beneath Arkady's feet fired on full strength, lifting Soyuz away from the regolith. The thrust was sufficient to hold eighty percent of the Soyuz's weight up from the surface; the actual depth of contact ought to be no more than a few inches. Other thrusters fired intermittently, to keep the craft upright, stop it tumbling.

Second, the Star Wars laser fired from the craft's nose.

If this South Pole crater was indeed a frozen lake of water, dusted over by regolith, then the laser should blast-melt a shallow furrow, a canal of glowing steam, utterly straight ahead of Arkady. The liquid water—persisting for a few seconds before boiling away—would lubricate the ferocious contact between the hull of the Soyuz and the ancient ice.

The Soyuz would shed its orbital speed in friction with the water, and—sliding home like a baseball player coming to a plate—would come to a gentle halt, with barely any fuel expended.

That, at any rate, was the theory.

A hundred seconds and it would be over, one way or another.

Arkady was thrust forward against his chest restraints. The impact was violent, spine-jarring, harder than he expected.

The Soyuz groaned like a tin can. The craft rattled and jumped, as if some giant were battering its hull, the vibration so violent he could no longer see the instruments. The deceleration should be less than one and a half G, but it was a long time since he had been on Earth, and it was in any case the vibration that was shaking him to pieces.

. . . But the craft held. The cabin lights flickered, but stayed bright.

The pressure, the noise and vibration, continued. He struggled to stay upright, to keep breathing. His ribs ached, and there was a graying around the rim of his vision.

He heard a series of jolts and bangs: that was the solar panel wings, the optical sighting system periscope, perhaps the rendezvous antenna on its stand, being ripped off the hull. His craft was being stripped down to its basics by this brutal passage.

In the first ten seconds, hardly any of his velocity gone, he covered ten miles, scouring across the Moon's shadowed surface.

But the seconds wore on, his heart continued to beat, and the structure of the craft was still holding. He allowed himself a grin. This rattling Soyuz was a tank, plowing resolutely through the lunar ice; the Americans' tin-foil Apollo would not have lasted a dozen yards!

He caught glimpses of the Moon, fleeing past his window: dune fields lit up by a red, spectral glow, obscured by sprays of steam. The glow was his own, he realized: it was the hull of his Soyuz and the dirt of the Moon, turned red hot by his spectacular arrival.

He must be a wonderful sight, raising parabolic plumes of glowing spray and steam to either side, as he cut his geometrically straight line across the surface of the Moon. If the Moon were tipped up a little more, in fact, on Earth they would even be able to *see,* with the naked eye, the gash he must cut in the surface.

Twenty seconds, seventeen miles covered; thirty seconds, twenty-four miles . . .

His velocity was dropping, then, almost as planned. Yet the ride grew no less violent, the shuddering dips and bangs of the craft no less pronounced. Sometimes the bangs were very severe, as the Soyuz hit some inhomogeneity in the ice.

Suddenly the deceleration increased, and he was thrown with fresh vigor against the restraint straps. But he had been expecting that; as his velocity reduced the Soyuz was sinking more deeply into the lunar ice, digging in, braking him more rapidly.

Now a full minute had elapsed since that first jarring touchdown, and, by God, he was still breathing. Just ten miles to go, and his speed must be no more than Mach Two, and falling . . .

He had of course broken all land-speed records in the process of this landing. And, whatever the outcome, he would become the first human to die on another planet, the first to create a myth on this world without history, without monuments. Let them engrave that on the statue they would build to him, on Leninski Prospect!

Seventy seconds, eighty; forty-five miles, forty-seven. The shuddering of the craft, the howling of the metal scraping on poorly-lubricated ice, all of it seemed to him to be smoothing out and reducing. The vibration now was much diminished, and he was even able to read his instruments.

Ninety seconds. Another lurch, a plummet downwards, another savage bite of deceleration.

Now the attitude thrusters had cut out, and he would complete his final glide unpowered, the Soyuz ploughing ever deeper into the ice of the Moon.

Ten more seconds. The Soyuz slowed in violent lurches, and Arkady was still pinned forward against his straps. But he felt exultant. It had worked, by God! His speed was now no more than a couple of hundred miles per hour, and he began to believe, cautiously, that he might actually live through this. He would be a Russian cosmonaut, alive on the Moon, even if for just a few minutes or hours . . . It would be glorious!

As its speed dwindled, the Soyuz dipped forward, and it started to slew sideways, as if skidding across an icy runway. The cloud of steam that had obscured the front rendezvous port cleared, and Arkady, for the first time, was able to see ahead.

And, he saw, there was something in his way.

It was a sheer cliff face; perhaps it was even the central mountain of the South Pole crater, or a foothill of it. So big, whatever it was, it filled half the universe.

Disappointment surged, overwhelming his fear.

He reached out to the laptop. He held his gloved finger over the destruct button he had configured.

He allowed himself a moment's sweet regret at this misfortune, for it was a beautiful plan, and it had worked, all but this final detail.

He thought of Lusia, and Vitalik, and Geena.

Near enough.

He pushed the button, and he brought the light of the stars to the shadows of the Moon.

Watch the Moon.

It was as if the message ran around the battered planet.

Watch the Moon. The satellite shone down on its parent, as it always had; but now the air of Earth was murky with ash and smoke, its night side glowing bright with fires and volcanism, the infernal light of Earth bright enough to banish the Moon glow . . .

Watch the Moon.

That was what Henry had told Jane to do, in the last message she got from him, via NASA.

It was 4:00 A.M., nearly dawn, when she woke Jack. They dressed quickly, and went to stand in the middle of the lawn, at the rear of this rental house in Houston, that Henry had fixed up for them. Snow crunched under their feet: snow like Moon dust, snow in late Texas summer.

Jack walked silently, withdrawn. But that was okay. All he had seen in the last few weeks was going to take some silent time to take in, and she was determined he was going to get that time; even if she couldn't give him anything else but that.

The weather was shot to pieces around the planet, but this August cold snap was unprecedented, it seemed. But the air was still laden with moisture, a damp ghost of summer humidity, so much clear ice had collected everywhere.

Ice whiskers had clustered together to make a carpet as thick as snow on the roads and structures. The drivers on the freeways were very cautious, and seemed to be baffled by such phenomena as ice on their windscreens. De-icer seemed unknown here; Jane felt a little contemptuous, like a Swede mocking British attempts to cope with a few measly inches of snow. The roads were gritted, but with what looked like beach sand. The bridges on the freeways were iced up, pretty deadly, and the traffic was crawling and scared. It was easy to

skid as you came off the freeway around those right-angle turns.

She had thought they were safe when they arrived here, at the house Henry had set up for them. Well, maybe they were. But there were power outages that lasted days. The TV had images of plucky Houstoners loading frozen hamburgers onto their summer barbecues . . . News Lite, the cynics called it.

Anyhow she knew they would have to move soon, Henry's protection notwithstanding. The Administration was preparing to remove ration privileges for aliens. But Jane knew where she would take Jack: north, into Canada, to the center of the Shield. The most stable rocks in the continent . . .

It was a clear night, with only a trace of sunset pink staining the horizon. And the Moon, in the tall Texan sky, was almost full, a dish of light mottled by gray, just as it had always been.

She had brought a small telescope, a child's toy. She lifted it now.

Jane looked to the upper left corner of the Moon, where Henry had told her he would be, at Aristarchus. It was impossible to comprehend that the Moon was a globe-shaped planet in the sky, that Henry was standing there, perhaps looking back at her.

She clutched Jack, hoping the sky stayed clear of clouds and ash.

Henry was walking on the surface of the Moon.

The Earth was low in the south, God's blue eyeball in the sky, now lidded by darkness. Maybe Jane was up there, watching, thinking about him.

When he stood in the shadow of the rille wall, he could see stars.

He walked over the undulating ground, through quiet, in the soft rain of starlight.

Geena kept calling the Moon a dead world. She was

wrong. It wasn't dead. It was a world of rocks, of rock flowers and rock forests and rock colors, a subtle, still, Zenlike beauty that would take a lifetime to explore.

The Moon as a giant Zen rock garden. Blue Ishiguro would have enjoyed that thought.

It was true that the Moon was a quiet world. There wasn't even the brush of wind, the crash of a remote wave. It was a quiet that had persisted for billions of years, since the end of the heavy bombardment that had shaped the landscape. Even the light here was old, the light of the stars that had taken centuries or millennia to reach here.

But there was change here. There was even weather.

There was frost, on the Moon.

The Moon had an atmosphere, of hydrogen, helium, neon and argon. It was so thin it was probably replenished by the solar wind. At night, the argon would freeze out. It sublimated quickly at dawn.

Now, walking in shadows disturbed only by milky blue Earthlight, here and there, he convinced himself he could see a sparkle, a glint of lunar ice . . .

He was encased in stars, surfing on rocky blue waves.

He could feel the regolith crunch beneath his feet, his weight crushing the floury structure constructed by a billion years of micrometeorite gardening. All that information, lost as soon as he touched it.

And now, there was no time left to decode it.

If Henry had got his math right, soon this place—like every site on the Moon—would be overwhelmed by *weather*.

Henry knew he should be anticipating the great events to come. If it worked—*if*—he would be giving humanity, perhaps, a whole new world.

If the Moon was the only safe world in the Solar System, because of the Moonseed hive at its core, humans were going to have to come here to live. Henry's plan would—*might*—make that possible.

But Henry was a geologist. He might be creating a new Earth, but he was going to have to wreck the Moon to do it.

For instance, the structure of the ice at the Pole, strata laid down over billions of years, was a record of the impact history of the inner Solar System—a unique record that was probably already lost, thanks to the nuke.

He would destroy the Moon, to save humanity. Grandiose bullshit.

Somehow, he had maneuvered himself into a situation where the history of two worlds was resting on his shoulders. As if he was Jesus Christ himself.

But he had no pretensions; this was no part of the deal as far as his life plan was concerned.

Especially as Christ died for his mission, as he might have to now.

He checked the watch clumsily strapped to his dust-grimed sleeve.

Watch the Moon . . .

Jays Malone climbed up Mount Wilson to do just that. He came with Sixt Guth, who was not much younger than him, now grounded from the Space Station. Everybody was grounded now, it seemed.

The old observatory stood two thousand yards above Los Angeles. The city's lights flowed in rectangular waves about the foot of the hill, washing out the horizon with a salmon-pink glow; but the sky above was crisp and cool and peppered with stars.

The opened dome curved over Jays's head, a shell of ribbing and panels that looked like the inside of an oil tank. The dome, with its brass fixtures and giant gears, smelled vaguely of old concrete. The telescope itself was an open frame, vaguely cylindrical, looming in the dark.

Sixt had taken one of his several doctorates, in astronomy, at UCLA, and had put in some observational work on this 'scope. Now, his old contacts had made the place available for Sixt and his buddy, on this night of all nights.

Sixt was fussing around the telescope. "This is the

Hooker telescope," he said. "When it was built, in 1906, it was the largest telescope in the world . . . Kind of ironic."

Jays had a pair of Air Force binoculars around his neck, big and powerful. He lifted them to the Moon, squinting through the aperture in the dome.

"What's ironic?"

"The use of that bunker-buster."

"The what? Oh, the bomb on the Moon."

"Those conventional earthquake bombs they used in the Gulf War were too good. So the pariah states started buying up deep excavation equipment, to escape the bombs, and bury their command posts and their nuclear and chemical and biological stockpiles . . ."

Jays stared at the old Moon until the muscles at the edges of his eyes started to ache. He didn't know what to expect, tonight. Would the changes on the Moon be visible at all, from a quarter million miles? Would it be over in the blink of an eye?

". . . The B61–11 is like a nuclear dum-dum bullet," Sixt was saying. "It directs most of its damage straight down into the ground, toward the bunker. It can do as much damage in that way as an H-bomb. So it's a nuclear weapon with a role for which conventional weapons are useless. It blurs the line between conventional and nuclear war." He laughed. "Saddam's superbunkers probably never existed anyhow. Do you remember *Doctor Strangelove?* We managed to get ourselves into a deep-mining arms race . . ."

"What?" Jays looked at him vaguely, a little dazzled by Moonlight; he'd heard maybe one word in three. "What are you talking about?"

And so, he missed the moment of detonation.

. . . And Henry thought he *felt* the shock of the detonation: the gentlest of tremors transmitted through the layers of his suit, waves in the rock, passing through the silent heart of the Moon, from an explosion the planet's width away.

He should get back to the shelter in the lava tube. He turned and loped over the regolith, rock flour deposited by billions of years of meteorites, lunar ground never broken by a human footstep before.

The shock wave from the bunker-buster punched down into the strata of ice and dust, crushing the ancient layers, and slammed into the bedrock crust beneath. A central ball was flashed to vapor, which strove to flee the explosion. Surrounding layers of dirty ice were smashed and crushed, and the cavity expanded, growing at last to a hundred yards across.

When the stellar energy of the initial explosion faded, the weight of the layers above bore down on the cavity. It caved in, and layers of rubble collapsed down into it and over each other, forming a deep rubble chimney four hundred yards tall. It was surrounded by a fracture zone, cracks racing outward, and its base was lined with radioactive glass, the remnants of the rock dust layers.

When the chimney collapse reached the surface, volatiles—water and carbon dioxide steam—began to fount from the growing crater. It was a volcano, of water and air . . .

Jane had found too many symptoms to ignore, now. Changes in her bowel habits. Blood in her stools and urine; pain when she pissed. Sores in her mouth that wouldn't heal; hoarseness and coughs and difficulty swallowing; bleeding between her normal periods. It was as if she had wished this illness on herself, and now it was coming true.

She knew she would have to face it, go find a doctor. But that would confirm what she feared. It would be like picking up the revolver to play Russian Roulette—

"I can see it," Jack said. "I can *see* it. Wow."

Jane lifted the toy telescope. The Moon leapt into

detail, the craters at the terminator finely detailed by shadow, her view obscured only by the trembling of her hands and by the false-color spectral rings of the cheap lens.

She'd almost missed the flash, the few seconds after ignition: the moment when fire touched the surface of the Moon, shining over the southern limb, brought there by human hands. Already that glow was fading. But she could see the consequences.

There was a cloud, of yellow-white vapor, which fountained up—it must have been tens of miles high to be visible from here—erupting from the limb of the Moon into the darkness of space, in slow snakes, fingers of gas.

Henry was right: there was ice at the Pole, and here was the proof of it.

The soft white glow fell back, already much brighter than the Moon's native glow, splashing against the Moon's gray surface, and racing over that barren ground.

For a moment she felt a stab of regret. What harm had the Moon ever done humanity? For billions of years it had patiently regulated the tides, drawing up the sap in oceans and plants and humans. It was inspiration for a million myths, maybe more bad love songs, and dreams of flight.

And now, just a few decades after humans first reached it, we've visibly wounded it, she thought. Whatever the outcome of all this in human terms, it must be a tragedy for the Moon.

But some of the vapor was dissipating, great wisps of it branching away from the Moon. Perhaps it was escaping from the Moon's gravity well altogether.

Maybe the new atmosphere wouldn't stick.

She watched anxiously as the flower of steam blossomed on the surface of the Moon.

Now Sixt was using the Air Force glasses. "Oh, my God," he kept saying. "Oh, my God." Over and over.

Jays sat down in a rickety old chair that had once, it seemed, belonged to Edwin P. Hubble, who had used this telescope to observe distant galaxies, and so figure out that the universe is expanding. Jays craned his head back, and pressed his eye to the cylindrical eyepiece.

It took him a few moments to figure out how to see. He had to keep one eye closed, of course, and even then he had to align his head correctly, or his view would be occluded by the rim of the eyepiece.

A gibbous disc floated into his view. It was a washed-out gray with a splash of white at one part of the edge.

It was, of course, the Moon.

And he could *see* the vapor fountaining from its invisible source on the Moon's far side. Some of it was escaping the Moon's gravity. But most of it was falling back to the surface, and creeping sluggishly over the face of the Moon.

Right now, the vapor formed a loose cap, sitting over the South Pole region. It was growing, but with almost imperceptible slowness. It was like watching a mold spread across a smear of nutrient in a petri dish.

But it wasn't growing uniformly. It seemed to be pooling, in the deeper craters and valleys incised into the Moon, before flooding on. In fact, it seemed to be flowing generally northeast—into the mouth of the Man in the Moon—avoiding the brighter area in the southwest corner of the visible face.

He knew the reason for that. The brighter area was the lunar highlands, older and higher than the gray areas, the lava-flooded maria. The volatiles Meacher had liberated were pouring over the Moon's surface like fog, seeking out the low points, the crater pits and the valleys, the lava seas that flooded the great basins.

In a deep mare to the south—that must be Mare Nubium, he thought—he could almost *see* the surge of the air as it flowed, a bowl of atmosphere sloshing against eroded rim mountains like dishwater; and at the leading edges of the flood there were waves, hundred-mile crests

distinctly visible, reflecting back from the basin's walls like ripples in a bathtub, moving with a sluglike slowness.

It was, he thought, the first stirring of a new geography.

The cap of steam was much brighter, area for area, than the native surface of the Moon, which was starting to look drab by comparison. Earth's reflective clouds of water vapor made it one of the brightest objects in the Solar System. And already, with maybe twenty percent of the Moon's surface covered, the Moon was much brighter than before . . .

He looked away from the eyepiece. He was slightly dazzled. When he looked down, the shadow of his liver-spotted hands against his shirt was much sharper than before.

Sixt was staring up at the Moon, its new light shining on his bare scalp. "My God," he said. "You guys going up there, hopping around for three days, that was something. But now we're changing the face of the Solar System. My God."

Jays found he was trembling. Lights in the sky. He wanted to cower, hide like a dog under Edwin Hubble's chair.

Henry—restless, excited—walked until he came to a rise, which he climbed in a few loping paces, and looked south.

The undulating lunar surface stretched away before him, its surface shaped by fractal crater layers into a frozen rocky sea. The sun was to his left—the east, for even after all that had happened it was still morning on the Moon—and he could feel the touch of its heat, through the thick layers of his suit. And the Earth was before him, a blue crescent: it was an old Earth, its phase locked in opposition to the new Moon's. He imagined human faces all over that night side, turned up toward him, watching the Moon.

The sky above was still black, unmarked by the great events which ought to be occurring on the other side of the planet.

Ought to be.

All those volatiles were going to spread around the curve of the Moon.

How quickly?

The leading edge, spreading into vacuum, would diffuse as rapidly as molecules moved at such temperatures—say, a thousand miles an hour. Enough to cloak the Moon in cloud, from pole to pole, in three or four hours.

That was his theory, such as it was.

He was looking south, away from the Aristarchus Complex, over the extent of the Oceanus Procellarum, the Ocean of Storms. The way it would come.

The released vapor, like heavy fog, would rush into the low-lying areas first. It would have to flow around the big bright block of the lunar highlands to the south, the Apennine and Altai Mountains, and then gush down into the lower-lying maria. Much of the left-hand side of the visible face of the Moon, as seen from Earth, was pocked with gray maria, including the place he was standing now, on the invisible line between Procellarum and the Mare Imbrium. The volatiles would just gush across these immense gray plains, as the thin basalt lava had once flowed, a billion years before. Maybe, he thought, the new weather was going to reach him sooner than he expected.

It was indeed a judo trick.

His single bomb, no matter how precisely delivered, could never have melted enough of the putative volatiles at the Poles to make a difference. There hadn't been enough energy in the nuke to melt more than that initial hundred-yard spherical chamber in the dust. But his intention was to achieve more than that: much more.

To melt *all* the volatiles he believed were locked at the South Pole would need something of the order of a *billion* times the energy released by his nuke. One hell of a feedback factor.

But the energy he needed was there: superstring energy,

locked up in the inert Moonseed, which permeated the aluminum-rich rock that was the crust of the Moon.

Henry had modeled it over and over.

Elsewhere on the Moon, there was no evidence of Moonseed in the upper layers of the regolith. Presumably the action of sunlight had long ago activated whatever was there to activate; only shadowed rocks, like 86047, retained infection. And deeper in, the Witch in the Well had suppressed any chain reaction that might have led to the disassembly of the Moon.

The gamma-ray flash from the nuke would, he figured, start a chain reaction in the deep-buried Moonseed. It would be activated in the upper layers of the crust, to a sufficient depth that there would be enough energy released to melt his volatiles—so he figured—before the chain-reaction reached the deeper crust layers and was suppressed by the Witch.

So he figured. His lack of data, particularly on the suppression mechanism, was a little worrying.

He looked at the black, inert horizon. Nothing might happen at all. Or, he might just have destroyed the Moon. I'll settle for anything in between . . .

It was a little spooky, in fact, the way the Moonseed had configured itself to offer him this mechanism. A lever, with which to move a planet.

Terraforming the Moon would have been possible without this bizarre partnership with the Moonseed, and it had been Henry's vision—what he had hoped to prove with *Shoemaker*—that the Moon had sufficient resources one day to become a true sister planet to Earth.

They could have done it anyhow. But it would take a long time before humans could assemble the energy required. Centuries, even millennia.

The Moonseed infestation seemed curiously *designed.* It was as if it was meant to be like this. The Alfred Synge cosmic conspiracy theory.

Maybe he was being foolish, to be out in the open at a time like this. Or maybe he wasn't. Who could tell? Nobody had sat through a terraforming before. Maybe nobody ever would get the chance again . . .

But now there was something in the sky.

He raised his gold sun visor. The unwavering sun beamed in on him, shining in his eyes like a spotlight. But he masked his eyes with his gloved hands, holding them over his plexiglass visor, in a tunnel before his eyes. He stared out, letting his eyes dark-adapt once more.

Gradually, the stars came out for him, over the Ocean of Storms.

But those pinpoint lights were flickering, he saw: for the first time since the last of its internal atmosphere was lost to space, the stars in the Moon's sky were twinkling.

There was *air* up there.

The old surface, where it was still exposed, was looking dingy gray by comparison with the glowing mask of cloud; and that diminishing cap was crowded, even as Jays watched, by the rippling ring of cloud that closed around it.

It must almost have reached Meacher and Bourne, he thought. They would see it any time now.

He envied them. Christ, to be there now . . .

"I knew it from the moment I picked up that damn rock," he said.

"Knew what?" Sixt asked, sounding puzzled.

"That there was something in that rock." And he told Sixt about the dust pool he'd seen on the Moon, the way his purloined fragment of bedrock had glowed in the sun.

Sixt said, "You *knew?* Christ, man, if you'd said something—"

"We might have avoided all this?" Jays shrugged. "Maybe. But if I'd reported something as crazy as that, they wouldn't have let me fly again. What would you have done?"

Sixt mulled it over. "What you did. I guess you shouldn't blame yourself. The damn thing is a planetary plague. It would have gotten here anyhow."

"The irony is I never flew again anyhow. Maybe there is a just God. What do you think?"

The Moon glowed in the sky, already as bright as a new sun; even the darkened crescent to its western limb was clearly visible. It was almost featureless, so bright was it now; but Jays thought he could make out a bright triangle in the southeast—the old highland area, poking above much of the new atmosphere—and perhaps dim shadows of the old maria. Here and there on the new, bland face of the Moon, he could see the crackle of lightning: gigantic storms which must have straddled hundreds of miles, with lightning leaping between clouds, illuminating them from beneath, as if the planet's surface itself was cracking.

Some vapor hung away from the Moon, in a thin cloud, trails of it hovering over the South Pole. The Moon floated within its wreath of air, like a huge lantern. And he thought he could see structure in that escaped cloud: shadows cast upward by the new, brighter Moonlight. Maybe those escaped volatiles would ultimately form some kind of ring—

The ground lurched. The telescope seemed to come alive, and the eyepiece ground into his eye socket, and he fell.

He was on his back, in the ruins of Hubble's chair.

He'd heard a cracking sound. Maybe it was the dome. Or maybe it was the bones of his skull.

He couldn't see too well. That eye, poked by the eyepiece, didn't seem to be functioning at all. There was no pain, though.

Here was Sixt, hovering over him, his face a blurry Moon shape.

"We've got to get out of here," Sixt said. "My God. Your eye."

Sixt tried to lift him to his feet. Jays had never felt so old.

"Can you see?"

"Not so well," he said. But he didn't think it would matter, very much longer.

The ground quivered again, and he heard a metallic crash, as some piece of equipment or other came shearing off its mount.

"What do you think?" he asked. "Richter seven? Eight?"

"It's the fucking San Andreas," Sixt said. "Half of Los Angeles is on fire. A hell of a view . . ."

"The San Andreas," Jays said. "It took its own sweet time to join the party."

"We have to get out of here."

"And," said Jays calmly, "go where, exactly?"

"Jays—"

"Can you still see the Moon?"

"Yes. Yes, Jays, I see the Moon."

"Then tell me," he whispered. "Tell me what's happening up there."

At least, he thought, I got to see this. This and Aristarchus: maybe that's enough, for one lifetime.

But he wished he'd had a chance to say good-bye to Tracy and the boys.

And so the old astronaut sat in the ruins of the observatory dome, trying to ignore the mounting pain from his smashed eye socket, listening as his friend described the waves of light traveling across the Moon, until the fires from the city filled the air with smoke, hiding the Moon, and began to close in on them for the last time, and the next shock hit them, even more violent than the last—

They woke up Monica to see it.

You've got to watch the Moon.

Not live, of course; she couldn't be moved. But they gave her a little TV, set up on a table over her bed, tipped so she could see it.

Circles closing in.

In the end it was the liver disease that was getting her. Nausea, loss of appetite, drastic weight loss; her skin had turned yellow and itched like all hell. She had turned into a giant, misshapen, irritable cantaloupe. But at that it was preferable to going crazy first, which had been another option.

... There had come a day when she could not get herself out of her chair unaided, and a day when she knew she would never see another spring, and at last, maybe soon, there would be a day which would be the final day of all for her, a day without a sunset, or a night without a dawn. The circles would close in, walling her off from this world of books and music and mathematics and sunlight, everything she knew and cherished. And on the other side of the wall was nothing she could understand or anticipate, perhaps—probably—not even her identity. Even now her universe was reduced to this poky little hospital room, the last flowers Alfred Synge had sent her before he got himself killed in the Seattle event ... Now, I won't even get to see the outside air again.

Watch the Moon ...

A disc, floating in the screen, obscured somewhat by the volcanic ash in the air: it was recognizably the Moon, still, the familiar layout of seas and highlands easy to make out. But now there was cloud pooling in the lowlands. What looked like auroras, lightning.

Henry Meacher, she thought. So he did it. Hot damn.

She felt a surge of satisfaction, banishing for a few minutes the coldness that seemed to cluster around her the whole day now. I knew I was right to back him. I knew he had something.

She watched the clouds, swirling across the face of the Moon. Damn, damn, I wish I could see it for real. Just for a moment.

But she knew that was impossible.

* * *

. . . And now it came crowding over the horizon, as suddenly as that, a thick, crawling layer of fog, spreading toward him like, he thought irrelevantly, a dry ice layer at a 1980s rock concert. It spread right around the curving horizon, and stretched to a wispy thinness above.

Incredible, he thought; he was still standing in vacuum, but he was looking at a layer of atmosphere, from the outside. He could see how turbulent it was: wherever it touched the ground, two hundred degrees hot, it was soaking up rock heat and boiling afresh.

On the Moon's dark side—in shadow—it would be different. There, the ground was two hundred below freezing; there, over the high cratered plains of farside, good God, it must already be snowing.

The turbulent gas was picking up dust. That stuff could be a problem if it scoured at the seams of his suit.

But it advanced toward him ferociously, turning into a towering tsunami of gas and steam and dust, coming at him at a thousand miles an hour—more than the speed of sound, back on Earth.

He had time to look down, once more, at the ancient, complex surface of the regolith, his own boot print there, as sharp as Armstrong's.

Geena is going to kill me for not being in the shelter, he thought. But he couldn't have missed this.

The new air was white, and as tall as the sky.

Then it was on him, a wall of vapor sweeping over him.

It hit him harder than he'd expected, like a fire hose battering him from head to foot, a wall of rushing steam . . . *Sound,* on the Moon: he could hear the howling of this primordial wind across the plain, around his suit, the first sound in four billion years. The dust at his feet fled toward the vacuum, tiny dunes piling up over his blue Moon boots. There was a continual patter, almost like rain; it was probably pebble-sized fragments of regolith, trying to smash through his helmet.

He tried to lift his arms, to protect his face, but he couldn't.

He fell backward.

He bounced on Geena's backpack and rolled sideways, and skidded a few feet over the surface. He tried to shield the control panel of his suit, protect the backpack itself; but he was just scrabbling in the dirt like an animal, helpless before this planetary violence. And it was *hot*, Jesus, but after all he was in a jet of live steam.

He looked up. There was structure to the air already, he saw: the thick, ground-level fog, clearer air above, and, masking the vanishing remnants of black sky, some high, racing cirrus clouds: not billowing, just bannerlike streamers. Perhaps they were ice crystals.

The air closed over him, like fog.

There were waves in the still-tenuous gas encasing him—huge density waves pulsing past him—and his vision periodically cleared, affording him glimpses of the sky.

The sun seemed shrunken and remote, reduced to a pale disc in a milky sky. There was the old Earth. The disc of shadowed world cradled within the arms of the crescent was clearly visible, illuminated more brightly by the Moonlight than he had seen it before. He thought, in fact, he could make out the shape of continents, Africa and west Asia and Europe, and the soft bowling-ball glow, where the Moonlight shone over the Indian Ocean.

It wasn't such a surprise; the Earth was entitled to be lit up like a Christmas bauble on a tree. For it had a brand new Moon, a Moon that had never been so bright before . . .

But now clouds closed over the sky.

Earth was gone. He was encased in a glowing fog, sealed under a lid of cloud.

The wind was dying. He was still buffeted by gusts—he imagined the air scouring in great currents over this huge lava plain, the new lands it had conquered, seeking equilibrium—but it wasn't as violent as before.

And he was still breathing. He could hear, above the diminishing battering of the breeze, the steady hiss of his oxygen supply. Good NASA engineering, conservative to the last.

He tried to stand up.

Jane put down the toy telescope.

The naked-eye Moon was bright: brighter than Jane had ever known it, as bright as if the sun had exploded. It cast a sharp shadow behind her, and the sky, masking the stars, was a deep, lustrous blue she'd never seen before: the new Moonlight, scattered by Earth's ash-laden air. And the great lantern hanging in the sky shed enough light for her to pick out the details of the landscape, the coast, the sparkling waves. There were *colors,* she realized: colors by Moonlight.

Actually, it was unearthly.

The very light seemed unnatural: neither full daylight, nor night, nor Moonlight. And the Moon continued to evolve in the sky, a crawling, sparking thing. The Moon wasn't supposed to *change* . . .

But it was wonderful.

Jack's face, upturned, was shining in the new light. He was crying, the tears streaming down his cheeks, the moisture sparkling.

She could hear sounds: dogs barking, birds, the rustle of insects.

The animals think it's daylight, she realized. It was the opposite of an eclipse. She wondered how long it would take them to adapt to the new world in the sky, to throw off all that evolution.

She shivered.

She could hear people cheering. Clapping, from gardens and patios all over the neighborhood.

Now there were flashes around the cloud-covered pole of the Moon: sparks, urgent flappings of yellow light, spark-

ing, dying, reforming like trick candles. They were auroras. Lightning strikes. The first storms.

Weather, on the Moon.

She imagined faces all over the darkened hemisphere of the planet, in shattered homes and refugee camps, turned up to the new Moon, which hung in the sky bright as a sun: a symbol of hope, inchoate yet, but nevertheless real. It was the most beautiful thing she had ever seen. For the first time in many days, her soul was lifted above her own concerns, her fears for Jack.

She lifted the telescope again, but now her own vision was blurred with tears.

His suit bent at the waist, comparatively easily. The suit was still pressurized, above ambient—but now there was *air* out there, not just vacuum; he wasn't a starfish anymore.

It was hard to see out of his gold sun visor, though. It had been scoured and starred comprehensively by that first wave of fragments. But when he raised it, his helmet remained clear.

There was a soft sound, a gentle tap, on his helmet. Another on his shoulder. And his chest.

The pattering came more steadily now. And when he looked around he could see new craters being dug into the battered regolith, little pits a couple of inches wide, all around him.

He tipped back and raised his face to the hidden sky.

Raindrops, falling toward his face.

It wasn't like rain on Earth. This was Moon rain.

The biggest drops were blobs of liquid a half inch across. They came down surrounded by a mist of much smaller drops. The drops fell slowly, perhaps five or six feet in a second. The drops were big flattened Frisbees of liquid, flattened out by air resistance. They caught the murky light, shimmering.

When the drops hit his visor, they impacted with a fat,

liquid noise; their splash was slow and languid. The drops spread out rapidly, or else collapsed into many smaller, more compact droplets over the plexiglass.

He stood up. He stood in Moon rain, the first for five billion years, wishing it could go on forever.

He leaned forward, compensating for the mass of his pack, and looked down. As it hit the ground, each raindrop broke up into many smaller drops, which trickled rapidly into the regolith, turning it to mud.

BOTTLENECK

50

A day later . . .

Well, after a day, the Moon hadn't exploded, but outside the lava tube, the wind and rain kept on. The roof of the inflatable shelter sagged, because it couldn't sustain its own weight over the pressure of the new air outside. It made getting around harder; Henry had to shove billows of fabric out of his face the whole time. It was irritating.

They were both hot and miserable, and they bickered.

But then the rain stopped, or at least tailed off a little. They could hear it, even inside the shelter.

So Henry was going to get to go outside, to explore the new Moon. He felt like a kid, waking up on the morning after a snow fall.

He put on his blue coveralls, regolith-stained gloves and Moon boots. He checked over his POS, his portable oxygen system. There were straps for him to fix the pack to his chest, and more to tie on his scuba diver mask. There was the smell of rubber, of stale sweat, inside the mask; and immediately he put it on it started to mist up.

Geena watched him. Behind her, their lunar surface suits lay abandoned in a corner, grayed fabric sagging, like two fat men slumping side by side; Henry's fishbowl helmet stared at him accusingly from where he had dumped it.

She said, "You sure this is going to be enough?"

"I'm sure. Believe me. Haven't I been right so far?"

"About the Moon, maybe."

He eyed her. They were going to be stranded together here for a while yet.

"I think we need to get out of here before we kill each other," he said.

"Amen to that."

Geena ran one last check of the shelter's systems, and then followed Henry out of the cramped airlock. They carried their comms unit between them.

Henry looked up from the base of the rille. Before the nuke, he recalled, he'd been able to see stars up there.

Now, things were different. Now, the narrow rille was roofed over by a slab of gray sky, fat with cumulus clouds that looked low enough to touch. The murky light diffused down over the walls of the rille, and his blue coverall.

It was still raining, in fact, a slow drizzle of fat drops that hammered on his POS faceplate and rapidly soaked into his coverall.

But he wasn't cold. In fact the air was hot.

. . . But it was thin, just a layer of carbon dioxide, nitrogen, water vapor and trace gases amounting to maybe a sixth of Earth's atmospheric pressure. Like a mountaintop.

You wouldn't want it much thicker, in fact. The gravity was one-sixth G, so to get the same air pressure as Earth you'd need a column height six times that of Earth's. And then you'd suffer from a lot of haze and a greenhouse effect, all that cee-oh-two trapping excessive heat.

So, thin and dry was best, just the way it should be. It was as if they had been transported to the summit of a mountain two hundred and forty thousand miles tall, wrapped in comet air.

When he took a step, he squelched in red-brown mud. It was soaked regolith. He could swear the rille was a little deeper than it had been before—well, perhaps it was; perhaps the deeper regolith layers had collapsed. After a couple of steps it was hard to lift his boots, low gravity or not, so caked were they in clinging lunar mud.

He reached the walls of the rille. They were shallow,

but now they were slick with mud, and their profile seemed to have changed. Farther down the rille he could see evidence of landslips, great swathes of mud which had come shearing off the rille walls.

And, down the center of a valley cut a billion years before by a flow of lava, a rivulet of water was gathering. It was the start of a river which would gather, Henry knew, until it pooled with dozens of others in the great sea that must be forming in the Oceanus Procellarum.

Geena shivered.

He turned to her. "You okay?"

"I think so."

Her voice sounded thin . . . and then he realized that he was *hearing* her, her voice faintly transmitted by the thin new air.

"How about that. I can hear you."

"What?"

"Never mind. You shivered."

"It's just being out here," she said. "In the open."

"And not on Earth. I understand. We're the first humans to walk around unsheltered like this, on another world, in all our history. We've had nothing to prepare us for this. If you weren't scared—"

"It would prove I'm even more unimaginative than you think already?"

"I didn't mean that."

"You're so patronizing, Henry."

She walked away from him, her feet leaving great glopping craters in the mud. After three paces she slipped, and landed on her butt with a slow motion splash; gobbets of mud sprayed up around her.

Henry knew, absolutely, imperatively, he must not laugh.

She growled. "Probably the low gravity. Reduced friction."

"Probably."

"Watch your step, Henry."

"Copy that."

They powered up the comms unit, and set up its low-gain antenna. They put headphones to their ears, and Geena started sending an automated telemetry feed; Henry could hear static, and the chatter of the telemetry.

For long minutes, there was no reply.

"Don't give up," Geena said doggedly.

"Yeah. There's a lot of electrical activity in this atmosphere. It must be hard to punch a signal through—"

The static broke up. It was replaced by a chaotic noise.

At first Henry thought they were picking up the crackle of lightning from some remote storm—could an ionosphere have formed here so quickly? Then his mind resolved the sound.

Cheering.

It was human voices, raised in cheers and whoops, either at Korolyov, or Houston, or both; he couldn't tell, and right now didn't care.

His eyes prickled. As if he was the one who had just found a planet full of people who were alive after all, and not the other way around. Damn it.

They climbed the rille wall.

It was a *lot* harder than it had been before. The thirsty regolith had soaked up the rainwater to a depth Henry hadn't anticipated, and the wall had pretty much turned to a shallow slope of slippery mud. It was impossible to get a footing, or to grip with gloved hands, and they slipped back almost as much as they made headway. After a few minutes, Henry dumped his mud-caked gloves in frustration, despite Geena's admonitions.

Eventually Geena found a way of zigzagging up the slope, like a mountain path: it was longer, but her footing held in the low G long enough for her to take each step and climb a little farther.

Henry sought a more direct route. One of the many

landslips had exposed a gutter of lunar bedrock. Henry found he was able to run at this, scrambling at the rock to get purchase before his feet slid out from under him, until, by sheer momentum, he'd reached the top of the rille.

Side by side, panting so hard their oxygen masks were steamed up, they stared out over the Moon's new landscape.

It was a drab, muddy plain.

The sky was a steel gray lid, laden with water vapor clouds, clamped over this subtly curving sheet of red-brown mud. Here and there, Henry could still make out the overlapping craters which had populated this landscape—some of them had filled up with water, so the land was dotted with circular lakes, rippling sluggishly—but many of the crater walls had slumped. It was like standing in the flood plain of some unruly river.

The landscape was all but unrecognizable from the way it had been just a couple of days earlier.

A wind moaned, soft but guttural. And he thought he could hear thunder, somewhere around the curve of the world—maybe halfway round the planet, he thought; this was still a small world.

Geena was working her way around the Lunar Rover. It was a sorry sight: half tipped up into a flooded crater, its aluminum surfaces streaked with mud, its wire mesh wheels sunk deep into the soggy surface. The big umbrella-shaped S-band antenna had slumped to the dirt, under the weight of the water which had pounded into it.

Geena got hold of the control column and tried to lift the Rover out of the mud.

"It wouldn't work now even if you dug it out," Henry said. "Those wheels—"

"I know." She peaked a hand over her eyes and looked east, toward the old Apollo site. "We ought to go over there," she said. "I bet the rain has made a hell of a mess."

"I bet."

"The flag, for instance—"

He bent down and was pulling off his boots.

She said, "And what the hell are you doing now?"

"What does it look like?"

"Are you crazy?"

"No." He placed one bare foot into the mud, then another. He wriggled his toes, and felt the mud ooze between his toes. "Feels like river bottom mud. When I used to go fishing with my brother as a kid—"

"Spare me the cornball reminiscences."

He eyed her. "Back off, Geena. I'm in no danger. What do you think is going to happen to me? I'll step on a stinging nettle? The Moon might be wet, but it's still dead."

"Except for the Moonseed."

"Except for the Moonseed, and that doesn't count right now . . ."

The light changed, subtly; it became a little brighter, and for the first time Henry made out shadows, around the steeper of the muddy mounds.

Geena was looking up at the sky. "Wow."

He turned and looked. The clouds had parted: through shreds of cumulus, Henry made out a lacing of higher, streaming cirrus, and there was the Earth, a thin crescent, huge and pale—and there, directly above, was a patch of blue sky.

Blue sky, on the Moon.

Well, of course it's blue, he thought. The Moon gets the same strength sunlight as Earth. The light is scattered by the same sized particles as on Earth . . .

"All we need is a rainbow," Geena said.

"Yeah."

On impulse, he lifted his facemask. His ears popped, as his oxygen rushed out; he took a single, deep sniff of the air.

Geena rushed up to him. "Are you crazy?"

He dropped his mask back into place. "Probably." He took deep breaths. "But I'm okay."

"What did you do that for?"

"I wanted to smell it. To smell the Moon."

"And?"

He stared around, at the subsiding mud. "Wood smoke," he said. "It smelled of wood smoke."

The regolith was oxidizing, even as comet water soaked into it. All around him, all over its surface, the Moon was slowly burning.

They walked farther, across the blank, muddy plain.

Henry looked at the empty sky, which was closing over once more. "How long do you figure before they come to get us?"

"It depends how long it takes to assemble another mission," she said. "At least a month, I'd think; we used up both the prototype *Shoemaker* landers. They'd have to build more, and—"

He shook his head. "You're not thinking. Those landers won't work anymore. The air, remember? You don't need to bring rocket fuel for the descent; you could just glide down. There are going to be strong winds for a while, though. And we'll need a new design, a way to get back off the surface through this thick air . . ."

She nodded. "Months, then."

"At least. Still, resupply will be easy. They can drop stuff by aerobrake and parachute. I don't think they will let us starve."

"Or X–38s," she said. "Space Station escape gliders."

"Yeah . . ."

He looked at her sideways. It was hard to read her behind her mask. She still seemed brittle, to him.

Fear and grief, he thought, the loss of Arkady, the pummeling of the terraforming. But it barely showed, at her surface.

Maybe she was in shock. Or maybe it just showed how little he knew her, he thought gloomily.

"We'll get through this, you know," he told her.

"I know. But I'd rather be home."

"Umm." He thought that over. "Where is home now, for you? Houston? Or—"

"Russia," she said firmly. "With Arkady's family. They always made me welcome."

"Shows where we went wrong, huh."

"Frankly, yes."

"I'm sorry. About Arkady."

She nodded. "I know. But it was unavoidable."

"Yes," he said. "Yes, I think it was. But I can see you loved him."

After a time, she said, "What about you? Scotland?"

He shrugged. "Hell, no. Scotland is Olympus Mons now. Nobody will be going back there . . . I need to find Jane, and her kid, and we'll find some place that will last a little longer than Britain."

"I wish you well," she said seriously. "I wish you happiness."

"Thanks."

"I mean it."

"I know you do," he said. "What about Rocky?"

"My mother still has him." She added, "Much you care." But he could tell it was a reflex jab.

He looked around. "Maybe one day this will be home, for somebody. That's the idea, anyhow."

"You think they'll let us come back?"

"No," he said sadly.

"Why not?"

"Because we'll be too old to breed," he said bluntly. "Our time is gone, Geena. Gone with Earth. It's up to the children now . . . Hats."

"What?"

"Hats. When the sun breaks through, we'll fry. No ozone layer up there, remember. And I don't suppose you packed any sun cream. Maybe we can take the S-band antenna off the Rover, use it as a parasol."

"You have a strange sense of priority, Henry."

"I have a strange mind."

"What else?"

"It wouldn't hurt to find a source of water." He dug a bare toe into the ground; the little pit he excavated slumped back immediately, like wet sand. "The rain is just going to soak away into this stuff. We ought to find the basin of a young crater. Maybe Aristarchus. The regolith is only a few inches thick there, and we should find liquid water pooling. Then we have to keep moving."

"Moving? Where?"

"East, of course. We ought to go east."

"Why?"

"Because night will come." He looked at the sky, seeking the sun. "It isn't lunar noon yet; we have some time. But the terminator, the line between night and day, moves across the landscape at around ten miles an hour. We can't outrun it. We have to give ourselves as much time as we can, hope they get the resupply to us before night falls—"

"And what happens then?"

He looked at her, his eyes narrow over his mask. "Figure it out. No sunlight for fourteen days."

"Oh. The mud is going to freeze—"

"Geena, depending on the atmospheric dynamics, the *air* is probably going to freeze. For two weeks the Moon will be like it used to be, and we're going to have to find some way to live through it." He shrugged. "Or maybe we should just hole up inside our lava tube. We'll have to think about it. As long as it doesn't collapse, or flood. I sure don't want to be caught out in the open when the sun goes down. There will be a wind from hell, all that air sweeping around from the hot side to the cold—"

"But the air will boil off after dawn."

"Most of it. Some of it is going to collect back where it came from, the cold traps at the Poles. And it will stay there. Nothing has changed the basic geometry of the Moon, Geena. Eventually all this lovely air will finish up back where it started, back at the Poles . . . Somebody is going to have to figure out a way to stop that, some day.

"But that won't be for a while. For now, the comet debris is still boiling off, powered by the Moonseed . . . I figure things won't start to stabilize until all the ice has boiled off. Which will take a year, at least." He squinted at the Earth. "Maybe they will send the first biogens. There's no reason to delay. Photosynthetic plants, algae maybe, to start the job of turning all this sunlight and carbon dioxide to oxygen and food."

"Henry, how long is all this—" she waved a hand "—going to last?"

"Well, even if we keep it from freezing at the Poles, long term the atmosphere is going to leak away into space. But it's a slow process. It's like putting a bucket of water in the desert. Sure, the water evaporates, but it takes a long time because it can only get out through the comparatively small surface area of the top. In the same way the upper rim of the atmosphere will only allow the air to leak out slowly . . ."

She pulled at her mask, adjusting it. "Always the scientist. You tell me everything except what I want to know. How long is *long term,* Henry?"

He shrugged. "Maybe ten thousand years."

She said gently, "Time enough to think of something else, then."

"I guess so. Come on. Let's go pack."

Side by side, arguing, planning, they walked back toward the lava tube.

51

A year later . . .

She was in hospital when Henry returned from the Moon.

She hadn't wanted it this way, but the tests had become overwhelming: the best American technology, X rays and scans and ultrasound and blood tests, and a whole set of 'scopies that left her bewildered, sore and humiliated: sig-

moidoscopy, colonoscopy, gastroscopy, bronchoscopy, cystoscopy.

"I didn't know I had so many orifices," she told Henry.

"Oh, Christ, Jane," he said, and he sat on the edge of her bed.

After a year on the Moon his gait and movements were clumsy, as if he expected everything around him to happen in slo-mo. She could see where the rigors of reentry to Earth's atmosphere had left him bruised, around the neck and eyes.

And every pore, every fold in his skin, was etched with deep-ingrained Moon dust.

Still, it was Henry, more dear to her than she had anticipated—and more distressed than she had, somehow, imagined, when she had played through this scene in her head.

"It isn't so bad," she said. "Leukemia. I'm only here for tests; I'll be out of here soon. I might live for years."

"But not forever," he said.

"No. Not forever."

"It ain't fair."

He was trying to handle this, she realized, and she needed to give him time. She'd had more than a year to get used to the idea.

He said, "You never even told me."

"The NASA psychologists wouldn't let me. They were worried about your morale, up there on the Moon."

"Pointy-headed assholes," he murmured. He took her hand. "But it ain't fair, whether you told me or not. I did it for you."

"Did what?"

He shrugged. "Blew up the Moon. Saved mankind. Whatever it was I did it for you, for us. To give us a future."

"Maybe the NASA shrinks were right, then."

They fell silent, and started to avoid each other's eyes.

After all, what were you supposed to say? *How's your cancer? How was life on the Moon?*

She dug out a letter from the stack on her bedside table. "I got this from someone called Garry Beus."

"Beus?"

"Son of Monica Beus? The physicist lady you knew?"

He nodded stiffly.

She said, "She learned about me, through my connection to you, before she died, and told Garry." She glanced over the letter. "So he wrote to me. Kind thought. He's in the Air Force here. He's applying for the astronaut corps, the new Earth-Moon ferry pilot positions they are opening up . . . He says Monica left a memory box for him. Actually for his children, her grandchildren. Do you think I should do that for Jack?"

But he didn't reply. When she looked up at him again he was crying, the tears spilling down his cheeks, pooling Moon dust in the lines under his eyes.

52

Ten years later . . .

Coming inland from the sea, driving northeast from Cape Town on the N1 highway, it took Henry and Jane two hours to drive through the coastal mountains to reach the Karroo itself.

The ride, through mountain passes and the contorted passages through vales of rock, was spectacular. But then the landscape flattened to a desert, populated by what the old Afrikaners called fynbos, a mixed, complex flora of shrubs and bushes. It was spring, here in the southern hemisphere, and the desert—sheltered by its encircling mountains from the acid rain and climate shifts suffered by most of the world's land masses—was putting on a show, red white and yellow flowers of every shape.

At last, though, even the fynbos submitted to the logic of the climate, and only aloe and cacti relieved the panorama of rocks and sky.

At a village called Touws River—abandoned now—

they came upon the first Karroo rocks: squat black mud-
stones, sitting atop the younger Cape sands. Henry knew
that the mudstones had been dumped from icebergs, float-
ing on the surface of the polar ocean that had once covered
this land, an ocean four hundred million years gone.

Jane stared out the window, with that mix of patience
and intelligent interest that had always characterized her,
and the low, smoky sun picked out her old melanoma scars.

Ten years. And still, every day they were granted
seemed like a bonus to him, a new gift.

Henry drove on, and the rock grew more complex.

In a lifetime of geology Henry had never been here
before, to this high-veldt plateau that covered two thirds of
South Africa. It was a large, empty place, devoid of human
history, unpopulated save for a few scattered towns and
farms—most of them abandoned now—crossed only by the
immense road between Cape Town and Johannesburg. But
to geologists and paleontologists this land of sandstones
and shales, piled up into the tablelands the Afrikaners
called koppies, was one of the Earth's greatest storehouses:
a thousand mile slab of sedimentary rock that was the best
record on Earth of land-animal evolution.

The Karroo had always been, for Henry, a place for
the future, to visit before he got too old, or died. Now he
was forty-five, though he felt a lot older, but the future was
self-evidently running out.

So here he was, before it was too late.

They stopped near a large koppie, and clambered
stiffly out of the car. It was still morning, and the air was
blessedly cool; Henry found himself surrounded by cactus
and aloe and wild flowers.

Henry and Jane didn't speak; their routine, working
together, was long enough established by now.

Henry shucked off his antique Air Jordan trainers and
pulled on his heavy field boots. He smeared sunblock on
the exposed flesh of his arms, legs and face. He donned his
broad-brimmed hat, pulled on his oxy-resp and dust and

humidity filters—his spacesuit, as he thought of it—and he attached his digital Kodak to his chest bracket.

He buckled on the old leather of his field gear and picked up his hammer and chisel, all of it worn smooth by hundreds of days of sun and rain.

The familiar ritual, which for Henry long predated the coming of the Moonseed, was a great comfort to him. It was a prelude to the greatest pleasure of his working life, which was field work. The nature and objectives of the work had changed, but the pleasure he took in it hadn't.

Jane knew him well enough now to let him be, to relish this moment.

So he walked into the desert, looking for fossils.

The ground was full of so much detail it would be easy to miss the fossils; the trick was to train the eye and brain to filter out the noise and pick out the key signs. But right now, he didn't know what those signs would be. Bones, of course, but would they be white or black? Crushed or whole? In the sandstone, river bed deposits, or the shale, silt and mud deposited by ancient floods, now metamorphosed to rock?

It took a half hour before he began to see them: fragments of bone, protruding from the rock. He recorded their location with the Kodak; the camera was tied into the GPS satellites so the location and context of the specimens were stamped on their images. He scooped up the fragments, unceremoniously, and stuffed them in a sample bag.

As the day wore on, and his eye grew practiced, he found more impressive samples. Bones of ancient amphibians, two hundred and fifty million years dead. The tiny skeletons of two burrowing protomammals, his earliest ancestors, white and delicate, embedded in a dark silty matrix. Here, peering ghoulishly out of a layer of flat sediment, was the skull of a dicynodont, a low slung, piglike animal a couple of feet long, covered with fur and sprouting impressive tusks.

He tried to imagine what it must have been like here, a quarter of a billion years ago.

But right now there was no time to study, classify, identify, deduce. For now, all Henry could do was to collect the raw data.

Geology and paleontology had always been a race against the predations of weathering and human expansion.

As Earth's upper layers wore away, ancient bones were exposed, removed from their quarter-billion-year storage, and, in a relative flash, eroded or frost-cracked to dust. Humans could only hope to collect a handful of these ancient treasures before they evaporated like dew.

Now, of course, that time pressure had gotten a lot worse.

He came at last to a new layer of rock, a coarse brown sandstone which overlay the black shales below.

The upper bed was almost devoid of fossils.

This layer marked the boundary between the Paleozoic and Mesozoic eras, a boundary in time marked by the greatest extinction of life in Earth's history. The ancient spasm of death, recorded in rock, had been obvious to the first modern geologists, the gentlemen-scientists from Edinburgh.

Even now, nobody knew how it had happened. The more famous extinction pulse at the end of the Cretaceous, the one that had killed off the dinosaurs, had attracted a great deal more study, but that event had involved far fewer species. The best explanation was a slow deterioration of the climate, accompanied by a lowering of sea level, that had created conditions inimical to most life existing at the time.

That was plausible. But nobody *knew*.

The answer was surely embedded in these rocky layers somewhere, in the bones and skulls eroding out of the Karroo. But Henry could grab all the samples he liked; he was sure the answer would never, now, be found.

Henry had grown up believing that the future was, more or less, infinite, and that there would be time—for

generations to come, if not for him—to figure out answers to most of the great questions. Earth itself held the clues to the great puzzles of geology and paleontology, and Earth would always be there . . .

But the future wasn't infinite any more, and Earth wasn't going to last forever.

There just wasn't *time* for the slow processes of science to unpick the secrets of Earth's past. When the evidence was gone, it would be gone *forever,* and they would *never know.*

So, here was Henry clambering over the Karroo, grab-bagging bones out of the ground.

Field work was now the only game in town, in all the sciences.

Nobody was doing analytical science any more. The only people working in labs were directing the others, out in the field.

Most of the effort, in fact, was in biology. In what was left of the rain forests, half-trained researchers were wrapping entire giant trees in plastic and drenching them with bug spray, hoovering up the stiff little bodies into nitrogen cooled collection flasks, for eventual shipping to the great Arks that were flying to the Moon.

The National Institutes of Health's Natural Products Repository in Maryland—fifty thousand samples of plant, microbial and marine material from thirty tropical countries, stored in forty-one walk-in freezers—had been compactified, roughly catalogued and fired off to a cryogenic store in some deep-shadowed crater on the Moon. Some of the big bioprospecting drug companies, like Merck which had spent years trawling the flora and fauna of Costa Rica for resources for new products, had had similar repositories impounded and shipped off-Earth, though not without bloody battles over compensation.

And so on.

No time to classify, even to count the species, even those living; of Earth's estimated *thirty million* species of

plant and animal and insect, only a million had been identified and named by all the generations of biologists that had ever worked. *Last chance to see.*

There were problems, of course.

There was a lot of vertebrate bias, for instance, in the strategies for rescue. The big mammals and pretty birds were always top of the list, followed by other vertebrates, reptiles, amphibians, fish—even though many of the reptiles, for instance, were already literally drowning in the moisture-laden air that had followed the final melting of the ice caps, and the evaporation of so much ocean water.

And nobody could agree on the corner cases. Biodiversity or not, was it *right* to preserve the last samples of anthrax, or the Ebola virus, or the last tsetse flies?

And there were the bad guys. Like the cartel who had hunted down and wiped out the last elephants—before the geneticists managed to collect embryos for cryostorage—in order to get an all-time monopoly on ivory. Not to mention the reports, many substantiated, of crazies who were deliberately spreading the Moonseed, accelerating its propagation . . .

There were lots of reasons to do this, to evacuate the biosphere.

The new Moon needed to be colonized, of course, by the right creatures to coexist with mankind, to flesh out a new biosphere. And looking further ahead, a lot of people muttered vaguely about biodiversity. Nobody knew what benefits might be waiting to be discovered: new foods, better medicines, waiting to be derived from plants and animals yet to be catalogued.

And then there was the potential of species, far beyond their economic value to humans. It would have been hard to extrapolate the rise of mankind from the tree-dwelling mammals that hid from the dinosaurs seventy-five million years ago. Who could say what great societies might arise from the beetles and reptiles and birds, if they were only given the chance?

But for Henry there was a deeper sense of ethics involved.

Homo sapiens was one of the newest species on Earth. Maybe it was *homo sap*'s fault that this calamity had been visited on the planet; maybe it wasn't. At any rate, wasn't there an obligation on the species that commanded most of the planet's primary production to save as many of the other, older species as it could?

But in the end, maybe it was going to make little difference. For there just wasn't enough *time*.

Upcoming was the greatest extinction pulse of all, dwarfing even the end-Paleozoic. This time there would be no recovery, no slow million-year clambering back to diversity, no reconquest of abandoned ecological niches. Now, evolution on Earth was at an end; now, whatever wasn't sampled or collected was lost forever.

Even the rocks were going to die, this time.

So here were Henry and his wife, running through the desert and grabbing the rocks and bones, for all the world like the Apollo astronauts during their three brief, precious days on the Moon.

. . . *Apollo.*

Suddenly, as seemed to happen too often these days, he was hit by a jolt of nostalgia. Apollo 11: Moonwalk parties, under clear starry skies, when Henry was eight or nine or ten. God, it seemed a million years ago, a world that was ten degrees cooler, or more, where there were still ice caps, and the new inland sea hadn't covered over the state of Henry's birth . . .

Jane tired first. The cancers and their treatment had left her weakened. She returned to the cool of the car and turned on the radio. Henry could hear the voices of news announcers.

The human world continued to turn. Less news than a decade ago, because less people. The volcanoes and the quakes and the floods and famine and war had killed off all but—the estimates went—around a billion people. Now,

numbers were still declining, but more slowly. Almost gracefully.

Less news. Nuclear war in the Balkans. Mutant riots in Asia. There was something about the war crimes trial of Dave Holland, the former British Prime Minister, who, he vaguely recalled, Henry had once met. The trial had finished with Holland being convicted of genocide during that desperate last-ditch British invasion of southern Ireland, mounted from Ulster, Prime Minister Bhide apologizing to the world, a death sentence ordered . . .

But the murmur of words, emanating in digitized perfection from some satellite, meant little to Henry beside the dusty reality of these ancient rocks.

Henry labored on as the sun climbed higher in the sky. The sun was surrounded by a Bishop's Ring, fat and oppressive, volcano ash.

That night they ate their simple meal, and huddled together in zipped-up sleeping bags, and waited for the Moon to rise.

Here it came, fat and full and cloudy, banishing the stars. And as they watched, a fine, white streak flashed across the Moon's fat equator, a meteor scratch that wrapped itself half the way around the twin planet.

Jane, her head cradled in Henry's arm, stirred, half asleep. "Do you think that was Jack?"

"Perhaps." Or someone else's child, he thought, falling to the Moon in one of the Arks, the huge, heavy, clumsy mass transports, cushioned by the Moon's new atmosphere behind a fat aeroshell.

Henry's outlandish scheme had worked.

It was no less difficult to get out of Earth's gravity well than it had ever been. But the presence of a braking atmosphere on the Moon had reduced the fuel load the big Arks had to carry by an order of magnitude, and made mass evacuation, of humans and the biosphere, possible. Not only that, he had given them somewhere worthwhile to go.

And so the Shuttle-Zs launched almost daily, from Canaveral and Kourou and Baikonur, crude Saturn V-class boosters assembled from Space Shuttle technology, people crammed into sardine can spaceships, fleeing to the Moon. He knew that Geena had emerged from her voluntary exile in the Russian heartland to work at Baikonur, trying to maintain some kind of standard of excellence among the fragmented, ill trained and badly frightened work force there.

Or maybe it was a Chinese ship, or one of the Indian fleet, based on old Soviet era Energia technology, built with such haste and crammed even more full than the Shuttle-Zs, with even less precaution and safety checks than in the western sites. The Indian failure rate was a whopping forty percent, and the toll in lost lives, on those crowded space trucks, was immense. Frank Turtle, the strange little guy from the bowels of NASA who had done so much to return humans to the Moon, had lost his life when one of those big old Energia clones had dropped back to the launch pad on Sri Lanka and blown apart, taking half the island with it.

The rumors were that the failure statistics in China weren't much better.

It wasn't going to stop the launches, though, nor the desperate press of people to get themselves or their children on those ramshackle ships. And Henry knew that any government that tried to scale down its launch program would suffer massive civil unrest. The launches were a safety valve, he supposed, the promise of one route, at least, out of the trap Earth had become.

There was a lot of bitter conflict among the nations sending people to the Moon—the violation of international agreements on quotas and priorities went on daily—and it looked to Henry as if humanity was just going to transport all its old prejudices and inner conflicts intact to the new world, and presumably beyond. Depressing, but entirely predictable.

The evacuation was gigantic, but it could never be complete.

It would be possible to save only a fraction of the billions of people with which Earth had once teemed. Hence the Bottleneck laws. If the population was reduced to the minimum, by savage birth control measures, then, simply, there would be less people to be abandoned, to die, when the end came.

Most people accepted that. About the only thing humans could control about this catastrophe was their own numbers: the human souls who would be spared a birth that would doom them only to the flame.

Most people, it seemed to Henry, were doing their best, in this changing world. Behaving honorably, remarkably so in the circumstances. Surveys showed most populations around the planet were restricting their child birth rates voluntarily, accepting the Bottleneck laws.

And, it was estimated, millions could be saved, before the final destruction.

Remarkable, he thought. I bootstrapped a world. In the end, perhaps I really did save mankind. A fraction of it, anyhow.

He'd saved Jack, at least: still just twenty-one years old, the boy was healthy as an ox and smart as a tack. Maybe that one achievement was enough, to justify Henry's life.

Now Jack was going to the Moon. But not us, Henry thought. There is nowhere for us, but here.

Jane stirred again. He kissed the top of her head, the thinning hair there, and she settled deeper into sleep.

As it turned out the Karroo was their last trip together, before Jane entered what the doctors delicately called her terminal stage: when their various treatments served no further purpose, and Henry, geologist turned amateur paleontologist, became a nurse.

Some of what they had to face was much as he anticipated. The painkillers and their side effects. Her loss of

appetite; he learned to cook Lebanese-style, masses of small, spiced dishes, to tempt her. After she was bedridden, there was the need to care for her skin: rubber rings, protective pads for her heels and elbows, and a bed cradle to keep the weight of the covers off her legs.

And there were some things he didn't anticipate. The constipation that doubled her in pain. The soreness in her mouth, which he treated with lip salves, mouth rinses and flavored crushed ice for her to suck.

He wanted to move her bed downstairs, in their home in Houston, but she wouldn't accept that. It would be the mark of the end, she said.

She would die upstairs.

Strange thing. He'd been to the Moon, but he'd never seen anyone die close up.

It wasn't sudden. She slept more, sometimes drifting into unconsciousness, from which he couldn't rouse her. Her breathing became noisy, like a rattle, but the doctors said it was just moisture on her chest.

Sometimes, though, when she appeared unconscious she was aware, but unable to speak or see. But her hearing probably still worked—hearing was the last sense she lost—and so he spoke to her, reading her letters from Jack on the Moon, or news items, or, just, talking to her.

Until there came a day when she seemed to fall ever more deeply into sleep, and she simply stopped breathing, and that was all.

And Henry knew that he would be alone, for the rest of his life.

53

And ten years more . . .

Ten years on, ten years older, and here was Henry putting on his spacesuit, fifty-five years old and utterly

alone, letting the E-letter buzz in his earpiece for the fourth time, devouring this communication from the nearest thing to a son he ever had.

Dear Dad . . .

. . . I took little Nadezhda out to see the ecopoiesis farms in your old stamping ground of Aristarchus. They tell me they modeled the ecosystems here on the dry valleys of Antarctica, back when there used to be ice caps. Mats of green algae and cyanobacteria, lapping up the sunlight, resistant to the shortage of water and low partial pressure of oxygen, pumping out the oxygen. In some of the more clement areas there are even lichens and mosses, growing out in the open . . .

The ground here was mud, baked utterly dry, cracked into hexagons the size of dinner plates. No water anywhere, of course. Mud, as far as Henry could see, ocean bottom mud, baked dry and hard as concrete; mud, and sand dunes, and salt flats, and gravel fans, covering this dried-up ocean bed.

. . . We went to see the Apollo Museum there, at Aristarchus. They put it under a dome and reconstructed a lot of the original landing site, right down to the footprints they repaired from the rain damage they suffered. The day we were there they had Tracy Malone, the daughter of one of the astronauts, unveiling a plaque to her father, along with Geena, your ex-wife, who's been working on lunar heritage projects now she's retired. Quite symbolic: a representative of the first wave of lunar travelers, and the second, Geena, surrounded by the likes of us, the third. We introduced ourselves to Geena and she said to say hello. They showed Tracy Malone the place her father wrote her name in the dust with his fingertip. It's under glass now. She cried a river, and it was a nice moment of closure, but I don't think anyone had the heart to tell her they had to reconstruct it from the photos . . .

The sky was just a dome of mud-orange haze. But it wasn't hard to see his way here, about as bright as an early evening in L.A. used to be. In fact there was more sunlight

than appeared, still enough to sustain agriculture, to feed what was left of the Earth's population, under the big domes in the old deserts.

Not that there *was* much left of the Earth's population, all things considered. And if the stories were true about Siberia—it was said that because of the Venus radiation, and a lot of ancillary shit when the Chernobyl-era reactors out there started to go pop, a new *homo* species had emerged, viable, unable to interbreed with outsiders—the estimates of surviving *human* populations might be even further off.

. . . Nadezhda is going to spend her next break from school working at the Tycho carbon-sequestration pit.

I've got mixed feelings about her working there.

With all those burners and flues, Tycho is heavily industrial—something like Pittsburgh used to be, or the Ruhr cities. And with the same darker social side. They burn the biomass to recover volatiles, before burying the carbon-rich residue. It's all part of the global scheme to maximize the production of free oxygen, which not many of us understand . . . But Tycho is one of the few places where the work we're doing is simple enough for a five-year-old kid to contribute to.

I've taken Nadezhda around the place I work, the oxygen fountain at Landsberg. It sounds exotic—the ten-thousand-megaton thermonukes, the controlled energy cascades from Moonseed beds, all of it cracking the lunar regolith for oxygen—but there isn't much, really, to see.

It can be a little bleak here.

For the foreseeable future, humans are going to be consuming eighty percent of the lunar biosphere's net primary production. And that's a hell of a lot, maybe three times as high as humans ever reached on old Earth.

That means all the arable land surface we make, even most of the plankton in the crater lakes, is going to have to be turned over to crops. Other than humans, only those creatures that can survive in fields and orchards can be permit-

ted. Any that need virgin forest or any kind of undisturbed habitat are going to have to stay in the zygote banks for now.

They tell me it's going to take all of ten thousand years before we're stable and self-regulating, before a human will be able to take off her resp mask and walk out of the domes . . . Still, we're promised the first trees and grasses under the Copernicus dome before the decade is out. They are concentrating for now on developing the most useful crops: food, like potatoes, bananas, yams, sugarcane, coconut; but also gourds and bamboo and plants we can use to make tapa cloth, dyes and oil.

It's a grand vision, for all that. When the full terraforming gets started, the ecologists say it is going to be like the colonization of new volcanic islands, like Hawaii. The few species we release here to this native soil will explode into all the niches they find, over time, and diversify, new plants and animals to complete the colonization of the Moon. No doubt producing a new ecosystem the like of which Earth never saw.

But that will take a million years, they say. I wish I could fast-forward to see it. Morning on the Moon . . .

Henry checked his recording equipment, balky modern stuff which he didn't know how to work, and thought about Earth.

It was the great tectonic events, of course, which had done the greatest damage. There had been the great lava flows off the east African coast, six thousand square miles of new basalt spilling in waves across the land, spewing out gases; everyone thought that was a stupendous catastrophe.

But the coup de grâce had been the giant magma plume that had burst, unexpectedly and explosively, through the crust beneath Yellowstone.

It was an explosion that had been ten thousand times as powerful as all mankind's nuclear weapons, at their peak, ignited together. From a caldera the size of New Hampshire, blazing material had punched out of the atmosphere—some even entering low orbit—most of it falling

back as giant fireballs which ignited what was left of the Earth's vegetation.

And from the crater itself a huge fireball, followed by a dust plume, had swept up to the stratosphere, and added to the soot and dust from the burning forests to create a planet-covering pall of darkness.

Lights out, all over the Earth.

The atmospheric shock-heating was enough to cause oxygen and nitrogen to combine to nitrous oxide, which had combined with rain water to make acid; and enough acid rain had fallen on the planet to make the top three hundred feet of the oceans sufficiently acidic to dissolve calcareous shell material, so driving still more orders of life to final extinction. The food chains, already tenuous, had finally collapsed. Death soaked the planet, starting with the phytoplankton.

Ash falling, all over the Earth, like the thin layer that had been found in the rocks following the Cretaceous extinction, once puzzled over by scientists like Henry in bright, clean labs . . .

The magma plumes, giant wellings-up in the Earth's molten substance that originated as deep as the core mantle boundary, had been significant in Earth's deep history. They had shattered continents, breaking up the Pangaea supercontinent, splitting Gondwanaland into two halves, splitting India, Madagascar and Antarctica from Africa. But all that had taken hundreds of millions of years. Now, the plumes' violence was manifested on timescales of mere decades, even years.

There was the mountain building event in Antarctica, for instance, where the Indo-Australian plate had suddenly decided to set off south. More of the great magma plumes under Earth's hotspots had come boiling through the crust, at the Canaries, under the tsunami-lashed wreckage of Hawaii, under Iceland. And the rift valleys all over the Earth had started to open up, in east Africa and Lake Baikal and the Red Sea, the continents just splitting apart.

The river Rhine had disappeared into a crack in the ground, and then the graben through which it once flowed started to bubble with new ocean floor plate.

What all the volcanism was mostly doing, in addition to killing people and boiling the seas, was pumping out a new atmosphere for the Earth: an unwelcome air of carbon dioxide and sulfur dioxide and hydrogen laced with arsenic and chlorine, that would, the estimates went, finish up ten times as thick as the old nitrogen-oxygen one. Immense greenhouse cycles had already started, and the oceans were evaporating and would soon start to boil . . .

And Henry's beloved Earth was turning into what Venus used to be.

One large community of people had retreated to what was left of the oceans, sheltering from the heat there. But even the marine invertebrates were choking on ash. And the volcanism had polluted the water with exotic trace elements—like cadmium and mercury and iridium and osmium—and the oceans, the birthplaces of life on Earth, were, in their last days, becoming toxic.

But, in a way, it was geologist's heaven. Processes that ought to take millions of years were occurring in mere years, even months. As if the Earth was trying to cram in her best special effects while she still had time. Geology, overwhelmed with unwelcome evidence, was at last becoming a mature science—just as, so he heard, fundamental physics had been galvanized by the study of the Moonseed processes, so that whole new areas of theory and technological achievement were being opened up.

None of it any use, though, in stitching poor Earth back together.

Dear Jane had called the sites of the great magma plumes Earth's *chakras*. The energy centers, the wheel of light from which Earth's energies were bleeding away. It was as good a description as any.

He stepped forward cautiously, keeping an eye on the compass set into his chest pack. The compass was inertial, a

little spinning gyroscope system, like they used to use in air-craft and spaceships. It was the only type that was reliable nowadays; the electronic kind that communicated with the GPS satellites was too easily thrown out by the auroras and the big electrical storms that flapped around the planet, and you couldn't use a magnetic compass, of course, since Earth's magnetic field had gone to hell. The geophysicists said it was all to do with the melting of the ice caps and the oceans' evaporation, all that mass redistribution making Earth wob-ble like a kid's top after a hefty kick. The reversals in the magnetic field's polarity were coming about once a year now, thus screwing up the magnetosphere and letting through the cosmic rays, just adding to the fun down here, and coinci-dentally fouling up Henry Meacher's map reading . . .

But he couldn't make head or tail of this damn astro-naut's compass.

Well, maybe it was a little brighter to his left, to the east, where the sun must be rising. Maybe there were miles of cloud above him, the evaporated oceans lofted into the sky; maybe his green Earth had turned to a pearly white ball like Venus had been, where an American needed a spacesuit to walk out of the big underground shelters; but as far as he knew the world was still *spinning* the right way.

Anyhow, he might get lost, but wasn't going to come to any harm, on this plain of mud.

He stepped forward, carefully.

. . . It still seems remarkable to me to see Nadezhda bounding around in the low gravity without an ounce of self-consciousness.

Of course she has no memory of the Moon before the modification. It seems perfectly natural to her to lope around the mare with nothing more than cold weather clothing, sun-glasses and an oxygen pack! I've shown her recordings of the old Apollo Moonwalks, but she doesn't say much.

I suspect among the young people born here there is already a conspiracy theory circulating: that the Moon has always been this way—that maybe the old airless Moon

*never existed—that maybe our "terraforming" is a clumsy
attempt to rectify some eco screwup on a previously pristine
Moon. God, if only that was true!*

*I do know that the images the young ones see of Earth
are affecting them in ways we didn't anticipate.*

*For sure, the kids are evolving away from us, Henry.
Already. Oh, Nadezhda doesn't look much different from
me at her age, when I was nagging mum to take me to the
McDonald's on Princes Street; it's going to take generations
even to work through the obvious physiological changes—
the low G adaptations, for instance; Nadezhda will have to
spend her life on courses of treatment against bone calcium
loss and body fluid imbalances.*

*But her children will be a little taller, and a little more
resistant; and her grandchildren a little more so . . . and so on.*

*Humans will survive here. I'm sure of that now. What
I'm not convinced about is how much they will care about
old Earth.*

*The young ones already have their own agenda. It's
hard for them to have any loyalty for the home planet when
they see that now you need spacesuits just to survive down
there . . .*

*There has already been some trouble at the drop points
in Procellarum. Resistance to new immigrants, even to accept-
ing more loads of rocks and frozen bugs from Earth.*

*I just hope it all holds together long enough to get the
best of it away, before the end.*

*Well, maybe it's inevitable. We've done all we can to
equip the kids and educate them. Now, the future is theirs . . .*

As the tectonic events accelerated, predictions were
being revised, and it seemed they were approaching the
Bottleneck itself, the great, final die-back from which noth-
ing on the surface of Earth, *nothing,* was going to escape.
The laws had gotten harsher. *No more children to be born
on Earth.* Anybody who refused to comply would be
refused boarding, for themselves or their children, to the
Arks to the Moon.

It was harsh, and not universally accepted by the governments, and had caused revolution, and more than one war. In South America, where the Pope had mounted his last stand against the managed decline of the population, the fallout of thermonuclear destruction had added to Earth's final woes.

And nevertheless—despite the logic and wisdom, despite the inevitability of the Bottleneck—there were still children being born on the Earth: the animal response of frightened humans to the threat of death, life trying to propagate in the face of hopelessness. But the helpless new kids were only more moths to the flames, Henry thought.

In a way, he was glad Jane wasn't here to see this.

At least she had lived to see her grandchildren, growing straight and tall in the thin, clean air of the Moon.

But as for Henry, this was his home.

He had been in love with the Earth since the first time he opened a geology book, the first time he picked up a pebble from a beach and wondered how it got there. Now it was burning down around him, but he wasn't about to abandon it.

He found himself walking on a layer of salt, white and bright in the smoggy twilight, that crunched under his feet.

This ocean had dried once before, though not in human history. And that had been significant. The ocean had ceased to buffer the local climate, feeding land areas with rainfall and reducing temperature swings. Forests had disappeared, to be replaced by dry grasslands, and the arboreal creatures had faced the choice of migrating, adapting, or dying.

One group of tree-dwelling primates was forced out of the branches that had hidden them from predators, and pushed onto the new grasslands of Africa, where they were going to need greater size and better locomotion and, above all, to get smarter.

They had never looked back.

Now, five million years later, a descendant of those frightened primates, dressed in a fragile spacesuit, stalked across the dried up bed of the Mediterranean, looking for fossils and human artifacts, a few last treasures for the final Arks to the Moon.

54

And a final ten years . . .

Henry was standing on the Earth's oldest rocks, and talking to his granddaughter, on the Moon.

. . . So here I am, Nadezhda, your honorary grandfather, sixty-five years old and no smarter than I ever was, waiting for the other shoe to fall.

I don't suppose you know what that means. I can't even remember how long it takes a shoe to fall on the Moon. Or if you wear shoes in those domes of yours.

Whatever.

I have instruments here, various sensors that show me what is happening inside the planet. I have a whole-Earth image here broadcast from one of your nearside observatories, I think at Kepler. I'm glad you can see the surface, from up there. The giant volcanoes blew off the crud, the Venusian atmosphere that was gathering, and who'd have thought that would be a blessing? . . .

He was in Isua, in west Greenland. He was standing on supracrustal rock bounded on both sides by granitoid gneisses: three point six billion years old. Babies for the Moon, but these rocks were the old men of Earth, the oldest, most stable place on the planet.

It seemed appropriate, to be here, now.

He was in a concrete, heat insulated, pressurized bunker, which in turn was protected by what he would have called a force field when he was growing up, a piece of the smart stuff the kids on the Moon had been dreaming up. Technological evolution, force-fed by its environment, filling the niches.

He was here because it was one of the few solid, stable places left on the planet.

Earth, from space, looked like a jigsaw puzzle, or maybe like a pan coming to the boil, black continent pieces outlined by blood red.

It was astonishing how events had accelerated, toward the end. It had been faster than anyone had believed.

He wondered how long he'd last. How much of it he would see.

. . . Did you know I was alive when Apollo 8 flew by the Moon? The astronauts, Borman, Lovell and Anders, were the first humans to see the Earth whole. They thought it was blue, and fragile, like a Christmas tree ornament. Well, they were right. Fragile.

I know you think I'm crazy to stay.

You know, one of the most beautiful theories of the history of the Earth was published by a guy called the Reverend Thomas Burnet, in England in the seventeenth century. Burnet said the Earth originated from chaos, a fluid mass of particles of matter. The particles grew together to form a perfect sphere with a smooth surface, concentric shells of liquid and air around a solid core. But there was an oily fluid in with the water, and when dust mixed with it, it formed a firm and fertile envelope over the layer of oily water.

But the sun's heat made the fertile shell dry and crack. The waters below boiled, vaporized and exploded, and the Earth was flooded. When the agitation settled out, the waters drained back to the low places. Fragments of Paradise were left sticking up as continents and islands.

And that's the world I was born on.

Eventually, though, flames would come to purify the Earth, and it would return to its paradisical state, and finally merge with God by becoming a star.

Well, it was a theory. That's the way geology used to be, kid, a thing of dreams and fancies unsullied by brute fact. We only got into all that science stuff when the industrialists came along and started asking where they were going to find

coal and iron ore and oil, and why the hell is the world so complicated anyhow?

We know the answers now, of course: all those eons of mountain building and destruction, the rise and fall of the seas, the compaction, pressure, heating, cooling, sedimentation, erosion. The Earth is a rocky labyrinth.

Was, anyhow. It's getting kind of simpler, even as I stand here.

Strange how Burnet seems to have been right all along, though, doesn't it?

It had been a couple of years since the Moonseed made the mantle so hot that plate tectonics effectively stopped. The plates were too hot to behave in the rigid way they used to; and the rock of the mantle was just too runny to support big horizontal movements.

It had been thought that would reduce the volcanism for a time, but it didn't turn out that way.

Still, the map of Earth was recognizable. Just.

The ocean plates were softening and melting back. The continents showed up in his images as black and dark islands in glowing oceans, the ancient granite cratons surrounded by crumpled greenstone. The cratons were the cores around which the continents had accreted in the first place, crust slabs which had formed in the center of ancient mantle convection cells; now they were being uncovered once more.

It was as if, Henry thought, someone was winding back Earth's evolution.

And there were giant mantle plumes breaking out all over the planet, flood lavas, volcanic domes, cones and even coronae—features never seen on Earth before, only on lost Venus, basaltic domes surrounded by annuli of ridges and grooves. Nowhere was left untouched in the catastrophic resurfacing of the planet.

Hardly anything of the works of humanity survived.

There was one consolation, though. For a time, Earth was the youngest place in the Solar System.

. . . I want to tell you how much I admire you people up there. My God, you guys think big. Your schemes to bring in comets to graze the Moon's atmosphere and increase the volatile content. Rebuilding the crater walls and lunar mountains that are already getting eroded by the rain. No plate tectonics on the Moon, to maintain the carbon and oxygen cycles: so you'll bake the silicate rocks into glass, drive out the carbon dioxide that's weathered there, and reverse the erosion . . . Jesus.

I'm not sure if I agree with your projections that you can reduce the time to true terraforming to a thousand years, but I haven't had the time to run the math. I don't think you ought to concern yourself with the objections of the Siberians who have colonized farside. They aren't even human; let them build their own damn world.

But you talk about using the extremal black holes from the Earth's debris to tip the Moon, to give it seasons, then to spin it up. It's a nice idea. A final gift from the Earth, to its daughter . . .

But, Nadezhda, I have to counsel caution. Are you guys sure you know what you're doing? You're going to have sixty-feet tides in those new lunar oceans of yours—

Shit.

Sorry. That was a surface wave, a big one. I think it will be over soon . . .

The continental cores, the ancient cratons, had resisted the magma plumes for billions of years, and, like knots in wood, were tough to crack. But they were not indestructible.

Even as he watched he could see the last of the African plate—cracking and dissolving like scum—there it went . . .

Africa had been the oldest continent, most of it formed more than two and a half billion years earlier, surviving for geological ages as the hard, protected core of Pangaea, the world continent. Now it was gone, just a puddle of magma.

Good-bye, Africa. Birth place of man. My God.

And now, where Africa used to be, another huge magma plume was starting. It looked like a solar flare. A fountain of rock blasting straight up, uncurling with perceptible speed . . .

No, not a fountain. More like a fist, punching out of a sack. A mass the size of a small moon, thrusting out of the Earth.

Henry couldn't begin to compute the energy behind events like that.

The end must be close now.

Already there had to be significant mixing between the core and the mantle layers. The planet as a whole used to spin at a different speed from its core . . . Now the whole globe was coupled, structurally. It must be tearing itself apart, like an unregulated motor.

Another pressure wave swept beneath his bunker, cracking the floor. Maybe that was the aftershock of the Africa plume.

He kept to his feet, though.

Now another plate was gone, after five billion years just crumbling away like sugar in water. He thought that was Indo-Australia—the planet was such a mess now it was hard to be sure—and the other plates were starting to slide and crack.

. . . I know you think I'm crazy to have stayed. I know your new generation of Arks, skimming down from the Moon, had the capacity to take off almost everybody who was left. I know you think I'm like the crazy old fucker who wouldn't get out of his house when they want to build the highway through it.

Sorry. I guess you don't know what I'm talking about.

I just didn't want to leave, is the top and bottom of it. This is my home: here, on the shitty side of the Bottleneck. On the other side is the future, all of the universe, waiting for you.

What would I do on the Moon, except bitch about the processed algae and yack about the old days?

This is my home.

Listen to me. Don't tip the Moon. Harness the black hole wind. Use it for what it was meant for.

Get out of here, go to the stars.

Godspeed to all of you.

There was more bare magma ocean than continent left now. Giant plumes, everywhere, more of those fists punching out to space—

And here came another shock wave, slamming into the bunker.

An instant of confusion, pain, extreme noise.

He was on his back.

The force field had held. But the whole bunker was over on its side, the floor and walls cracked, shattered to powder.

It felt as if he had busted a leg, a couple of ribs. He couldn't move. He couldn't hear anything.

He didn't suppose it mattered. He was lucky to have survived so long.

The force field was *tough.* Maybe it would come sailing out of the final destruction event with his old bones preserved inside, battered and crushed.

One monitor was still working, by some miracle. He could still see the Earth.

The planet was a ball of red-brown light, an ocean of magma, barely differentiated, just a few scraps of continent, patches of black slag. But now there were spreading pools of white light at the rims of the magmatic convection cells: plasma, presumably, from the high-energy stuff going on in the interior.

Just like Burnet said. This is the fire. And soon we will merge with God.

The planet looked lopsided. Here came the biggest plume yet, poking out of the equator, where the Pacific plate used to be.

The limb of the planet was ... lumpy. Jets of rock

vapor pushing out of the lumps, into space. Some of the lumps were falling back, creating craters hundreds of miles across, spectacular impact basins that weren't going to last more than minutes. And now, a new upswelling—

Shit. You can't call that *a plume. The core must be splitting.*

Oh. I'm rising. Like an elevator. The continent must have split. Jane, I think—

55

Earth was once more a ball of magma, everywhere molten, reduced to a primordial smoothness, as it had been when young.

But the planet was expanding.

The unified-force energy released in its core and mantle was overcoming the controlling pull of its gravity. But the expansion was uneven, and bolides, giant chunks of rock, burst out of the churning surface and traced long, glowing curves around the world.

New cracks appeared in the magma ocean, wide fissures filling up with rivers of plasma light, white and yellow and green. As if emerging from a rocky egg, the plasma ball broke open the last shells of Earth, the remnants of the mantle and asthenosphere, molten rock and iron, and hurled out giant globules of spinning, cooling fragments.

The Earth became briefly flattened, its rotation driving its fluid form outward.

Then the cloud expanded, suddenly, an eruption of light and fire, the energy embedded in its own substance being exploited to destroy it in a silent concussion.

Thus it ended, in a moment of unimaginable violence.

The debris formed a cloud, through which the plasma glow, fading, cast thousand-mile shadows.

Shallow gravitational waves crossed the Solar System, subtly perturbing the orbits of the planets.

Then, placidly, the remaining children of the sun resumed their antique paths, barely affected by the loss of their sibling.

Earth's closest companion was more disturbed.

At the loss of the tides from its lost parent, the Moon shuddered. Water sloshed in its crater lakes, in giant circular ripples. Ancient faults gaped, for the first time in a billion years, and dusty lava flowed, as if the satellite was aping its parent's demise.

Some humans died.

But it didn't last long. And the inhabitants were prepared.

Then the orphan Moon sailed on, alone, cradling its precious cargo of humanity.

And, at the site of Earth, when the cloud of dust and volatiles and planetesimals dispersed, something new was revealed: a tear in space, a jewel of exotic particles, a wind of massless black holes fleeing at the speed of light.

Cautiously, tentatively, the ships from the Moon crept toward the ruin of Earth.

VI

NADEZHDA

... And, twenty years beyond the Bottleneck:

In the confines of *Sagan*'s airlock Nadezhda put on her
gloves and snapped home the connecting rings. Then she
lifted her helmet over her head.

The ritual of the suit assembly checklist was oddly
comforting, a litany now decades old: in fact, almost
unchanged from the routines endured by the original astro-
nauts from Earth.

But the *Sagan* was no dinged-up low-Earth-orbit space
truck, and right now Nadezhda was far from home.

She felt her heart hammer under her suit's layers.

Jean Massie, on the hab module's upper deck, was
monitoring her. *Nadezhda, you have a go for depress.*

Nadezhda heard a distant hiss. "Let's motor."

She twisted the handle of the outer airlock hatch and
pushed.

Nadezhda Pour-El Meacher Dundas gazed out into
space.

She was looking along the length of the *Sagan*'s hab
module. It was a tight cylinder, just ten yards long and
seven wide, home to four crew for this six-month jaunt. The
outer hull was crammed with equipment, the sensors and
antenna clustered over powder-white and gold insulating
blankets. The flags of the contributing lunar nations and
agencies were here: NASA-L, the Russians, the Euro-
peans, the Chinese, the Japanese, and the star-in-crescent
flag of the Federal Republic of the Moon itself. At the back
of the hab module she could see the bulging upper domes
of the big cryogenic fuel tanks, and when she turned the

other way there was the emergency return module, a capsule stuck sideways under the canopy of its big airbrake.

The whole thing was just a collection of cylinders and boxes and canopies, thrown together as if at random. She knew every cubic inch of it.

She moved out through the airlock's round hatchway.

There was a handrail, and two slide wires that ran the length of the curving hull, and Nadezhda tethered herself to the wires. It was a routine she'd practiced a hundred times in the sims at Clavius and New Houston, and a dozen times in lunar orbit. There was no reason why now should be any different.

No reason, except that the Moon wasn't where it should be.

In lunar orbit, the Moon had been a bright, curving carpet beneath her all the time. But out here, the Moon was all of five million miles away, reduced to a blue button three or four arms lengths away. And Nadezhda was suspended in a huge three-hundred-sixty-degree planetarium just studded with stars, stars everywhere . . .

Everywhere, that is, except for one corner of the sky blocked by a vaguely elliptical shadow, sharp edged, one rim picked out by the sun.

It was Icarus: a near-Moon asteroid, Nadezhda's destination.

When she was selected for this mission, Nadezhda had studied the history of the Earthborn astronauts, right back to the beginning, Yuri Gagarin and Alan Shepard in their tin can spaceships. She'd learned she had at least one thing in common with them.

She supported the objectives of the mission, of course. She had trained up on the science of Icarus, on near-Earth objects in general. She had trained up on the Moonseed, on the various coexistence and communications and exploitation schemes that had been proposed. She was interested in

the science, the future of mankind, all of that stuff. Of course she was. She wouldn't have come so far otherwise.

But what really motivated Nadezhda, here and now, five million miles from home, was not screwing up.

Every astronaut, right back to the beginning, had felt the same, she suspected. Don't screw up. Finish the checklist, smile for the cameras. Because not screwing up was the only way to get on another flight.

Maybe that particularly applied to her, the first lunar-born deep-space astronaut, on this NASA-L mission. If she screwed up, the Earthborns would have a field day, and it would be a long time before she, or another Moonborn, would get another chance.

Of course, inevitably, their time would come.

All lunar citizens were astronauts anyway. The Earthborns just didn't see that.

Under the big glass domes at Clavius and Tycho, human-powered flight was the most popular sport: thick air, low gravity . . . Nadezhda had grown up in a world where children flapped back and forth all the time like bony chickens, learning the rudiments of three-dimensional navigation and aerodynamics as soon as they were born.

And, on the Moon, *everyone* flew in space. You could reach orbit with a back yard rocket motor smaller than a car engine; even Armstrong and Aldrin had proved that. People went through suborbital lobs longer than Alan Shepard's just to go *shopping*. Lunar inhabitants were nature's astronauts.

But not to those Earthborn mission planners in New Houston, however.

She supposed it was pride.

Well, it would pass, with time. After all, when the present generation had retired, there would be no more Earth-born, *ever*.

So she put up with their prejudices, and waited for her own time to come, and listened to their stories—endless stories, five billion of them—tales of the time before the Bottleneck, of bravery and disaster and displacement—of

unlikely acts of heroism linked with names in her own family lines—and of even earlier times, of an incomprehensible, vanished world, when everyone believed the Earth would forever be their home, as it always had . . .

But she didn't want to wait for dead men's shoes.

She pulled herself tentatively along the slide wire, and made her way to the PMU station, on the starboard side of the hab module. The Personal Maneuvering Unit was a big backpack shaped like the back and arms of an armchair, with foldout head and leg rests on a tubular frame. Nadezhda ran a quick check of the PMU's systems.

Then she turned around, and backed into the PMU.

"*Sagan,* Nadezhda," she said. "Suit latches closed."

Copy that.

She pulled the PMU's arms out around her and closed her gloved hands around the hand controllers on the end of the arms. She unlatched the folded up body frame. She rested her neck against the big padded rest, and settled her feet against the narrow footpads at the bottom of the frame, so she was braced. Today's EVA was just a test reconnaissance, but a full field expedition to Icarus could last all of eight hours; the frame would help her keep her muscle movements down, and so reduce resource wastage.

Nadezhda released her tethers. A little spring-loaded gadget gave her a shove in the back, gentle as a mother's encouraging pat, and she floated away from the bulkhead.

. . . Suddenly she didn't have hold of anything, and she was falling.

She had become an independent spacecraft. The spidery frame of the PMU occulted the dusting of stars around her.

She tested out her propulsion systems.

She grasped her right-hand controller, and pushed it left. There was a soft tone in her helmet as the thruster worked; she saw a faint sparkle of exhaust crystals, to her

right. In response to the thrust, she tipped a little to the left.

When she started moving, she just kept on going, until she stopped herself with another blip of her thrusters.

She turned in space, and looked at the Moon.

She pressed a stud on the side of her helmet, and the Moon's image was magnified, so that its crescent filled her helmet. And the crescent's edge was softly blurred by a band of light, which stretched part way around the darkened hemisphere.

Sparks crawled over the globe: ocean-going vessels, surface cars, low-orbit spacecraft. There were more lights, strung out in lines, on the darkened surface itself: towns and cities, outlining hidden continents. Buildings on the Moon were mostly made entirely of glass; lunar glass, manufactured from deep-lying dehydrated lunar ore, was incredibly strong. From space, all that glass made the cities *bright*.

But the sun-shadowed hemisphere was not truly dark, for it basked in the light of the *Noviy Svet*—the Russian-designed solettas, the huge mirror farms built and launched by Boeing and Kawasaki Heavy Industries, artificial suns which cast enough daylight over the shadowed half of the Moon to keep its new air from snowing out in the weeks-long night. The solettas worked well, and anyhow the engineers said the Spin-Up should be completed before the solettas reached the end of their design life.

Not that anybody was confident of predicting when that would be, since the solettas, grown from lunar rock, were the first large-scale application of Moonseed-derived technology.

She could see the cold deserts of the lunar poles, bone white.

On the Moon, the weather was simple. Sunlight lifted masses of moist warm air over the equator; the air quickly dumped its moisture, in sometimes violent rainstorms, and, displaced by colder, lower layers of air, the hot air drifted to the poles. There it cooled and sank, dry and cold, creating

deserts, and joined the circulation back to the equator.

So there you had it. The prevailing winds were hot, dry air coming out of the poles, deflected a little by the Moon's sluggish spin, shaped and moistened by the bodies of water it passed, the maria and the great crater lakes.

On the Moon, there were no weather forecasters.

She couldn't remember much of Earth, before the Bottleneck. She found it hard to understand how *big* it had been, so big there had been room for more than one air circulation cell per hemisphere, so big there had been room for too much weather. Bizarre.

Anyhow, the Moon's North Pole was the site of something much more interesting than weather, as far as Nadezhda was concerned. It was from the Pole that the great deep-core drilling project had been initiated by the Americans: a thousand-mile shaft designed to reach all the way to the Witch in the Well, the ancient, shattered hive at the heart of the Moon which, until now, had only been visible by seismic probes and neutrino light. And nobody knew what treasures *that* would bring.

The Moon's highlands and Farside were visibly peppered with circular crater lakes, glimmering in soletta light. The first oceans, which had pooled in the basins of the old maria, still glittered blue where they had formed, all over the hemisphere which was still called Nearside; but they had been shrinking steadily since then. The problem was drainage. The oceans evaporated, the water returning as rain; but every time rain fell on the highlands it got trapped in the high craters. As the Moon had been born dry, there was no natural drainage to return the water to the oceans, as on Earth.

So great channels were being dug, canals to restore the water to the oceans. Nadezhda could see Tycho-Nubium, for instance, a straight line thread of blue light.

Thus, on the Moon, by the side of the canals with their huge waves and feathery pleasure boats, the crystal cities glistened in the sun.

As she looked at the Moon's surface now, it was pre-

dominantly blue and white, ocean and cloud, or the powder gray or baked red of desert. Much of the Moon was still not much more habitable than it had been for Meacher and Bourne themselves. It would take some time for the green of life to show on the Moon.

It would come.

But the Moon would never be a shrunken twin of vanished Earth. The engineers' dreams would see to that. They could do a lot better.

There was a scheme to go further than Spin-Up. Perhaps the black hole wind from ruined Earth could be used to *move* the Moon: to the orbit of Jupiter, perhaps, where there were whole worlds full of frozen volatiles, waiting to be tapped . . .

Or even farther, to the stars themselves.

But that was the future. For today, Nadezhda had work to do.

Nadezhda tipped herself up so she was facing Icarus, with the *Sagan* behind her.

"*Sagan*, I'm preparing to go in."

We copy, Nadezhda.

She fired her thruster. Computer graphics started to scroll across the inside of her face plate, updating burn parameters. She was actually changing orbit here, and she would have to go through a full rendezvous procedure to reach Icarus.

The angle of the sun was changing, and the slanting light changed Icarus from a flat silhouette to a potato-shaped rock in space, fat and solid. Icarus was crumpled, split by ravines, punctured by craters of all sizes, the beat-up surface a record of this little body's dismal, violent history. There was one massive crater that must have been a half mile across, its walls spreading around the cramped horizon.

The rock was more than three miles long, spinning on its axis once every twenty hours. It was as black as coal

dust. Icarus was a stony asteroid, its substance baked dry of water and other volatiles by a billion years of passes around the sun, here in the hot heart of the Solar System.

Primordial rock. Ideal resource for the Moonseed.

It was a decade now since Icarus had been deliberately implanted with Moonseed, by an automated probe. The purpose was to test experimental asimov circuits, to see if the Moonseed could be inhibited.

Well, since the asteroid hadn't blown up, the asimov circuits seemed to have worked. And now, Nadezhda was here to find out what the Moonseed had built, at the heart of the asteroid. *We know you can make solar sails. We know you can turn planets into black hole guns. Now let's see what the hell else you can do . . .*

Even now, nobody understood the Moonseed. But there were those who believed the Moonseed was not malevolent.

Look at the evidence. This hive thing crashes into a primordial Earth, that was probably too big anyhow. It creates a Moon, just big enough to kick up the geological stuff that enabled life to start up in the first place. Then, just when we've had time to get smart enough to survive it all—in fact, don't forget, our intelligence, bringing the Moonseed to Earth, was the trigger for this happening—it takes Earth apart, gives us a tool kit to rebuild other worlds, and gives us a way to the stars . . .

This is no threat. The Moonseed is no Berserker. It's a life-giver.

There were other unanswered questions.

Why had the destruction of Venus taken such a different course from Earth's?

Why was Mercury spared? And Mars, come to that—after all, craft from Earth had landed on Mars before they reached Venus.

Maybe it was just accident. Or maybe it was design.

Or maybe the Moonseed, for all its power, was like plankton—the bottom of some cosmic food chain whose upper reaches humans couldn't even glimpse.

Maybe. Maybe not. Nobody knew for sure. But as Earth receded in memory, there were more who were prepared to give the Moonseed the benefit of the doubt.

At a computer prompt, she prepared for her final burn. "Ready for Terminal Initiation."

Copy that, Nadezhda.

One last time the thrusters fired, fat and full.

Coming up to your hundred-yard limit.

"Copy that."

She came to a dead stop, a hundred yards from the surface of Icarus. The asteroid's complex, battered surface was like a wall in front of her. She felt no tug of gravity—Icarus's G was a thousandth of the Moon's—it would take her more than two minutes to fall in to the surface from here, compared to a few seconds on the Moon.

She was comfortable. The suit was quiet, warm, safe.

She blipped her cold-gas thrusters, and drifted forward a little more quickly. This wasn't like coming in for a landing; it was more like approaching a cliff face that bulged gently out at her, its coallike blackness oppressive.

She made out more detail, craters overlaid on craters down to the limit of visibility. She tweaked her trajectory until she was heading for the center of a big crater, away from any sharp-edged walls or boulder fields.

Then she just let herself drift in, at a yard a second. If she used the thrusters anymore she risked raising dust clouds that wouldn't settle.

There were four little landing legs at the corners of her PMU frame; they popped out now, little spear-shaped penetrators designed to dig into the surface and hold her there.

The close horizon receded, and the cliff face turned into a wall that cut off half the universe.

She collided softly with Icarus.

The landing legs, throwing up dust, dug into the regolith with a grind that carried through the PMU structure. The dust hung about her.

So Nadezhda was stuck here, clinging to the wall inside

her PMU frame, like a mountaineer on a rock face in the Lunar Apennines.

She turned on her helmet lamp. Impact glass glimmered before her.

Unexpectedly, wonder pricked her. Here was the primordial skin of Icarus, as old as the Solar System, just inches before her face. She reached out and pushed her gloved hand into the surface, a monkey paw probing.

The surface was thick with regolith: a fine rock flour, littered with glassy agglutinates, asteroid rock shattered by eons of bombardment. Her fingers went in easily enough for a few inches—she could feel the stuff crunching under her pressure, as if she was digging into compacted snow—but then she came up against much more densely packed material, tamped down by the endless impacts.

She closed her fist and pulled out her hand. A cloud of dust came with it, gushing into her face like a hail of meteorites. She looked at the material she'd dug out. There were a few bigger grains here, she saw: it was breccia, bits of rock smashed up in multiple impacts, welded back together by impact glass. There was no gravity to speak of; the smallest movement sent the fragments drifting out of her palm.

She had to get on with her work, think about her checklist. But she allowed herself a moment to savor this triumph.

She was, after all, the first human to touch the surface of a whole new world since Neil Armstrong.

And the Moonseed was *here:* hardened and eternal, riding the winds that blow between the stars. And now a human had come to meet it, on equal terms.

She grinned at the dust. "We need to talk," she said.

Nadezhda? We don't copy.

"Never mind."

She pushed her hand back into the pit she'd dug, and went to work.

AFTERWORD

Kent Joosten of the Solar System Exploration Division, NASA Johnson Space Center, was once again extremely generous in hosting my research at JSC and taking me through the modern mission studies which formed the basis of the lunar expedition featured here, and also reading drafts of the manuscript later; thanks also to Eric Brown for reading a draft. I'm indebted for assistance with the Edinburgh-based sections of this book to Dr. Roger Scrutton, head of the Department of Geology and Geophysics, Edinburgh University; and to Peter Willdridge, Emergency Planning Officer, Buckinghamshire.

NASA's *Apollo Lunar Surface Journal,* annotated transcripts of the Apollo missions, is available online and was an invaluable source on the astronauts' experience of the Moon. I learned about lunar geology and resources from Paul Spudis's *Once and Future Moon* (1996), *The Lunar Source Book* ed. G.H. Heiken (1991), *Lunar Bases and Space Activities in the 21st Century* ed. W. Mendell (1986) and other references. The unlikely art of harenodynamics was suggested by Krafft Ehricke in a paper printed in *Lunar Bases.* Terraforming the Moon has been explored by Martyn Fogg in his masterly *Terraforming* (1995) and by earlier authors; I'm indebted to Martyn for his blunt review of an early draft of my terraforming scenario here.

Any errors are, of course, all mine.

It seems we really could get back to the Moon for under two billion dollars. The Moonseed may not be waiting for us—but a sister world is.

<div style="text-align: right">

Stephen Baxter
Great Missenden
March 1998

</div>